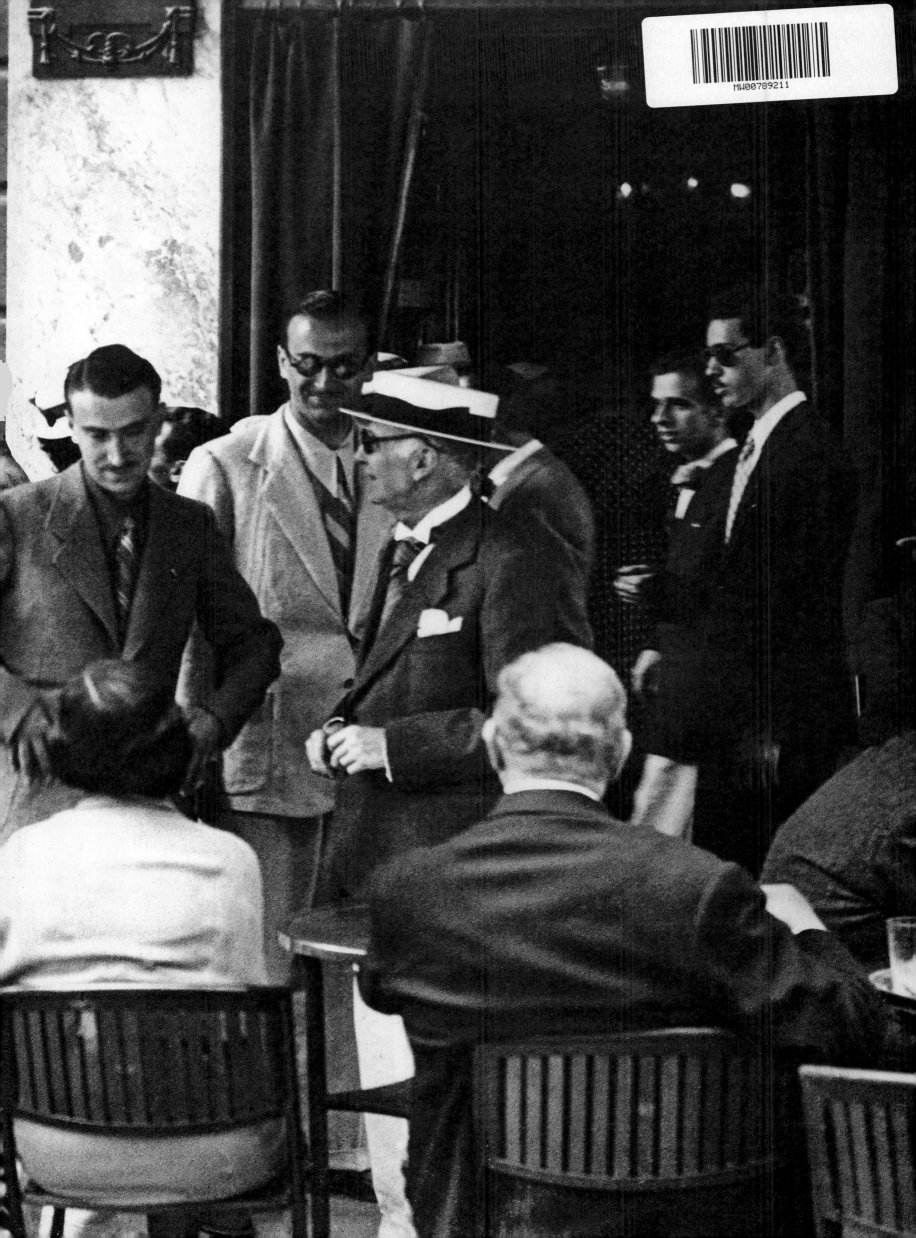

Rome

Giovanni Fanelli

Rome

Portrait of a City • *Porträt einer Stadt* • *Portrait d'une ville*

TASCHEN

Contents / Inhalt / Sommaire

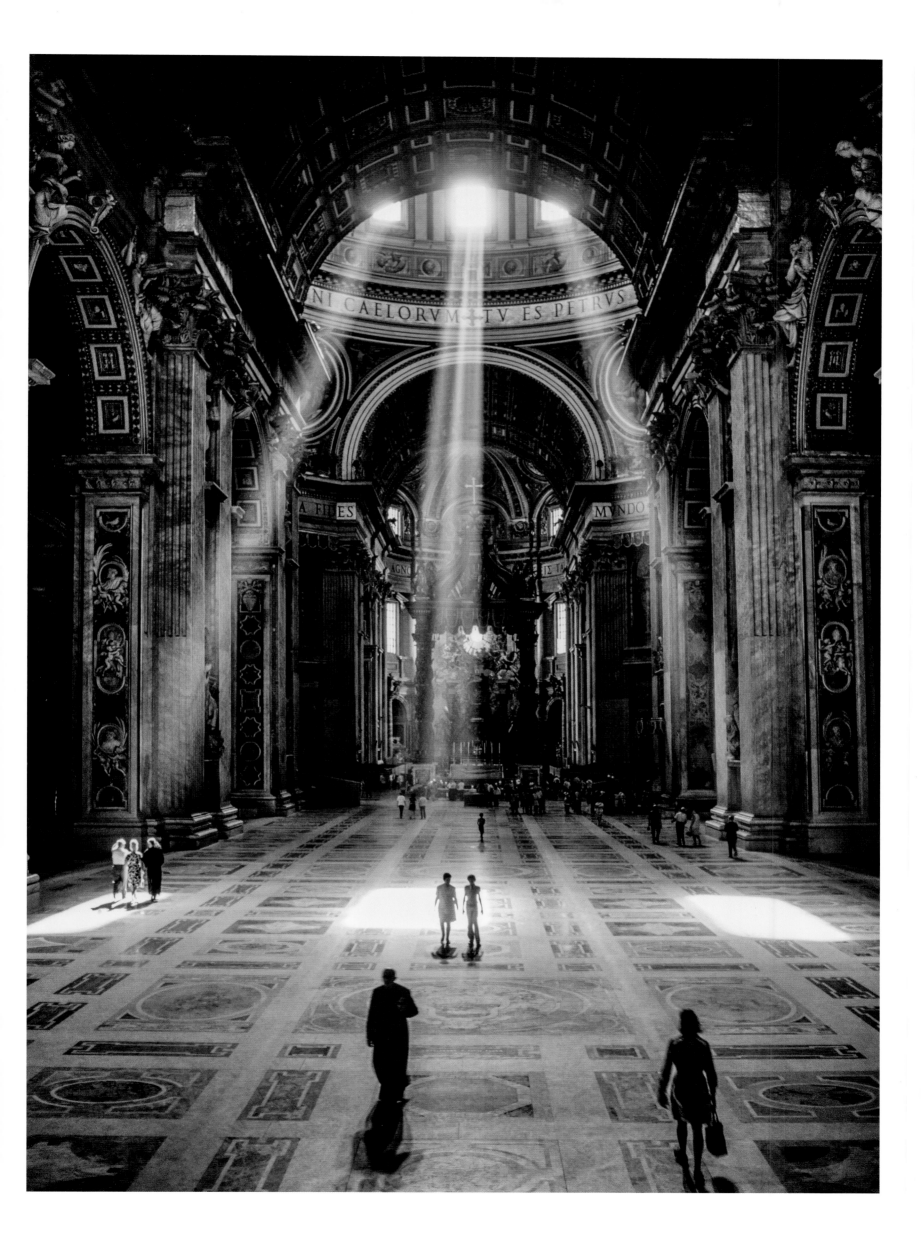

1

From Capital of the Papal States to Capital of Italy 1839–1870

p. 5
Dmitri Kessel

The architecture of St. Peter's Basilica gives the interior light a particular quality that makes things look huge. There is no darkness, no marked shadows, only countless light effects, 1963.

Die Architektur des Petersdoms erzeugt eine ganz besondere Stimmung. Alles wirkt beeindruckend, nirgends herrscht Dunkelheit, kaum scharfe Schatten, der Raum ist erfüllt von lebendiger Helligkeit, 1963.

L'architecture de la basilique Saint-Pierre confère à la lumière intérieure une qualité particulière qui agrandit tout. Il n'y a là ni ténèbres, ni ombres marquées, mais seulement d'innombrables effets de lumière, 1963.

*"Only in the city that dominated the pagan world and unified
the Christian world in its womb could Victor Emmanuel, Pius IX and
Garibaldi coexist without anyone giving it another thought."*
GIGGI ZANAZZO, *I PROVERBI ROMANESCHI,* 1886

Roma aeterna, caput mundi, aurea, maxima, pulcherrima, sacra.

Following a time of radical upheavals, Rome, once the capital of the Papal States, became the capital of Italy.

During his papacy – the longest in modern history (1846–1878) – Pius IX embraced a moderately progressive policy, initiating social, technological, and artistic advances, though his aim was mainly to provide assistance rather than to prevent or solve the problems that stood in the way of Rome achieving a cultural and economic development comparable to that of central and northern Europe.

The first railways connecting Rome with other cities was one of his initiatives: in 1856, Rome-Frascati, and in 1859 Rome-Civitavecchia, which required building the iron bridge of San Paolo over the river Tiber. In 1862 the opening of the Rome-Ceprano line coincided with the inauguration of Termini station (then called Central Station of the Roman Railroads), which united and replaced the stations of Porta Maggiore (1856) and Porta Portese (1859). The urban development of this area began, and the first stretch of via Nuova Pia (later via Nazionale) was built, connecting the station with the city center.

A gas works that was opened in Trastevere in 1846 enabled the transformation of the whole street lighting system. In 1854, for the first time, St. Peter's Square, Via Papale, Via del Corso, Piazza del Gesù, and Piazza Venezia were illuminated at night. Alongside the limited forms of public transport that existed, the first scheduled, public horse-drawn omnibus connecting the residential zones of the city opened in 1866: one line went from Piazza del Popolo to Piazza Venezia, and another to St. Peter's. Hospitals were constructed or renovated: Fatebenefratelli, 1865; Santo Spirito, 1856–1860; the lunatic asylum in 1864–1867. Schools for underprivileged children were built in some working-class districts. Many churches were restored, and a number of interventions were carried out in the Vatican complex. Piazza del Quirinale was completed, and the column of the Immaculate Conception was installed in Piazza di Spagna. As a result of private initiatives, many building units were joined with adjacent ones and raised in height, a process that altered the traditional relationship between the physical prominence of the aristocratic palaces and the surrounding landscape of streets and piazzas.

Although these initiatives were not at the same level of growth as seen in other major European capitals, they heralded a period of modernization; Rome, however, remained underdeveloped and failed to make progress from its pre-industrial conditions: half of its population was unemployed, 78 per cent illiterate (there were many public scribes all over the city), and 30 per cent lived on subsidies, donations, and charity; there were almost 8,000 members of the clergy; the only industry was tobacco manufacture, which started in 1863, employing around 1,000 workers; tourism was the main source of income; due to a deficient sewer system and to recurring malaria epidemics from the surrounding countryside, the health of the population was precarious; there were frequent public executions. The clergy held all the powerful roles in the administration and the judiciary in the city. "A great number of people," observed Hippolyte Taine in 1866, "live in Rome, who knows how, they have neither income nor trade [...] They make ends meet by all sorts of means and expedients."

Streets and piazzas were the Romans' real home, especially during the summer; for longer chats they used the taverns. The Sunday stroll in Villa Borghese was something of a ritual for the aristocratic and upper-class families, providing fodder for gossip throughout the following week. Until 1865, on Saturdays and Sundays in August the fountain drains in Piazza Navona – which at the time had a slightly concave ground – were shut off, flooding the whole area and forming a "lake," a tradition that began in the 17th century, possibly from a suggestion by Bernini. Arriving in coaches, the nobility and the clergy converged there to be refreshed. From the adjacent streets, drivers, carters, stable hands, and cavalry squadrons brought their horses to drink. The piazza was still used for public games and entertainment, like the maypole, raffle and tombola, or for puppet shows, merry-go-rounds, and tightrope walkers.

In the 19th century, Rome was more and more one of the favorite destinations for travellers on their Grand Tour; by 1860 the first grand hotels were being built.

Rome was a subject for photographers from the very beginning of this medium, with the daguerreotype and the calotype; in June 1841 Lorenzo Suscipj produced a rare daguerreotype landscape in eight plates; and several images of Rome featured in the *Excursions daguerriennes* by Noël-Marie Paymal Lerebours (1840–1843). In the course of a few years, Rome became one of the European capitals of photography, and the technique spread widely. It was through photography that architectural and urban projects (particularly railways) initiated by the papacy were documented, but it was mainly used to immortalize visitors'

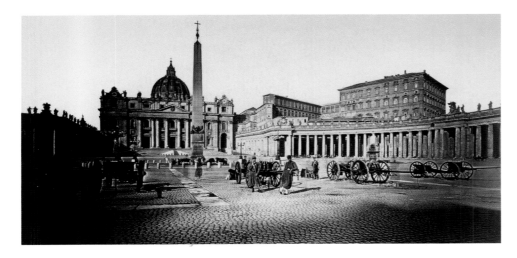

←
Robert Macpherson

St. Peter's Square, one of the major urban "theaters" in Rome, is animated by the presence of papal soldiers and cannons, with a particular effect created by their actual and reflected shadows, c. 1867.

Der Petersplatz ist einer der monumentalsten Plätze Roms, hier im Wechselspiel von Halb- und Schlagschatten; päpstliche Soldaten mitsamt Kanone lockern das Bild auf, um 1867.

La place Saint-Pierre, l'un des principaux « théâtres » urbains de Rome, est animée par la présence des soldats du pape et des canons, et par un effet d'ombres propres et d'ombres portées, vers 1867.

favorite sites of the "eternal city." Photographers included many expatriates and aristocrats who had an interest in the sciences, and who enjoyed photography as a hobby. Some (Frédéric Flachéron, Giacomo Caneva, James Anderson, Eugène Constant, Alfred-Nicolas Normand) earned the nickname of the "circle of the Caffè Greco," as they gathered almost every day at the renowned café of that name. Many of them were trained sculptors or painters.

Some, like James Anderson or Robert Macpherson, took pictures of architecture from antiquity, the Renaissance and the Baroque era, the Tiber and the scenic piazzas, but rarely the streets. Some of them produced their first printed catalogues with the intention of appealing to travellers visiting the city. Architect Adriano De Bonis, in 1859 and the 1860s, is now recognized as a great photographer of architecture and urban spaces. Francis Wey, the critic of *La Lumière*, used tens of his images for woodcuts on a series of articles on Rome published in *L'Illustration, journal universel*, later collected in the volume *Rome* (1872).

The painters and architects who had fellowships at Villa Medici were particularly interested in Roman archaeology. Architect Alfred-Nicolas Normand surveyed and photographed monuments. An erudite patron of the arts and a passionate scholar of archeology, the Englishman John Henry Parker photographed and documented various stages of archeological excavations. As founder of Rome's British and American Archaeological Society, between 1864 and 1877 Parker sponsored a series of photographic campaigns documenting the remains of art and architecture from

antiquity and the Middle Ages discovered on the Palatine Hill, in the Roman Forum, and the Baths of Caracalla; later, he took an active interest in the threatened monuments that would be destroyed to make space for the wide new roads being built in the city center. In this documentary campaign he collaborated with Carlo Baldassarre Simelli, Charles Smeaton, Adriano De Bonis, Giovanni Battista Colamedici, Filippo Lais, Francesco Sidoli, Filippo Spina, and Pompeo Molins (who owned Parker's archive of negatives). Thanks to photogravure, Parker used part of the impressive photographic documentation of the almost 4,000 images he amassed to compile his oeuvre in 13 volumes, *The Archaeology of Rome* (1874–1878), which was first sold in the Spithöver bookshop in Piazza di Spagna.

Brothers Antonio and Paolo Francesco D'Alessandri were renowned photographers at the papal court (Antonio was himself a priest). For a time they had the exclusive rights on the portraits of Pius IX and his court; they also photographed the drills of the Vatican army and the battlefields of Mentana and Monterotondo (some of these featured as woodcuts in *L'Illustration*).

The pope's efforts, supported by the long-established alliance with France, to prevent the new Italian state from annexing Rome and its territories proved futile, for in 1870 Italian troops broke through the gate of Porta Pia and entered the city, thus marking the end of the pope's temporal power. In the same year, for the first time the members of the city council were appointed by election. In 1870 Rome had around 225,000 residents (about one-tenth of the population of Paris).

→
Anonymous

The Roman Forum was a dream come true for archeologists from Rome and abroad, but it was also a magical space where pasture land was interspersed with the remains of magnificent monuments, parked carts, craftsmen carrying out their trades in front of the poor hamlet houses. It was even used as a place to dry laundry in the sun, 1857.

Das Forum Romanum: ein Paradies für römische ebenso wie für zugereiste Archäologen. Aber auch ein Ort wie aus dem Märchen: Zwischen den Ruinen einer großen Vergangenheit weiden Kühe, werden Fuhrwerke abgestellt, und man geht seinem Handwerk nach wie auf einem Dorfplatz; auch die zum Trocknen aufgehängte Wäsche gehört dazu, 1857.

Le Forum romain, paradis des archéologues romains et étrangers, était un espace féérique où se mêlaient aux vestiges de monuments grandioses les pâturages des troupeaux, le parcage des chars, les activités artisanales exercées devant de misérables maisonnettes paysannes. On l'utilisait également pour étendre et faire sécher le linge, 1857.

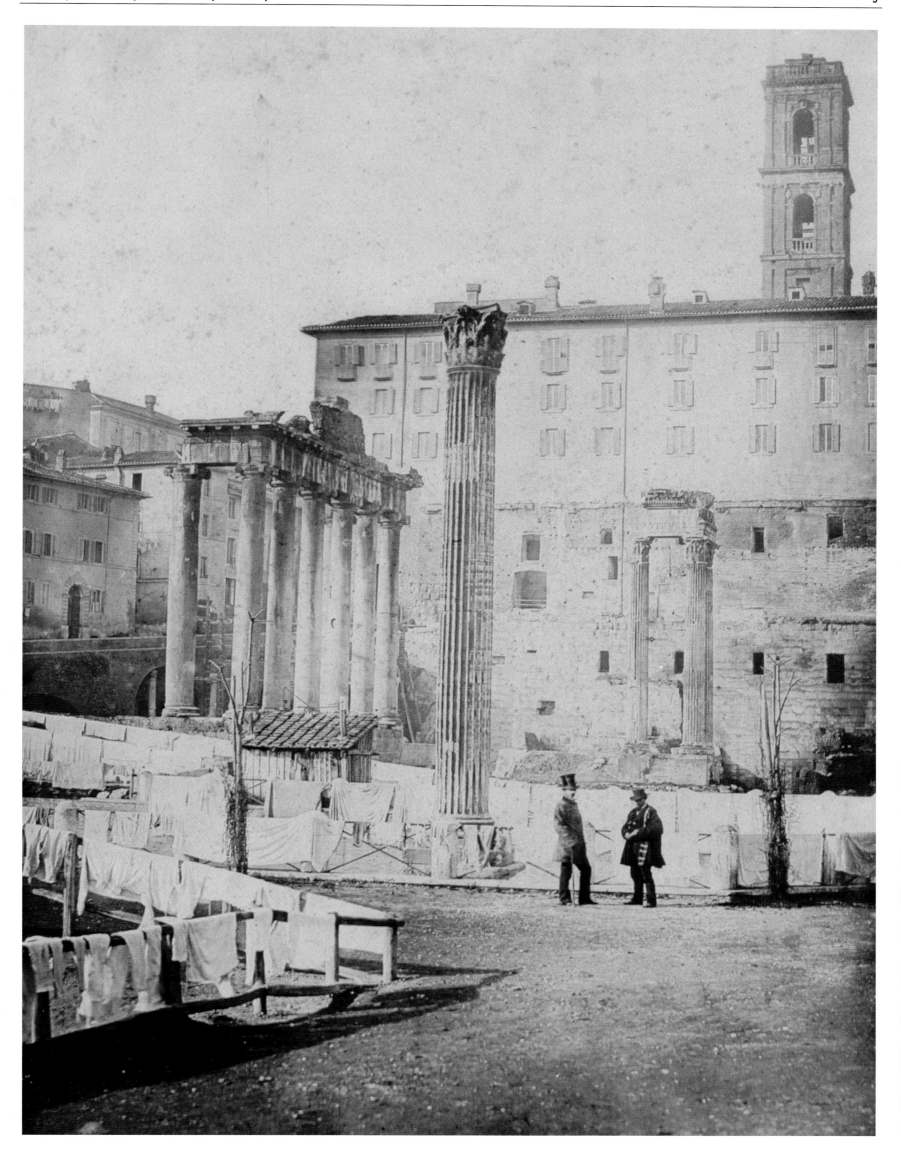

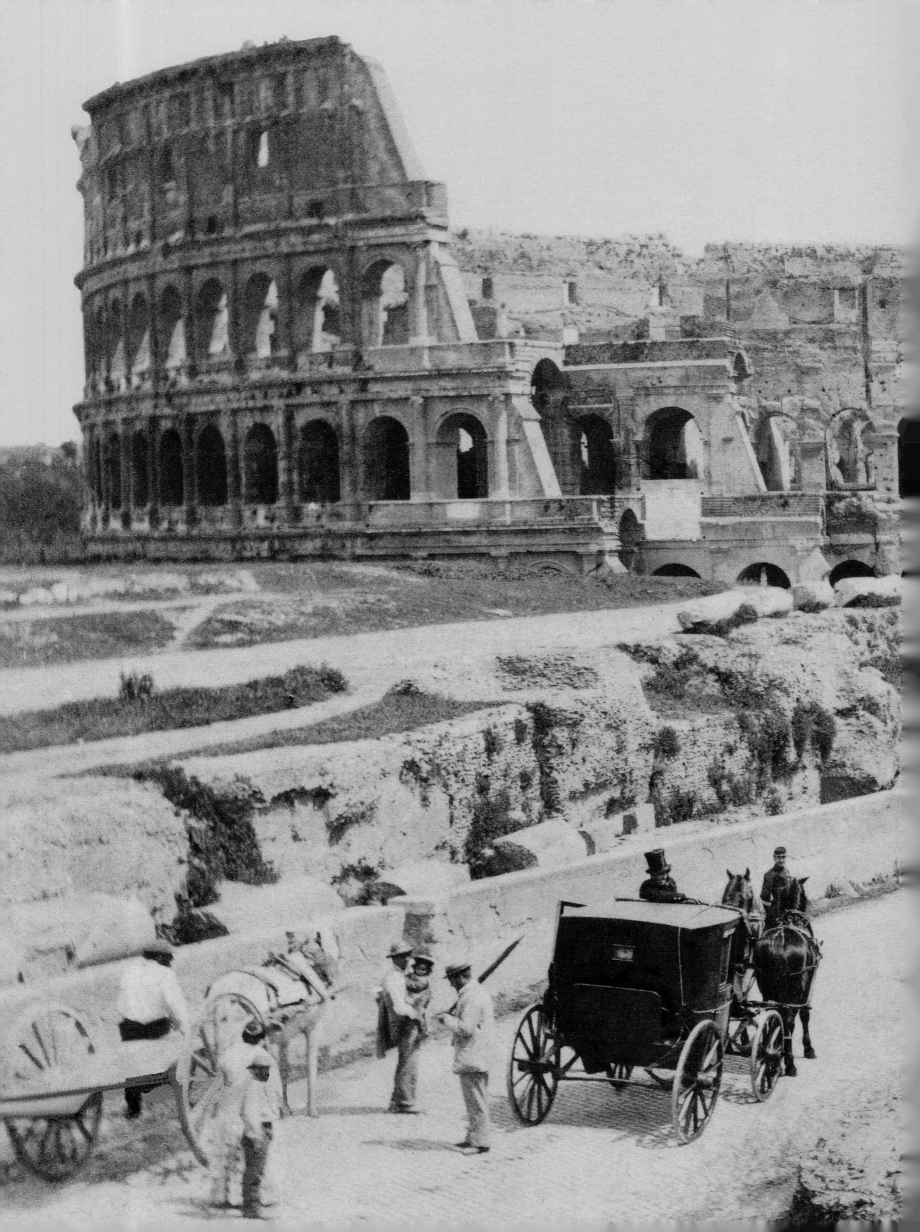

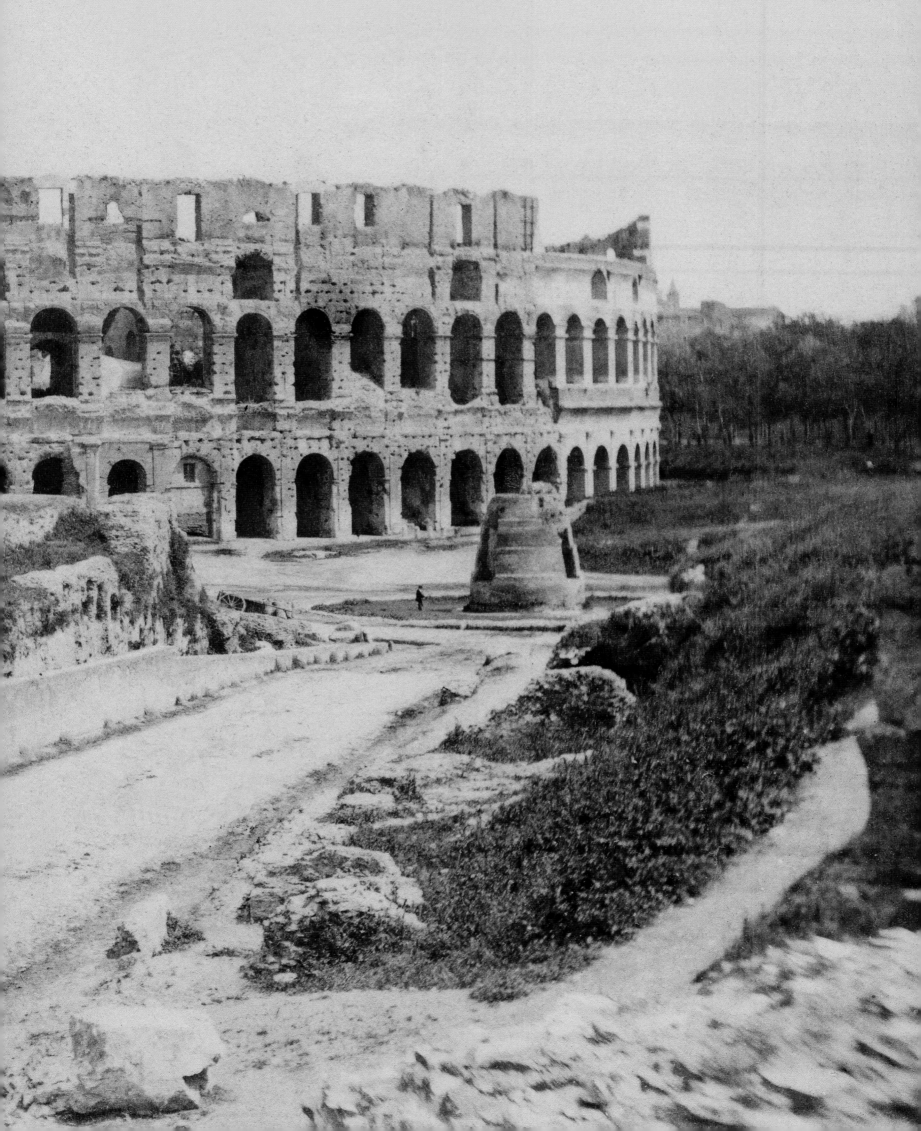

I

Von der Kapitale des Kirchenstaats zur Hauptstadt Italiens 1839–1870

pp. 10/11
Fratelli D'Alessandri

The Colosseum viewed from the Arch of Titus. At the end of the perspectival view, in which there is a wagon and an elegant carriage, we see the truncated cone of the Meta Sudans, the fountain of the age of Domitian that took its name ("sweating cone") from the droplets of water that gushed from its bronze top through small holes into the circular basin (demolished in 1934 during the creation of Via dei Fori Imperiali by order of Mussolini), c. 1860–1865.

Das Kolosseum vom Titusbogen aus gesehen. Fluchtpunkt der von einem Lastkarren und einer Pferdekutsche belebten Blickachse ist der Kegelstumpf der Meta Sudans, eines Brunnens aus der Zeit Kaiser Domitians, aus dessen bronzener Spitze durch kleine Löcher Wasser in ein kreisförmiges Becken darunter rieselte (beim Bau der Via dei Fori Imperiali unter Mussolini 1934 abgetragen), um 1860–1865.

Le Colisée, photographié depuis l'arc de Titus. Au point de fuite de la perspective marqué par un chariot et une élégante voiture à cheval s'élève le cône tronqué des vestiges de la Meta Sudans (« borne qui suinte »), fontaine construite sous Domitien, qui doit son nom à son sommet en bronze percé de petits trous par lesquels l'eau s'échappait avant de s'écouler dans le bassin circulaire. Elle fut démolie en 1934 lors de la création de la via dei Fori Imperiali décidée par Mussolini, vers 1860–1865.

p. 14
Michele Petagna

During the 19th century, stereoscopic photographs were very popular. Until 1867, Piazza Navona was flooded on Sundays throughout the summer, to refresh the horses and the wheels of carriages, 1864.

Während des 19. Jahrhunderts erfreuten sich Stereoskopaufnahmen großer Beliebtheit. Bis 1876 wurde die Piazza Navona an den Sonntagen der Sommermonate unter Wasser gesetzt, um von Pferd und Kutsche aus das kühle Nass genießen zu können, 1864.

Au XIXᵉ siècle, les photographies stéréoscopiques connurent un vif succès. Jusqu'en 1867, la piazza Navona était inondée les dimanches d'été pour permettre aux chevaux et aux roues des carrosses de se rafraîchir, 1864.

„Nur in einer Stadt, welche über die antike Welt geherrscht und die christliche in ihren Schoß aufgenommen hatte, konnten König Viktor Emanuel, Papst Pius IX. und Garibaldi zur selben Zeit leben, ohne dass jemand daran Anstoß nahm."
GIGGI ZANAZZO, *I PROVERBI ROMANESCHI*, 1886

Roma eterna, caput mundi, aurea, maxima, pulcherrima, sacra.

Wechselvolle politische Ereignisse führten dazu, dass 1871 aus der Hauptstadt des Kirchenstaates der Regierungssitz des vereinten Italiens wurde.

Unter dem Pontifikat Pius' IX., der von 1846 bis 1878 regierte und damit länger als jeder andere Papst seit Beginn der Neuzeit, waren vorsichtige Neuerungen im technischen, kulturellen und sozialen Bereich in Angriff genommen worden. Doch lag der Schwerpunkt der Reformen auf der Linderung offenkundiger Probleme und weniger auf der Beseitigung all jener Hindernisse, die dem Anschluss Roms an die kulturellen und wirtschaftlichen Entwicklungen im Wege standen, die im Europa nördlich der Alpen vor sich gingen.

Unter Pius IX. erhielt der Kirchenstaat seine ersten Bahnlinien: 1856 wird die Strecke Rom–Frascati eröffnet, 1859 Rom–Civitavecchia – verbunden mit dem Bau der Eisenbahnbrücke von S. Paolo über den Tiber – und 1862 die Verbindung Rom–Ceprano. Zur Aufnahme des Zugverkehrs nach Ceprano erfolgte die Einweihung des am Rande der damaligen innerstädtischen Bebauung errichteten Bahnhofs Termini. Als Zentralbahnhof der Römischen Eisenbahnen sollte er die Stadtbahnhöfe an der Porta Maggiore von 1856 und der Porta Portese von 1859 ersetzen. Die Gegend um Termini wird nun bebaut, als Verkehrsader Richtung Altstadt das erste Teilstück der Via Nuova Pia, der heutigen Via Nazionale realisiert.

1846 nimmt im Stadtbezirk Trastevere das erste Gaswerk der Tiberstadt seinen Betrieb auf, sodass die Straßenbeleuchtung nach und nach auch in Rom auf Gas umgestellt werden kann. 1854 brennen am Petersplatz die ersten Gaslaternen, ebenso an der Via Papale, der Via del Corso, der Piazza del Gesù und der Piazza Venezia. Hatte es bisher nur vereinzelte Ansätze zu einem öffentlichen Personentransportwesen gegeben, werden nun die ersten Pferde-Omnibusse auf festen Strecken innerhalb des Stadtgebiets und mit einem offiziellen Fahrplan in Dienst gestellt. 1866 nimmt die Linie von der Piazza del Popolo zur Piazza Venezia den Betrieb auf, ferner eine zweite mit Endhaltestelle Petersplatz. Neue Krankenhäuser werden gebaut und alte erneuert: 1856 bis 1860 S. Spirito unweit des Vatikans, 1865 das Hospital der Fatebenefratelli auf der Tiberinsel, 1864 bis 1867 die römische Nervenklinik. In einigen Vierteln öffnen Schulen für Kinder aus einfachen Verhältnissen ihre Pforten. Etliche Kirchen werden restauriert, und auch im Vatikan wird gebaut; der Quirinalsplatz erhält eine neue Gestalt, und auf der Piazza di Spagna wird zum Gedenken an die Verkündigung des Dogmas der Unbefleckten Empfängnis eine Mariensäule aufgestellt. Gleichzeitig führt die Aufstockung und Zusammenlegung bestehender Häuserblocks zu einer spürbaren Veränderung des vom Wechsel großer Adelspaläste mit weiten Plätzen und umgebender Bebauung geprägten überkommenen Stadtbilds.

Für das päpstliche Rom bedeuten diese Initiativen – wenn auch in sehr viel bescheidenerem Maßstab als in anderen europäischen Metropolen – ein Stück Modernisierung, doch noch immer hinkt die Stadt der Entwicklung hinterher, verharrt auf vorindustriellem Niveau, ihre Haupteinnahmequelle ist der Tourismus. Die Hälfte der Bevölkerung hat keine Arbeit, die Analphabetenrate liegt bei 78 Prozent (daher die zahlreichen Lohnschreiber, die in der Stadt ihre Dienste anbieten), fast ein Drittel aller Römer lebt von Zuwendungen, Spenden und mildtätigen Gaben. Allein die Zahl der Kleriker beträgt 8000, während produzierendes Gewerbe im industriellen Maßstab fast völlig fehlt (sieht man von einer 1863 eröffneten Tabakfabrik ab, die knapp 1000 Menschen beschäftigt). Aufgrund des unzureichenden Abwassersystems sind die hygienischen Bedingungen teils prekär, dazu kommt die aus den Sümpfen der römischen Campagna eingeschleppte Malaria. Hinrichtungen sind an der Tagesordnung, sämtliche Schaltstellen in Justiz und Verwaltung werden von Klerikern besetzt. 1866 spricht Hippolyte Taine von „einer Unzahl Menschen, die wer weiß wovon lebt, ohne Einkommen und ohne Beruf [...] Man behilft sich, wie es eben geht."

Das eigentliche Zuhause der Römer sind, vor allem im Sommer, die Straßen und Plätze, daneben die zahlreichen volkstümlichen Gasthäuser. Fester Gewohnheit folgend flanieren Adel und Bürgertum allsonntäglich durch den Park der Villa Borghese, was Anlass für genügend Klatsch unter der Woche bietet. Bis 1865 verstopft man an den Samstagen und Sonntagen im August – wie schon im 17. Jahrhundert und wohl auf Anregung Berninis – die Abflusslöcher der Brunnen auf der Piazza Navona, das Wasser flutet auf die leicht konkav gewölbte Fläche des Platzes und verwandelt ihn in einen künstlichen See. Adel und Klerus lassen sich über das kühle Nass kutschieren, aus den Nebenstraßen führen Kutscher, Fuhrleute und Reitknechte ihre Pferde herbei, um sich auf der Piazza zu erfrischen, ebenso verfährt die päpstliche Kavallerie. Auch sonst

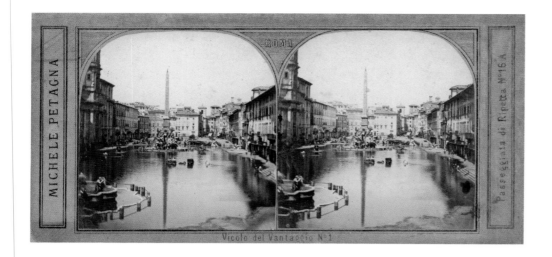

MICHELE PETAGNA

ROMA

Passeggiata di Ripetta N°16 A

Vicolo del Vantaggio N°1

→
Adriano De Bonis

Villa Giulia was built (1551–1553) by Pope Julius III as his country residence on the right bank of the Tiber, c. 1860.

1551 bis 1553 ließ Papst Julius III. vor den Toren der Stadt am rechten Tiberufer die Villa Giulia errichten, zu der er sich einmal pro Woche mit dem Boot bringen ließ, um dort zu entspannen, um 1860.

La villa Giulia était la résidence de campagne que le pape Jules III fit édifier en 1551–1553 sur la rive droite du Tibre ; il s'y rendait en barque une fois par semaine pour se reposer, vers 1860.

ist die Piazza Ort für Vergnügungen und allerlei Belustigungen der volkstümlichen Art: Maibaumklettern, Verlosungen und Gewinnspiele, Puppentheater, Akrobaten und Seiltänzer – sie alle haben hier ihre Bühne.

In der Nachfolge der Bildungsreisenden des 18. Jahrhunderts besuchen auch immer mehr Touristen der Belle Epoque die Ewige Stadt; um 1860 öffnen die ersten römischen Grandhotels ihre Foyers.

Schon in der Frühzeit der Fotografie wird Rom zum Motiv für Daguerreotypien und Kalotypien. Im Juni 1841 bannt Lorenzo Suscipj eines der seltenen Panoramen der Ewigen Stadt in Daguerreotypietechnik auf insgesamt acht Platten; römische Motive finden auch Eingang die *Excursions daguerriennes d'après le daguerréotype* von Noël-Marie Paymal Lerebours (1840–1843). Innerhalb weniger Jahre findet die neue Technik in Rom weite Verbreitung, ja die Tiberstadt kann als eine der ersten Metropolen der europäischen Fotografie überhaupt gelten. Fotografen dokumentieren die päpstlichen Bauvorhaben und städtischen Erneuerungsprojekte, speziell die neuen Eisenbahnen, vor allem aber machen sie Aufnahmen von den beliebtesten Orten und Denkmälern der Ewigen Stadt. Bei diesen Fotografen handelt es sich nicht selten um adlige Amateure mit wissenschaftlichen Interessen, manche von ihnen Ausländer, die sich in Rom niedergelassen haben. Etliche, darunter Frédéric Flachéron, Giacomo Caneva, James Anderson, Eugène Constant, Alfred-Nicolas Normand, treffen sich beinahe täglich Tag im Caffè Greco, deshalb auch die Bezeichnung Caffè-Greco-Zirkel. Viele römische Fotografen jener Jahre haben eine Ausbildung als Bildhauer oder Maler genossen. Einige aus diesem Kreis, James Anderson und Robert Macpherson etwa, richten sich mit ihren Katalogen bevorzugt an Romreisende und lichten deshalb in erster Linie Denkmäler und Bauten aus Antike, Renaissance und Barock ab, dazu Tiberansichten und Veduten der großen Plätze, seltener der römischen Straßen.

Der Architekt Adriano De Bonis – heute für seine Architektur- und Stadtansichten bekannt – betätigt sich schon in den 1860er-Jahren als Fotograf. Dutzende seiner Aufnahmen wurden von Francis Wey, Kritiker der Zeitschrift *La Lumière*, als Grundlage zu den Holzstichillustrationen seiner in der Zeitschrift *L'Illustration* erschienenen und 1872 in dem Band *Rome* wiederabgedruckten Artikelserie über die Tiberstadt verwendet.

Weilten französische Maler und Architekten als Stipendiaten der Villa Medici in Rom, galt ihr Interesse vor allem archäologischen Themen. So entdeckte und fotografierte der Architekt Alfred-Nicolas Normand mehrere antike Denkmäler. Auch der gebildete englische Mäzen John Henry Parker – zugleich passionierter Archäologe – dokumentierte Fortgang und Ergebnis seiner Ausgrabungen mit den Mitteln der Fotografie. Als Gründer der British and American Archaeological Society in Rom regte er zwischen 1864 und 1877 eine Reihe von Fotokampagnen zur Bestandsaufnahme der Architekturspuren und Kunstwerke aus Antike und Mittelalter an, die bei Ausgrabungen auf dem Palatin, dem Forum Romanum und den Caracallathermen zutage gefördert wurden. Später widmete er sich auch historischen Bauten, die im Zuge des Abrisses ganzer Stadtviertel dem Bau neuer Verkehrsachsen weichen mussten. Für seine Kampagnen griff er auf die Mitarbeit von Fotografen wie Carlo Baldassarre Simelli, Charles Smeaton, Adriano De Bonis, Giovanni Battista Colamedici, Filippo Lais, Francesco Sidoli, Filippo Spina und Pompeo Molins zurück (in dessen Besitz sich das Parkers Negativarchiv befand). Aus seinem eigenen, fast 4000 Aufnahmen umfassenden Bestand schöpfte Parker ebenfalls zur Bebilderung seiner 13 Bände umfassenden *Archaeology of Rome* (1874–1878) mit Heliogravüren. Das monumentale Werk wurde zuerst in der Buchhandlung Spithöver an der Piazza di Spagna angeboten.

Als päpstliche Porträtfotografen taten sich die Brüder Antonio (selbst Priester) und Paolo Francesco D'Alessandri hervor, denen zeitweise das alleinige Recht zustand, Bildnisse von Pius IX. und seinem Hof anzufertigen. Daneben stammten von ihnen Fotografien der Exerzierübungen des päpstlichen Heeres sowie der Schlachtfelder von Mentana und Monterotondo, wovon einige als Holzschnitte in *L'Illustration* abgedruckt wurden.

Alle Bemühungen des Papsttums, unterstützt von seinem traditionellen Verbündeten Frankreich, Rom vor einer Annektierung durch den neu entstehenden italienischen Nationalstaat zu bewahren, sollten sich als vergeblich erweisen, als 1870 die Truppen Garibaldis an der Porta Pia eine Bresche in die Stadtmauern schlagen und in Rom einmarschieren. Damit endet die weltliche Regierung des Papsttums über die Ewige Stadt. Im selben Jahr finden die ersten Kommunalwahlen statt. Die Einwohnerzahl von Rom beträgt zu dieser Zeit 225.000 Menschen, gerade einmal ein Zehntel der Einwohnerschaft von Paris.

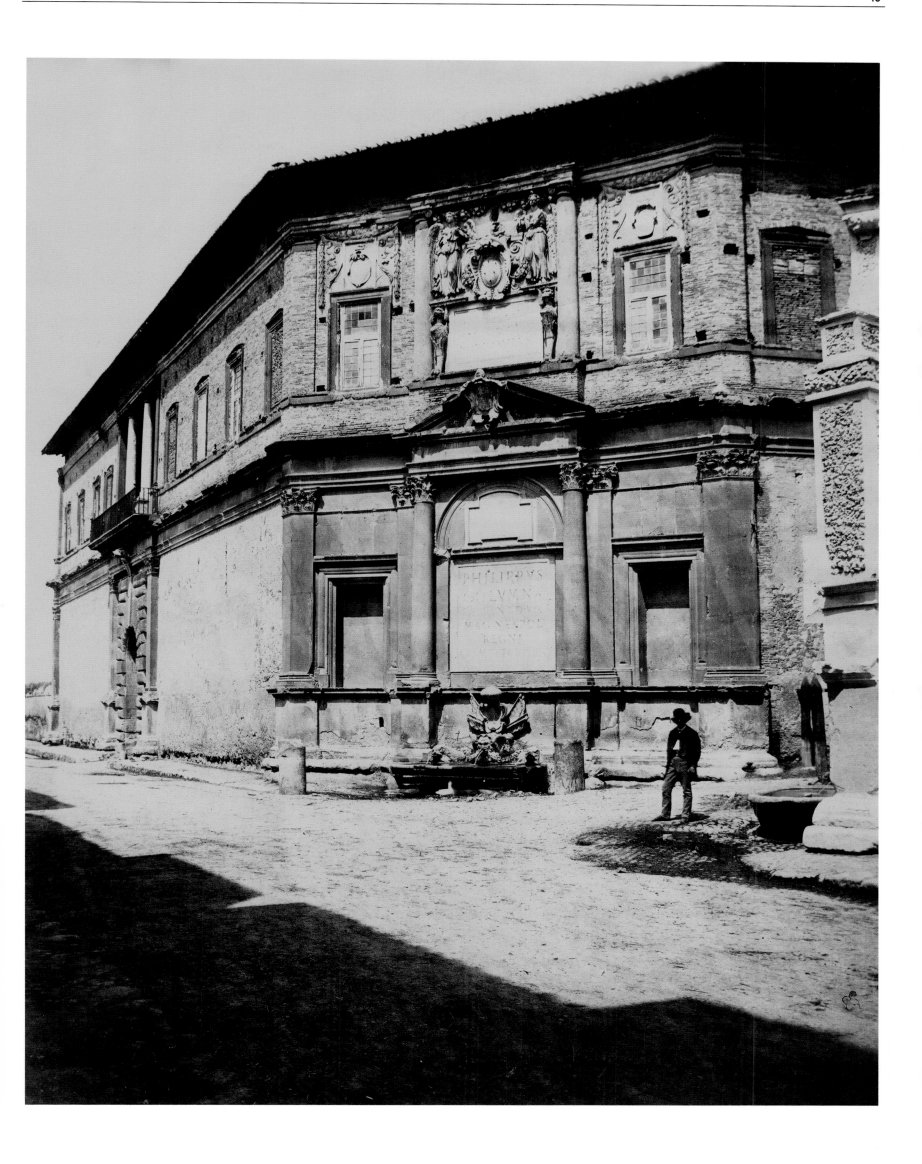

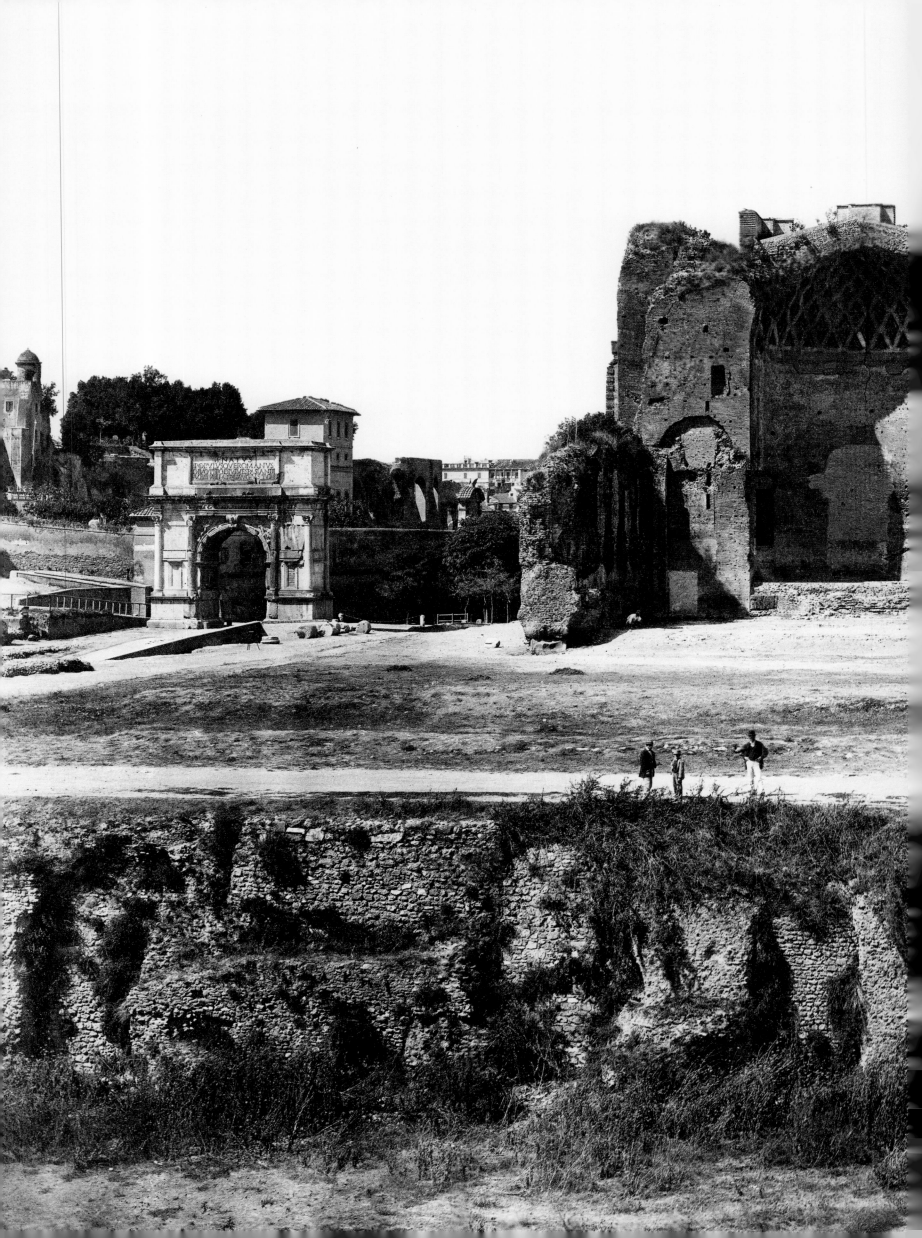

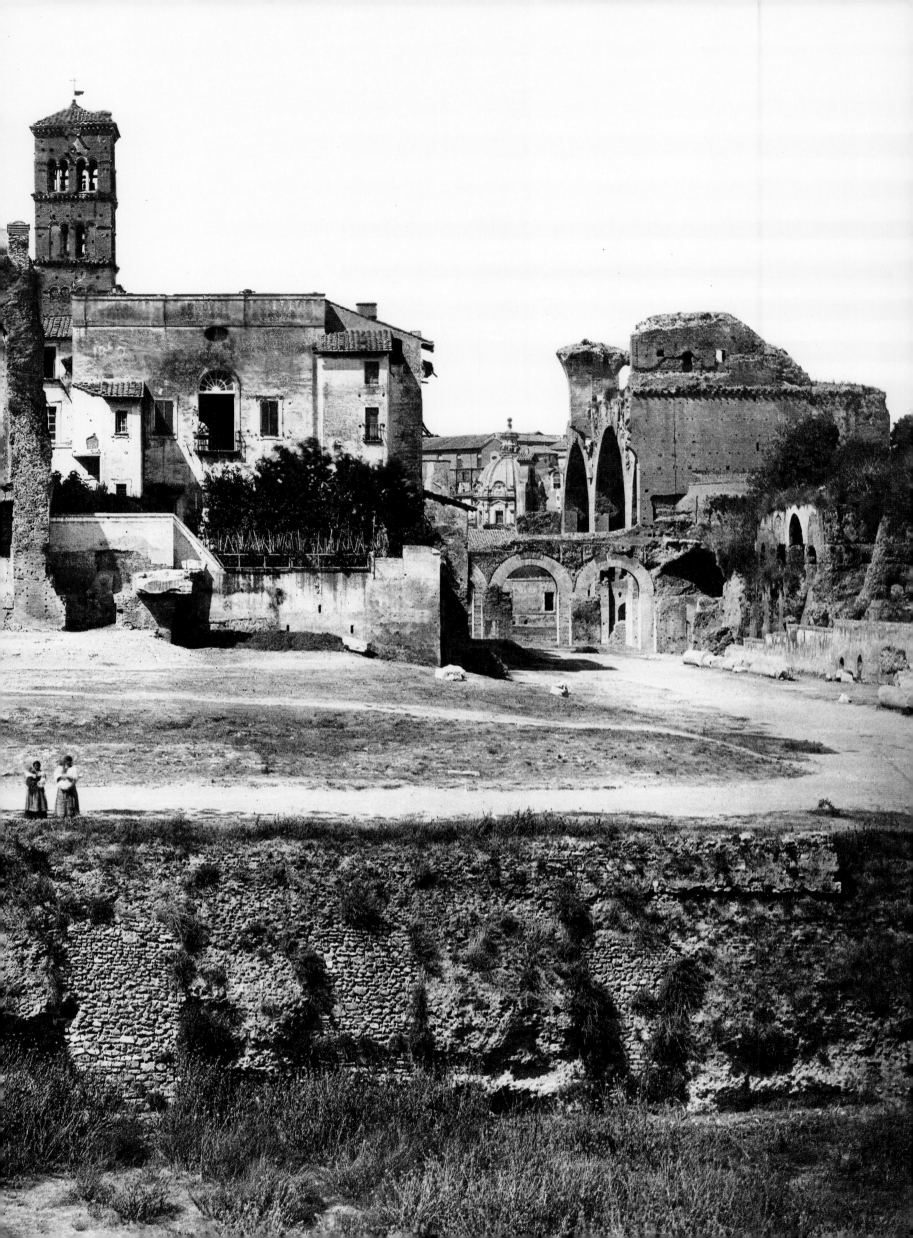

\# I

De capitale des États pontificaux à capitale de l'Italie 1839–1870

pp. 16/17
Atelier Robert Rive

This view of the Roman Forum was taken from the top of the Colosseum, and in the foreground it features people standing on the edge of the rampart. In the background, to the center, stand the ruins of the Temple of Venus and Rome, to the back is the bell tower of the Church of Santa Maria Nuova. To the left is the Arch of Titus, and to the right, the Basilica of Maxentius, c. 1865.

Blick auf das Forum vom oberen Stockwerk des Kolosseums aus. Eine Handvoll Menschen auf der Stützmauer belebt die Szenerie, in der Mitte ragen die Ruinen des Tempels der Venus und Roma auf, dahinter der Turm von Santa Maria Nuova; links der Titusbogen, rechts die Maxentiusbasilika, um 1865.

Prise du sommet du Colisée, la vue du Forum romain est animée par la présence au premier plan de quelques personnes en lisière du terre-plein. Au second plan, au centre, les vestiges du temple de Vénus et Rome, avec au fond le campanile de l'église Santa Maria Nuova ; à gauche, l'arc de Titus ; à droite, la basilique de Maxence, vers 1865.

« La ville qui domina le monde païen et unifia en son sein le monde chrétien
était la seule où pouvaient cohabiter Victor-Emmanuel, Pie IX et Garibaldi
sans que personne n'y prêtât attention. »
GIGGI ZANAZZO, *I PROVERBI ROMANESCHI*, 1886

Roma eterna, caput mundi, aurea, maxima, pulcherrima, sacra.

À la suite de graves bouleversements, Rome passe du statut de capitale des États pontificaux à celui de capitale de l'Italie.

Durant son pontificat, le plus long de l'histoire moderne (1846–1878), Pie IX exerce une action modérément novatrice en lançant quelques initiatives dans les domaines social, technologique et artistique; pour autant cette action ressort davantage de l'assistance que de la prévention et de la résolution des problèmes qui font obstacle à un essor économique et culturel proche de celui de l'Europe centrale et septentrionale.

Le pape encourage le développement des premières lignes ferroviaires (1856, Rome-Frascati; 1859, Rome-Civitavecchia qui comporte la construction du pont métallique San Paolo sur le Tibre; 1862, Rome-Ceprano). À la lisière du tissu urbain, alors qu'est inaugurée la ligne Rome-Ceprano, une gare ferroviaire (la Gare centrale des chemins de fer romains) est ouverte au public à Termini; elle remplace et réunit les fonctions de deux gares préexistantes situées l'une à Porta Maggiore (1856), l'autre à Porta Portese (1859). Les alentours de la nouvelle gare s'urbanisent, et le premier tronçon de la via Nuova Pia (future via Nazionale), qui relie la gare au centre, voit le jour.

Dans le quartier du Trastevere, une usine à gaz, construite en 1846, permet de moderniser le système d'éclairage public. Dès 1854, des lampadaires sont installés place Saint-Pierre, via Papale, via del Corso, piazza del Gesù et piazza Venezia. Exception faite de quelques modestes précédents en matière de transport public, les premières liaisons intra-muros sont inaugurées en 1886; assurées par des omnibus hippomobiles, elles sont organisées selon un horaire préétabli avec des départs réguliers: une ligne relie la piazza del Popolo à la piazza Venezia et une autre à Saint-Pierre. Plusieurs structures hospitalières sont construites ou améliorées (1865, Fatebenefratelli; 1856–1860, Santo Spirito; 1864–1867, asile d'aliénés). Des écoles sont ouvertes pour les enfants déshérités dans plusieurs quartiers populaires. Maintes églises sont restaurées et le complexe du Vatican fait l'objet de nombreuses interventions. La place du Quirinal est aménagée et la colonne de l'Immaculée Conception est dressée piazza di Spagna. Nombre d'initiatives privées consistant à rehausser ou à regrouper des édifices finissent par modifier en profondeur le rapport traditionnel entre les palais nobiliaires et leurs alentours de rues et de places.

Bien que leur ampleur n'ait rien de commun avec le rythme de croissance des grandes capitales européennes, ces initiatives constituent pour Rome une période de modernisation; pour autant, la ville accuse un grave retard et son niveau de développement demeure préindustriel: la moitié de ses habitants est sans emploi, 78% sont analphabètes (les écrivains publics sont nombreux), 30% vivent de subsides, de largesses et d'aumônes; les religieux sont au nombre de 8000, ou presque; la seule et unique industrie est la manufacture de tabacs, inaugurée en 1863, qui emploie près de 1000 travailleurs; le tourisme constitue la principale source de revenus; la santé des habitants est précaire à cause d'un système d'assainissement déficient et des épidémies de malaria dues aux marécages entourant la ville; les exécutions capitales sont fréquentes. Dans l'administration comme dans le milieu judiciaire, tous les postes de décision sont aux mains du clergé. « Une quantité de gens vivent à Rome on ne sait comment, sans revenu ni métier », observe Hippolyte Taine en 1866. « […] Ils ont toute sorte de ressources et d'expédients. »

Les rues et les places sont la véritable maison des Romains, l'été surtout. Pour bavarder, les gens du peuple se retrouvent à l'*osteria* [bistrot]. Chez les aristocrates et les grands bourgeois, la promenade dominicale à la villa Borghèse est un rite et l'on en parle une semaine durant. Jusqu'en 1865, les samedis et les dimanches d'août, les bouches d'évacuation des fontaines de la piazza Navona – alors légèrement concave – sont bouchées et l'eau déborde pour former un « lac », comme au XVIIIᵉ siècle déjà, selon un usage attribué au Bernin. Les carrosses de l'aristocratie et du clergé en quête de fraîcheur y convergent tandis que des rues avoisinantes affluent voituriers, charretiers, palefreniers et escadrons de cavalerie venus rafraîchir leur monture. La place demeure un lieu de jeux et de divertissements publics dont font partie cocagne, loterie et tombola, théâtres de marionnettes, manèges et spectacles de funambules.

Rome est une destination sans cesse plus recherchée par les voyageurs du Grand Tour tel que pratiqué au XIXᵉ siècle. À partir de 1860, les premiers grands hôtels font leur apparition.

Dès les débuts de la photographie, la Ville éternelle est le sujet de daguerréotypes et de calotypes. En juin 1841, Lorenzo Suscipj réalise un panorama rare en daguerréotype obtenu avec huit plaques. Nombre d'images de Rome figurent dans les *Excursions daguerriennes. Vues et monuments les plus remarquables du globe* de Noël-Marie Paymal Lerebours (1840–1843).

En l'espace de quelques années, la photographie se répand largement à Rome qui devient alors l'une des capitales européennes

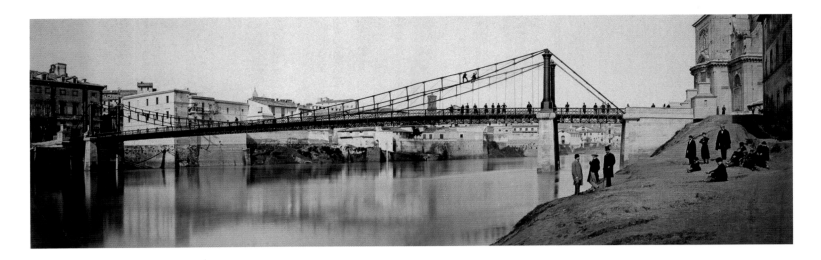

de cette nouvelle pratique artistique. Celle-ci illustre les initiatives pontificales en matière d'architecture et d'urbanisme (notamment de développement ferroviaire) mais aussi et surtout les lieux de la Ville éternelle les plus prisés des voyageurs. Les photographes, dont un grand nombre sont des étrangers établis à Rome, sont pour la plupart des amateurs aristocratiques ou passionnés de science. Maints d'entre eux (Frédéric Flachéron, Giacomo Caneva, James Anderson, Eugène Constant, Alfred-Nicolas Normand) se réunissent presque quotidiennement au Caffè Greco si bien qu'ils sont aujourd'hui connus comme le «Cercle du Caffè Greco». Beaucoup d'entre eux ont reçu une formation de peintre ou de sculpteur. Profitant de l'intérêt des voyageurs, quelques-uns, ainsi James Anderson ou Robert Macpherson, publient les premiers catalogues. Ils photographient les monuments de l'Antiquité, de la Renaissance et de l'âge baroque, le Tibre et les places pittoresques, mais très rarement les rues.

Adriano De Bonis, architecte de formation, actif de 1850 à 1868, est considéré aujourd'hui comme un grand photographe d'architecture et d'espaces urbains. Des dizaines de ses clichés sont utilisés par Francis Wey, critique à la revue *La Lumière,* pour illustrer – via des gravures sur bois – une série d'articles sur Rome publiés dans *L'Illustration, journal universel,* puis réunis dans le volume *Rome. Description et souvenirs* (1872).

Les peintres et les architectes pensionnaires de la Villa Médicis montrent un profond intérêt pour l'archéologie romaine. L'architecte Alfred-Nicolas Normand effectue les relevés de plusieurs monuments qu'il photographie. Mécène érudit, chercheur passionné d'archéologie, l'Anglais John Henry Parker utilise la photographie au cours de ses fouilles et après. En tant que fondateur de la British and American Archæological Society de Rome, il

lance, entre 1864 et 1877, une série de campagnes photographiques destinées à documenter les vestiges architecturaux et artistiques de l'Antiquité et du Moyen Âge mis au jour lors des fouilles menées sur le mont Palatin, dans le Forum romain et dans les thermes de Caracalla ; par la suite, il s'intéressera aux monuments menacés de démolition lors des travaux entrepris pour percer les nouvelles grandes artères de Rome. Pour documenter tout cela, il entre en relation avec Carlo Baldassarre Simelli, Charles Smeaton, Adriano De Bonis, Giovanni Battista Colamedici, Filippo Lais, Francesco Sidoli, Filippo Spina et Pompeo Molins – qui possédait les archives des négatifs de Parker. Grâce à la photogravure, Parker utilise une partie de la vaste documentation photographique de près de 4000 images qu'il a réunie pour illustrer les treize volumes de son ouvrage *The Archæology of Rome* (1874–1878) mis en vente par la librairie Spithöver située piazza di Spagna.

Au service de la cour pontificale, les frères Antonio et Paolo Francesco D'Alessandri se distinguent comme photographes (Antonio était lui-même prêtre). Un temps, ils ont l'exclusivité des portraits de Pie IX et de sa cour. Ils photographient également les exercices de l'armée pontificale et les champs de bataille de Mentana et de Monterotondo (dont *L'Illustration* publie des gravures sur bois).

Les efforts déployés par la papauté et soutenus par la France, son allié traditionnel, pour empêcher que le nouvel État italien n'englobe Rome et ses territoires, échouent en 1870 lorsque les troupes italiennes ouvrent une brèche dans le mur d'Aurélien près de la porta Pia et entrent dans la ville. C'est la fin du pouvoir temporel des papes. La même année, pour la première fois, un conseil municipal est élu. En 1870, Rome compte 225 000 habitants environ, soit près d'un dixième de la population de Paris.

↑
Gioacchino Altobelli & Pompeo Molins

Until the fall of the Papal States, there were only four city bridges over the Tiber. The Ponte dei Fiorentini was the first suspension bridge in Rome (1861–1863). It was nicknamed "Ponte del Soldino" (Bridge of the Coin) because a toll had to be paid, c. 1863.

Bis zum Ende der Herrschaft des Kirchenstaates führten innerhalb der Stadt nur vier Brücken über den Tiber. Der Ponte dei Fiorentini war Roms erste Hängebrücke (errichtet 1861–1863). Sie wurde im Volksmund „Ponte del soldino" genannt, weil zu ihrer Benutzung ein Brückenzoll von einem Soldo zu zahlen war, um 1863.

Jusqu'à la chute des États de l'Église, Rome ne comptait que quatre ponts sur le Tibre. Le pont des Florentins fut le premier pont suspendu de la ville. Il était surnommé «ponte del soldino» [pont du petit sou] car, pour l'emprunter, il fallait débourser un sou ; vers 1863.

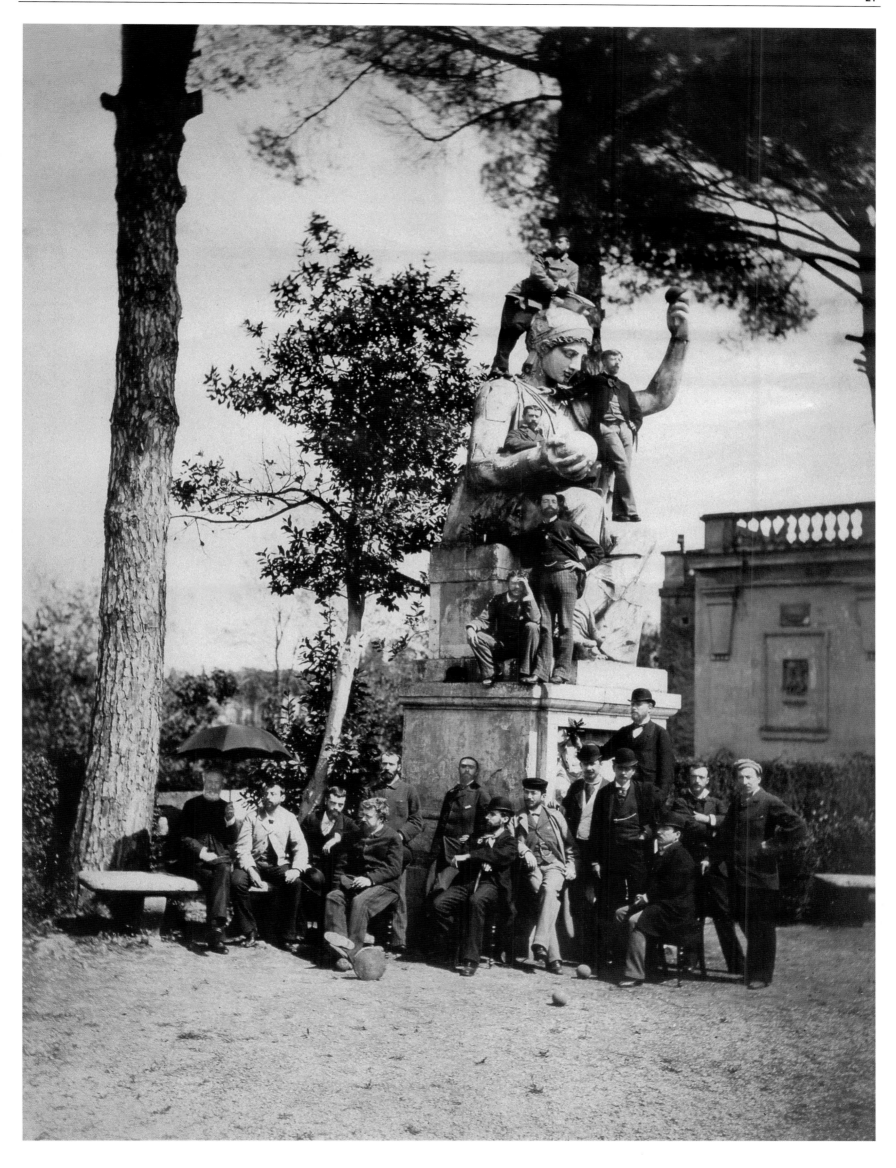

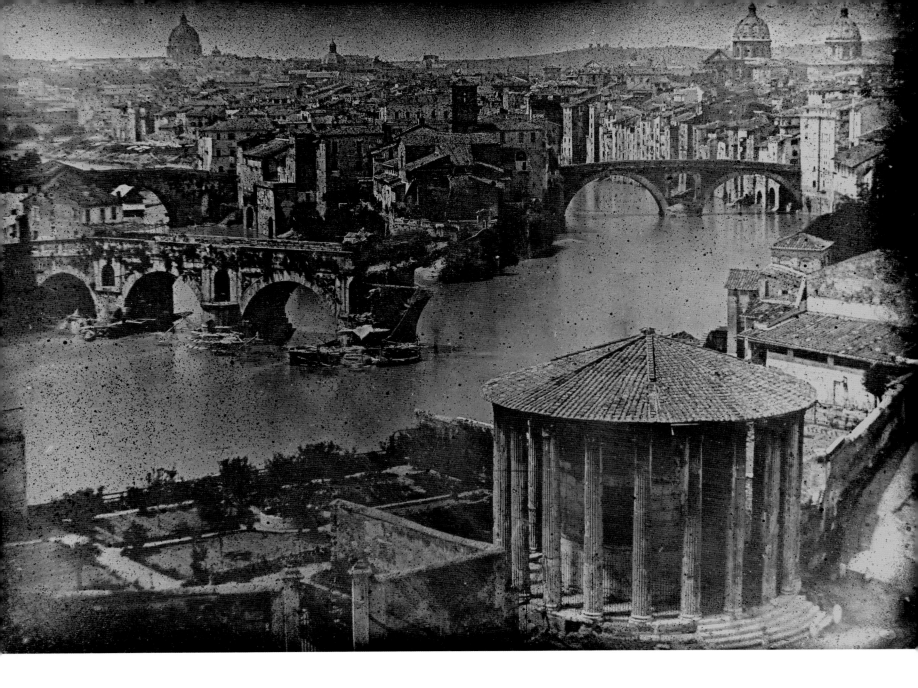

p. 21
Domenico Rocchi

A group of people in the garden of Villa Medici, which since 1803 to the present day has hosted the French Academy in Rome. The great statue of Minerva was on the eastern side of the garden terrace at the time of Cardinal Alessandro dei Medici. He bought the land in 1576 and designed the villa and the garden, which are at the highest point in Rome, to be a picturesque stage for works of art from antiquity, 1863–1864.

Eine Gruppe von französischen Stipendiaten im Garten der Villa Medici, die seit 1803 als Sitz der Académie Française in Rom dient. Kardinal Alessandro dei Medici, der das Gelände 1576 erworben hatte, um dort auf der höchsten Erhebung der Stadt eine Villa mit Park zu errichten, ließ die überlebensgroße Minervastatue auf der Ostseite der großen Gartenterrasse aufstellen. Die Villa Medici vereint zahlreiche antike Kunstwerke zu einem beeindruckenden Ensemble, 1863/64.

Groupe de pensionnaires dans le jardin de la Villa Médicis, siège de l'Académie de France à Rome depuis 1803. La monumentale statue de Minerve fut placée sur le côté est de la terrasse qui était un jardin du temps du cardinal Alexandre de Médicis. Le prélat acheta le terrain en 1576 et conçut la villa et le jardin, situés dans la partie la plus élevée de Rome, comme un spectaculaire ensemble d'œuvres d'art antique, 1863–1864.

↑
Lorenzo Suscipj

Daguerreotype taken from the bell tower of Santa Maria in Cosmedin. In the foreground stands the Temple of Vesta; along the Tiber we can see Ponte Rotto (collapsed) and Ponte Cestio to the left of Tiber Island, and Ponte Fabricio to the right; in the background, on the left, is the dome of St. Peter's, 1840.

Daguerreotypie, aufgenommen vom Turm von S. Maria in Cosmedin aus. Ganz vorn der sogenannte Vestatempel; dem Tiber folgend der Ponte Rotto sowie die Cestiusbrücke links und die Fabritiusbrücke rechts der Tiberinsel; ganz hinten links die Kuppel von St. Peter, 1840.

Daguerréotype pris depuis le campanile de Santa Maria in Cosmedin. Au premier plan, le temple de Vesta ; le long du Tibre, l'œil distingue le ponte Rotto [pont effondré], le pont Cestius et le pont Fabricius respectivement à gauche et à droite de l'île Tibérine ; au fond, à gauche, la coupole de la basilique Saint-Pierre, 1840.

→
Unidentified daguerreotype artist

The 18th-century Port of Ripetta on the Tiber, in a daguerreotype mounted by the Parisian optician Noël-Marie Paymal Lerebours. The series Excursions daguerriennes by Lerebours, published first in booklet form and then in two volumes, includes 111 aquatints derived from daguerreotypes, of which 47 are dedicated to France and 28 to Italy, c. 1840.

Tiberhafen an der Ripetta mit Bauten aus dem 18. Jahrhundert; Daguerreotypie montiert vom Pariser Optiker Noël-Marie Paymal Lerebours. Dessen Excursions daguerriennes, zunächst in mehreren Lieferungen, dann gesammelt in zwei Bänden erschienen, enthalten 111 Aquatintadrucke nach Daguerreotypien, von denen 47 französische und 28 italienische Motive zeigen, um 1840.

Le port de Ripetta aménagé au XVIIIe siècle sur le Tibre, daguerréotype monté par l'opticien parisien Noël-Marie Paymal Lerebours. Les Excursions daguerriennes de Lerebours, publiées en fascicules avant d'être réunies en deux volumes, comprennent 111 aquatintes réalisées à partir de daguerréotypes, dont 47 sont consacrées à la France et 28 à l'Italie, vers 1840.

"One of the chief causes that make Rome the favorite residence of artists […] is, doubtless, that they there find themselves in force, and are numerous enough to create a congenial atmosphere. In every other clime they are isolated strangers; in this land of art, they are free citizens."

„Einer der Hauptgründe, warum Rom der bevorzugte Aufenthaltsort so vieler Künstler ist […], liegt zweifelsohne darin, dass sie hier die Kraft finden und zahlreich genug sind, um eine ihnen seelenverwandte Atmosphäre zu erzeugen. In jedem anderen Klima bleiben sie vereinzelte Fremde, in diesem Land der Kunst aber sind sie freie Bürger."

« Une des principales raisons qui font de Rome le séjour favori des artistes […] c'est sans doute qu'ils sont allés en assez grand nombre pour y engendrer une atmosphère amicale. Sous tout autre ciel ils se sentent étrangers, isolés. Au pays de l'Art, ils sont citoyens et libres. »

NATHANIEL HAWTHORNE, *THE MARBLE FAUN: OR, THE ROMANCE OF MONTE BENI*, 1860

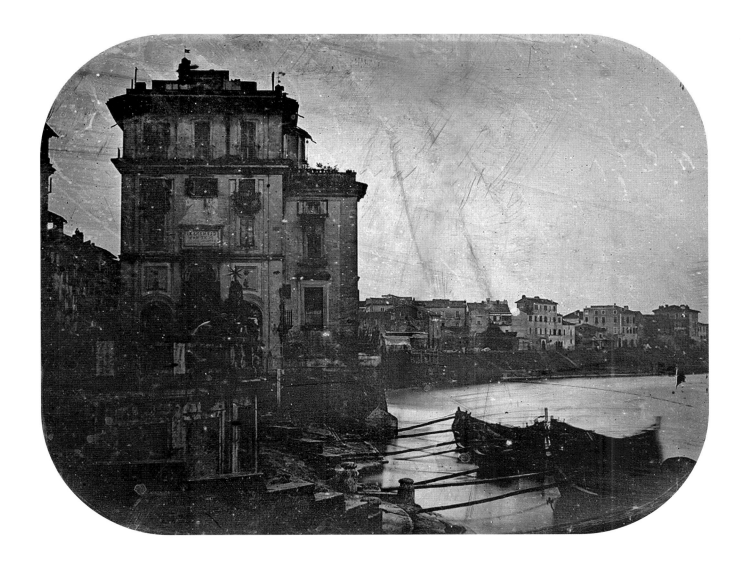

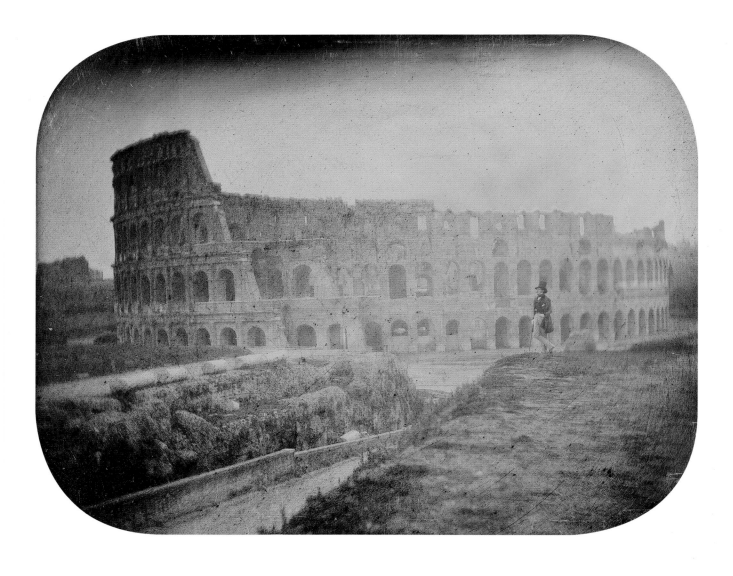

↑
Unidentified daguerreotype artist

The Colosseum has always been the monument that, more than any other, illustrates the idea of Roman grandeur. Built in the 1st century AD, it was named after a colossal statue that stood near it. "As long as the Colosseum exists, Rome will exist. When the Colosseum falls, Rome will fall too. When Rome falls, the whole world will fall with her." (The Venerable Bede, Collectanea, *8th century), c. 1845.*

Von jeher steht das Kolosseum wie kein anderes Monument für die Größe des antiken Rom. Erbaut im 1. Jahrhundert n. Chr., leitet sich sein Name von einer in unmittelbarer Nähe aufgestellten Kolossalstatue ab. „Solange das Kolosseum besteht, wird auch Rom bestehen. Wenn das Kolosseum stürzt, wird auch Rom stürzen. Stürzt aber Rom, stürzt auch die Welt." (Beda Venerabilis, Collectanea, *8. Jh. n. Chr.)*

Le Colisée a toujours été le monument qui, plus que tout autre, évoque la grandeur romaine. Érigé au 1ᵉʳ siècle après J.-C., il doit son nom à la présence à proximité d'une statue colossale. « Tant que le Colisée sera debout, Rome le sera. Lorsque le Colisée tombera, Rome tombera. Lorsque Rome tombera, le monde tombera. » (Bède le Vénérable, Collectanea, *VIIIᵉ siècle), vers 1845.*

→
Unidentified daguerreotype artist

This is probably the first photographic image of the Trevi Fountain, built in the 18th century, 1841.

Die wahrscheinlich erste fotografische Aufnahme des Trevibrunnens, 1841.

Il s'agirait de la première représentation photographique de la fontaine de Trevi édifiée au XVIIIᵉ siècle, 1841.

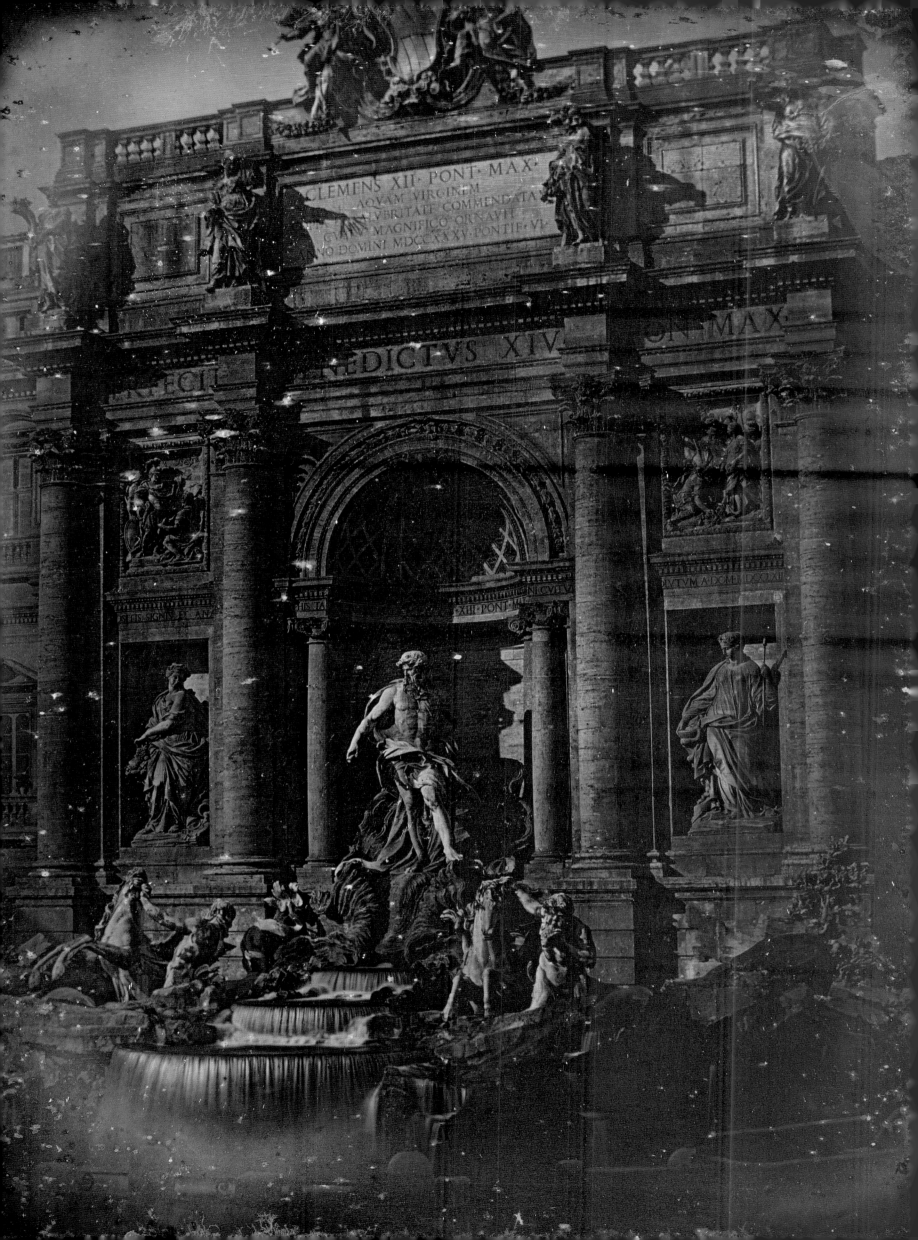

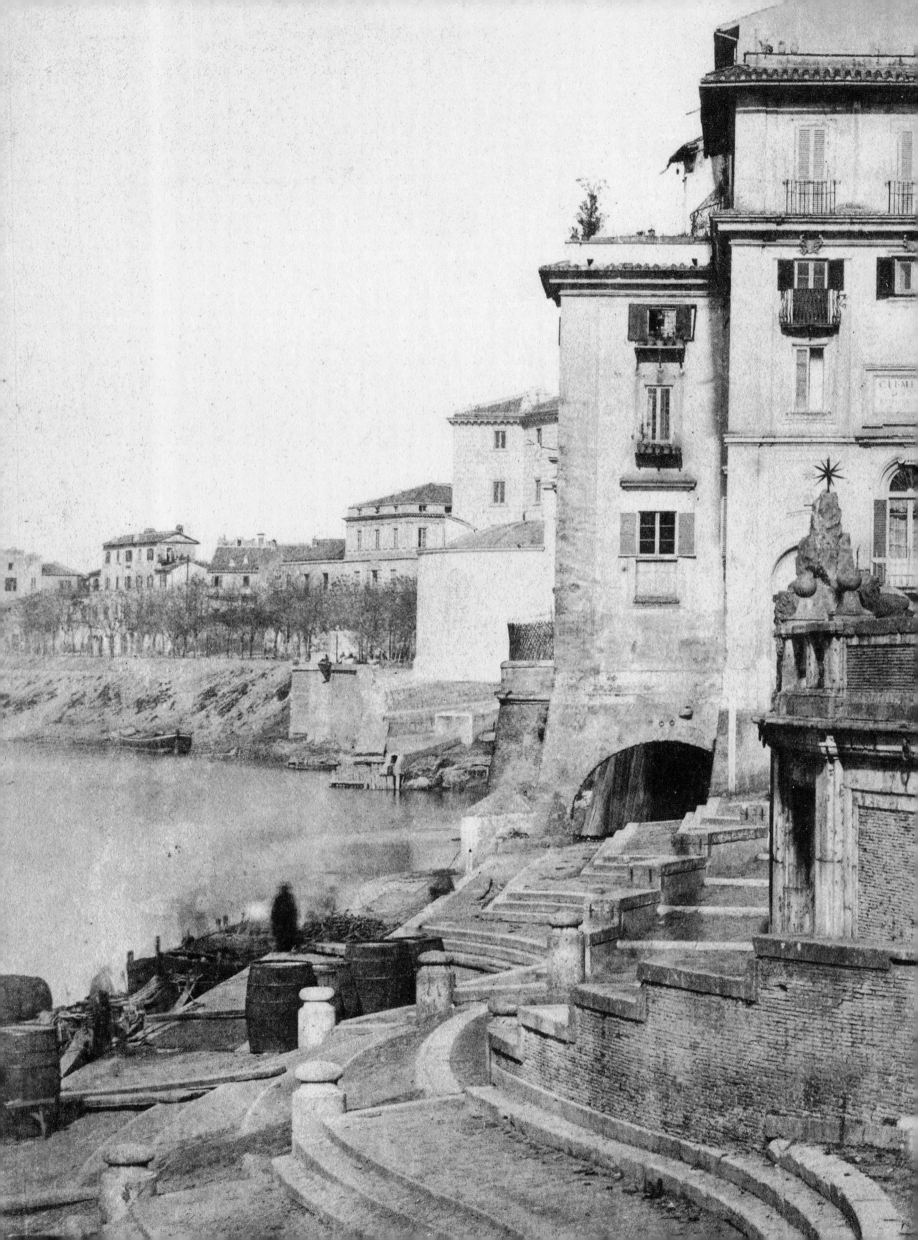

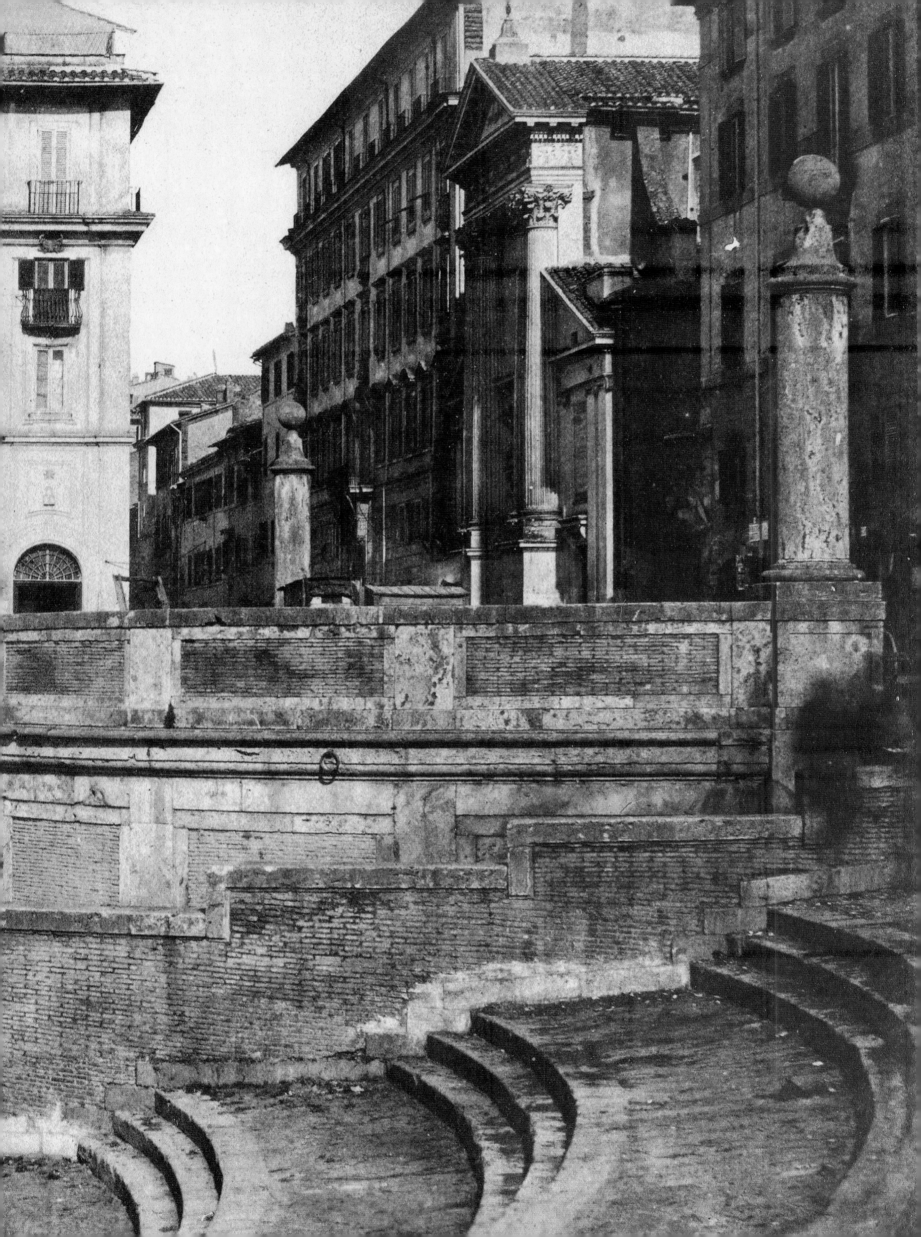

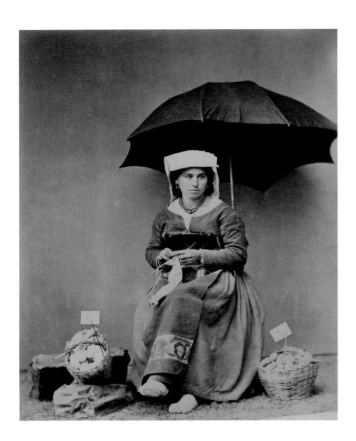

pp. 26/27
Giacomo Caneva

In the 19th century the Tiber was still used as a waterway, and Rome had three main ports. The port of Ripetta was reserved for the traffic of boats and barges carrying timber, coal, and wine coming from the head of the river, c. 1852.

Der Tiber wurde noch bis zur Jahrhundertwende als Transportweg genutzt, und es gab drei größere Häfen. Der Tiberhafen an der Ripetta war den Lastkähnen vorbehalten, die, beladen mit Holz, Kohle und Wein vom oberen Tiberlauf, dort anlegten, um 1852.

Au XIXᵉ siècle, le Tibre demeurait utilisé comme voie fluviale et Rome comptait trois ports principaux; celui de Ripetta était réservé aux embarcations qui descendaient le fleuve, chargées de bois, de charbon ou de vin, vers 1852.

←
Carlo Baldassarre Simelli

A working-class seller of knitted garments, photographed in the studio. The photographs of genre and costume scenes were very popular among 19th-century travellers, c. 1860.

Römische Strickwarenhändlerin im Atelier. Genreszenen und Trachtenbilder wie diese erfreuten sich bei den Reisenden des 19. Jahrhunderts großer Beliebtheit, um 1860.

Femme du peuple vendant des ouvrages en tricot, photographiée en atelier. Les scènes de genre et les personnages en costume traditionnel étaient très appréciés des voyageurs du XIXᵉ siècle, vers 1860.

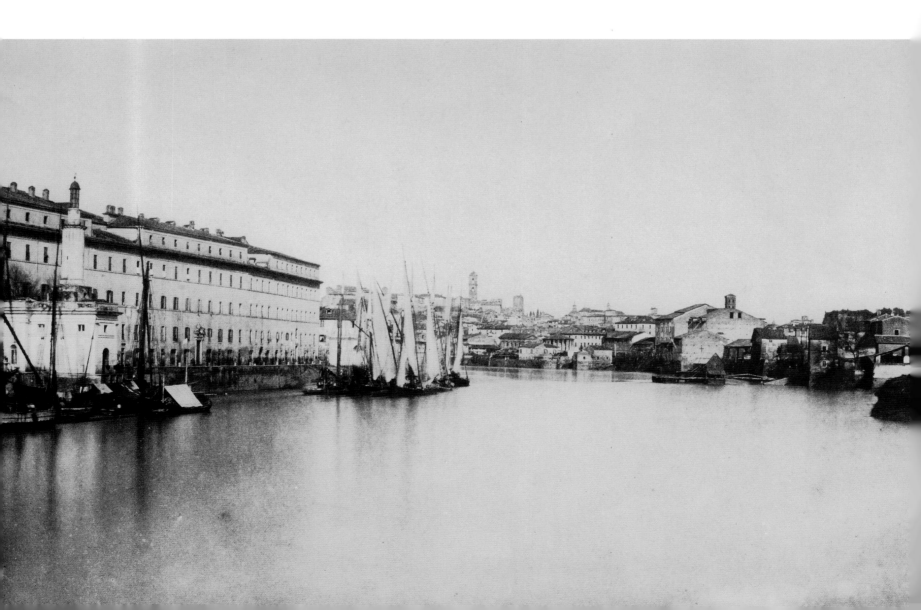

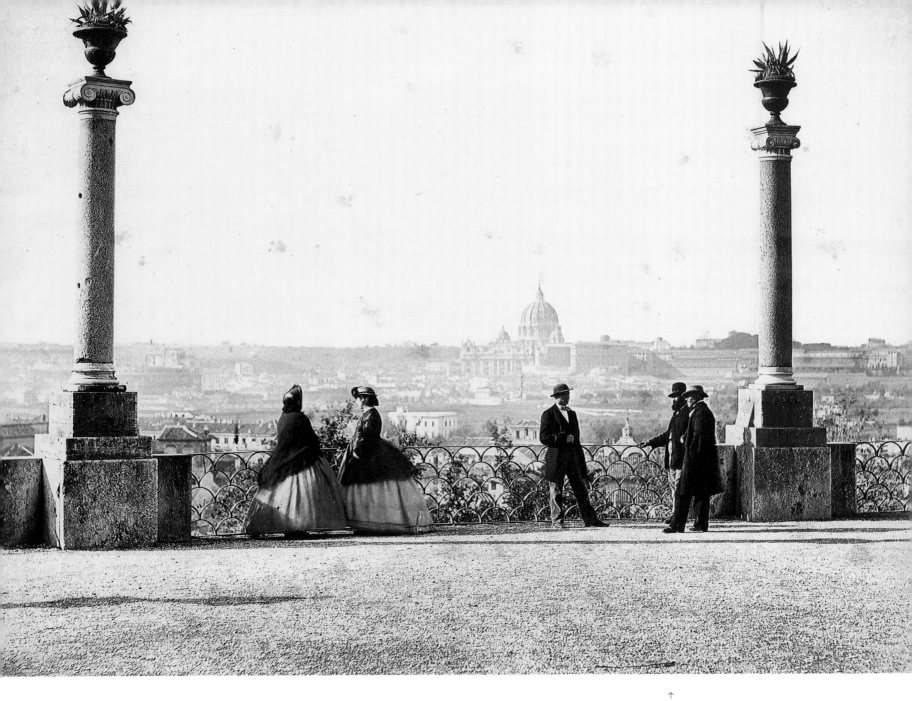

↑
Pompeo Molins

Walking along the Pincio was one of the favorite pastimes for Romans and travellers alike, especially because its terrace affords a stunning panoramic view of the city, dominated in the background by the dome of St. Peter's, c. 1860.

Ein Spaziergang auf dem Pincio gehörte für Einheimische wie für Reisende einfach dazu, ließ sich doch von der Terrasse des Pincio die von der Peterskuppel beherrschte Aussicht über die Stadt wunderbar genießen, um 1860.

La promenade du Pincio était l'une des préférées des Romains et des voyageurs, en raison de la magnifique vue de la ville – dominée par la coupole de la basilique Saint-Pierre à l'horizon – dont on jouissait depuis la terrasse, vers 1860.

←
Giacomo Caneva

The port of Ripa Grande received sailing and steamboats coming from the sea. It was active until the early 20th century, 1855.

Der bis Anfang des 20. Jahrhunderts betriebene Tiberhafen an der Ripa Grande war für Segelboote und Dampfschiffe bestimmt, die vom Meer kommend dort festmachten, 1855.

Le port de Ripa Grande accueillait des navires à voiles et des bateaux à vapeur venant de la mer. Il resta actif jusqu'aux premières années du xxᵉ siècle, 1855.

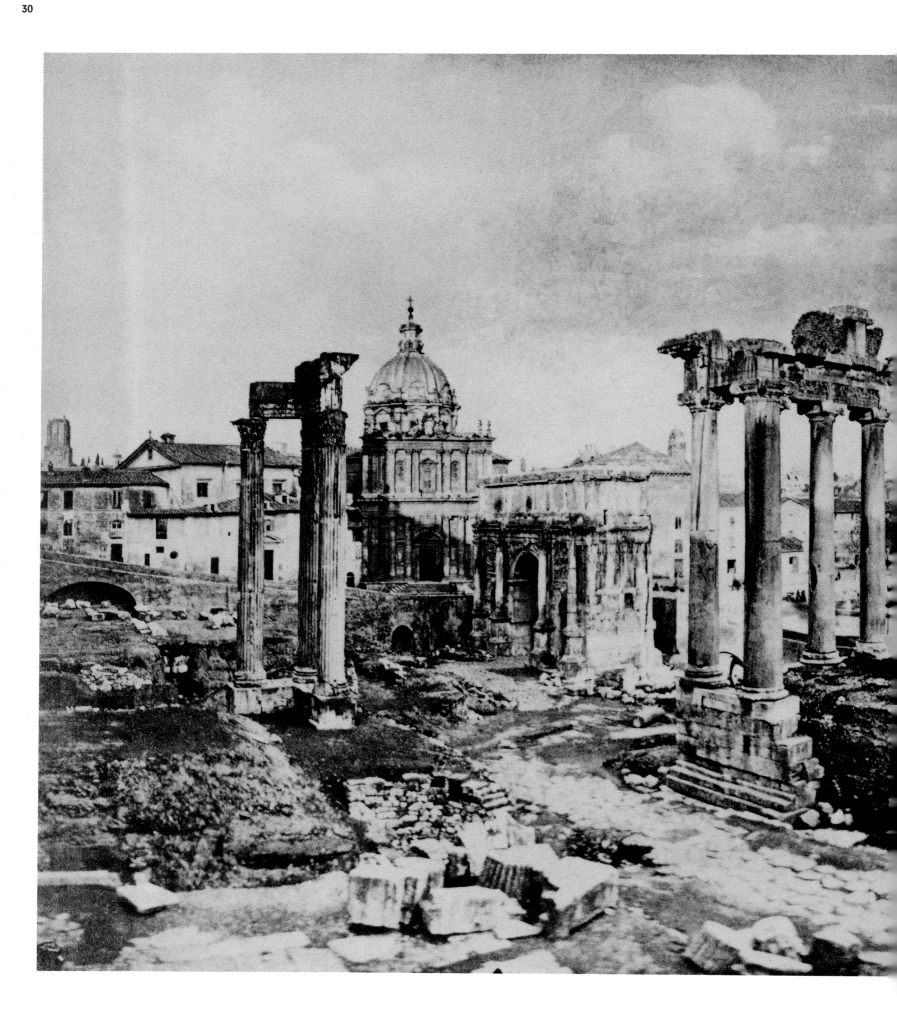

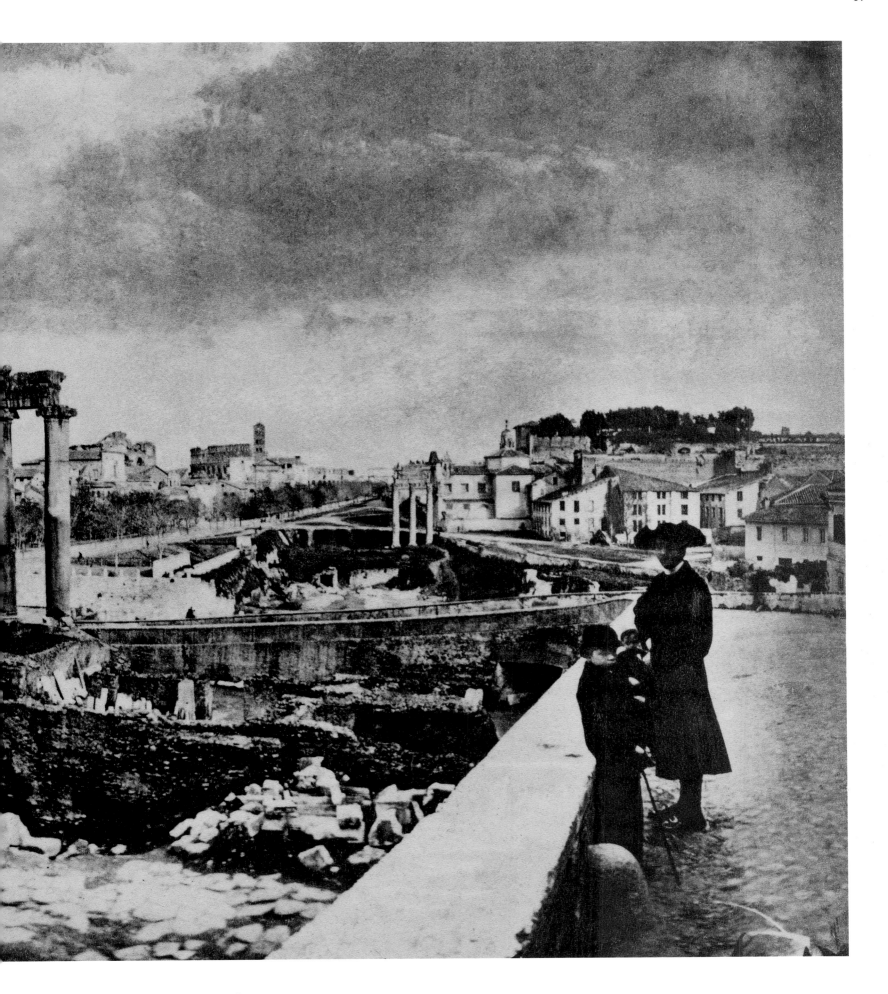

↑

Oswald Ufer

Along the descent from the Capitoline Hill to the Roman Forum, we see a tutor with two boys; he is wearing a cocked hat and buckled shoes, the traditional habit of an abbot. In the background, to the right, beside the three columns of the Temple of Castor and Pollux, the side of Santa Maria Liberatrice is visible, a church demolished at the end of the 19th century, c. 1857.

Hauslehrer in der traditionellen Tracht eines Abate mit Dreispitz und Schnallenschuhen mit seinen Zöglingen an der Rampe vom Kapitol zum Forum Romanum. Im Hintergrund, rechts von den drei Säulen des Castor- und Polluxtempels, ist die Seitenfront der Ende des 19. Jahrhunderts abgerissenen Kirche Santa Maria Liberatrice zu erkennen, um 1857

Descendant du Capitole au Forum romain, le précepteur, accompagné de deux enfants, porte la traditionnelle tenue d'abbé, avec tricorne et chaussures à boucle. Au fond, à droite, près des trois colonnes du temple de Castor et Pollux, on distingue le flanc de Santa Maria Liberatrice démolie à la fin du XIXᵉ siècle, vers 1857.

→
Fratelli D'Alessandri

Princess Luisa Corsini with the portrait of her son, who died aged 18, c. 1856.

Die Fürstin Luisa Corsini mit dem Porträt ihres im Alter von 18 Jahren verstorbenen Sohnes, um 1856.

La princesse Luisa Corsini avec le portrait de son fils mort à l'âge de 18 ans, vers 1856.

↓
Ludovico Tuminello

A Roman aristocrat in horse-riding dress, photographed in the studio, 1858.

Römische Adlige in Reitdress, Atelieraufnahme, 1858.

Aristocrate romaine en tenue d'équitation, photographiée en atelier, 1858.

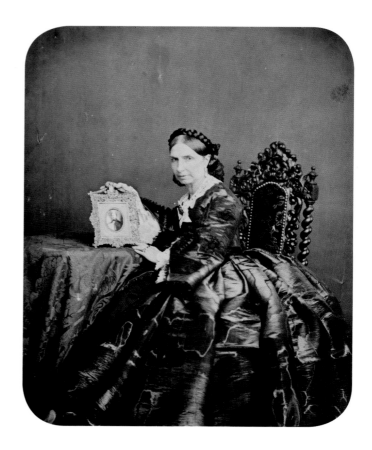

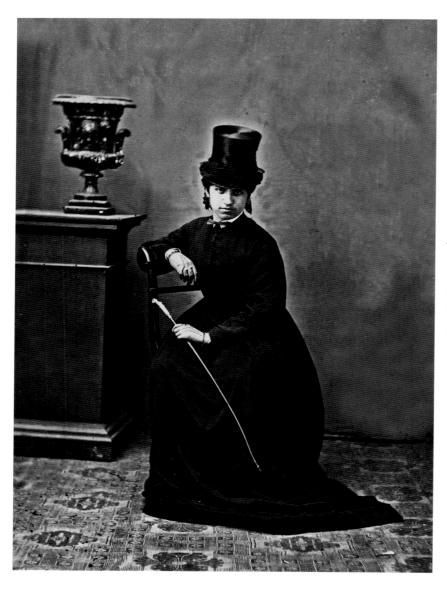

→
Anonymous

Bagpipe player and pifferaro (piper) photographed in the studio. Itinerant players from all regions of the central south, Abruzzo, and Lazio were often found playing in the streets of Rome, especially at Christmas time, attracting the attention of Roman residents and foreign visitors alike, c. 1860.

Sackpfeifer und Schalmeispieler im Atelier. Vor allem in der Weihnachtszeit kamen aus Mittel- und Süditalien, den Abruzzen und Latium, die pifferari, fahrende Spielleute, in die Stadt – eine Attraktion für Römer und Reisende gleichermaßen, um 1860.

Joueurs de cornemuse et de fifre, photographiés en atelier. Les pifferari, musiciens ambulants originaires des régions centrales du Mezzogiorno – Abruzzes, Latium, notamment –, animaient souvent les rues de Rome, surtout vers Noël, et suscitaient l'intérêt et la curiosité des Romains et des voyageurs, vers 1860.

pp. 34/35
Giorgio Sommer

The Roman Forum, a complex built between the 7th century BC and the 6th century AD, was the center of Roman public life, of its political, religious, commercial, and even judicial activities, as well as the site of important monuments. In the Middle Ages, it became an indefinite stretch of land known as Forum Boarium ("cattle market"), where livestock was sold, and in the 19th century it was known as Campo Vaccino ("cattle field"), c. 1860.

Die Baugeschichte des Forum Romanum reicht vom 7. Jahrhundert v. Chr. bis zum 6. Jahrhundert n. Chr.. Hier schlug das Herz des alten Rom, hier war der Mittelpunkt des politischen, religiösen, wirtschaftlichen und juristischen Lebens, hier wurden Denkmäler und Triumphbogen aufgestellt. Im Mittelalter verwandelte sich das Forum in eine große Brache, auf der ein Viehmarkt abgehalten wurde und die Kühe weideten, worauf die noch im 19. Jahrhundert geläufige Bezeichnung „Campo Vaccino" hindeutet, um 1860.

Issu de travaux réalisés entre le VIIᵉ siècle avant J.-C. et le VIᵉ siècle après J.-C., le Forum romain fut le centre de la vie publique romaine, des activités politiques, religieuses, commerciales et judiciaires, ainsi que le site d'importants monuments commémoratifs. Au Moyen Âge il devint un terrain vague faisant office de forum Boarium (littéralement « marché aux bœufs ») où se tenait un marché aux bestiaux ; au XIXᵉ siècle, il prit le nom de « Campo Vaccino », vers 1860.

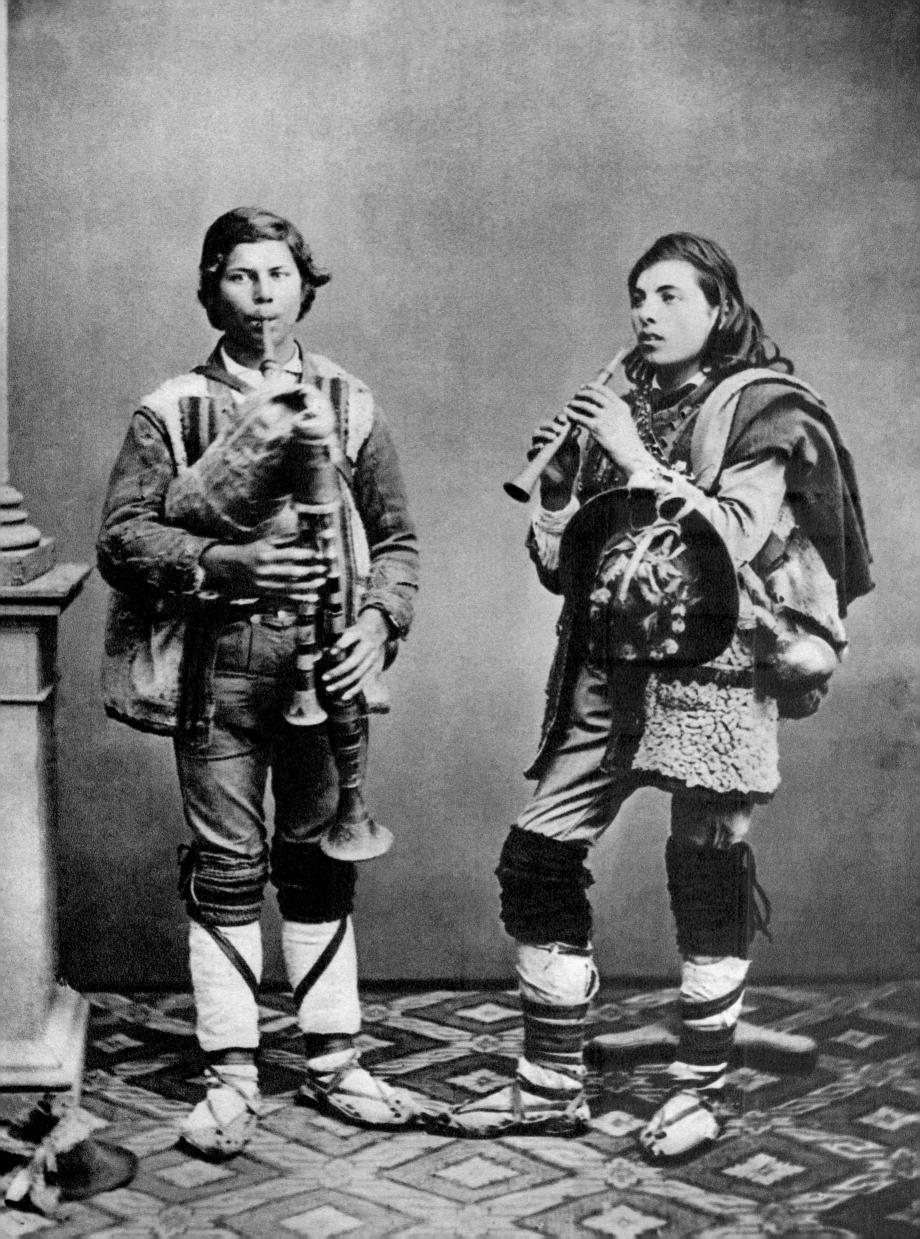

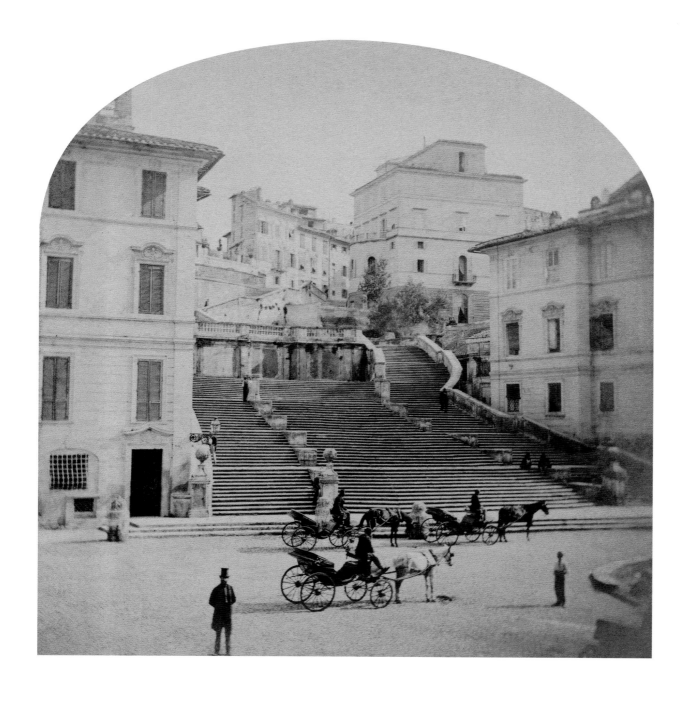

↑
Fratelli D'Alessandri

The view of Piazza di Spagna and the stairway of Trinità dei Monti, a place designed to encourage leisure, seen here with a few gas lamps. Stereogram from a stereoscopic pair of images, c. 1865.

Auf diesem Bild ist die Spanische Treppe – „ein Zögern, das zum Ort geworden" – noch kaum belebt. Erste Gaslaternen sind zu erkennen. Einzelbild einer Stereoskopie, um 1865.

La vue de la piazza di Spagna et de l'escalier de Trinità dei Monti – qui incite à s'y attarder – est discrètement animée. On notera quelques réverbères à gaz. Stéréogramme d'une paire stéréoscopique, vers 1865.

→
Anonymous

Piazza della Rotonda, the site of the Pantheon, has always been a particularly vibrant square, where nine roads converge around the ancient monument. Stereogram from a stereoscopic pair of images, c. 1865.

Die Piazza della Rotonda vor dem Pantheon, auf die nicht weniger als neun Straßen münden, war von jeher einer der belebtesten Plätze der Tiberstadt. Einzelbild einer Stereoskopie, um 1865.

La piazza della Rotonda, où s'élève le Panthéon, a toujours été très animée; en effet, pas moins de neuf rues convergent vers le monument antique. Stéréogramme d'une paire stéréoscopique, vers 1865.

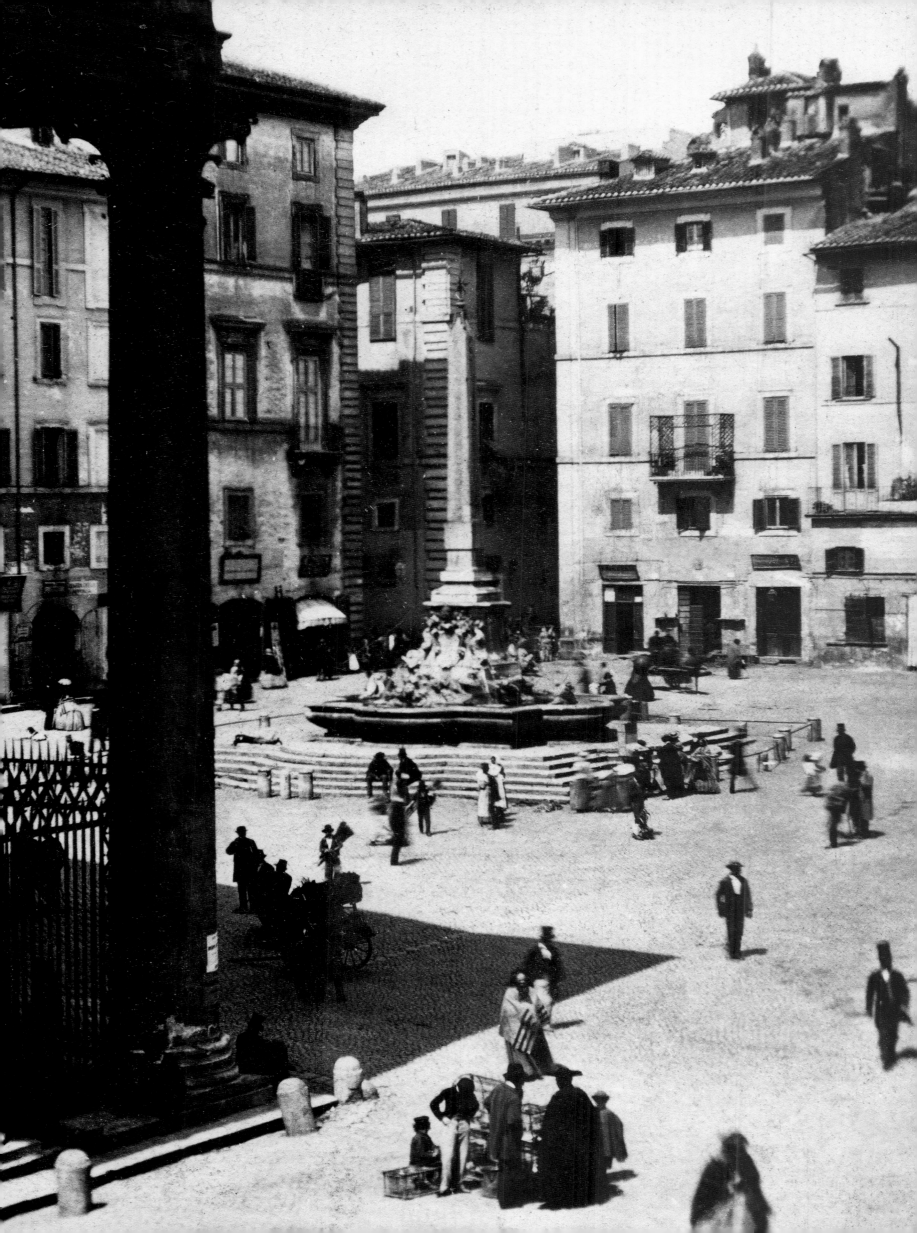

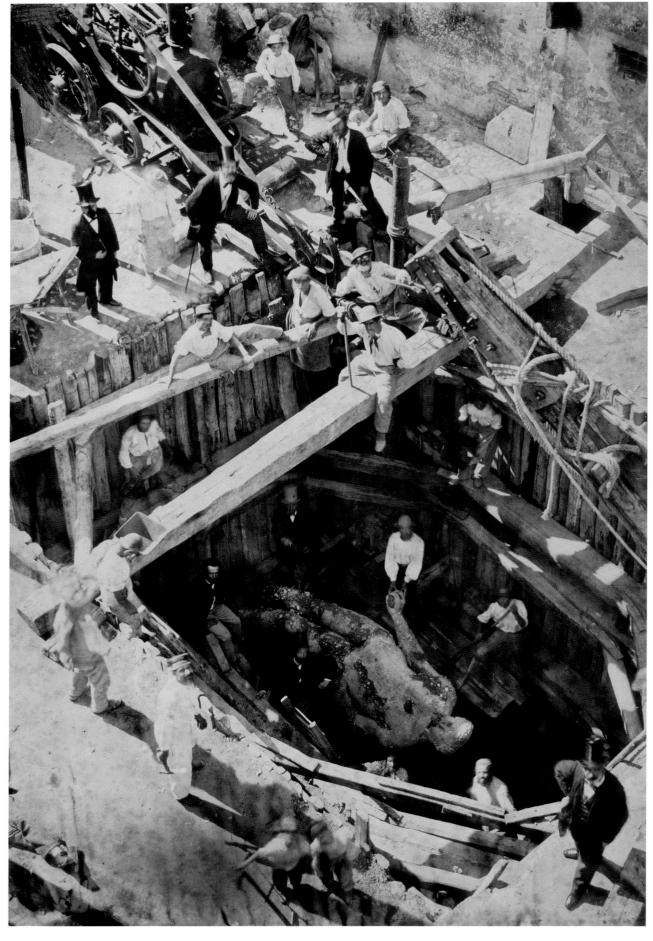

←

Gioacchino Altobelli

The colossal bronze statue of Hercules (known as the Mastai Hercules) erected near the Theater of Marcellus was buried for ritual reasons after being struck by lightning. Found in the courtyard of the Pio-Righetti palace, behind Campo de' Fiori, it was donated to Pius IX, and since 1866 it has been in the Pio Clementino Museum in the Vatican, 1864.

Die überlebensgroße Bronzestatue des sogenannten Herkules Mastai stand ursprünglich neben dem Marcellustheater und wurde, nachdem ein Blitzschlag sie getroffen hatte, in antiker Zeit rituell bestattet. 1864 im Hof des Palazzo Pio-Righetti, hinter dem Campo de' Fiori, aufgefunden, machte man sie Pius IX. zum Geschenk, seit 1866 ist sie in der Sammlung des Museo Pio Clementino in den Vatikanischen Museen zu bewundern, 1864.

Érigée près du théâtre de Marcellus, la colossale statue en bronze de l'Hercule Mastai fut enterrée pour des raisons rituelles après avoir été frappée par la foudre. Mise au jour dans la cour du palais Pio-Righetti, derrière le Campo de' Fiori, elle fut offerte à Pie IX ; depuis 1866, elle est conservée au Vatican, au musée Pio-Clementino, 1864.

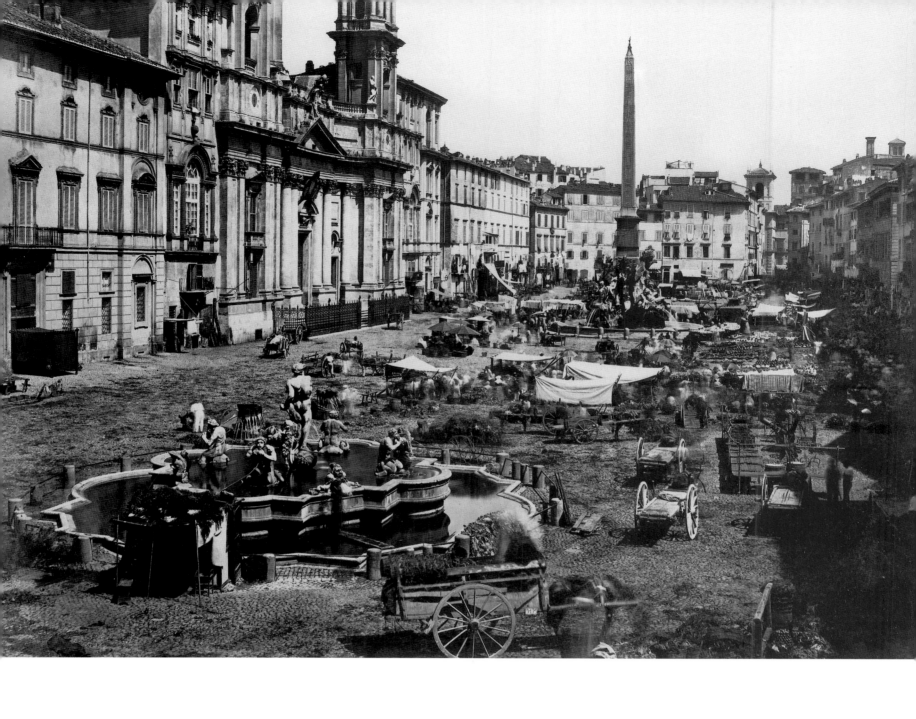

↑

Giorgio Sommer

Piazza Navona was already used as a market at the end of the 15th century. In the 19th century it was the site of a daily fruit and vegetable market, and every week a place for sellers of antiquities and bric-à-brac. In 1869 these activities were moved to Piazza Campo de' Fiori, c. 1860.

Ab Ende des 15. Jahrhunderts diente die Piazza Navona als Marktplatz. Im 19. Jahrhundert fand hier täglich der Obst- und Gemüsemarkt statt, und einmal wöchentlich kam antiker Trödel aller Art zum Verkauf. 1869 wurde der Markt auf den Campo de' Fiori verlegt, um 1860.

Dès la fin du XVᵉ siècle la piazza Navona accueillait un marché; au XIXᵉ siècle, un marché quotidien de fruits et légumes et une brocante hebdomadaire s'y tenaient, qui furent transférés piazza Campo de' Fiori en 1869, vers 1860.

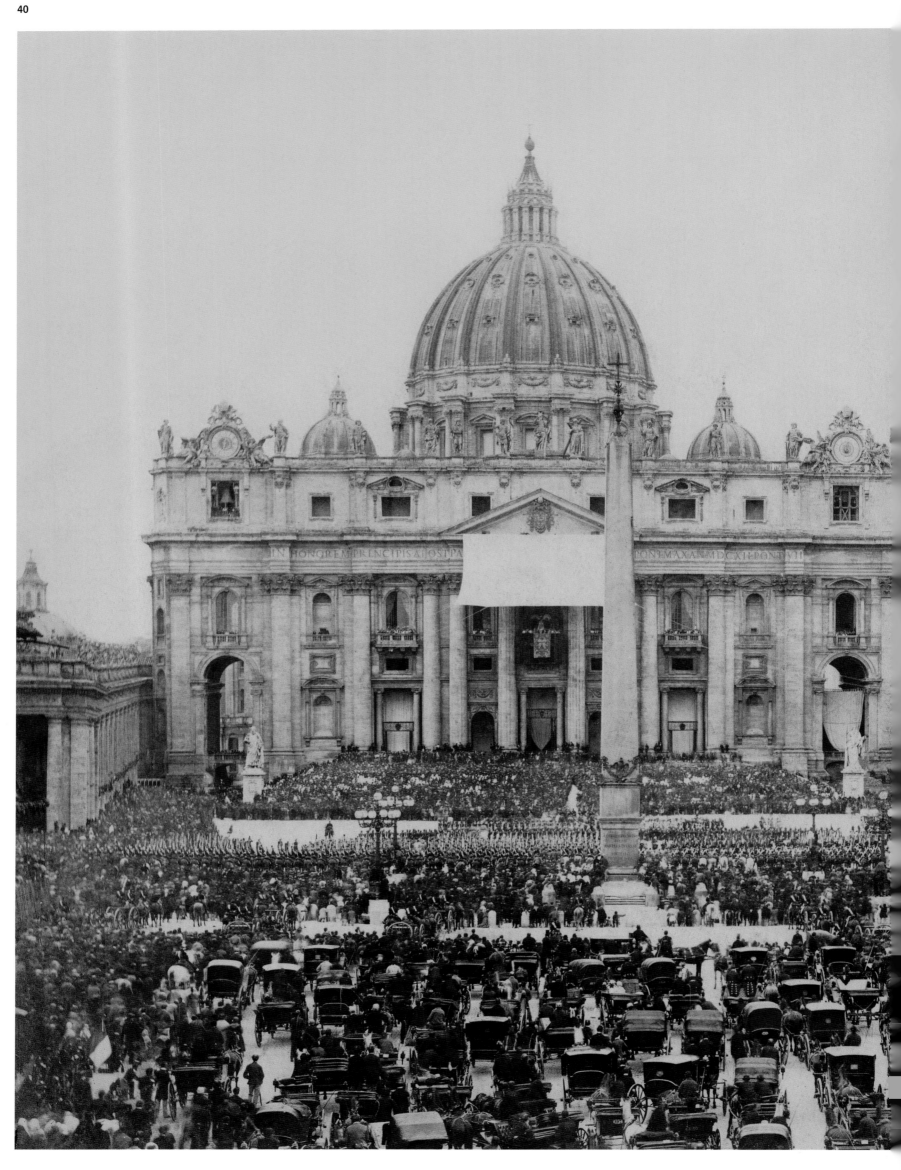

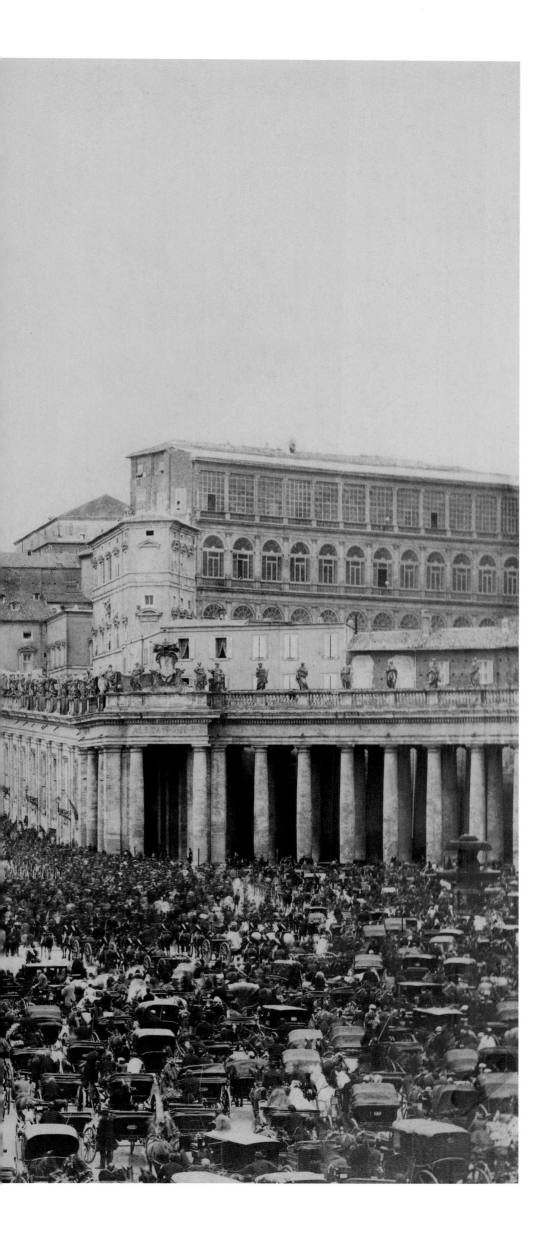

Giorgio Sommer

When St. Peter's Square was filled with crowds receiving the papal blessing, as during the Easter celebrations, photographers had an opportunity to get animated shots of the scene using long exposure – here showing carriages in the foreground, deployed troops, and people on the steps of the church. The awning stretched above the loggia sheltered the Pope from the sun, c. 1865.

Der anlässlich des päpstlichen Ostersegens von Gläubigen übersäte Petersplatz bot den Fotografen ein willkommenes Motiv, das sie teils mit langen Belichtungszeiten festhielten. Die Reihen der abgestellten Kutschen und angetretenen Soldaten, die Menschenmenge, die sich auf den Stufen des Petersdoms drängt – all dies vermittelt ein äußerst lebendiges Bild. Das über der Benediktionsloggia aufgespannte Segel schirmt den Papst gegen die Strahlen der Sonne ab, um 1865.

Envahie par la foule venue recevoir la bénédiction papale à l'occasion des fêtes de Pâques, la place Saint-Pierre permettait aux photographes d'obtenir, avec de très longs temps de pose, une vue animée (carrosses au premier plan, troupes déployées et fidèles massés sur les marches de la basilique). La toile tendue au-dessus de la loggia protégeait le pontife des rayons du soleil, vers 1865.

↓
Antonio D'Alessandri

From 1847 to 1861, Princess Carolyne of Sayn-Wittgenstein was the companion of Franz Liszt, whom she knew in Kiev, and with whom she moved to Poland and then to Rome, where the composer was unable to obtain the annulment of his marriage. The paintings, the flowers, the crucifix, and the bust of Homer attest to the romantic character of the Slavic aristocrat, 1865.

Carolyne Fürstin zu Sayn-Wittgenstein lebte von 1847 bis 1861 mit Franz Liszt zusammen. Sie lernten sich in Kiew kennen, lebten in Weimar und dann in Rom, wo es dem Komponisten nicht gelang, beim Heiligen Stuhl die Annullierung ihrer ersten Ehe zu erreichen. Marienbild, Kruzifix, Homerbüste und Blumen deuten auf die romantische Veranlagung der slawischen Adeleligen hin, 1865.

De 1847 à 1861 la princesse Carolyne de Sayn-Wittgenstein fut la compagne de Franz Liszt qu'elle rencontra à Kiev et avec lequel elle s'établit en Pologne, puis à Rome où l'annulation de son mariage lui fut refusée. Les tableaux, les fleurs, le crucifix et le buste de Homère témoignent du caractère romantique de l'aristocrate slave, 1865.

→
Fratelli D'Alessandri

Pius IX was one of the most photographed personalities of his time. A man of lively temperament, he was one of the key actors at the historical end of the Papal States, in 1864. "Sometimes, in the Corso, the Pope would leave the carriage to continue his walk on foot […]. Immediately the carriages would form a line, the men would step onto the pavement to kneel, while the women would simply stand there, bowing their heads devoutly." (Émile Zola, Rome, 1896)

Pius IX. war eine der meistfotografierten Persönlichkeiten seiner Zeit. Von lebhafter Wesensart, lenkte er die Geschicke des Kirchenstaats in Zeiten des historischen Umbruchs, 1864. „Manchmal stieg der Papst auf dem Corso aus seiner Kutsche und setzte seinen Weg zu Fuß fort […] Sogleich hielten die übrigen Kutschen in einer Reihe an, die Männer stiegen aus und knieten sich auf das Pflaster, während die Frauen einfach stehen blieben und ergeben den Kopf senkten.“ (Émile Zola, Rome, 1896)

Pie IX fut l'une des personnalités les plus photographiées de son temps. Doté d'un tempérament vif, il fut l'un des acteurs de la période de bouleversement que représenta la fin des États de l'Église. « Parfois, au Corso, le pape quittait le carrosse, poursuivait sa promenade à pied […]. Aussitôt, les voitures se rangeaient, les hommes en descendaient pour s'agenouiller sur le pavé, tandis que les femmes, simplement debout, inclinaient la tête dévotement. » (Émile Zola, Rome, Paris, 1896)

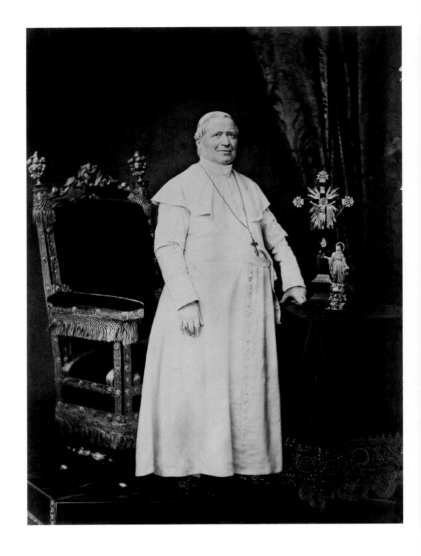

→
Gioacchino Altobelli

The Marquis Francesco Cavalletti, the last Senator (or leader) of the Roman municipality of the Papal States, a man who, albeit devout, was known for his independent character, is portrayed here on the day of his investiture, with a medallion featuring the image of Pope Pius IX on his chest, 1865.

Der Marchese Francesco Cavalletti war der letzte Senator und damit der Leiter der römischen Stadtverwaltung unter päpstlichem Regiment. Der für seine Frömmigkeit nicht weniger als für seine innere Unabhängigkeit bekannte Kleriker ist hier am Tag seiner Amtseinführung zu sehen. Vor der Brust trägt er ein Medaillon mit dem Porträt von Papst Pius IX., 1865.

Dernier sénateur de la Rome pontificale, autrement dit chef du corps municipal, le marquis Francesco Cavalletti, pieux mais néanmoins d'une grande indépendance d'esprit, est représenté le jour de son investiture, la poitrine ornée d'un médaillon avec le portrait de Pie IX, 1865.

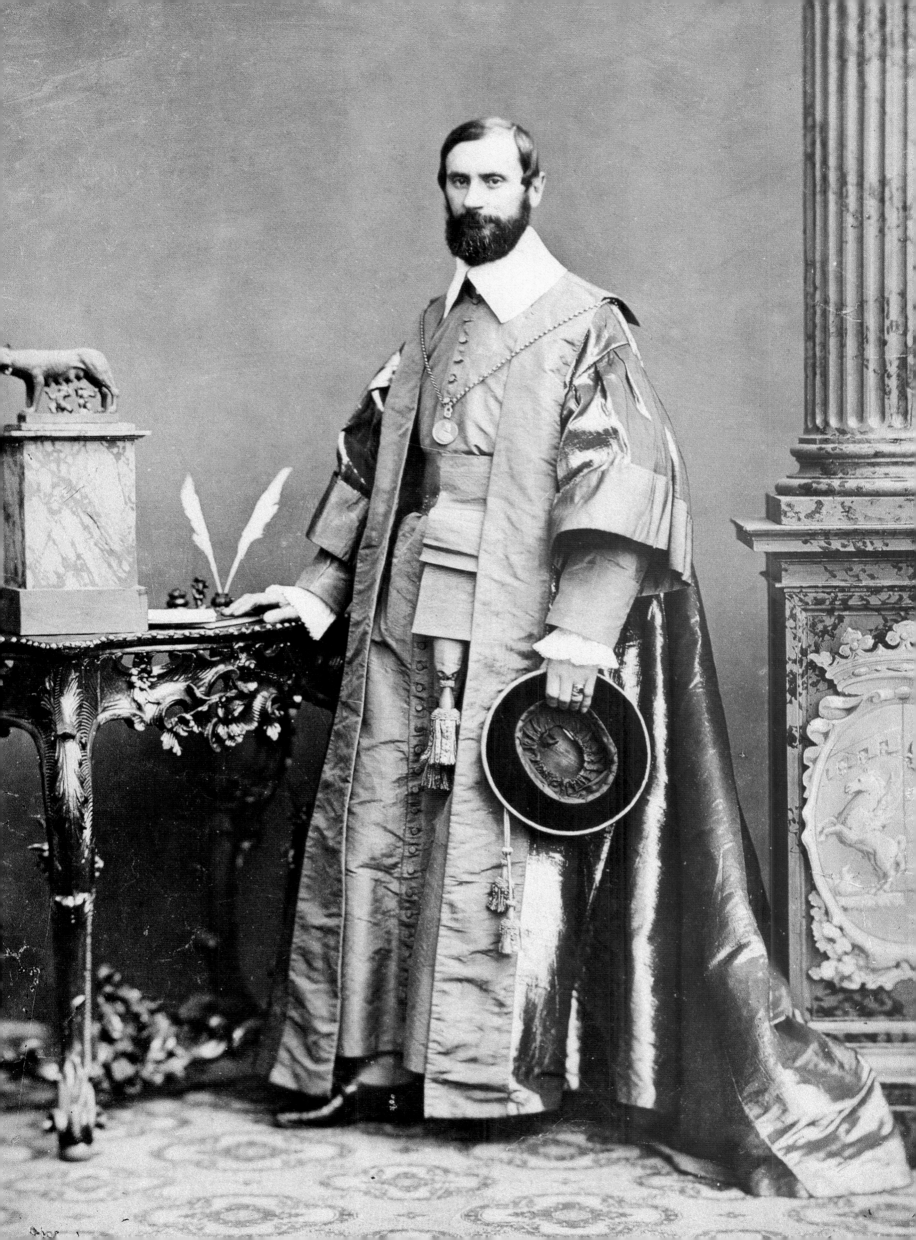

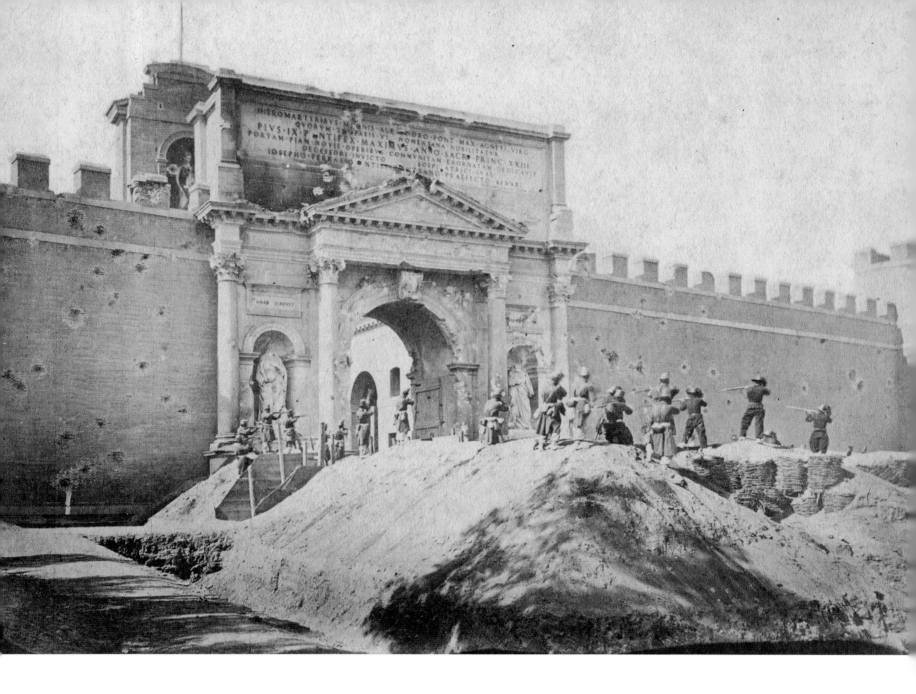

↑

Gioacchino Altobelli

According to 19th-century custom, photographs depicting military endeavors were taken after the event, in a staged reconstruction. This photograph depicts the conquest of Porta Pia by the Piedmontese infantry and the bersaglieri. *Note the defense equipment and the remains of battle, the marks made by cannons in the wall, and the decapitated statues in the lateral niches of the arch, 1870.*

Erstürmung der Porta Pia durch piemonte- sische Truppen. Wie in der Kriegsbericht- erstattung des 19. Jahrhunderts nicht un- üblich, wurden die Ereignisse nachgestellt. Authentisch sind dagegen der Schanzwall, die Einschusslöcher in der Mauer und die Statuen mit abgeschlagenen Köpfen in den das Tor flankierenden Nischen, 1870.

Prise de la porta Pia par l'infanterie et les bersagliers piémontais. La photographie fut prise après l'événement dans une mise en scène reconstituée, selon une pratique courante dans les reportages de guerre du XIXᵉ siècle. On notera les ouvrages défensifs et les stig- mates des combats : traces de bombardement sur la muraille et statues décapitées dans les niches latérales du grand arc, 1870.

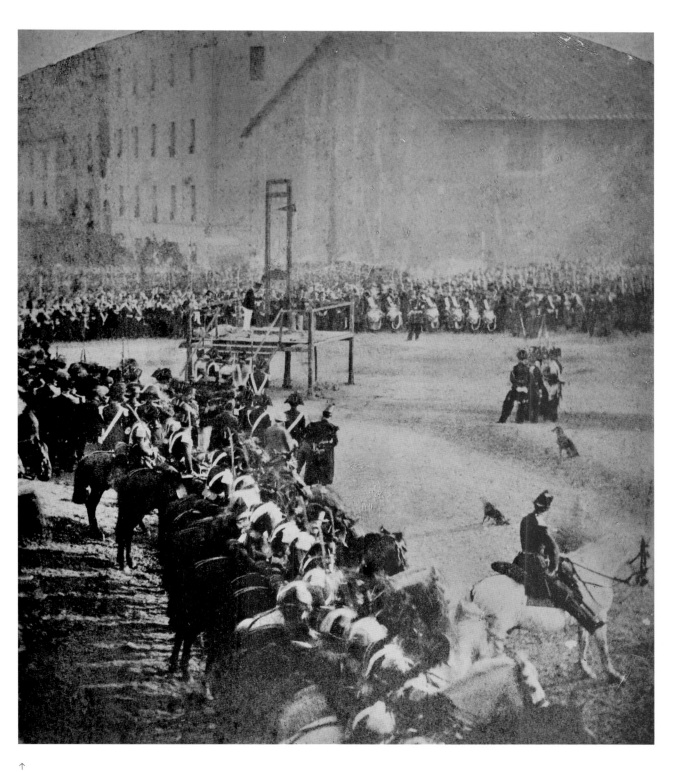

↑

Anonymous

*The guillotine in Via dei Cerchi: the decap-
itation of a patriot. The Roman* mannaia,
*very similar to the French guillotine, but with
a crescent-shaped rather than oblique blade,
remained in use in papal Rome until the
victory of the Kingdom of Italy, c. 1865.*

*Hinrichtung eines Patrioten auf dem Schafott
in der Via dei Cerchi. Die römische* mannaia,
*im päpstlichen Rom bis zur Eroberung durch
das Königreich Italien im Einsatz, ähnelte
der französischen Guillotine, war aber mit
einem halbmondförmigen Fallbeil aus-
gestattet, um 1865.*

*La guillotine dressée via dei Cerchi:
décapitation d'un patriote. La* mannaia
*romaine, très proche de la guillotine
française, mais pourvue d'une lame non pas
oblique mais en demi-lune, resta en usage
dans la Rome pontificale jusqu'à sa conquête
par le royaume d'Italie, vers 1865.*

"Are they Italians or Papists? [...] it is hard to give a precise answer.
These people are too ignorant, too pedestrian, too immersed in their hatreds
and their peasant interests to have an opinion on such matters."

„Sind die Römer nun Italiener oder Untertanen des Papstes? [...] eine genaue
Antwort ist schwer zu bekommen. Dieses Volk ist zu unwissend, zu erdverbunden,
zu sehr seinem Hass und seinen Bauerninteressen verhaftet, um in dieser
Frage eine Meinung zu haben. "

« Sont-ils Italiens ou papalins? [...] toute réponse précise est difficile ; ces gens-ci
sont trop ignorants, trop collés au sol, trop enfoncés dans leurs haines et dans
leurs intérêts de village pour avoir un avis sur de telles questions. »

HIPPOLYTE TAINE, *VOYAGE EN ITALIE*, 1866

→
Anonymous

Butteri *resting in the Roman countryside in
the shade of a large mulberry. The* buttero –
*a term roughly equivalent to the English
cowboy – was the typical shepherd on horse-
back of the Campagna Romana, of the Agro
Pontino, and of Maremma, c. 1865.*

Butteri *bei der Rast unter einem großen
Maulbeerbaum in der römischen Campagna.
Buttero – nur entfernt dasselbe wie ein
amerikanischer Cowboy – nennt man einen
berittenen Hirten der römischen Campagna,
des Agro Pontino und der Maremma, um 1865.*

Butteri *au repos dans la campagne romaine
à l'ombre d'un grand mûrier. Le buttero –
équivalent approximatif du cow-boy – est
un berger à cheval typique de la campagne
romaine, des marais pontins et de la
Maremme, vers 1865.*

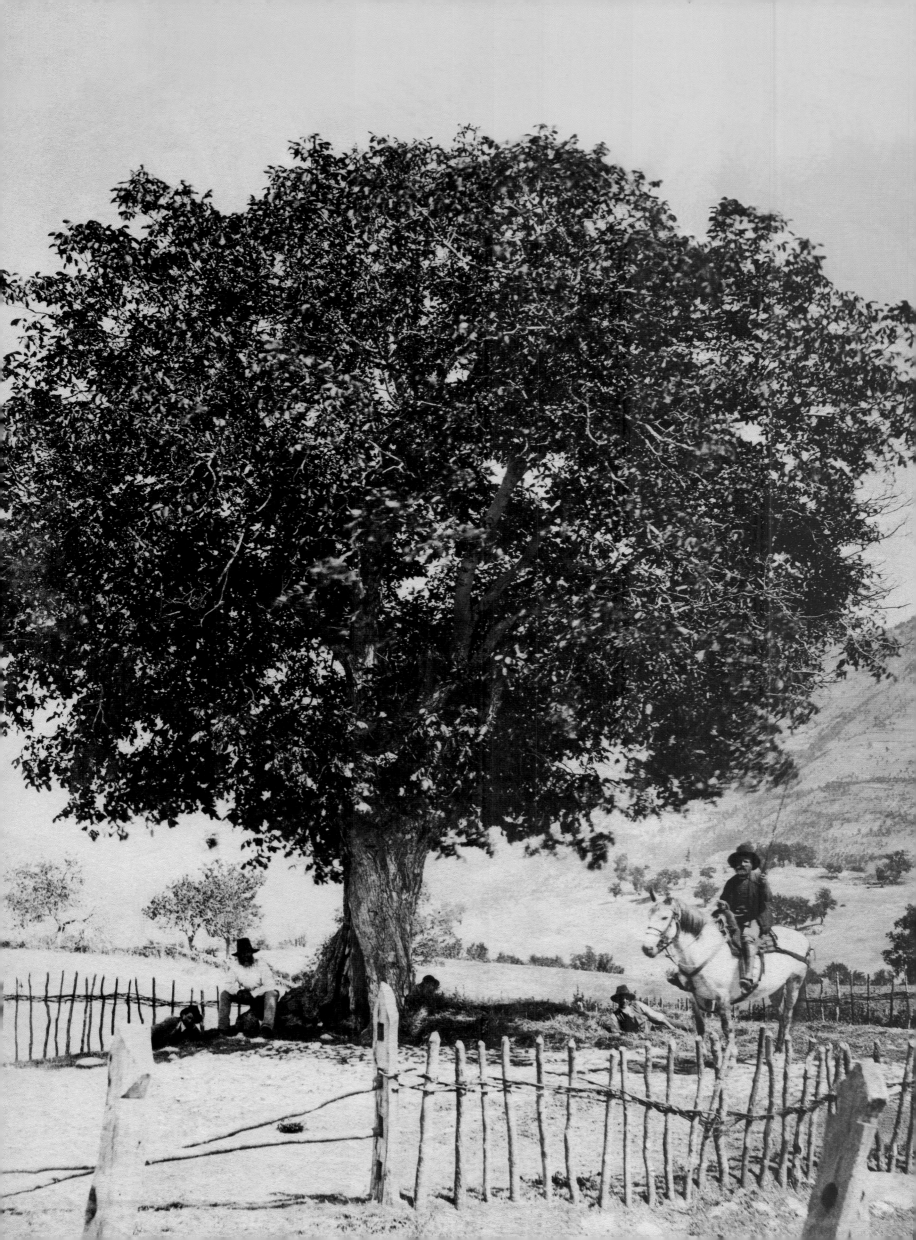

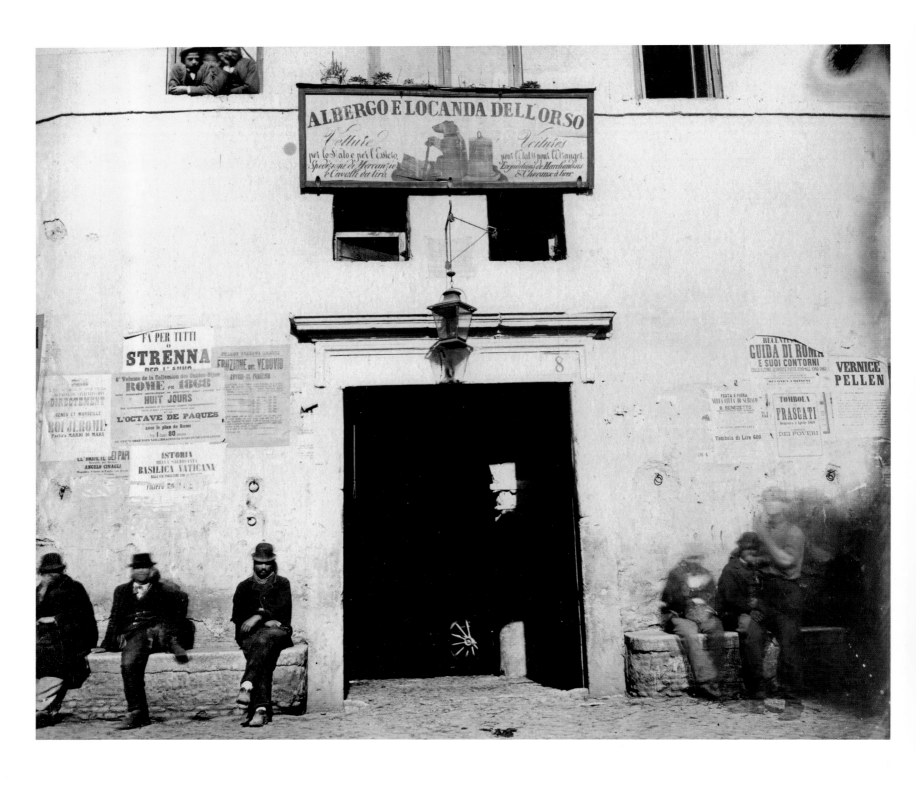

↑

Giovanni Battista Colamedici

The sign above the entrance to the Albergo e Locanda dell'Orso (The Bear Inn, the bear being depicted chained to a column) is in Italian and French, and reads: "Vehicles for the State and abroad, dispatch of merchandise and horses." The notices on the wall advertise festivals, raffles, and new books (including a guide to Rome), 1868.

Das Schild über dem Eingang der Albergo e Locanda dell'Orso (Gasthof Zum Bären, wobei der Bär an eine Säule gekettet ist) setzt den Besucher in französischer und italienischer Sprache darüber in Kenntnis, dass hier „Postkutschen in den Kirchenstaat und ins Ausland, Frachtabfertigung und

Zugpferde" erhältlich sind. Die Aushänge an der Hauswand werben für Feste, Verlosungen und neu erschienene Bücher, darunter ein Romführer, 1868.

L'enseigne suspendue au-dessus de l'entrée de l'Albergo e locanda dell'Orso [hôtel et pension de l'ours]. L'animal représenté enchaîné à une colonne est bilingue (italien et français) et annonce : « Voitures pour les États [de l'Église] et pour l'étranger, expédition de marchandises et chevaux de trait ». Sur les murs les affiches annoncent des fêtes, des tombolas et des livres récents, dont un guide de Rome, 1868.

↗

Giovanni Battista Colamedici

The Albergo e Locanda di Bucimazza in Via Sant'Omobono. In papal Rome, the elegant hotels were located in Piazza di Spagna and the surrounding areas. More modest inns were in other areas, used by freight carriers and street vendors from outside the city, 1868–1869.

Der Gasthof Bucimazza an der Via Sant'Omobono. Die vornehmen Lokale des päpstlichen Rom lagen an der Piazza di Spagna und Umgebung. Daneben gab es unzählige einfache Gasthöfe, in denen Fuhrleute und fahrende Händler von außerhalb abstiegen, 1868/69.

Albergo e locanda Bucimazza dans la via Sant'Omobono. Dans la Rome pontificale, les hôtels élégants étaient concentrés sur la piazza di Spagna et dans les rues adjacentes. Pour le reste, il existait d'innombrables pensions modestes qui accueillaient les transporteurs de marchandises et les vendeurs ambulants étrangers à la ville, 1868–1869.

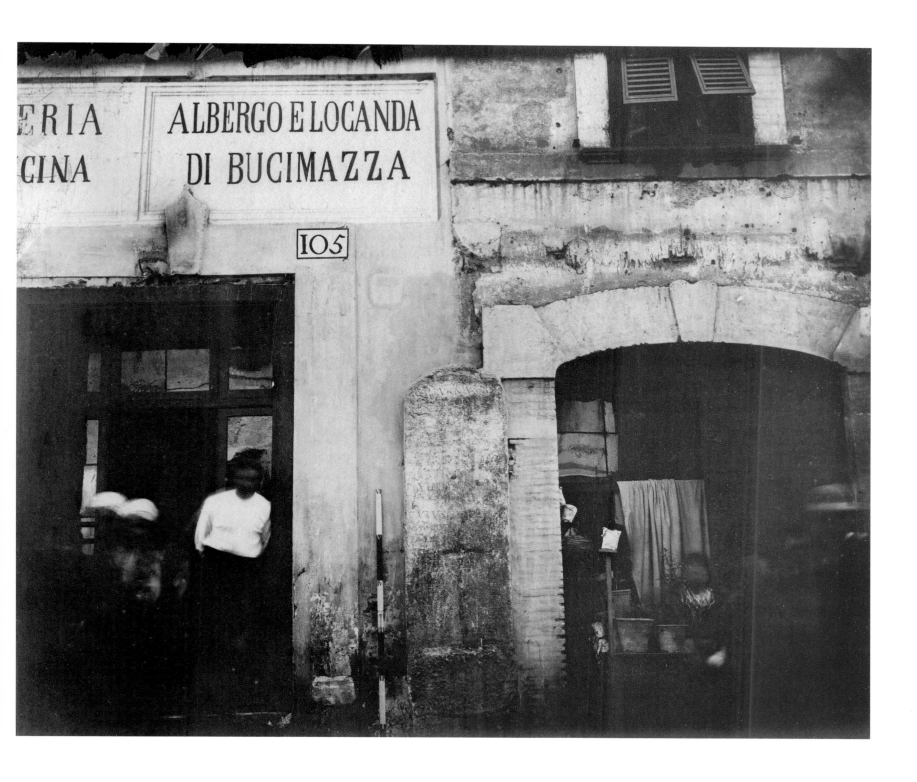

pp. 50/51
Atelier Robert Rive

In the background can be seen the Palazzo del Quirinale, for centuries the residence of the popes, after 1870 of the royal family, and in modern times of the presidents of the Republic. In the center of the square stands the Dioscuri Fountain with the obelisk. The area was nicknamed Monte Cavallo (Horse Hill), from the statues of Castor and Pollux, popularly known as the "horse tamers," next to the obelisk. They are over 5 meters (16 feet) tall, and once stood at the entrance of the Baths of Constantine, c. 1865.

Im Hintergrund der Quirinalspalast, für Jahrhunderte Sitz der römischen Päpste, nach 1870 der Königsfamilie, heute des italienischen Staatspräsidenten, in der Platzmitte der Dioskurenbrunnen mit Obelisk. Der volkstümliche Name „Monte Cavallo" für den Quirinalshügel leitet sich von den als

„Pferdebändiger" bekannten Skulpturen des Brüderpaars Castor und Pollux ab, die mit ihren über fünf Metern Höhe ursprünglich den Eingang zu den antiken Konstantinsthermen flankierten, um 1865.

En arrière-plan se dresse le palais du Quirinal qui, des siècles durant, fut la résidence des pontifes, puis celle de la famille royale après 1870 et qui est aujourd'hui celle des présidents de la République italienne. Le centre de la place est occupé par la fontaine des Dioscures et son obélisque. Le nom de « Monte Cavallo » [mont du cheval] donné à ce quartier dérive des deux statues de part et d'autre de l'obélisque, qui représentent Castor et Pollux familièrement appelés les « dompteurs de chevaux ». Hautes de plus de 5 mètres, elles ornaient jadis l'entrée des thermes de Constantin, vers 1865.

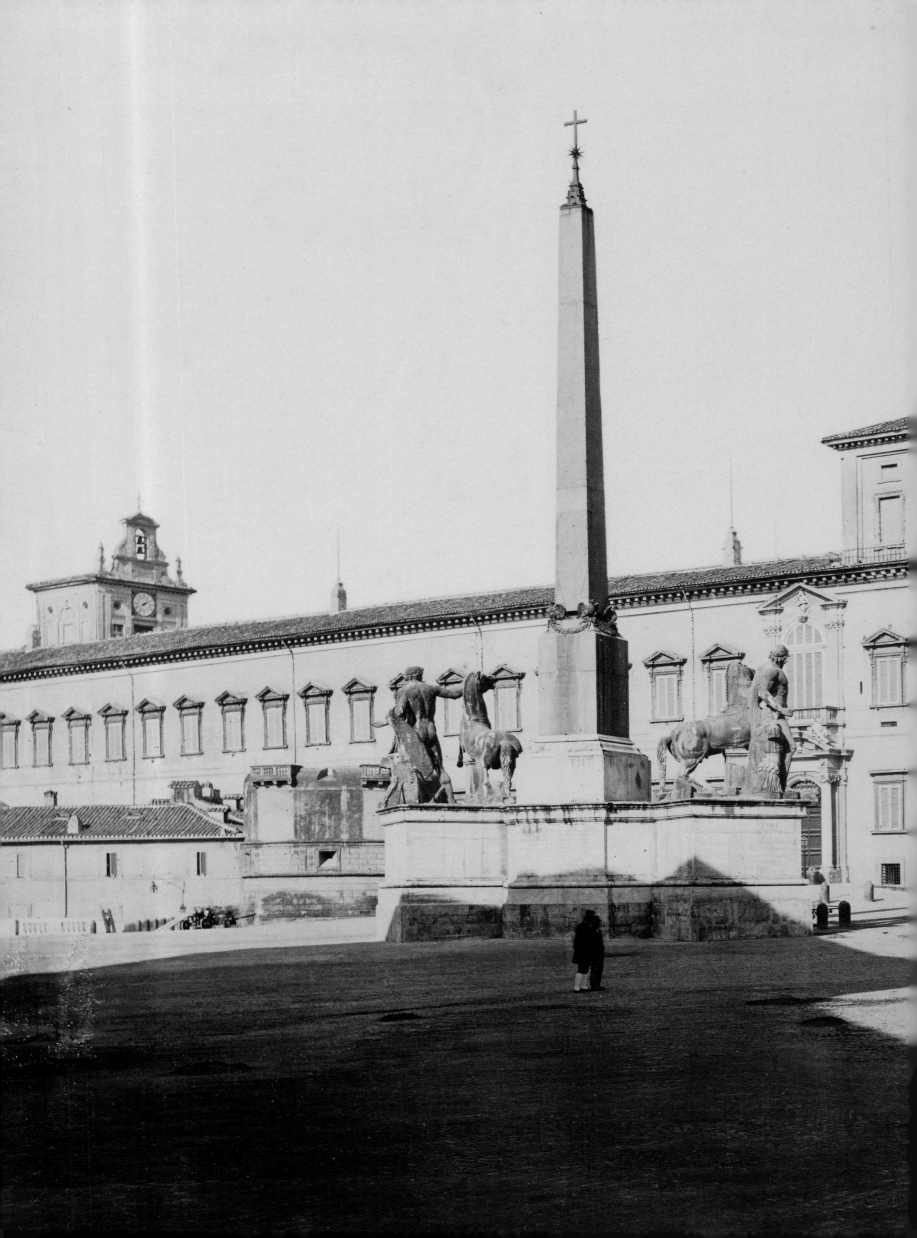

2

The City of Symbolic Significance: A Great Village 1871–1918

p. 54
Ludovico Tuminello

In the early 1870s, the neighborhood of Prati di Castello saw extensive urban renovation. The area was used for military drills, and sports and leisure exercises (in the left margin we can see the building that contained a view of the Battle of Palestro). It also included administrative offices of the Kingdom of Italy, c. 1882.

Das Gelände der Prati di Castello, nördlich vom Vatikan, wurde seit den 1870er-Jahren in die Stadt einbezogen. Dort fanden Truppenübungen sowie Sport- und Freizeitveranstaltungen statt (links das Gebäude, in dem ein Panoramabild der Schlacht von Palestro zu sehen war). Das Prati-Viertel wurde auch zum Standort zahlreicher Regierungsbauten des Königreichs Italien, um 1882.

À partir du début des années 1870, la zone des Prati di Castello fit l'objet de travaux d'urbanisation. Elle fut utilisée comme champ de manœuvres, terrain de sport et espace de loisirs (tout à gauche, l'édifice qui abritait le panorama de la bataille de Palestro). C'est également ici que se concentraient les structures administratives du royaume d'Italie, vers 1882.

"A new people does not exist yet, and soon the aristocracy will be gone too [...] there is only a greedy bourgeoisie, leading the looting of ruins."

ÉMILE ZOLA, *ROME*, 1896

In 1871 Rome, a city representing thousands of years of historical pre-eminence, became the capital of the new republic of Italy. As the center of the country's administration and government, it became more and more a city of symbolic significance, even in the most bombastic and vacuous sense of the word.

The political headquarters of a state that based its economy elsewhere (Turin, Milan), Rome was still a "big village," unprepared for its new role as a capital. "The Roman people were the same as they had always been, so corrupt through the course of the centuries that they had got to love the civic irresponsibility in which they had grown, bourgeois [but entirely oblivious of the revolutionary origins of this class] in their moral substance, but rustic in their customs" (Ludovico Quaroni, 1952). There was no overall plan, no concept of a new city, and the situation is still the same today. The opposition to political and cultural progress had the effect of encouraging the only possible industry – the construction of houses to rent or sell. Speculators from Turin, Milan, and Florence, and from abroad, brokered deals with the members of the Roman aristocracy who had connections with the Church. Between 1880 and 1886, a "building fever" took hold, followed by a crisis in that sector that lasted until 1892.

Claiming that their initiatives were necessary to improve the city's traffic circulation (in fact a nonexistent problem at the time) and sanitation (in 1868 a cholera epidemic had killed 8,489 people), speculators carried out some radical demolitions (Via Venezia in 1873; Via Cavour in 1883; Corso Vittorio Emanuele in 1884) and heavy-handed interventions, devoid of an overall vision of urban and architectural planning, unlike the projects of urban development that were taking place in London and Paris.

Between 1870 and the mid-1880s, hundreds of huge apartment buildings from five- to seven-stories tall were erected, forming new, eccentric city districts (Piazza Vittorio, Piazza Indipendenza, Prati di Castello). But the population growth that ostensibly justified their existence never materialized. The impoverished citizens who were forced to leave their houses when these were demolished to make space for the wide new avenues in the city center had no option but to move to the new districts. This migration was encouraged because it prevented the display of extreme poverty in the heart of Rome. In the rest of the city, the priority was to erect large, stately buildings: the new ministerial headquarters on the axis of the Corso and around Piazza Colonna, important banks, the new Palazzo di Giustizia

(1889–1910), the synagogue in the Trastevere district on the edge of the Jewish Ghetto (1899–1904), and the enlarged Palazzo Montecitorio (1903–1925). These are hybrid architectural designs in form and dimensions, forcibly planted in the ancient heart of the city. A case in point is the Vittoriale, a mass of travertine marble dedicated to the first king of Italy, begun in 1885 and inaugurated in 1911; it earned a number of unsavory nicknames, such as the "luxury pisspot" (Giovanni Papini), "wedding cake," "typewriter," and "coffee pot."

The first grand hotels were constructed in this period, including the Hotel de Rome, mentioned by Henry James, and the Albergo Europa in Piazza di Spagna, referenced several times in D'Annunzio's novel *Il Piacere* (1889; *The Child of Pleasure*). The Albergo Quirinale was erected on the new Via Nazionale in 1874; subsequently the Teatro dell'Opera, in revival Renaissance style, was built on the adjacent lot. The hotel connected with the theater by way of an underground walkway for the performers, ensuring their privacy. The Opera opened in 1880 in the presence of King Umberto I and Queen Margherita, with a performance of Rossini's *Semiramide*.

"The Corso," noted Henry James in 1873, "was always a well-filled street, but now it's a perpetual crush" (*A Roman Holiday*, 1873). The Corso featured important boutiques of fashion and hat designers, as well as elegant cafés such as the Caffè Giglio and the Caffè Nuovo, the Swiss patisserie Caflisch, and the Merle and the Loescher bookshops. Alongside these shops there were also the stores selling photographic and optical instruments, such as Suscipj, Ansiglioni, D'Alessandri, Verzaschi, and later Brogi and Alinari.

Street sellers were numerous and many trades were practiced in the streets: barbers welcomed their customers under beach umbrellas, scribes wrote letters for illiterate clients. In the Piazzetta San Carlo, streetsellers fried fish or tripe; in Piazza Colonna, cattleherders and brokers roamed about, while the *caffettari* roasted coffee beans.

Cafés became a crucial part of city life; the Caffè Greco in Via Condotti was the most fashionable and popular among them. By the end of the 1880s, *café-chantants* and music halls started to appear; singers such as Lina Cavalieri, or showgirls like Suzanne Duvernois – known as "the rival of Venus" – were a roaring success. The sport *pallone col bracciale* (a ball game in which players wear a wooden cylinder, *bracciale*, on one hand) was all the rage. At

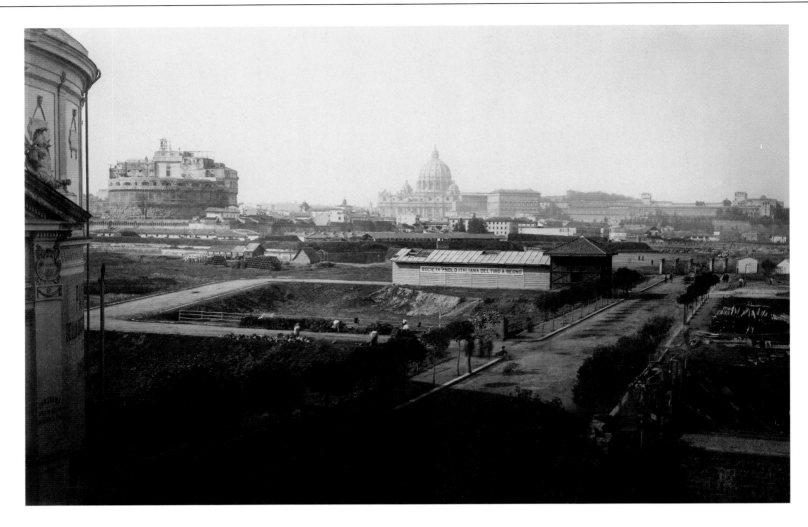

the end of the century, the new social classes were passionate about cycling, rowing, gymnastics, and shooting; there were also numerous social clubs and associations. During Umberto's reign, the capital city was the stage for the new high society – predominantly populated by wealthy foreign aristocrats – but also for the *demi-monde;* there were parties, carnival celebrations, horse races at the hippodromes in Capannelle or at the Galoppatoio in Villa Borghese, events that featured in the writings of Matilde Serao and Gabriele D'Annunzio.

In 1877 the public horse-drawn street-car line opened, serving the line Porta del Popolo-Ponte Milvio. In 1907 Sigmund Freud's attention was caught by the advertisements projected onto canvas on the rooftops and on walls of the buildings in Piazza Colonna.

The Tiber was still used as an inland waterway. The port of Ripa Grande welcomed steam- and sail-boats from the sea; to the north, the port of Ripetta managed the traffic of vessels and barges carrying wood, coal, and wine arriving from the upper course of the Tiber. But the river flooded the Campo Marzio each year, and Rome lacked a sewer system; so between 1883 and 1892 many buildings and factories facing the water were demolished, and colossal white travertine walls were erected (completed in 1926) to create the tree-lined, riverside boulevards of the Lungotevere, which had new sewers built underneath them. The D'Alessandri brothers were commissioned to photograph the sites before construction began.

Extreme poverty lingered on, in the lives of the more indigent citizens living in the old houses next to Rome's palaces. After the unification of Italy, tens of churches remained empty,

attended only for the occasional ceremony, such as a baptism or marriage, and some opened only once a year, on the feast day of their patron saint.

In 1894 Rome gave Zola the impression of being a great village, scattered and dejected, an ancient Rome forced to become modern, an enormous space built for a nonexistent population, demoralized by the ravaged belt of sterile soil surrounding it and by a dead river: a capital city that could not compare with Milan, which, alone in Italy, was a "grande ville pareille à Paris" ("a great city like Paris").

Perhaps because it was not suited to monumental architecture, the "Liberty" style (Art Nouveau) did not take root in Rome, with the exception of a few residential villas.

To celebrate the 50th anniversary of the unification in 1911, showy and monumental temporary pavilions were erected in Villa Giulia for the international exhibition of fine arts. On this occasion, the Galleria d'Arte Moderna was also created, replacing the Palazzo delle Esposizioni, built in 1873 on the Via Nazionale. The Galleria soon established itself as an important presence on the international art scene; its inauguration was celebrated with the acquisition of *The Three Ages of Woman,* a masterpiece by Gustav Klimt. On the right bank of the Tiber, the area of the regional and ethnographic exhibition was created, linked with the Villa Giulia by way of the new Flaminio bridge, featuring regional pavilions as well as the main festival pavilion, which contained a 3,000-seat cinema on the lower level. Other monumental and celebratory projects were carried out for the exhibition, including the Vittorio Emanuele Bridge and the Stadio Flaminio, both decorated with winged Victories.

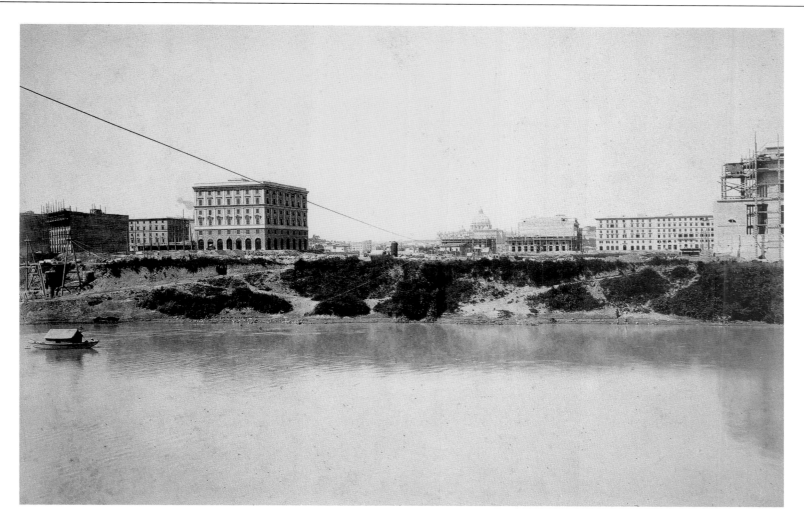

With the victory of the popular bloc (composed of radicals, republicans, socialists) in the 1904 elections, and the appointment of mayor Ernesto Nathan (who served in this role until 1914) the first publicly financed residential buildings were constructed; the district of San Saba, the first of the ICP (Istituto Case Popolari = popular residences institute, founded in 1903) in 1907; and from the 1920s whole areas of the city were developed, housing workers from the rail and postal services.

In 1914 Rome experienced some difficult times: in "Red Week," during the protest demonstrations against Giovanni Giolitti's reforms, barricades were erected in the streets. In the same year, Italy declared war on Austria. And during the war, women began to work outside the home.

From the 1880s, and more notably towards the end of the century, photography started to become widely popular, thanks to the invention of smaller cameras, lighter and easier to operate, ideal for taking spontaneous shots.

In Rome, count Giuseppe Primoli, a cosmopolitan man of the world, a humanist and a talented author of memoirs, had no equals in adapting instantaneous photography to the watchful and insatiable eye of the Belle Époque. He took photographs of the great Roman families and common people alike. Similarly,

Mario Nunes Vais, born into a rich, upper-class Florentine family, cultivated his passion for photography for almost 30 years, starting in the 1890s. He painted social and popular aspects of Rome life, as well as convincing portraits.

At the 1911 exhibition, Alfredo De Giorgio presented stereoscopic photographs of Rome by night, illuminated by electric light, and the tables of a *café-chantant*.

Even King Vittorio Emanuele III and Queen Elena enjoyed taking photographs: on the occasion of the exhibition to celebrate unification, each of them published an album of photographs.

In 1908 Adolfo Porry-Pastorel worked on contract for *Il Giornale d'Italia.* With him, the photographic chronicles of Rome were born. In 1908 he created an innovative photographic agency VEDO (Visioni Editoriali Diffuse Ovunque). He often took photographs of Mussolini, and in the 1930s dominated photography; he distributed watches bearing VEDO's logo and telephone number to traffic wardens, so that they would alert him to road accidents when they occurred.

During the Great War, graphic and photographic images became the vehicle for an early kind of mass propaganda, through the use of postcards, daily newspapers, and illustrated periodicals.

↑
Fratelli D'Alessandri

The stretch of the right bank of the Tiber in the area of Prati di Castello, shortly before the erection of the Lungotevere embankments, 1887.

Rechtes Tiberufer auf Höhe des Prati-Viertels kurz vor dem Bau der Tibermauern, 1887.

Rive droite du Tibre au niveau de la zone des Prati di Castello, peu avant les travaux d'endiguement, 1887.

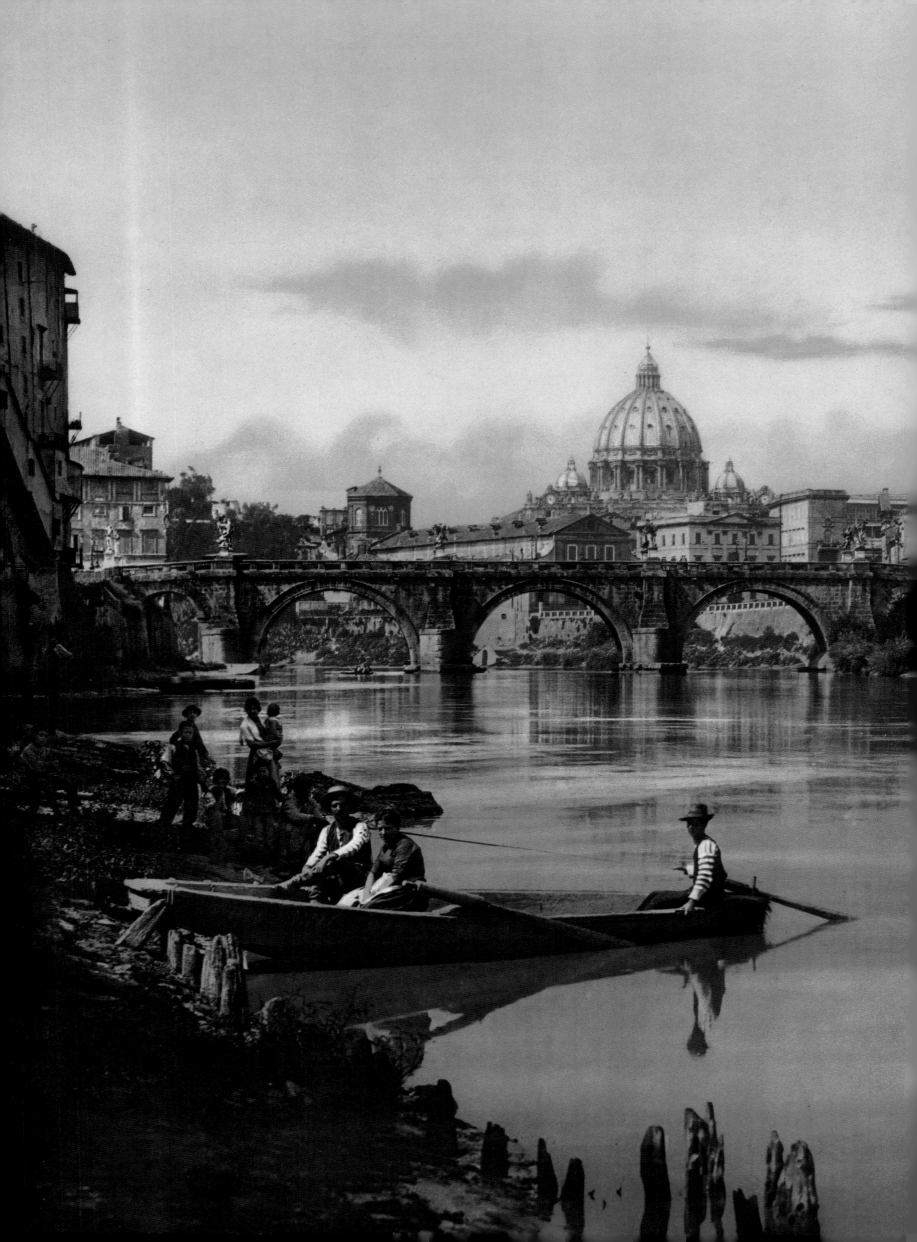

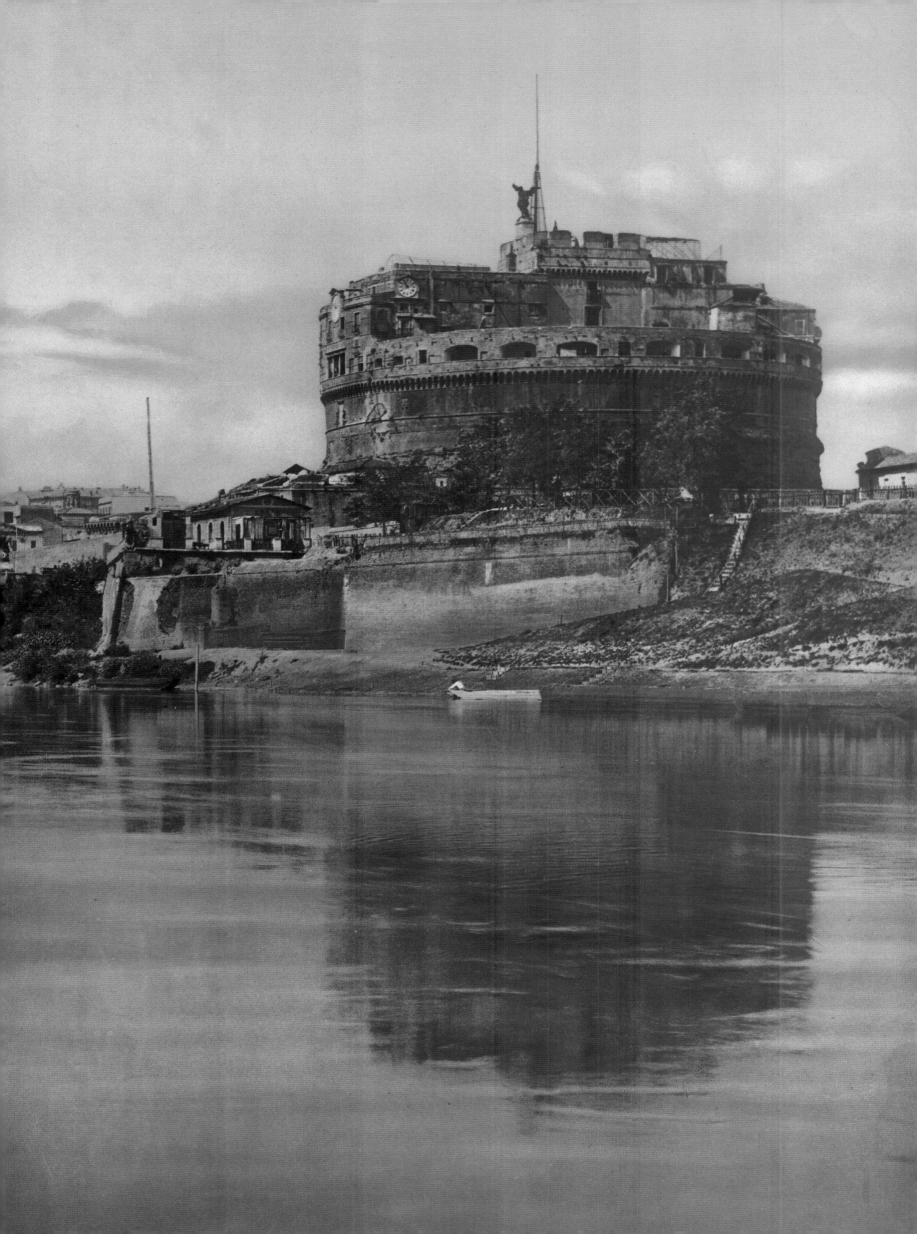

2

Zwischen Repräsentation und Rückständigkeit 1871–1918

pp. 56/57
Photoglob Zürich

The view over the Tiber with Castel Sant'Angelo in the foreground and the dome of St. Peter's in the background was one of the most popular subjects in the history of photographic imagery from the 19th century onwards. The crepuscular light effect created by the Photoglob professional retoucher accentuates the picturesque character of the view, c. 1905.

Die Tiberansicht mit Engelsburg und im Hintergrund der Peterskuppel gehört zu den beliebtesten Motiven der Romfotografie des 19. Jahrhunderts und darüber hinaus. Das Abendrot verdankt sich hier der Farbretusche des Photochroms und betont den pittoresken Charakter des Motivs, um 1905.

La vue sur le Tibre avec le château Saint-Ange (Castel Sant'Angelo) au premier plan et la coupole de la basilique Saint-Pierre au fond a constitué l'un des sujets privilégiés de l'iconographie photographique au XIXᵉ siècle et après. Les effets de lumière crépusculaire créés par le chromiste de la société Photoglob accentue le caractère pittoresque de la vue, vers 1905.

„Noch existiert kein neues Volk, und bald wird es auch
keine Aristokratie mehr geben […] und das gierige Bürgertum
wird die Ruinen plündern."
ÉMILE ZOLA, *ROME,* **1896**

Seit zwei Jahrtausenden Sitz der Regierung, zunächst des römischen, danach des päpstlichen Imperiums, wird Rom 1871 Hauptstadt des geeinten Italiens und damit zur Metropole der Repräsentation, der Bürokratie – „Residenzstadt" nicht ohne die negativen Begleiterscheinungen, die eine solche Funktion mit sich bringt.

Politisches Zentrum eines Staates, dessen wirtschaftlicher Machtschwerpunkt anderswo liegt, im Norden, in Turin und in Mailand, steht Rom, im Grunde noch immer ein „großes Dorf"; den Aufgaben einer Hauptstadt gänzlich unvorbereitet gegenüber. „Die römische Bevölkerung blieb dieselbe, die sie immer gewesen war, im Lauf der Jahrhunderte derart korrumpiert, dass sie die unerträglichen Zustände, aus denen sie stammte, lieben gelernt hatte, moralisch bürgerlich (ohne sich jedoch des revolutionären Ursprungs der bürgerlichen Klasse bewusst zu sein), kulturell aber zutiefst bäuerlich" (Ludovico Quaroni, 1952). Was Rom fehlte und bis heute fehlt, ist ein Masterplan, die Vision einer neuen Stadt.

Politische und kulturelle Erstarrung führen dazu, dass in Rom bald nur ein einziger „Industriezweig" blüht: der einer ungebremsten Produktion von Wohnraum zu Vermietung und Verkauf, wozu sich Spekulanten aus Turin, Mailand und Florenz mit dem mit der Kurie verbundenen römischen Adel ins Benehmen setzen. Zwischen 1880 und 1886 herrscht in Rom ein regelrechtes „Immobilienfieber", gefolgt von einer schweren Krise des Bausektors, die bis 1892 anhält.

Unter dem Vorwand, damals noch inexistente Verkehrsprobleme lösen oder hygienische Verhältnisse verbessern zu wollen (1868 waren 8489 Menschen der Cholera zum Opfer gefallen), wurden ganze Viertel abgerissen: 1873 im Bereich der Via Venezia, 1883 an der Via Cavour, 1884 am Corso Vittorio Emanuele, ohne dass diesen Maßnahmen ein architektonisches oder städtebauliches Konzept zugrunde lag, wie man es von ähnlichen Projekten im Paris oder London des 18. und 19. Jahrhunderts kannte.

Zwischen 1870 und der Mitte der 1880er-Jahre werden in Rom Hunderte Mietskasernen mit fünf bis sieben Geschossen in die Höhe gezogen. Ganze Stadtviertel außerhalb des historischen Zentrums entstehen so: an der Piazza Vittorio Emanuele, der Piazza Indipendenza oder im Prati-Viertel. Einen Bevölkerungszuwachs aber, der dieses Vorgehen gerechtfertigt hätte, gibt es nicht. Stattdessen werden die Häuserriesen von ebenjenen Armen aus dem ehemaligen Getto oder den Vierteln, die den neuen

Prachtstraßen hatten weichen müssen, bezogen, die nun keine Bleibe mehr haben. Man lässt sie gewähren, um zu vermeiden, dass der Notstand im Zentrum der Hauptstadt allzu offensichtlich wird.

Im Übrigen widmet man sich der Errichtung repräsentativer Prachtbauten. Zu nennen sind hier die neuen Ministerien an der Achse des Corso und an der Piazza Colonna, einige Großbanken, der Justizpalast (1889–1910), die neue Synagoge in Trastevere am Rande des ehemaligen Gettos (1899–1904) oder die Erweiterung des Parlamentssitzes im Palazzo Montecitorio (1903–1925). Gigantomanisch in Größe und Gestalt, werden diese Klötze rücksichtslos inmitten der Altstadt platziert. Unübersehbar in dieser Hinsicht ist das Monument zu Ehren des ersten Königs des vereinten Italien, Viktor Emanuel III.: ein Berg aus Travertin mitten im historischen Herzen der Stadt (begonnen 1885, eingeweiht 1911), für manche schlicht ein »Luxuspissoir« (Giovanni Papini), für andere wahlweise eine überdimensionale Hochzeitstorte, Schreib- oder auch Espressomaschine.

In dieser Zeit entstehen die ersten Grandhotels, wie das Hotel de Rome, von dem Henry James schreibt, oder das Hotel Europa an der Piazza di Spagna, das in D'Annunzios Roman *Lust* (1889) mehrfach auftaucht. An der neuen Via Nazionale wird 1874 das Albergo Quirinale eröffnet, in dessen Nachbarschaft entsteht im Neorenaissancestil ein Opernhaus. Hotel und Oper sind durch einen unterirdischen Gang miteinander verbunden, der den Künstlern erlaubt, ungesehen an ihre Wirkungsstätte zu gelangen. 1880 wird die Oper in Gegenwart von König Umberto I. und Königin Margherita mit Rossinis *Semiramis* eröffnet.

Henry James schreibt 1873 über den Corso, dieser sei „zwar immer schon eine belebte Straße gewesen, jetzt aber ist er zu einem unablässigen Strom von Menschen geworden" (*A Roman Holiday,* 1873). An der Via del Corso liegen die Geschäfte der großen Hutmacher und Modisten, elegante Caféhäuser wie das Caffè Giglio, das Caffè Nuovo oder die Schweizer Konditorei Caflisch, nicht zu vergessen die Buchhandlungen Merle und Loescher. Optiker und Fotografen von Rang unterhalten am Corso ebenfalls ihre Ateliers: Suscipj, Ansiglioni, D'Alessandri, Verzaschi, später auch Brogi und Alinari.

Auch fahrende Händler sind in Rom damals noch allgegenwärtig, viele Berufe werden unter Sonnenschirmen im Freien ausgeübt, Barbiere laden zur Rasur, Lohnschreiber erledigen die Korrespondenz für die vielen Analphabeten. Auf der Piazzetta

←
Anonymous

Vicolo del Governo Vecchio being demolished during the 1883 city restructuring works. At the end of the alley on the right is Borromini's façade of the Oratorio dei Filippini, 1888–1900.

Der Vicolo del Governo Vecchio während der Abrissarbeiten im Zuge der vom Regulierungsplan des Jahres 1883 vorgesehenen Altstadtsanierung. Am Ende der Gasse ist die Fassade von Borrominis Oratorianerkirche S. Filippo Neri zu erkennen, 1888–1900.

Vicolo del Governo Vecchio en cours de démolition, conformément au plan régulateur de 1883. Au fond de la ruelle, à droite, la façade de l'oratoire des Philippins (Oratorio del Filippini), œuvre de Borromini, 1888–1900.

San Carlo werden Fisch und Kutteln frisch frittiert, und auf der Piazza Colonna bauen Kaffeeröster ihre mobilen Stände auf, während sich Viehzüchter und Bauern dort mit ihren Zwischenhändlern treffen.

Die Caféhäuser, allen voran das piekfeine Caffè Greco an der Via Condotti, avancieren zum Mittelpunkt des gesellschaftlichen Lebens. Ende der 1880er-Jahre eröffnen die ersten Musikcafés und Varietétheater, auf deren Bühnen Primadonnen wie Lina Cavalieri oder die Soubrette Suzanne Duvernois – bekannt als „Rivalin der Venus" – Publikumstriumphe feiern. Im sportlichen Bereich erfreut sich Ende des 19. Jahrhunderts der *pallone col bracciale* (eine Art Schlagball) größter Beliebtheit, während die neuen Schichten in zahlreichen Vereinen leidenschaftlich dem Rad- und Rudersport, gymnastischen Leibesübungen und dem Sportschießen huldigen. Eine Bühne bietet das Rom der Belle Epoque auch der mondänen Welt des neuen Italien. Adlige, reiche Ausländer und Halbweltgrößen – sie alle sind das Personal der eleganten Bälle und des Karnevals, bilden jene Hautevolee, die sich an der Pferderennbahn der Capanelle oder der Villa Borghese ein Stelldichein gibt; Matilde Serao und Gabriele D'Annunzio haben diese Welt in ihren Romanen verewigt.

1877 nimmt die erste Pferdetrambahn zwischen der Porta del Popolo und der Milvischen Brücke ihren Betrieb auf. 1907 zeigt Sigmund Freud sich von den Leuchtreklamen der Piazza Colonna – teils Leuchttafeln, teils auf große Leinwände auf den umliegenden Dächern projiziert – beeindruckt.

Ende des 19. Jahrhunderts verkehren auf dem Tiber noch Schiffe. Im Hafenkai an der Ripa Grande machen Dampfboote und Hochseesegler fest, weiter nördlich, an der Ripetta, Fähren und Lastkähne, die hier Holz, Kohle oder Wein vom Oberlauf des Tiber löschen. Weil aber der Fluss alljährlich über die Ufer tritt, das Marsfeld überschwemmt und kein Abflusssystem existiert, werden 1883 bis 1892 etliche Häuser und Werkstätten längs des Tiberufers abgerissen, um Platz für die 1926 fertig gestellten monumentalen Ufermauern aus Travertin und die parallel führenden platanenbestandenen Uferalleen des Lungotevere zu schaffen, unter denen sich die Überlaufkanäle befinden. Vor dem Abriss erhalten die Brüder D'Alessandri den Auftrag, die Tiberufer in ihrem alten Zustand fotografisch festzuhalten.

In der römischen Altstadt lebt das einfache Volk derweil unter beengten Verhältnissen in Häusern aus vergangenen Zeiten Seite an Seite mit den Palästen des Adels.

Seit der Einigung Italiens stehen auch in Rom Dutzende Kirchen leer oder sind nur an ganz bestimmten Tagen zum Gottesdienst zugänglich, manche sogar nur einmal im Jahr zum Patronatsfest.

Émile Zola bescheinigt Rom 1894 zwar noch immer erhabene Größe, empfindet die Stadt aber als leer und trist. Das alte Rom sei gezwungen worden, sich zu modernisieren, eine riesige Stadt, gebaut für eine Bevölkerung, die nicht existiert, eingeklemmt zwischen einem Ödstreifen unfruchtbarer Erde und einem Fluss ohne Leben. Mit Mailand, der einzigen Paris vergleichbaren Großstadt Italiens, so Zola, könne dessen Hauptstadt Rom es nicht aufnehmen.

Der Jugendstil, vielleicht weil er zur Monumentalität vieler Neubauten nicht recht passen will, hat es in Rom schwer, Wurzeln zu schlagen, seine Formen bleiben auf einige Privathäuser beschränkt.

Im Rahmen des 50-jährigen Jubiläums der Einigung Italiens 1911 werden in Nachbarschaft der Villa Giulia Pavillons für die Internationale Kunstausstellung errichtet. Selbst diese, wenngleich nicht auf Dauer angelegt, verraten eine Vorliebe für das Monumentale. Den Einigungsfeierlichkeiten verdankt auch die Galleria d'Arte Moderna ihre Entstehung, die von nun an ein wichtiger Bezugspunkt für die Auseinandersetzung mit der aktuellen internationalen Kunstentwicklung sind und in dieser Funktion an die Stelle des 1873 an der Via Nazionale eröffneten Palazzo delle Esposizioni tritt. Für den Neubau unweit der Villa Giulia wird Gustav Klimts *Die drei Lebensalter der Frau* erworben. Am rechten Tiberufer entsteht parallel das Gelände der *Mostra regionale e etnografica*, das mit der Kunstausstellung über den neu errichteten Ponte Flaminio verbunden ist und neben Ausstellungspavillons der italienischen Regionen über eine Festhalle mit einem 3000 Menschen fassenden Lichtspielsaal im Tiefparterre verfügt. Die Ausstellung von 1911 beschert Rom überdies Denkmäler und andere Jubiläumsbauten wie den Ponte Vittorio Emanuele und das Stadio Flaminio mit ihren Siegessäulen.

Der Wahlsieg des Blocco Popolare aus Radikalen, Republikanern und Sozialisten und die Wahl Ernesto Nathans zum Bürgermeister im Jahr 1904 (im Amt bis 1914) öffnet den Weg zu ersten Projekten eines öffentlich geförderten Wohnungsbaus, in deren Rahmen vor allem ab den 1920er-Jahren zahlreiche Neubauviertel entstehen. Zunächst sind es Genossenschaften von Eisenbahnern und Postbeamten, die sich auf diesem Feld betätigen.

→
Giuseppe Primoli

Pope Leo XIII, aged 80, walking in the
Vatican Gardens, 1889.

Der 80-jährige Papst Leo XIII. beim
Spaziergang in den Vatikanischen Gärten,
1889.

La promenade du pape Léon XIII,
alors octogénaire, dans les jardins du
Vatican en 1889.

1907 errichtet das ICP, das Istituto Case Popolari (das im Jahr 1903 gegründet wurde) die Mustersiedlung San Saba auf dem Kleinen Aventin.

1914 kommt es in Rom während der *Settimana Rossa*, der „roten Woche", zu Unruhen und Kundgebungen gegen einige von Premierminister Giovanni Giolitti beschlossene Reformen, auf den Straßen werden Barrikaden errichtet. Im selben Jahr erklärt Italien Österreich den Krieg. Die Kriegsjahre führen zu einer verstärkten Einbeziehung der Frauen in der Arbeitswelt und im öffentlichen Leben.

Zwischen den 1880er-Jahren und der Jahrhundertwende wird die Fotografie weltweit zu einem Massenphänomen. Die Entwicklung kleinerer, leichterer und einfacher zu bedienender Fotoapparate ermöglicht kürzere Belichtungszeiten.

In Rom ist es der Graf Giuseppe Primoli – Kosmopolit, Freund der Literatur und der Künste sowie begabter Memoirenschreiber –, der es wie kein Zweiter versteht, die neue Technik zu Momentaufnahmen aus dem Leben der Belle Epoque zu nutzen, sei es aus dem Leben der großen römischen Familien, sei es aus dem der kleinen Leute.

Ähnlich widmet sich auch der aus reichem Florentiner Bürgertum stammende Mario Nunes Vais mit Beginn der 1890er-Jahre drei Jahrzehnte lang mit Leidenschaft der Fotografie. Viele seiner Motive entstammen der feinen römischen Gesellschaft, andere dem Alltagsleben, daneben schuf Nunes Vais ausdrucksstarke Porträts.

Auf der Kunstausstellung von 1911 präsentiert Alfredo De Giorgio Stereoskopaufnahmen, die das nächtliche Rom bei elektrischer Beleuchtung zeigen oder das Innere eines Varietés vorführen. Auch König Viktor Emanuel III. und seine Gattin Elena betätigen sich als Fotografen. Anlässlich der Jubiläumsausstellung zur nationalen Einigung wird je eines ihrer Motive als Fotokarte herausgegeben.

1908 nimmt das *Giornale d'Italia* den Fotografen Adolfo Porry-Pastorel unter Vertrag. Damit beginnt auch in Rom das Zeitalter des Fotojournalismus. Im selben Jahr gründet Porry-Pastorel die Bildagentur VEDO (Visioni Editoriali Diffuse Ovunque). Porry-Pastorel fotografiert auch Mussolini, und in den 1930er-Jahren beherrscht er die fotografische Szene. Er lässt Uhren mit Logo und Fernsprechnummer seiner Agentur an die römische Polizei verteilen, um als Erster am Ort des Geschehens zu sein.

Während des Ersten Weltkriegs tragen grafische Illustrationen und Fotografien auf Postkarten und Plakaten, in Tageszeitungen und illustrierten Zeitschriften wesentlich zur Ausbreitung der Fotografie als frühem Massenmedium bei.

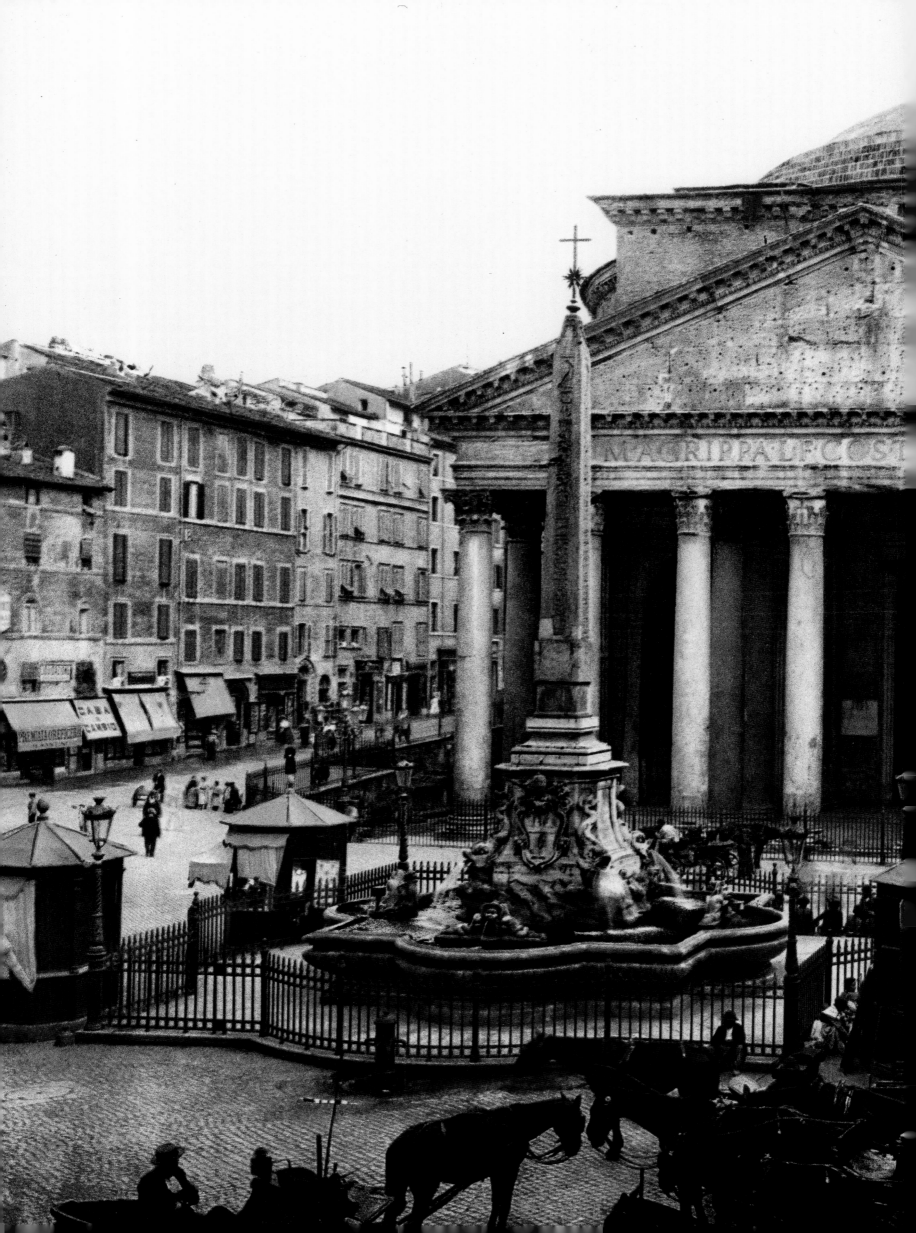

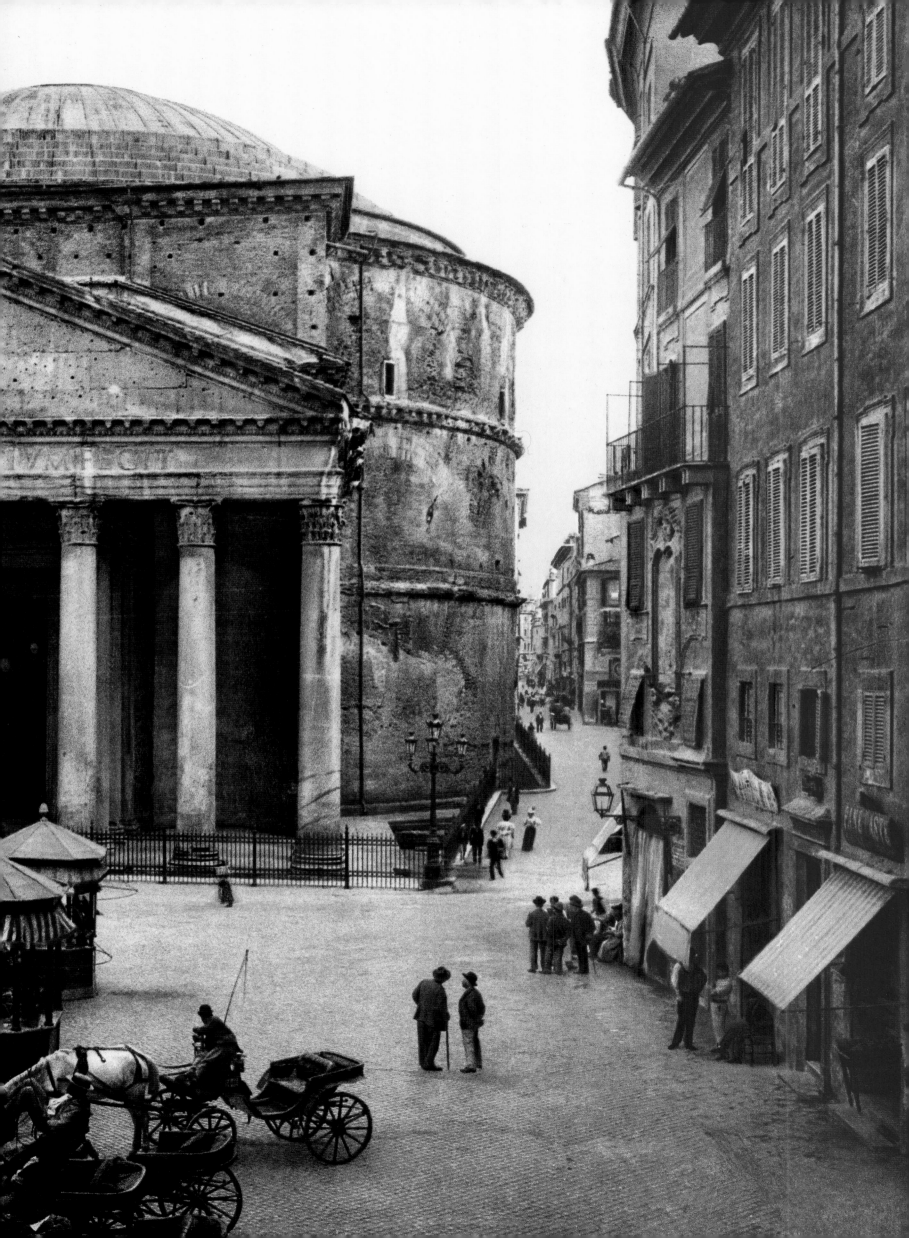

2

Entre ville symbole et « grand village » 1871–1918

pp. 62/63
Photoglob Zürich

Piazza della Rotonda with typical kiosks selling drinks and sweets at the four corners of the fountain, and some parked carriages, c. 1905.

Die Piazza della Rotonda mit den charakteristischen Getränkebuden an den vier Ecken des Brunnens und davor wartenden Droschken, um 1905.

La piazza della Rotonda avec ses kiosques typiques vendant boissons et pâtisseries placés aux quatre coins de la fontaine et quelques voitures en stationnement, vers 1905.

*« Pas encore de peuple et bientôt plus d'aristocratie [...]
et une bourgeoisie dévorante, menant la curée parmi les ruines. »*
ÉMILE ZOLA, *ROME*, PARIS, 1896

Ville millénaire, Rome devient la capitale du nouvel État italien en 1871. Elle sera toujours davantage une ville symbole, une ville administrative et résidentielle, y compris dans le sens noble et vide du terme.

Centre politique d'un État dont les leviers du pouvoir économique se trouvent ailleurs (Turin, Milan), Rome demeure un « grand village » nullement préparé à son nouveau rôle de capitale. « Le peuple romain était celui de toujours, corrompu depuis des siècles au point d'aimer cet état d'irresponsabilité civile dans lequel il avait grandi, moralement bourgeois [mais totalement oublieux de l'origine révolutionnaire de cette classe] et culturellement paysan. » (Ludovico Quaroni, 1952). Il lui manque alors et il lui manquera par la suite une vue d'ensemble, un projet de ville nouvelle.

L'immobilisme politique et culturel stimule une seule et vaste industrie, celle du bâtiment qui produit des maisons à vendre ou à louer. Les spéculateurs de Turin, de Milan, de Florence, voire d'au-delà des Alpes, s'entendent avec l'aristocratie romaine liée à l'Église. Entre 1880 et 1886 se manifeste une véritable fièvre de construction à laquelle fera suite une grande crise du secteur qui se prolongera jusqu'en 1892.

Sous prétexte de résoudre des problèmes de circulation (alors inexistants) ou de salubrité (en 1868 le choléra a fait 8 489 victimes), les spéculateurs font procéder à diverses démolitions (1873, via Venezia ; 1883, via Cavour ; 1884, corso Vittorio Emanuele) totalement étrangères à une vision d'ensemble et inconsidérées du point de vue urbanistique et architectural comparativement à celles effectuées à Londres ou à Paris aux xviiie et xixe siècles.

Entre 1870 et le milieu des années 1880, des centaines d'énormes immeubles, des casernes de cinq à sept étages, sont construits pour constituer de nouveaux quartiers excentrés (piazza Vittorio, piazza Indipendenza, Prati di Castello). Mais la croissance de la population qui aurait dû en justifier l'édification n'est pas au rendez-vous. Aussi les pauvres, chassés des maisons détruites du ghetto juif et de celles rasées pour faire place à de grandes artères de prestige, iront-ils « occuper » les nouveaux immeubles : une occupation tolérée car elle évitait que la misère ne se manifeste ouvertement dans le centre.

Pour le reste, on se préoccupe surtout de construire quelques édifices prestigieux tels que les nouveaux ministères sur l'axe du Corso et autour de la piazza Colonna, plusieurs grandes banques, le nouveau palais de justice (1889–1910), la synagogue du

Trastevere en lisière de l'ancien ghetto (1899–1904), l'agrandissement du palazzo Montecitorio (1903–1925). Pharaoniques par leurs dimensions et leurs formes, ces édifices s'imposent avec violence au cœur de la Rome antique. Le plus emblématique d'entre eux est le monument à Victor-Emmanuel II (le Vittoriale), véritable montagne de marbre travertin dédiée à la mémoire du premier roi d'Italie, construit entre 1885 et 1911. Il est affublé des sobriquets les plus variés dont la « vespasienne de luxe » (Giovanni Papini), la « pièce montée », la « machine à écrire » ou encore la « machine à café ».

À cette époque, les premiers grands hôtels sortent de terre, dont l'Hôtel de Rome cité par Henry James ou l'hôtel Europa sur la piazza di Spagna cité plusieurs fois dans *L'Enfant de volupté* (1889) de D'Annunzio. L'hôtel Quirinale est construit dans la toute nouvelle via Nazionale en 1874 tandis que sur le terrain le jouxtant est édifié le théâtre de l'Opéra de style néo-Renaissance. L'hôtel communique avec le théâtre par un passage souterrain qui protège l'intimité des artistes. En 1880, le roi Humbert Ier et la reine Marguerite inaugurent l'Opéra où est donnée la *Sémiramis* de Rossini.

« Le Corso, note Henry James, a toujours été une artère très animée, mais c'est maintenant une bousculade perpétuelle » (*Vacances romaines*, 1873, in *Heures italiennes*). Le Corso est bordé de prestigieux magasins de modistes et de chapeliers, de cafés élégants comme le Caffè Giglio et le Caffè Nuovo ou la pâtisserie suisse Caflisch, et des librairies Merle et Loescher. Des opticiens et des photographes de renom y tiennent boutique dont Suscipj, Ansiglioni, D'Alessandri, Verzaschi et, un peu plus tard, Brogi et Alinari.

Les vendeurs ambulants ne manquent pas et nombre de métiers s'exercent dans la rue : sous de grands parasols, des barbiers accueillent leurs clients et des écrivains publics rédigent la correspondance des analphabètes. Sur la petite place San Carlo on fait frire du poisson et on cuisine des tripes tandis que sur la place Colonna, où se retrouvent maquignons et gardiens de troupeau, quelques « cafetiers » torréfient des grains.

La vie des cafés occupe une place croissante. L'un des plus remarquables est le très élégant Caffè Greco de la via Condotti. À la fin des années 1880 s'ouvrent des cafés-concerts et des théâtres de variétés ; des chanteuses comme Lina Cavalieri ou Suzanne Duvernois, surnommée la rivale de Vénus, y connaissent un triomphe. Le spectacle sportif le plus populaire est le *pallone col*

←

Jano Dubravcik

Lemon seller in the street, c. 1907.

Zitronenhändler in einer römischen Gasse, um 1907.

Vendeur de citrons ambulant, vers 1907.

bracciale, un jeu de ballon dérivé du jeu de paume. À la fin du siècle, les nouvelles classes se passionnent pour la bicyclette, le canotage, la gymnastique et le tir. Les cercles et les associations se multiplient. Au temps du roi Humbert, la capitale est le théâtre d'une nouvelle mondanité dont les acteurs sont les aristocrates et les riches étrangers mais également le demi-monde ; c'est l'époque des fêtes, du carnaval, des courses à l'hippodrome des Capannelle ou sur les pistes de la villa Borghèse tels que les ont décrits Matilde Serao ou Gabriele D'Annunzio.

En 1877, la ligne d'omnibus hippomobile Porta del Popolo-Ponte Milvio est mise en service. Trente ans plus tard, l'attention de Sigmund Freud sera retenue par les réclames, entrecoupées de vues photographiques et de courts métrages cinématographiques, projetées piazza Colonna sur un écran tendu sur un toit.

La voie fluviale qu'est le Tibre conserve une activité soutenue. Le port de Ripa Grande accueille des navires à vapeur et à voiles en provenance de la mer tandis que le port de Ripetta, au nord, est réservé au trafic des bateaux et des péniches chargés de bois, de charbon et de vin qui descendent le cours du Tibre. Mais le fleuve inonde le Champ de Mars (Campo Marzio) chaque année et il manque à Rome un système d'assainissement ; aussi, entre 1883 et 1892, de nombreux édifices et ateliers donnant sur le fleuve sont-ils démolis pour faire place à de puissantes et hautes digues en travertin blanc (achevées en 1926) et à des allées plantées d'arbres, dites « Lungotevere », sous lesquelles courent les égouts. Les frères D'Alessandri sont chargés de photographier les lieux avant les travaux.

Au centre de la ville, dans les vieilles maisons proches des palais, la misère perdure. Après l'Unité, les églises vides se comptent par dizaines, certaines n'étant fréquentées qu'à date fixe pour les cérémonies, d'autres s'ouvrant une fois par an pour la fête de leur saint protecteur.

En 1894, aux yeux de Zola, la ville se distingue par son caractère grandiose, mais aussi par son éparpillement et sa tristesse, une Rome antique contrainte de devenir une Rome moderne, une ville énorme édifiée pour une population inexistante, une ville mortifiée par une ceinture de terre stérile, par un fleuve mort, une capitale ne soutenant pas la comparaison avec Milan qui, unique en Italie, est une « grande ville pareille à Paris ».

Du fait, peut-être, qu'il est peu adapté à une architecture monumentale, le style Art nouveau ne s'implante pas à Rome où seules quelques villas l'adoptent.

Dans le cadre des expositions et des projets organisés pour commémorer le cinquantenaire de l'unité italienne (1911) sont aménagés à la villa Giulia les pavillons éphémères de l'Exposition internationale des beaux-arts conçus et construits avec une certaine complaisance monumentale. À cette occasion, la Galleria d'Arte Moderna (Galerie d'art moderne) voit le jour : remplaçant le Palazzo delle Esposizioni (palais des Expositions), édifié via Nazionale en 1873, elle s'imposera désormais comme un lieu incontournable de la culture artistique internationale. Pour la nouvelle Galerie, on fait l'acquisition d'un chef-d'œuvre de Gustav Klimt, les *Trois Âges de la femme*. Sur la rive droite du Tibre est aménagé le quartier de l'Exposition régionale et ethnographique, relié au secteur de la villa Giulia grâce au nouveau pont del Risorgimento, qui accueille plusieurs pavillons des régions et le pavillon des fêtes dont le sous-sol abrite une salle de cinéma de 3 000 places. Dans le cadre de l'Exposition, d'autres interventions monumentales et commémoratives voient le jour dont les ponts Victor-Emmanuel et le stade Nazionale, tous deux ornés de Victoires ailées.

Avec la victoire du bloc populaire (radicaux, républicains et socialistes) lors des élections municipales de 1904 et la nomination au poste de maire d'Ernesto Nathan (en exercice jusqu'en 1914) débute la construction de logements bénéficiant de financements publics, qui caractériseront des quartiers entiers de Rome à partir des années 1920 ; sont ainsi édifiés les immeubles liés aux coopératives des chemins de fer et des postes et télégraphes, et, en 1907, le quartier San Saba, le premier de l'Istituto Case Popolari fondé en 1903, l'équivalent de l'office des HLM.

En 1914, Rome connaît des heures difficiles : durant la « semaine rouge » et les manifestations organisées contre une série de réformes introduites par Giovanni Giolitti, des barricades sont dressées dans les rues. L'année suivante, l'Italie déclare la guerre à l'Autriche. Pendant le conflit, les femmes prennent une part active au monde du travail et à la vie publique.

À partir des années 1880, et de manière plus en plus perceptible à l'approche du nouveau siècle, la photographie devient un phénomène de masse grâce, notamment, à l'apparition d'appareils de petites dimensions, maniables et légers, adaptés aux prises rapides.

À Rome, le comte Giuseppe Primoli, cosmopolite, homme du monde, ami des arts et des lettres, mémorialiste de talent, n'a pas son pareil pour mettre la photographie instantanée au service

→

Jano Dubravcik

*Siesta in the Colonnade of St. Peter's Square,
c. 1907.*

*Siesta in den Kolonnaden von St. Peter,
um 1907.*

*Sieste sous la colonnade de la place Saint-
Pierre, vers 1907.*

du regard avide de la Belle Époque. Il photographie la vie des grandes familles romaines comme celle des milieux populaires.

De manière analogue, Mario Nunes Vais, né au sein d'une riche famille de la bourgeoisie florentine, cultive une passion pour la photographie pendant presque trente ans, à partir du début des années 1890. Nombre de ses clichés illustrent des aspects de la vie romaine, mondaine comme populaire, et se révèlent des portraits efficaces.

Lors de l'Exposition de l'unité italienne de 1911, Alfredo De Giorgio présente des photographies stéréoscopiques de la Rome nocturne éclairée à l'électricité ou encore des tables de café-concert. Victor-Emmanuel III et la reine se plaisent à faire de la photographie, eux aussi, et, à l'occasion de l'Exposition de l'Unité, chacun d'eux publie un album de photographies.

En 1908, Adolfo Porry-Pastorel signe un contrat avec *Il Giornale d'Italia* ; c'est ainsi que naît la chronique photographique romaine. La même année, il fonde une agence de photographie moderne intitulée VEDO (« je vois » en italien, pour Visioni Editoriali Diffuse Ovunque). Il photographie souvent Mussolini et, dans les années 1930, fait autorité. Il distribue des montres aux gardiens de la paix avec le nom et le numéro de téléphone de la VEDO pour être prévenu de tout événement survenant dans la capitale.

Durant la Première Guerre mondiale, les images des dessinateurs et des photographes deviennent les moyens de diffusion d'une première forme de propagande de masse grâce aux cartes postales, aux affiches, aux quotidiens et aux périodiques illustrés.

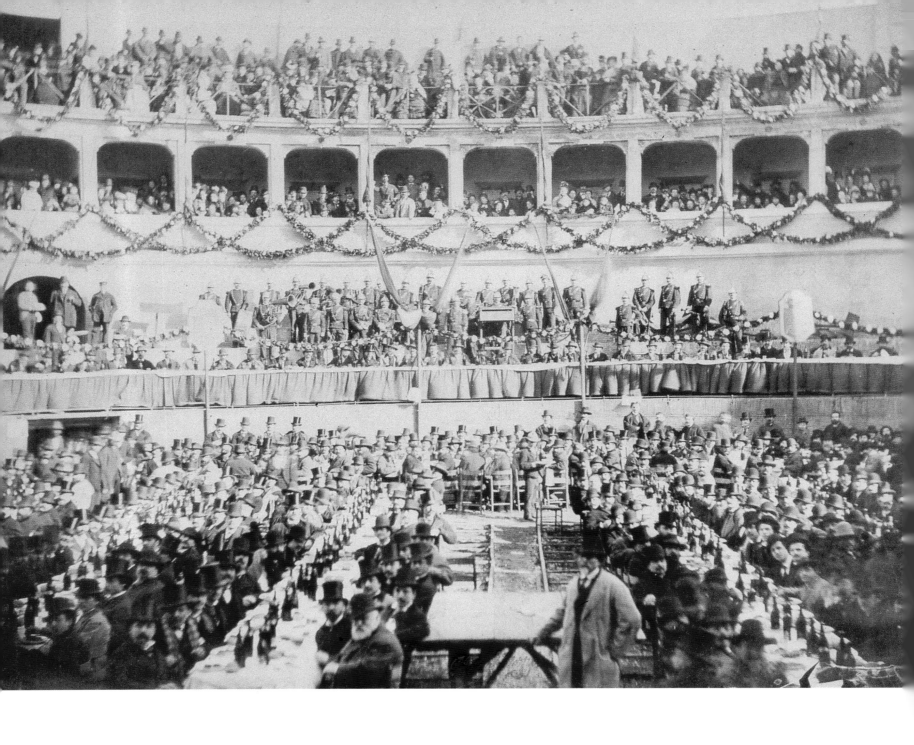

Pacifico Tagliacozzo

The grand banquet in honor of Giuseppe Garibaldi on the occasion of his entrance to Parliament was hosted by the Roman Workers' Society in the Corea Amphitheater. Built on the ruins of the Mausoleum of Augustus between 1907 and 1937, it was used as a concert hall. The hero ate only a pasta dish and drank a glass of Marsala, February 14, 1875.

Großer Festschmaus zur Feier von Giuseppe Garibaldis Einzug ins Parlament, ausgerichtet von den römischen Arbeitverbänden im Anfiteatro Corea, das, auf den Ruinen des Augustusmausoleums erbaut, von 1907 bis 1937 als Konzertsaal diente. Garibaldi begnügte sich mit einem Teller Pasta und einem Glas Marsala, 14. Februar 1875.

Le gigantesque banquet donné en l'honneur de Giuseppe Garibaldi à l'occasion de son entrée au Parlement fut offert par les Società Operaie Romane [sociétés ouvrières de Rome] dans l'amphithéâtre Corea ; construit sur les ruines du mausolée d'Auguste, il fit office de salle de concert entre 1907 et 1937. Le héros se contenta d'un plat de pâtes et d'un verre de Marsala, 14 février 1875.

→

Gioacchino Altobelli

A group of Tiber rowers in front of their club, 1875.

Römische Ruderer vor ihrem Vereinshaus, 1875.

Groupe de canoteurs du Tibre devant leur club sportif, 1875.

"30 October 1870: Rome will lose the air of world republic that I breathed for 18 years. She is downgraded to the status of capital of the Italians, who, owing to the position in which our victories have placed them, are too weak."

„30. Oktober 1870: Rom wird die weltrepublikanische Luft einbüßen, die ich hier 18 Jahre geatmet habe. Es sinkt herab zur Hauptstadt der Italiener, welche für eine große Lage, in die sie unsere Siege versetzt haben, zu schwach sind."

« 30 octobre 1870 : Rome perdra son atmosphère de république mondiale que j'y ai respirée pendant dix-huit ans. Elle régresse au rang de capitale des Italiens qui, du fait de la situation où les ont plongés nos victoires, sont trop faibles. »

FERDINAND GREGOROVIUS, *RÖMISCHE TAGEBÜCHER*, 1892

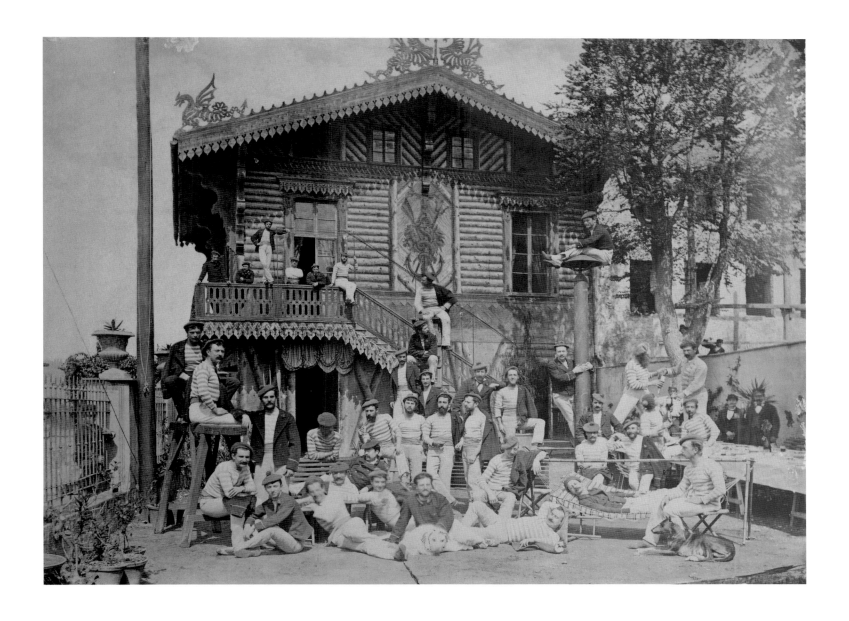

"Like a burning pyre, since the time of its fall Rome has purified all the errors, the vagaries, the extravagance and the ignorance that men have unceasingly heaped on her."

„Rom ist wie ein großer Scheiterhaufen und reinigt alles, was an menschlichen Irrtümern, Launen und Extravaganzen seit dem Niedergang der Stadt unablässig dort aufgehäuft wurde."

« Rome, comme un bûcher, purifie tout ce que, depuis sa ruine, les erreurs, les caprices, l'extravagance et l'ignorance des hommes n'ont cessé d'y entasser. »

MAURICE MAETERLINCK, *VUE DE ROME,* 1904

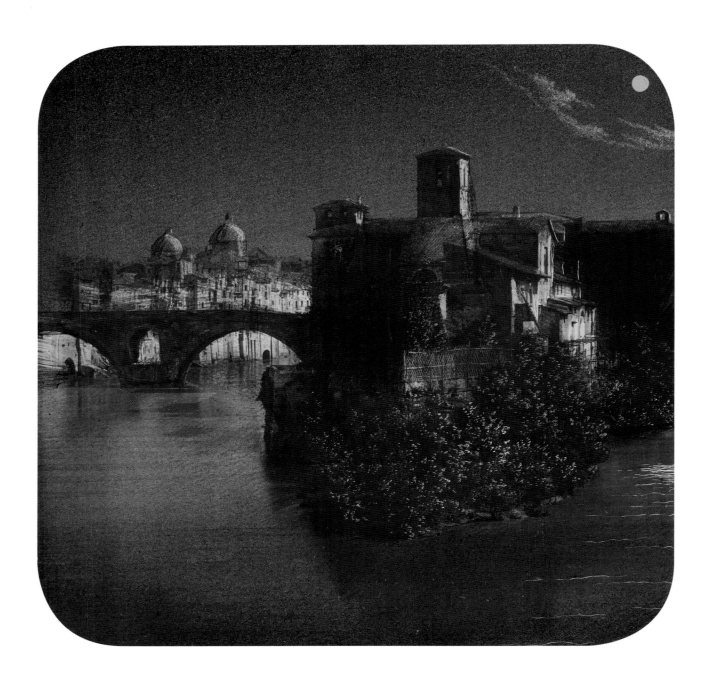

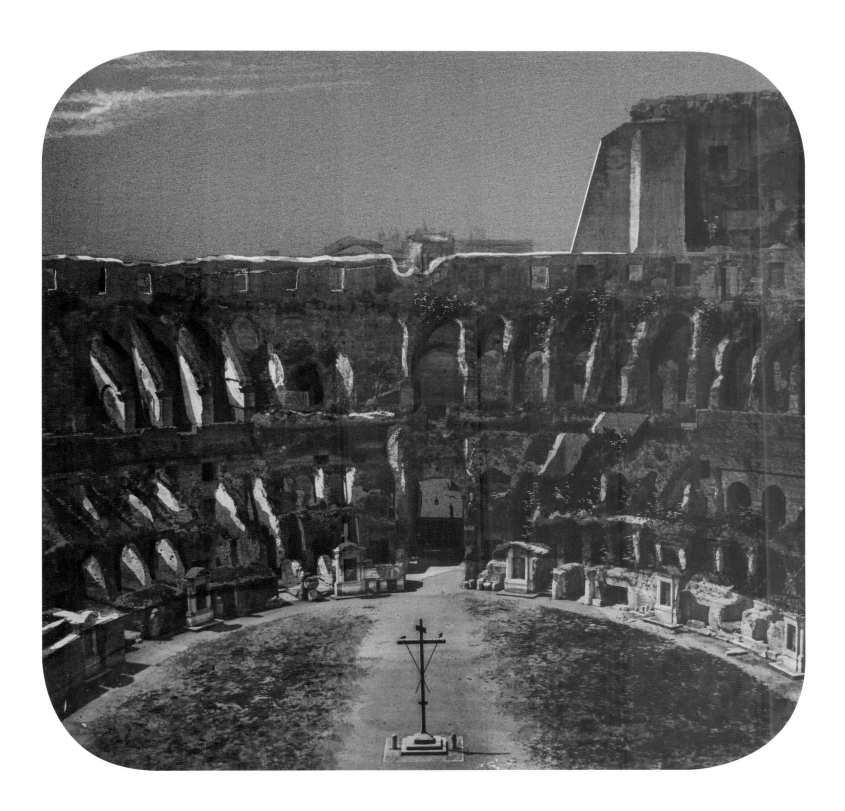

←

T.H. McAllister

Like stereoscopic photographs, transparencies were a way to embark on virtual travels from one's armchair. The Tiber Island, transparency for a magic lantern, c. 1880.

Wie zuvor die Stereoskopie luden auch die Farbbilder der Laterna Magica zu einer Reise ins Imaginäre ein, hier etwa auf die Tiberinsel, koloriertes Diapositiv, um 1880.

À l'instar de la photographie stéréoscopique, la diapositive permettait de voyager idéalement sans quitter son fauteuil. L'île Tibérine, diapositive pour lanterne magique, vers 1880.

↑

T.H. McAllister

The interior of the Colosseum, colored transparency for a magic lantern, c. 1880.

Das Innere des Kolosseums, koloriertes Diapositiv, um 1880.

L'intérieur du Colisée, diapositive colorée pour lanterne magique, vers 1880.

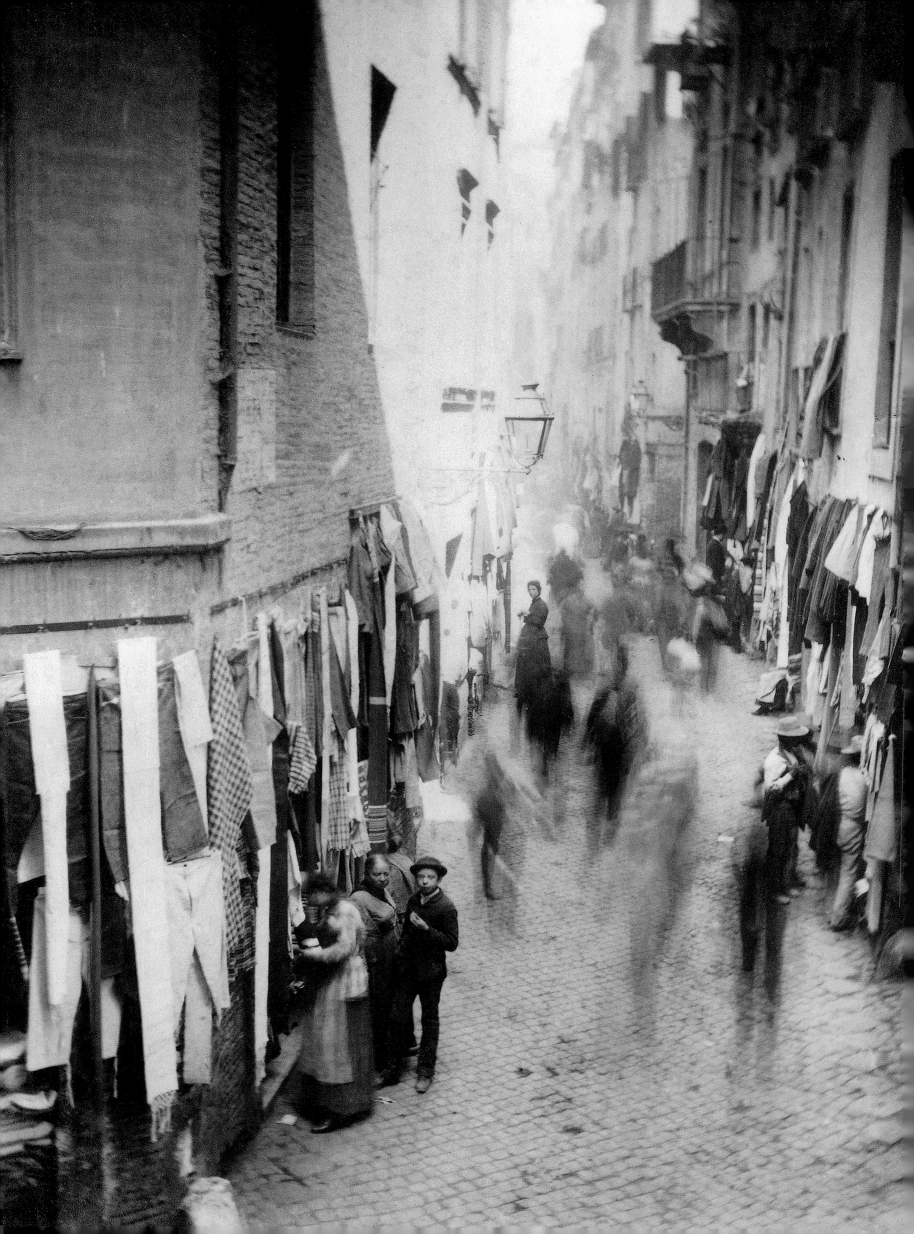

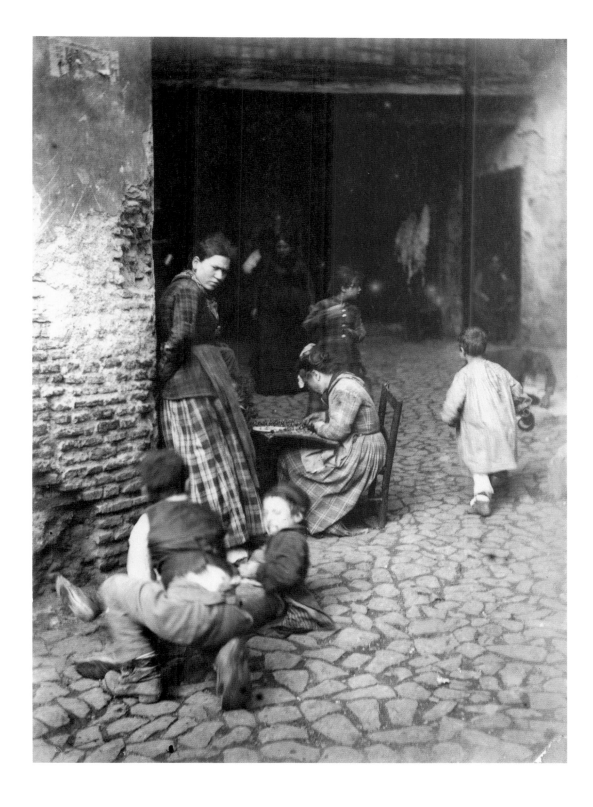

Ettore Roesler Franz

*Following the demolition of the ancient
Ghetto and the opening of new circulation
routes, many poorer people occupied the
unfinished buildings of the new neighbor-
hoods. The authorities tolerated this forced
takeover, dreading the exposure of people's
extreme poverty in the streets of the city
center. Scene in an alley of the Ghetto with
women working and boys playing in the
street, c. 1885.*

*Infolge der Niederlegung des Gettos und
des Baus neuer Straßenzüge wichen viele
römische Arme in die noch unfertigen Häuser
der Neubauviertel aus und nahmen von
ihnen Besitz. Die Behörden tolerierten dies
in der Sorge, dass das Elend andernfalls auf
den Straßen des Zentrums offen zutage treten
würde. Frauen bei der Arbeit und spielende
Kinder auf einer Gasse des alten Gettos,
um 1885.*

*À la suite de la démolition d'une partie
de l'ancien ghetto juif et du percement de
nouvelles artères, de nombreux pauvres
occupèrent des immeubles inachevés dans les
nouveaux quartiers ; les autorités fermèrent
les yeux et tolérèrent cette prise de possession
brutale de crainte que la misère aille s'exposer
dans les rues du centre. Scène de rue dans le
quartier du ghetto avec des femmes au travail
et des enfants qui jouent, vers 1885.*

Ettore Roesler Franz

*Textile shops in via Rua, in the Jewish
Ghetto. Papal laws allowed Jews to collect
and resell rags, later extended to include
textiles, but forbade the pursuit of other
commercial activities, c. 1885.*

*Stoffläden an der Via Rua im römischen
Getto. Die päpstliche Gesetzgebung erlaubte
den Juden das Sammeln und den Verkauf
von Lumpen, später auch von Stoffen, verbot
aber jede andere Form des Handels, um 1885.*

*Magasins de tissus dans le quartier du ghetto,
via Rua. La législation pontificale autorisait
les juifs à récupérer et à revendre les chiffons,
autorisation étendue par la suite aux étoffes,
mais leur interdisait toute autre activité
commerciale, vers 1885.*

"She had long before this taken old Rome into her confidence, because in a world of ruins the ruin of her happiness seemed a less unnatural catastrophe. She rested her weariness on things that had crumbled for centuries and still remained upright."

„Schon lange zuvor hatte sie das alte Rom in ihr Vertrauen gezogen, denn in einer Welt voller Ruinen musste der Ruin ihres Glücks als eine weniger unnatürliche Katastrophe wirken. So ließ sie ihre Müdigkeit auf etwas ruhen, das schon vor Jahrhunderten gestürzt war und sich doch noch aufrecht hielt."

« Elle avait depuis longtemps fait de la Rome antique sa confidente, car dans un monde en ruine, la ruine de son bonheur semblait moins anormale. Elle reposait sa lassitude sur les vestiges toujours debout d'édifices écroulés depuis des siècles. »

HENRY JAMES, *THE PORTRAIT OF A LADY*, 1881

→
Ettore Roesler Franz

Boys playing in a street in the Ghetto, snapshot, c. 1885.

Spielende Kinder auf den Gassen des Gettos, um 1885.

Jeux d'enfants dans une rue du quartier du ghetto, vers 1885.

pp. 76/77
Photoglob Zürich

View from the Palatine Hill. Ancient monuments (to the right the Palazzo dei Cesari, to the left the Arch of Janus Quadrifrons) seem to stand in no particular order alongside the new buildings, c. 1900.

Ansicht des Palatinhügels. Die antiken Ruinen (rechts der Kaiserpalast, links der Bogen des Janus Quadrifons) wirken vor den Neubauten im Hintergrund recht planlos gebaut, um 1900.

Vue depuis le mont Palatin. Les vestiges antiques (à droite, le palais des Césars, à gauche l'arc de Janus Quadrifons) font face dans le désordre aux nouvelles constructions, vers 1900.

↑

Ettore Roesler Franz

The market in Campo de' Fiori, snapshot taken on a rainy day, c. 1885.

Markt auf dem Campo de' Fiori bei Regen, um 1885.

Le marché du Campo de' Fiori un jour de pluie, vers 1885.

↗

Ettore Roesler Franz

Street oven and vendors of fruit and other foods in Via delle Tre Cannelle, in the Jewish Ghetto, c. 1885.

Gemeinschaftsofen und Lebensmittelhändler in der Via delle Tre Cannelle im jüdischen Getto, um 1885.

Four et vendeurs ambulants de fruits et de produits alimentaires, via delle Tre Cannelle dans le quartier du ghetto, vers 1885.

→

Mario De Maria

Interior view of the kitchen of the Osteria di Ponte Mammolo, Rome, c. 1885.

Küche einer Osteria im Viertel Ponte Mammolo vor den Toren Roms, um 1885.

Intérieur de la cuisine de l'Osteria di Ponte Mammolo à Rome, vers 1885.

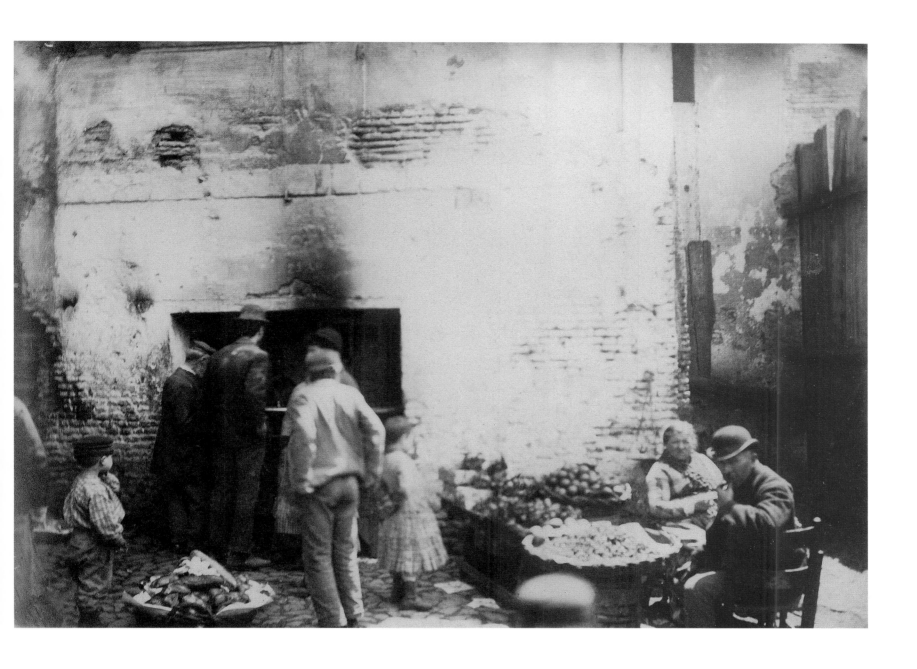

"As the priest continued to speak, wanting to know how old he was, what school he attended, in which neighborhood he was born, Tito abruptly cut him short, solemnly declaring, while pointing his finger to his chest: 'Io son Romano di Roma!' (I am a Roman from Rome) […] Pierre smiled sadly, and fell silent. He had never felt the pride of his race, the ancient legacy of glory, weigh so heavily on his shoulders."

„Als der Priester nun weitersprach und wissen wollte, wie alt er war, welche Schule er besucht hatte und aus welchem Viertel er stammte, schnitt Tito ihm brüsk das Wort ab und sagte mit ernster Stimme und mit erhobenem Finger auf seine Brust weisend: ‚Io son Romano di Roma!' […] Pierre lächelte traurig und schwieg, nie hatte er den Stolz dieser Rasse stärker gespürt, ihren von altersher ererbten Ruhm, der so schwer auf den Schultern lastete."

«Comme le prêtre continuait, voulant savoir son âge, à quelle école il était allé, dans quel quartier il était né, Tito, brusquement, coupa court, en disant d'une voix grave, un doigt en l'air, tourné vers sa poitrine: "Io son Romano di Roma!" […] Pierre eut un sourire triste et se tut. Jamais il n'avait mieux senti l'orgueil de la race, le lointain héritage de gloire, si lourd aux épaules.»

ÉMILE ZOLA, *ROME,* **1896**

pp. 82/83
Studio of Domenico Anderson

During the obligatory trip to the Roman countryside, the long, desolate line of the arches of the Claudian Aqueduct never failed to strike the imagination of travellers. The outline of their ridges reminded Henry James of the spine of a decomposing monster, c. 1890.

Auf jeden Reisenden, der die römische Campagna besuchte, machten die Ruinen des Claudischen Aquädukts unfehlbar einen tiefen Eindruck. Henry James erinnerten die hoch aufragenden Bogen an die Wirbelknochen eines im Zerfall befindlichen vorzeitlichen Ungetüms, um 1890.

Lors de l'incontournable excursion dans la campagne romaine, la succession désolée des arcs de l'aqueduc de Claude frappait immanquablement l'imagination des voyageurs. Leur crête découpée rappela à Henry James la colonne vertébrale du squelette de quelque monstre en décomposition, vers 1890.

→
Photoglob Zürich

The Arch of Titus in the Roman Forum, c. 1900.

Titusbogen am Forum Romanum, um 1900.

L'arc de Titus dans le Forum romain, vers 1900.

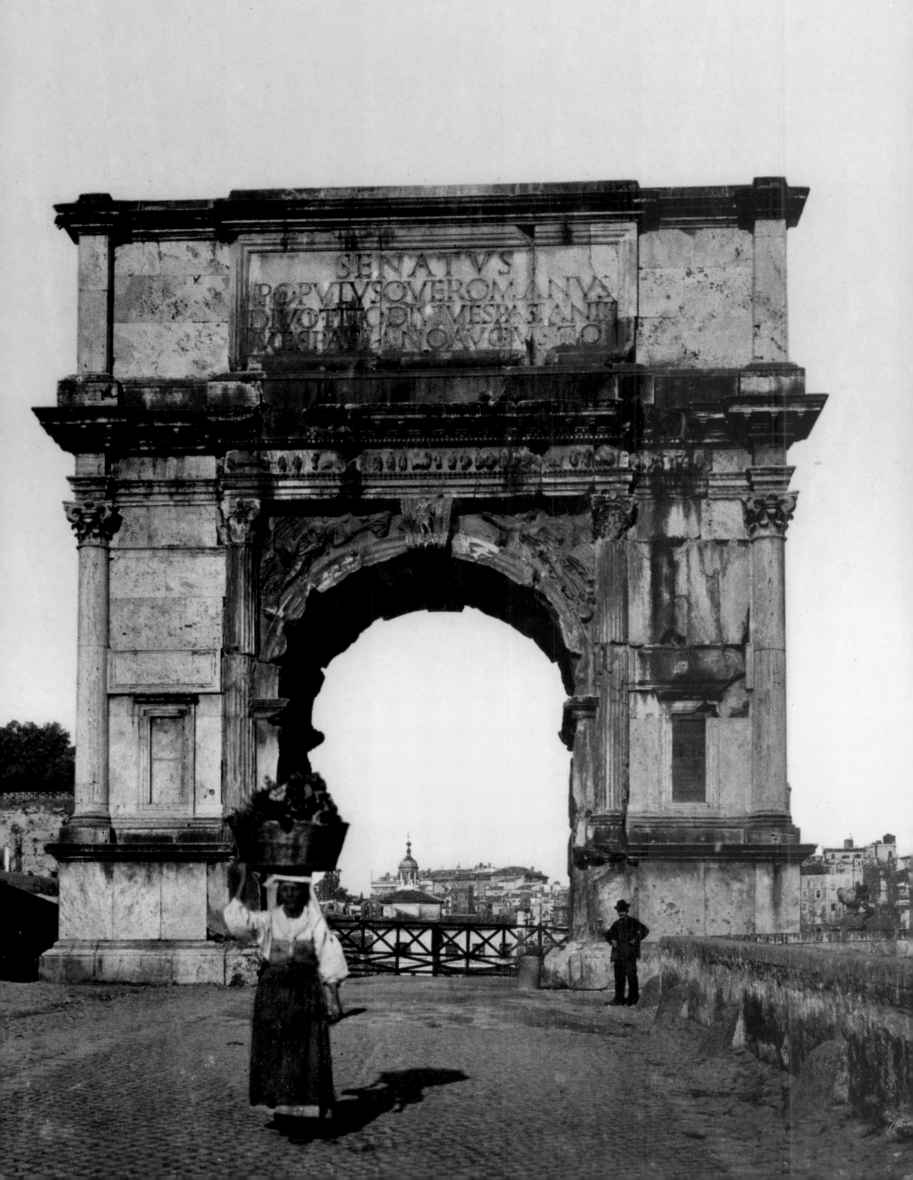

"In short, these were people who let themselves live, working just enough to have food, contenting themselves with vegetables, pasta, cheaper cuts of mutton, without protest, without ambition for the future, only concerned with securing a precarious lifestyle, living from day to day. Their only vices were gambling, and the red and white wines of the Roman Castelli."

„Eine Bevölkerung, der es reichte, am Leben zu bleiben, die gerade so viel arbeitete, wie nötig war, um zu essen zu haben, sich von Gemüse, Nudeln, dem weniger geschätzten Fleisch der Schafe ernährte, ohne je den Willen zu verspüren, sich aufzulehnen, ohne jeden Ehrgeiz für die Zukunft, einzig darum bemüht, sich dies bisschen Leben zu sichern, von einen Tag auf den nächsten. Ihre einzigen Laster waren das Glücksspiel und die roten und weißen Weine der Castelli Romani.“

« En somme, c'était une population se laissant vivre, travaillant juste assez pour manger, se contentant de légumes, de pâtes, de basse viande de mouton, sans révolte, sans ambition d'avenir, n'ayant que le souci de cette vie précaire, au jour le jour. Les deux seuls vices étaient le jeu et les vins rouges et blancs des Châteaux romains. »

ÉMILE ZOLA, *ROME*, 1896

→

Photoglob Zürich

The long line of arches of the Claudian Aqueduct viewed from Via Appia Nuova, here and there dotted with large pine trees, c. 1905.

Die Bogen des Claudischen Aquädukts von der piniengesäumten Via Appia Nuova aus gesehen, um 1905.

La longue succession des arcs de l'aqueduc de Claude est prise de la via Appia Nuova, ponctuée çà et là d'un majestueux pin parasol, vers 1905.

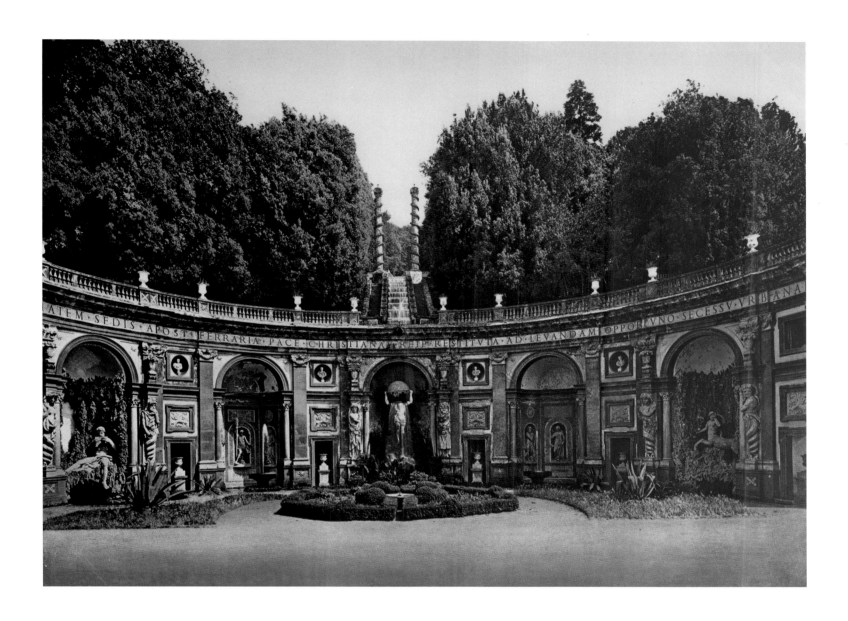

←

Photoglob Zürich

Tivoli, Villa d'Este, the Cardinal's gardens; the fountains under the stairs to the villa. To thank him for his support in getting the papacy (1550), Julius III appointed Cardinal Ippolito II d'Este governor of Tivoli and its territory. The cardinal transformed the convent, which was used as the governor's residence, into a grand villa. For its construction, among other materials, travertine marble from the base of the tomb of Cecilia Metella was used. The villa subsequently became the property of the Habsburgs. Franz Liszt was inspired by it for parts of his solo piano suites Années de Pèlerinage, *c. 1900.*

Park der Villa d'Este in Tivoli. Als Dank für dessen Unterstützung im Konklave ernannte Julius III. Kardinal Ippolito II. d'Este 1550 zum päpstlichen Statthalter von Tivoli. Der Kardinal ließ das als Amtssitz dienende Kloster in eine prachtvolle Villenanlage umbauen, dabei wurde unter anderem die Travertinverkleidung vom Grabmal der Cecilia Metella verwendet; später kam das Anwesen in den Besitz der Habsburger. Franz Liszt ließ sich von der Villa d'Este zu einigen Klaviersuiten seiner Années de Pèlerinage *inspirieren, um 1900.*

Tivoli, villa d'Este. Pour le remercier du soutien qu'il lui avait accordé lors de son élection au trône de Saint-Pierre (1550), Jules III nomma le cardinal Hippolyte II d'Este, gouverneur de Tivoli. Le cardinal transforma le couvent, qui servait de résidence au gouverneur, en une fastueuse villa. Pour sa construction, on utilisa, notamment, le revêtement en travertin du tombeau de Cecilia Metella. Par la suite, la villa passa aux Habsbourg. Franz Liszt s'en inspira pour composer certaines pièces pour piano seul des Années de pèlerinage, *vers 1900.*

↑

Photoglob Zürich

Frascati, the waterfalls of Villa Aldobrandini, c. 1900.

Frascati, die Wasserkaskade der Villa Aldobrandini, um 1900.

Frascati, les cascades de la villa Aldobrandini, vers 1900.

pp. 88/89
Photoglob Zürich

*For the 19th-century traveller, the Tivoli Hill
offered an incomparably picturesque view.
The city, the villas, the ruins, the rocks, the
domes, the waterfalls in the foreground and
the Roman countryside in the background
offered – as Joseph Forsyth observed at the
beginning of the century – a picture worthy
of Claude Lorrain, c. 1905.*

*Das Bergstädtchen Tivoli besaß für die
Italienreisenden des 19. Jahrhunderts einen
unwiderstehlichen pittoresken Reiz. Stadt,
umliegende Villen, Felsen, Tivolis Wasserfälle,
all dies vor dem Hintergrund der römischen
Campagna, boten ein Bild – so schrieb Joseph
Forsyth Anfang des Jahrhunderts – wie auf ei-
nem Gemälde von Claude Lorrain, um 1905.*

*Aux yeux d'un voyageur du xixᵉ siècle, la
colline de Tivoli constituait un site incom-
parablement pittoresque. La ville, les villas,
les ruines, les rochers, les ravins, les cascades
au premier plan et la campagne romaine en
arrière-plan offraient, comme l'observa Joseph
Forsyth au début du siècle, un tableau digne
de Claude Lorrain, vers 1905.*

→
Filippo Belli

*Washerwomen in Marino. Located in the
Alban Hills in the Castelli Romani region,
along the route to Naples, the town was an
important military outpost in the Middle
Ages and a major center of commerce, known
for its production of white wine, c. 1875.*

*Waschfrauen in Marino in den Albaner
Bergen. Das auf dem Weg nach Neapel in
der Gegend der Castelli Romani gelegene
Bergdorf spielte im Mittelalter strategisch
und als Handelszentrum eine wichtige Rolle
und wurde für den dort gekelterten Weißwein
bekannt, um 1875.*

*Lavandières à Marino. Située sur les monts
Albains dans la région des Castelli Romani
(«châteaux romains»), le long de la route
conduisant à Naples, la localité fut au Moyen
Âge un avant-poste militaire et un centre
commercial importants; elle était et demeure
réputée pour son vin blanc, vers 1875.*

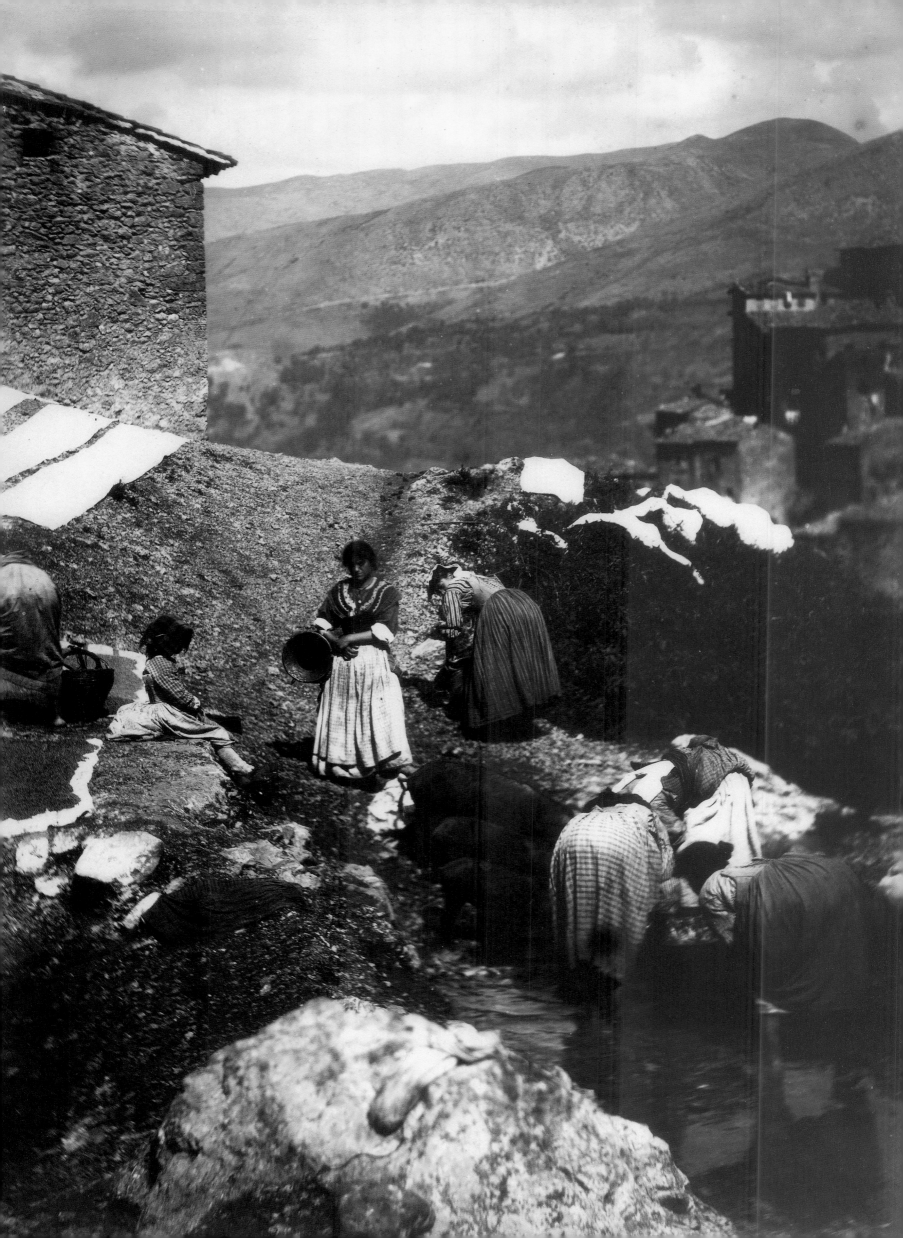

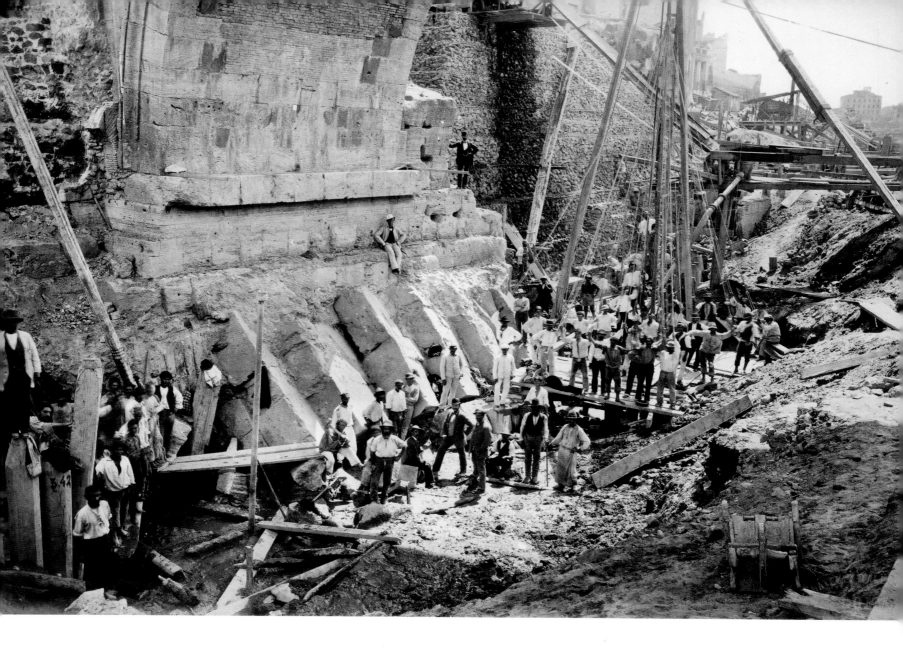

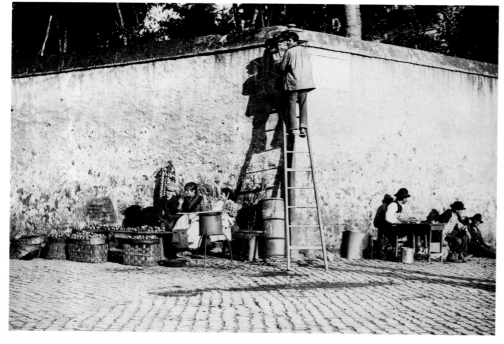

←

Giuseppe Primoli

A street-light installer at work in the Via Casilina. Along the high perimeter wall surrounding a garden, we see street vendors selling chestnuts, braids of garlic and fruit, and a cobbler. In some suburban areas, gas lights lasted until World War I, c. 1890.

Laternenputzer bei der Arbeit in der Via Casilina. Vor einer Gartenmauer haben Straßenhändler ihre Stände mit Röstkastanien, Knoblauchzöpfen und Früchten aufgestellt, daneben ein Schuhmacher. In einigen Außenbezirken Roms wurde die Straßenbeleuchtung noch bis zum Ende des Ersten Weltkriegs mit Gas betrieben, 1890.

Allumeur de réverbères, via Casilina. Au pied du haut mur d'enceinte d'un jardin sont installés des vendeurs ambulants de marrons chauds, de tresses d'ail et de fruits, et un cordonnier. Dans certains quartiers périphériques, l'éclairage au gaz subsista jusqu'à la fin de la Première Guerre mondiale, vers 1890.

←

Anonymous

Installation of the banks on the river Tiber: construction of the left bank of Ponte Sisto, 1887.

Beim Bau der Ufermauern auf Höhe des Ponte Sisto am linken Tiberufer, 1887.

Aménagement des berges du Tibre : construction de la digue gauche au niveau du ponte Sisto, 1887.

↑

Giuseppe Primoli

The speakers' podium at a demonstration on Labor Day (May 1) between Piazza San Giovanni and Piazza Santa Croce in Gerusalemme. During the period of the building crisis, violent demonstrations took place in Rome, 1891.

Rednertribüne bei den Feiern zum Tag der Arbeit zwischen Piazza San Giovanni und Piazza Santa Croce in Gerusalemme. In den Jahren der Immobilienkrise kam es in Rom zu gewaltsamen Kundgebungen, 1. Mai 1891.

La tribune des orateurs lors du défilé du 1ᵉʳ Mai entre la piazza San Giovanni et la piazza Santa Croce in Gerusalemme. À l'époque de la crise du bâtiment, Rome fut le théâtre de violentes manifestations, 1891.

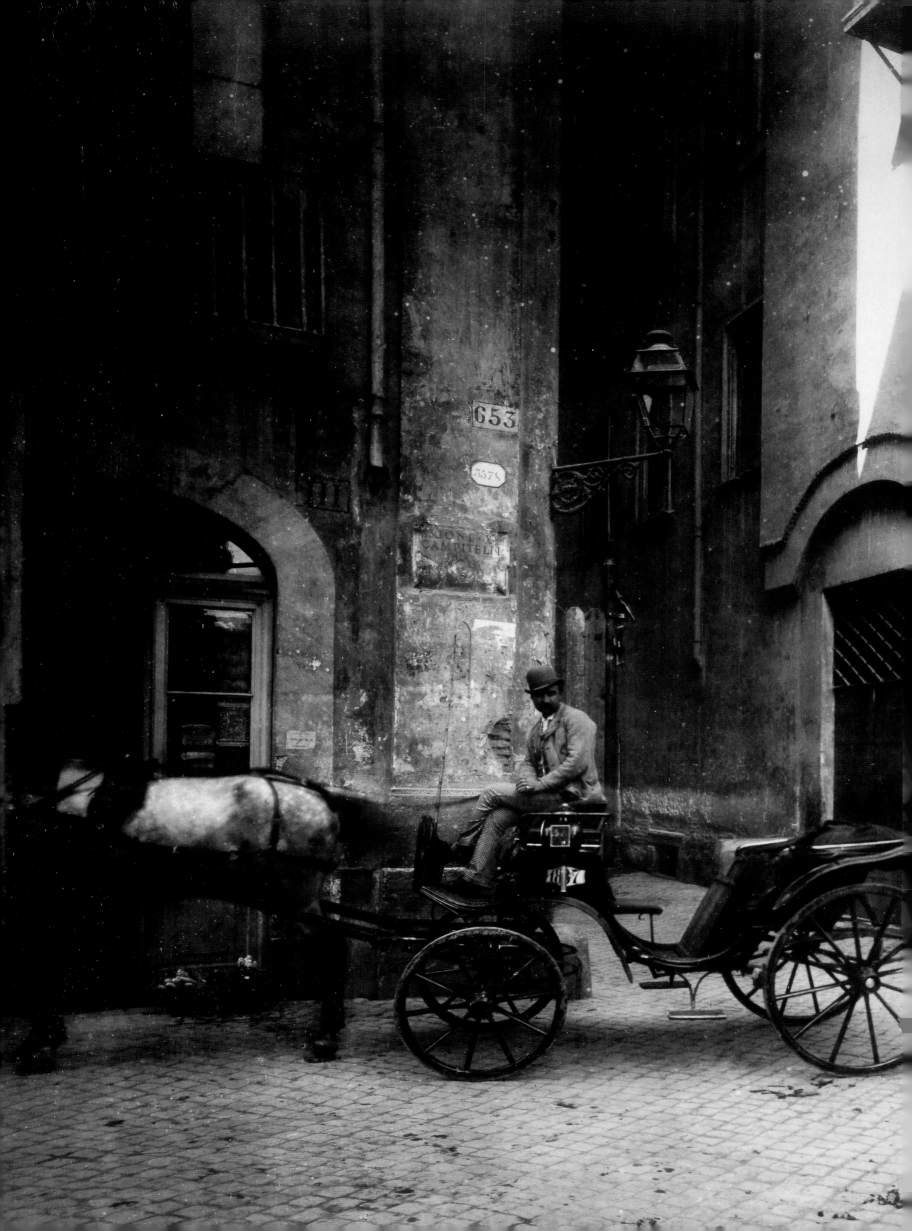

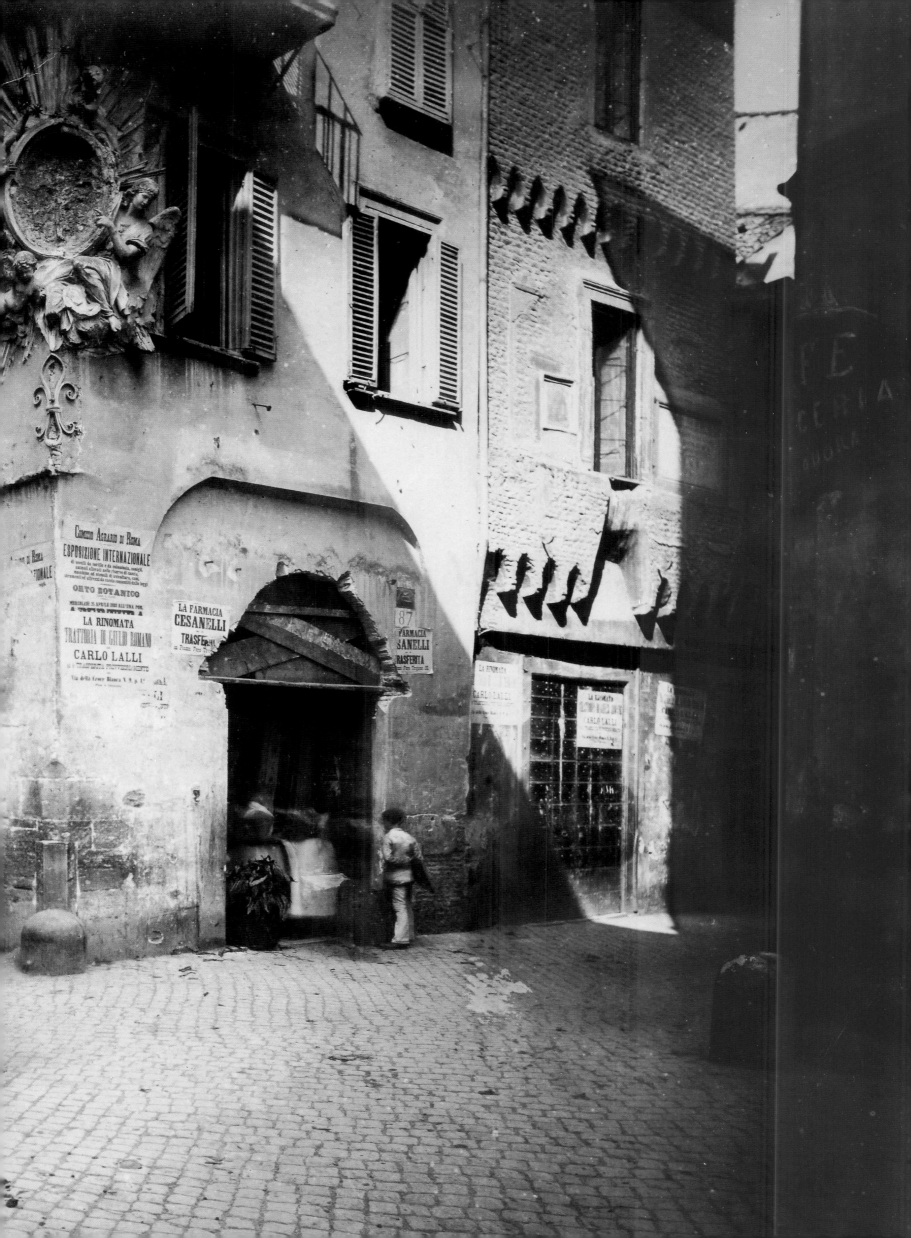

←
Giuseppe Primoli

*Sellers of sacred images on the steps of a
church, 1889–1900.*

*Verkauf von Heiligenbildern auf den Stufen
einer römischen Kirche, 1889–1900.*

*Vendeurs d'images pieuses sur le parvis
d'une église, 1889–1900.*

→
Giuseppe Primoli

*Palazzo Montecitorio, in the square named
after it, during the ceremony for the opening
of Parliament, c. 1890.*

*Palazzo Montecitorio während der Feierlich-
keiten zur Eröffnung der Amtsperiode des
Parlaments, um 1890.*

*Le palais de Montecitorio sur la place
éponyme lors de la cérémonie solennelle
d'ouverture de la législature, vers 1890.*

pp. 94/95
Anonymous

*Via Giulio Romano before the demolitions
that made space for the Vittoriale. Note the
medieval houses, the street shrine on the
corner of the alley, the sign of a café, c. 1889.*

*Die alte Via Giulio Romano vor den Abriss-
arbeiten für den Bau des Denkmals für
Viktor Emanuel. Beachtenswert die mittel-
alterlichen Häuserfronten und die barocke
Andachtsnische, um 1889.*

*La via Giulio Romano avant les démolitions
effectuées pour faire place au Vittoriale, le
monument dédié à Victor-Emmanuel II. On
remarquera les maisons médiévales, l'édicule
religieux à l'angle de la ruelle et l'enseigne du
café, vers 1889.*

pp. 98/99
Teodoro Fabbri

*Inauguration of the monument to Giordano
Bruno in Piazza Campo de' Fiori. The initia-
tive to build this monument caused intense
controversy, June 9, 1889.*

*Einweihung des seinerzeit heftig umstrittenen
Denkmals für Giordano Bruno auf dem
Campo de' Fiori, 9. Juni 1889.*

*Inauguration de la statue de Giordano Bruno
sur le Campo de' Fiori. Cette initiative donna
lieu à de violents affrontements, 9 juin 1889.*

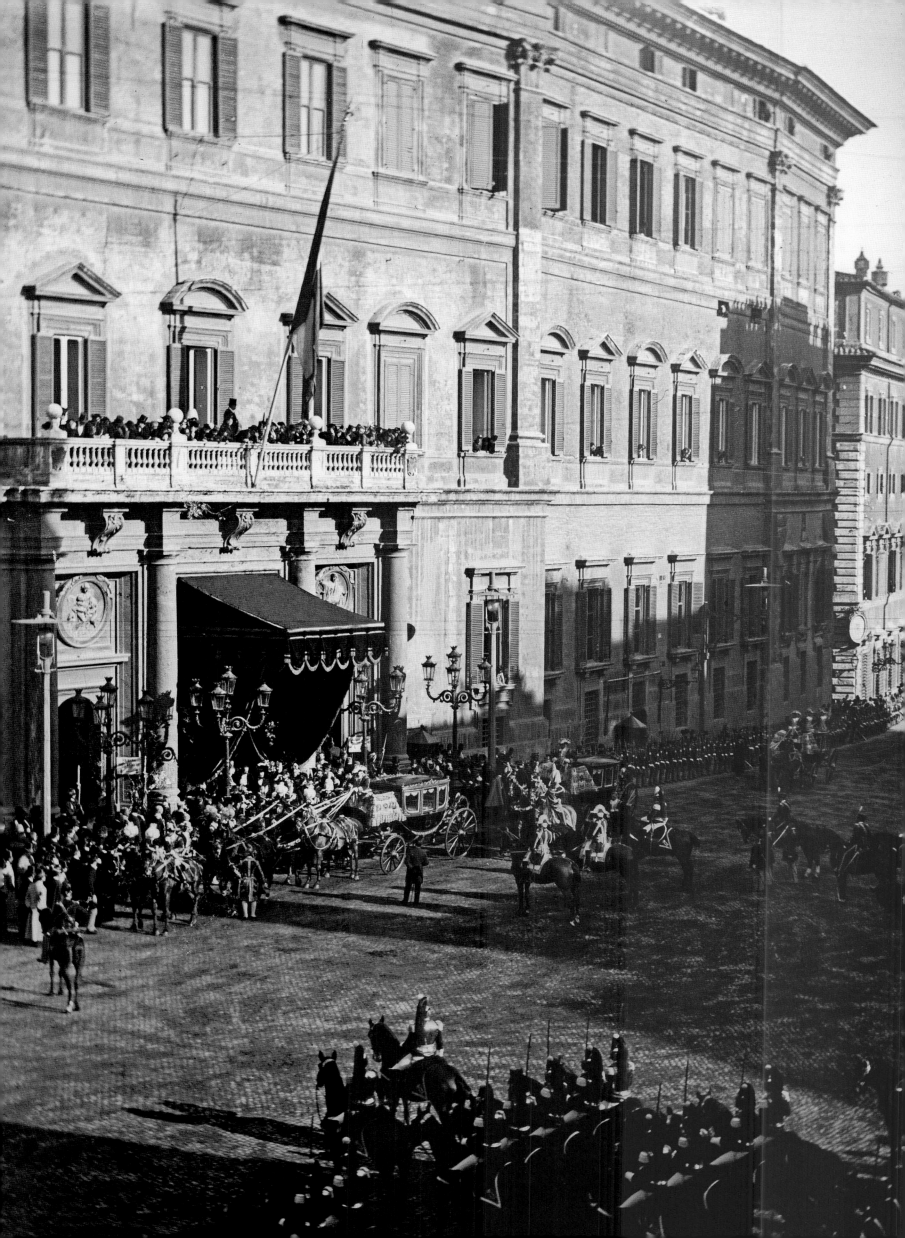

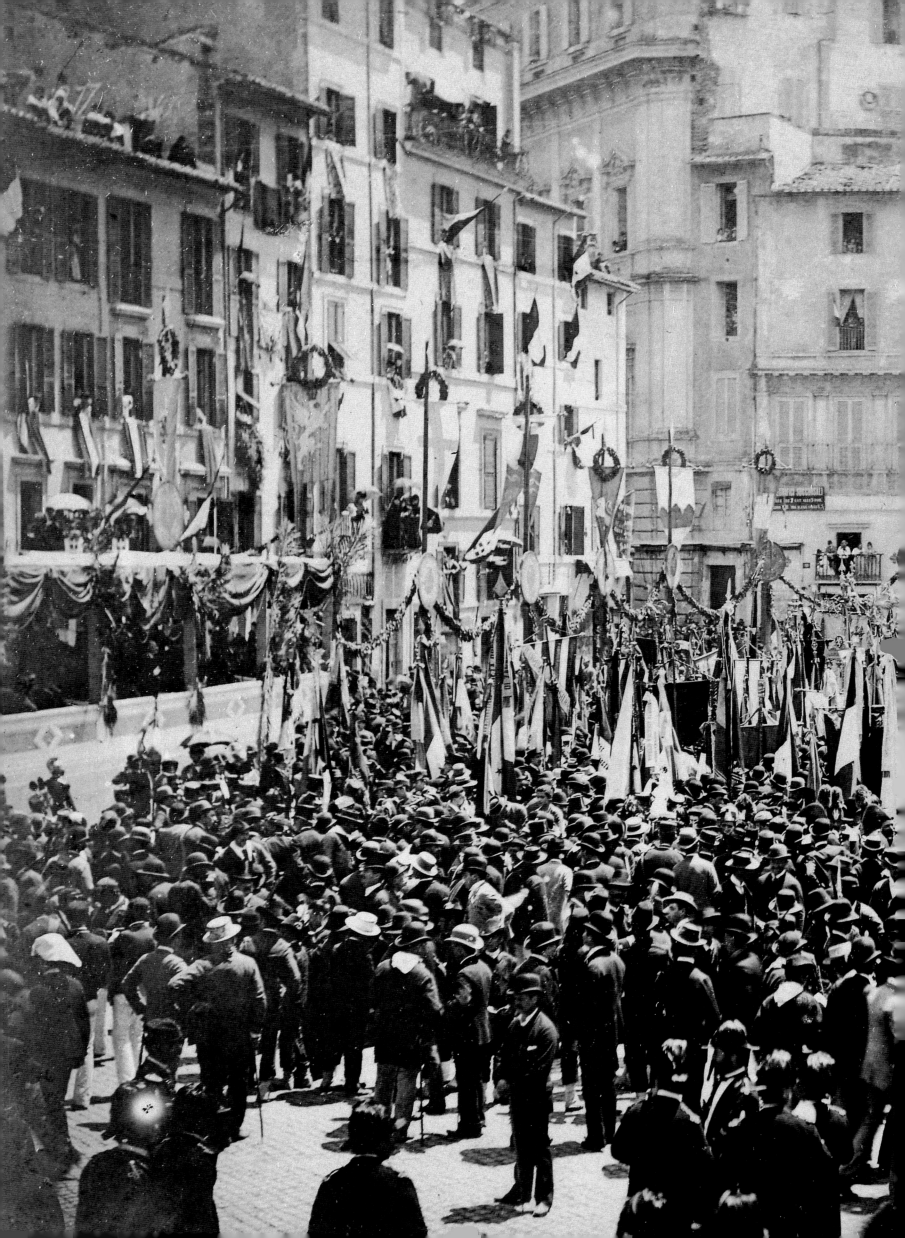

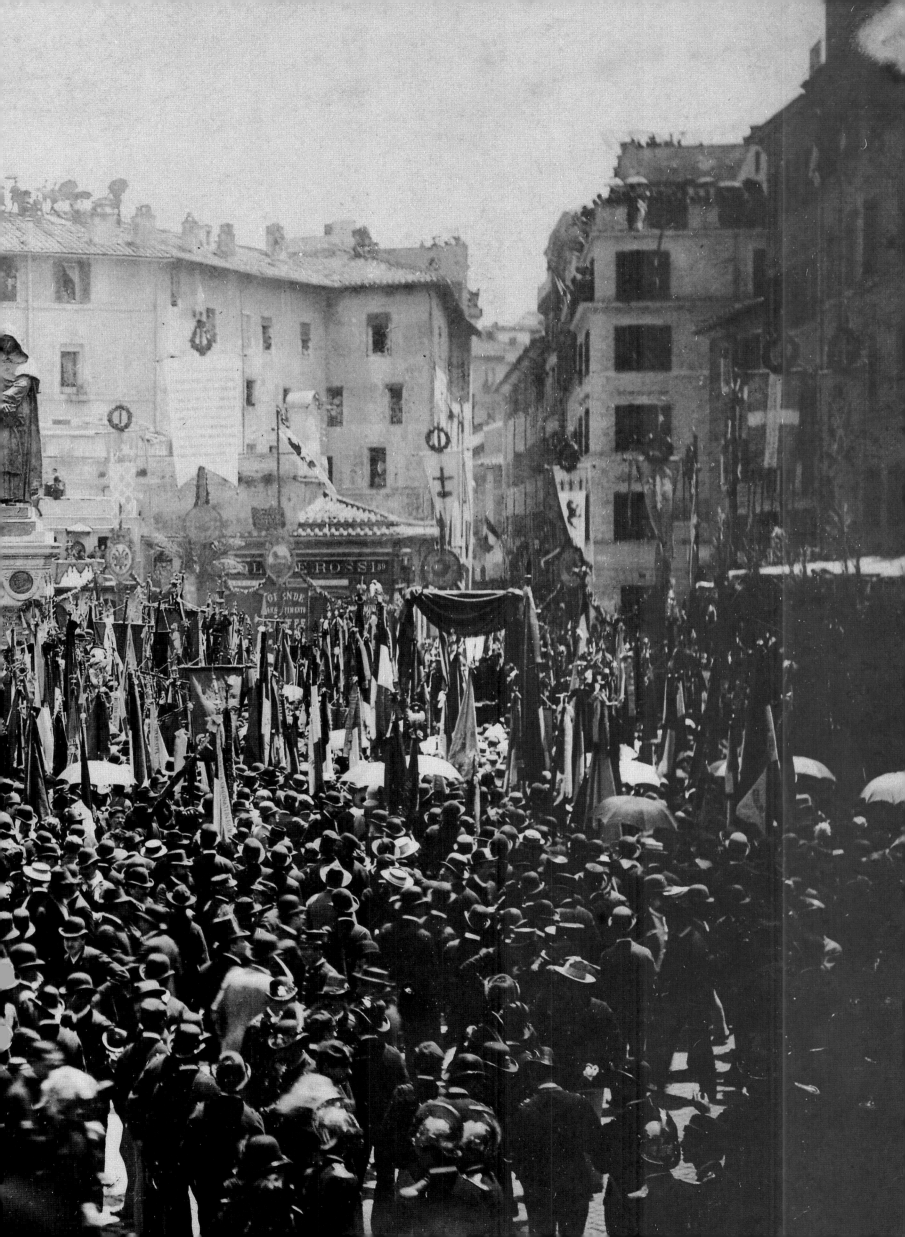

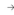

Giuseppe Primoli

Street vendor and patrons in front of the Osteria del Barcone, 1889–1900.

Straßenhändler und Gäste vor der Osteria del Barcone, 1889–1900.

Vendeur ambulant et clients devant l'Osteria del Barcone, 1889–1900.

→

Giuseppe Primoli

Delicatessen, cheese and spice shop at the Portico di Ottavia, 1889–1900.

Wurst- und Käsegeschäft am Portikus der Oktavia, 1889–1900.

Boutique de charcuterie, fromages et épices près du portique d'Octavie, 1889–1900.

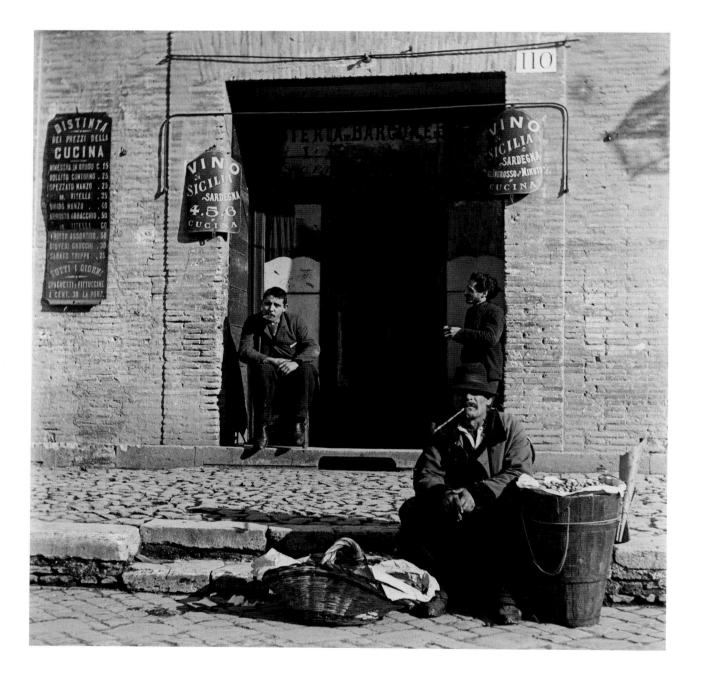

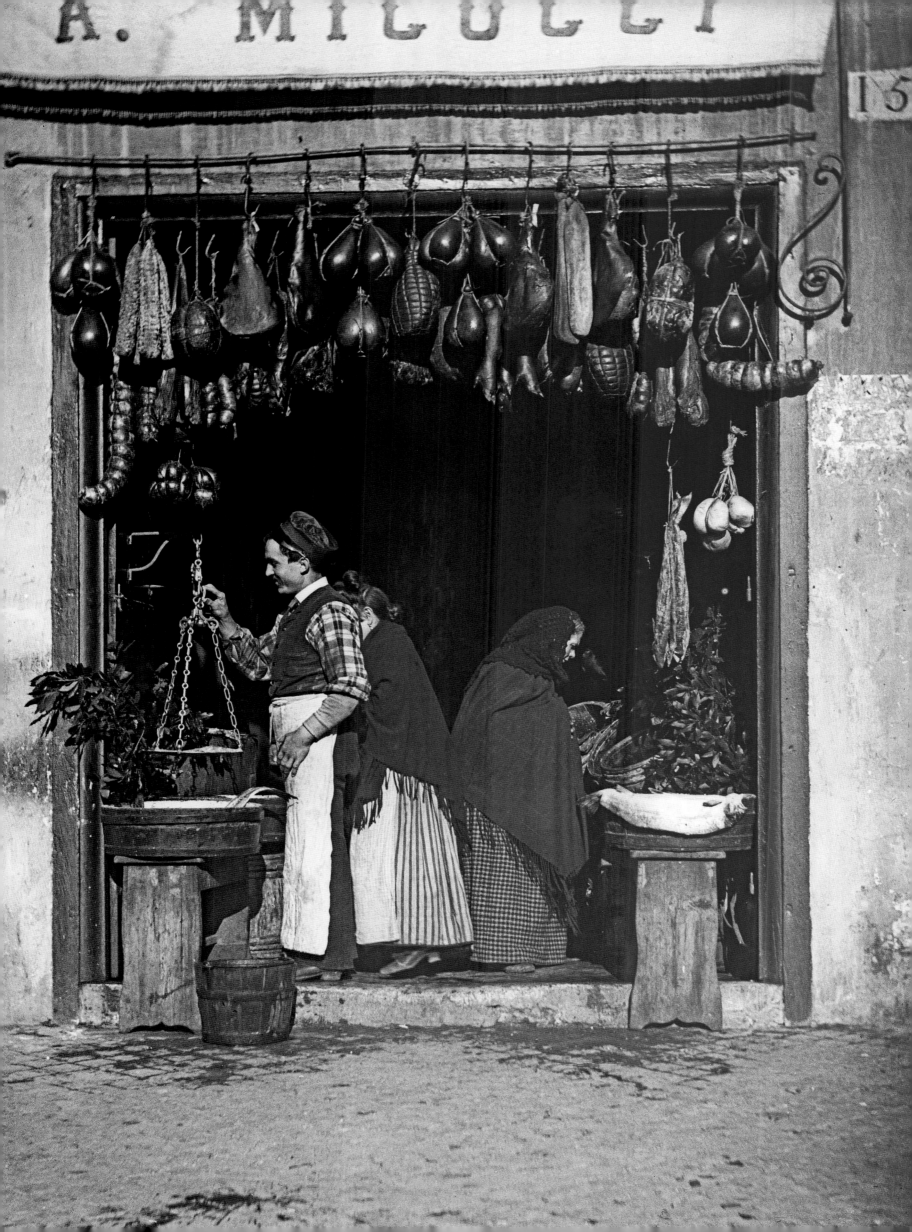

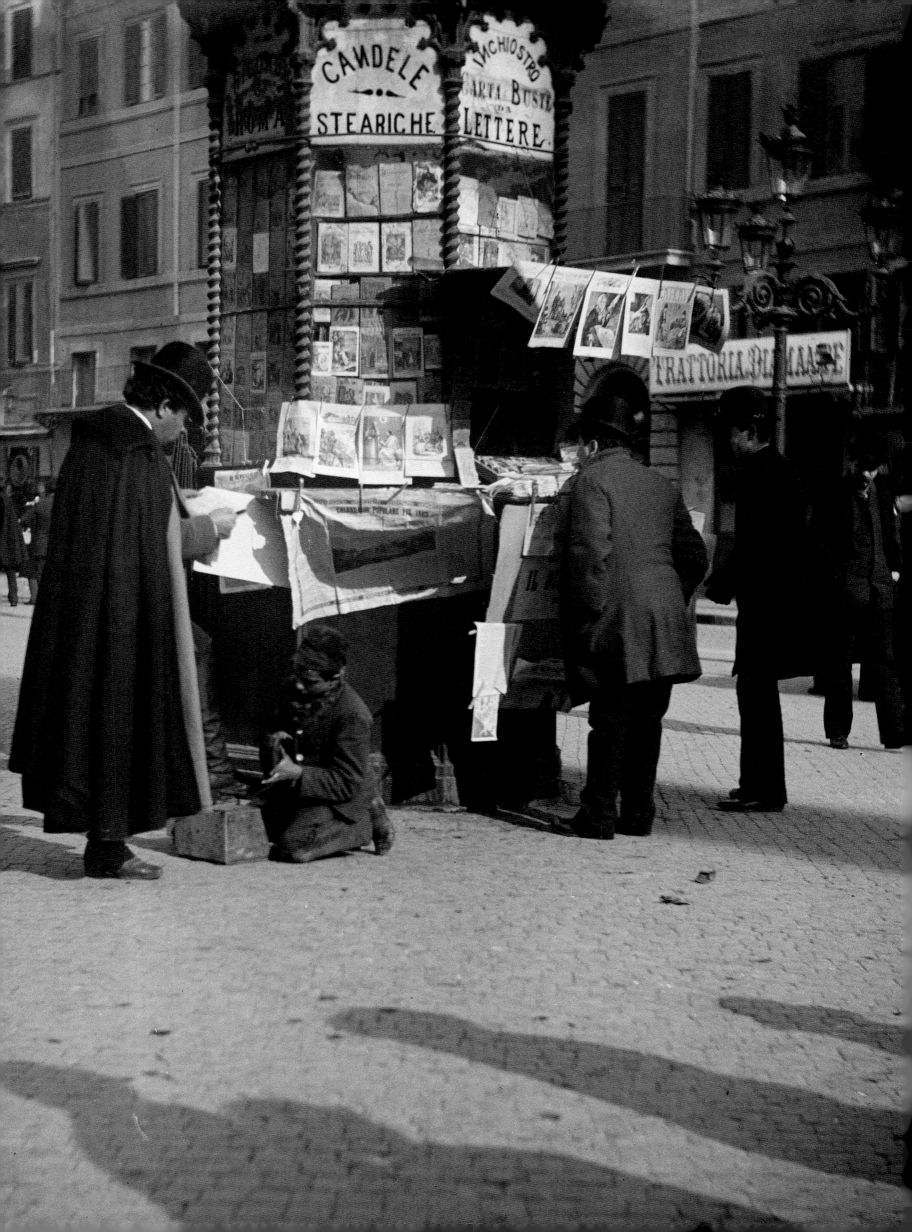

"From Via del Babuino came the jingling of bells and the dull sound of footsteps, like those of a marching herd. [...] The thick whiteish wool of the gathered sheep proceeded with a continuous rise and fall, overlapping, like muddy water flooding the pavement."

„Aus der Via del Babuino drang helles Geklingel und dumpfes Getrappel wie von einer heranrückenden Herde herüber. [...] Die dichte, weiß schimmernde Wolle der aneinander-gedrängten Schafe zog mit unaufhörlichem Schwanken und sich überschlagend voran, ganz wie schlammiges Wasser, das sich über das Pflaster ergießt. "

« De la rue du Babuino venaient un tintement de clochettes et une sourde rumeur de pas, comme d'un troupeau qui chemine. [...] L'épaisse toison blanchâtre des brebis serrées s'avançait avec une fluctuation continue, en une seule masse mobile pareille à une eau fangeuse inondant le pavé. »

GABRIELE D'ANNUNZIO, *IL PIACERE,* 1889

←

Giuseppe Primoli

Shoeshine near a newspaper stand in Piazza Navona, 1889–1900.

Schuhputzjunge an einem Zeitungskiosk auf der Piazza Navona, 1889–1900.

Cireur de chaussures près d'un kiosque à journaux de la piazza Navona, 1889–1900.

→

Giuseppe Primoli

Shepherd with a herd of goats in Via Sistina, 1889–1900.

Ein Ziegenhirt treibt seine Herde durch die Via Sistina, 1889–1900.

Berger et son troupeau de chèvres dans la via Sistina, 1889–1900.

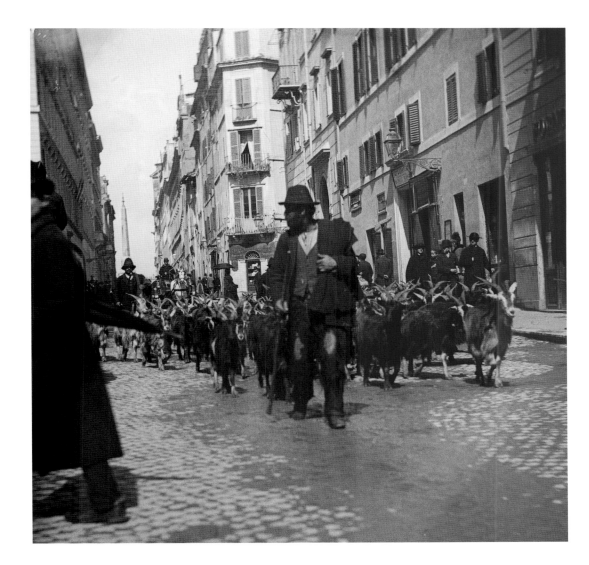

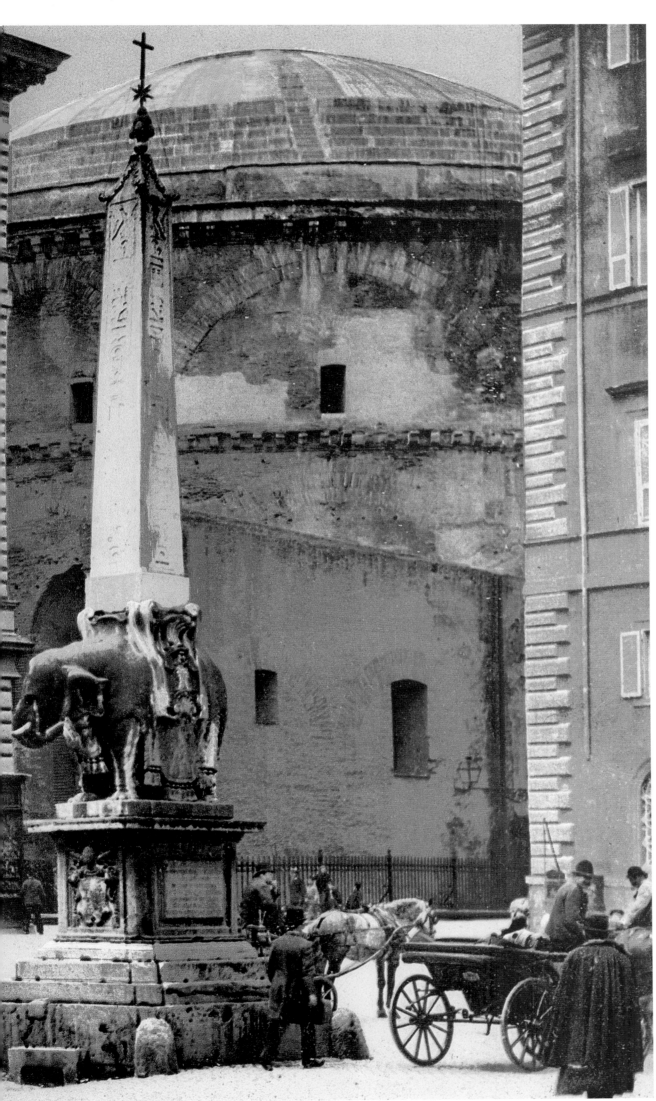

Photoglob Zürich

*Piazza della Minerva: in the gap between
the façade of the Pontifical Ecclesiastical
Academy and the corner of Palazzo Bianchi
(demolished in 1883 to make space around
the Pantheon), a portion of the dome of the
Pantheon emerges, c. 1905.*

*Die Piazza della Minerva – mit Berninis
Elefant in der Mitte – wird noch heute von der
päpstlichen Diplomatenschule der Pontificia
Accademia Ecclesiastica flankiert, während
der Palazzo Bianchi 1883 weichen musste, um
dem im Hintergrund aufragenden Pantheon
mehr Raum zu verschaffen, um 1905.*

*Piazza della Minerva: dans l'espace compris
entre la façade de l'Académie pontificale
ecclésiastique et l'angle du palazzo Bianchi
(démoli en 1883 afin d'isoler le Panthéon)
apparaît une partie de la coupole du Panthéon,
vers 1905.*

"In that year [1886], in Rome, the love of bibelot and bric-à-brac became excessive; all the salons of the aristocracy and of the upper classes were filled with 'curiosities'; every lady was full of 'curiosity'; every lady cut the cushions of her sofa in the shape of a plant or of a cope, and put her roses in an Umbrian pharmacy vase or in a chalcedony cup. Public sales were a favorite meeting place [...]."

„Damals [1886] erreichte die Liebe zu Nippes und zu Trödel in Rom gerade ihren Höhepunkt. Die Salons des Adels und des Großbürgertums waren vollgestopft mit ‚Kuriositäten', die Damen bezogen die Kissen ihrer Sofas mit den Stoffen alter Paramente und stellten ihre Rosen in umbrische Arzneikrüge oder in eine Schale aus Chalzedon. Versteigerungen waren ein beliebter Treffpunkt der Gesellschaft."

« À Rome, cette année-là [1886], l'amour du bibelot et du bric-à-brac avait grandi jusqu'à l'excès ; tous les salons de la noblesse et de la haute bourgeoisie étaient encombrés de "curiosités"; les dames taillaient les coussins de leurs divans dans des chasubles ou dans des chapes, et mettaient leurs roses dans un vase de pharmacie ombrien ou dans une coupe en calcédoine. Les ventes publiques étaient les rendez-vous de prédilection [...]. »

GABRIELE D'ANNUNZIO, *IL PIACERE,* 1889

→
Giuseppe Primoli

In the Via del Corso, an elegant flâneur *with a top hat accompanied by a "fashionably" groomed dog. A contemporary journalist called Primoli "the king of the snapshot," 1899–1900.*

Ein elegant gekleideter Flaneur mit Zylinder führt seinen modisch getrimmtem Pudel auf der Via del Corso spazieren. Primoli wurde von einem Journalisten einmal als „König der Momentaufnahme" tituliert, 1899–1900.

Dans la via del Corso, un flâneur élégant coiffé d'un haut-de-forme, accompagné d'un chien tondu à la lionne. Un journaliste contemporain de Giuseppe Primoli qualifia celui-ci de « roi de l'instantané », 1899–1900.

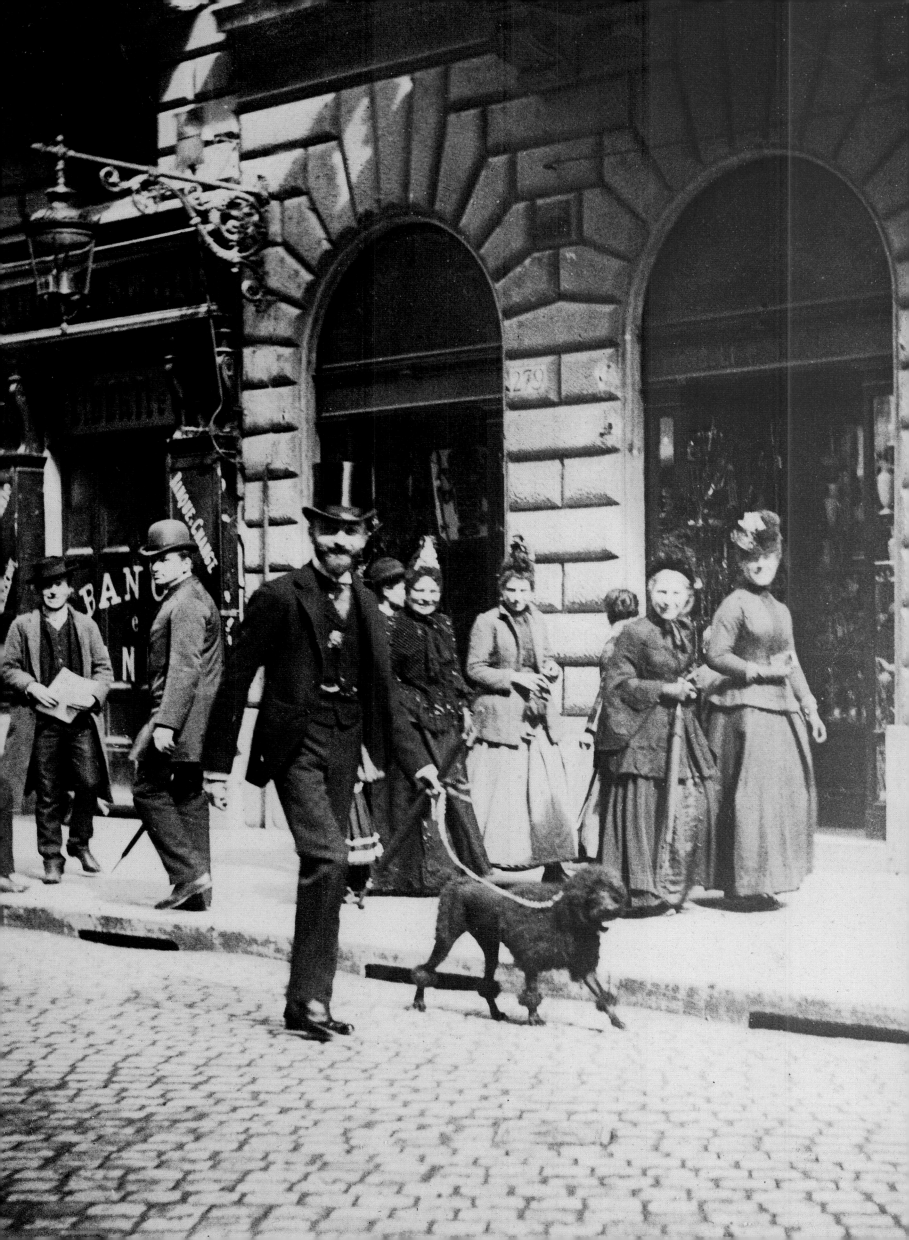

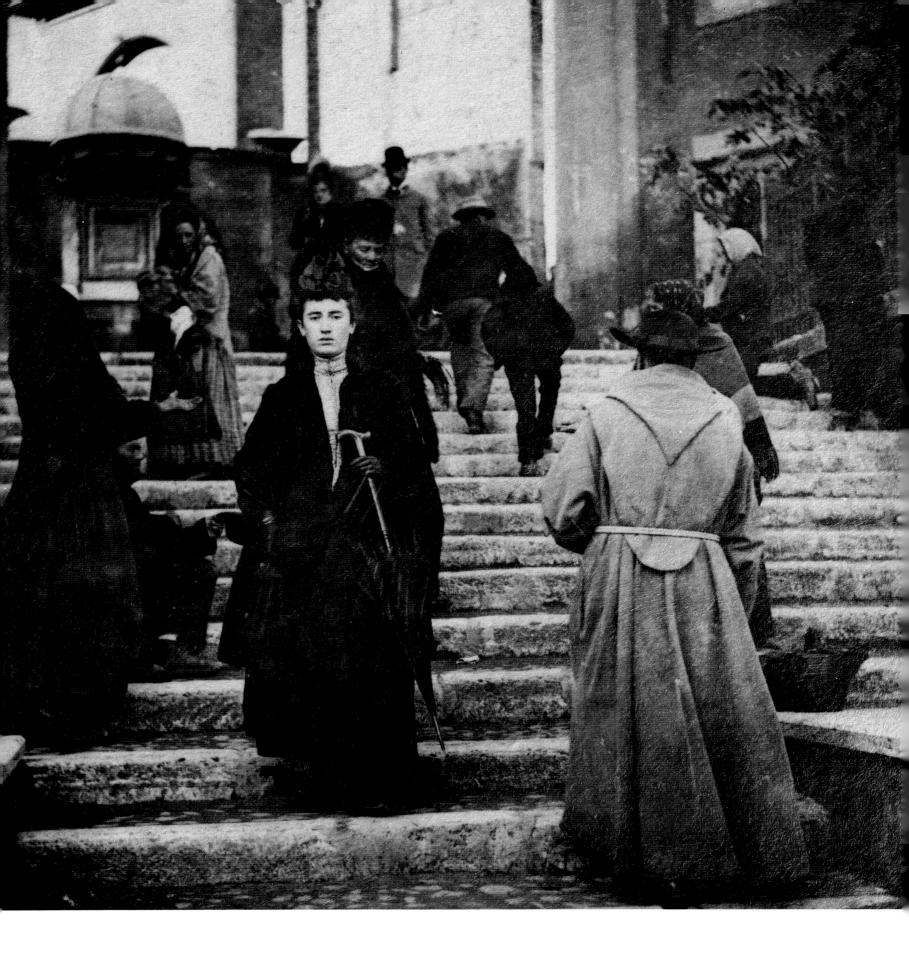

Giuseppe Primoli

Worshippers on the stairway ascending from
Piazza del Campidoglio to the church of the
Aracoeli, during the Forgiveness of Assisi
in Aracoeli, a plenary indulgence granted
by the Catholic Church to the faithful every
year, from midday August 1 to midnight
August 2, c. 1893.

Gläubige auf der Stiege vom Kapitolsplatz
zur Kirche Santa Maria in Aracoeli anlässlich
des Portiunculafestes, bei dem von Mitter-
nacht des 1. Augusts bis zur Mitternacht des
nächsten Tages bußfertigen Besuchern ein
vollkommener Ablass gewährt wird, um 1893.

Fidèles sur les marches de l'escalier qui
conduit de la place du Capitole à la basilique
Santa Maria in Aracoeli, à l'occasion du
pardon d'Assise, indulgence plénière qui, dans
la tradition de l'Église catholique, s'obtient
entre le 1ᵉʳ août à midi et le 2 août à minuit
de chaque année, vers 1893.

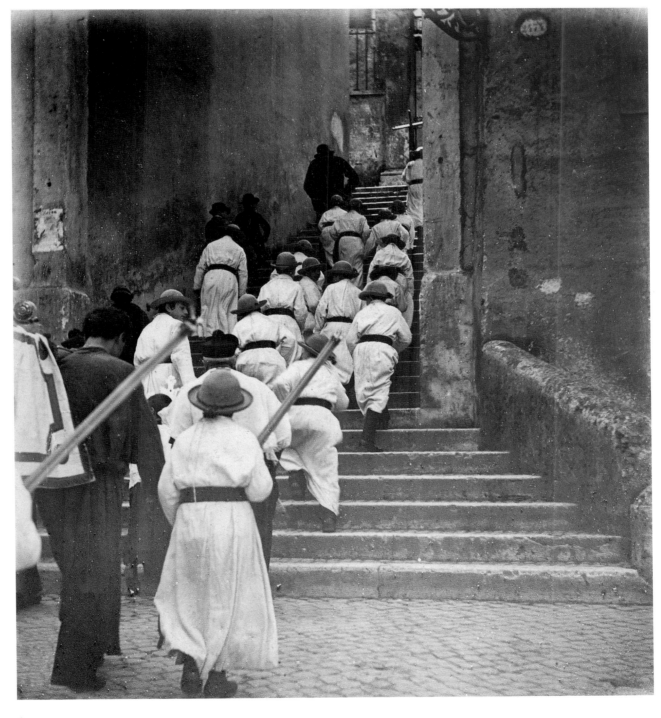

↑
Giuseppe Primoli

*A priest and some orphans in a funeral
march headed towards the Church of the
Santi Michele e Magno in Borgo, 1899–1900.*

*Priester mit Waisenknaben bei einem
Leichenzug zur Kirche Santi Michele e
Magno in Borgo, 1899–1900.*

*Prêtre et orphelins d'un cortège funéraire se
dirigeant vers l'église Santi Michele e Magno
in Borgo, 1899–1900.*

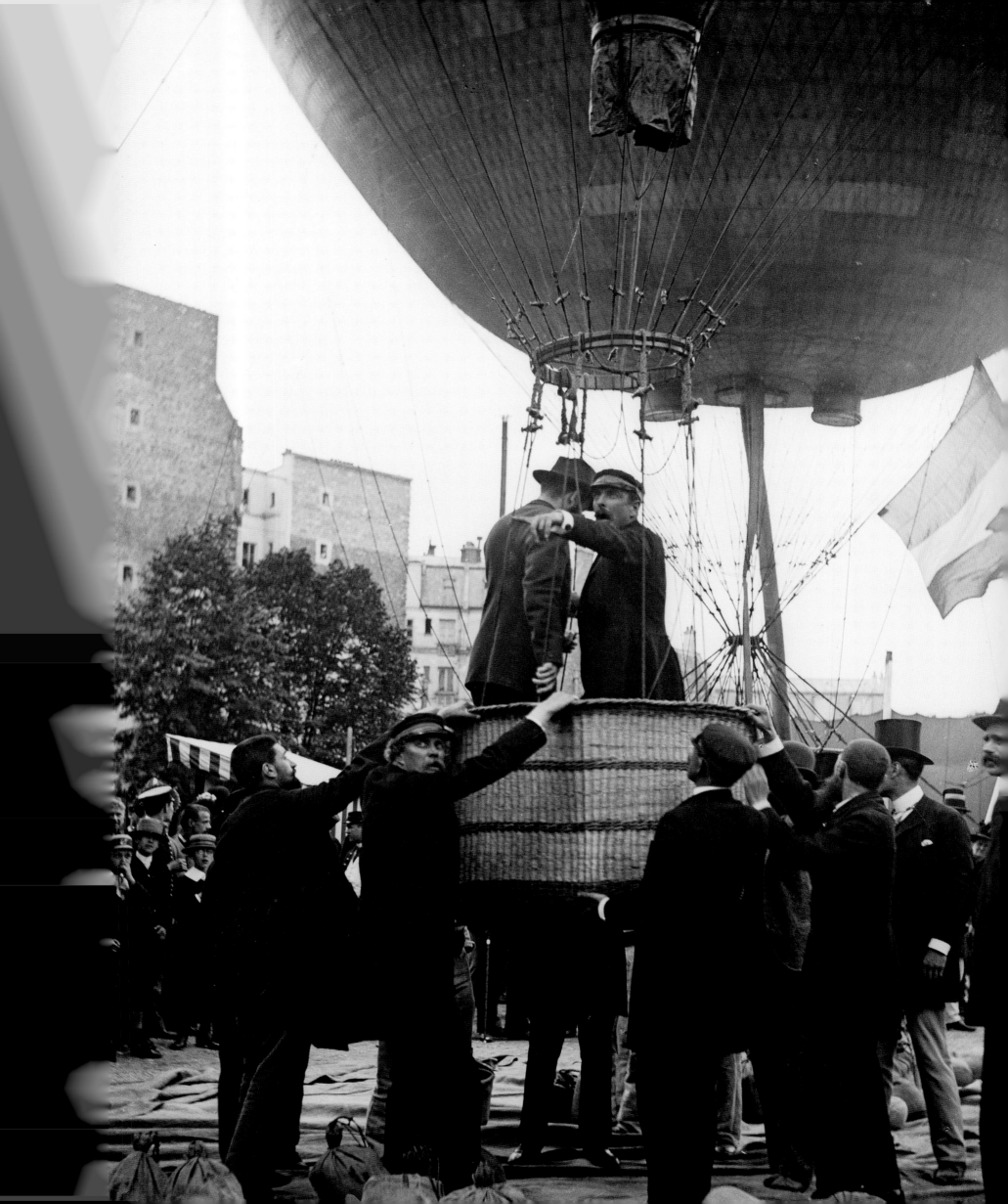

Giuseppe Primoli

The streets of the city center, especially Via del Corso, were the sites of the Romans' daily stroll. Here everyone enjoyed people-watching while at the same time being part of the spectacle, and had the chance to meet people, to indulge in curiosity and vanity, to exchange chatter and gossip on any subject, including commercial advertisements, c. 1890.

Die Straßen des römischen Zentrums, namentlich der Corso, boten die Bühne für den allnachmittäglichen Stadtbummel. Hier konnte man die Menge zugleich bewundern und Teil von ihr sein, seine Neugier befriedigen, unerwartete Begegnungen machen, seiner Eitelkeit frönen, ein wenig plaudern und tratschen und die Werbeplakate studieren, um 1890.

Les rues du centre de la capitale, et notamment le Corso, étaient le lieu où se déroulait la promenade quotidienne, où tout un chacun jouissait du spectacle de la foule dont il était partie intégrante ; un lieu pour faire des rencontres inattendues, satisfaire sa curiosité, donner cours à sa vanité, s'enquérir des derniers potins et lire les affiches publicitaires, vers 1890.

↓

Giuseppe Primoli

Ladies enacting a mock-duel in front of the Casino Algardi in Villa Doria-Pamphilj, 1888.

Damen in Fechterpose vor dem Casino Algardi der Villa Doria-Pamphilj, 1888.

Faux duel féminin devant le casino Algardi de la villa Doria-Pamphilj, 1888.

Giuseppe Primoli

The hot-air balloon built by Louis Godard, who can be seen on board with his arm stretched as he gives an order. A pioneer of flight, Godard, with his friend Nadar, was the first to experiment with airborne photography from a balloon, 1890.

Louis Godard, mit ausgestreckter Hand letzte Anweisungen gebend, im Korb seines Heißluftballons. Der französische Flugpionier machte gemeinsam mit seinem Freund Nadar die ersten Luftbilder aus einem fliegenden Ballon, 1890.

Le ballon aérostatique de Louis Godard que l'on reconnaît à bord de la nacelle, le bras tendu, en train de donner un ordre. Véritable pionnier, Godard effectua avec son ami Nadar les premières expériences de photographie en ballon, 1890.

"Things here are not going much better; the great Roman families are more or less ruined, and from the point of view of the transfer of property, 1893 will be no better than 1793. Those fortunes were swept away by speculation fever. This time it is a Jewish invasion, and the loot will be carted off to America."

„*Hier stehen die Dinge auch nicht viel besser: Die großen römischen Familien sind mehr oder weniger ruiniert, und was die Enteignungen angeht, ist es 1893 kaum anders als 1793. Mit dem Unterschied, dass die heutigen Vermögen vom Spekulationsfieber dahingerafft werden. […] Diesmal haben wir es mit einer jüdischen Invasion zu tun, und die Beute wird nach Amerika verbracht werden.*"

« *Ici nous ne valons guère mieux ; les grandes familles romaines sont plus ou moins ruinées et, au point de vue de l'aliénation des biens, 1893 n'aura rien à envier à 1793. Seulement ces fortunes auront été enlevées par la fièvre de la spéculation. […] Cette fois c'est une invasion juive et c'est en Amérique que le butin sera transporté.* »

GIUSEPPE PRIMOLI IN A LETTER TO SOPHIE DE CASTELLANE, COUNTESS DE BEAULAINCOURT, 1853

→

Anonymous

Buffalo Bill and two Indians at the Caffè Greco. In 1890 Buffalo Bill (Colonel William Cody) with his cowboys gave a series of shows in the Prati di Castello, attended by large crowds of spectators. The performance ended with Indians attacking a stagecoach, 1890.

Buffalo Bill mit zwei Indianern im Caffè Greco. 1890 gastierte Colonel William Cody, alias Buffalo Bill, mit seiner Wildwestshow auf dem Prati di Castello. Scharen von *Zuschauern verfolgten die Darbietung, die mit einem Indianerangriff auf eine Postkutsche endete, 1890.*

Buffalo Bill et deux Indiens au Caffè Greco. En 1890 le colonel William Cody, dit Buffalo Bill, et ses cow-boys donnèrent aux Prati di Castello une série de spectacles qui attirèrent des foules nombreuses ; ils se terminaient par l'attaque d'une diligence par les Indiens.

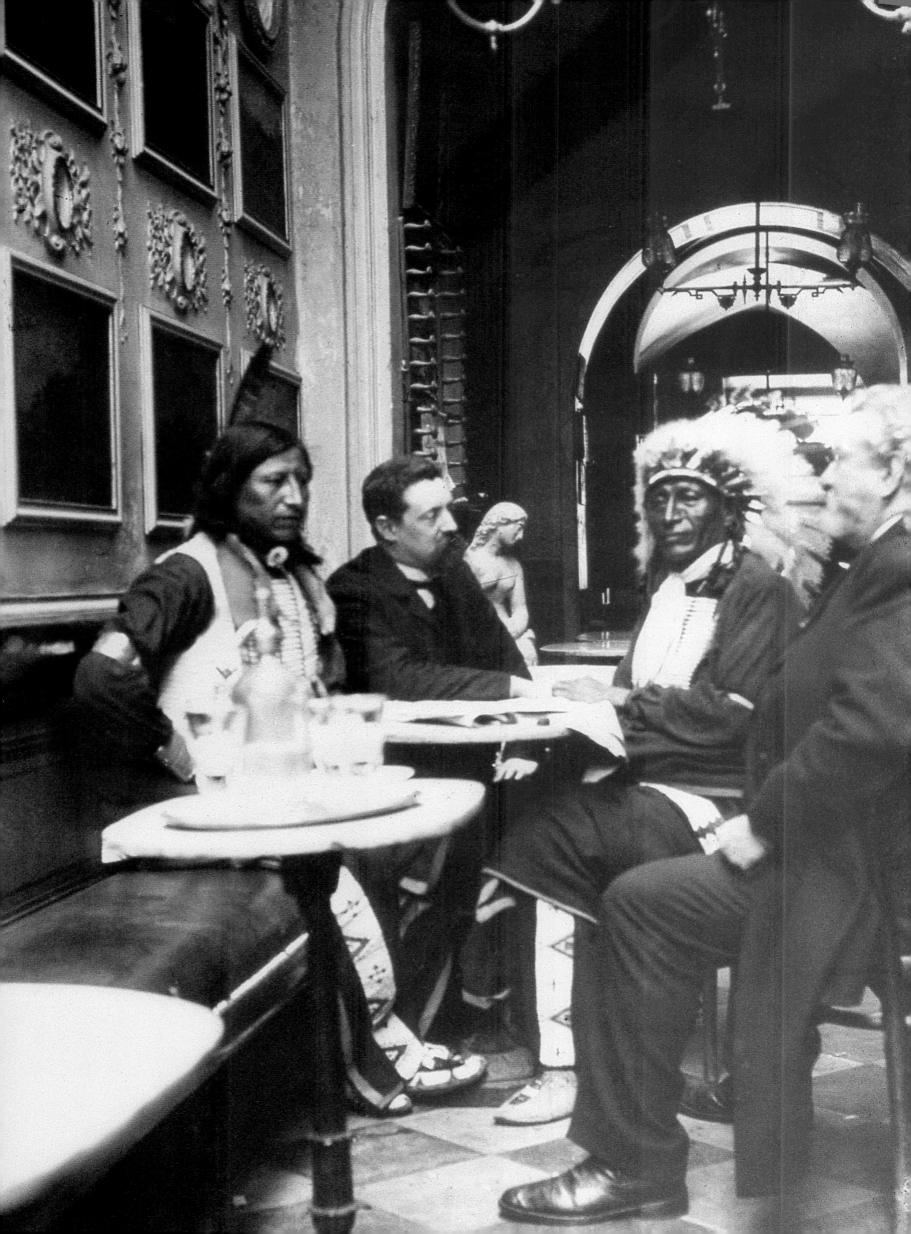

↓
Anonymous

*A family at a seaside resort in Anzio,
c. 1895.*

*Familie am Badestrand von Anzio,
um 1895.*

*Famille à la station balnéaire d'Anzio,
vers 1895.*

→
Giuseppe Primoli

An officer of the bersaglieri *and some civilians
on a boat watch the celebrations organized by
various Roman rowing clubs, May 1890.*

*Ein Offizier der Bersaglieri und Zivilisten in
einem Boot beim Fest der römischen Ruderer,
Mai 1890.*

*Un officier des bersagliers et des civils assistent
depuis une barque aux fêtes organisées par
différents clubs de canoteurs de la capitale,
mai 1890.*

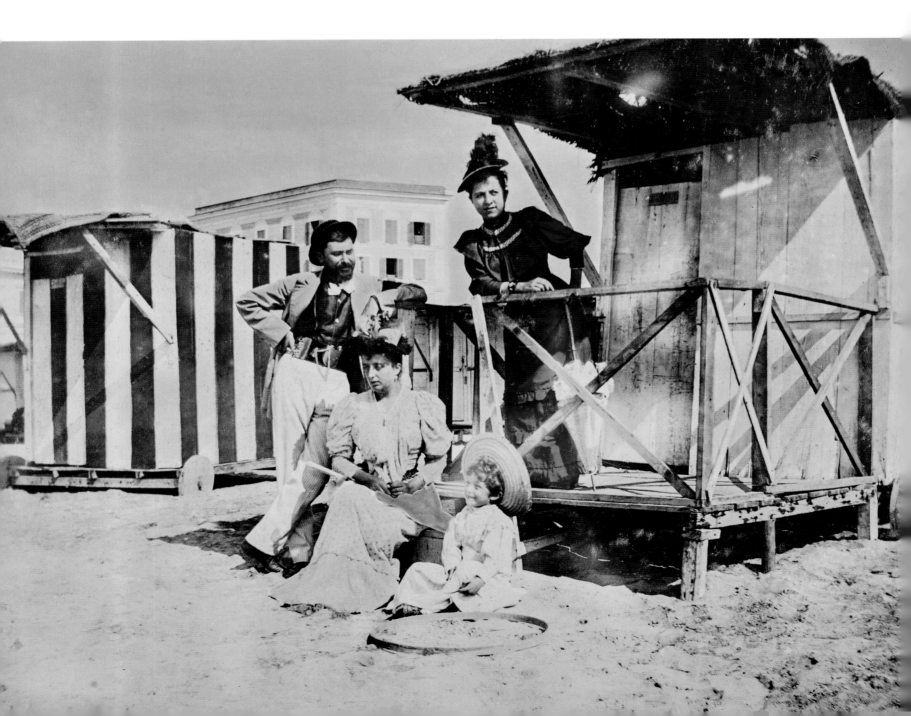

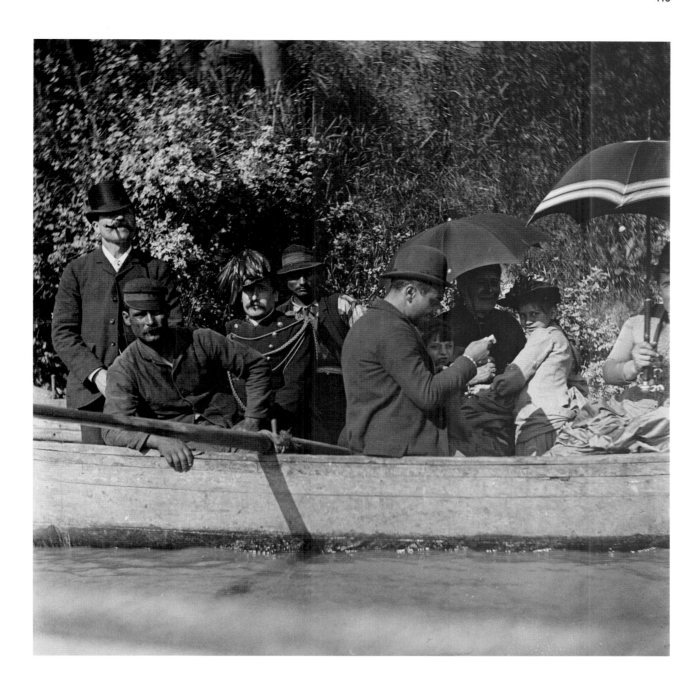

pp. 116/117
Giuseppe Primoli

A group of rowers around a lady on a float on the Tiber. In the background, on the left, the dome of San Carlo al Corso, c. 1890.

Dame im Kreise von Ruderern auf einem Badesteg am Tiber; hinten links die Kuppel von San Carlo al Corso, um 1890.

Un groupe de canoteurs encadrant une dame sur un ponton flottant du Tibre. Au fond, à gauche, la coupole de San Carlo al Corso, vers 1890.

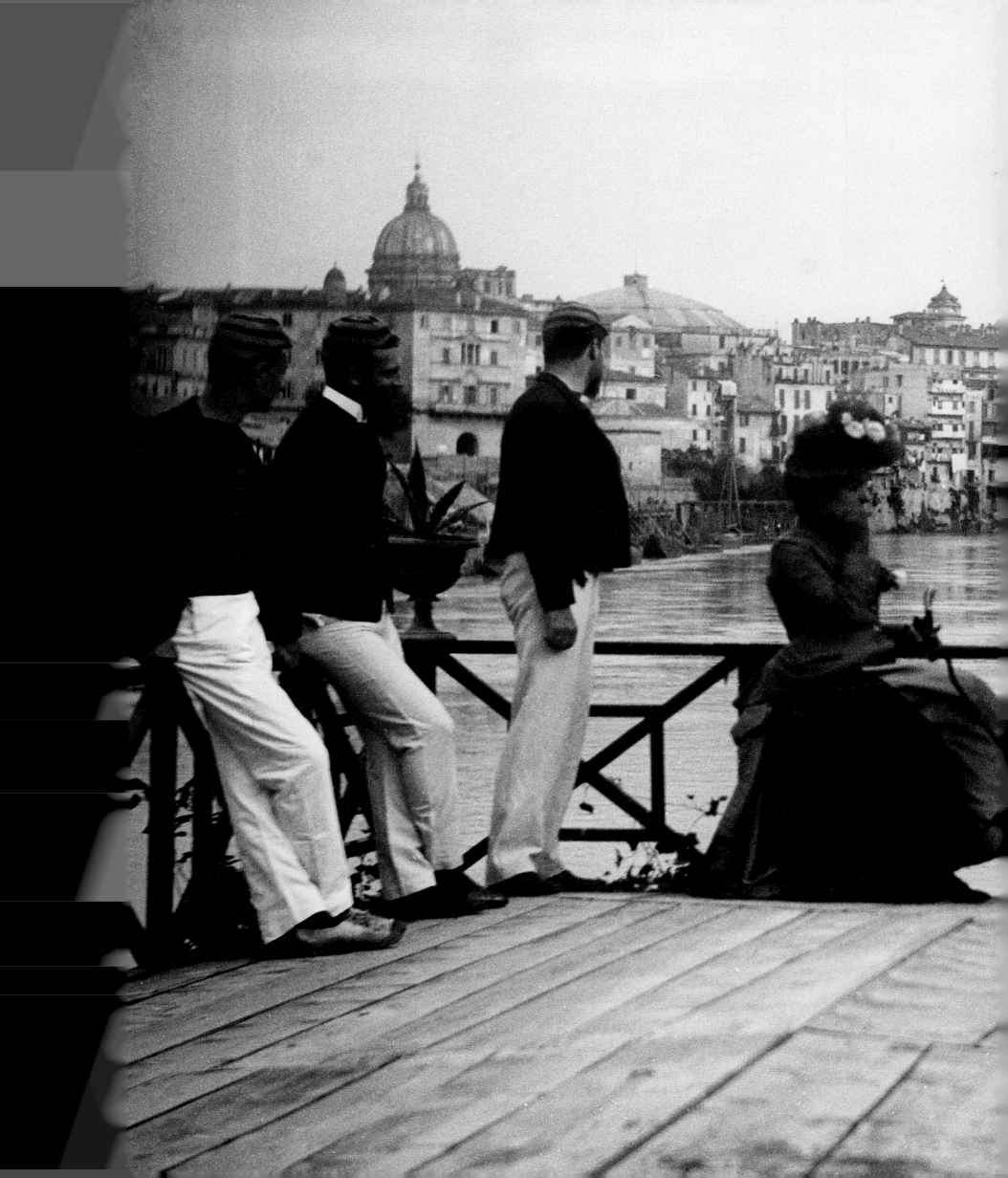

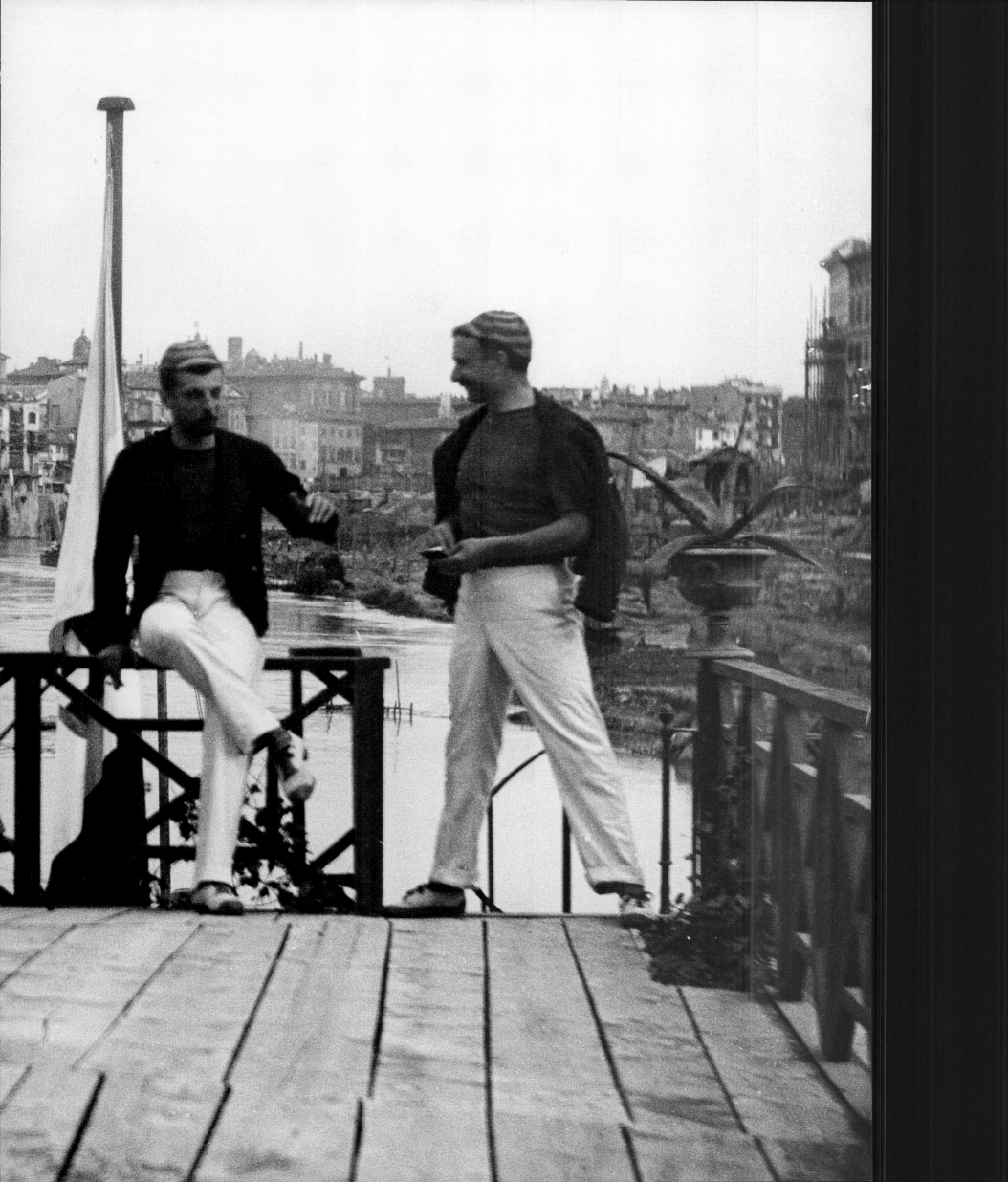

→

Giuseppe Primoli

A lady posing for a photographer in the garden of the Villa Medici, 1889–1900.

Posierende Dame mit Fotograf im Garten der Villa Medici, 1889–1900.

Dame posant devant un photographe dans le jardin de la Villa Médicis, 1889–1900.

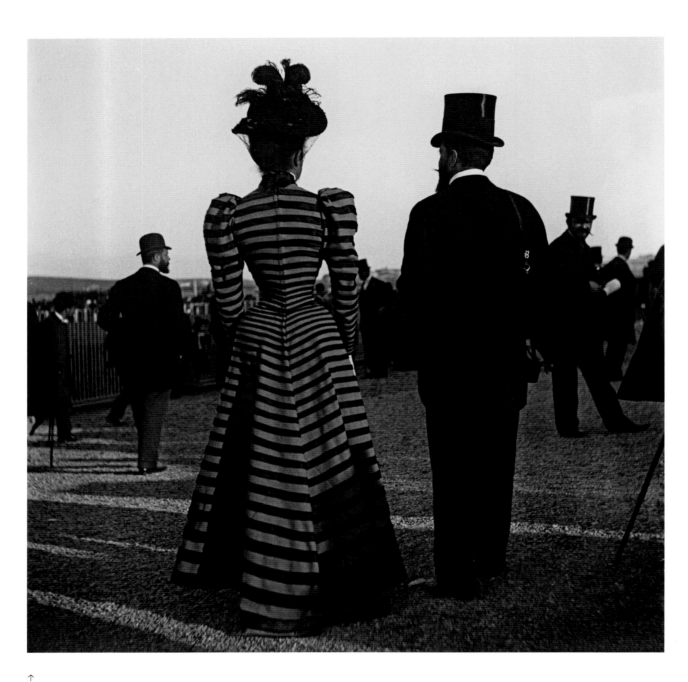

↑

Giuseppe Primoli

An elegant couple at the racetrack in Capannelle, opened in 1884 near Via Appia Nuova, 1890–1900. "The women in this crowd are very beautiful, unless they are foreigners; Roman women are strangely beautiful even when they are ugly; but this cannot be said of many of them." (Sigmund Freud, letter to his family, Rome, September 22, 1907)

Elegantes Paar auf der 1884 eingeweihten Rennbahn Capannelle an der Via Appia Nuova, 1890–1900. „Die Frauen in der Menge sind sehr schön, soweit sie nicht Fremde sind, die Römerinnen merkwürdigerweise auch noch schön, wenn sie hässlich sind, und das sind eigentlich nicht viele von ihnen." (Sigmund Freud, Brief an die Familie vom 22. September 1907)

Un couple élégant à l'hippodrome des Capannelle, inauguré en 1884 près de la via Appia Nuova, 1890–1900. « Les femmes, dans la foule, sont très belles, dans la mesure où elles ne sont pas étrangères. Les Romaines, bizarrement, sont belles même lorsqu'elles sont laides et, en fait, il y en a peu qui le soient parmi elles. » (Sigmund Freund, lettre à sa famille datée du 22 septembre 1907)

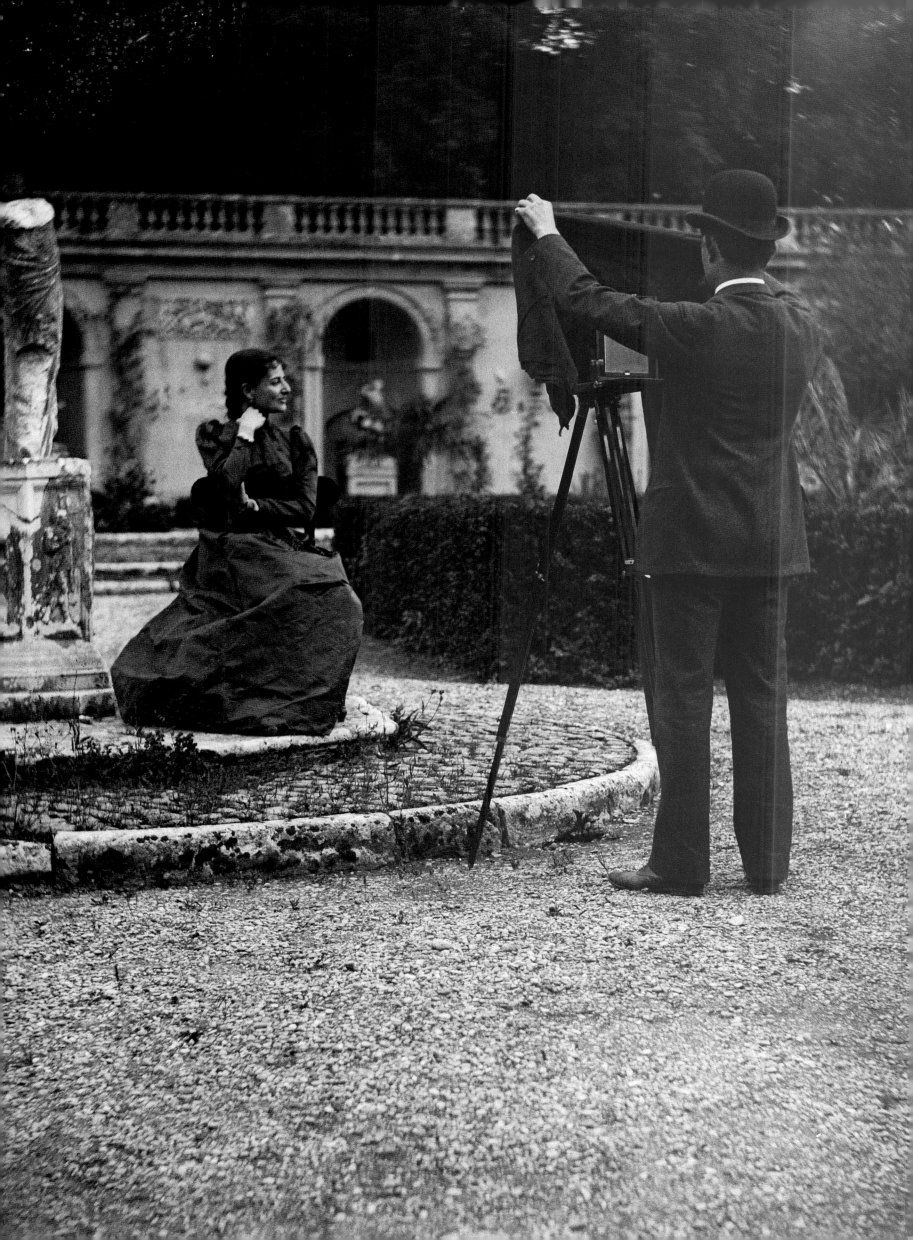

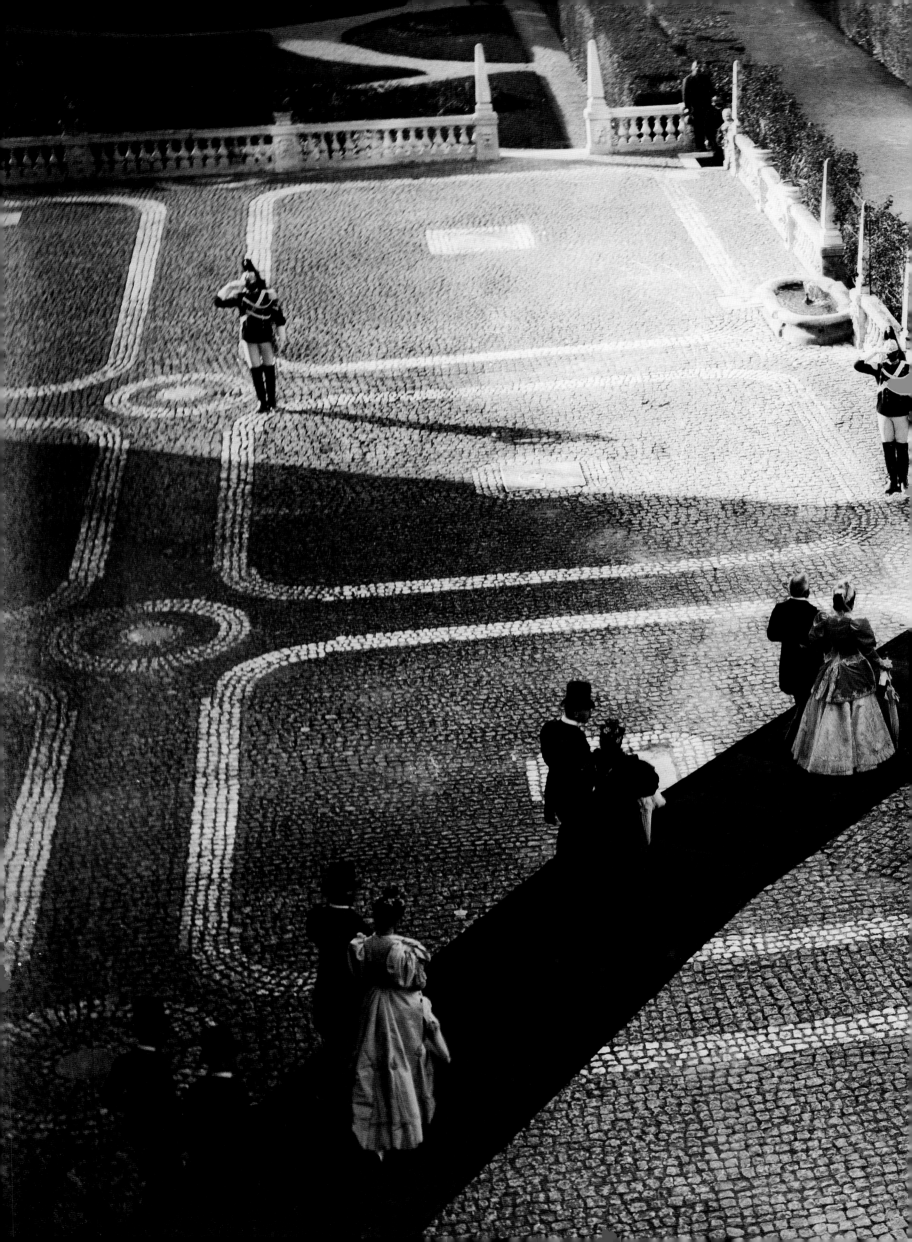

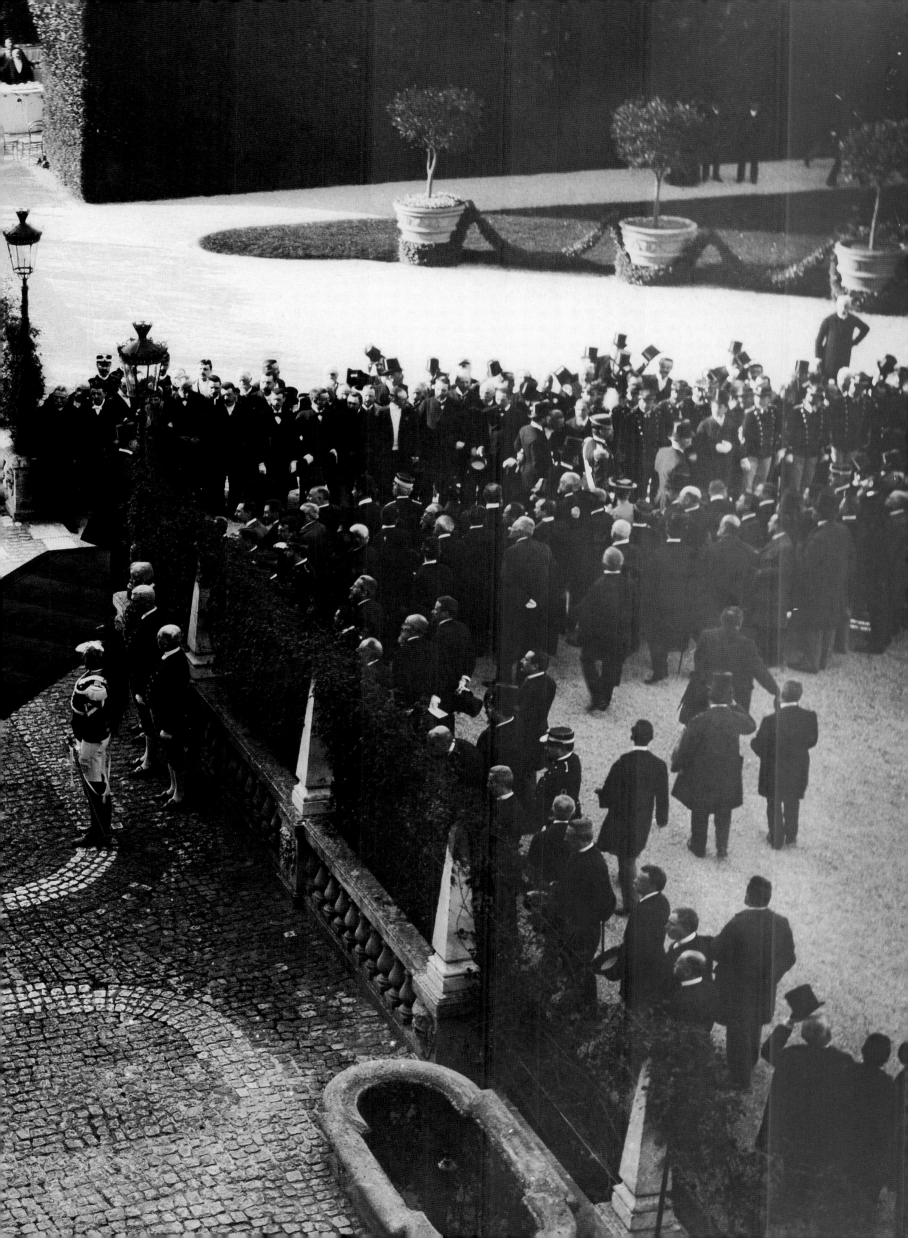

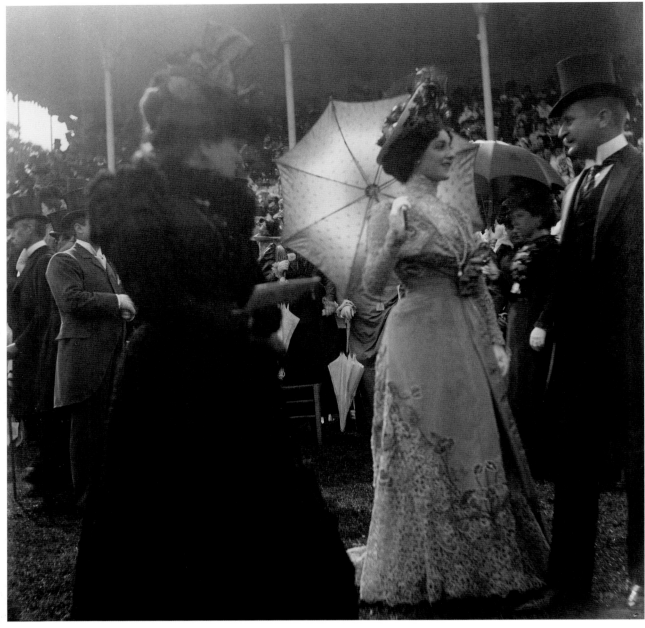

←
Giuseppe Primoli

Lina Cavalieri, a café-chantant performer and then an opera singer, popular in Rome and well known abroad, described by Gabriele D'Annunzio as "the supreme evidence of Venus on earth," seen here in the company of Prince Obolensky, at the racetrack in Tor of Quinto, c. 1895.

Die Soubrette und spätere Primadonna Lina Cavalieri war nicht nur in Rom sehr beliebt, sondern auch im Ausland keine Unbekannte. Gabriele D'Annunzio nannte sie einmal „die vollkommenste Manifestation der Venus auf Erden", hier in Begleitung des Fürsten Obolenski auf der Rennbahn von Tor di Quinto, um 1895.

Lina Cavalieri, vedette de café-concert puis artiste lyrique, très populaire à Rome et très connue à l'étranger, dont Gabriele D'Annunzio disait qu'elle était la « plus sublime manifestation de Vénus sur terre », en compagnie du prince Obolensky à l'hippodrome de Tor di Quinto, vers 1895.

pp. 120/121
Giuseppe Primoli

The cortege of the sovereigns (King Umberto and Queen Margherita) leaves Palazzo del Quirinale to go to the gardens during a formal party, 1893.

König Umberto und Königin Margherita mit ihrem Gefolge bei einem Empfang auf dem Weg vom Palast in die Gärten des Quirinal, 1893.

Le cortège royal – le roi Humbert Ier et la reine Marguerite – quitte le palais du Quirinal et descend dans les jardins lors d'une réception, 1893.

→
Giuseppe Primoli

Advertising posters for Singer sewing machines and Mrs. S.A. Allen's Hair Lotion, c. 1895.

Plakatwerbung für Nähmaschinen der Marke Singer und Haarlotion von Mrs. S.A. Allen, um 1895.

Affiches publicitaires pour les machines à coudre Singer et la lotion capillaire de Mrs S.A. Allen, vers 1895.

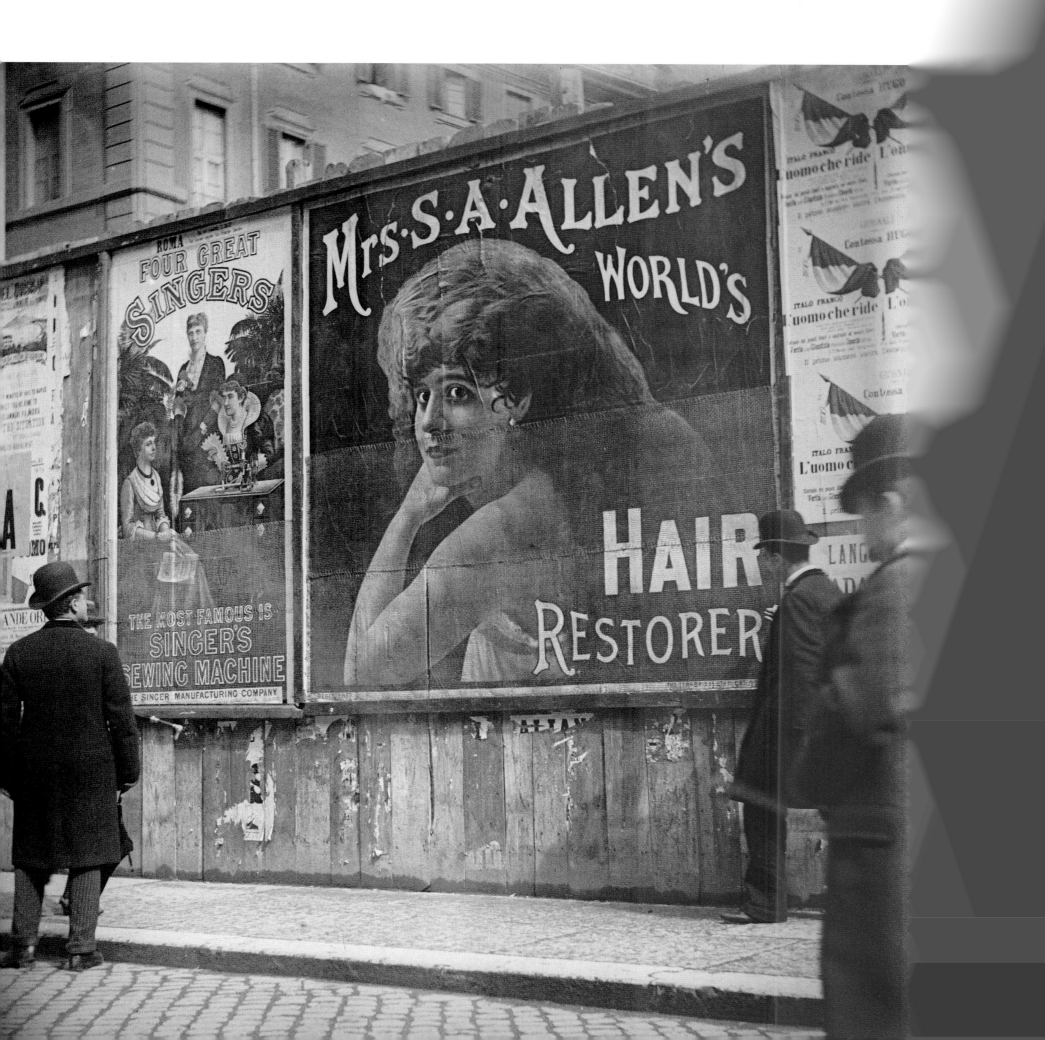

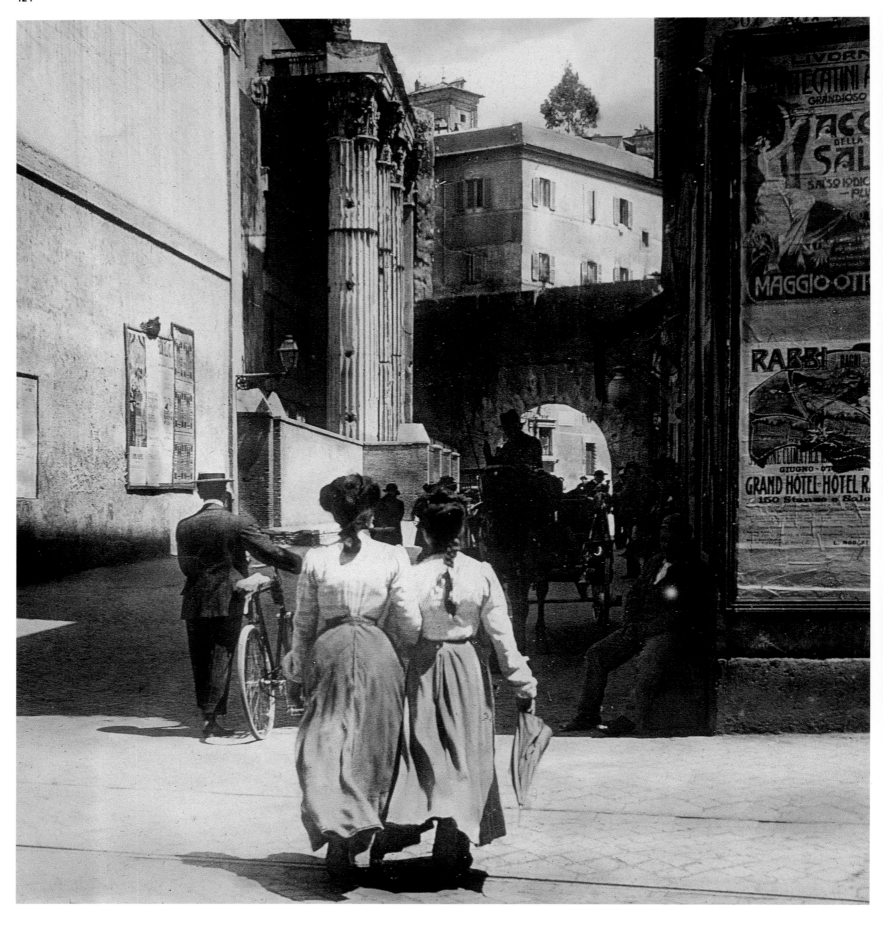

↑

Jano Dubravcik

*Two young women walking along the ruins
of the Temple of Mars Ultor and the Arco dei
Pantani, c. 1907.*

*Zwei junge Römerinnen spazieren am Arco
dei Pantani und am Tempel des Mars Ultor
vorbei, um 1907.*

*Deux jeunes femmes se promenant en
direction des vestiges du temple de Mars Ultor
et de l'arc des Pantani, vers 1907.*

→

Jano Dubravcik

*A carro a vino (wine carriage) parked in
front of the Piccola Trattoria. The carro a
vino, typical of Lazio, was one of the most
popular genre images among the visitors to
Rome, c. 1907.*

*Weinfuhrwerk vor der Piccola Trattoria.
Solche in Latium traditionell weit verbreite-
ten Fuhrwerke für Weinfässer waren ein bei
Romreisenden sehr beliebtes Motiv, um 1907.*

*Char à vin arrêté devant la Piccola Trattoria.
Typique du Latium, le char à vin constituait
l'un des sujets traditionnels chers aux
voyageurs, vers 1907.*

"He talked to her of earlier times, of the ball at Palazzo Farnese, the hunt in the countryside of the Divino Amore, the morning encounters in Piazza di Spagna by the displays of the jewelry stores, or along the tranquil and elegant Via Sistina, when she would leave Palazzo Barberini followed by the peasant women offering her baskets of roses."

„Er erzählte ihr von den ersten Tagen in Rom, vom Ball im Palazzo Farnese, von der Jagdgesellschaft in der Campagna bei der Kirche Divino Amore, von den morgendlichen Begegnungen auf der Spanischen Treppe, vor den Schaufenstern der Juweliere oder in der stillen vornehmen Via Sistina, wenn sie aus dem Palazzo Barberini trat und die Frauen aus der Ciociaria ihr die Rosen in ihren Körben feilboten."

« Il lui parla des premiers jours, du bal au palais Farnèse, d'une partie de chasse à la campagne du Divin Amour, des rencontres matinales sur la place d'Espagne, devant les vitrines des orfèvres, ou dans la tranquille et aristocratique rue Sixtine, lorsqu'elle sortait du palais Barberini suivie par les bouquetières qui lui offraient des roses dans des corbeilles. »

GABRIELE D'ANNUNZIO, *IL PIACERE,* **1889**

↑
Charles Abéniacar

Émile Zola's wife, Gabrielle, in the studio of painter Baldassarre Surdi, 1894.

Gabrielle Zola, die Frau des Schriftstellers, im Atelier des Malers Baldassarre Surdi, 1894.

Gabrielle Zola, épouse de l'écrivain, dans l'atelier du peintre Baldassare Surdi, 1894.

←
Charles Abéniacar

A group of journalists in the Vatican, 1902.

Journalisten im Vatikan, 1902.

Un groupe de journalistes au Vatican, 1902.

→
Anonymous

Carabinieri, *in their elegant uniform, were often to be seen populating the urban spaces of Rome, c. 1902.*

Carabinieri in ihren schmucken Uniformen sind auf römischen Straßen und Plätzen häufig zu sehen, um 1902.

Avec leur élégant uniforme, les carabiniers animent souvent les espaces urbains de Rome, vers 1902.

"Paris, as I passed along the Boulevards *three evenings before to take the train, was swarming and glittering as befits a great capital. Here, in the black, narrow, crooked, empty streets, I saw nothing I would fain regard as eternal. But there were new gas-lamps round the spouting Triton in Piazza Barberini and a newspaper stall on the corner of the Condotti and the Corso – salient signs of the emancipated state.*"

„Als ich drei Abende zuvor in Paris noch einmal über die Boulevards schlenderte, bevor ich den Zug nahm, summte und glitzerte die Stadt, wie es sich für eine echte Hauptstadt gehört. Hier dagegen, in den schwarzen, engen, krummen Straßen, sah ich nichts, das ich als ewig hätte ansprechen wollen. Immerhin gab es neue Gaslaternen rund um den wasserspeienden Triton auf der Piazza Barberini und einen Zeitungsstand an der Ecke der Via Condotti und des Corso – sichtbare Zeichen eines freiheitlichen Staates."

« Paris, où je me promenais sur les boulevards trois soirs auparavant, grouillait et brillait comme il convient à une grande capitale. Ici, dans les rues noires, étroites, tortueuses, je n'ai rien vu que je considérerais volontiers comme éternel. Mais il y a de nouveaux réverbères autour des Tritons vomissants de la piazza Barberini et un kiosque à journaux à l'angle de la via Condotti et du Corso – indices saillants d'un État émancipé. »

HENRY JAMES, "FROM A ROMAN NOTE-BOOK", IN *ITALIAN HOURS,* **1873**

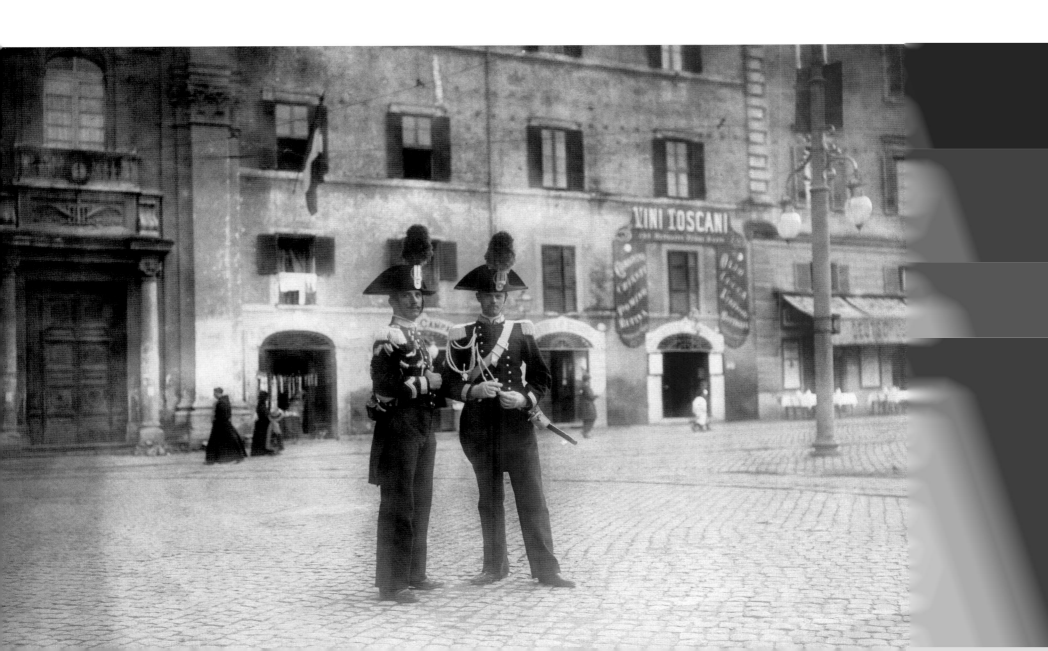

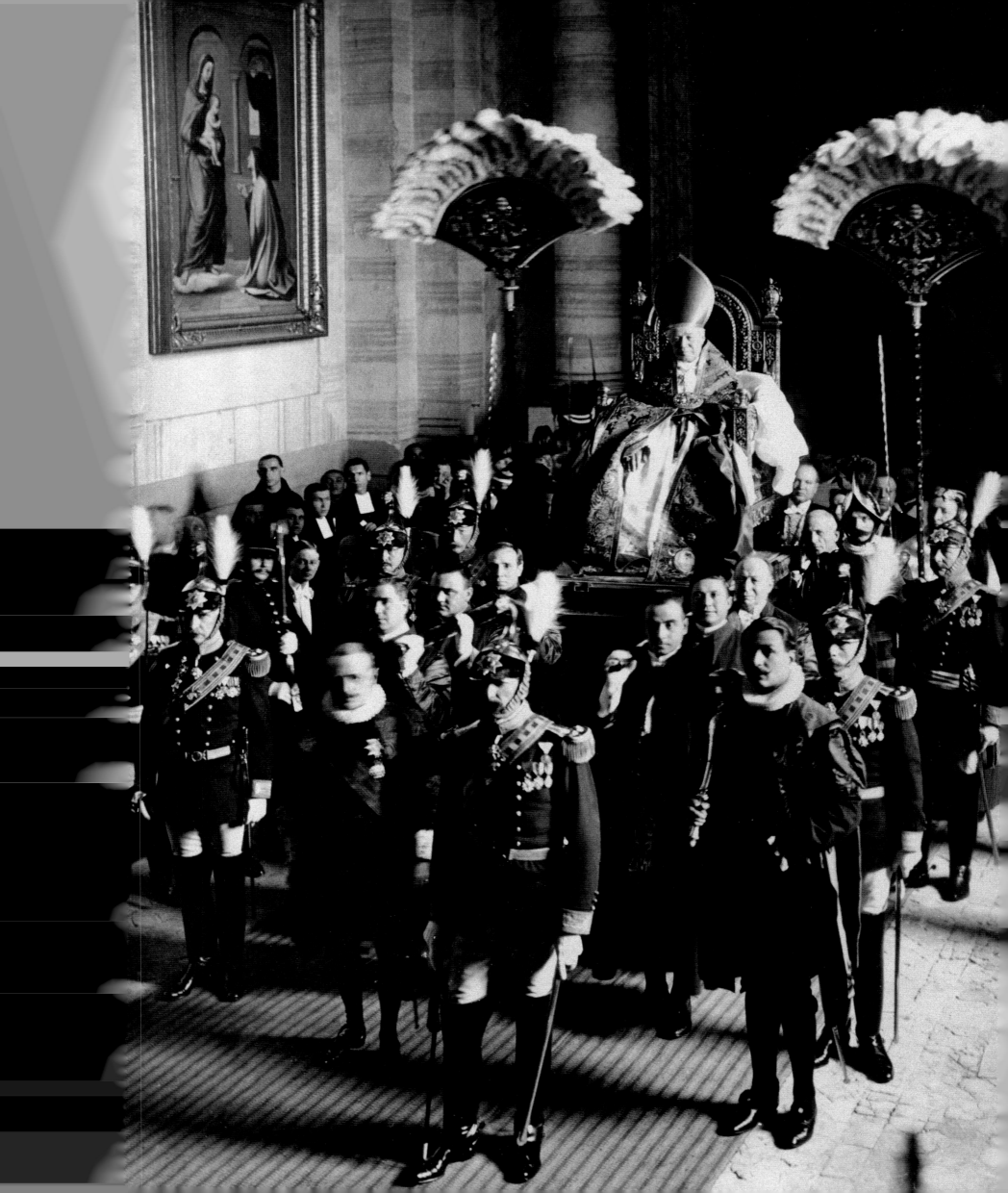

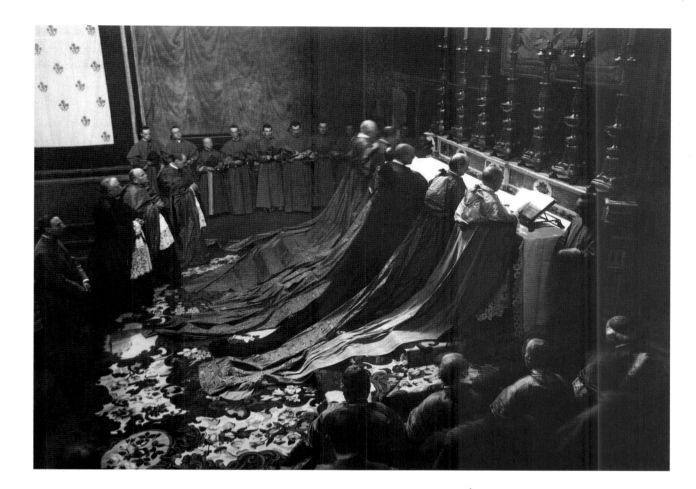

↑

Anonymous

Newly elected cardinals in the Sistine Chapel in the Vatican, 1914.

Neu eingesetzte Kardinäle vor dem Altar der Sixtinischen Kapelle, 1914.

Cardinaux nouvellement nommés dans la chapelle Sixtine, 1914.

←

Anonymous

Pius X lived a spartan life in the Vatican, assisted by his sisters. He had a traditionalist approach to the Catholic Church, and opposed modernism. Apparently, after being asked by the ecclesiastical authorities of Paris to ban the new, sensual dance imported from Argentina, he requested a demonstration of the tango, and after the two dancers had performed it he lifted the sanctions imposed on those who practiced it. This episode inspired Trilussa's poem Tango e Furlana, *1912.*

Unter dem Pontifikat Pius' X. schlug die katholische Kirche eine traditionalistische Richtung ein. Als aus Pariser Kirchenkreisen Forderungen nach einem Verbot des Tangotanzens laut wurden, ließ der Papst (der, von seinen Schwestern versorgt, zurückgezogen im Vatikan lebte) ein Tanzpaar kommen – so wird erzählt –, um sich den argentinischen Skandaltanz vorführen zu lassen; nachdem er sich selbst einen Eindruck gemacht hatte, ließ er die angedrohten Maßnahmen gegen tangotanzende Katholiken rückgängig machen – eine Anekdote, die den römischen Dichter Trilussa zu seinem Gedicht Tango e Furlana *inspirierte, 1912.*

Au Vatican, Pie X mena une vie frugale, assisté par ses sœurs. Il donna à l'Église catholique une orientation traditionnaliste, hostile au modernisme. On raconte que les autorités ecclésiales parisiennes lui ayant demandé d'interdire une nouvelle danse sensuelle venue d'Argentine, il demanda qu'un couple de danseurs lui permette de se faire une idée précise du tango et qu'à la suite de cette démonstration il révoqua la sanction prévue à l'encontre des adeptes. L'incident inspira au poète Trilussa son Tango e Furlana, *1912.*

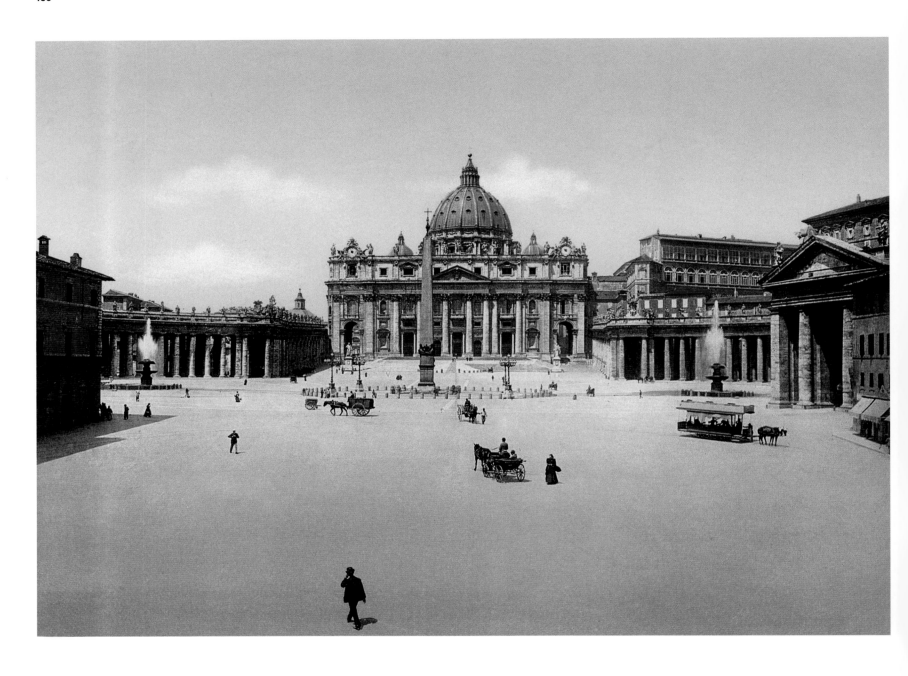

↑

Photoglob Zürich

*St. Peter's Square. Some elements of this
urban scene have been added by way of
retouching the image during the production
of the photochrom, c. 1905.*

*Der Petersplatz. Einige Details der Szenerie
sind nachträglich in das Photochrom hinein-
retuschiert worden, um 1905.*

*Place Saint-Pierre. Plusieurs éléments ont
été ajoutés à la scène urbaine lorsqu'elle a été
retouchée durant l'élaboration du photo-
chrome, vers 1905.*

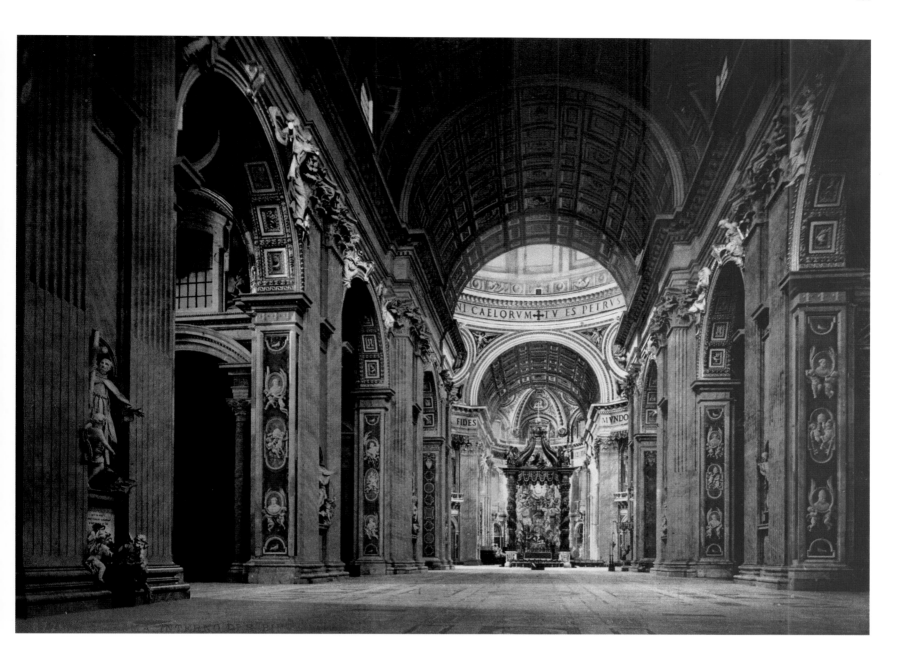

↑

Photoglob Zürich

The interior of St. Peter's Basilica, c. 1905.

Innenansicht von St. Peter, um 1905.

Vue intérieure de la basilique Saint-Pierre, vers 1905.

"There is a great divergence in our way of thinking: / Father is a Christian Democrat,
and since he is employed by the Vatican, every evening he recites the rosary,
of the three brothers, Giggi, who is the eldest, / is a Socialist revolutionary;
I, on the other hand, am a royalist, as opposed to / Ludovico, who is a republican.
Before dinner, we often argue / because of these blessed principles:
one of us wants something, the other something else… it's like a convention! / We make a racket!
But as soon as Mamma tells us that the spaghetti are ready / we are all agreed on what to do."

„Grundverschieden ist die Denkungsart: / mein Vater ist Christ-Demokrat,
angestellt beim Vatikan, weshalb allabendlich das Rosenkranzgebet er wahrt.
Von uns drei Brüdern Giggi ist der Älteste, ist Sozialist und Revolutionär;
ich ganz dagegen Monarchist, verschieden sehr / von Ludovico, Republikaner er.
Noch vor dem Essen wird gestritten / um die hochheiligen Prinzipien:
Der eine so, der andere so … wie in des Parteitag 's Mitten, / geht's da hoch her!
Doch ruft Mama: / ‚Die Nudeln sind gleich gar,' / herrscht Einigkeit in allen Fragen."

« Dans la manière de penser, il y a de grandes divergences : / mon père est chrétien démocrate,
et, comme il est employé au Vatican, il récite le rosaire tous les soirs ;
des trois frères, Giggi qui est l'aîné / est socialiste révolutionnaire ;
moi, je suis monarchiste, contrairement / à Ludovico qui est républicain.
Avant le dîner nous nous disputons souvent / à cause de ces sacrés principes :
qui tient pour ceci, qui tient pour cela… On se croirait à un congrès ! /
On fait un tapage de tous les diables ! Mais dès que maman /
nous dit que les spaghettis sont cuits / nous sommes tous d'accord avec le programme. »

TRILUSSA (CARLO ALBERTO SALUSTRI), *LA POLITICA*, 1915

→
Anonymous

*During World War I, on the occasion of the
Day of the Italian Flag – a benefit for the
Italian Red Cross – Girl Scouts decorate
a young officer on leave in a street in Rome
with a small tricolor cockade in the colors
of the flag, June 1915.*

*Anlässlich der im Ersten Weltkrieg einge-
führten „Giornata Tricolore" zugunsten
des italienischen Roten Kreuzes stecken
Pfadfinderinnen einem Offizier auf Urlaub in
Rom eine Kokarde in den Landesfarben an,
Juni 1915.*

*Dans une rue de Rome, avant la Première
Guerre mondiale, à l'occasion de la Journée
tricolore au bénéfice de la Croix-Rouge, des
jeunes filles scouts décorent d'une cocarde
tricolore un jeune officier en permission,
juin 1915.*

pp. 134/135
Anonymous

*Via Nazionale: horse-drawn carriages and a
streetcar powered by means of aerial wires
transmitting electricity. Line 3 connected
Termini Station with Trastevere, 1910–1915.*

*Via Nazionale: Pferdekutschen neben einer
Trambahn mit Oberleitung zur Stromversor-
gung. Die Linie 3 verkehrte zwischen dem
Bahnhof Termini und Trastevere, 1910–1915.*

*Via Nazionale : voitures à cheval et tramways
électriques avec fil aérien, perches et retour
du courant de traction par les rails. La ligne
numéro 3 reliait la gare Termini au Traste-
vere, 1910–1915.*

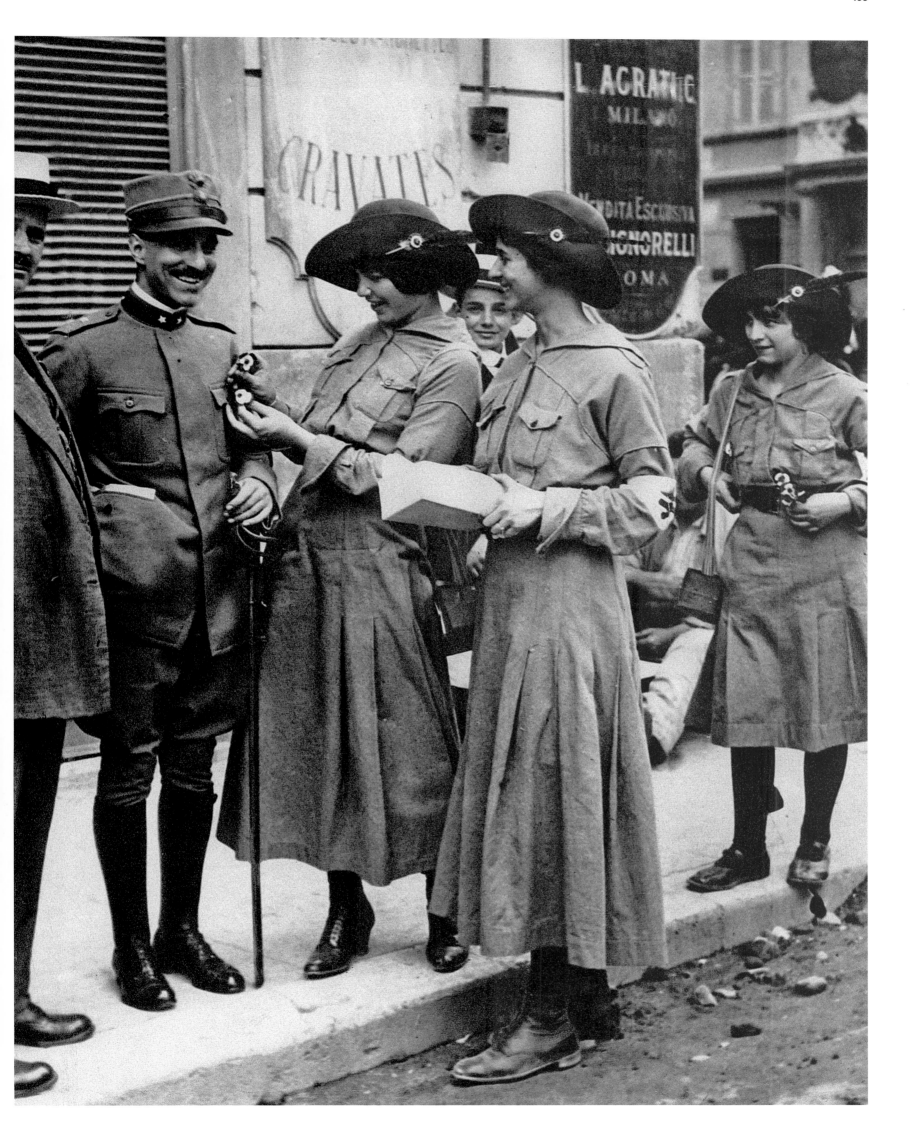

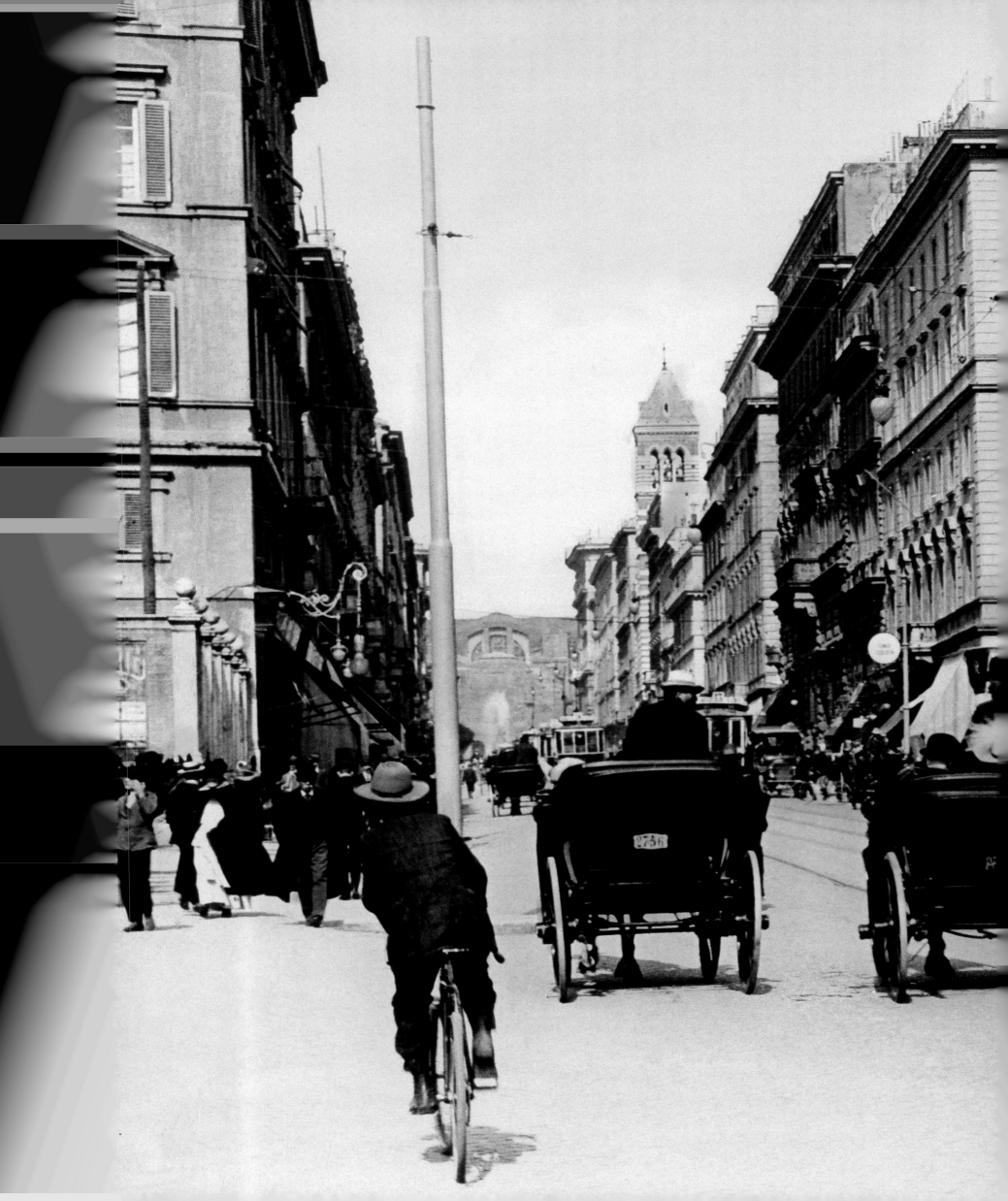

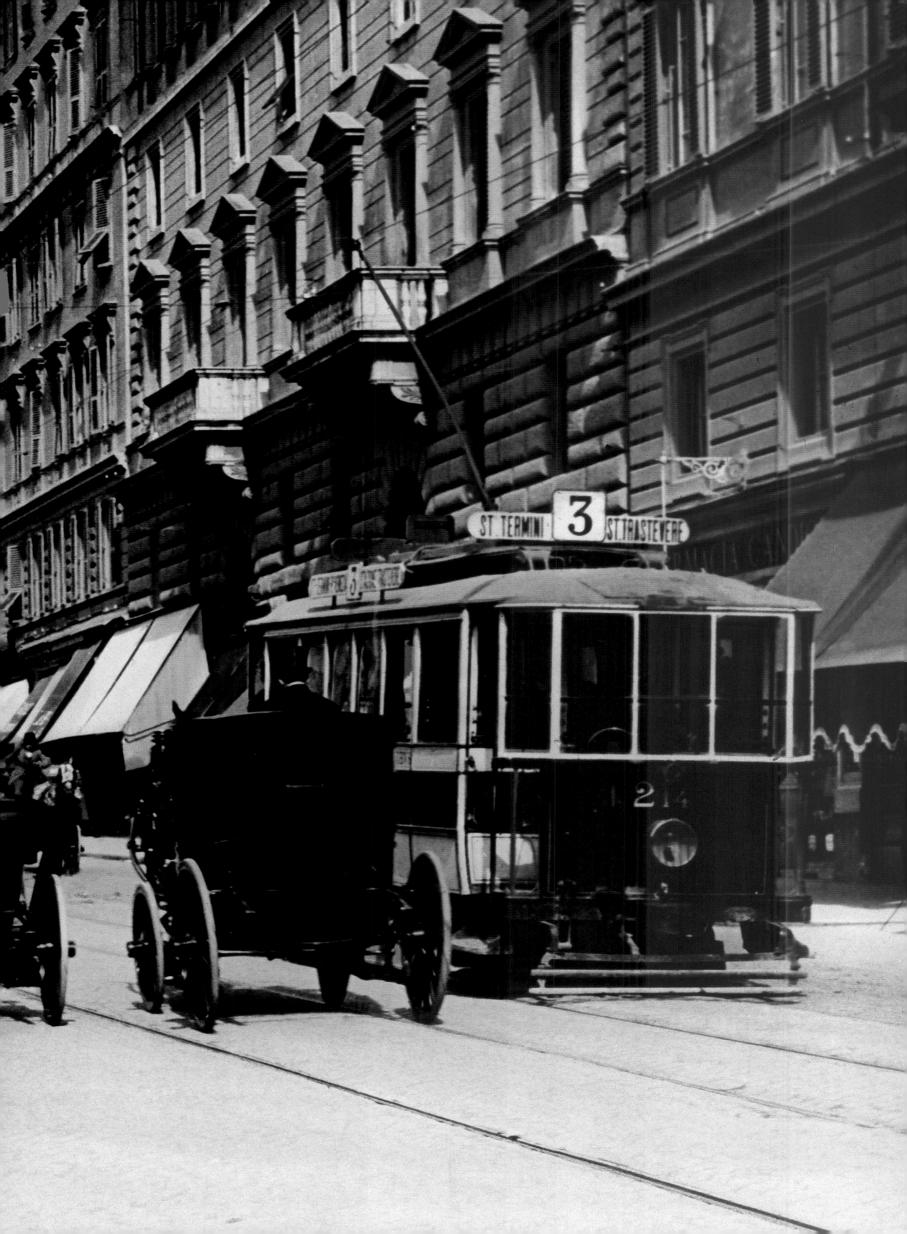

3

Darkness and Light During the Fascist Years

1919–1944

p. 138
Armando Bruni

Textiles shop in Campo de' Fiori, c. 1919.

Stoffgeschäft am Campo de' Fiori, um 1919.

*Magasin de tissus situé Campo de' Fiori,
vers 1919.*

"The soul of a country does not change. It is still there, observing us from behind the fortified palaces, behind all this calm and discipline, behind the romantic uniforms, behind the tragi-comic mask of the Duce."
JEAN COCTEAU, *MON PREMIER VOYAGE (TOUR DU MONDE EN 80 JOURS)*, 1937

At the end of World War I, Italy did not achieve the results it had hoped for with the victory it had obtained at such a high price: many demobilized soldiers could not find work, and the economy was in tatters. Socio-political conditions favored the rise to power of a strong personality, a future dictator, Il Duce. As head of the Fascist Party, in 1922 Benito Mussolini engineered the "March on Rome" and thus succeeded in his plan of forming a new government. In 1929 the Fascist regime and the Vatican signed an agreement ending the conflict between Italy and the Church that had existed since 1870. The agreement allowed Mussolini to consolidate his position and image in the Catholic world.

During the 1920s, the Sunday *passeggiata* in the Corso was still an important event for many, but by then the carriages parked along the road belonged to the families of those who had the most lucrative trades: the innkeepers and guesthouse landlords. Local commerce, with the exception of a few luxury stores, was based on some of the lowest quality merchandise available in Italy.

Tourism was more successful, and new grand hotels opened: in the early 1920s, Pablo Picasso and the Ballets Russes of Sergei Diaghilev stayed at the Hotel de Russie, and Picasso also had a studio in Via Margutta. In *Tender is the Night* (1934), F. Scott Fitzgerald wrote of the clients of the Hotel Quirinale and the Excelsior (built in 1906), which had a private orchestra. Another grand and monumental building was the Ambasciatori, the first modern hotel to be erected after the war, designed by Marcello Piacentini on the model of sober Berlin architecture in order to distinguish it from the overly luxurious and cosmopolitan Excelsior. Piacentini also reconfigured the cinema-theater Corso (formerly Lux et Umbra, subsequently Étoile, 1916–1919), and designed the *café-chantant* La Quirinetta in Art Deco style in 1920.

According to the 1931 census, during the Fascist period Rome had over a million residents. For a city unwilling to renew itself, and unfit for its role as a modern capital city, the increase in population – mainly the result of immigration from rural areas, especially from southern Italy – was not a positive phenomenon.

Rome's urban configuration became a shapeless mosaic. The building expansion produced residential districts composed of monumental single houses, apartments in *barocchetto* (Rococo) style (Piazza Bologna, Parioli, etc.), and mass housing estates financed by the Istituto Case Popolari, like Aniene, the "city-garden" in Monte Sacro, and Garbatella (1924). Additionally, there were the edifices erected in infringement of building regulations, and 15 hastily built *borgate* (suburbs) – ostensibly as a temporary solution (Pietralata, Gordigiani, Primavalle, etc.) – to house the people evicted from their homes as the regime gutted and restructured the area of the ancient city center (Largo Argentina, 1927; the precinct of the Imperial Forum, 1924 and 1930; the area surrounding the Mausoleum of Augustus, etc.). In 1924, as he outlined his project of demolitions, Mussolini declared that the "problems of necessity" had been tackled, and it was time to focus on the issue of "greatness." An indiscriminate campaign ensued to build a new transport system, connecting previously autonomous spaces for the sake of a staged visual effect. Parts of the urban palimpsest were destroyed to "uncover" the ruins, all the while burying them to create Via dell'Impero.

Under Mussolini, Rome represented a central element of Fascist ideology, something that also led to a symbolic kind of urban renovation and relative modernization. Some laws promoting liberal cultural values were put into effect: the law on historical, archeological, artistic, and landscape heritage (1939) and the law on city planning (1942). The positive initiatives launched by the Fascist regime in terms of architecture and urban planning were the Città Universitaria (1932–1935), the Foro Mussolini (now Foro Italico), Palazzo Littorio (now Palazzo della Farnesina), initiated in 1935 and completed between 1947 and 1950 in the shape of the ministry of foreign affairs, and the complex of EUR (Esposizione Universale di Roma). The architectural style used for post offices, the buildings housing the Gioventù italiana del Littorio, or schools, featured some elements not altogether disagreeable.

In 1938, preparing to receive Hitler in Rome, the Duce commissioned the Ostiense rail station, but since this could not be completed in time a temporary structure made of fake travertine was erected in its place.

After the Ethiopian war, between 1937 and 1941, an intense construction campaign was put into operation to the south of the historic center, to be completed in time for the Esposizione Universale (E42, now EUR). The group of monumental structures along the axis of an "Imperial road" designed by Piacentini (from Piazza Venezia in the direction of the sea) included a lake, the Palazzo della Civiltà italiana – known as the "square Colosseum" – Piazza Imperiale, Palazzo dei Ricevimenti e Congressi, and the large Piazza with exedras designed to rival Trajan's Markets or the

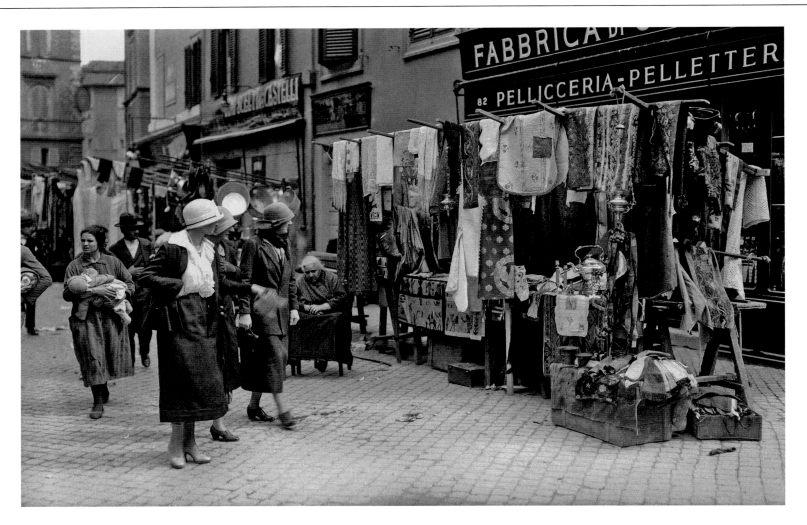

Procuratie in Venice, and some museums. During construction, between 1940 and 1942, the opulent periodical *Civiltà. Rivista trimestrale della Esposizione Universale di Roma* was published, illustrated with beautiful black-and-white and color photographs.

Mussolini used radio, *cinegiornali* (cinema newsreels), and photography as his media to consolidate his power. Unlike the radio programming of other totalitarian regimes, the Italian broadcasts were light and varied, including popular songs, or theater and variety shows, and allowed generous time for commercials. Listening to the radio became an Italian custom. Photojournalism established itself, providing striking illustrations of gatherings and military parades, or images of the ideal "Fascist type," as well as news sections.

In 1925 the Istituto LUCE ([acronym for "light"] L'Unione Cinematografica Educativa = The Educational Film Union of Cinema) was founded; it produced primarily documentaries, but two years later it added a journalist service staffed by its own photographers. Istituto LUCE's cinematic newsreels documented the demolitions of the historic center, and the construction of the new city districts and the new cities in the Agro Pontino area. Mussolini appeared in about 20 per cent of LUCE's images: "The photographer photographed him, the film-maker filmed him, straight-up, feathered-up, stiff as a Priapus" (Carlo Emilio Gadda, 1945).

The *Mostra del decennale della rivoluzione fascista* (Exhibition of the First Decade of the Fascist Revolution) of 1932 aimed at glorifying the regime's early achievements. Forty painters, sculptors, architects, journalists, historians – including Mario Sironi, Achille Funi, Marcello Nizzoli, Giuseppe Terragni, Enrico Prampolini, Adalberto Libera, Cesare Maccari –

contributed to the show, which relied to an unprecedented extent on photomontages and blow-ups.

In 1932 Alessandro Blasetti founded the Centro Sperimentale di Cinematografia (Experimental Center for Cinematography) in Rome. In 1937 Mussolini founded Cinecittà, in an effort to counteract the American films dominating the market in Roman cinemas, and to use it as an instrument of Fascist propaganda. With financial support from the state, almost 300 films were produced there in just six years (1937–1943). Between 1945 and 1965, Cinecittà was at the apex of its success, allowing Italian cinema to take its place on the international scene. In 1938 Vittorio Mussolini, the Duce's son, was the director of the periodical *Cinema.* Between the mid-1930s and the mid-1940s an important share of Italian film production was taken up by comedies known as the "*cinema dei telefoni bianchi*" (white telephone films), since the white telephone was a status symbol in comparison with the ordinary telephones in black Bakelite.

Besides photography and cinema, Fascism used other visual media: illustrated news magazines and periodicals, photobooks, and postcards. Periodicals containing fine photographs were established in this period: in 1937 *Omnibus,* a prototype of the weekly illustrated periodicals of the time after the war, with images by Cesare Barzacchi; in 1939 *Tempo,* with images created by the new photographer Federico Patellani.

In the 1930s the height of elegance was the fur stole made with two silver foxes; women wore overstated makeup: red-black lipstick, fake eyelashes, and plenty of face powder. In 1940 there was a ration book not only for food (bread, butter, sugar, oil, and meat), but also for clothing.

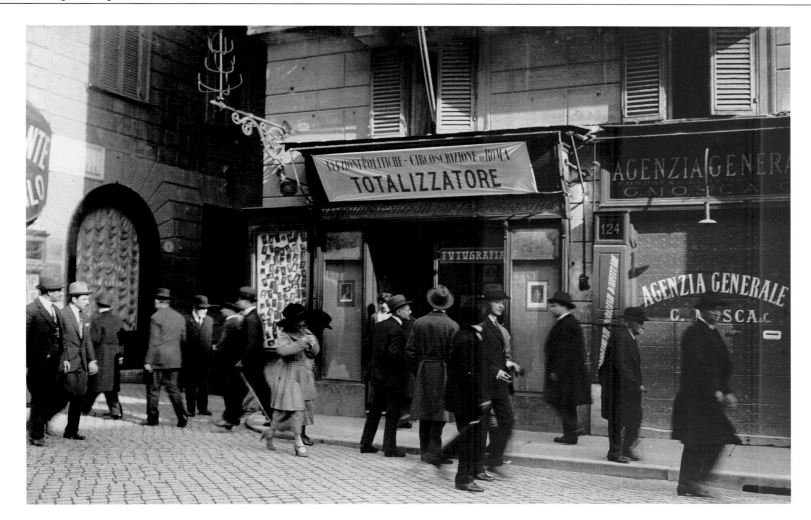

During the war and under Mussolini's dictatorship, fashion designers continued to produce dresses, even if in limited numbers, especially for famous actresses, whose photographs appeared on postcards.

Elio Luxardo, who arrived in Rome in 1932, took Hollywood-style photographs of actors and celebrities but gave his images an angle compatible with the current political climate. Arturo Ghergo was a portrait artist who worked in a cinematic style, which he used for his fashion shoots as well.

"Rome of the 1930s was populated by the usual papal aristocracy, the Savoia, the stars of Cinecittà, the powerful hierarchs: categories who appreciated the slick portrait style offered by these photographers": Gabriele D'Autilia, 2012.

On July 19, 1943, there was the first bombing of Rome in the district of San Lorenzo, which the pope visited in the aftermath; he declared Rome an "open city." On July 23, Fascism collapsed. In September, after the Italian king and General Badoglio asked the Allies to concede an armistice, and the subsequent dismantling of the Italian army, the Germans occupied Rome. It was the first of the European capitals to be liberated by the Allies, on June 4, 1944.

During the almost eight months of German occupation, the city had no electricity, coal, or other heating (benches and trees were destroyed and used as fuel), and a 7 pm curfew was imposed. The exceptional summer drought led to enforced turns in the use of drinking water, and the population went hungry. The only guaranteed food was rationed bread: 100 grams per person per day (but bakeries were besieged). The city parks, including the garden in Piazza Venezia, became war orchards. The Nazis rounded up able-bodied men, tortured and executed hostages, raided Jewish homes and deported their families to Germany. The resistance on the part of citizens of all social backgrounds was carried out in secret.

With their arrival, the Allies brought to Rome the V-disks (disks of victory), boogie-woogie (*In the Mood*), jazz, and radio broadcasts of the American Forces Network. The Forum and the Palatine Hill were the areas most rife with prostitutes and *sciuscià* (shoeshines), who made deals with American troops. Gambling was rampant, people danced everywhere, there was a flurry of activity in cinemas, clubs, and theaters; vaudeville and comedy shows were the most successful.

↑

Armando Bruni

People strolling a street in the city center in front of a totalizer used for counting the results of the political elections in which the Socialist Party and Sturzo's Popular Party succeeded, and Mussolini was not elected, 1919.

Passanten im Stadtzentrum vor einer Wett-annahmestelle zu den Parlamentswahlen, aus denen die Sozialisten und der Partito Popolare Don Sturzos als stärkste Kräfte hervorgingen, während Mussolini leer ausging, 1919.

Piétons dans une rue du centre, devant un bureau de paris, lors des élections à l'issue desquelles le parti socialiste et le parti populaire de Sturzo firent un bon score et Mussolini ne fut pas élu, 1919.

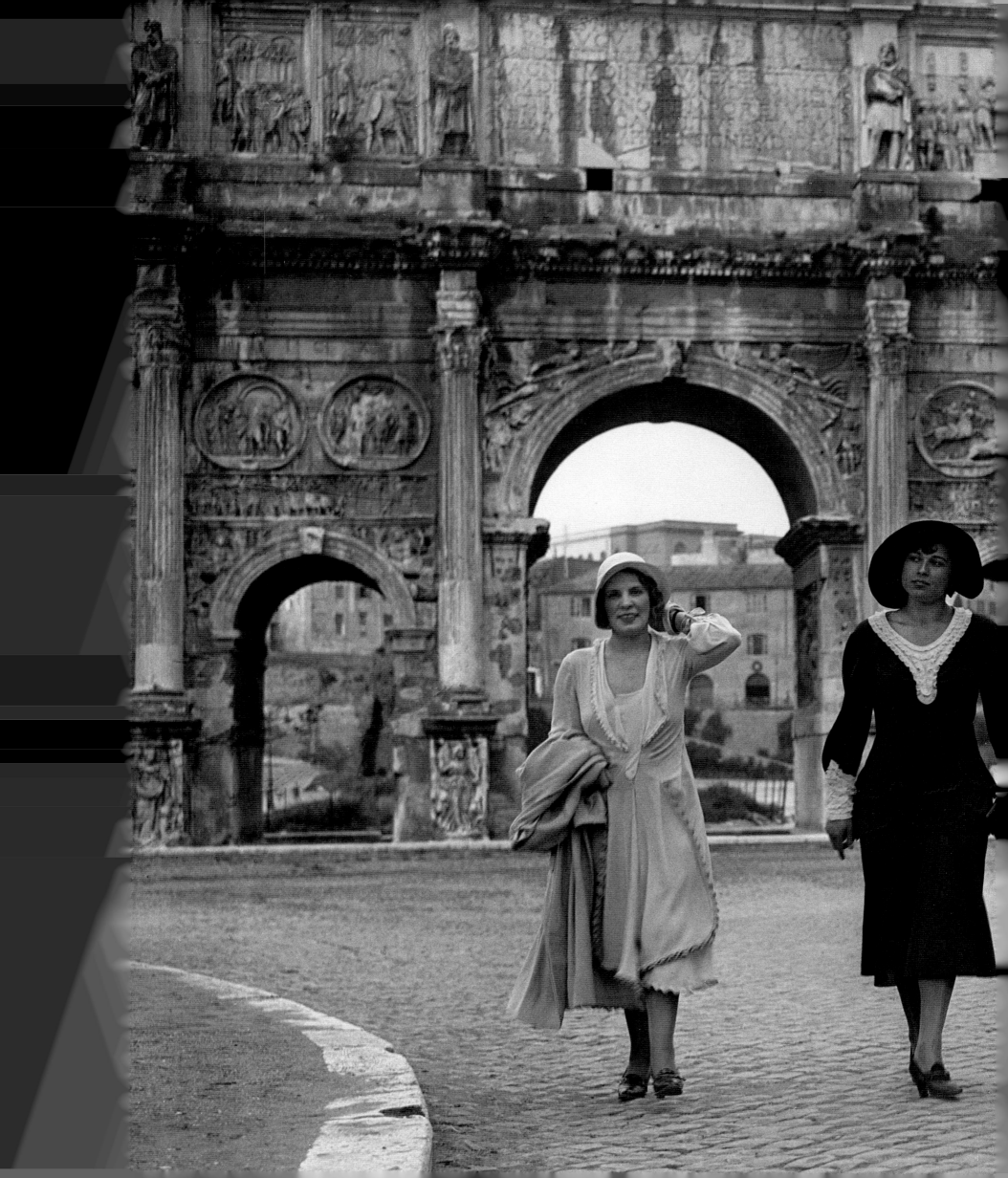

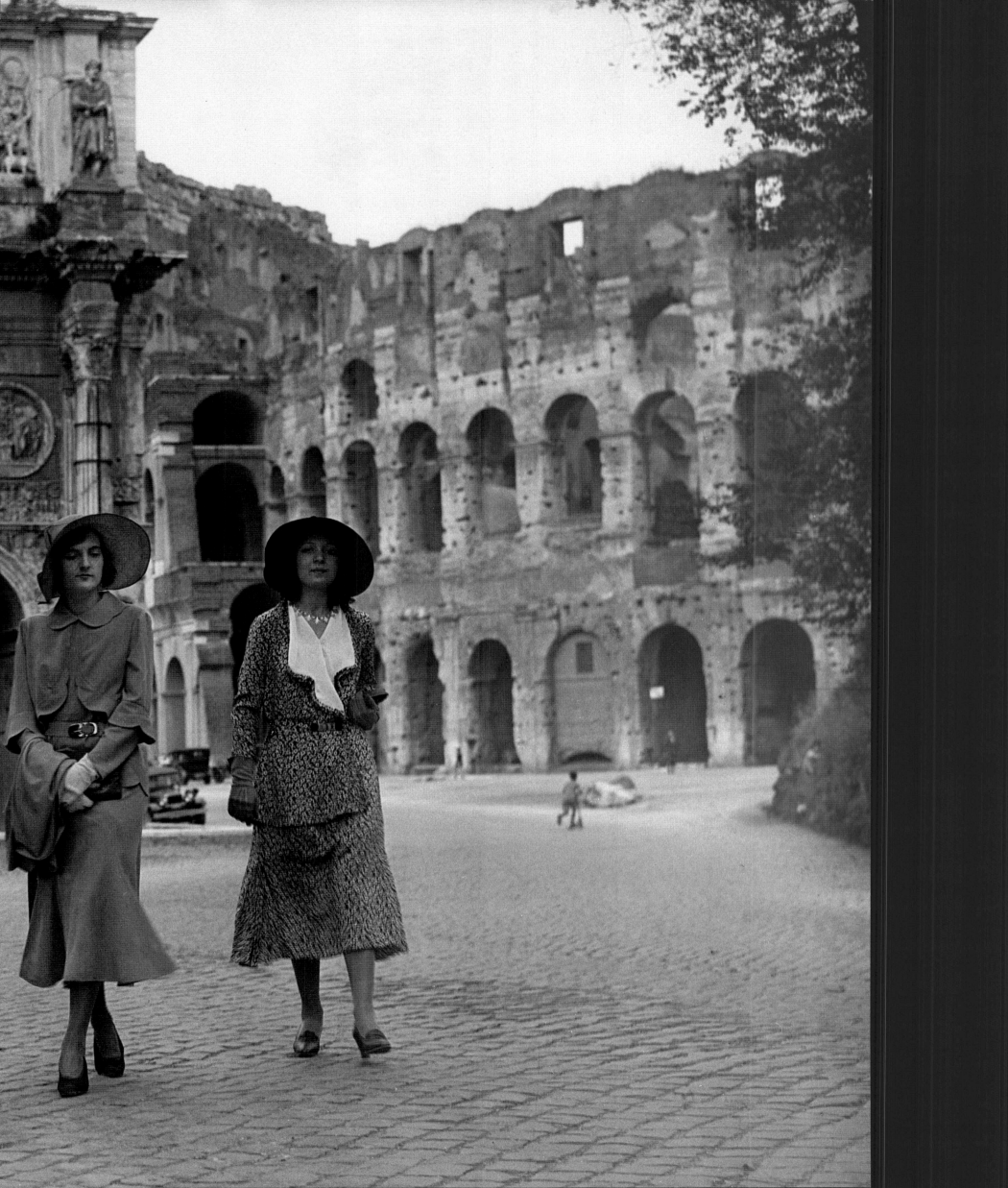

3

Licht und Schatten: die Jahre des Faschismus 1919–1944

pp. 140/141
Foto Farabola

Spring fashion being modeled against the background of the Arch of Constantine and the Colosseum, May 1931.

Präsentation einer Frühjahrsmodekollektion mit Konstantinsbogen und Kolosseum im Hintergrund, Mai 1931.

Présentation de modèles printaniers avec, en arrière-plan, l'arc de Constantin et le Colisée, mai 1931.

*„Die Seele eines Landes ändert sich nicht. Sie ist es, die uns aus den schwer
bewachten Palästen, der äußerlichen Ruhe, der Disziplin, den Fantasieuniformen
und der tragikomischen Maske des Duce anblickt."*
JEAN COCTEAU, *MON PREMIER VOYAGE (TOUR DU MONDE EN 80 JOURS),* 1937

Das Ende des Ersten Weltkriegs beschert Italien nicht, was es sich von dem teuer erkauften Sieg erhofft hatte. Viele Kriegsheimkehrer finden keine Arbeit, die Wirtschaft liegt danieder. Bedingungen, die den Aufstieg eines „starken Mannes" begünstigen: Benito Mussolini. 1922 marschiert der „Duce" an der Spitze seiner faschistischen Partei auf Rom und erhält prompt den Auftrag zur Regierungsbildung.

1929 erreicht das faschistische Regime eine Einigung mit dem Vatikan und setzt so der seit 1870 währenden Opposition von Kirche und Staat ein Ende. Der Pakt mit dem Papst stärkt Mussolini und steigert sein Ansehen in der katholischen Welt.

Unverändert gehört in den 1920er-Jahren der Sonntagskorso zu den regelmäßigen gesellschaftlichen Ereignissen der Tiberstadt, doch sind es nun die offenen Wagen der reichen Familien aus Hotel- und Gastgewerbe, die dort vorüberparadieren. Abgesehen von ein paar Luxusgeschäften hat der römische Handel im Vergleich zu anderen italienischen Metropolen nur Dutzendware zu bieten. Lediglich das Hotelgewerbe gedeiht. Neue Grandhotels werden gebaut. Zu Beginn der 1920er-Jahre logieren Sergei Dhiagilew und die Ballets Russes sowie Pablo Picasso (der Spanier hat sein Atelier in der Via Margutta) im Hotel de Russie. In *Zärtlich ist die Nacht* beschreibt F. Scott Fitzgerald 1934 die Gäste des Hotels Quirinale und des Excelsior (erbaut 1906), das ein eigenes Orchester unterhält. Monumental gibt sich auch das Ambasciatori, das erste moderne Hotel nach dem Ersten Weltkrieg, nach Entwürfen des römischen Architekten Marcello Piacentini, der hier schlichten Berliner Vorbildern folgt, um sich vom luxuriösen, kosmopolitischen Flair des Excelsior abzusetzen. Piacentini leitet auch den Umbau des Lichtspieltheaters Corso (zuvor Lux et Umbra, später Etoile, 1916–1919) und entwirft, in den Formen des Art déco, das Quirinetta (1920).

Unter dem Faschismus erreicht und überschreitet die Einwohnerzahl der Kapitale schließlich die Millionengrenze (Volkszählung 1931).

In einer Stadt wie Rom, die der wirtschaftlichen Entwicklung hinterherhinkt und zugleich den Aufgaben einer modernen Hauptstadt nicht gewachsen ist, wird das Bevölkerungswachstum – gespeist durch den Zuzug vom Land und aus dem Süden des Landes – unweigerlich zum Problem.

Die Folge ist eine Zersplitterung des Stadtbilds in ein unübersichtliches Mosaik von Einzelbezirken: die gutbürgerlichen Quartiere mit pompösen Stadthäusern und neobarocken mehrstöckigen Wohnblocks an der Piazza Bologna oder des Parioli-Viertels, Wohnblocks des Istituto Case Popolare wie Aniene, die „Gartenstadt"-Siedlungen Monte Sacro und Garbatella (1924), wo das Istituto Case Popolari Mietshäuser baut; dazu gut 15 offiziell geplante Stadtrandsiedlungen, die römischen *borgate:* Pietralata, Gordigiani, Primavalle usw. (ganz abgesehen von den vielen illegal, ohne Genehmigung in die Landschaft gesetzten Wohnblöcken). In diesen eilig aus dem Boden gestampften Trabantenstädten bringt das Regime die Bewohner der abgerissenen Altstadtviertel unter, die zuvor am Largo Argentina (1927), in der Gegend der Kaiserforen (1924 und 1930) oder um das Mausoleum des Augustus eine Bleibe hatten. 1924 verkündet Mussolini, nach der Lösung von Problemen praktischer Art, sei es für Rom nun Zeit, sich der „Aufgabe des Grandiosen" zuzuwenden. Rücksichtslos werden Verkehrsadern und Sichtachsen zwischen Bereichen geschlagen, die zuvor städtebaulich autonome Einheiten bildeten. Weite Teile der historischen Bebauung müssen dem Vorhaben weichen, die Relikte der Antike freizulegen, während im selben Moment die Via dell'Impero große Flächen der Kaiserforen wieder zudeckt.

Mussolinis Romvorstellung wird von der Idee antiker Größe beherrscht. Dass der Faschismus dennoch über eine stadtplanerische Grundidee verfügte, die ein gewisses Maß an Modernisierung mit einschloss, lässt sich indes nicht leugnen. Teils werden darin Vorstellungen aufgegriffen, die aus liberaler, präfaschistischer Zeit stammen, das Gesetz über das historische, archäologische, künstlerische und landschaftliche nationale Kulturgut von 1939 etwa oder das Stadtplanungsgesetz von 1942. Zu den positiv zu bewertenden größeren Projekten aus faschistischer Zeit zählen die Città universitaria (1932–1935), das Mussolini-Forum (heute Foro Italico) von 1935, der Palazzo del Littorio auf dem Gelände der Farnesianischen Gärten (begonnen ebenfalls 1935; 1947/50 als Sitz des Außenministeriums fertiggestellt) und der Neubaukomplex EUR (Esposizione Universale di Roma). vor den Toren der Stadt. Auch die Architektur des Sitzes der faschistischen Jugendorganisation, aber auch einiger römischer Postämter und Schulen aus dieser Zeit kann sich durchaus sehen lassen.

Eigens für den Empfang Hitlers 1938 lässt Mussolini den Bahnhof Roma Ostiense bauen; da die Arbeiten nicht termingerecht fertig werden, wird eine Schaufassade aus imitiertem Travertin errichtet.

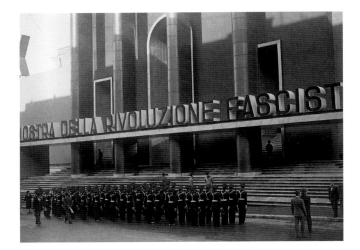

The Exhibition of the Decade of the Fascist Revolution, *which was publicized through the extensive use of mass media, lasted two years (1932 to 1934) and attracted over four million visitors. It was repeated twice (in 1937 and in 1942), 1932.*

Die Ausstellung „Zehn Jahre faschistische Revolution" wurde vom massiven Einsatz moderner Massenkommunikationsmittel begleitet. Zwei Jahre lang kamen insgesamt mehr als vier Millionen Besucher, um sie zu sehen. 1937 und 1942 wurden erneut entsprechende Jubiläumsausstellungen abgehalten, 1932.

L'Exposition de la décennie de la révolution fasciste, caractérisée par un large emploi des moyens de communication de masse, dura deux ans et accueillit plus de 4 millions de visiteurs; elle connut deux rééditions (en 1937 et en 1942), 1932.

Der Beschluss zum Bau des EUR-Viertels, das die Weltausstellung von 1942 beherbergen soll, fällt 1937, am Vorabend des Äthiopienkriegs; bis 1941 wird in dem neuen Areal im Süden von Rom fieberhaft gebaut. An der Achse der von Piacentini geplanten Via Imperiale (an der Piazza Venezia beginnend bis zum Meer reichend) wächst eine Reihe monumentaler Bauten in die Höhe: der Palazzo della Civiltà italiana, im Volksmund als „quadratisches Kolosseum" bezeichnet, die Piazza Imperiale, der Palazzo dei Congressi, ein großer, von halbrunden Fassaden flankierter Platz nach dem Vorbild der römischen Trajansmärkte und der Prokurazien von Venedig, mehrere Museen; dazu ein dreiteiliger künstlicher See. Noch während der Bauarbeiten erscheint im Dreimonatsrhythmus die luxuriös aufgemachte Zeitschrift *Civiltà* zur geplanten Weltausstellung, bebildert mit Hochglanzfotos in Farbe und Schwarz-Weiß.

Mussolini macht sich die modernen Massenkommunikationsmittel Fotografie, Radio und (in Form der Wochenschauen) das Kino zunutze, um seine Macht zu festigen. Das italienische Radio kann sich einen vielseitigeren Programmcharakter als das anderer totalitärer Systeme bewahren, bietet seinen Hörern Schlagermusik, Theaterstücke, Unterhaltungsprogramme und jede Menge Werbung – Radiohören wird zur festen Gewohnheit der Italiener.

Auch der Fotojournalismus spielt in faschistischer Zeit eine wichtige Rolle. Aufmärsche und Versammlungen, überhaupt der faschistische „Typ" werden spektakulär in Szene gesetzt, doch auch von anderen Ereignissen und vom Tagesgeschehen wird berichtet.

1925 nimmt das neugegründete Filminstitut LUCE (L'Unione Cinematografica Educativa) zunächst die Produktion von Dokumentarfilmen auf. Zwei Jahre später erhält es einen Zeitschriftenableger mit einem eigenen Stab von Fotografen. Die Wochenschauen aus dem Hause LUCE berichten begeistert von den Abbrucharbeiten im historischen Zentrum, aus den Neubauvierteln in und um Rom und den Neusiedlerstädten im Agro Pontino. Auf 20 Prozent der Fotos von LUCE ist Mussolini zu sehen: „So fotografierten ihn die Fotografen, so filmten ihn die Filmleute: das Kinn gereckt, den Federbusch auf dem Kopf, aufrecht wie ein Priap …", schrieb treffend 1945 Carlo Emilio Gadda.

Zur Zehnjahrfeier der „faschistischen Revolution" wird 1932 eine Ausstellung zur „Verherrlichung der Errungenschaften" des Regimes auf die Beine gestellt. Gut 40 Maler, Bildhauer,

Architekten, Journalisten und Historiker – darunter Mario Sironi, Achille Funi, Marcello Nizzoli, Giuseppe Terragni, Enrico Prampolini, Adalberto Libera, Cesare Maccari – zeichnen für das Ausstellungskonzept verantwortlich. Fotomontagen und Fotoplakate kommen in bisher ungeahntem Ausmaß zum Einsatz.

Im selben Jahr 1932 gründet Alessandro Blasetti in Rom das Centro Sperimentale di Cinematografia. Um der amerikanischen Dominanz im italienischen Kino eigene Produktionen entgegenzusetzen und um faschistische Propaganda zu betreiben, werden 1937 auf Anweisung Mussolinis die Studios von Cinecittà ins Leben gerufen. In nur sechs Jahren, bis 1943 also, werden dort mit staatlicher Unterstützung fast 300 Filme gedreht. Ihre größte Zeit erlebt die Filmstadt vor den Toren Roms in den zwei Jahrzehnten zwischen 1945 und 1965, als von dort aus der italienische Film die Lichtspielhäuser der ganzen Welt erobert.

1938 wird Vittorio Mussolini, der Sohn des Duce, Herausgeber der Zeitschrift *Cinema.*

Ein Großteil der italienischen Filmproduktion besteht bis Kriegsende aus Komödien nach Art des „Kinos der weißen Telefone" (im Gegensatz zu den herkömmlichen schwarzen Bakelitapparaten ein gesuchtes Statussymbol).

Neben Kino und Fotografie als visuelle Massenmedien nutzt das faschistische Regime illustrierte Magazine, Fotobildbände und Fotopostkarten für seine Propaganda. In dieser Zeit entstehen die ersten wöchentlich erscheinenden Fotoillustrierten: 1937 die Zeitschrift *Omnibus,* die zum Prototyp für die Illustrierten der Nachkriegszeit wird und für die Cesare Barzacchi fotografiert; 1939 *Tempo,* die die ersten Aufnahmen von Federico Patellani abdruckt.

Highlight der Damenmode der 1930er-Jahre ist die doppelte Fuchspelzstola, dazu üppige Schminke, dunkelroter, fast schwarzer Lippenstift, falsche Wimpern und reichlich Puder.

Seit dem Kriegseintritt Italiens 1940 werden Lebensmittel (Brot, Butter, Zucker, Öl, Fleisch) und Kleidung rationiert. Auch während des Kriegs und unter den Bedingungen der Mangelwirtschaft arbeiten die Modestudios weiter, jedoch mit Einschränkungen und meist nur für Schauspielerinnen.

Fotos beliebter Schauspieler werden als Postkarten verkauft. Der seit 1932 in Rom arbeitende Fotograf Elio Luxardo porträtiert Filmgrößen und andere Berühmtheiten im Hollywoodstil, wenngleich mit „nationalem" Einschlag; ähnlich die Porträtfotos Arturo Ghergos, der diesen Stil auch in der Modefotografie einsetzt. „Das Rom der 1930er-Jahre wird noch immer

→

Paul Wolff

Gymnastics performance at the Stadio Mussolini, also known as the "Stadium of the Marbles" because of the colossal statues of athletes placed along its perimeter. It was part of the vast sports complex (today known as Foro Italico) built by the Fascist regime at the foot of Monte Mario, 1934.

Gymnastische Darbietung im Mussolini-Stadion, wegen der ringsherum aufgestellten monumentalen Marmorstatuen auch „Stadio dei Marmi" genannt; Teil der weitläufigen Sportanlagen, die das faschistische Regime am Fuß des Monte Mario errichten ließ (heute „Foro Italico"), 1934.

Démonstration de gymnastique au stade Mussolini, également appelé « stade des Marbres » en raison de la présence sur son pourtour de colossales statues d'athlètes: ce stade, qui faisait partie d'un vaste complexe sportif (actuel Foro Italico), fut construit par le régime fasciste au pied du monte Mario, 1934.

von der päpstlichen Aristokratie, der Königsfamilie, den Diven von Cinecittà und den faschistischen Großfunktionären dominiert – Leute, die auf altmodische Porträtkunst dieser Art großen Wert legen" (Gabriele D'Autilia, 2012).

Am 19. Juli 1943 fallen die ersten Bomben auf Rom, der Papst besucht das betroffene Viertel San Lorenzo, Rom wird zur „offenen Stadt" erklärt. Am 23. Juli stürzt das faschistische Regime. Nach dem vom König und der Regierung Badoglio mit den Amerikanern vereinbarten Waffenstillstand und der Auflösung des italienischen Heeres marschieren deutsche Truppen in Rom ein. Als erste europäische Hauptstadt wird Rom am 4. Juni 1944 von den Alliierten befreit.

In den gut acht Monaten unter deutscher Besatzung fehlt es der Stadt an praktisch allem: Strom, Kohle und Heizmaterial (sodass Parkbänke und Bäume zu Brennholz geschlagen werden); abends um sieben beginnt die Verdunklung. Während der ungewöhnlich trockenen Sommermonate des Jahres 1944 wird sogar das Trinkwasser rationiert. Die Bevölkerung hungert, garantiert

ist allein die tägliche Brotration: 100 Gramm pro Kopf; es kommt zu Überfällen auf Bäckereien. In den öffentlichen Parks, selbst in den Grünanlagen der Piazza Venezia mitten in der Stadt, wird Gemüse angebaut. Die Deutschen veranstalten Razzien, foltern, lassen Geiseln erschießen und Juden in die Konzentrationslager deportieren. Im Widerstand gegen die Besatzer finden Menschen aller Schichten zusammen und agieren gemeinsam aus dem Untergrund.

Die amerikanischen Befreier bringen die sogenannten V-Discs, (Victory-Discs) mit, Schallplatten mit Jazz und Boogie-Woogie (*In the Mood*); das American Forces Network nimmt den Sendebetrieb auf.

Forum und Palatin werden für römische Prostituierte und Schwarzhändler zu beliebten Treffpunkten, um mit den GIs ins Geschäft zu kommen. Das illegale Glücksspiel floriert, überall wird getanzt, etliche Kinos und Vergnügungslokale öffnen ihre Pforten, Varietéprogramme und Nummernrevuen vor Filmbeginn erfreuen sich großer Beliebtheit.

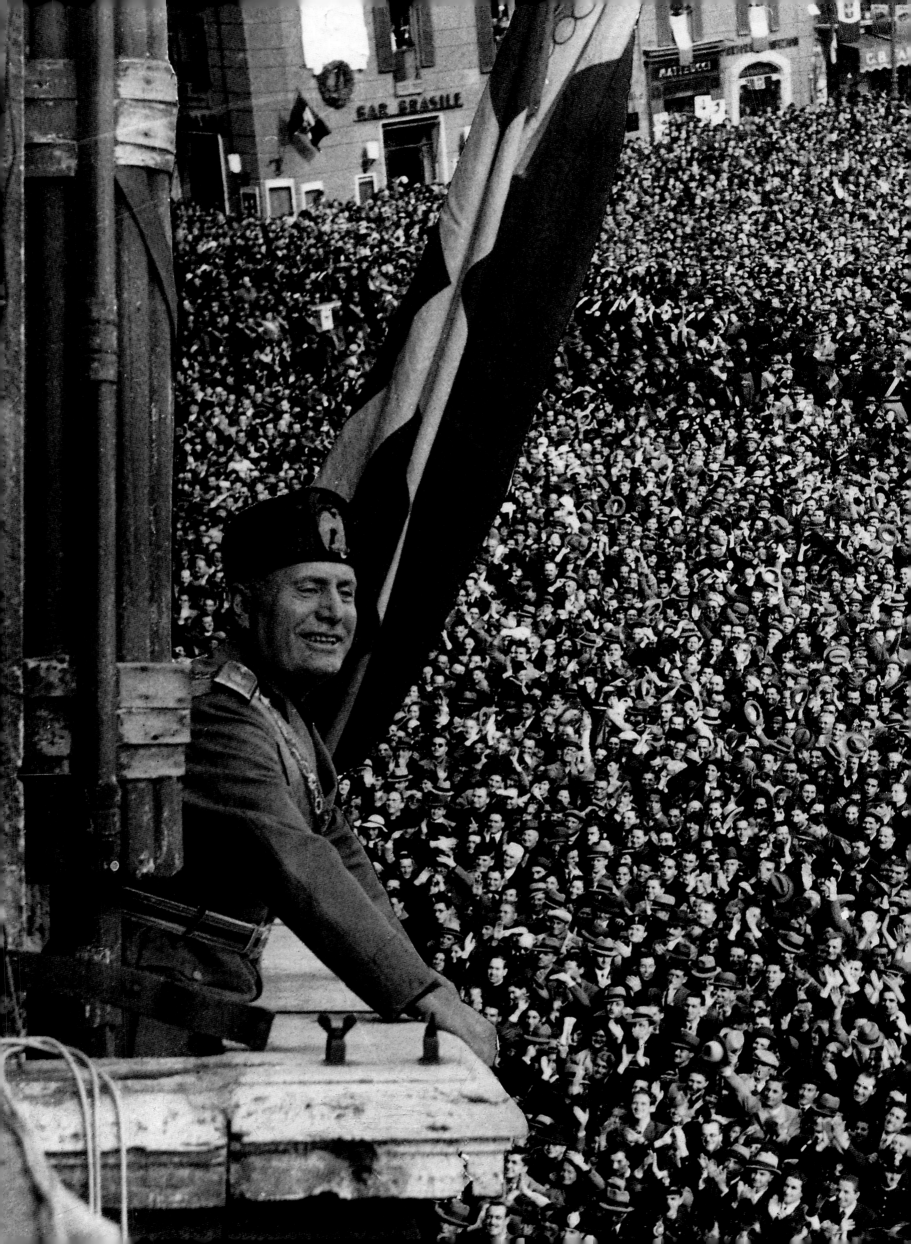

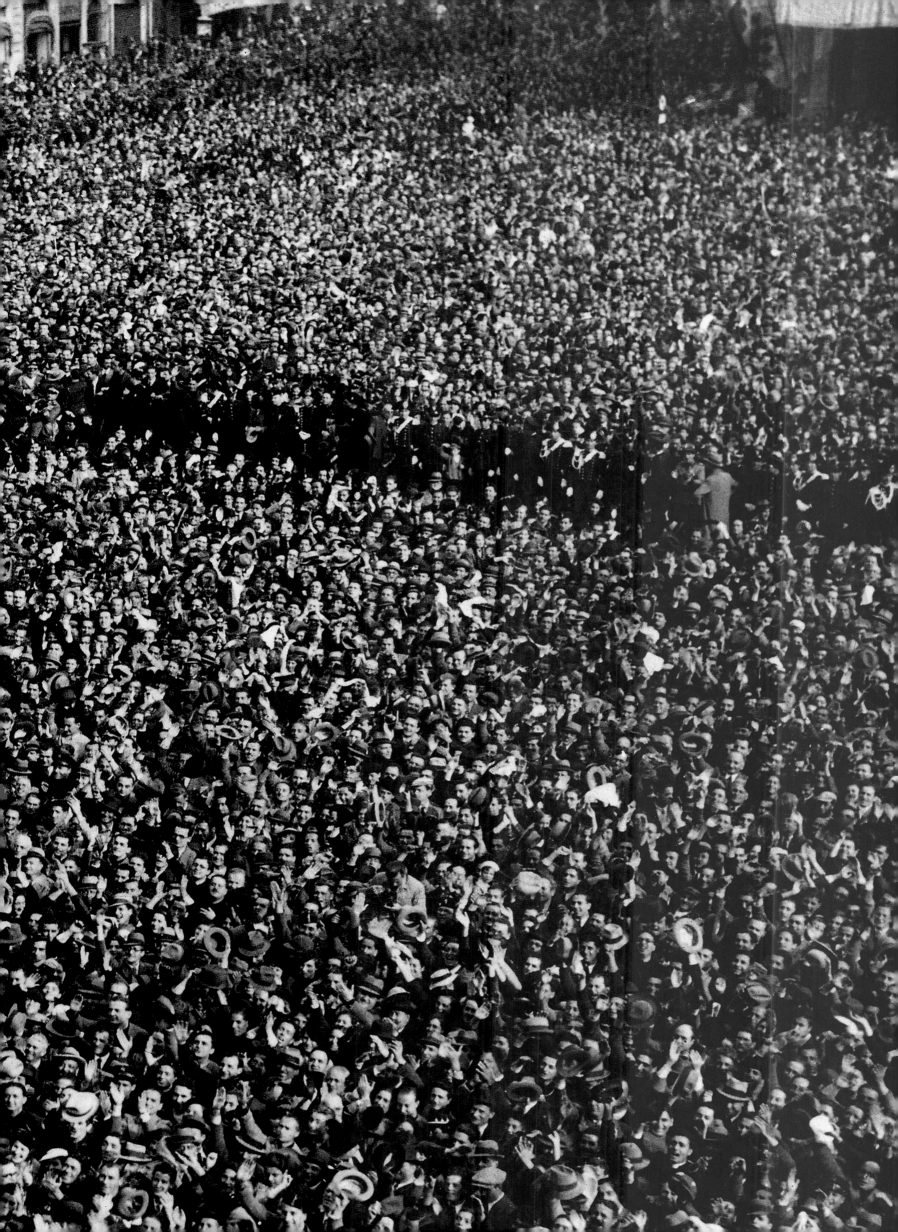

3

Ombres et lumières des années fascistes 1919–1944

pp. 146/147
Anonymous

Mussolini addresses the crowd from the balcony of Palazzo Venezia during the proclamation of the Italian Empire, on May 9, 1936. However, this is a propaganda image obtained through the skillful montage of a photograph of the Duce standing at the balcony in the foreground and of several photographs of cheering crowds in the background.

Mussolini hält vom Balkon des Palazzo Venezia anlässlich der Ausrufung des italienischen Kolonialreichs am 9. Mai 1936 eine Rede an die jubelnde Menge. Allerdings handelt es sich hier um eine Fotomontage zum Zwecke der Propaganda: Das Bild der Menschenmasse, zu der Mussolini vom Balkon im Bildvordergrund aus zu sprechen scheint, wurde aus mehreren Aufnahmen zusammengesetzt.

Mussolini harangue la foule depuis le balcon du palazzo Venezia lors de la proclamation de l'Empire italien le 9 mai 1936. Toutefois, l'image résulte d'un habile montage qui assemble à des fins de propagande une photographie du Duce au balcon pour le premier plan et plusieurs clichés de foule l'acclamant pour l'arrière-plan.

« L'âme d'un pays ne change pas. C'est elle qui nous observe derrière les palais blindés, derrière ce calme, derrière cette discipline, derrière ces uniformes romanesques, derrière le masque tragique et comique du Duce. »
JEAN COCTEAU, *MON PREMIER VOYAGE (TOUR DU MONDE EN 80 JOURS)*, 1937

À la fin de la Première Guerre mondiale, l'Italie ne récolte pas les fruits d'une victoire chèrement payée. De nombreux soldats démobilisés ne trouvent pas de travail. L'économie est sinistrée. Le climat social et politique favorise l'arrivée au pouvoir d'un homme fort, un futur dictateur, le Duce. En 1922, à la tête du parti fasciste, Mussolini lance la « marche sur Rome » avant d'être chargé de former un nouveau gouvernement.

En 1929, le régime fasciste et le Vatican signent un traité mettant fin au conflit qui opposait l'État italien et l'Église depuis 1870. Celui-ci permet à Mussolini de consolider sa position et son image au sein du monde catholique.

Dans les années 1920, le dimanche, la via del Corso demeure le théâtre des événements mondains, mais désormais les fiacres formant de longues files sont ceux de familles nombreuses, de ceux qui exercent les métiers les plus rémunérateurs : les aubergistes et les logeurs. Exception faite de quelques magasins de luxe, le marché local absorbe des produits parmi les plus médiocres d'Italie.

Le tourisme connaît quelques succès. De nouveaux grands hôtels ouvrent leurs portes. Au début des années 1920, Pablo Picasso, qui occupe un atelier via Margutta, et les ballets russes de Serge de Diaghilev séjournent à l'Hôtel de Russie. Dans *Tendre est la nuit*, F. Scott Fitzgerald évoque la clientèle de l'hôtel Quirinale et de l'Excelsior (construit en 1906) qui dispose d'un orchestre privé. Grandiose, monumental, tel est l'Ambasciatori, le premier hôtel moderne de l'après-guerre conçu par Marcello Piacentini pour rivaliser avec les établissements berlinois et se démarquer de l'Excelsior jugé trop épicurien et international. Il revient également à Piacentini de rénover le cinéma-théâtre (anciennement Lux et Umbra, puis Etoile, 1916–1919) et de dessiner La Quirinetta (1920) dans le style Art déco.

Durant la période fasciste, Rome atteint puis dépasse le million d'habitants (recensement de 1931). Dans une ville qui refuse d'évoluer sur le plan économique et d'assumer pleinement son rôle de capitale moderne, l'augmentation de la population – dont la première cause est l'immigration des campagnes et de l'Italie méridionale – n'est pas un phénomène positif.

L'expansion urbaine de Rome devient une mosaïque informe qui se caractérise par de nouveaux quartiers bourgeois (piazza Bologna, Parioli, etc.) aux *palazzine* [villas de style monumental] et aux petits immeubles de style *barocchetto* [d'inspiration baroque] ; les habitations populaires de l'Istituto Case Popolari comme la cité-jardin Aniene à Monte Sacro et la Garbatella (1924) ; des « hameaux illégaux » et une quinzaine de *borgate* [faubourgs] officiels édifiés en toute hâte, destinées à être provisoires (Pietralata, Gordigiani, Primavalle, etc.), où le régime relègue les habitants expulsés à la suite des démolitions et du réaménagement du centre antique (Largo Argentina, 1927 ; secteur des Forums impériaux, 1924 et 1930 ; secteur du mausolée d'Auguste, etc.). En 1924, évoquant le programme des démolitions, Mussolini déclare que « les problèmes de nécessité » ayant été résolus, le temps est venu de s'occuper de ceux « de la grandeur ». Sans discrimination, on perce de nouvelles artères qui relient avec un grand souci scénographique des espaces autonomes jusqu'alors. On détruit des pans entiers du palimpseste urbain pour « découvrir » les vestiges tandis que, par ailleurs, on les recouvre pour tracer la via dell'Impero…

Rome est une composante centrale de l'idéologie fasciste et mussolinienne qui donne lieu, reconnaissons-le, à un projet urbain et symbolique et à une relative modernisation. Des lois dans la droite ligne des valeurs libérales sont adoptées par le régime : la loi sur le patrimoine historique, archéologique, artistique et du paysage (1939) et la loi d'urbanisme (1942). Les réalisations majeures et positives de la politique urbanistique et architectural du fascisme sont la Cité universitaire (1932–1935), le Foro Mussolini (actuel Foro Italico) en 1935, le palazzo del Littorio (futur palazzo della Farnesina), commencé la même année et achevé entre 1947 et 1950 pour abriter le ministère des Affaires étrangères, et le complexe de l'EUR (Esposizione Universale di Roma). Il en va de même pour les bâtiments postaux, le siège de la Gioventù italiana del Littorio et certains établissements scolaires, dont l'architecture possède des qualités non négligeables.

En 1938, pour accueillir Hitler, le Duce ordonne la construction de la gare de Rome Ostiense, mais devant l'impossibilité de l'achever à temps, une façade provisoire de travertin en trompe-l'œil est élevée à la hâte.

Entre 1937 et 1941, on travaille d'arrache-pied pour aménager le nouveau quartier situé au sud du centre historique, dont la création a été décidée par le régime fasciste au lendemain de la guerre d'Éthiopie en vue de l'Exposition universelle (E42, aujourd'hui EUR). Les équipements et les édifices monumentaux bordant la « voie impériale » tracée par Piacentini (depuis la piazza Venezia vers le littoral) incluent un lac à trois bassins,

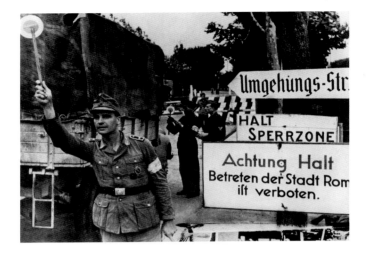

←
Anonymous

*German soldiers guarding the entrance to
the city, 1944.*

*Soldaten der Wehrmacht riegeln die Stadt
ab, 1944.*

*Soldats de la Wehrmacht contrôlant l'accès à
la ville, 1944.*

le palazzo della Civiltà italiana – familièrement dit le «Colisée
carré» –, la place Impériale, le palais des réceptions et des congrès,
la grande place avec exèdres rivalisant avec le modèle des marchés
de Trajan ou les Procuratie de Venise, et plusieurs musées. Au
cours des travaux est publiée une luxueuse revue intitulée *Civiltà.
Rivista trimestrale della Esposizione Universale di Roma* (1940–1942),
illustrée de magnifiques photographies en noir et blanc et
en couleurs.

Mussolini utilise la radio, le cinéma (actualités filmées)
et la photographie comme moyens de communication de masse
pour consolider son pouvoir. À la différence d'autres régimes
totalitaires, la programmation de la radio italienne est plus variée
et légère : elle comprend des chansons à succès, des émissions de
variétés, du théâtre, et fait une large place à la publicité. Écouter la
radio devient une habitude en Italie.

Le photojournalisme s'affirme et, à grand renfort d'effets
spectaculaires, donne à voir les grands rassemblements, les
défilés ou encore le «type» fasciste ainsi que des faits divers et
d'autres événements.

L'institut LUCE (L'Unione Cinematografica Educativa),
qui voit le jour en 1925, produit des films documentaires. Deux
ans après sa naissance, il crée un service de presse qui fait appel
à ses photographes. Les actualités de l'institut LUCE témoignent
avec emphase des démolitions du centre historique, de l'édifi-
cation des quartiers neufs, de la construction de villes nouvelles
dans les Marais pontins asséchés. Mussolini apparaît sur environ
20 % des photographies LUCE. «Le photographe le photographia
et le cinéaste le filma, droit, emplumé, empriapé» (Carlo Emilio
Gadda, 1945).

L'«Exposition de la décennie de la révolution fasciste»
(Mostra del Decennale della Rivoluzione Fascista) inaugurée
en 1932 a pour objet de «glorifier» les principales conquêtes
du régime. Une quarantaine de peintres, sculpteurs, architectes,
journalistes et historiens dont Mario Sironi, Achille Funi, Marcello
Nizzoli, Giuseppe Terragni, Enrico Prampolini, Adalberto Libera,
Cesare Maccari, collaborent à son organisation et à sa scénographie
et font un usage spectaculaire et sans précédent de photomontages
et de photographies géantes.

En 1932 Alessandro Blasetti fonde à Rome le Centre
expérimental de cinématographie. Cinecittà est créée en 1937
à la demande de Mussolini pour faire contrepoids au cinéma
américain, omniprésent dans les salles romaines, et comme

instrument de propagande fasciste. Bénéficiant de financements
publics, près de 300 films sont produits en l'espace d'à peine six
ans (1937–1943) à Cinecittà qui connaîtra un véritable triomphe
entre 1945 et 1965 quand elle permettra au nouveau cinéma
italien de s'imposer à l'échelle internationale. En 1938, Vittorio
Mussolini, l'un des fils du Duce, dirige la revue *Cinema*.

Entre le milieu des années 1930 et le milieu des années
1940, une part importante de la production cinématographique
italienne est constituée de comédies connues sous l'appellation
de cinéma des «téléphones blancs», cet appareil étant un signe
extérieur de richesse contrairement aux téléphones ordinaires en
bakélite noire.

Parmi les instruments visuels de communication, le
fascisme utilise, outre la photographie et le cinéma, les magazines
richement illustrés, les périodiques, les livres de photographies,
les cartes postales photographiques. Les hebdomadaires illustrés de
belles photographies font leur apparition : en 1937 naît *Omnibus*,
prototype des illustrés populaires d'après-guerre, auquel collabore
Cesare Barzacchi et, en 1939, *Tempo* dans lequel Federico Patellani
fait ses débuts.

Dans les années 1930, en matière de mode féminine,
le comble de l'élégance est de porter une étole de fourrure
composée de deux renards argentés. Les femmes se maquillent
à outrance : fard rouge foncé, presque noir, faux cils, et poudre de
riz en abondance.

En 1940 une carte de rationnement est instaurée non
seulement pour l'alimentation (pain, beurre, sucre, huile, viande)
mais également pour les vêtements.

Durant la guerre, malgré la politique autarcique en
vigueur, les ateliers de couture poursuivent leur activité, certes au
ralenti et surtout pour une clientèle d'actrices dont les photo-
graphies, ainsi que celles des acteurs, sont reproduites sous forme
de cartes postales.

Arrivé à Rome en 1932, Elio Luxardo photographie
acteurs et célébrités dans un style «hollywoodien» aux normes
de l'idéologie politique. Arturo Ghergo, autre portraitiste, possède
un style cinématographique qu'il applique à la photographie de
mode. «La Rome des années 1930 est habitée par la traditionnelle
aristocratie pontificale, par la maison de Savoie, par les divas de
Cinecittà et par de puissants hiérarques : des catégories sensibles
au portrait sur papier glacé que proposent ces photographes»
(Gabriele D'Autilia, 2012).

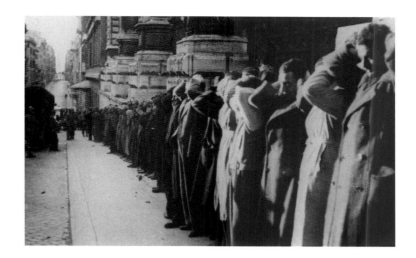

Le 19 juillet 1943, Rome subit son premier bombardement qui touche le quartier San Lorenzo où se rend le pontife ; la ville où il demeure est déclarée « ville ouverte ». Le 23 juillet marque la chute du fascisme. En septembre, après l'armistice que le roi et Badoglio demandent aux Alliés et la débandade de l'armée italienne, Rome est occupée par les Allemands. Le 4 juin 1944, elle est la première capitale d'Europe à être libérée par les Alliés.

Durant les huit mois de l'occupation allemande, Rome manque d'électricité, de charbon et de chauffage (les bancs publics et les arbres sont transformés en combustible) et le couvre-feu entre en vigueur dès 19 heures. Durant l'été, une sécheresse exceptionnelle rend nécessaire le rationnement de l'eau potable. La population souffre de la faim. La seule distribution assurée est celle du pain, rationné lui aussi : 100 grammes par personne (les fours sont pris d'assaut). Les jardins publics sont transformés en potagers de guerre, y compris celui de la piazza Venezia. Les nazis procèdent à des rafles d'hommes valides, torturent et fusillent les otages, arrêtent les juifs qui sont déportés en Allemagne. Des résistants issus de toutes les classes sociales agissent dans la clandestinité.

Avec les Alliés arrivent les V discs (disques de la victoire), le boogie-woogie (« In the Mood »), le jazz et les émissions de l'American Forces Network.

Les Forums et le Palatin sont les lieux les plus fréquentés par les prostituées et les *sciusià* (cireurs de chaussures) qui font affaire avec les militaires américains. Le jeu fait rage. On danse partout. Les cinémas et les salles de spectacles sont nombreux. Numéros de variétés et spectacles légers remportent un vif succès.

↑
Anonymous

Via Quattro Fontane: a line of civilians seized shortly after the Partisans attack in Via Rasella that killed 33 German troops. In retaliation, 335 people including political prisoners, Jews, and civilians (more than 10 for each soldier killed in the attack) were executed at the Fosse Ardeatine, March 1944.

Bei einer deutschen Razzia festgesetzte Zivilisten in der Via Quattro Fontane. Als Vergeltungsmaßnahme für einen Partisanen-anschlag gegen die SS in der Via Rasella wurden 335 Italiener, darunter politische Gefangene, Juden und einfache Bürger in den Fosse Ardeatine bei Rom erschossen, zehn für jeden getöteten SS-Mann, März 1944.

Civils arrêtés au cours d'une rafle dans la via Quattro Fontane juste après l'attentat commis via Rasella par les partisans contre une compagnie de 32 SS. En représailles, 335 personnes, prisonniers politiques, juifs et civils – plus de 10 pour tout soldat mort dans l'attentat – furent exécutées dans les Fosse Ardeatine, mars 1944.

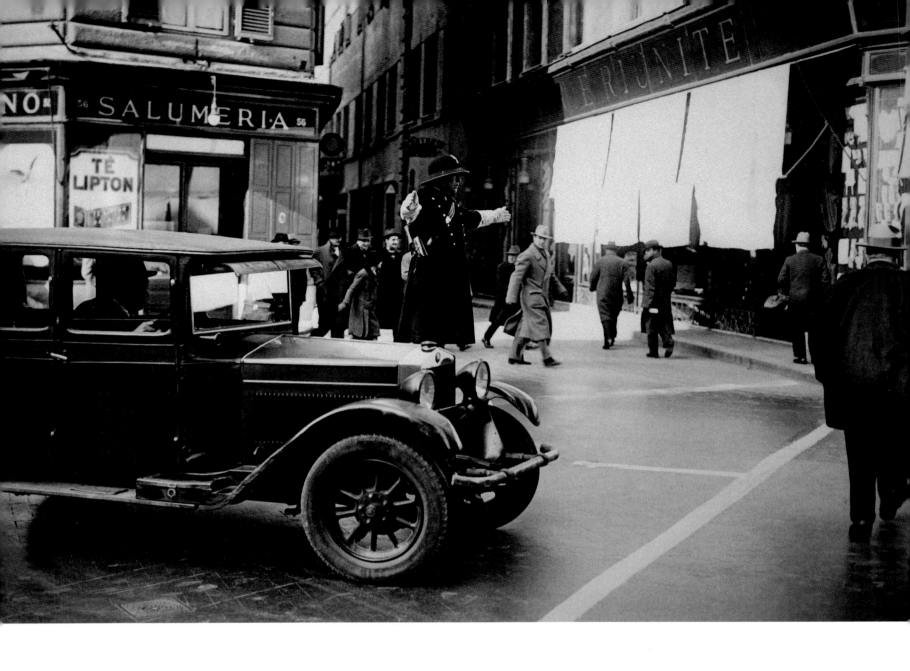

ALBERTO MORAVIA
GLI INDIFFERENTI

"Farewell, streets, deserted neighborhood lashed by the rain as though by an army, villas asleep in their humid gardens, long tree-lined avenues, and parks in turmoil; farewell, high and rich neighborhood: motionless in her place next to Leo, Carla watched in wonder as the violent rain wept on the windshield, as in the intermittent streams all the city lights poured dissolved on the glass."

„Lebt wohl, Straßen, verlassenes Viertel, durch das der Regen rauscht wie eine Armee, Villen, die in ihren feuchten Gärten schlummern, lange, baumgesäumte Alleen und Parks in Aufruhr, leb wohl, hohes reiches Viertel – reglos auf ihrem Platz neben Leo sitzend sah Carla mit Erstaunen den starken Regen auf die Windschutzscheibe tränen und in diesen immer wieder unterbrochenen Strömen die verschwimmenden Lichter der Stadt über das Glas fließen."

« Adieu, rues, quartier désert, parcouru par la pluie comme par une armée, villas assoupies dans leurs jardins humides, longues avenues bordées d'arbres, parcs en tumulte ; immobile à côté de Léo, Carla regardait avec stupeur la pluie violente heurter le pare-brise, et, parmi les flots intermittents, se dissoudre sur la vitre toutes les lumières de la ville. »

ALBERTO MORAVIA, *GLI INDIFFERENTI,* 1929

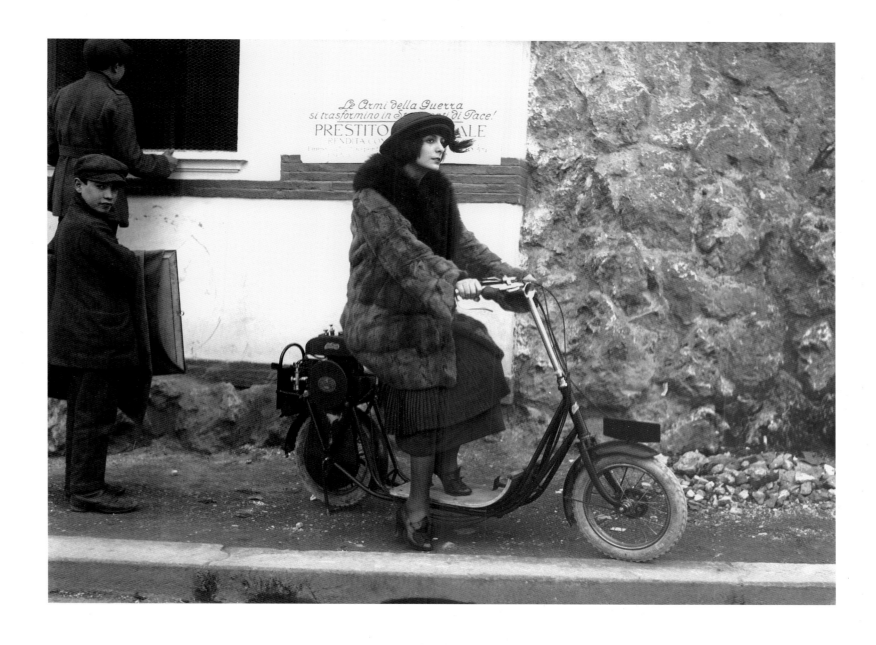

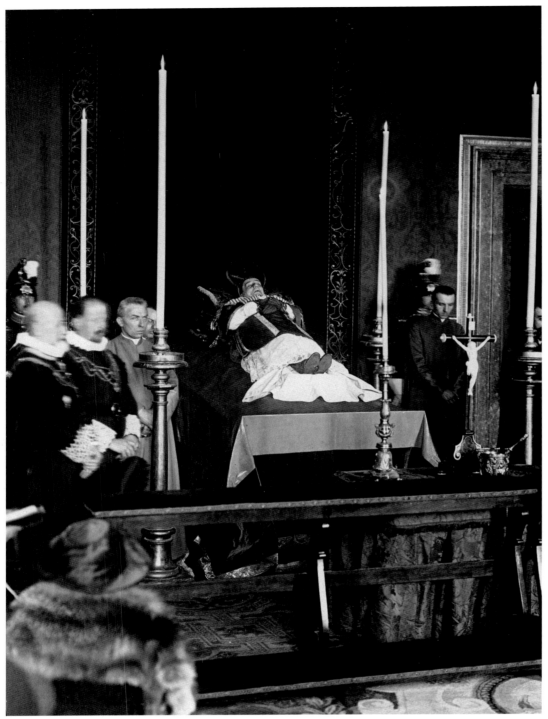

←
Anonymous

The body of Pope Benedict XV – who was firmly opposed to World War I – lies on display on a catafalque in the Throne Room of the Apostolic Palace, attended by members of the clergy, whose presence is strictly regulated, and by Roman princes wearing the typical 16th-century collar, January 1922.

Benedikt XV., der während des Ersten Weltkriegs vehement auf Frieden gedrungen hatte, auf der Totenbahre im Thronsaal des Apostolischen Palastes. Die Totenwache halten neben den vom Protokoll vorgeschriebenen Klerikern auch Angehörige des römischen Adels, erkennbar an der barocken Halskrause, Januar 1922.

La dépouille mortelle de Benoît XV, pape fermement hostile à la Première Guerre mondiale, est exposée sur un catafalque dans la salle du Trône du palais apostolique; elle est veillée par différents ecclésiastiques, dont la présence relève d'un protocole strict, et par plusieurs princes romains reconnaissables à leur fraise, janvier 1922.

→
Giuseppe Felici

The announcement to the crowd of the election of Pope Pius XI, from the balcony of St. Peter's Basilica, 1922.

Von der Benediktionsloggia des Petersdoms aus wird die Wahl Pius' XI. zum Papst ausgerufen, 1922.

L'élection du pape Pie XI est annoncée à la foule depuis la loggia de la basilique Saint-Pierre, 1922.

pp. 156/157
Anonymous

Scene from the film One Night in Rome, *by Clarence Badger, produced by Metro-Goldwyn-Mayer, 1924. Madame L'Enigme (Laurette Taylor) is recognized by her client as the woman who disappeared after the scandal that ensued after her husband's suicide.*

Szene aus dem Metro-Goldwyn-Mayer-Film One Night in Rome *unter der Regie von Clarence G. Badger von 1924. Einer ihrer Klienten erkennt in der Wahrsagerin*

Madame L'Enigme (Laurette Taylor) die Frau wieder, die nach dem Skandal um den Selbstmord ihres Mannes verschwunden ist.

Scène du film One Night in Rome *de Clarence Badger produit par la Metro-Goldwyn-Mayer en 1924. Un de ses clients reconnaît dans la chiromancienne Madame l'Énigme (Laurette Taylor) la femme qui a disparu à la suite des scandales liés au suicide de son mari.*

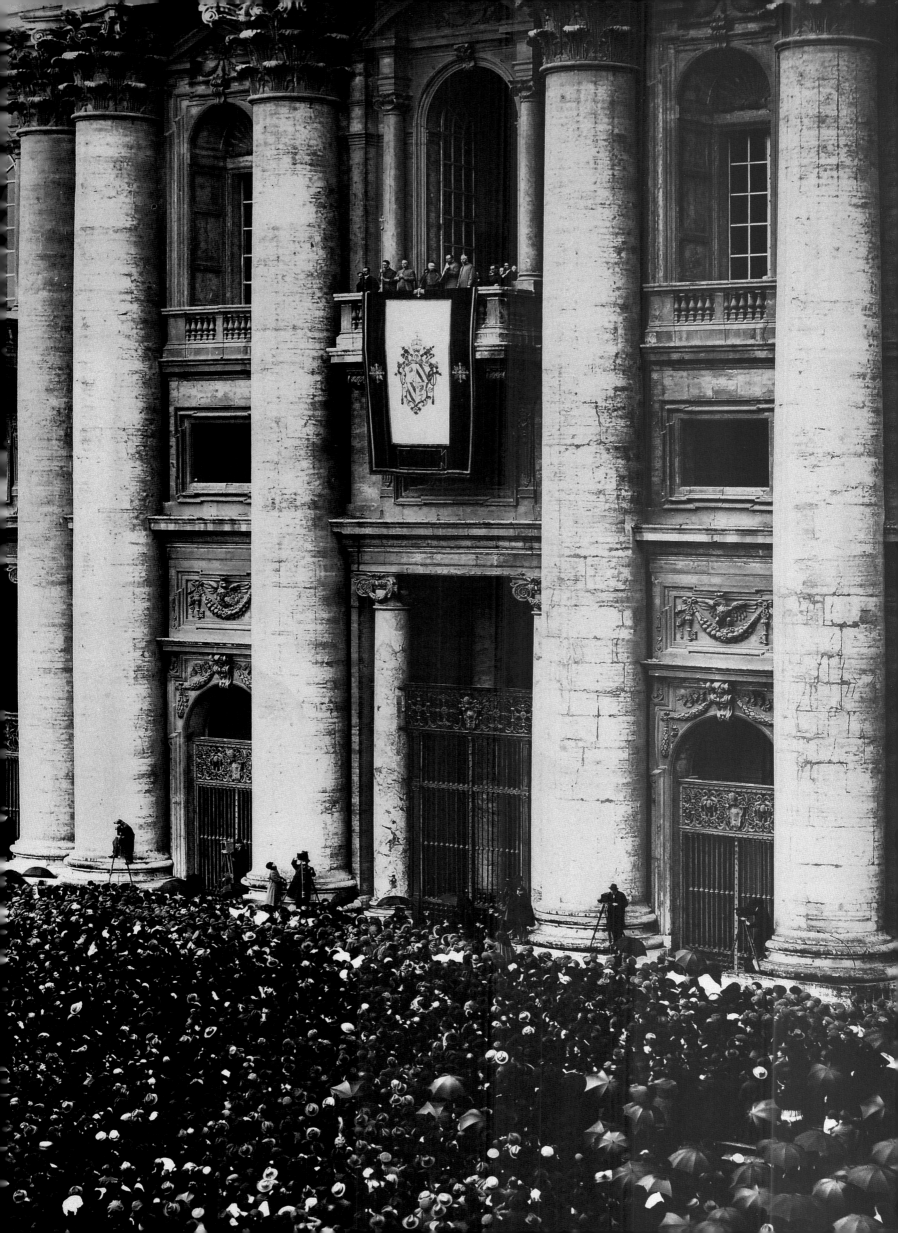

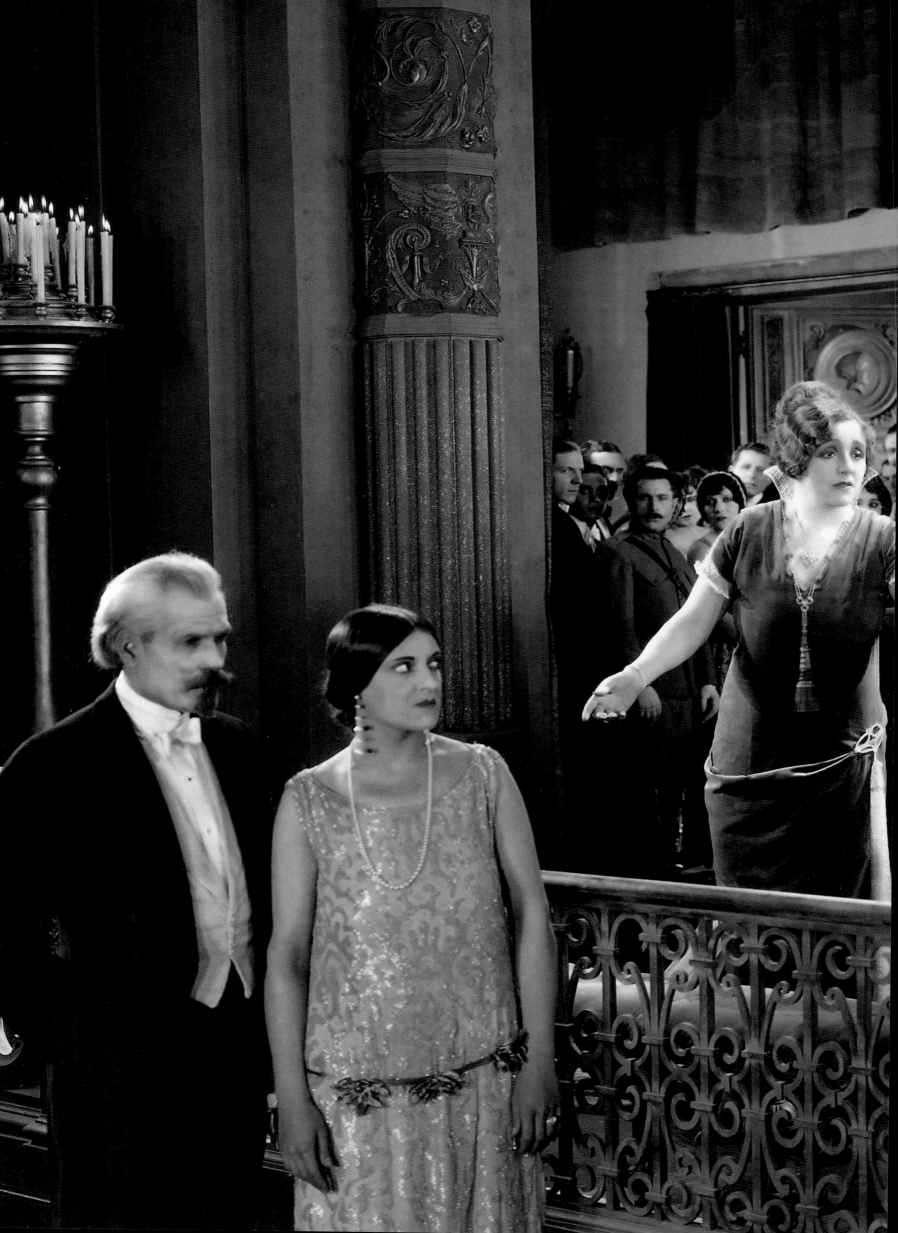

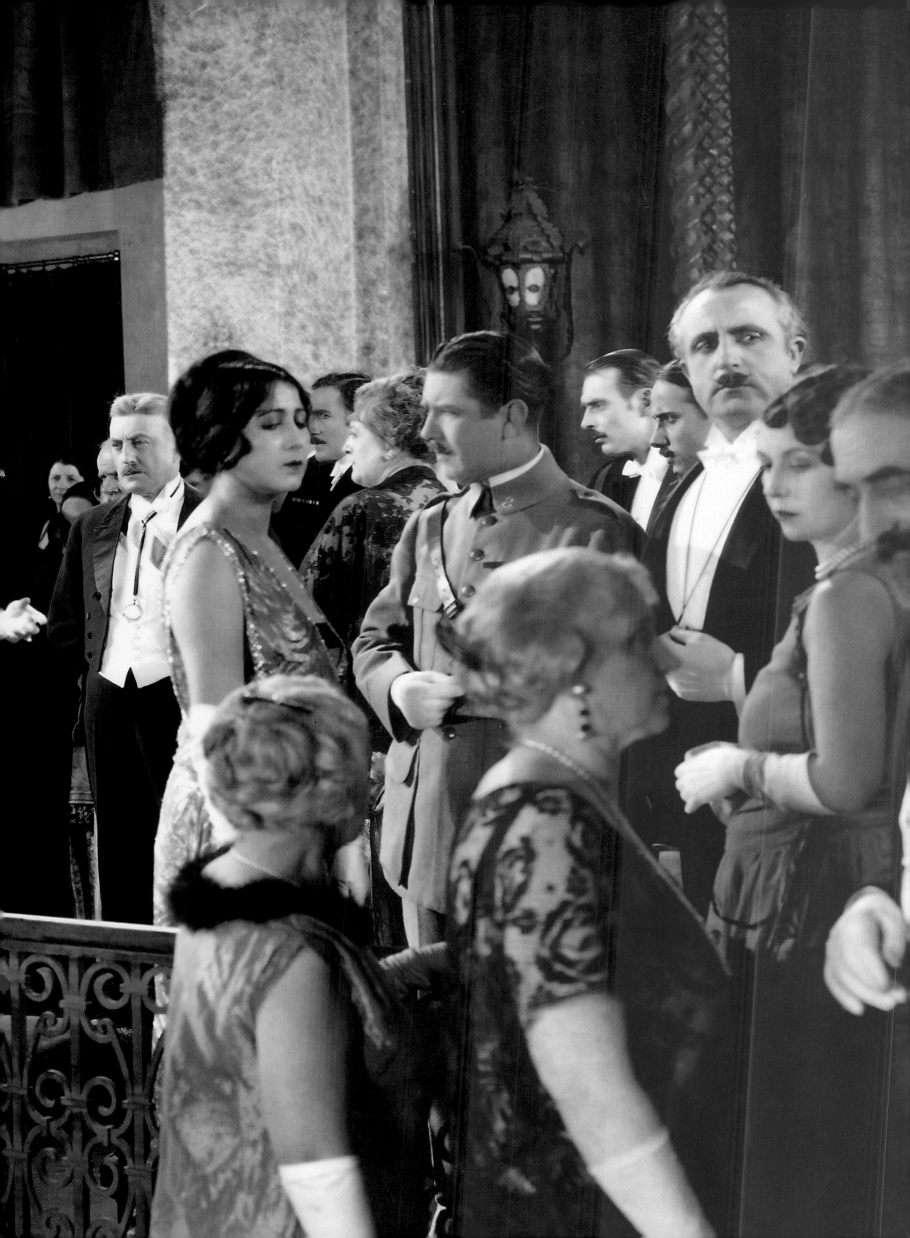

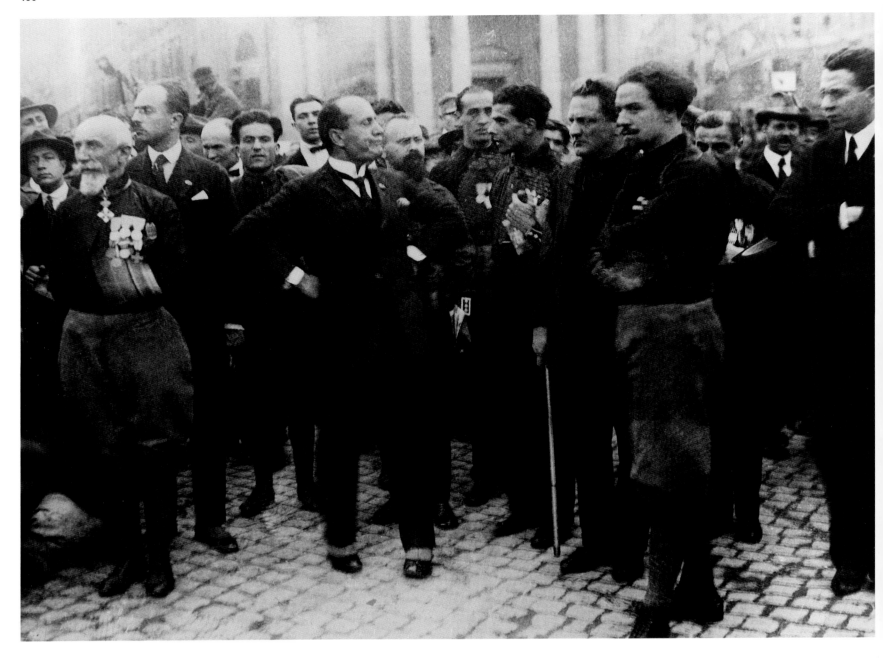

Adolfo Porry-Pastorel

*The March on Rome (October 28 –
November 1, 1922), aimed at forcing the king
to hand power over to the Fascists. Mussolini
in Piazza del Popolo, 1922.*

*Der „Marsch auf Rom" (28. Oktober –
1. November 1922) sollte den König stärken,
damit dieser den Faschisten die Regierung
übertrug. Mussolini auf der Piazza
del Popolo, 1922.*

*La marche sur Rome (28 octobre –
1er novembre 1922) fut organisée pour
contraindre le roi à confier le gouvernement
aux fascistes. Mussolini sur la piazza
del Popolo, 1922.*

Adolfo Porry-Pastorel

*The March on Rome: Fascists and Blackshirts,
wearing imaginative uniforms, and animated
by an aggressive energy, crammed together
holding the portraits of Marx and Lenin that
they were about to destroy, October 1922.*

*Faschisten und „Schwarzhemden" in ihren
gewollt „volkstümlichen" Fantasieuniformen
mit Marx- und Leninbildern, die anschlie-
ßend verbrannt werden, Oktober 1922.*

*La marche sur Rome: fascistes et squadristes
– vêtus d'uniformes fantaisistes et animés
d'une vitalité toute populaire – excités par
des portraits de Marx et de Lénine exhibés
pour être détruits, octobre 1922.*

Adolfo Porry-Pastorel

*The March on Rome: Fascists burning
books and anti-nationalist papers seized at
the headquarters of a Socialist newspaper,
November 1, 1922.*

*Faschisten verbrennen auf offener Straße
anti-nationalistische Bücher und Schriften,
die sie am Sitz einer sozialistischen Tages-
zeitung gestohlen haben, 1. November 1922.*

*La marche sur Rome: dans la rue des fascistes
brûlent des livres et des documents anti-
nationalistes saisis dans les locaux d'un
journal socialiste, 1er novembre 1922.*

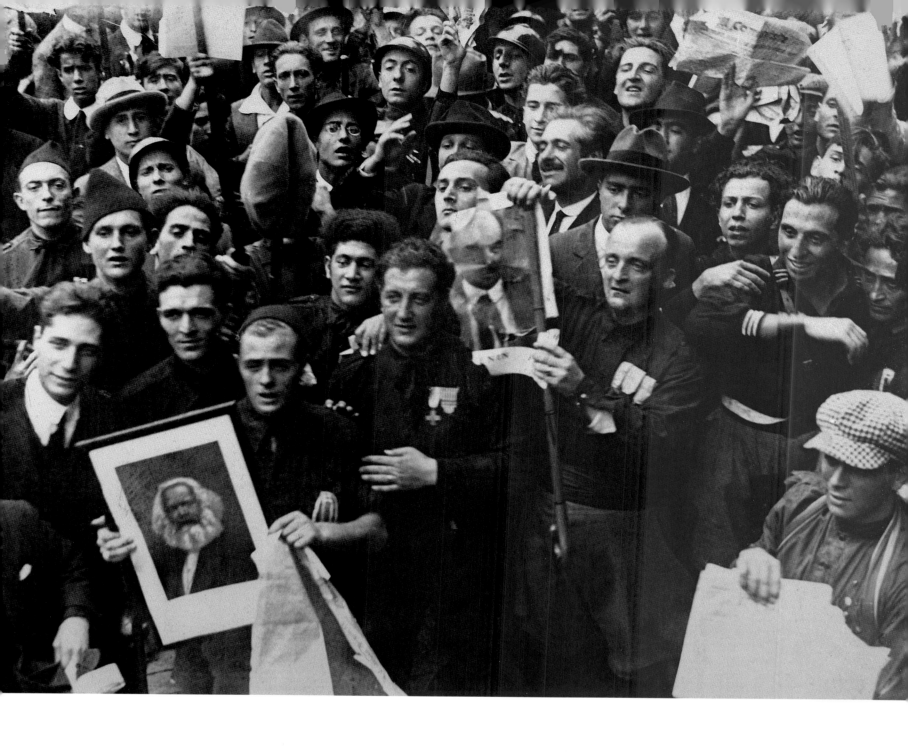

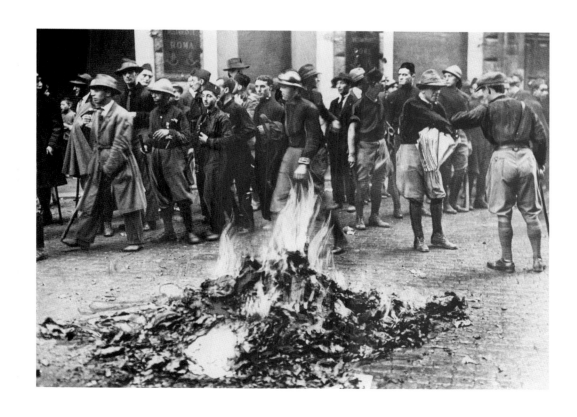

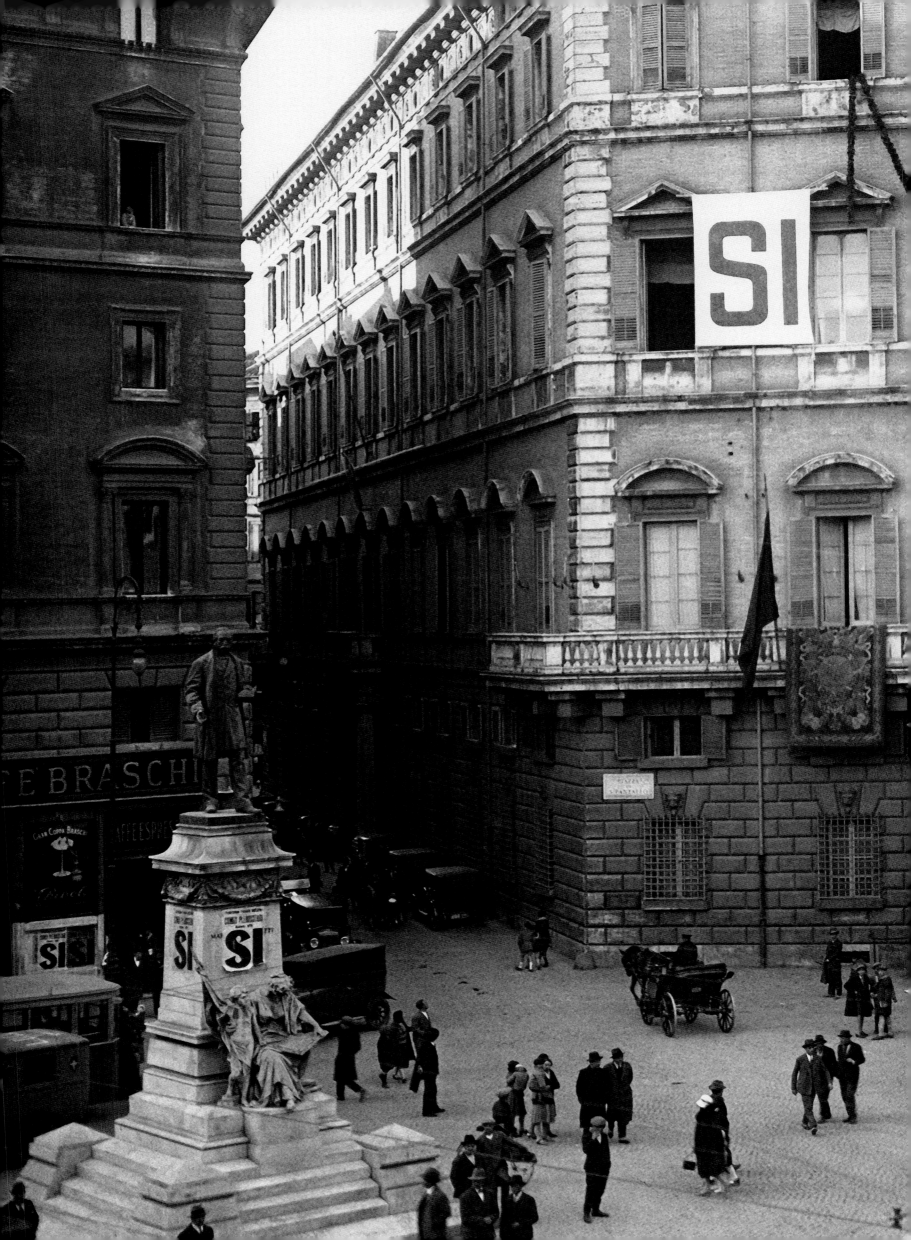

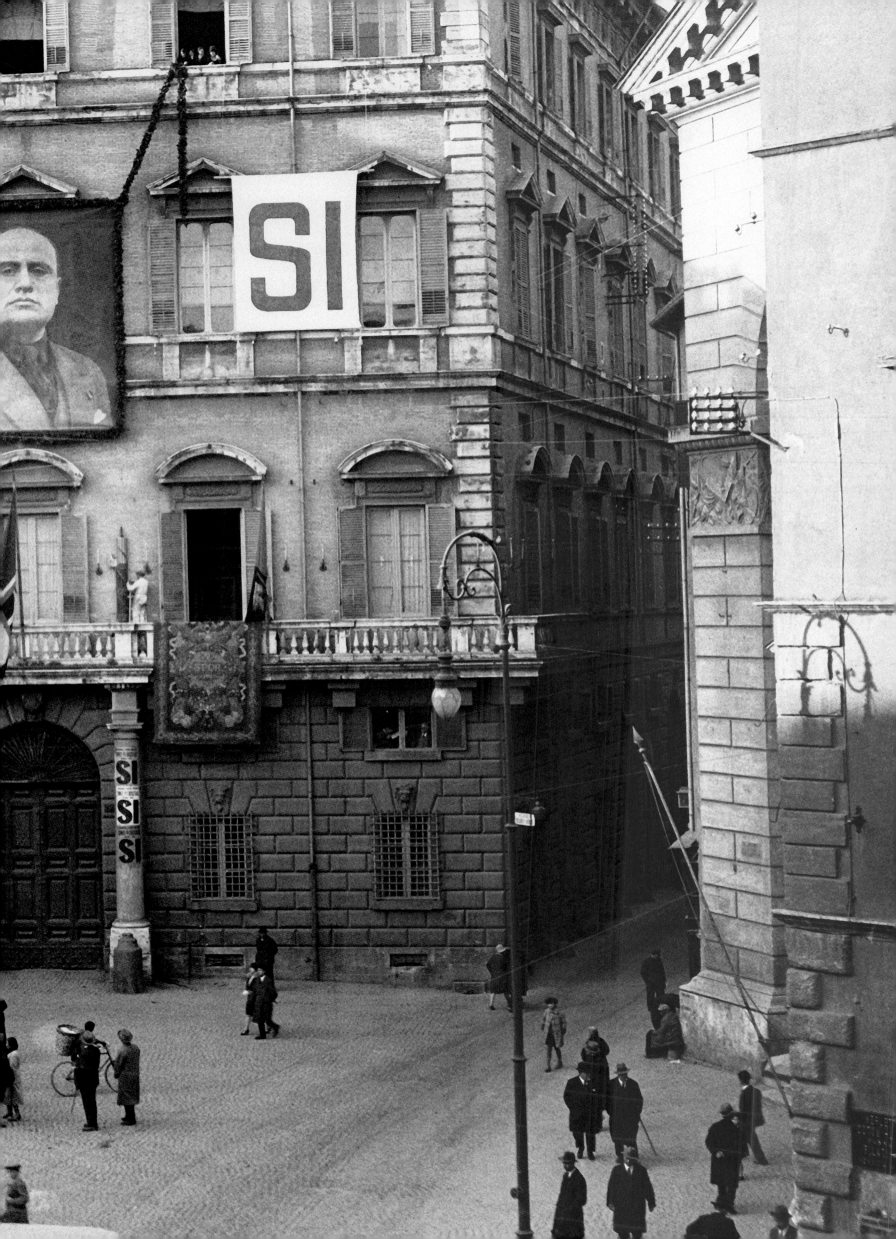

pp. 160/161
Istituto LUCE

Propaganda at the Roman Fascist Federation during the referendum elections: the portrait of Mussolini on the façade of Palazzo Braschi, March 1929.

Wahlpropaganda der faschistischen Federazione dell'Urbe vor der Volksabstimmung zur Wahl der Abgeordnetenkammer mit dem Konterfei Mussolinis an der Fassade des Palazzo Braschi, März 1929.

Propagande affichée par la fédération fasciste de l'Urbe à l'occasion du plébiscite: portrait de Mussolini sur la façade du palazzo Braschi, mars 1929.

↑
Armando Bruni

Mussolini opens construction work on the Via dell'Impero. This was one of the many occasions when he demonstrated his "pickaxe demolition" politics designed to create the "new Rome" by "revitalizing" the ancient city center, creating large circulation arteries, eliminating Medieval and Baroque "defacements," isolating the monuments, and resurfacing the Forum through archaeological excavations. In the background is the huge Vittoriale, c. 1935.

Mussolini bei der Eröffnung der Arbeiten für den Bau der Via dell'Impero. Eine der vielen Gelegenheiten, bei denen der Duce seine „Politik der Spitzhacke" vorführte, die durch die „Sanierung" des historischen Zentrums ein „neues Rom" erstehen lassen sollte. Die

„Verschandelungen" aus mittelalterlicher und barocker Zeit sollten verschwinden, die Monumente der Antike herausgestellt, die Foren freigelegt werden; im Hintergrund das Denkmal für Viktor Emanuel, um 1935.

Mussolini inaugure le chantier de la via dell'Impero, une occasion parmi tant d'autres pour célébrer sa politique du «pic démolisseur» destinée à créer la «Rome nouvelle» en assainissant le centre ancien, en perçant de larges artères et en éliminant les «défigurations» médiévales et baroques, en isolant les monuments et en dégageant les forums grâce aux fouilles archéologiques; en arrière-plan, on notera l'imposant monument à Victor-Emmanuel II, vers 1935.

→
Anonymous

Workers during the restoration of the Colosseum, c. 1930.

Arbeiter bei der Restaurierung des Kolosseums, um 1930.

Ouvriers travaillant à la restauration du Colisée, vers 1930.

"Rome at night. A dead city. A mute city. A city where the only shout that will escape from façades and walls, always the same with small variations, will be the Duce: his portrait or his profile, wearing a feathered hat or a helmet, amiable or terrible."

„Rom bei Nacht. Tote Stadt. Stumme Stadt. Stadt, wo Fassaden und Mauern sich nur einen einzigen, immer nur in Details variierten, Schrei erlauben werden: Duce – sein Gesicht von vorn und im Profil, mit Federhut oder Helm, freundlich oder schrecklich. "

« Rome la nuit. Ville morte. Ville muette. Ville où le seul cri que se permettent ses façades et ses murailles, toujours le même avec de petites variantes, sera le Duce, sa figure de face et de profil, en bonnet à aigrette ou en casque, aimable ou terrible. »

JEAN COCTEAU, *MON PREMIER VOYAGE (TOUR DU MONDE EN 80 JOURS)*, 1937

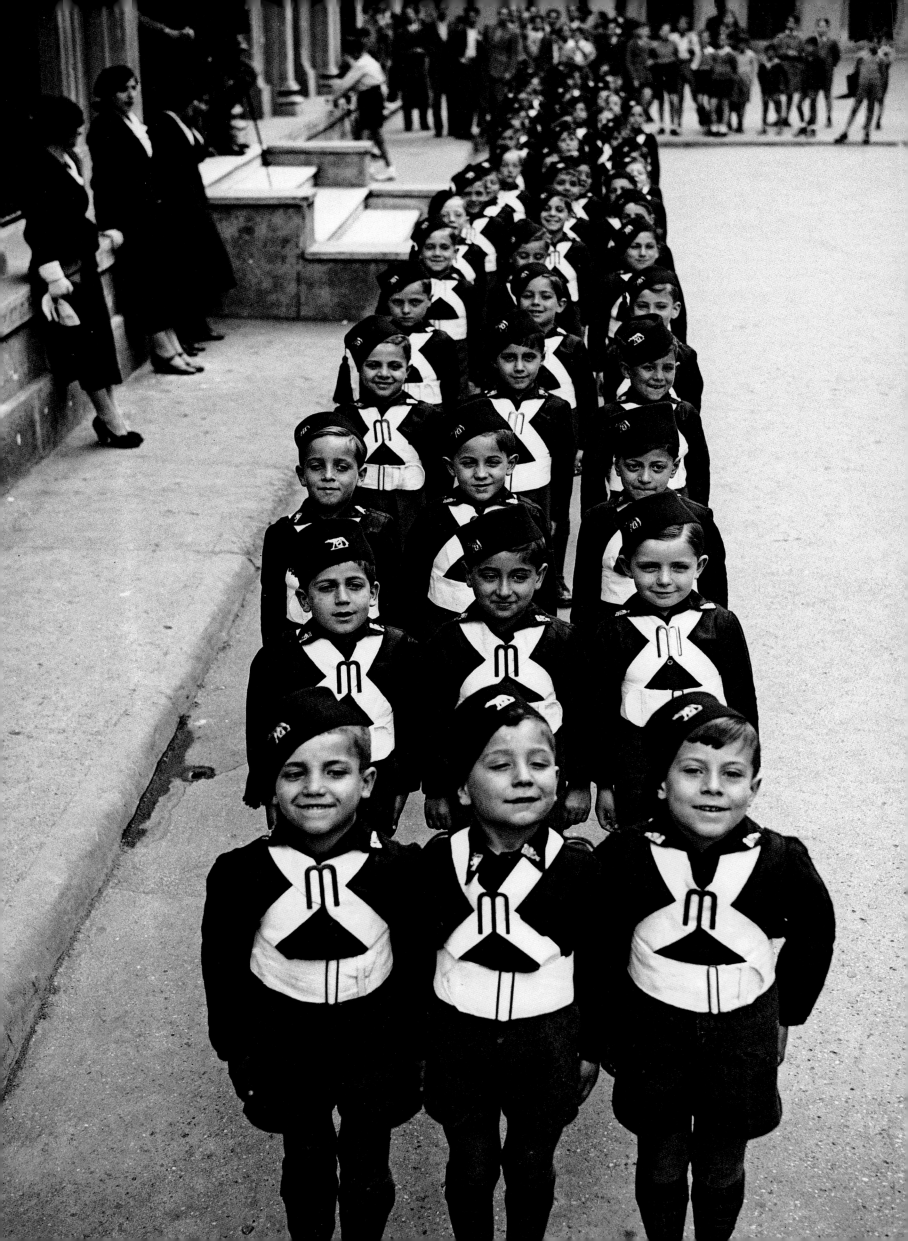

↑
Anonymous

Due to growing poverty and unemployment during the years of the economic crisis, in 1931 the Ente Opere Assistenziali della Federazione dell'Urbe (Welfare Assistance Body of the Roman Federation) was created. Their popular and widely publicized initiatives included the Fascist Befana (Epiphany) and the Duce's Christmas, when parcels containing gifts for the children of poor families were distributed, c. 1931.

Im Zuge der Verschärfung der wirtschaftlichen Lage und zunehmender Arbeitslosigkeit in den Jahren der Weltwirtschaftskrise wurde 1931 das Hilfswerk der faschistischen Federazione dell'Urbe ins Leben gerufen. Beliebt und propagandistisch ausgeschlachtet wurden unter anderem das „Weihnachtsfest des Duce" und das „Faschistische Dreikönigsfest", zu denen das Regime Geschenkpakete an die Kinder bedürftiger Familien verteilen ließ, um 1931.

Avec l'aggravation de la situation économique et l'augmentation considérable du chômage durant les années de la crise, l'Ente Opere Assistenziali della Federazione dell'Urbe (EOA) [service d'assistance] vit le jour en 1931. Bénéficiant d'une large publicité et remportant un vif succès, la Befana fasciste et le Noël du Duce étaient synonymes de distribution de colis aux enfants des familles déshéritées, vers 1931.

←
Armando Bruni

A lineup of young "Figli della Lupa" of the ONB (Opera Nazionale "Balilla"), c. 1930.

Figli della Lupa der ONB (Opera Nazionale Balilla) – in Reih und Glied, um 1930.

Déploiement de jeunes Figli della Lupa (Opera Nazionale « Balilla »), vers 1930.

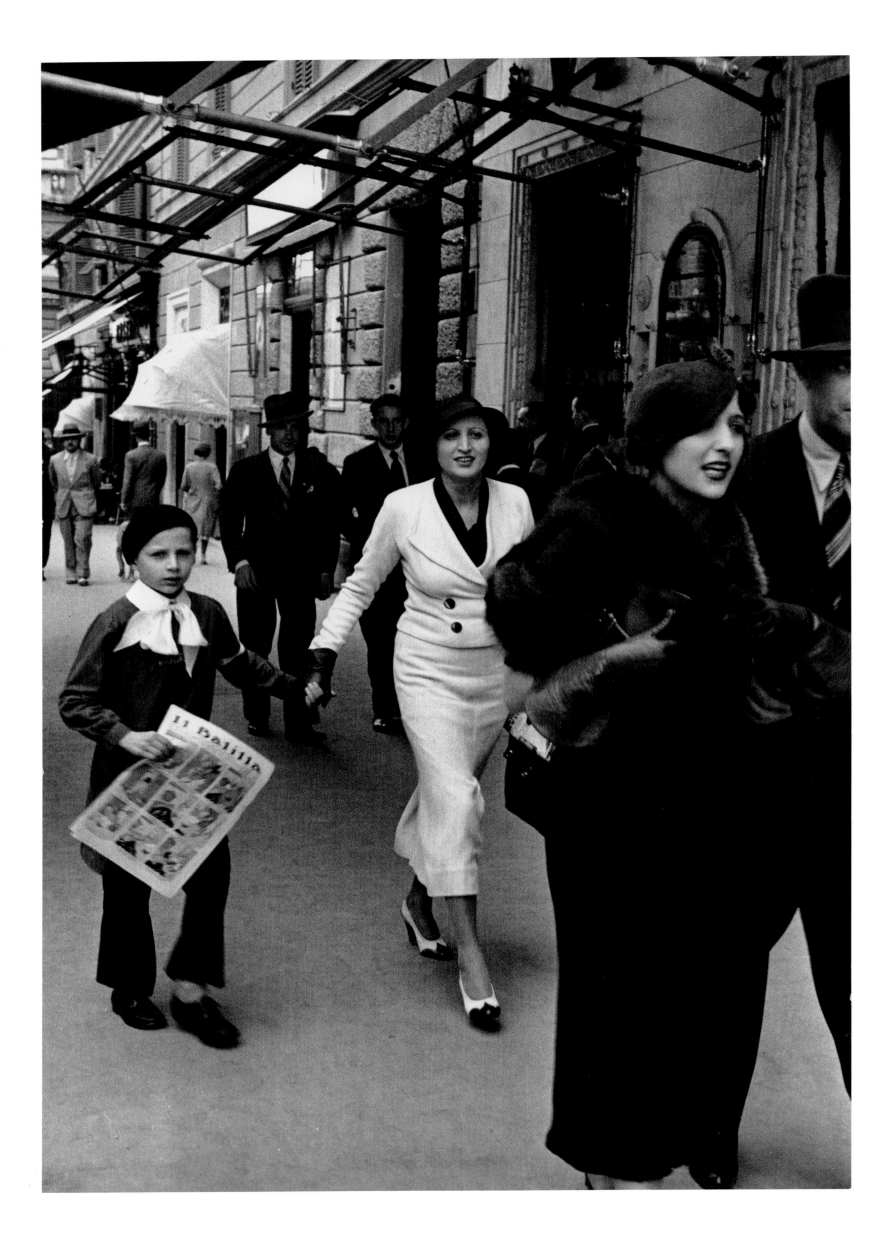

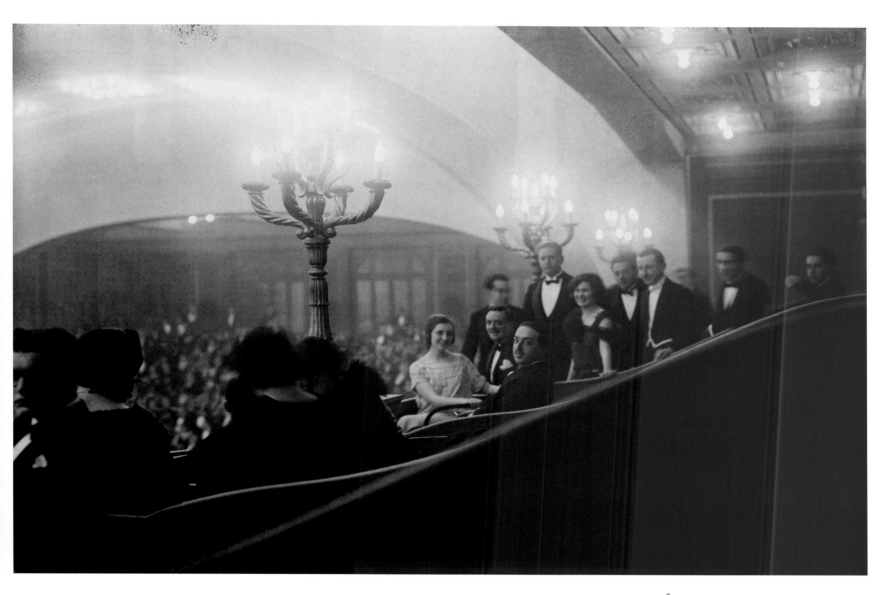

↑
Alberto Cartoni

The interior of the Teatro dell'Opera, renovated by Marcello Piacentini, 1932.

Das Innere der von Marcello Piacentini umgebauten Oper, 1932.

Intérieur du Teatro dell'Opera remanié par Marcello Piacentini, 1932.

←
Alfred Eisenstaedt

An elegant young woman walking in a street of the historic center, holding by the hand her little boy who carries a copy of the illustrated periodical Il Balilla, *1932.*

Elegant gekleidete Dame beim Gang durch das historische Zentrum; der Junge an ihrer Hand hält die illustrierte Zeitschrift Il Balilla, *1932.*

Jeune élégante se promenant dans une rue du centre historique et tenant par la main un enfant avec le journal illustré Il Balilla, *1932.*

168

"As things for Midas turn to gold, here things turn to stone."

„*Wie König Midas alles zu Gold wurde, wird in Rom alles zu Stein.*"

« *De même qu'elles se muaient en or pour le roi Midas,
les choses se changent ici en pierre.* »
CORRADO ALVARO, *ITINERARIO ITALIANO*, 1941

←
Max Peiffer Watenphul

Max Peiffer Watenphul trained as a painter at the Bauhaus in Weimar. During his fellowship at the German Academy of Villa Massimo between 1931 and 1932, he took a series of photographs of ancient and Renaissance Rome, infused with magic realism.

Max Peiffer Watenphul studierte Malerei am Weimarer Bauhaus. Während seines Aufenthalts in der Villa Massimo 1931/32 machte er Aufnahmen von römischen Motiven aus Antike und Renaissance, die von einem eigenwilligen magischen Realismus geprägt sind.

Max Peiffer Watenphul a étudié la peinture au Bauhaus à Weimar. Durant sa résidence à l'Académie allemande de la Villa Massimo, entre 1931 et 1932, il fit une série photographique sur l'art antique et de la Renaissance à Rome, tout empreinte de « réalisme magique ».

→
George Hoyningen-Huene

Princess Ruspoli posing in front of the Fountain of the Four Rivers by Bernini, in Piazza Navona, 1933.

Die Fürstin Ruspoli vor Berninis Vierströmebrunnen auf der Piazza Navona, 1933.

La princesse Ruspoli posant piazza Navona, devant la fontaine des Quatre-Fleuves du Bernin, 1933.

"Although immersed in the great cares of politics, after summarily outlining the plan for the transformation and beautification of the old city [...] the Duce follows day by day, hour by hour, the implementation of the vast program in its finest details. Nothing escapes his watchful eye: from the restoration of a prestigious building [...] to the advertising billboard that defaces an old square, to the streetlight out of order, to the dry tree in a park."

„Wenn auch von den Sorgen der großen Politik in Anspruch genommen, verfolgt der Duce, nachdem er in kraftvollen Linien den Plan für die Umgestaltung und Verschönerung der Altstadt vorgezeichnet hat, [...] Tag für Tag und Stunde für Stunde die Umsetzung des umfassenden Programms bis in die kleinste Einzelheit. Nichts entgeht seinem wachsamen Auge, von der Restaurierung eines bedeutenden Gebäudes [...] bis zum Werbeplakat, das einen alten Platz verschandelt, und zum falsch platzierten Scheinwerfer, zum vertrockneten Baum in einem Park."

« Bien qu'il soit accaparé par les affaires de l'État, le Duce, qui a fermement défini le programme des travaux de transformation et d'embellissement de la vieille ville [...], suit quotidiennement, heure par heure, la mise en œuvre du vaste programme dans ses moindres détails. Rien n'échappe à son regard vigilant ; de la restauration d'un magnifique édifice [...] à l'affiche publicitaire qui défigure une place ancienne, à l'éclairage mal placé, à l'arbre sec d'un jardin. »

ANTONIO MUÑOZ, *LA ROMA DI MUSSOLINI*, 1932

←
VEDO Agency

The Italian team triumphantly carries the coach after winning during extra time in the World Cup finals (against Czechoslovakia). The Fascist regime counted on the victory of the national team for its propaganda. Mussolini and the princesses Maria Francesca and Mafalda of Savoy attended the match, June 1934.

Die italienische Mannschaft lässt nach dem Sieg nach Verlängerung gegen die Tschechoslowakei im Finale der Fußball-weltmeisterschaft ihren Trainer hochleben. Für das faschistische Regime war der Erfolg der Nationalmannschaft propagandistisch besonders wichtig; auf den Rängen zugegen: Mussolini in Begleitung der Prinzessinnen Maria Francesca und Mafalda von Savoyen, Juni 1934.

Les footballeurs italiens portent leur entraîneur en triomphe pour célébrer leur victoire, après prolongation, sur l'équipe de Tchécoslovaquie lors de la finale de la Coupe du monde. Le régime fasciste comptait beaucoup sur la victoire de l'équipe nationale à des fins de propagande; Mussolini et les princesses Maria Francesca et Mafalda de Savoie assistèrent au match, juin 1934.

↓
VEDO Agency

Piero Taruffi and Guerino Bertocchi arriving in a Maserati 4CS 1100 at Rome's pit stop on the eighth edition of the Mille Miglia car race, April 1934.

Ankunft von Piero Taruffi und Guerino Bertocchi in ihrem Maserati 4CS 1100 am Kontrollpunkt in Rom während des achten Rennens der Mille Miglia, April 1934.

L'arrivée de Piero Taruffi et de Guerino Bertocchi sur la Maserati 4CS 1100 au contrôle à Rome lors de la huitième édition des Mille Miglia, avril 1934.

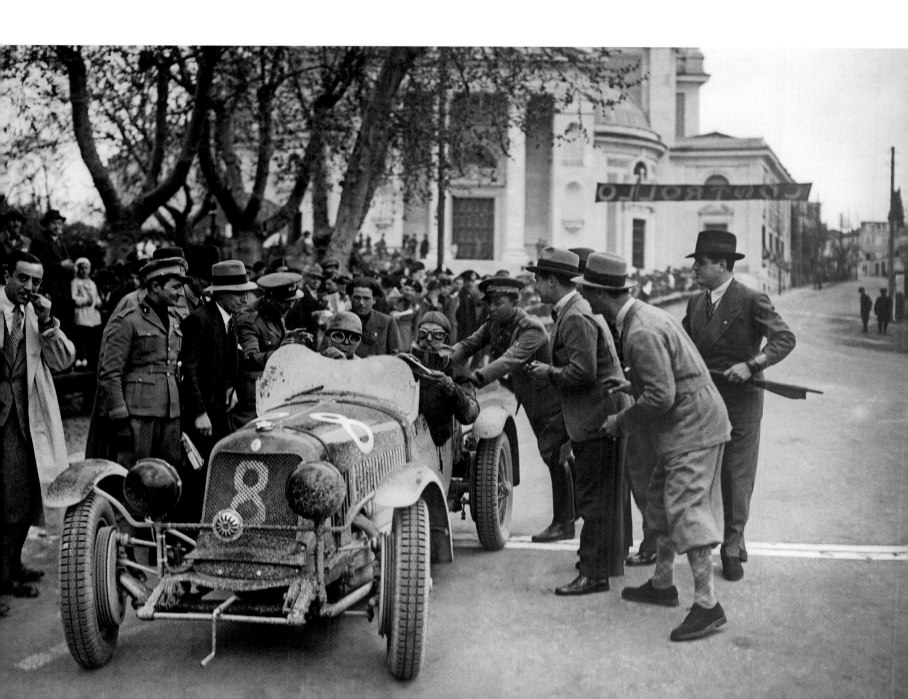

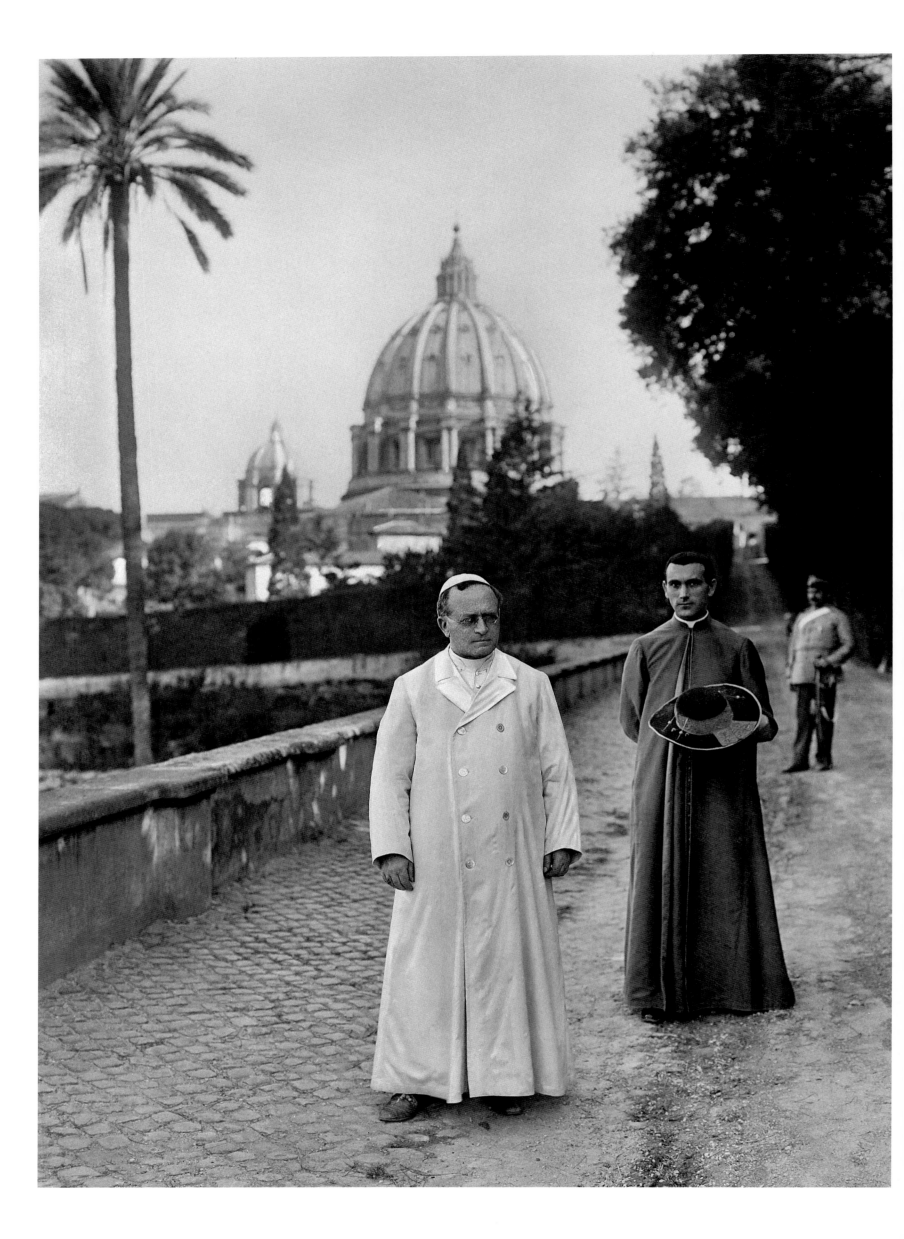

"The Roman people [...] faced with any regime or form of government do not oppose it, they accept it unquestioningly, on principle, and everyone takes the part he likes; the people love the show, the theatricality; the performances that the Romans can give are of an incomparable beauty, which is the reason they are ready to make noise, so much noise, with their mouths, their hands, because it is all part of the happiness of being, and because nothing hides it better than noise."

„*Das römische Volk [...] leistet keinerlei Regime oder Regierungsform Widerstand, es akzeptiert sie ohne Weiteres, aus Prinzip, und von allen nimmt es sich das, was ihm gefällt; es liebt das Spektakel, das Theatralische, und das Schauspiel, das es zu veranstalten in der Lage ist, ist von unsagbarer Schönheit, deshalb ist es immer bereit, Lärm zu machen, großen Lärm, mit dem Mund und mit den Händen, denn dieser Lärm ist Teil der Glückseligkeit, auf der Welt zu sein, und nirgends kann es sich so gut verstecken wie hinter diesem Lärm.*"

« *Face à un régime ou à une forme de gouvernement, quels qu'ils soient, il [le peuple de Rome] ne tente pas de s'opposer, il les accepte sans histoires, par principe, et il prend chez chacun la part qui lui plaît ; il aime le spectacle, la théâtralité ; les spectacles que le peuple romain sait donner sont d'une beauté inestimable, c'est la raison pour laquelle il est prêt à faire du tapage, et quel tapage, avec la bouche, avec les mains, parce que cela fait partie du bonheur d'exister, et parce que rien ne le cache mieux que le bruit.* »

ALDO PALAZZESCHI, *ROMA,* **1953**

←

Anonymous

Pope Pius XI strolling in the Vatican gardens. During his papacy, relations with the Italian state were normalized thanks to the Treaty and Accords of the Lateran Pacts of February 11, 1929, which sanctioned the birth of the new Vatican City State, under the sovereignty of the Pontiff, and with the recognition by the Holy See of the "Kingdom of Italy under the dynasty of the Savoy, with Rome as the capital of the Italian state." In the same period, several agreements with various European nations were created, c. 1935.

Pius XI. beim Spaziergang in den Vatikanischen Gärten. Unter Pius XI. kam es zu einer Normalisierung des Verhältnisses zum italienischen Staat. Mit den Lateranverträgen vom 11. Februar 1929 entstand der Vatikanstaat unter päpstlicher Souveränität; zugleich erkannte der Heilige Stuhl das „Königreich Italien unter der Dynastie des Hauses Savoyen mit Rom als Hauptstadt des italienischen Staates" an. Ähnliche Konkordate wurden damals mit mehreren europäischen Regierungen geschlossen, um 1935.

Le pape Pie XI se promenant dans les jardins du Vatican. Sous son pontificat, les relations avec l'État italien furent normalisées grâce aux accords du Latran (traité et concordat) du 11 février 1929 qui sanctionnaient la naissance du nouvel État de la Cité du Vatican placé sous la souveraineté du pontife et la reconnaissance par le Saint-Siège du « royaume d'Italie sur lequel règne la maison de Savoie et dont Rome est la capitale ». Divers concordats furent alors conclus avec plusieurs nations européennes, vers 1935.

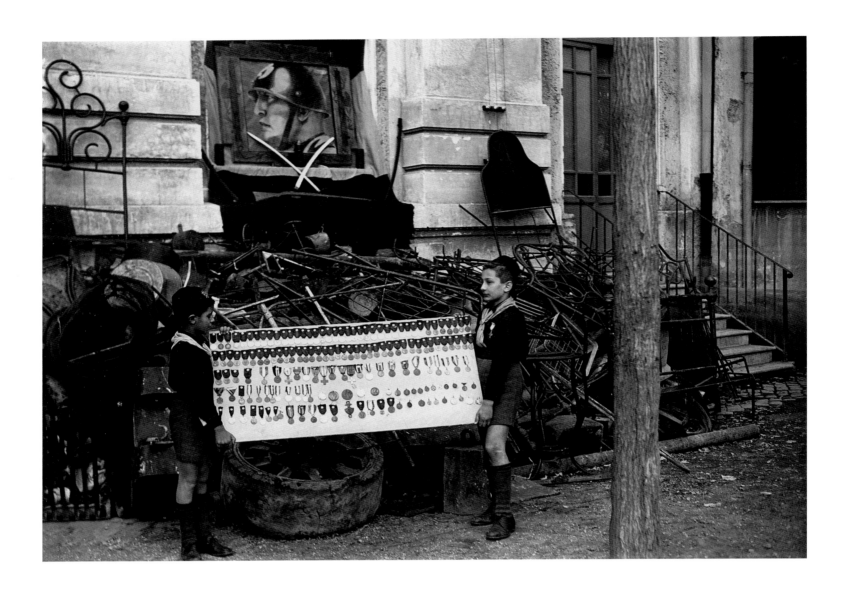

↑

Anonymous

Following the economic sanctions imposed on Italy by the League of Nations because of the war in Ethiopia, the regime campaigned for the collection of iron "for the good of the country." On the heap of metal collected from a school, two Balillas *(Fascist Youth) also lay a collection of medals, November 1935.*

Nachdem der Völkerbund wegen des Äthiopienkriegs Wirtschaftssanktionen gegen Italien verhängt hatte, lancierte das Regime eine Kampagne zur Sammlung von „Eisen für das Vaterland". Vor einer Grundschule legen zwei Balilla eine Medaillensammlung auf einen Haufen mit gesammeltem Alteisen, November 1935.

Au lendemain des sanctions économiques prises par la Société des Nations contre l'Italie à cause de la guerre d'Éthiopie, le régime lança une campagne de récupération du fer pour la patrie. Sur le tas de ferraille récoltée dans une école primaire, deux Balillas déposent un médaillier, novembre 1935.

→

Anonymous

Italian women exchange their gold wedding ring for a steel ring to help fund the war for the conquest of Ethiopia, January 1936.

Zur Finanzierung des Äthiopienkriegs wurden die Italiener aufgerufen, ihre goldenen Eheringe zu spenden, im Tausch erhielten sie einen Ersatz aus Stahl, Januar 1936.

Italiennes échangeant leur alliance en or contre un anneau en acier afin de contribuer au financement de la guerre de conquête de l'Éthiopie, janvier 1936.

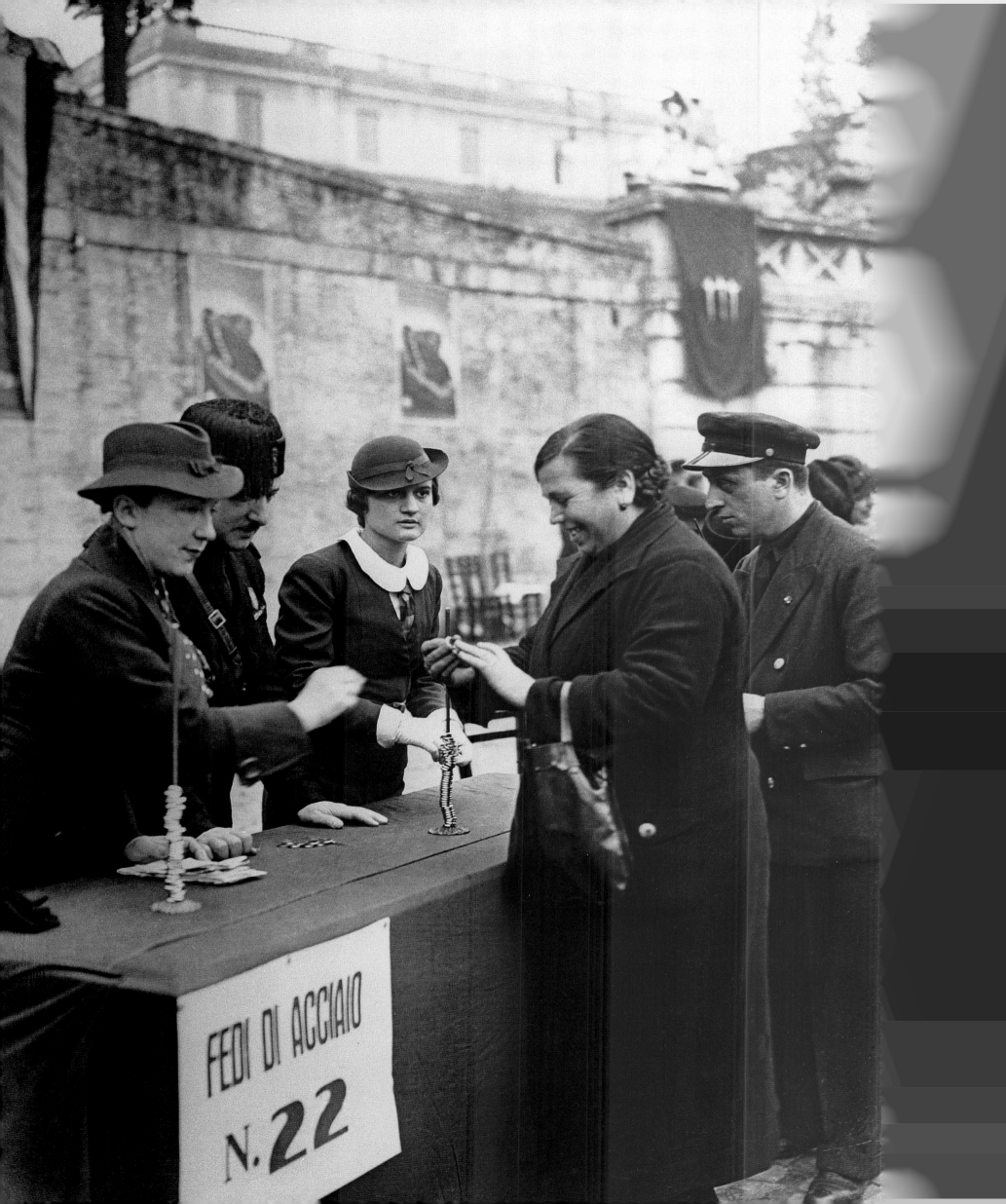

FEDI DI ACCIAIO
N. 22

↓
Anonymous

A group of Alpine troops on the way to the rail station, the first stop before the trip to Ethiopia, January 1935.

Gebirgsjäger auf dem Marsch zum Bahnhof, der ersten Etappe ihrer Verlegung auf den äthiopischen Kriegsschauplatz, 1935.

Une compagnie de chasseurs alpins défile dans une rue en direction de la gare ferroviaire, première étape du voyage la menant en Éthiopie, janvier 1935.

→
Istituto LUCE

On the tenth anniversary of the creation of the Opera Nazionale Balilla, a team of Balilla drummer boys parade at the Foro Mussolini during the inauguration ceremony for the monument to Giovan Battista Perasso, known as "Balilla," April 1936.

Trommlerschwadron der faschistischen Jugendorganisation auf dem Mussolini- forum bei der Einweihung des Denkmals für Giovan Battista Perasso, genannt Balilla, zum zehnjährigen Bestehen der Opera Nazionale Balilla, April 1936.

À l'occasion du dixième anniversaire de l'Œuvre nationale Balilla, un escadron de tambours Balillas joue au Foro Mussolini durant l'inauguration du monument à la gloire de Giovan Battista Perasso, dit « Balilla », avril 1936.

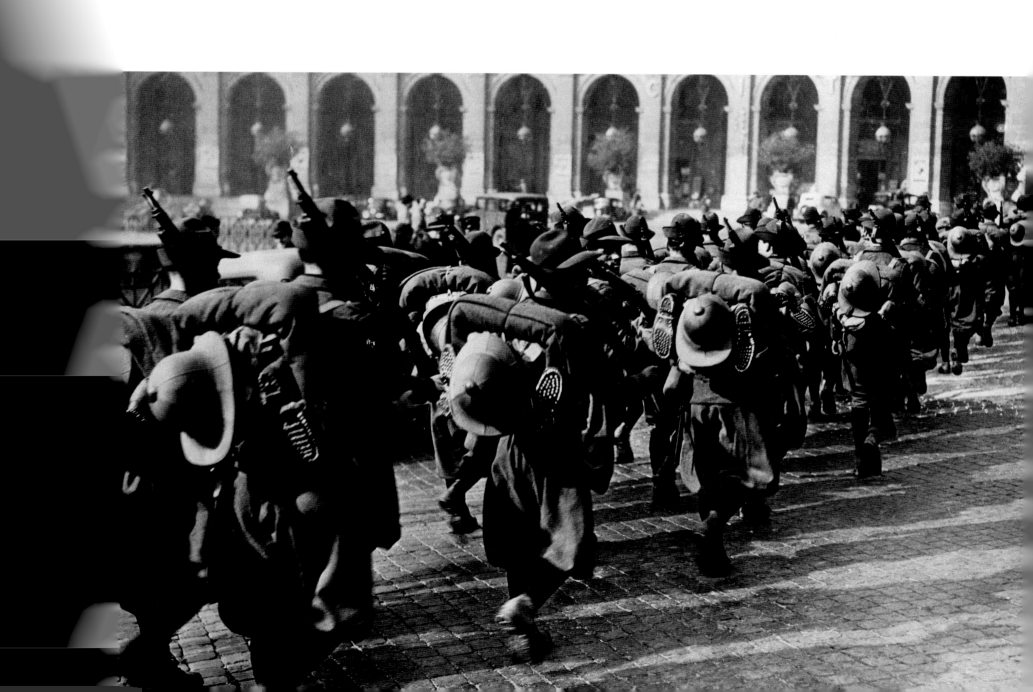

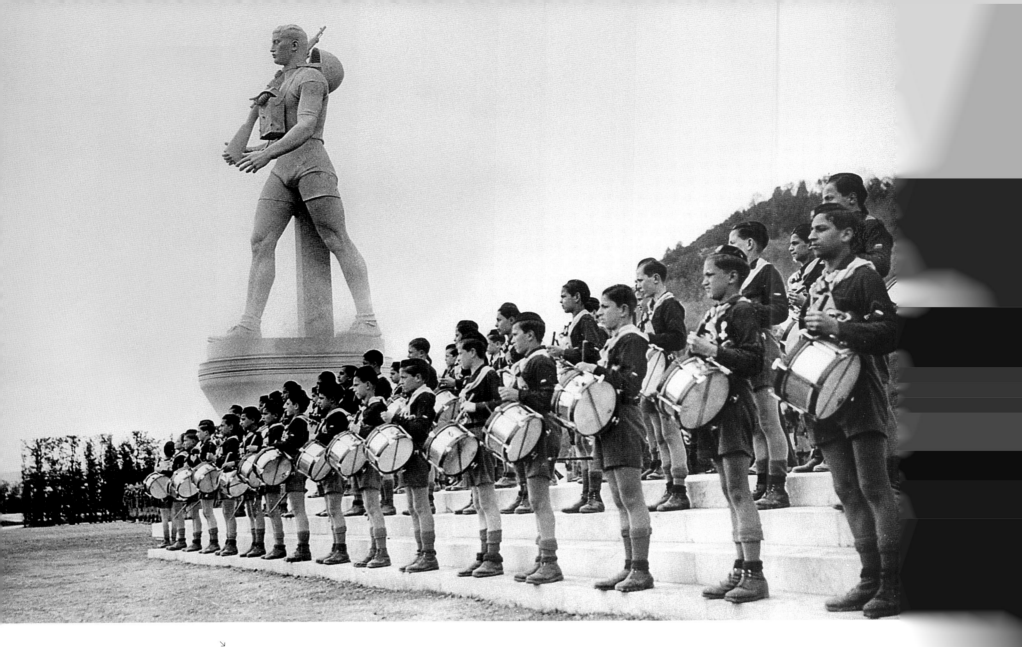

Istituto LUCE

Stage set with a gigantic cutout image of Mussolini taking a photograph, and a propaganda sign that reads "Cinematography is the strongest weapon," set up for the inauguration of the new headquarters of the Istituto LUCE. For the entire duration of the Fascist regime, the LUCE newsreels were a tool to broadcast information and visual propaganda for a population who did not enjoy reading (or did not know how to read), November 1937.

Festbühne anlässlich der Grundsteinlegung zum neuen Sitz des Istituto LUCE mit dem überlebensgroßen Konterfei des Duce hinter der Kamera und dem Schriftzug „Der Film ist die stärkste aller Waffen". Die Wochenschauen des Istituto LUCE waren während der gesamten faschistischen Herrschaft (neben dem Rundfunk) das bedeutendste Propagandawerkzeug und die wichtigste Informationsquelle für ein Volk, das nicht gern las (oder nicht lesen konnte), November 1937.

Mise en scène spectaculaire, avec un portrait géant de Mussolini derrière la caméra et une inscription de propagande (« le cinéma est l'arme la plus puissante »), organisée pour l'inauguration du nouveau siège de l'institut LUCE. Durant toute la période fasciste, les actualités cinématographiques LUCE furent un instrument d'information et de propagande visuelles à destination d'un peuple qui n'aimait pas (ou ne savait pas) lire, novembre 1937.

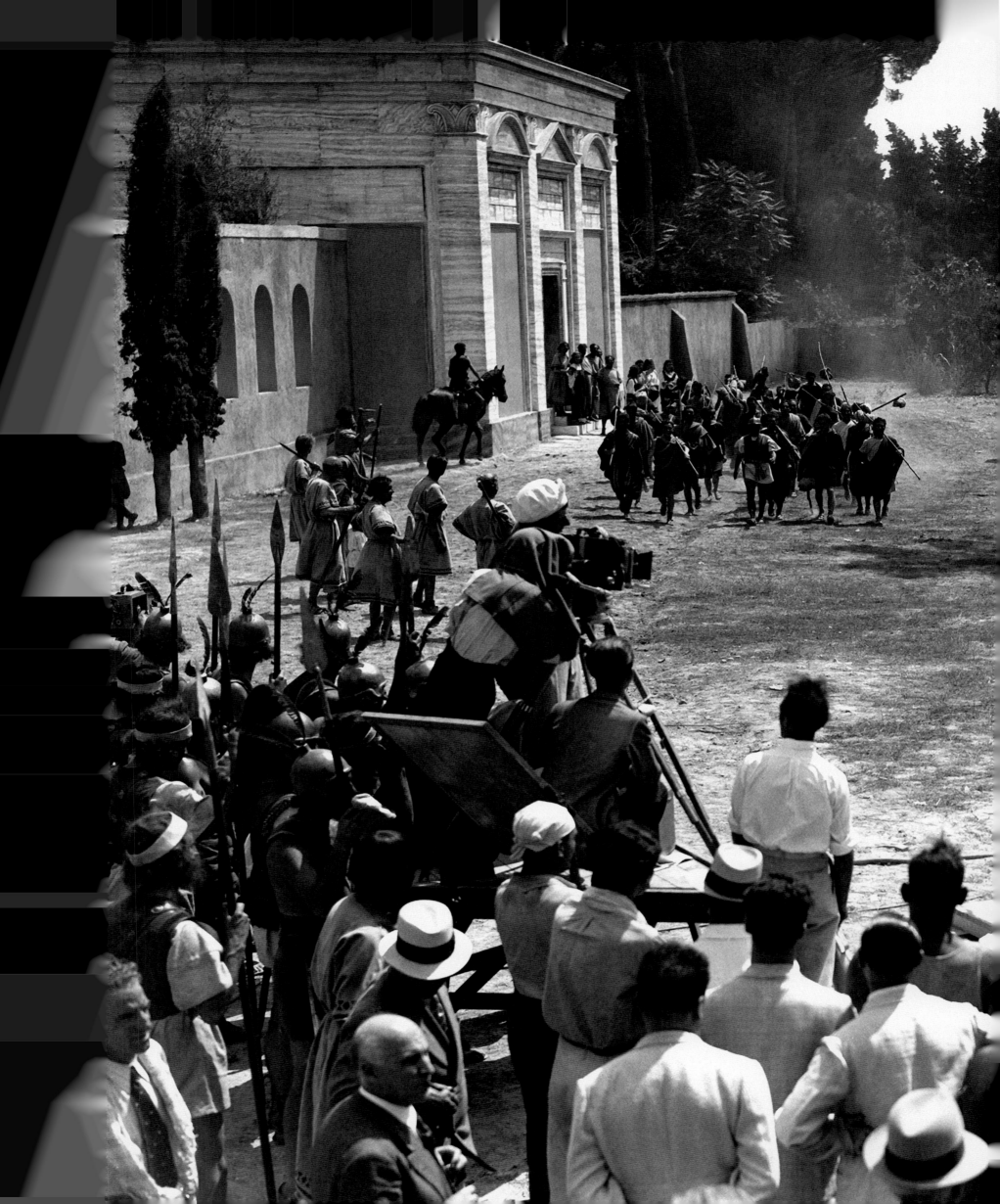

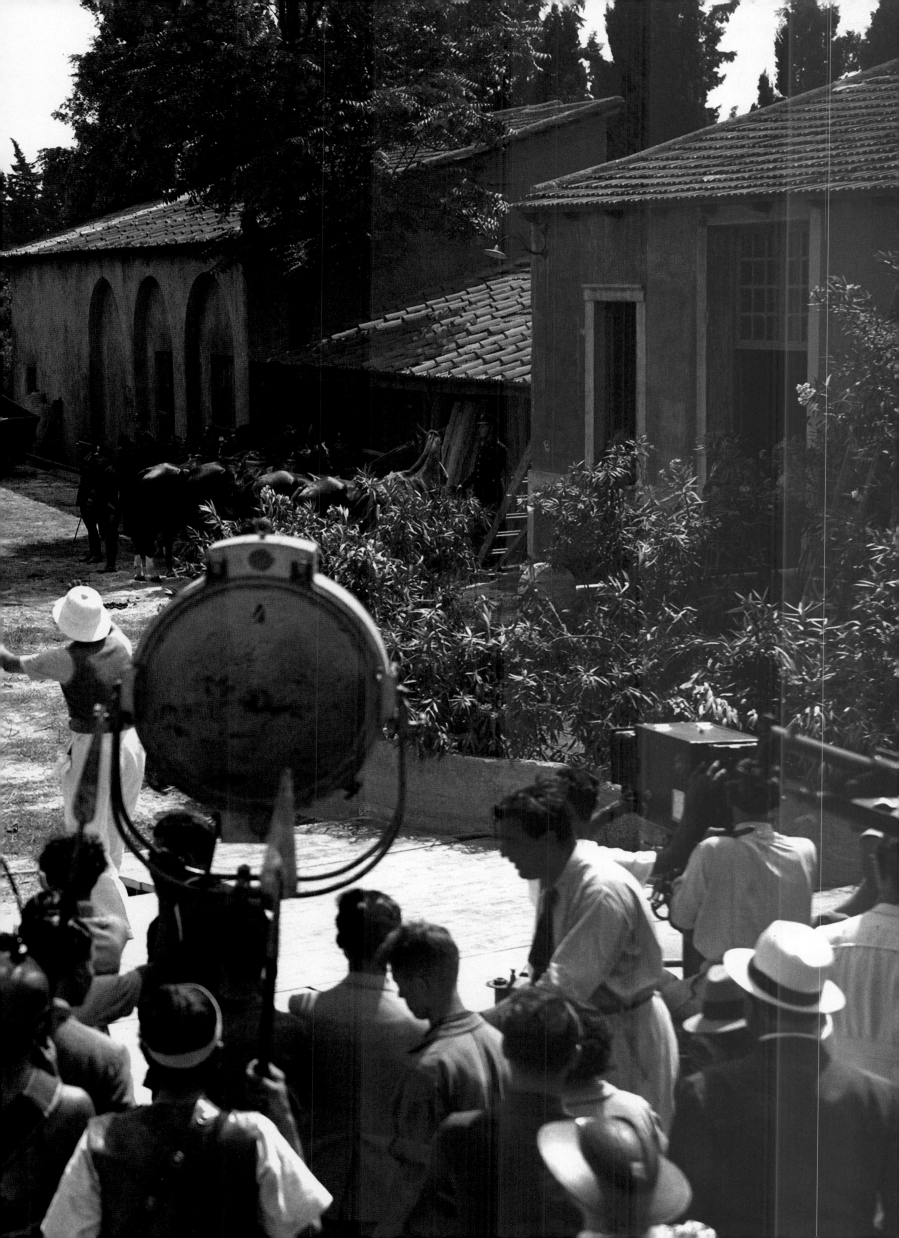

pp. 178/179
Istituto LUCE

Director Carmine Gallone (at the back) at the start of filming Scipione l'Africano *at the Stabilimenti Palatino Films, located at a short distance from the Colosseum, 1936.*

Beginn der Dreharbeiten zu Karthagos Fall *unter der Regie von Carmine Gallone (mit Tropenhelm) auf dem Gelände der Palatino-Filmstudios in unmittelbarer Nachbarschaft des Kolosseums, 1936.*

Premier tour de manivelle du réalisateur Carmine Gallone (de dos) pour le tournage de Scipion l'Africain *dans les studios de Palatino Film situés non loin du Colisée, 1936.*

↑
Bernard F. Rogers

Young woman in costume at a festival of wine, 1936.

Römerin in der typischen Tracht des Winzerfestes der „Festa dell'uva", 1936.

Jeune femme costumée pour la fête du raisin, 1936.

←
Bernard F. Rogers

Roman antiquities outside the Casino Borghese, 1937.

Römische Altertümer vor dem Casino Borghese, 1937.

Antiquités romaines à l'extérieur du casino Borghèse, 1937.

←

Bernard F. Rogers

Young Fascists shave at a camp organized on the sixth anniversary of the Fasci Giovanili di Combattimento (Fascist Youth for Combat Action), 1936.

Angehörige des Jugendkampfbundes der Faschistischen Partei bei der Rasur in einem Lager anlässlich des sechsten Gründungstages ihrer Organisation, 1936.

Deux jeunes fascistes se font tailler la barbe lors d'un camp organisé pour le sixième anniversaire de l'organisation des Fasci Giovanili di Combattimento (Jeunesse fasciste pour l'action du combat), 1936.

→

Bernard F. Rogers

Two young Fascists at the bar in the Città Universitaria, 1937.

Faschisten in Uniform in der Espressobar der Città Universitaria, 1937.

Deux fascistes au bar de la Cité universitaire, 1937.

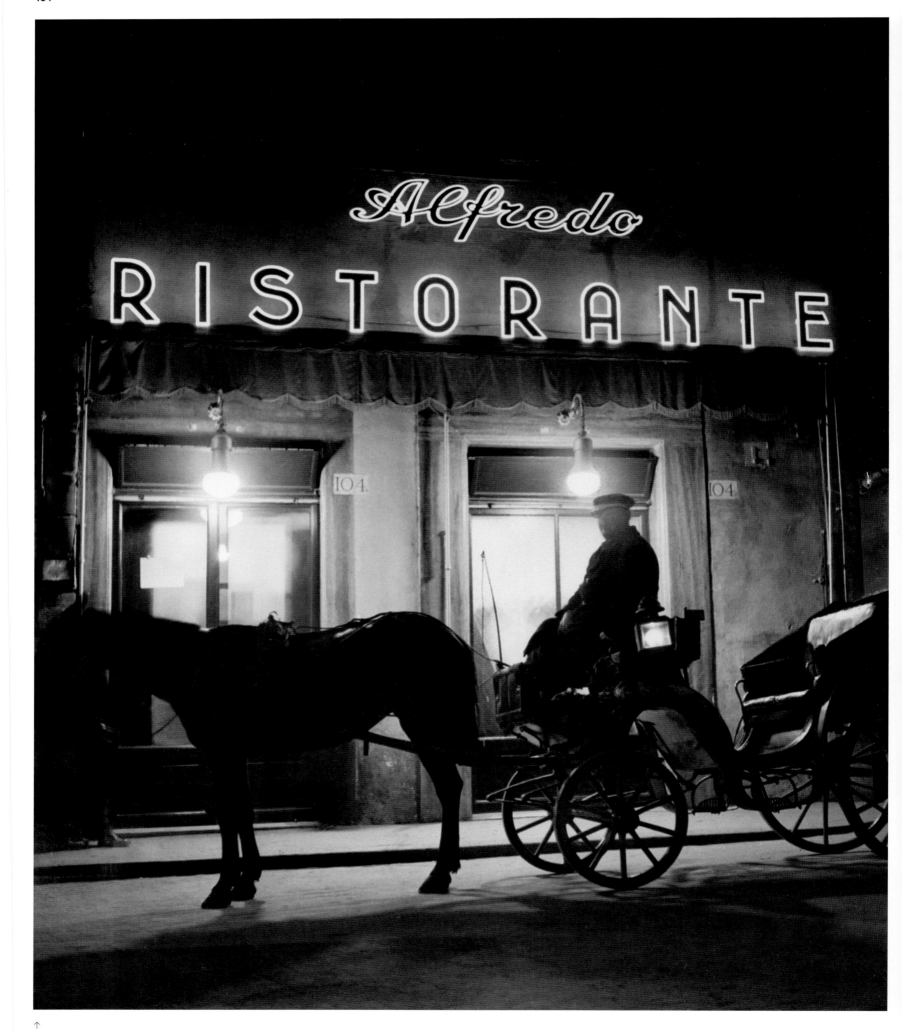

↑
Regina Relang

Fascism failed to eliminate the provincial character of the capital city, in fact it only emphasized it. In the 1930s, illuminated signs of shops, cafés, and restaurants became common; an example is the Ristorante Alfredo in Via della Scrofa, 1937.

In den 1930er-Jahren wurde auch in Rom für Lokale und Geschäfte immer öfter mit Leuchtreklamen geworben wie hier für das Ristorante Alfredo in der Via della Scrofa, 1937.

Non seulement le fascisme ne parvint pas à faire perdre son caractère provincial à la capitale, mais il l'accentua. Dans les années 1930, les enseignes lumineuses des magasins, des cafés et des restaurants se multiplièrent, ainsi celle du Ristorante Alfredo dans la via della Scrofa, 1937.

Regina Relang

In 1908 Alfredo Di Lello started a small family-run restaurant in Piazza Rosa, adjacent to the current Galleria Colonna and created the famous pasta dish of semolina fettuccine pasta seasoned with fresh butter and parmesan cheese. His son, Armando, nicknamed Alfredo II, moved Alfredo's restaurant to Via della Scrofa and earned the nickname of "King of Pasta," 1937.

1908 eröffnete Alfredo Di Lello ein kleines familienbetriebenes Restaurant an der Piazza Rosa, unweit der heutigen Galleria Colonna. Zu seinen Pastakreationen gehörten in Griesmehl gewälzte Fettuccine mit taufrischer Butter und Parmesan. Sein Sohn Armando, auch „Alfredo II., König der Pasta", zog mit dem Restaurant in die Via della Scrofa, 1937.

En 1908, Alfredo Di Lello ouvrit un petit restaurant à gestion familiale piazza Rosa, jouxtant l'actuelle galerie Colonna, et inventa une recette de fettucine fraîches accompagnées de beurre et de parmesan très frais. Son fils Armando, dit Alfredo II, transféra le restaurant via della Scrofa et conquit le surnom de « roi des pâtes », 1937.

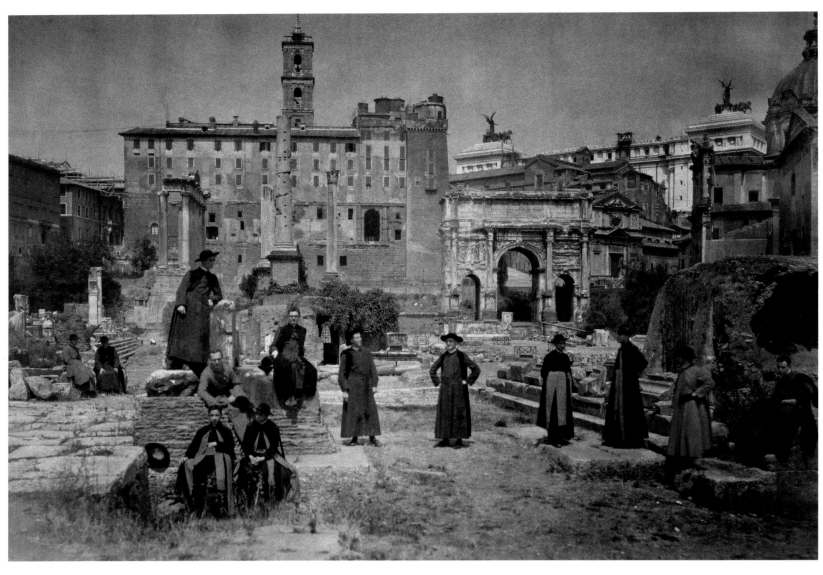

↑
Luigi Pellerano

Group of seminarians visiting the Roman Forum, 1937.

Seminaristen bei einem Ausflug am Forum Romanum, 1937.

Groupe de séminaristes visitant le Forum romain, 1937.

pp. 188/189
Luigi Pellerano

Group of seminarians in the courtyard of the German-Hungarian College, 1937.

Seminaristen im Hof des Collegium Germanicum-Hungaricum, 1937.

Groupe de séminaristes dans la cour du Collège germano-hongrois, 1937.

→
Bernard F. Rogers

The Scala Regia of the Apostolic Palace is part of the ceremonial entrance to the Vatican. The barrel-vault colonnade designed by Bernini narrows at the top, a perspective that creates the illusion that the staircase is longer. There are three pontifical militias: the Palatine Guard, with their excellent marching band, who wear a uniform created 150 years ago; the Swiss Guard, in the red and yellow costume from the 16th century; and the Corps of Gendarmerie of the Vatican City, who wear a Napoleonic uniform, 1937.

Die Scala Regia markiert den zeremoniellen Eingang zum Papstpalast des Vatikan. Der säulenflankierte, tonnengewölbte Aufgang der von Bernini entworfenen Treppe wird nach oben hin schmaler, sodass die Raumflucht länger erscheint, als sie in Wirklichkeit ist. Der Vatikan verfügte über drei Garden: die Palastgarde mit ihrem exzellenten Spielmannszug in Uniformen aus der Mitte des 19. Jahrhunderts, die Schweizer Garde in ihrer rot-blau-gelben Tracht und die Gendarmerie in Uniformen aus napoleonischer Zeit, 1937.

La Scala Regia du palais apostolique marque l'entrée d'honneur du Vatican. Œuvre du Bernin, la colonnade surmontée d'une voûte en berceau se resserre au sommet, offrant ainsi une perspective forcée qui crée l'illusion d'un parcours plus long qu'il n'est en réalité. Les milices pontificales sont au nombre de trois : la garde palatine, à l'excellente fanfare et à l'uniforme remontant à la moitié du XIXᵉ siècle, la garde suisse, dans son magnifique costume rouge et jaune du XVIᵉ siècle, et les gendarmes, pour les services de police, dans leur grand uniforme napoléonien, 1937.

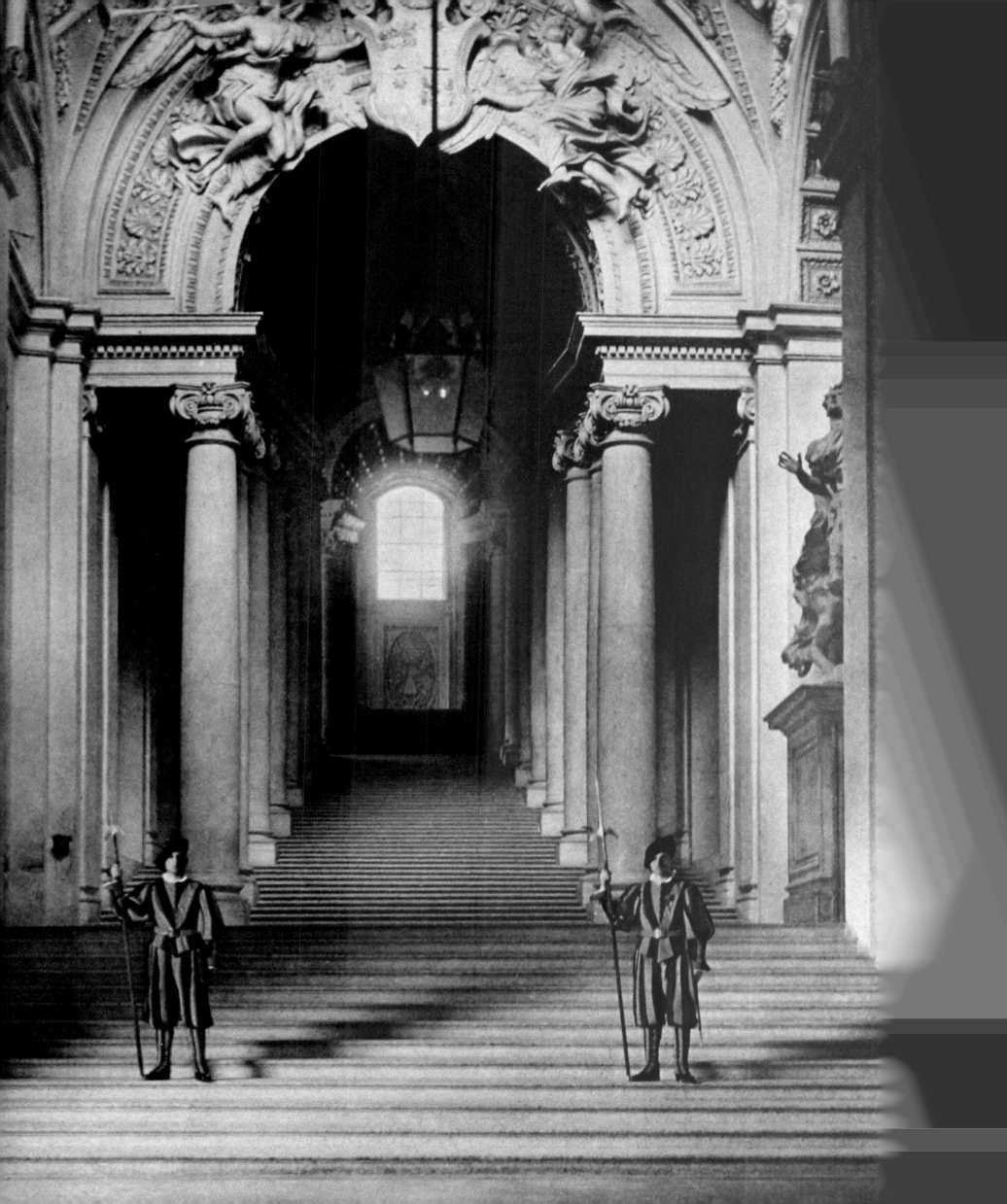

→
Istituto LUCE

Mussolini says goodbye to Hitler, who looks out of the window of the train taking him back to Germany at the end of his visit to Rome, May 1938.

Mussolini am Zug bei der Verabschiedung Hitlers nach dessen Rombesuch im Mai 1938.

Mussolini salue Hitler à la fenêtre du train qui le ramène en Allemagne au terme de sa visite, mai 1938.

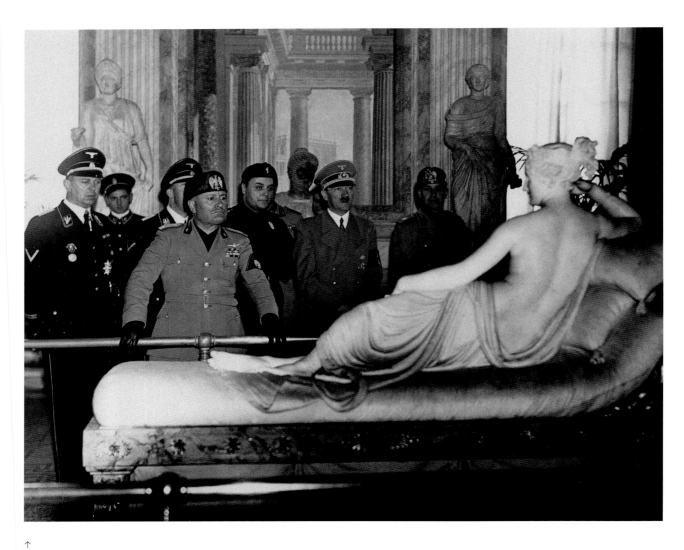

↑
Istituto LUCE

The Galleria Borghese. On the occasion of Hitler's visit in Rome, Mussolini and the Führer, accompanied by some Fascist and Nazi officials, admire the Canova's sculpture of Paolina Borghese. Between the two heads of state is the archeologist Ranuccio Bianchi Bandinelli, who guided the tour, and recalled in his private notes on Mussolini that "the oblique movements of his head attempt to conceal its massive bulk, but they are merely clumsy and sinister," and of Hitler as less repulsive, "composed, neat, almost servile, something like a street-car conductor," May 1938.

Bei seinem Rombesuch besichtigte Hitler in Begleitung Mussolinis sowie von faschistischen Partei- und deutschen SS-Größen die Villa Borghese, wo er Canovas Skulptur der Paolina Borghese bewunderte. Der römische Archäologe Ranuccio Bianchi Bandinelli, der ebenfalls zugegen war, notiert später, Mussolinis „schräges Kopfgewackel soll zwar verbergen, wie massig dieser ist, hinterlässt aber nur einen dümmlichen und finsteren Eindruck", während Hitler auf ihn offenbar weniger abschreckend, vielmehr „ernst, geordnet, fast servil, etwa wie ein Straßenbahnkontrolleur" wirkte, Mai 1938.

Galerie Borghèse : à l'occasion de la venue de Hitler à Rome, Mussolini et le Führer accompagnés de quelques hiérarques fascistes et de nazis admirent la Pauline Borghèse de Canova. Entre les deux chefs d'État, l'archéologue Ranuccio Bianchi Bandinelli joue le cicerone ; dans une note relative à la visite l'historien décrit Mussolini dont « la tête tenue penchée sur le côté, attitude censée atténuer son allure massive, produit un effet gauche et sinistre » et Hitler moins repoussant peut-être, « convenable, mesuré, presque servile, avec quelque chose d'un contrôleur de tram », 1938.

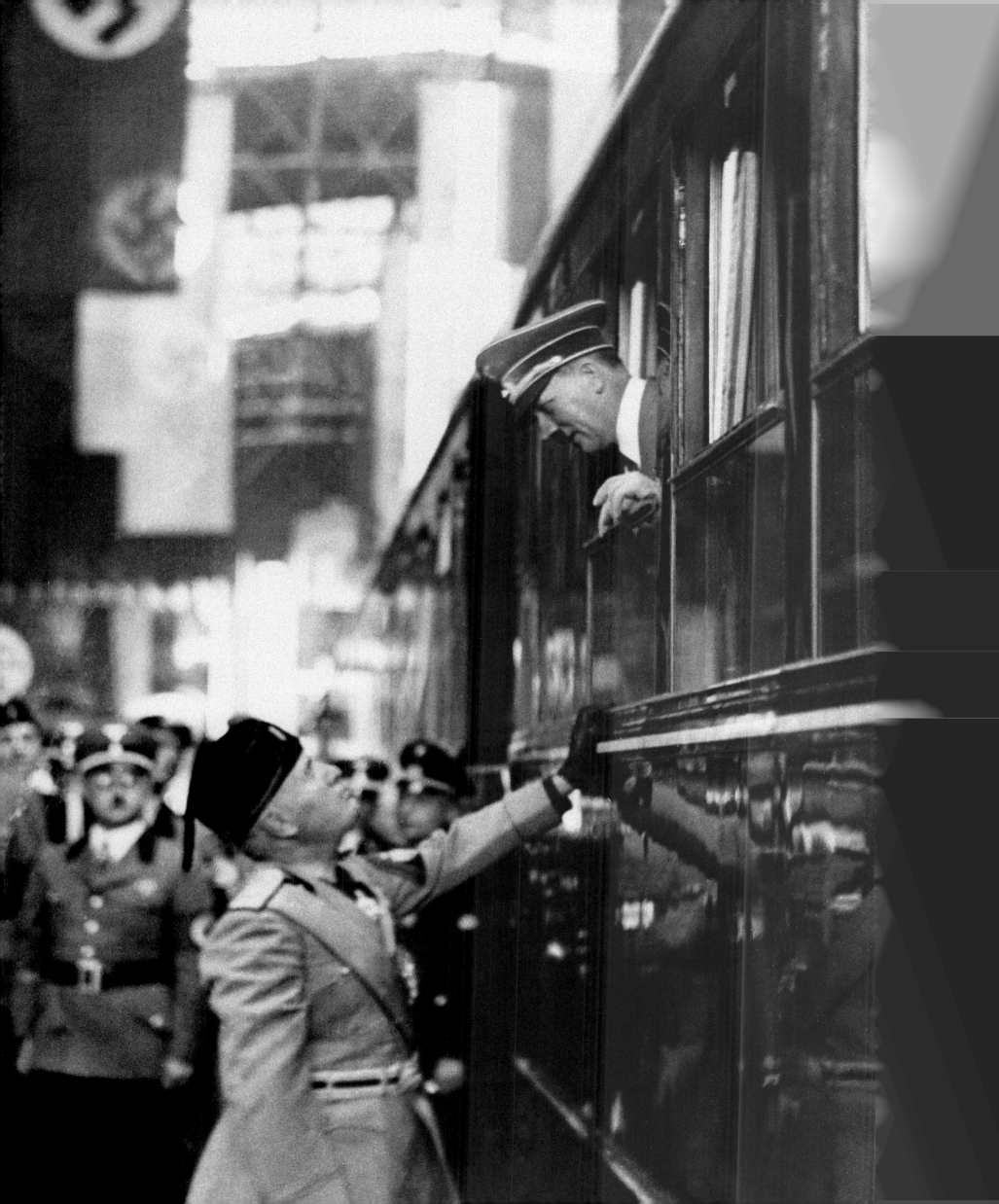

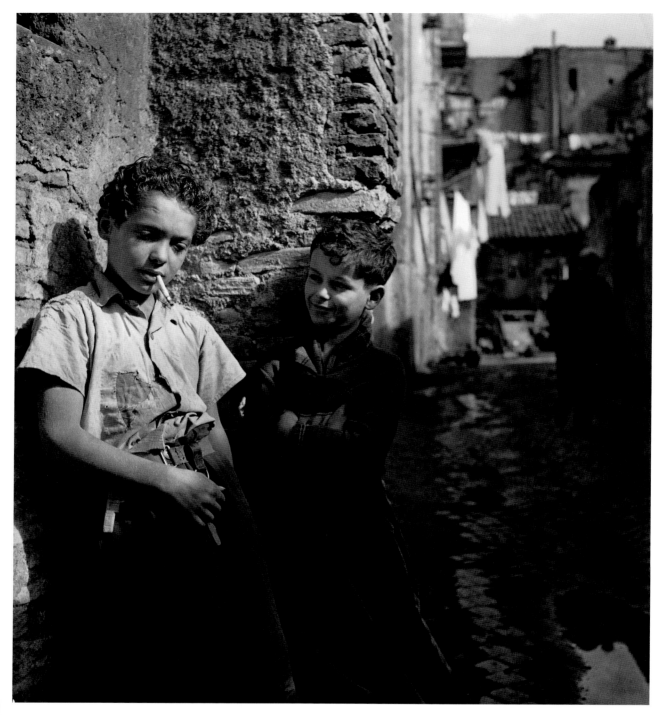

↑

Herbert List

Boys in the district of Trastevere, April 1939.

Gassenjungen in Trastevere, April 1939.

Enfants du quartier de Trastevere, avril 1939.

→

Istituto LUCE

Some passers-by, with a sergeant from the Italian Army, read the Notizie di Roma (News from Rome), *a wall poster hung by the Fascist Roman Federation, between some posters advertising movies, February 1942.*

Römische Passanten, darunter ein Korporal der italienischen Armee, lesen die öffentlichen Verlautbarungen der Notizie di Roma, *einer von der Federazione Fascista dell'Urbe verbreiteten Wandzeitung, flankiert von Kinoplakaten, 1942.*

Des passants et un sergent de l'armée italienne lisent un exemplaire des Notizie di Roma, *bulletin publié par la fédération fasciste de Rome et entouré ici de plusieurs affiches de film, février 1942.*

"[Rome] is the intelligence and the primitive spirit of the Italian stilled between two climates, two civilizations, two worlds, two cardinal points, north and south. The south has fossilized itself as if in a deep geological layer, the north frees itself from the ice."

„[Rom] ist die Intelligenz und die Ursprünglichkeit Italiens, eingeschlossen zwischen zwei Klimazonen, zwei Himmelsrichtungen, dem Norden und dem Süden. Der Süden ist dort zu Stein erstarrt wie eine geologische Tiefenschicht, der Norden befreit sich dort vom Eis."

« [Rome] est l'intelligence et le caractère primitif italiens pris entre deux climats, deux civilisations, deux mondes, deux points cardinaux, le nord et le sud. Le Sud s'est comme pétrifié dans une couche géologique profonde, le Nord s'est libéré du gel. »

CORRADO ALVARO, *ITINERARIO ITALIANO,* 1941

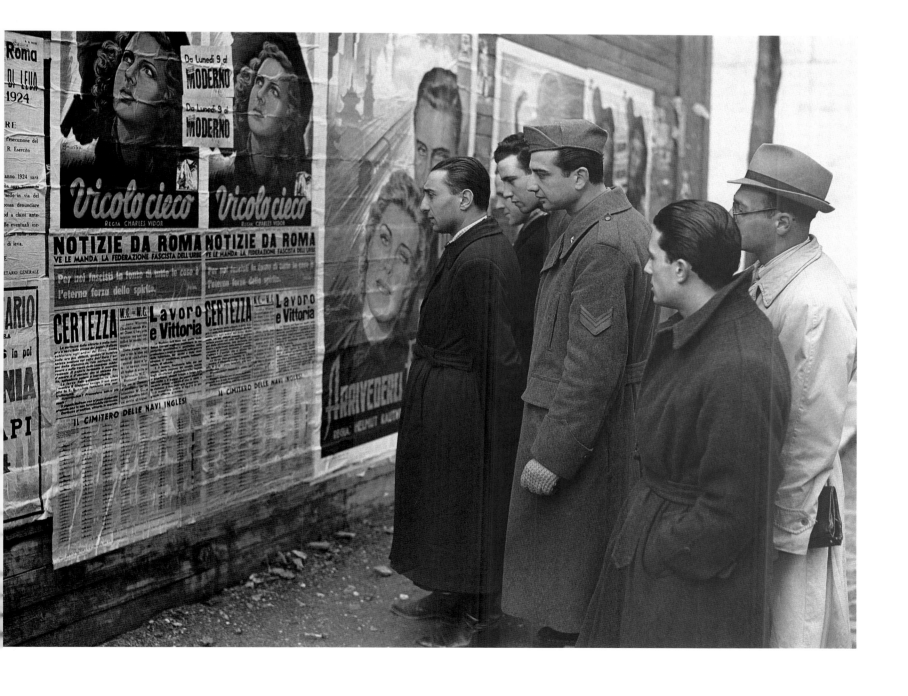

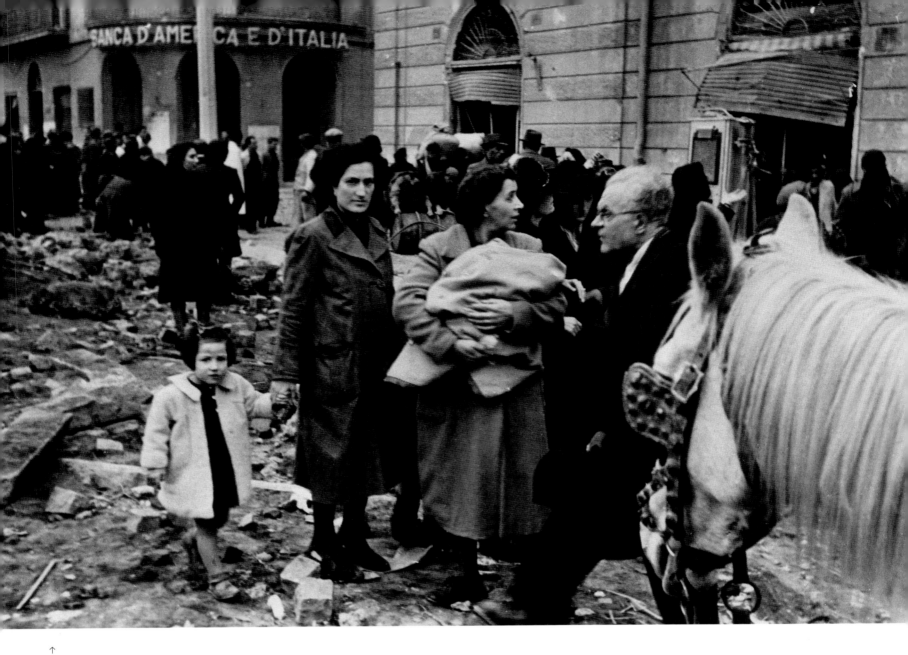

↑

Anonymous

*Between January and May 1944, Rome
suffered a series of devastating bombings by
the Allied forces.*

*Von Januar bis Mai 1944 wurde Rom
mehrfach Ziel massiver Bombenangriffe
der Alliierten.*

*Entre janvier et mai 1944, Rome subit
une série de violents bombardements par
les forces alliées.*

↓ →

Istituto LUCE

*The day after the first bombing of the city
by American planes, Pius XII went to meet
the citizens in Piazza San Lorenzo, eliciting
a strong emotional response, clearly visible
on the faces of the people in these celebrated
images. Wanting to demonstrate his solidarity,
the Pope showed a bundle of banknotes to the
crowd, promising that he would distribute
them, July 20, 1943.*

*Am Tag nach der Bombardierung der Stadt
durch amerikanische Flugzeuge am 19. Juli
1943, begibt Pius XII. sich zu den Menschen
auf die Piazza San Lorenzo – ein bewegender
Moment, wie auf den Gesichtern auf diesen
berühmt gewordenen Bildern eindringlich
ablesbar ist. Um seine Bereitschaft zu unmit-
telbarer Hilfe zu bekunden, hält der Papst ein
Bündel zur Verteilung bestimmter Banknoten
in die Höhe, 20. Juli 1943.*

*Au lendemain du premier bombardement de
la ville par les Américains, Pie XII alla à la
rencontre de la population sur la piazza San
Lorenzo, suscitant une vive émotion, clai-
rement visible sur les visages des personnes
figurant sur ces photographies qui devinrent
célèbres. Voulant exprimer concrètement sa
solidarité, le pape montra à la foule une
liasse de billets de banque dont il promit la
distribution, 20 juillet 1943.*

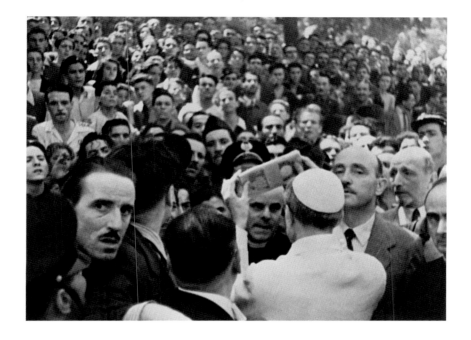

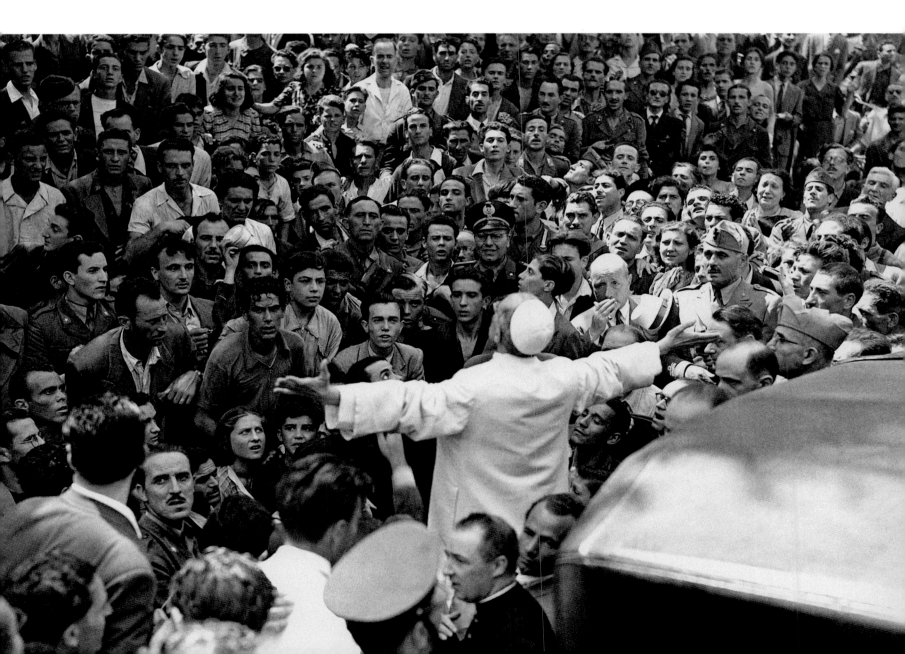

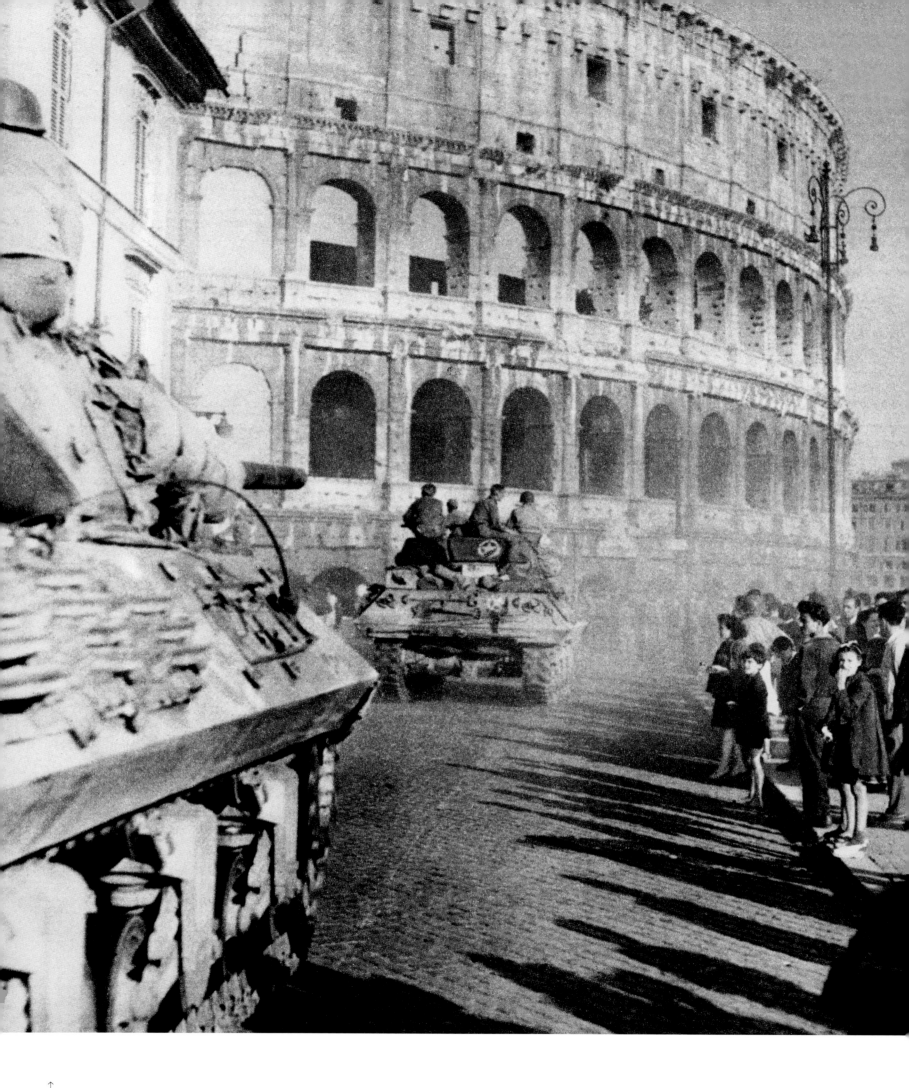

↑

Anonymous

"Auntie is sick and is about to die" was
the message in code transmitted by Radio
London in June 1944 to announce the
landing of the Allied forces on the coast near
Rome. American tanks parade in front of the
Colosseum, June 4, 1944.

„Die Tante ist krank und liegt im Sterben" –
mit dieser chiffrierten Nachricht über Radio
London wurde im Juni 1944 die Landung
alliierter Truppen an der Küste südlich von
Rom angekündigt. Amerikanische Panzer vor
dem Kolosseum, 4. Juni 1944.

« La tante est malade, elle va mourir », tel fut
le message codé transmis par Radio Londres
en juin 1944 pour annoncer le débarquement
des forces alliées sur les côtes proches de
Rome. Des chars américains défilent devant
le Colisée, 4 juin 1944.

Anonymous

On a street in the historic center, an elderly woman holds up the American flag as the troops of liberators parade, June 1944.

Im römischen Stadtzentrum begrüßt eine alte Dame die Befreier mit einer US-Flagge, Juni 1944.

Dans une rue du centre historique, une femme âgée brandit le drapeau américain lors du passage des libérateurs, juin 1944.

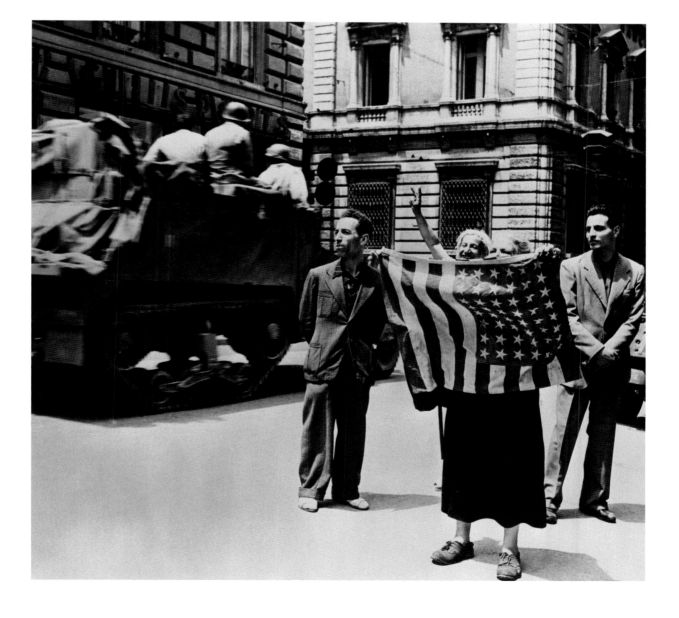

198

→
Anonymous

A man destroys the coat of arms featuring the
Fascio Littorio on the façade of the Ministry
of Finance; the flag with the Italian colors
and the Savoy coat of arms hangs from the
balcony, July 26, 1943.

Mit dem Vorschlaghammer werden die
Insignien des Faschismus von der Fassade des
Finanzministeriums geschlagen, vom Balkon
ist bereits die italienische Nationalflagge mit
dem Wappen des savoyischen Königshauses
gehisst, 26. Juli 1943.

Un homme détruit à coups de masse les
armoiries avec le faisceau de licteur fixées
sur la façade du ministère des Finances;
au balcon flotte le drapeau tricolore avec
les armoiries de la maison de Savoie,
26 juillet 1943.

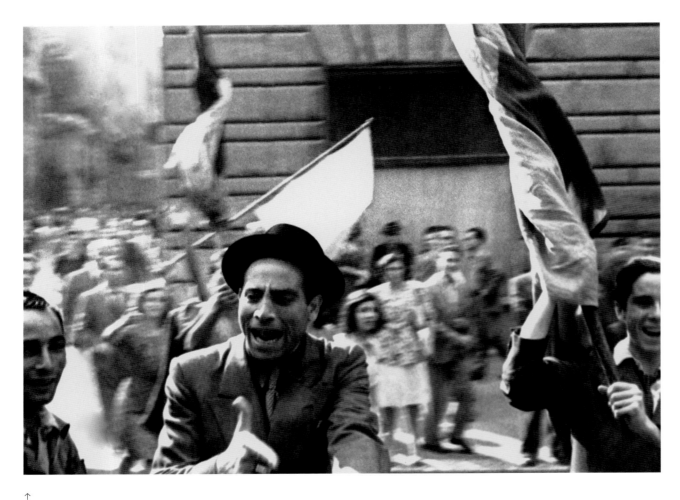

↑
Istituto LUCE

People rejoicing at the news of the fall
of Mussolini and the formation of the
government of General Pietro Badoglio,
July 26, 1943.

Die Bevölkerung reagiert auf die Nachricht
vom Sturz Mussolinis und der Bildung der
Regierung des Generals Pietro Badoglio mit
Jubel, 26. Juli 1943.

La population exulte à l'annonce de la
chute de Mussolini et de la formation du
gouvernement du général Pietro Badoglio,
26 juillet 1943.

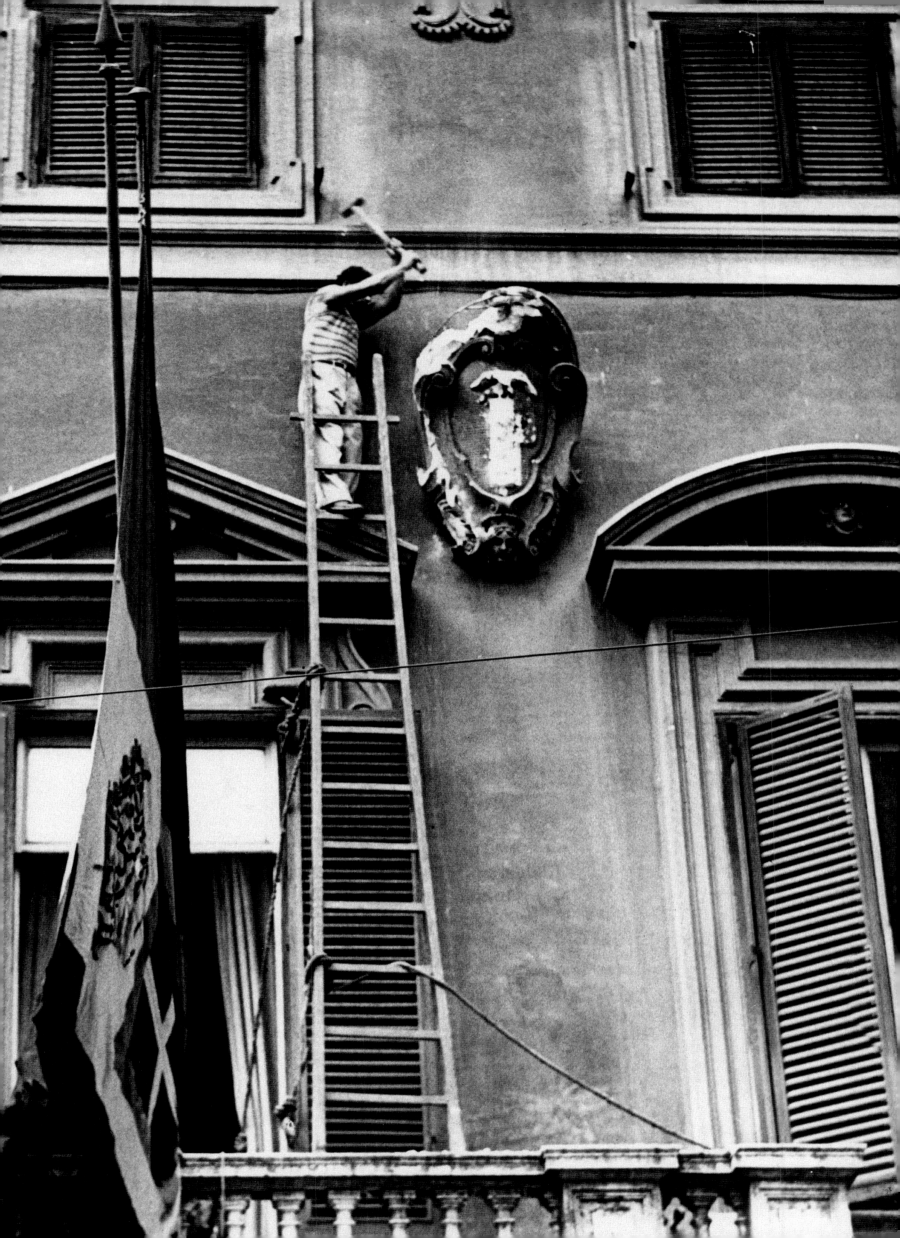

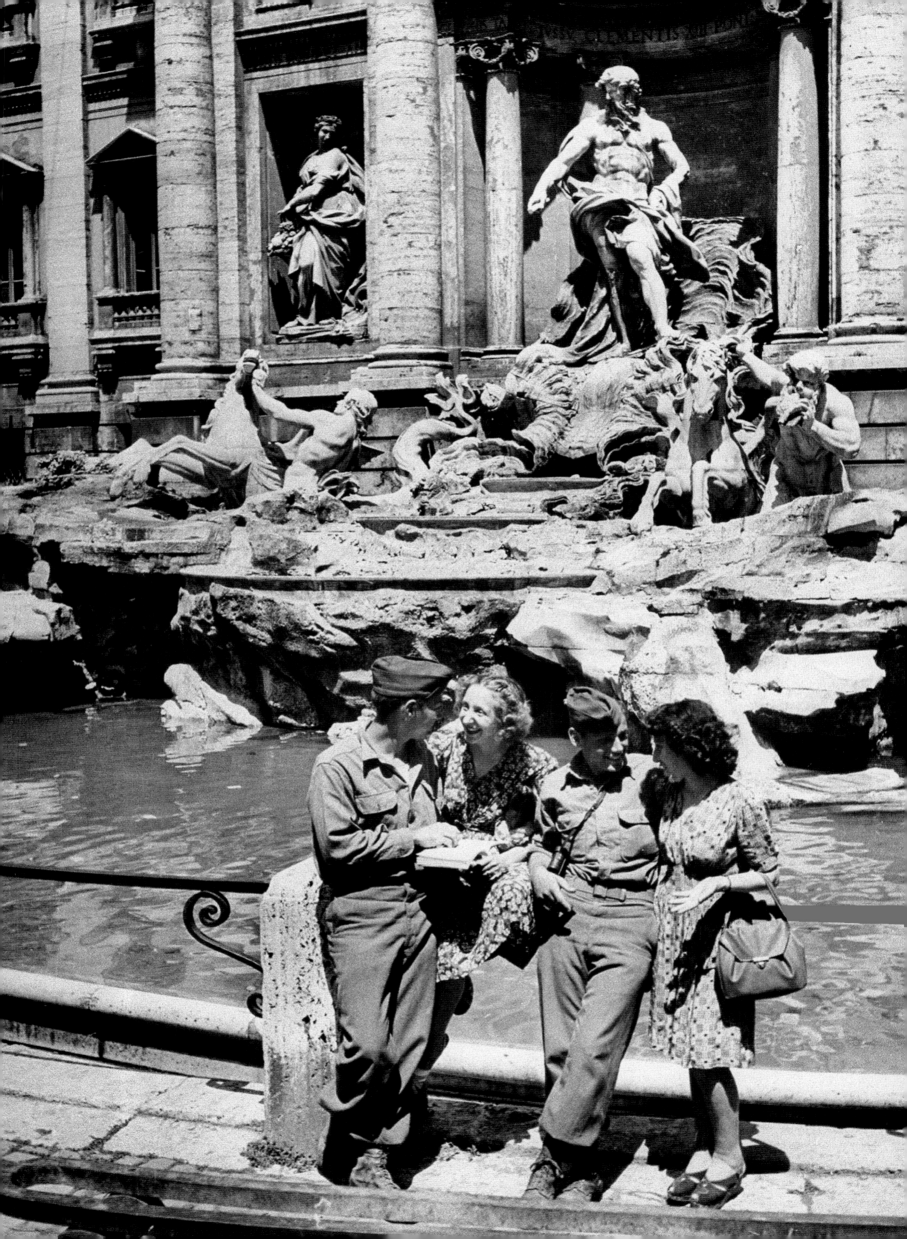

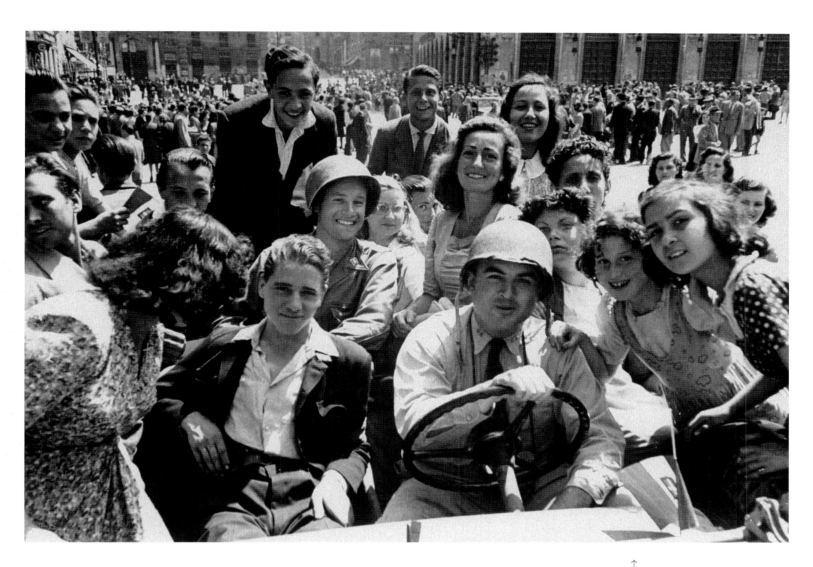

↑
Carl Mydans

Romans invade the streets and the squares, celebrating, weeping with joy, shouting and applauding the "liberators," June 4–5, 1944.

Um ihre „Befreier" zu begrüßen, strömen die Römer auf die Straßen und Plätze der Stadt, jubeln und weinen vor Freude, 4./5. Juni 1944.

Les Romains envahissent les rues et les places, exultent, pleurent de joie et acclament leurs « libérateurs », 4–5 juin 1944.

pp. 202/203
Bernard F. Rogers

Via Appia Antica, 1937.

←
Carl Mydans

American soldiers and young Roman women in front of the Trevi Fountain, June 1944.

Amerikanische Soldaten mit jungen Römerinnen vor dem Trevibrunnen, Juni 1944.

Soldats américains et jeunes Romaines devant la fontaine de Trevi, juin 1944.

4

From Neorealismo *to* La Dolce Vita *and the Economic Miracle* 1945–1967

"Roman citizens have Jewish roots, ... they derive from ancient slaves and freed slaves from the Orient. So there is a very eastern air in the eternal city: a lot of beauty and laziness. Soraya and Farouk almost feel at home here."

PIER PAOLO PASOLINI, IN WILLIAM KLEIN, *ROME*, 1959

After the war, recovery was hard. The rationing of pasta and bread came to an end only in 1949; the United States sent tons of secondhand clothes, distributed by the UNRRA (United Nations Relief and Rehabilitation Administration).

The Galleria Nazionale d'Arte Moderna reopened in December 1944. From 1945 until 1975 its director was Palma Bucarelli, a charismatic and insightful woman who improved its collections with new acquisitions and organized important exhibitions on both Italian and foreign themes.

The mass audiences wanted light entertainment, dance revue – so dear to Federico Fellini – comic theater, cinema and photo storybooks. In 1954 television was added to the list of entertainment available to the masses. In 1949 Louis Armstrong landed at Ciampino airport, where he was welcomed by the Roman New Orleans Jazz Band.

Between 1945 and 1968, the social and urban landscape, full of contradictions, was changing at a tireless pace.

On April 18, 1948, Italy held its first political elections. Voters could choose between the Christian Democrats (DC, Democrazia Cristiana) and Social Communism; between the USA and the USSR, between capitalism and socialism. The Church intervened, with Pius XII's appeal: "For Christ or against Christ, for his Church or against the Church. Wake up, Romans! The time has come for many of you to awaken from a long slumber." The Christian Democrats obtained a resounding victory, especially in Rome. In the same year, conforming with the Pope's wish to make Rome the capital of the Christian world, the Christian Democratic mayor Salvatore Rebecchini consecrated the city to the Immaculate Heart of Mary, in front of a crowd of 500,000 people gathered at the Campidoglio.

In 1949, following a bitter dispute in parliament and public demonstrations, Italy joined NATO. The Sant'Uffizio (the Holy Office, Congregation for the Doctrine of the Faith) decreed that communists, their allies, and even those who read newspapers associated with them, would be excommunicated. The city greeted this decree with indifference; many parish priests continued to baptize the children of communists and to celebrate their marriages. In July 1950 the Christian Democrat MP Oscar Luigi Scalfaro (who in 1992 became the president of the Italian Republic), had a lively altercation in a restaurant with a lady who "was showing too much cleavage." Orders were issued to cover the genitalia of statues in the Foro Italico with plaster. In 1950 Rome

celebrated the Holy Year; in 12 months 600 trains carrying pilgrims arrived in the capital city; Via della Conciliazione opened.

In this climate of liberation and hope following the difficult period after the war, some film directors chose to represent ordinary daily life, the privations and suffering of the Italian people from the war to the period of the reconstruction. Roberto Rossellini produced *Paisà* (1946) and *Roma città aperta* (*Rome Open City*, 1948). In 1948 *Ladri di biciclette* (*Bicycle Thieves*) by Vittorio De Sica came out, featuring amateur actors. This was the beginning of the great season of *neorealismo* (neo-realism). There was also a literary neo-realism: Pier Paolo Pasolini's *Ragazzi di vita* (*Street Kids*, 1955) is considered one of the masterpieces of Italian literature.

The 1951 census of Rome listed just over 1.5 million residents. Many houses did not have electric appliances yet. There were few vehicles; the main means of transport was the bicycle; the Vespa (1946) and the Lambretta (1947) were not only a means of transport, but also a new way of being: young people used these scooters to travel to secluded places or to the beach to make love; often one scooter was the shared property of three or four people. Fiat produced the 600 car, a *utilitaria* (from the *utilità* or benefit of cost versus fuel consumption), a vehicle that, like the Vespa and Lambretta, and later the 500, became iconic, both for its ingenious design and also for the role it played in changing social customs. In 1953, in the advertisement of the new Fiat 1100, for the first time a woman appeared at the steering wheel.

After the 1951 census the city population increased by about 100,000 people every year, the majority being southern Italians looking for work. They lived in the *borgate* (suburbs, shantytown neighborhoods), or within the walled-up arches of the ancient Roman aqueducts. By the end of the 1950s, there were about 400,000 immigrants. Within ten years, Rome doubled in geographical size and population.

The streets and piazzas were the true home of the Romans. During the warm summer evenings taverns, bars, trattorias, and dairy shops were turned into cafés and spread out on pavements, taking up as much space as traffic would allow, by means of an agile system of small tables and portable chairs. Coffee had several variants: *espresso, cappuccino, caffè-latte* (latte), *corretto* (with a shot of liquor), *misto* (coffee topped with whipped cream), *freddo con panna* (ice coffee with whipped cream), *freddo con gelato sopra* (ice coffee topped with ice cream).

←
Istituto LUCE

At the end of the 1920s, immigrants and citizens who had been driven out from the historic center after the first demolition works settled in the district of Garbatella, in brick houses partly built by the Istituto Case Popolari (Institute for Public Housing) and in wooden shacks: Borgata di Tor Marancia, demolished from 1948 in accordance with a law on the revitalization of the districts, 1947.

Ende der 1920er-Jahre zogen viele durch die Sanierungsmaßnahmen in der römischen Altstadt aus ihren Häusern vertriebene Römer und Zuwanderer von außerhalb in von der Wohnungsbaugesellschaft des Istituto Case Popolari errichtete Backsteinhütten und

Holzbaracken in der Garbatella-Gegend; hier die Siedlung von Tor Marancia, mit deren Abriss auf Grundlage eines Gesetzes zur Sanierung der römischen Vororte 1948 begonnen wurde, 1947.

À la fin des années 1920, les habitants expulsés du centre historique à la suite des premières démolitions et les immigrants s'installèrent dans le quartier de Garbatella, dans des maisonnettes en dur construites en partie par l'Istituto Case Popolari et dans des baraques en bois : ici, la Borgata di Tor Marancia, démolie à partir de 1948 en application d'une loi sur l'assainissement des faubourgs, 1947.

"Nylon stockings are an inexpensive investment, but if they get snagged there are hundreds of small shops, or dark little janitor's lodges where, for a few *liras*, they can be mended…" (Miriam Mafai, 2002). Mink fur became a status symbol; in 1956 Glauco Pellegrini even dedicated a film to this subject, *Una pelliccia di visone*.

From the early 1950s "made in Italy" became an established concept. The great Roman dressmakers were creative and had a talent for reworking French fashion. The Sorelle Fontana (the sisters Giovanna, Micol and Zoe Fontana) designed clothes for Ava Gardner, as well as Linda Christian's wedding dress when she married Tyrone Power (1949) – called "the wedding of the century" in the newspapers (the police stopped thousands of onlookers from invading the church) – and created the "priestly" dress for Anita Ekberg in *La dolce vita*. They also designed dresses for Palma Bucarelli, the director of the Galleria Nazionale d'Arte Moderna.

In 1947 the beauty contest to elect Miss Roma began – the contestants had a shot at celebrity in show business. The sensual and curvaceous divas of Italian cinema Silvana Mangano (Miss Roma 1947), Sophia Loren, and Gina Lollobrigida were sex symbols for men all over the world. Posters with their images invaded the city.

During the 1960s, Rome hosted some historic musical events: The Beatles played live in 1965, as did the Rolling Stones in 1967. The Piper Club became a symbol for the Roman youth and a model for similar venues in other Italian cities.

The Roman architects of the reconstruction period were the same ones active during the Fascist years. Marcello Piacentini, in spite of his well-known ties with the Fascist regime, nonetheless was entrusted with building Via della Conciliazione.

The new Termini station (1950) and the Stadio Olimpico (1951) were built. The first line of the Roman subway, begun in 1937 but interrupted during the war, opened in 1955. To reduce social tensions, after the war politicians focused on the construction business as the driving force of economic recovery, and on the sale of homes and on citizens' job stability. During the 1950s, several state-financed districts were built, including Valco San Paolo, Tuscolano, and Tiburtino. The 1960 Olympics presented the occasion to build sport complexes and the Olympic Village.

Rome was a lively center of artistic activity during the 1950s. In Via Margutta, artists' studios were side by side (Carla Accardi, Afro Basaldella, Giulio Turcato, Franco Gentilini, Mario

Mafai, Alberto Burri). The art debate centered on the contrast between abstract art and Renato Guttuso's realism, the latter enjoying the overt support of the Italian Communist Party. Every painting by Guttuso represents an event (tours on a Vespa, beaches, boogie-woogie in Rome, etc.). Artists, writers, directors, and intellectuals gathered at Caffè Greco, in Via Condotti, or at bar Rosati in Piazza del Popolo, the Osteria Menghi on the Via Flaminia, the Libreria Rossetti in Via Veneto. The private galleries L'Obelisco and La Tartaruga often exhibited European artists, but especially artists from the US living in Rome, and who were not well known at the time: Willem De Kooning, Mark Rothko, Franz Kline, Robert Rauschenberg – the latter was profoundly struck by a *Sacco* by Alberto Burri. Picasso's 1953 exhibition enjoyed a positive response from the neo-realists; and at the opening of his 1954 exhibition of scandalous work at the Casino dell'Aurora in Palazzo Pallavicini at the Quirinale, Salvador Dalí emerged from a cube inscribed with hermetic signs. Galleries provided another effective launching pad for Roman artists onto the international market.

Around the mid-1950s there were signs of a positive economic development and a dynamic society. In people's homes, in a physical as well as a metaphorical sense, television replaced the radio, and small, portable transistor radios became popular. In 1955 a new TV show entitled *Lascia o raddoppia? (Double or nothing?)* hosted by Mike Bongiorno was the first big television success. Pius XII warned the clergy to be vigilant about this new medium of communication entering people's homes. And between 1960 and 1970 television did produced a social transformation, encouraging Italians to conform to a petit bourgeois identity, a phenomenon lamented by Pasolini.

In 1959 London's *Daily Mail* used the term "economic miracle" for the first time when talking about Italy. In Rome, this meant primarily that the housing market was undergoing an abnormal development. Rome's city planning (PRG = Piano Regolatore Generale [General City Planning Scheme]) was under discussion for eight years: from 1954 to 1962. In the meantime, the new "sack of Rome" took place: at the end of the 1950s the residents of the center of Rome were mostly the descendants of aristocratic families, or ordinary people and American citizens; the wealthier middle class moved to the district of Parioli and surroundings; the immigrants, the unemployed, and the illiterate folks lived in the suburbs.

In 1958 the pope's physician sold photographs of Pius XII on his deathbed. The "Merlin" law came into effect, decreeing the closure of brothels; at the Rugantino, a nightclub in Trastevere, during a private party a Turkish dancer, Aïché Nana, improvised a striptease; and an outdoor performance of *Aida* at the Baths of Caracalla was the artistic event of the year. "The party on Via Veneto began, with crowds of intellectuals, exiled kings, girls seeking their fortune, directors looking for girls, and photographers looking for exiled kings, for directors, for great actresses and for girls who would become actresses" (Miriam Mafai, 2002).

The fascination of the Eternal City, its climate, its urban landscape and human characters, local habits, cuisine, even its backwardness in comparison with the efficiency of other countries at the time – in short, a different and picturesque world – created the myth of "Roman style," so appealing to tourists from all over the world.

Fellini's *La dolce vita* came out in 1960. Partly news coverage, satire, drama, and comedy, this film transcended neo-realism and opened the way to comedy "*all'italiana*" (in the Italian style). On set, Fellini appointed as his stage photographer Pierluigi Praturlon, the *paparazzo* who had taken the image appearing at the opening of *La ciociara* (1960) – the film that gave Sophia Loren her Hollywood breakthrough – so that he could instruct the actors playing the parts of the photojournalists hunting for a scoop on how to act their roles. Before they were called *paparazzi*, the tabloid photojournalists working seeking a scoop were called *scattini* ("snappers"); many of them were from the suburbs of Rome. After learning his trade from Adolfo Porry-Pastorel, Tazio Secchiaroli, who was the manager of Roma Press Photo, with Elio Sorci, became famous for photographing Aïché Nana's striptease. Actors sometimes would go to Via Veneto to get a chance to be photographed, and sometimes they even staged fights to attract attention to themselves.

With three masterpieces in the early 1960s – *Accattone*, *Mamma Roma,* and *La Ricotta* – Pier Paolo Pasolini established himself as the greatest director in the history of Italian cinema. The comedies *all'italiana* by directors like Dino Risi or Ettore Scola were a genre that became successful both in Italy and abroad. The limitation of this type of comedy *all'italiana* (to be fair, *alla romana*) was to illustrate the virtues and defects typical of Romans, often treating them with indulgence and complacency.

Rome during the 1950s, at the time of *la dolce vita*, found its visual reflection in photography. In 1959 William Klein arrived in Rome; he had just published *Life is Good & Good for You in New York*. He was supposed to collaborate with Fellini on *The Nights of Cabiria* as assistant director, but filming was delayed, so he travelled around Rome taking photographs in the company of Fellini, Pasolini, Alberto Moravia, Ennio Flaiano, and other writers and directors of this remarkable generation of Italian artists. Pasquale De Antonis excelled in his ingenious conception and elegance of fashion photography images. Illustrated periodicals like *Il Mondo* (1949–1966) and *L'Espresso* (1955) published photographs of a high caliber, thanks to the involvement of some leading photographers.

↗

Kurt Hutton

Pietralata, a township built during the Fascist period, a symbol of the Roman resistance against the Nazi-Fascists in the final years of World War II, memorably portrayed in Pasolini's novels: a house could consist of a single room that could accommodate up to ten people, 1948.

Die in den Jahren des Faschismus entstandene Vorstadtsiedlung Pietralata wurde gegen Ende des Kriegs zum Symbol des Widerstands gegen die Razzien der deutschen Besatzer und ihrer italienischen Helfershelfer. Pasolini hat sie in seinen Romanen beschrieben: Einraumwohnungen für bis zu zehn Personen, 1948.

Construit sous le fascisme, symbole de la résistance romaine aux ratissages des nazis-fascistes durant les dernières années de la Seconde Guerre mondiale, le faubourg de Pietralata est évoqué de manière frontale dans les romans de Pasolini: une habitation est constituée d'une unique pièce qui peut accueillir jusqu'à dix personnes, 1948.

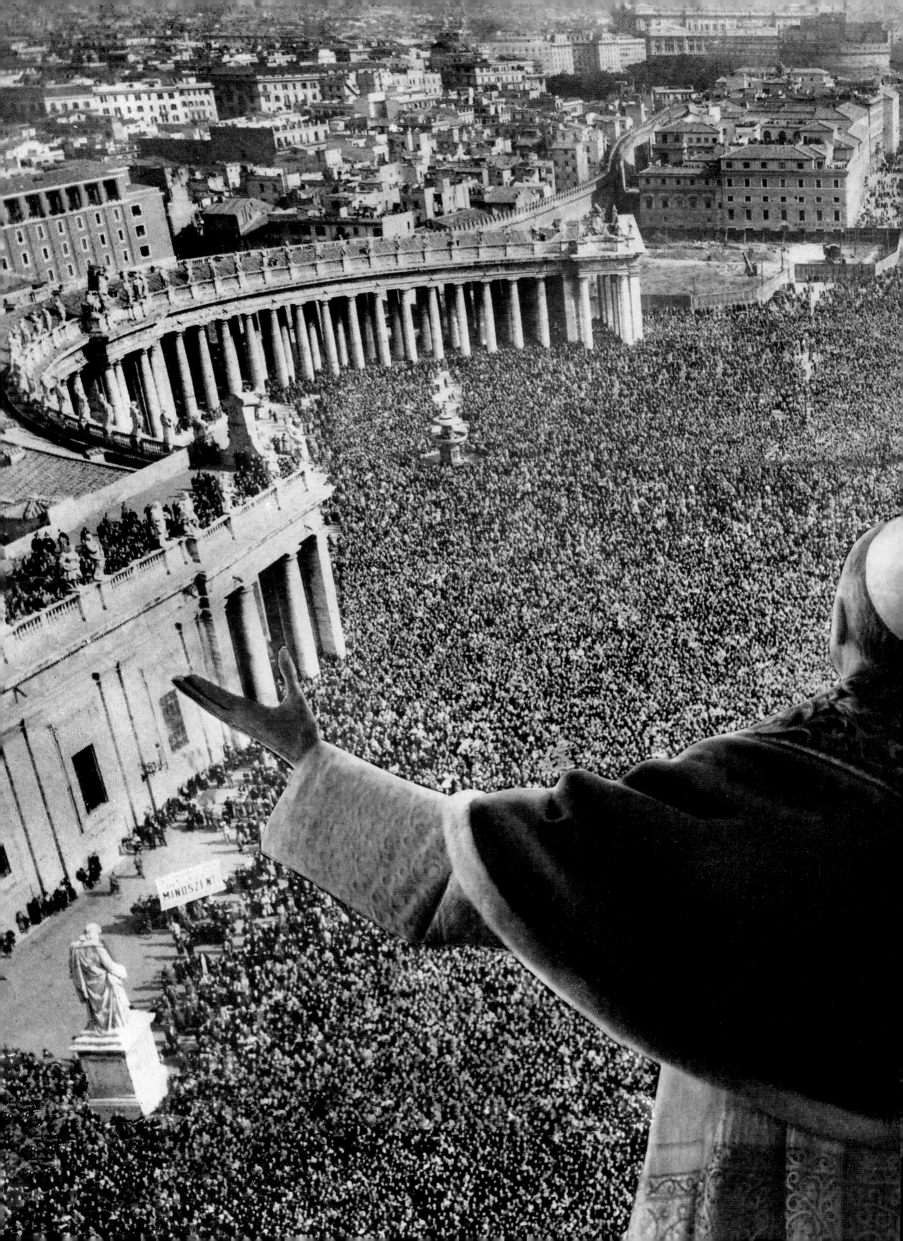

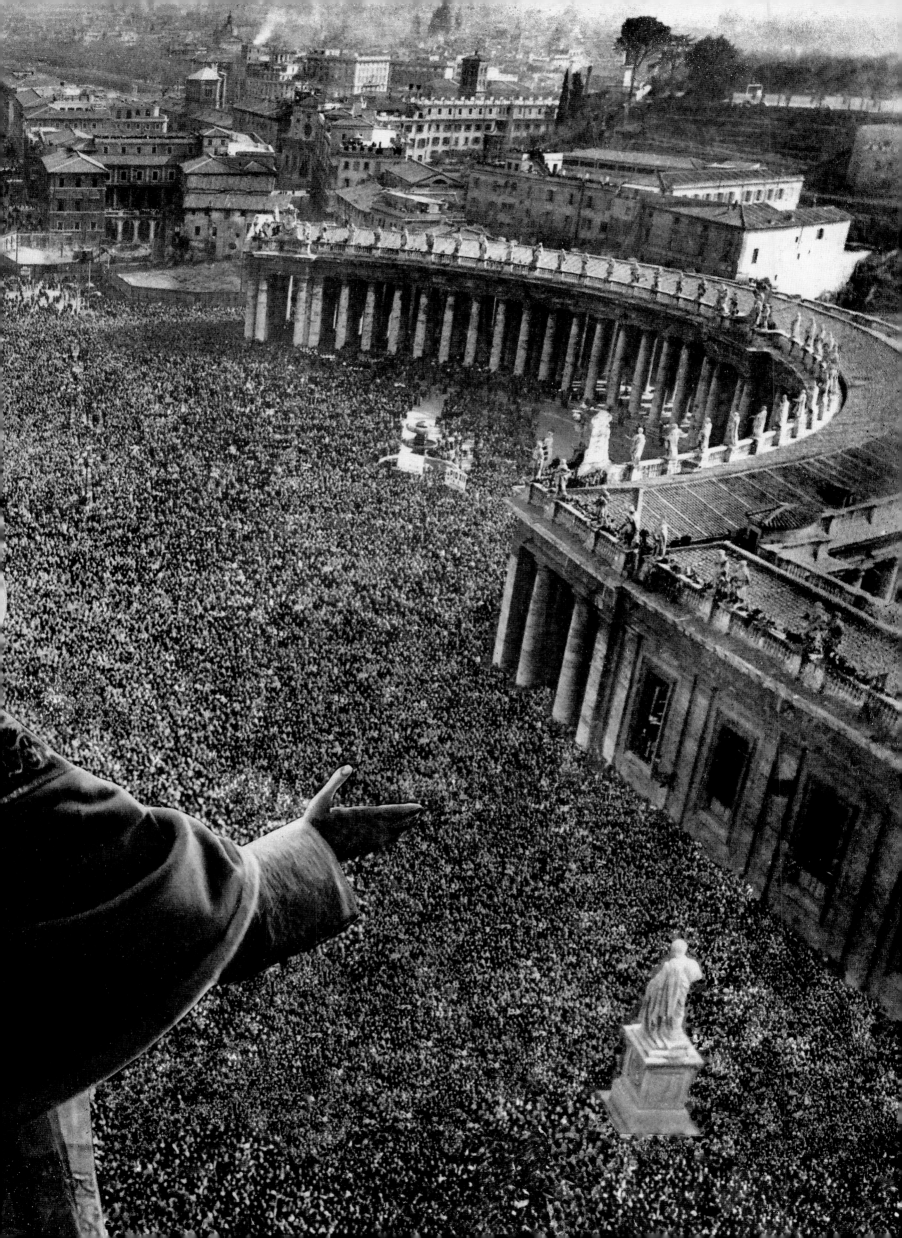

4

Neorealismus, Dolce Vita, Wirtschaftswunder 1945–1967

pp. 208/209
Albert Harlingue

Pius XII gives the Urbi et Orbi *blessing to the faithful gathered in St. Peter's Square, 1950.*

Pius XII. erteilt den auf dem Petersplatz versammelten Gläubigen den Segen Urbi et Orbi, *1950.*

Pie XII donne la bénédiction urbi et orbi *aux fidèles rassemblés sur la place Saint-Pierre, 1950.*

„Die Römer haben jüdische Wurzeln, oder sie stammen… von orientalischen Sklaven und Freigelassenen der Antike ab. Deshalb herrscht in Rom eine ausgesprochen levantinische Atmosphäre: viel Schönheit und viel Trägheit. Soraya und Faruk können sich hier wie zu Hause fühlen."

PIER PAOLO PASOLINI IN WILLIAM KLEIN, *ROME*, 1959

Nach dem Krieg kommt Rom nur langsam wieder auf die Beine. Erst 1949 wird die Rationierung von Pasta und Brot aufgehoben, die Flüchtlingshilfsorganisation der UNO lässt tonnenweise Kleiderspenden aus den USA verteilen.

Im Dezember 1944 öffnet die Galleria Nazionale d'Arte Moderna wieder ihre Tore, von 1945 bis 1975 leitet sie Palma Bucarelli, eine faszinierende, mit großem künstlerischen Sachverstand begabte Persönlichkeit. Ihr gelingt es, die Sammlung durch Neuerwerbungen auszubauen und wichtige Ausstellungen mit italienischer und internationaler Kunst auszurichten.

Nummernrevuen und Varieté – die Welt von Federico Fellinis erstem Film – erfreuen sich großer Beliebtheit; breiten Anklang finden auch Komödien, Kino und Fotoromane sowie, seit 1954, das Fernsehen. Als Louis Armstrong 1949 auf dem Flughafen von Ciampino landet, erwartet ihn dort die Roman New Orleans Jazz Band.

Die Jahre von 1945 bis 1968 bringen gesellschaftliche Umbrüche und soziale Gegensätze, das Gesicht der Stadt verändert sich unaufhaltsam. Am 18. April 1948 finden in Italien die ersten Parlamentswahlen statt. Der Wähler steht vor der Entscheidung zwischen Sozialisten und Kommunisten auf der einen und Democrazia Cristiana (DC) auf der anderen Seite, zwischen USA und UdSSR, zwischen Kapitalismus und Sozialismus. Die Kirche schaltet sich in den Wahlkampf ein, Pius XII. mahnt die Römer: „Für Christus oder gegen Christus, für seine Kirche oder gegen die Kirche. Erwachet – für nicht wenige von euch hat die Stunde geschlagen, sich aus einem langen Schlaf zu erheben." Die DC gewinnt die Wahlen landesweit mit deutlichem Vorsprung, am deutlichsten in der Hauptstadt. Im selben Jahr vollzieht Salvatore Rebecchini, der christdemokratische Bürgermeister von Rom, vor 500 000 am Kapitol versammelten Menschen die „Weihe der Stadt an das Unbefleckte Herz der Gottesmutter Maria" – dahinter steht das Bestreben des Papstes, Rom wieder zur Hauptstadt der Christenheit zu machen.

1949 tritt Italien nach heftigen parlamentarischen Auseinandersetzungen und Straßenprotesten der NATO bei. Das Heilige Offizium erklärt die Kommunisten, ihre Verbündeten sowie sämtliche Leser der kommunistischen Presse für exkommuniziert (in der Stadt wird das Dekret der Nachfolgeorganisation der Inquisition allerdings mit Gleichmut aufgenommen, etliche Pfarrer trauen weiterhin ungerührt kommunistische Brautleute und taufen deren Kinder). Im Juli 1950 liefert sich Oscar Luigi Scalfaro

(1992 zum Staatspräsidenten gewählt) in einem Restaurant einen erregten Wortwechsel mit einer Dame, die – nach Ansicht des Christdemokraten – ein zu tief ausgeschnittenes Kleid trug. Die Genitalien der Statuen am Foro Italico werden mittels Gips verhüllt.

1950 beherbergt Rom die Feierlichkeiten zum Heiligen Jahr. In zwölf Monaten erreichen 600 Pilgerzüge die Hauptstadt. Die noch unter Mussolini begonnene, auf St. Peter zuführende Via della Conciliazione wird eingeweiht.

In diesem Klima der Befreiung und zugleich schwierigen Situation unmittelbar nach Kriegsende, wendet sich eine Handvoll Filmregisseure der ungeschminkten Darstellung des Alltags zu und schildert die Entbehrungen und Leiden der Italiener in der Zeit vom Kriegseintritt 1940 bis zum Wiederaufbau. Den Anfang macht Roberto Rossellini 1946 mit *Paisà*, gefolgt von *Rom, offene Stadt* 1948; im selben Jahr kommt Vittorio De Sicas *Fahrraddiebe* in die Kinos: Die meisten Rollen sind mit Laiendarstellern besetzt. Die große Zeit des italienischen Neorealismus hat begonnen. Neorealismus auch in der Literatur: 1955 erscheint Pasolinis *Ragazzi di vita*, eines der Meisterwerke der italienischen Nachkriegsliteratur.

Die Volkszählung von 1951 ergibt eine Einwohnerzahl von knapp über 1,5 Millionen. Privatautos sind auf Roms Straßen nur spärlich unterwegs, man fährt Fahrrad, in den Haushalten gab es kaum Elektrogeräte. Vespa (1946) und Lambretta (1947) verändern nicht nur den Individualverkehr, sondern auch das Privatleben, mit ihrer Hilfe können die jungen Leute ans Meer fahren oder ein lauschiges Plätzchen außerhalb der Stadt aufsuchen, um sich dort der Liebe hinzugeben. Nicht selten legt man zu dritt oder zu viert zusammen, um einen Motorroller zu kaufen und ihn zu teilen. Wie Vespa und Lambretta vor ihm und der Cinquecento nach ihm erreicht der Fiat 600 mit seinem genial einfachen Design bald Kultstatus und hat Einfluss auf die gesellschaftlichen Verhältnisse. Die Werbung für den neuen Fiat 1100 zeigt 1953 das erste Mal eine Frau am Steuer.

Von 1951 an steigt die Einwohnerzahl jedes Jahr um gut 100 000, die meisten davon Zuwanderer aus dem italienischen Süden auf der Suche nach Arbeit. Sie ziehen in die *borgate*, die Trabantensiedlungen am Stadtrand, manche richten sich in den zugemauerten Bogen der bis ins Stadtzentrum reichenden antiken Aquädukte ein. Ende der 1950er-Jahre leben rund 400 000 Zugezogene: In zehn Jahren verdoppeln sich Flächenausdehnung

←
Istituto LUCE

*A glimpse in the Feast of St. Joseph (or
Father's Day) in the Trionfale district: a street
seller of porchetta (a whole pig, emptied,
boned, stuffed and roasted on the spit), the
traditional food of this annual festival,
March 1954.*

*Vatertag (am 19. März, dem Festtag des
heiligen Joseph) im Quartiere Trionfale; eine
Straßenhändlerin bietet das dazugehörige
Gericht an: porchetta, gefüllter und gerollter
Schweinebraten, ursprünglich aus einem
entbeinten Spanferkel, März 1954.*

*Un aperçu de la fête de Saint-Joseph
(« Giuseppe », ou fête des pères) dans le
quartier Trionfale : vendeuse ambulante
de porchetta (cochon de lait désossé, farci
et rôti à la broche), plat traditionnel de
cette célébration annuelle, mars 1954.*

und Bevölkerungszahl der Tiberstadt. Das eigentliche Zuhause der
Römer sind die Straßen und Plätze. An heißen Sommerabenden
werden Gasthäuser, Trattorien und Eisdielen zu Nachtcafés, die mit
ihren Stühlen und Tischen das bisschen Platz in Anspruch neh-
men, das der Verkehr ihnen lässt. Kaffee wird in allen erdenklichen
Varianten serviert: als Espresso, Cappuccino, Milchkaffee, Corretto
(mit Schuss), Misto (halbgefroren mit Sahne), als Eiskaffee mit
Sahne oder mit Speiseeis.

„Nylonstrümpfe kosten nicht viel; hat man eine Lauf-
masche, gibt es Hunderte kleiner Nähstuben, um sie im Halb-
dunkel einer Portiersloge aufnehmen zu lassen" (Miriam Mafai,
2002). Nerzmäntel sind der letzte Schrei; Glauco Pellegrini
widmet dem modischen Statussymbol 1956 einen ganzen Film.

Anfang der 1950er-Jahre tritt „Made in Italy" seinen
weltweiten Siegeszug an. Römische Mode-Ateliers erweisen sich
als kundige und findige Interpreten französischer Vorbilder. Ava
Gardner lässt bei den Sorelle Fontana (den Schwestern Giovanna,
Micol und Zoe Fontana) arbeiten, aus deren Werkstatt auch das
Kleid stammt, das Linda Christian 1949 bei ihrer Hochzeit mit
Tyrone Power trägt (in der Presse als „Hochzeit des Jahrhunderts"
gefeiert; ein Polizeikordon hindert die zu Tausenden erschienenen
Schaulustigen daran, in die Kirche zu strömen). Aus dem Atelier
der römischen Schwestern stammt auch das Kleid, das Anita
Ekberg in *La dolce vita* trägt. Auch Palma Bucarelli, die Direktorin
der Galleria Nazionale d'Arte Moderna, ist Stammkundin.

1947 findet die erste Wahl zur „Miss Roma" statt, die
Teilnehmerinnen reüssieren anschließend nicht selten im Show-
geschäft und im Film. Die sinnlichen, mit üppigen Formen ausge-
statteten Diven des italienischen Kinos werden weltweit glühend
verehrt: Silvana Mangano (Miss Roma 1947), Sophia Loren, Gina
Lollobrigida: Namen und Gesichter, die dank der Plakatwerbung
auch aus dem römischen Stadtbild bald nicht mehr wegzuden-
ken sind.

In den 1960er-Jahren erlebt Rom mit dem Auftritt der
Beatles 1965 und dem Konzert der Rolling Stones im Jahr 1967
Meilensteine der Musikgeschichte. Zum Symbol der Jugendkultur
wird das Piper, nach dessen Vorbild Lokale und Musikklubs auch
in anderen italienischen Städten aus dem Boden schießen.

Die Architekten des Wiederaufbaus der Nachkriegszeit
sind oft dieselben, die schon unter dem Faschismus gewirkt
hatten. Marcello Piacentini, durch seine enge Verbindung zum
Regime kompromittiert, wird trotzdem mit dem Bau zur Via

della Conciliazione betraut. Zum Heiligen Jahr 1950 wird auch
der neue Bahnhof Termini eingeweiht, 1951 folgt das Olympiasta-
dion. 1955 nimmt die erste römische U-Bahnlinie, begonnen
bereits 1937, nach kriegsbedingter Bauunterbrechung den Betrieb
auf. Die römische Politik der Nachkriegszeit setzt vor allem auf
den Bausektor als Motor der ökonomischen Erholung, und das
hieß auf die Schaffung von Wohneigentum, galt dieses doch
(neben dem *posto fisso*, der Festanstellung) als probates Mittel
zur Abfederung sozialer Ungleichheit. Als öffentlich geförderte
Wohnungsbauprojekte entstehen in den 1950er-Jahren große
Neubauviertel in den Bereichen Valco San Paolo, Tuscolano und
Tiburtino. Anlässlich der Olympischen Spiele von 1960 werden
Sportanlagen und ein olympisches Dorf errichtet.

In der Nachkriegszeit entwickelt sich Rom zum Haupt-
schauplatz des kulturellen und künstlerischen Lebens Italiens. In
der Via Margutta unterhalten bekannte Maler ihre Ateliers: Carla
Accardi, Afro Basaldella, Giulio Turcato, Franco Gentilini, Mario
Mafai, Alberto Burri, um nur einige zu nennen. Die künstleri-
schen Debatten kreisen vor allem um den Gegensatz von Abstrak-
tion und Realismus, wie ihn Renato Guttuso mit Rückendeckung
der Kommunistischen Partei vertritt. Auf Guttusos Bildern ist
richtig was los: Ausflüge mit der Vespa, Strandleben, Boogie-
Woogie-Tanzen in Rom.

Beliebter Treffpunkt der Künstler, Schriftsteller, Intel-
lektuellen, Theater- und Filmleute ist das Caffè Greco in der Via
Condotti. Man verabredet sich an der Bar des Rosati an der Piazza
del Popolo, zum Essen in der Osteria Menghi am Anfang der
Via Flaminia oder geht in die Buchhandlung Rossetti an der Via
Veneto. Galerien wie L'Obelisco und La Tartaruga stellen Arbeiten
von Künstlern aus ganz Europa und den USA aus, die in Rom
Station machen: Willem De Kooning, Mark Rothko, Franz Kline,
Robert Rauschenberg (nicht alle sind damals schon so berühmt
wie Rauschenberg, der sich von einem von Burris *Säcken* besonders
beeindruckt zeigt). Eine Picasso-Ausstellung weckt 1953 die Begeis-
terung der neorealistischen Szene. Bei der Eröffnung einer Schau
im Casino dell'Aurora im Palazzo Pallavicini am Quirinal 1954 tritt
Salvador Dalí aus einem mit hermetischen Aufschriften versehenen
Kubus vors Publikum. Für viele heimische Künstler sind die römi-
schen Galerien Sprungbrett zu einer internationalen Karriere.

Mitte der 1950er-Jahre mehren sich die Anzeichen, die auf
eine dynamische Entwicklung der italienischen Wirtschaft und
Gesellschaft hinweisen. In den Wohnzimmern ersetzt nach und

→
Anonymous

Comic actor Alberto Sordi in the famous scene from the film Un americano a Roma *by Stefano Vanzina, in which he says the famous words: "Maccarone, you have provoked me and now I destroy you, maccarone! I'm going to eat you, yummmm!". 1954.*

Alberto Sordi in einer berühmt gewordenen Szene des Films Ein Amerikaner in Rom *von Stefano Vanzina, in der Sordi ausruft: „Maccarone, du hast mich herausgefordert, und jetzt mach ich dich fertig! Mm, jetzt verputz ich dich!", 1954.*

Alberto Sordi dans une scène du film Un Américain à Rome *de Stefano Vanzina où il prononce la phrase devenue célèbre: « Macaroni, tu m'as provoqué, alors je vais te faire disparaître! Je vais te manger, slurp! », 1954.*

nach das Fernsehgerät den Radioapparat, gleichzeitig werden tragbare Transistorradios immer beliebter. 1955 geht die Quizshow *Lascia o radoppia?* („Aussteigen oder verdoppeln?") auf Sendung, ihr Moderator Mike Bongiorno wird zum Publikumsliebling der Italiener. Derweil mahnt Papst Pius XII. einen wachsamen Umgang mit dem neuen Medium an, dessen Bilder so unmittelbar in den „Schoß der Familie" wirken. In den 1960er-Jahren sorgt das Fernsehen für die von Pasolini beklagte „Gleichschaltung" der Italiener nach dem Modell des Kleinbürgers.

1959 taucht in einem Artikel der Londoner *Daily Mail* das erste Mal der Begriff des italienischen „Wirtschaftswunders" auf. Ein Mirakel, das in Rom vor allem in der Explosion der Grundstückspreise zu beobachten ist. Während acht Jahre lang, von 1954 bis 1962, über einen neuen Regulierungsplan debattiert wird, tobt auf dem Immobilienmarkt ein zweites „Sacco di Roma". Ende der 1950er-Jahre residiert in der Altstadt zwar noch der ein oder andere Abkömmling der römischen Aristokratie, ansonsten lebt dort das Heer der einfachen Leute – und Amerikaner. Das wohlhabende Bürgertum hat sich im Parioli-Viertel und Umgebung niedergelassen, die Zugezogenen vom Land, die Arbeitslosen und Analphabeten in den Vorstädten.

Als 1958 Pius XII. stirbt, verkauft sein Leibarzt Bilder des Papstes auf dem Totenbett an die Presse; im selben Jahr tritt die Lex Merlin zur Schließung der Bordelle in Kraft; bei einer privaten Feier im Rugantino in Trastevere lässt die türkische Tänzerin Aïché Nana die letzten Hüllen fallen; die Freiluftaufführung der *Aida* in den Caracallathermen wird zum kulturellen und touristischen Ereignis des Jahres. „Damals begann die große Zeit der Via Veneto: Hier drängen sich Intellektuelle, Könige im Exil, junge Damen auf der Suche nach einer Karriere beim Film, Regisseure auf der Suche nach jungen Damen und Fotografen auf der Suche nach Königen im Exil, nach Regisseuren, nach bekannten Schauspielerinnen und nach solchen, die es werden wollen" (Miriam Mafai, 2002).

So wird der *Roman Style* geboren, der Touristen aus aller Welt an den Tiber lockt, eine Mischung aus dem Mythos der Ewigen Stadt und dem Strahlen ewigen Sonnenscheins, römischem Charme und römischen Charaktertypen, römischer Küche und römischem Leben in seiner ganzen pittoresken Rückständigkeit gemessen an der Effizienz moderner Zeiten.

1960 kommt Fellinis *La dolce vita* in die Kinos, ein Film jenseits des Neorealismus, angesiedelt zwischen Boulevard, Satire, Drama und Komödie und damit ein Vorbote der *Commedia all'italiana*. Um am Set zu fotografieren und um die Schauspieler, die in *Dolce vita* die Paparazzi auf der Jagd nach Sensationsaufnahmen verkörpern sollen, in ihre Rolle einzuweisen, beschäftigt Fellini den römischen Fotoreporter Pierluigi Praturlon. Seine Bilder von Sophia Loren in *Und dennoch leben sie* ebnen der Römerin den Weg nach Hollywood. Viele dieser Paparazzi, die ihre Bilder an die Skandalblätter verkaufen, stammen aus den römischen Vorstädten. Tazio Secchiaroli, Schüler von Adolfo Porry-Pastorel, der mit Elio Sorci die Agentur Roma Press Photo leitet, etwa ist durch seine Bilder von Aïché Nanas Striptease berühmt geworden. Um fotografiert zu werden und damit auf sich aufmerksam zu machen, gehen Schauspieler auf die Via Veneto und zetteln sogar Raufereien an.

Mit den drei Meisterwerken *Accatone*, *Mamma Roma* und *La ricotta* wird Anfang der 1960er-Jahre Pier Paolo Pasolini zum größten Regisseur in der Geschichte des italienischen Films, als dessen Meister er bis heute gelten kann. Die Filme der *Commedia all'italiana* von Regisseuren wie Dino Risi oder Ettore Scola finden in Italien, aber auch im Ausland, ein großes Publikum. Das treffender als *Commedia alla Romana* zu bezeichnende Genre bringt die Stärken und Schwächen der Römer auf den Punkt, stößt jedoch dort an seine Grenzen, wo es wohlfeil zu verstehen gibt, Letztere seien nur allzu menschlich und daher verzeihlich.

Das Rom der 1950er-Jahre, das Rom des Dolce Vita, spiegelt sich auch in der Fotografie wider. 1959 kommt William Klein, der gerade *Life is Good & Good for You in New York* herausgebracht hat, in die Tiberstadt; eigentlich soll er für Fellini Aufnahmen am Set von *Die Nächte der Cabiria* machen, aber der Dreh verschiebt sich, und so geht Klein in Begleitung von Fellini, Pasolini, Alberto Moravia, Ennio Flaiano und anderen damals in Italien tonangebenden Schriftstellern und Künstlern auf Erkundungsreise durch Rom und fotografiert. In der Modefotografie sticht Pasquale De Antonis mit seinen klug komponierten und elegant inszenierten Aufnahmen hervor. Neu auf den Markt drängende Wochenillustrierte wie *Il Mondo* (1949–1966) und *L'Espresso* beschäftigen zahlreiche Fotoreporter und drucken Bilder von bemerkenswerter Qualität ab.

4

Du néoréalisme à la dolce vita *et au miracle économique* 1945–1967

pp. 214/215
William Klein

Klein's commentary in his memorable book of photographs Rome *(1959): "Piazzale Flaminio […] the course of the centuries stops at the traffic light. From left to right: Commander (seen from the back), stocky, bald, crosses the street on the zebra crossing; a beautiful, mature brunette in a white dress, shoes and white handbag, banters with a cynical dandy immaculately dressed, black shoes, a Don Giovanni half-Sordi and half-Fabrizi, an absolutely irresistible combination; an impenetrable* conquistador *on a Vespa; a young* fusto *(a good-looking working-class boy), exuding energy as he waits for the tram; a car expert, without a tie, inspects a parked car; a couple on a Vespa."*

Klein schreibt zu diesem Bild in seinem Fotobuch Rome *von 1959: „Piazzale Flaminio, […] der Lauf der Jahrhunderte, angehalten vor einer roten Ampel. Von links nach rechts Commendatore (von hinten), korpulent und kahlköpfig, geht über den Zebrastreifen; schöne Brünette reiferen Alters mit weißem Kleid, weißen Schuhen, weißer Handtasche scherzt mit einem zynischen Charmeur: piekfeiner Anzug, schwarze Schuhe, halb Alberto Sordi, halb Aldo Fabrizi, unwiderstehliche Mischung aus beiden; undurchdringlich blickender Konquistador auf seiner Vespa; junger* fusto *(schöner Mann aus dem Volk) wartet energisch auf die Straßenbahn; Autokenner, ohne Krawatte, begutachtet den vor ihm stehenden Wagen; Ehepaar auf Motorroller."*

Commentaire de Klein dans Rome *(1959), son livre de photographies: «Piazzale Flaminio, […] le cours des siècles s'arrête au feu rouge. De gauche à droite: commendatore (de dos), gros, chauve, traverse la rue dans les clous; belle brune mûrissante, robe, chaussures et sac blancs, badine avec charmeur cynique, costume immaculé, souliers noirs, Don Juan mi-Sordi mi-Fabrizi, combinaison irrésistible entre toutes; impénétrable conquistador à Vespa; jeune fusto (beau garçon du peuple), attend énergiquement le tramway; expert en automobile, sans cravate, inspecte la voiture en stationnement; ménage à Vespa.»*

« Les citoyens romains sont de souche juive, ... ils descendent des anciens esclaves et affranchis orientaux. Aussi règne-t-il dans la Ville éternelle, une atmosphère très levantine : beaucoup de beauté et de paresse. Soraya et Farouk s'y sentent presque chez eux. »

PIER PAOLO PASOLINI, IN WILLIAM KLEIN, *ROME*, 1959

Après la guerre, la reprise est difficile. Le rationnement des pâtes et du pain ne prend fin qu'en 1949. Des tonnes de vêtements de seconde main en provenance des États-Unis sont distribuées gratuitement par l'Administration des Nations unies pour le secours et la reconstruction (UNRRA).

En décembre 1944, la Galleria Nazionale d'Arte Moderna (Galerie nationale d'art moderne) rouvre ses portes. Entre 1945 et 1975, elle est dirigée par Palma Bucarelli, personnalité fascinante dotée d'une grande intelligence critique, qui en valorise les collections par de nouvelles acquisitions et organise d'importantes expositions sur des thématiques italiennes ou étrangères.

Le public populaire recherche les spectacles légers et les revues avec les danseuses chères à Federico Fellini, les comédies, le cinéma et les romans-photos. En 1954, il dispose de la télévision. En 1949, Louis Armstrong atterrit à l'aéroport de Ciampino où il est accueilli par le Roman New Orleans Jazz Band.

Entre 1945 et 1968, le paysage social et urbain, qui se caractérise par de multiples contradictions, évolue à toute allure.

Le 18 avril 1948, les premières élections politiques se tiennent en Italie. Les électeurs ont le choix entre la Démocratie chrétienne (DC) et le social-communisme, entre les États-Unis et l'URSS, entre le capitalisme et le socialisme. L'Église intervient et Pie XII lance un appel : «Pour le Christ ou contre le Christ, pour son Église ou contre l'Église. Romains, réveillez-vous ! L'heure est venue pour nombre d'entre vous de sortir d'un long sommeil». La DC l'emporte largement en Italie et surtout à Rome.

La même année, se conformant au désir du pontife qui veut faire de Rome la capitale de la chrétienté, Salvatore Rebecchini, maire démocrate-chrétien, consacre la ville au Cœur immaculée de Marie en présence d'une foule de 500 000 personnes rassemblées au Capitole.

En 1949, l'Italie adhère à l'Alliance atlantique (OTAN) au terme de rudes affrontements au Parlement et malgré l'opposition de l'opinion publique. Le Saint-Office prononce l'excommunication des communistes, de leurs alliés et des lecteurs de la presse communiste. À Rome, cette mesure est accueillie avec indifférence, et de nombreux prêtres continuent à célébrer le mariage des communistes et de leurs sympathisants et à baptiser les enfants. En juillet 1950, le député démocrate-chrétien Oscar Luigi Scalfaro, qui sera élu président de la République en 1992, a une vive altercation dans un restaurant avec une cliente qu'il juge «trop décolletée». Au Foro Italico, le sexe des statues est recouvert de stuc.

En 1950, Rome célèbre l'Année sainte. En l'espace de douze mois, 600 trains de pèlerins arrivent dans la capitale où est inaugurée la via della Conciliazione.

Dans le climat de libération et d'espoir de l'immédiat après-guerre, quelques réalisateurs choisissent de représenter le rude quotidien du peuple italien, les privations et les souffrances que celui-ci endure depuis l'entrée en guerre et qui persistent durant la reconstruction. Roberto Rossellini réalise *Paisà* en 1946 et *Rome, ville ouverte* en 1948, année où sort *Le Voleur de bicyclette* de Vittorio De Sica interprété par des acteurs non professionnels. C'est le début de la grande époque du cinéma néoréaliste. Le néoréalisme est aussi un mouvement littéraire auquel se rattachent *Les Ragazzi* (1955) de Pasolini, l'un des plus grands chefs-d'œuvre de la littérature italienne.

Lors du recensement de 1951, Rome compte un peu plus d'un million et demi d'habitants. Les automobiles sont rares et l'on se déplace à bicyclette ; quant aux appareils électroménagers, ils n'ont pas encore fait leur entrée dans les foyers. Loin de n'être qu'un moyen de transport, la Vespa (1946) et la Lambretta (1947) contribuent à un nouveau mode de vie : les jeunes l'utilisent pour aller faire l'amour dans des lieux isolés ou sur la plage. Il n'est pas rare que trois ou quatre personnes l'achètent en copropriété. Fiat commercialise la 600, une voiture économique par son coût et sa consommation qui, par l'ingéniosité de sa conception et de sa ligne et par son rôle social, deviendra à juste titre aussi mythique que la Vespa, la Lambretta, puis la Fiat 500. En 1953, dans la publicité de la nouvelle Fiat 1100 apparaît pour la première fois une femme au volant.

Après le recensement de 1951, la population de la ville augmente chaque année de 100 000 habitants dont la plupart sont des méridionaux en quête de travail. Ils s'installent dans les *borgate*, faubourgs aux allures de bidonvilles, ou dans les arcades murées des antiques aqueducs romains qui se trouvent en ville. À la fin des années 1950, ils sont près de 400 000. En l'espace de dix ans, la superficie et la population de Rome ont doublé.

Les rues et les places constituent la véritable maison des Romains. Durant les chaudes soirées d'été les *osterie*, les bars, les *trattorie* et les crèmeries se transforment en cafés dont les petites tables et les chaises légères prestement installées envahissent tout l'espace que le trafic laisse à leur disposition. Le café se décline à l'infini : *espresso*, *cappuccino*, café au lait, café arrosé d'un *schizzo*, café *misto* (granite de café avec de la crème), froid avec de la crème, froid avec une boule de glace.

←
Luigi Leoni

*Ingrid Bergman talking to Roberto Rossellini,
who is in a Ferrari 250 MM Vignale at the
start of the Mille Miglia race with his co-
driver, the assistant director of his films, Aldo
Tonti, April 1953.*

*Ingrid Bergman und Roberto Rossellini beim
Start der Mille Miglia. Neben Rossellini am
Steuer eines Ferrari 250 MM dessen Regieas-
sistent Aldo Tonti, April 1953.*

*Au départ des Mille Miglia, Ingrid Bergman
salue Roberto Rossellini à bord d'une Ferrari
MM Vignale avec son copilote et assistant
Aldo Tonti, avril 1953.*

« Les bas en nylon sont un investissement économique
et, lorsqu'on les file, il existe des centaines de petites boutiques,
de petites échoppes sombres où les faire remailler pour quelques
lires… » (Miriam Mafai, 2002) Quant au manteau de vison, signe
extérieur de richesse, il est le thème du film *Una pellicia di visione*,
tourné en 1956 par Glauco Pellegrini.

À partir du début des années 1950, le *made in Italy*
commence à s'affirmer. Les grands ateliers de couture romains
font preuve de créativité et montrent une grande habileté
pour revisiter la mode française. Les Sorelle Fontana (les sœurs
Giovanna, Micol et Zoe Fontana) habillent Ava Gardner, dessi-
nent la robe portée par Linda Christian lors de son mariage avec
Tyrone Power (1949), le « mariage du siècle » selon la presse – un
détachement de police empêche des milliers de curieux d'envahir
l'église –, et réalisent le modèle « pretino » que porte Anita Ekberg
dans *La Dolce Vita*. Elles habillent également Palma Bucarelli, la
directrice de la Galleria Nazionale d'Arte Moderna.

1947 est l'année du premier concours de beauté pour élire
Miss Rome ; il n'est pas rare que les concurrentes accèdent à la
célébrité dans le monde du spectacle. Les stars sensuelles et
pulpeuses du cinéma italien comme Silvana Mangano (Miss
Rome 1947), Sophia Loren et Gina Lollobrigida font rêver les
hommes, les Italiens et les autres. Grâce aux affiches publicitaires,
elles conquièrent la scène urbaine.

Dans les années 1960, plusieurs événements musicaux
font date à Rome, dont le concert des Beatles (1965) et celui des
Rolling Stones (1967). Le Piper Club devient un symbole pour les
jeunes et un modèle à imiter dans d'autres villes d'Italie.

Les architectes romains de la reconstruction sont ceux de
la période fasciste. Marcello Piacentini, compromis par ses liens
officiels trop étroits avec le fascisme, n'en conçoit pas moins la via
della Conciliazione.

La nouvelle gare Termini (1950) et le stade Olympique
(1951) voient le jour ; en 1955, la première ligne du métro de
Rome est inaugurée, dont la construction lancée en 1937 avait été
interrompue par la guerre. Dans l'après-guerre, la classe politique
décide d'encourager le bâtiment, activité censée favoriser la reprise
économique et l'accession à la propriété (et au contrat à durée indé-
terminée), afin d'atténuer les tensions sociales. Au cours des années
1950 plusieurs quartiers sont créés : Valco San Paolo, Tuscolano et
Tiburtino, entre autres. En 1960, à l'occasion des Jeux olympiques,
on construit des équipements sportifs et un village olympique.

À la même époque, Rome est un centre vivant dans le
domaine artistique. Via Margutta, les ateliers d'artistes se succèdent
sans interruption (Carla Accardi, Afro Basaldella, Giulio Turcato,
Franco Gentilini, Mario Mafai, Alberto Burri notamment). Les
débats artistiques portent sur l'opposition entre l'abstraction et le
réalisme de Renato Guttuso soutenu par le parti communiste
italien. Chaque tableau de Guttuso raconte le quotidien (excur-
sion en Vespa, plages, boogie-woogie à Rome, etc.). Les lieux
où se rencontrent les artistes, les écrivains, les réalisateurs et les
intellectuels sont le Caffè Greco situé via Condotti, le bar Rosati
sur la piazza del Popolo, l'Osteria Menghi au début de la via
Flaminia, la librairie Rossetti de la via Veneto. Les galeries privées
dont l'Obelisco et la Tartaruga accueillent fréquemment les
œuvres des artistes européens et surtout celles des Américains qui
séjournent à Rome : Willem De Kooning, Mark Rothko, Franz
Kline, Robert Rauschenberg ; tous ne sont pas devenus aussi célè-
bres que Rauschenberg, lequel fut très impressionné par un *Sacco*
d'Alberto Burri. En 1953, l'exposition Picasso enthousiasme les
néoréalistes. Lors de l'inauguration de la présentation des œuvres
scandaleuses de Salvador Dalí au Casino dell'Aurora Pallavicini
sur le Quirinal, l'artiste fait son apparition en sortant d'un cube
aux inscriptions hermétiques (1954). Les galeries constituent
une excellente rampe de lancement international pour la Rome
artistique.

Vers le milieu des années 1950, de nombreux indices
annoncent le développement de l'économie et l'évolution de la
société. Dans les foyers, la télévision remplace la radio tandis que
les postes à transistors portatifs se répandent. L'année 1955 est
celle de la naissance du jeu-concours *Lascia o raddoppia ?* [Quitte
ou double] animé par Mike Bongiorno, l'une des émissions de
télévision les plus populaires. Pie XII rappelle l'épiscopat à la plus
grande vigilance à propos de ce nouveau média dont les images
pénètrent directement dans les familles. Entre 1960 et 1970, la
télévision entraîne la mutation anthropologique, l'homologation
petite-bourgeoise des Italiens condamnée par Pasolini.

En 1959, le *Daily Mail* de Londres emploie pour la première
fois l'expression « miracle économique » à propos de l'Italie. À
Rome il est surtout synonyme de développement anormal de la
rente foncière. Le plan régulateur général de Rome est débattu
pendant huit ans (1957–1962), période durant laquelle a lieu le
nouveau « sac de Rome ». À la fin des années 1950, le centre
historique de Rome est habité par quelques descendants de

→

Pierluigi Praturlon

Sean Connery visiting Rome with actresses Evanne Gillian, Seyna Seyn, and Olivia Hill, walking in St. Peter's Square. After the war, for every film actor, from any country, all roads led to Rome, 1963.

Sean Connery auf dem Petersplatz in Begleitung der Schauspielerinnen Evanne Gillian, Seyna Seyn und Olivia Hill. Für die Kinogrößen aller Länder hieß es seit der Nachkriegszeit: „Alle Wege führen nach Rom!", 1963.

En visite à Rome, Sean Connery se promène place Saint-Pierre avec les actrices Evanne Gillian, Seyna Seyn et Olivia Hill. Après la guerre, pour les acteurs du monde entier, tous les chemins menaient à Rome, 1963.

familles aristocratiques, par le peuple et par des Américains ; la bourgeoisie aisée s'est installée dans le quartier des Parioli ou à proximité tandis que les immigrés, les chômeurs et les analphabètes vivent dans les *borgate*.

1958 : le médecin du pape vend les photographies de Pie XII agonisant ; la loi Merlin ordonnant la fermeture des maisons de tolérance entre en vigueur ; lors d'une fête privée au Rugantino dans le quartier du Trastevere, Aïché Nana, une danseuse turque, improvise un strip-tease quasi intégral ; donnée en plein air dans les thermes de Caracalla, *Aïda* est l'événement artistique et touristique de l'année. « C'est la naissance de la fête de via Veneto où se pressent intellectuels, rois en exil, starlettes en quête de succès, réalisateurs en quête de starlettes et photographes en quête de rois en exil, réalisateurs, grandes actrices et starlettes qui deviendront de grandes actrices » (Miriam Mafai, 2002).

Avec son atmosphère, ses traits urbains et humains, ses habitudes et sa cuisine et jusqu'à son retard par rapport à l'efficacité internationale contemporaine, bref avec son univers particulier, différent et pittoresque, la Ville éternelle est à l'origine du *roman style*, un mythe qui fascine le tourisme international.

La Dolce Vita de Federico Fellini sort en 1960. Tout à la fois chronique, satire, drame et comédie, le film transcende le néoréalisme et prélude à l'avènement de la comédie à l'italienne… Sur le tournage de *La Dolce Vita*, Fellini choisit comme photographe de plateau – également chargé de former les acteurs qui interprètent les photojournalistes en quête de scoops – le *paparazzo* Pierluigi Praturlon ; ce dernier est également l'auteur des photographies de plateau de *La Ciociara* (1960) qui ouvre les portes de Hollywood à Sophia Loren. Avant d'être appelés

« *paparazzi* », les photojournalistes en quête de scoops travaillant pour les revues à scandale étaient surnommés « *scattini* » [de *scatto*, « déclic »] et nombre d'entre eux étaient originaires des *borgate*. Tazio Secchiaroli – élève de Adolfo Porry-Pastorel et gérant avec Elio Sorci de l'agence Roma Press Photo – accède à la célébrité grâce à ses photographies du strip-tease d'Aïché Nana. Certains acteurs se rendent expressément via Veneto pour se faire photographier et il n'est pas rare que des disputes soient mises en scène.

Au début des années 1960, avec les trois chefs-d'œuvre que sont *Accattone*, *Mamma Roma* et *La Ricotta*, Pier Paolo Pasolini s'impose comme le plus grand réalisateur de l'histoire du cinéma italien. Les comédies à l'italienne de nombreux réalisateurs, dont Dino Risi et Ettore Scola, constituent un genre qui remporte un vif succès en Italie comme à l'étranger. La limite de la comédie à l'italienne, ou plus exactement « à la romaine », tient à ce qu'elle illustre les qualités et les défauts du Romain en cédant souvent à une complaisance équivoque pour les seconds.

La Rome des années 1950, celle de la *dolce vita*, a été documentée par la photographie. En 1959, William Klein, qui vient de publier *Life is Good & Good for You* in New York, arrive à Rome pour collaborer avec Federico Fellini sur le plateau des *Nuits de Cabiria* ; le tournage étant reporté, il parcourt et photographie Rome en compagnie de Fellini, Pasolini, Alberto Moravia, Ennio Flaiano et d'autres écrivains et artistes de cette glorieuse époque. Dans le domaine de la photographie de mode Pasquale De Antonis excelle par l'intelligence de ses conceptions et l'élégance de ses images. Les photographes collaborent activement aux nouveaux hebdomadaires illustrés tels *Il Mondo* (1949–1966) ou *L'Espresso* (1955) qui publient des photographies de très grande qualité.

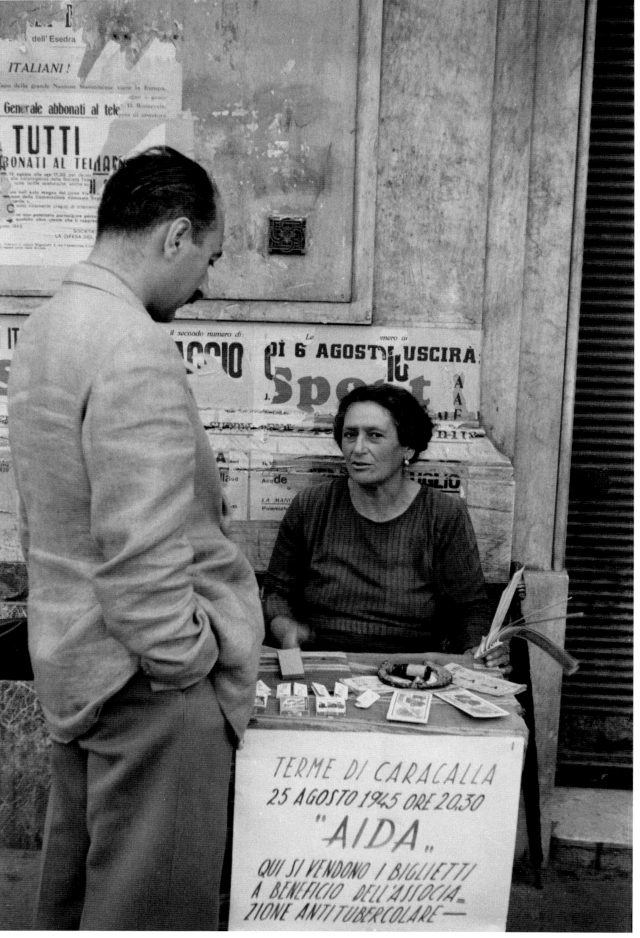

←
Federico Patellani

Tickets for Aida *staged at the Terme di Caracalla being sold for a benefit of the Anti-tuberculosis Association, August 1945.*

Kartenverkauf für eine Benefizaufführung der Aida in den Caracallathermen zugunsten der Antituberkulosegesellschaft, August 1945.

Vente de billets pour une représentation de Aïda donnée dans les thermes de Caracalla au profit de l'Association de lutte contre la tuberculose, août 1945.

→
Federico Patellani

Upper- and lower-class boys playing a game of morra *on the street in Trastevere; in the background, to the left, some American soldiers watch the scene, 1945.*

Straßenjungen und Bürgersöhne beim Morraspiel vor einem Haus in Trastevere; links verfolgen GIs das Geschehen, 1945.

Partie de mourre entre gamins du peuple et jeunes bourgeois dans une rue de Trastevere; à l'arrière-plan, à gauche, des soldats américains observent la scène, 1945.

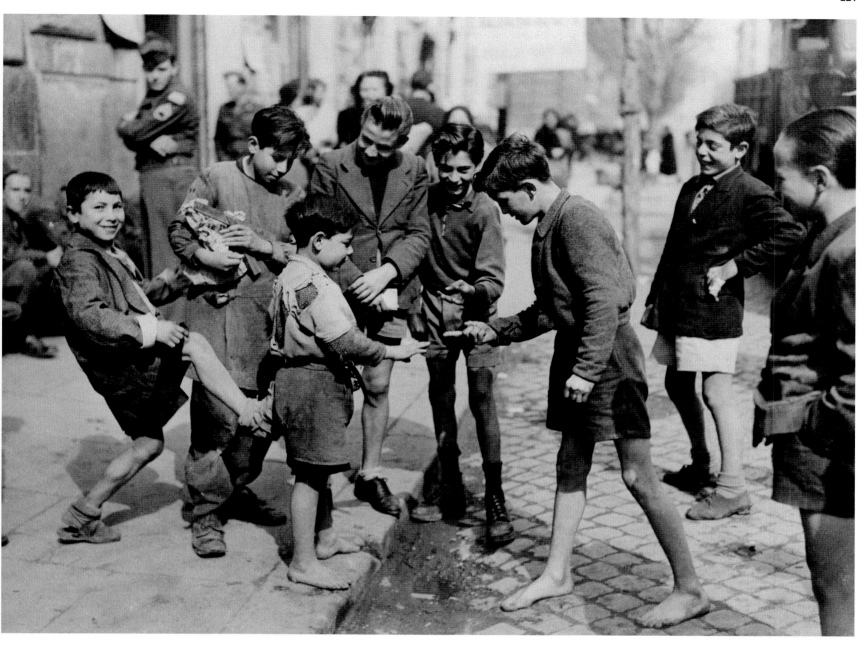

pp. 222/223
Anonymous

In the years just after the war, Rome was a village everywhere you went. A grocery store in a popular neighborhood: signs display the price of vegetables, beans, and charcuterie; note, on the left, two typical enamelled metal plates on the wall that read "olive oil" and "seed oil," March 1946.

Unmittelbar nach dem Krieg war Rom überall ein großes Dorf. Hier ein Lebensmittelladen in einem Viertel für einfache Leute; auf den Pappschildern die Preise für Salat, Gemüse und Wurstwaren; links oben an der Wand die charakteristischen Emailleschilder mit der Aufschrift „Olivenöl" und „Kernöl", März 1946.

Dans l'immédiat après-guerre, Rome est comme un grand village. Ici, une boutique d'alimentation dans un quartier populaire : les écriteaux annoncent le prix des légumes et de la charcuterie ; sur la façade, deux plaques typiques en tôle émaillée : « huile d'olive », « huile de pépin », mars 1946.

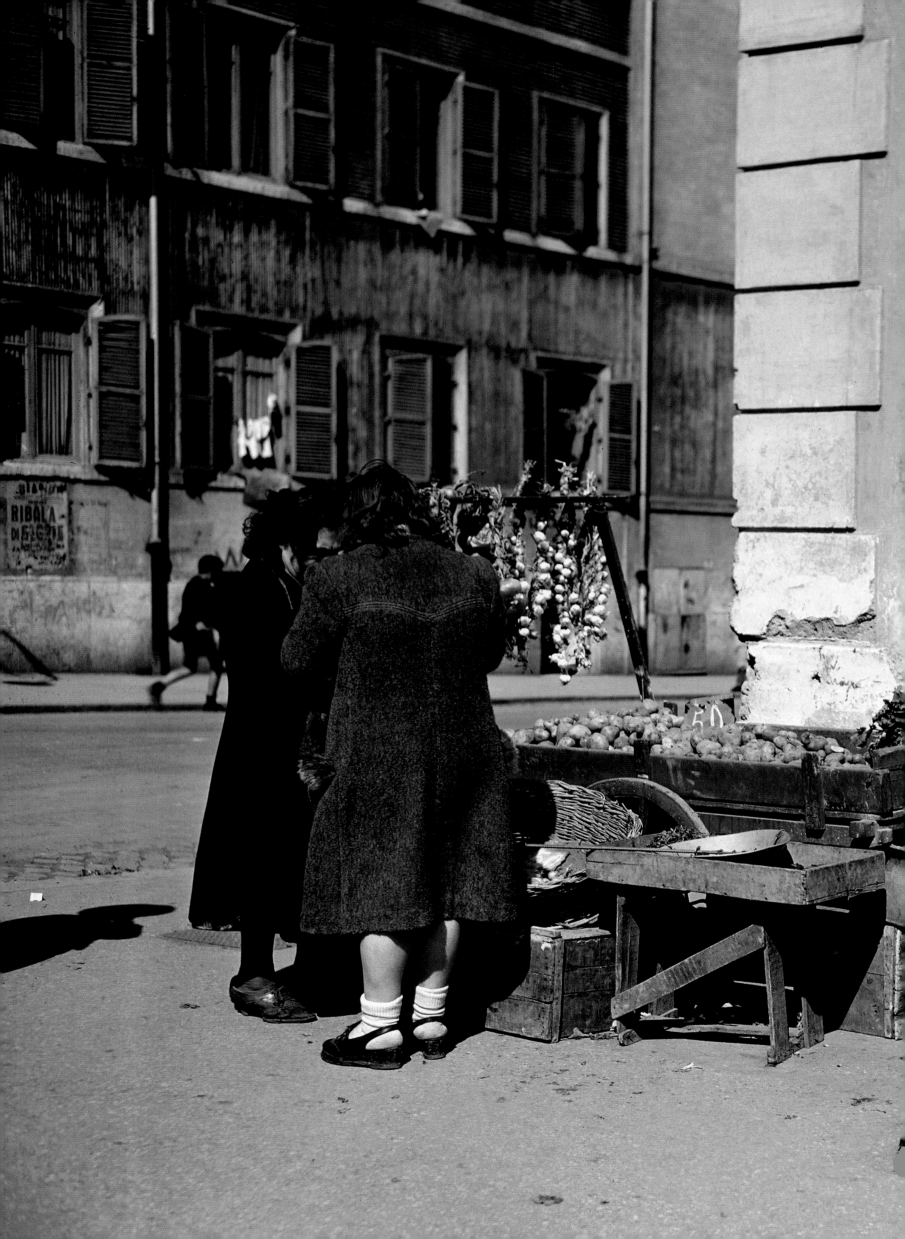

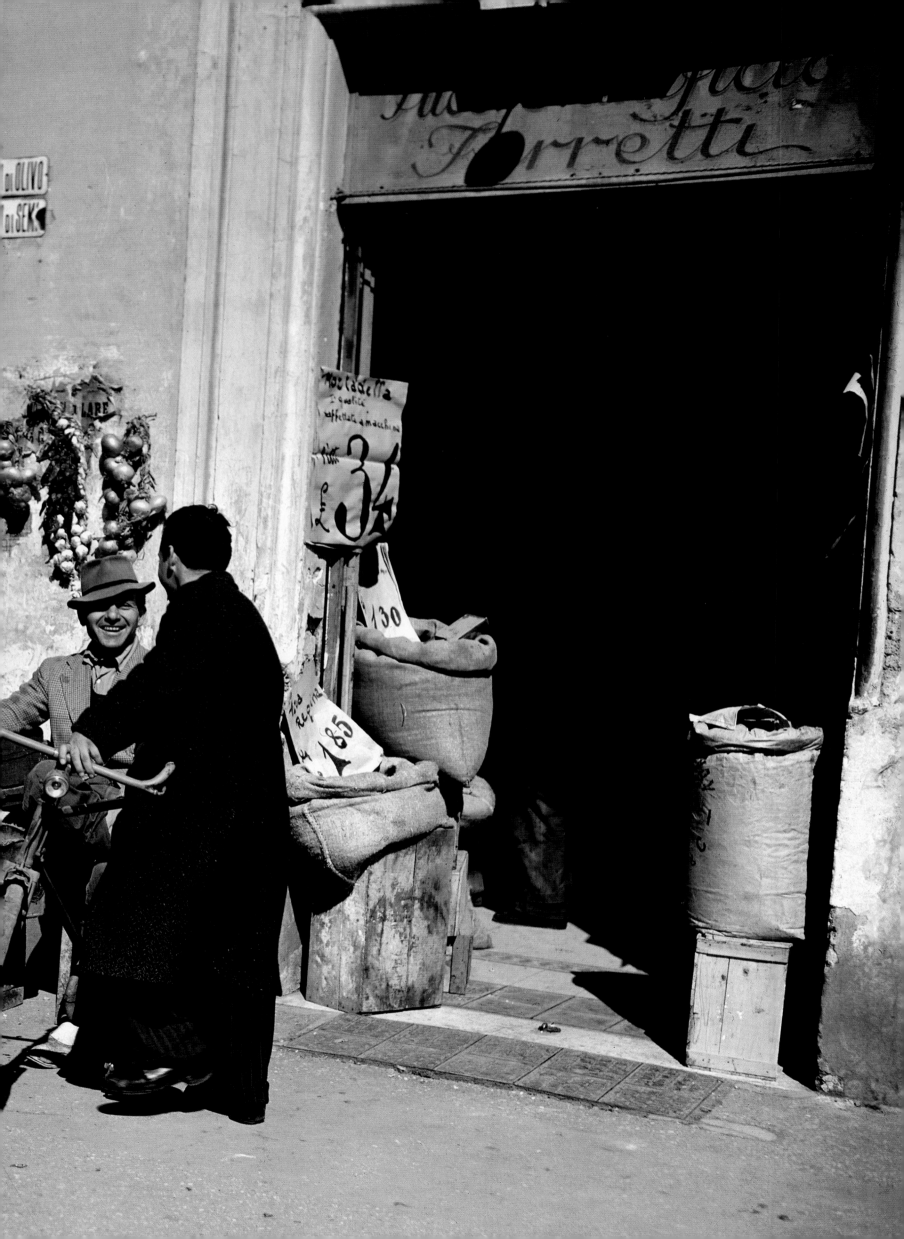

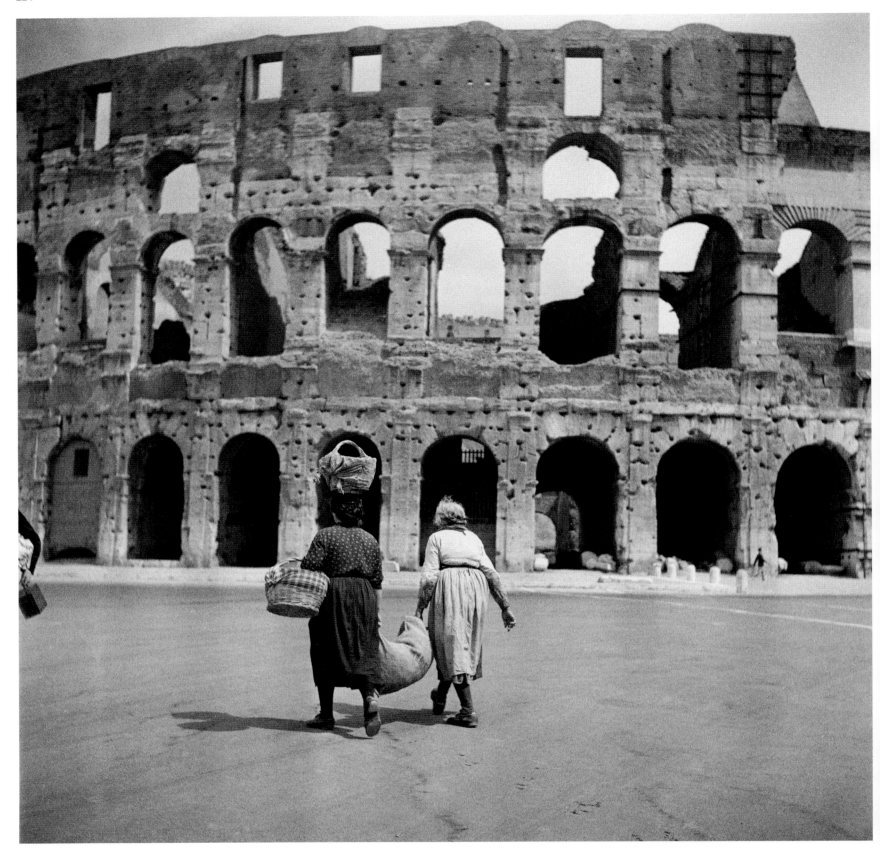

↑

Gaston Paris

*In front of the Colosseum: two countrywomen
in town to sell produce from the countryside,
c. 1946.*

*Zwei zum Verkauf ihrer Produkte in
die Stadt gekommene Bäuerinnen vor dem
Kolosseum, um 1946.*

*Devant le Colisée : deux paysannes venues
vendre leurs produits en ville, vers 1946.*

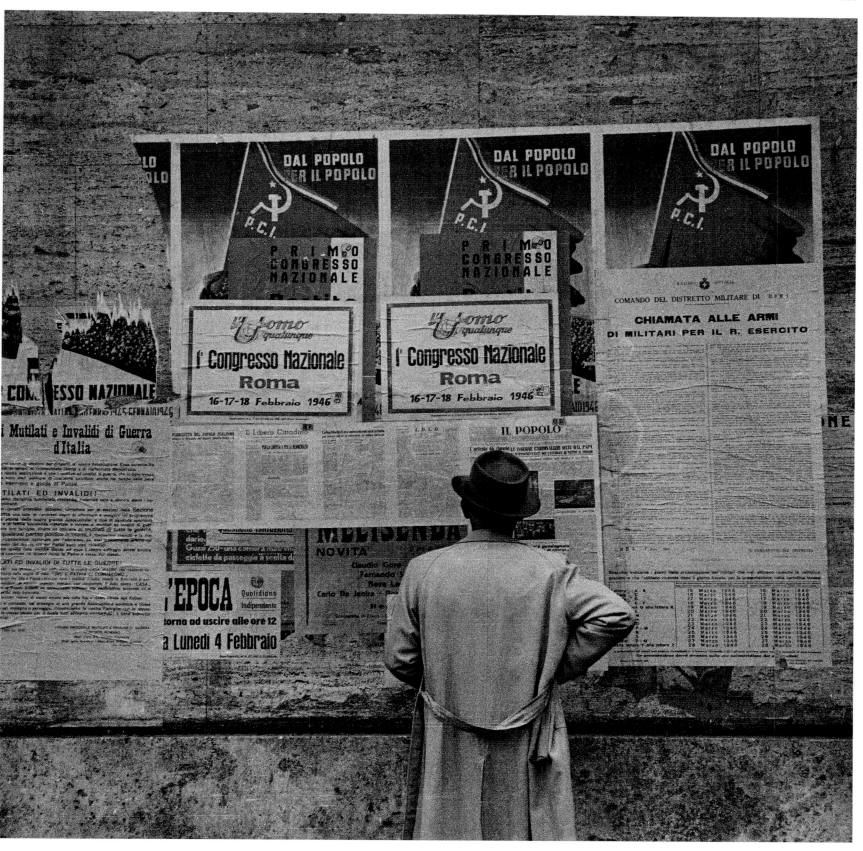

↑

Roger Berson

The walls of houses and monuments were still the main method of distribution of mass media: political posters, daily newspapers, and national service notices, February 1946.

Noch sind die Wände von Häusern und Monumenten ein wichtiger Ort öffentlicher Information: politische Plakate, Zeitungsseiten, Aufrufe zum Militärdienst, Februar 1946.

Les façades des maisons et des monuments demeurent le premier support des moyens de communication de masse: affiches politiques, pages des quotidiens et appels pour le service militaire, février 1946.

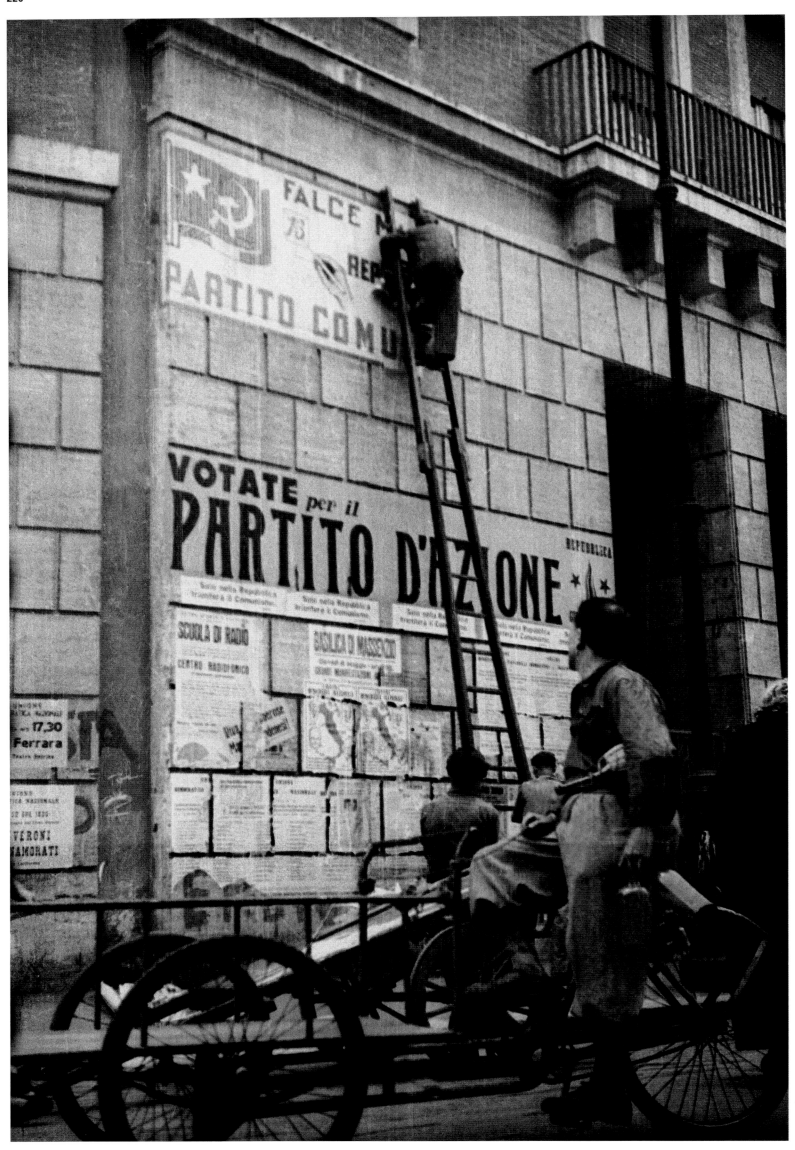

←

Luigi Leoni

Political posters during the referendum for the choice between the Republic or the Monarchy, 1946. "We were all aware [...] that this was about deciding if that extraordinary popular movement called the Resistance would find concrete development, renewing the structure of the country; or if it would be pushed back in the memory of history, negated as an active reality, at most relegated to the very depths of individual conscience [...]." (Carlo Levi, L'Orologio, 1950)

Parteiplakate zum Volksentscheid zwischen Monarchie und Republik, 1946. „Wir wussten genau [...], dass es darum ging, zu entscheiden, ob jene außergewöhnliche Volksbewegung, die sich ‚Resistenza' nannte, die Chance bekam, sich im Alltag weiterzuentwickeln und das Gesicht des Landes zu erneuern, oder ob sie in die historische Erinnerung zurückbeordert, als aktive Wirklichkeit verleugnet würde, schon bald nur mehr verbannt in die Tiefen des individuellen Bewusstseins [...]." (Carlo Levi, L'Orologio, 1950)

Affiches politiques relatives au référendum organisé pour choisir entre république et monarchie, 1946. « Nous savions tous fort bien [...] qu'il s'agissait de décider si cet extraordinaire mouvement populaire qui s'appelait la Résistance aurait une suite dans les faits, renouvelant ainsi la structure du pays ; ou s'il serait rejeté parmi les souvenirs historiques, renié comme réalité active, relégué tout au plus au tréfond de la conscience individuelle [...]. » (Carlo Levi, L'Orologio, 1950)

↑

Istituto LUCE

Largo Chigi scattered with sanpietrini *(cobblestones) pulled out of the street and thrown by protesters at a demonstration against unemployment, April 1947.*

Largo Chigi, übersät mit Steinen, die bei einer Demonstration gegen die Arbeitslosigkeit aus dem Pflaster gerissen und von den Teilnehmern geschleudert wurden, April 1947.

Le Largo Chigi parsemé de pavés descellés et lancés lors d'une manifestation contre le chômage, avril 1947.

←

Slim Aarons

Two children in a convent where orphans were taken in during World War II, c. 1945.

Kinder in einem Schwesternhaus, das während des Zweiten Weltkriegs verlassene oder elternlose Kinder aufgenommen hatte, um 1945.

Deux enfants dans un couvent de religieuses où ont été recueillis des enfants orphelins ou abandonnés durant la Seconde Guerre mondiale, vers 1945.

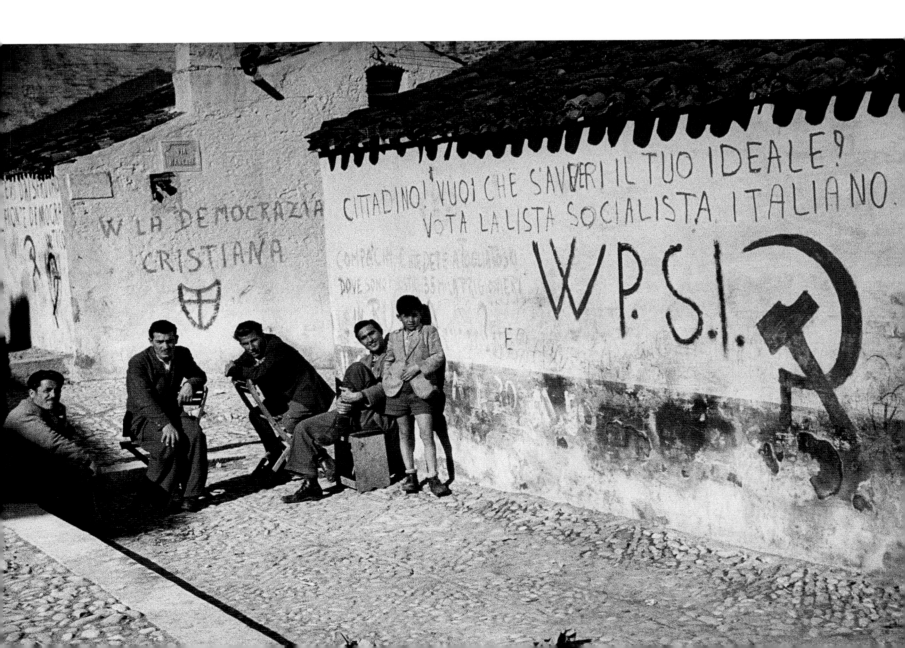

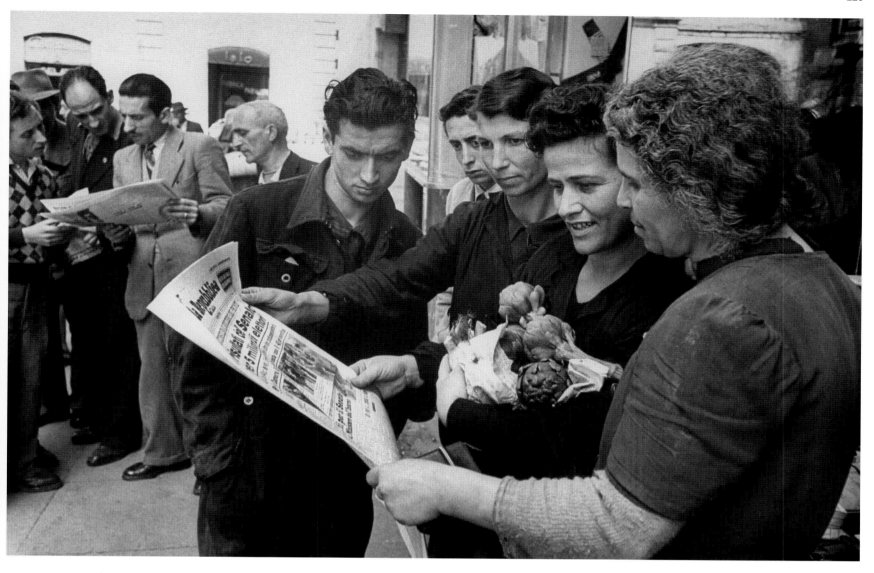

↑
Dmitri Kessel

People in the streets reading the results of the first political elections of the new republic, April 1948.

Menschen auf der Straße beim Studium der Wahlergebnisse der ersten Parlamentswahlen der jungen Republik Italien, April 1948.

Gens du peuple lisant dans les journaux les résultats des premières élections organisées par la nouvelle République, avril 1948.

←
Walter Sanders

Graffiti on the walls of houses in the Borgata Pietralata supporting the major political parties (Socialist, Communist, Christian Democrat) during the political elections of April 18, 1948.

Handgeschriebene Wahlslogans der drei größten Parteien (Sozialisten, Kommunisten und Christdemokraten) zu den Parlamentswahlen vom 18. April 1948 an Hauswänden der Vorortsiedlung Pietralata.

Sur les murs du faubourg de Pietralata, des inscriptions faites à la main en faveur des principaux partis (socialiste, communiste, démocrate-chrétien) à l'occasion des élections du 18 avril 1948.

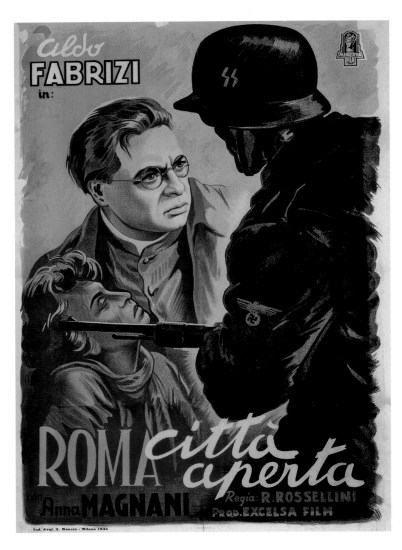

"Oh, it's not hard to die well;
it's hard to live well."

„Nein – gut zu sterben, ist nicht schwer.
Gut zu leben, das ist schwer."

« Il n'est pas difficile de bien mourir.
Il est plus difficile de bien vivre. »

ROBERTO ROSSELLINI, *ROMA CITTÀ APERTA,* **1945**

Slim Aarons

General Mark Clark posing with a group
of Roman citizens in front of a road sign of
the city he freed in June 1944 as he led the
Fifth Army of the United States, 1948.

General Mark Clark lässt sich mit einer
Gruppe Römer vor einem Ortsschild jener
Stadt ablichten, die er an der Spitze der
5. US-Armee im Juni 1944 befreit hat, 1948.

Le général Mark Clark posant avec un groupe
de Romains au pied d'un panneau où figure
le nom de la ville qu'il a libérée en juin 1944
à la tête de la 5ᵉ armée américaine, 1948.

↑
Anonymous

*Children and adolescents selling American
cigarettes (Lucky Strike and Camel) on the
black market, 1947.*

*Jugendliche und Kinder sind die Akteure
auf dem Schwarzmarkt für amerikanische
Zigaretten, 1947.*

*Adolescents et enfants vendant des cigarettes
américaines au marché noir, 1947.*

→
Anonymous

*A five-year-old orphan, whose father was
killed in a bombing in 1943, brings home
a food package sent by the United States
of America under the humanitarian aid
program CARE, March 1948.*

*Ein Fünfjähriger, dessen Vater 1943 bei einem
Bombenangriff ums Leben gekommen ist,
trägt ein CARE-Paket mit Lebensmittel-
spenden aus den USA nach Hause,
März 1948.*

*Un enfant de 5 ans, dont le père est mort
en 1943 dans un bombardement, rapporte
à la maison un carton de vivres envoyé par
les États-Unis dans le cadre du programme
d'aide humanitaire CARE, mars 1948.*

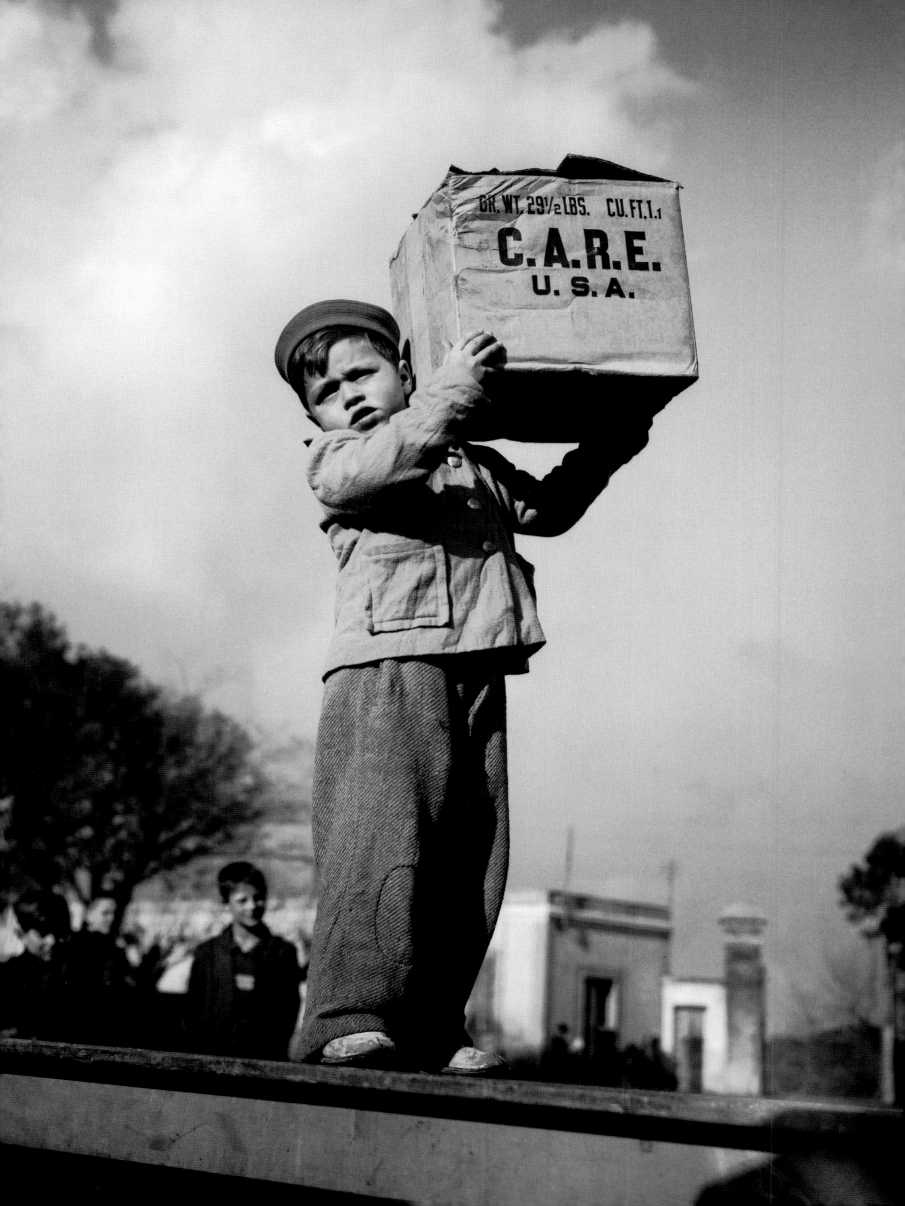

←
Ralph Crane

Taking lunch outdoors at the foot of the temple of Vesta in Tivoli is an old tradition, July 1949.

Zu Füßen des Vestatempels von Tivoli im Freien zu speisen, hat eine lange Tradition, Juli 1949.

Le repas en plein air au pied du temple de Vesta à Tivoli relève d'une longue tradition, juillet 1949.

→
Dmitri Kessel

In the post-war period, the beaches of the Roman coastline, Ostia (in the picture), Fregene, Ladispoli, Torvaianica, and Anzio, were very popular with the Romans who wanted to escape the summer heat and humidity in the city; several commedie all'italiana *(comedy films) were set here, June 1948.*

Um der sommerlichen Hitze und Schwüle der Stadt zu entkommen, wurden in der Nachkriegszeit die Badeorte an der Küste nahe Roms wie Ostia (im Bild), Fregene, Ladispoli, Torvaianica oder Anzio von vielen Römern besucht. Etliche Filme der Commedia all'italiana *spielen vor ihrer Kulisse, Juni 1948.*

Après la guerre, les plages du littoral romain, Ostie (sur la photographie), Fregene, Ladispoli, Torvaianica et Anzio, étaient très fréquentées par les Romains fuyant la chaleur étouffante de l'été dans la capitale ; elles ont inspiré nombre de films de la comédie italienne, juin 1948.

"Progress / made it grow / but this city / is not the same it was many years ago. / Lovers no longer / go along the Lungotevere / to steal a thousand kisses / under the trees."

„Der Fortschritt / hat dich groß gemacht / doch diese Stadt / ist nicht mehr die / wo wir früher zu Hause waren. / Die Verliebten / gehen nicht mehr / am Tiber spazieren, / um sich tausend Küsse zu geben / im Schatten der Bäume."

« Le progrès t'a faite grande, / mais cette ville n'est plus celle / où l'on vivait il y a longtemps. Les amoureux ne vont plus / le long du Tibre / pour voler mille baisers / sous les arbres. »

CLAUDIO VILLA (LUCIANO MARTELLI, MARIO RUCCIONE), *VECCHIA ROMA,* 1948

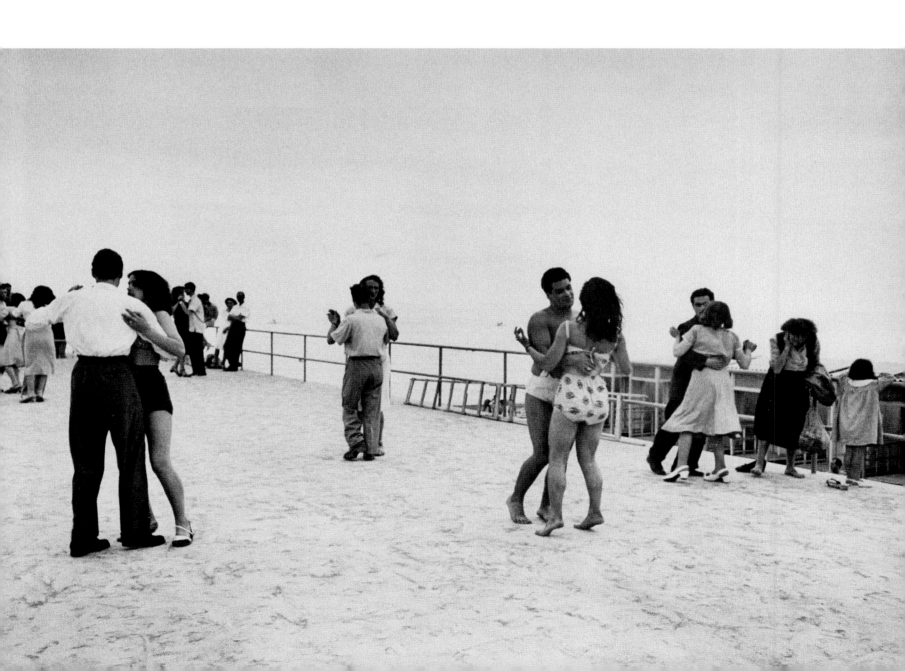

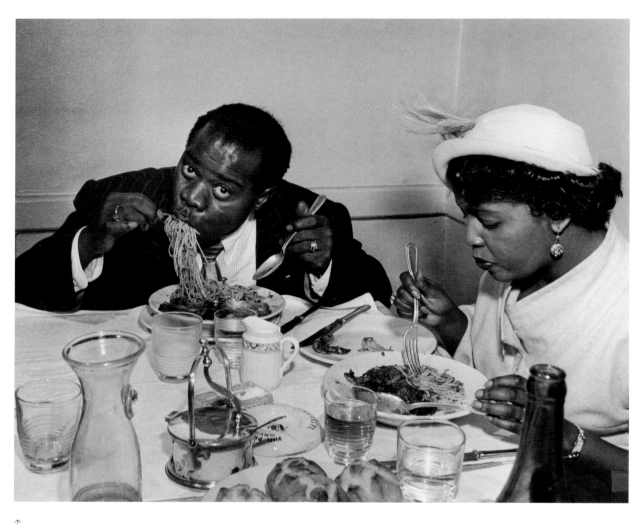

↑
Slim Aarons

Louis Armstrong eating spaghetti with his wife, 1948.

Louis Armstrong und seine Frau beim Spaghettiessen, 1948.

Louis Armstrong mangeant des spaghettis avec sa femme, 1948.

→
Slim Aarons

As they ride in front of the Colosseum, Lucille Brown takes control of the Vespa while her husband Louis Armstrong plays the trumpet, offering a musical homage to the monument, 1948.

Beim Vorbeifahren am Kolosseum übernimmt Lucille Brown den Lenker, während ihr Mann Louis Armstrong dem antiken Monument mit seiner Trompete seinen musikalischen Tribut zollt, 1948.

Passant devant le Colisée, Lucille Brown prend le contrôle de la Vespa tandis que Louis Armstrong, son mari, joue de la trompette pour rendre un hommage musical au monument, 1948.

pp. 238/239
Ruth Orkin

There are always many cats around the streets of Rome. Old people feed them, children play with them. They have important names: Caesar, Caligula, Nero, Tiberius, Othello, Benito, 1951.

Rom wimmelt nur so von Katzen. Die alten Leute füttern sie, die Kinder spielen mit ihnen, und sie tragen große Namen: Cäsar, Caligula, Nero, Tiberius, Othello, Benito, 1951.

Les chats demeurent très nombreux dans les rues de Rome. Les personnes âgées les nourrissent, les enfants jouent avec eux. Ils portent des noms peu banals : Caesar, Caligula, Nero, Tiberius, Othello, Benito, 1951.

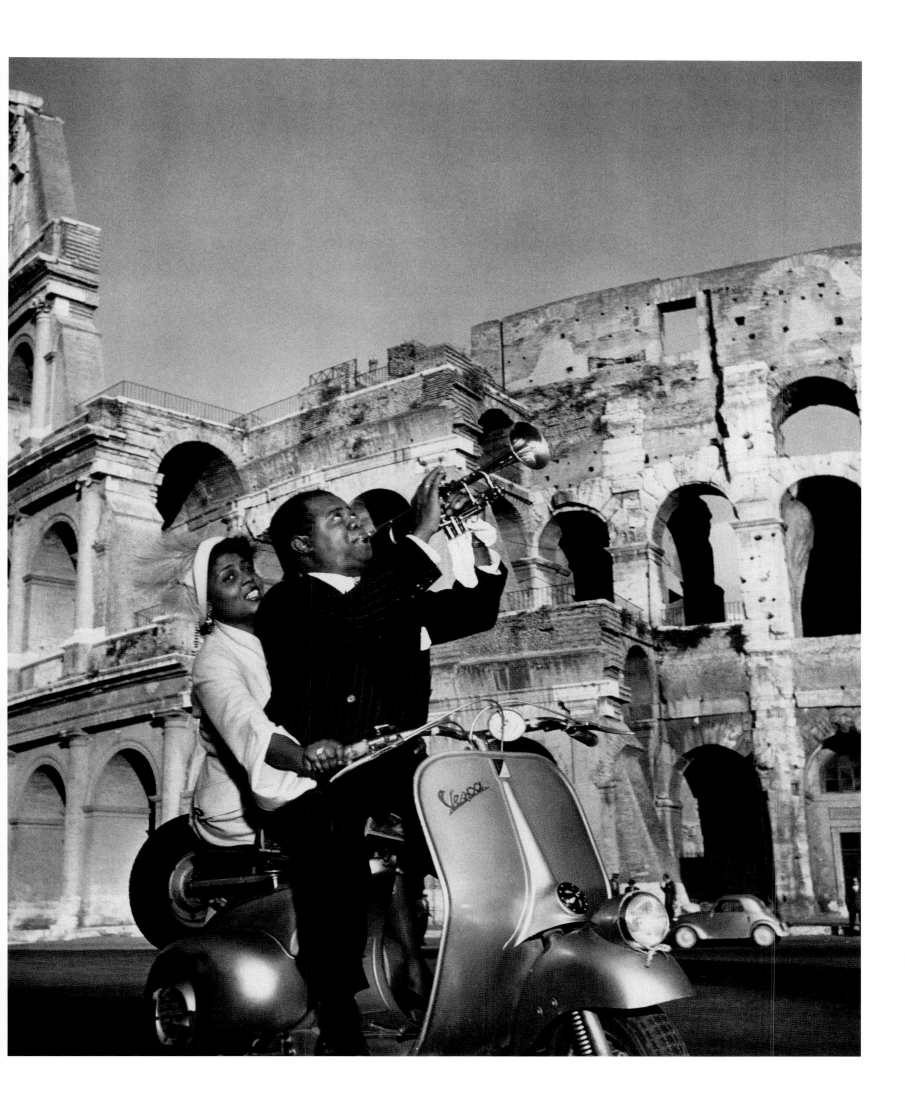

↑

Pasquale De Antonis

Two beauties compared in the Borghese Gallery: a model for the fashion designers Sorelle Botti next to Paolina Bonaparte *by Antonio Canova, 1947.*

„Venus im Vergleich" in der Galleria Borghese: Mannequin in einem Kleid aus dem Hause der Schwestern Botti neben Canovas Marmorbildnis der Paolina Bonaparte, 1947.

Concours de beauté à la galerie Borghèse : un mannequin portant une robe de la maison de couture Sorelle Botti assise près de la Pauline Borghèse *de Canova, 1947.*

→

Pasquale De Antonis

A model for the fashion designer Palmer posing for Bellezza *magazine in a face-off with Gian Lorenzo Bernini's* David *in the Galleria Borghese, 1947.*

Mannequin mit einem Kleid aus dem Hause Palmer vor Berninis David *in der Galleria Borghese, fotografiert für die Modezeitschrift* Bellezza, *1947*

Mannequin dans une robe de la maison de couture Palmer faisant face au David *du Bernin dans la galerie Borghèse, pour le magazine* Bellezza, *1947.*

←

Pasquale De Antonis

A model posing in a dress by the fashion house Carosa, 1949.

Mannequin in einem Kleid des Modehauses Carosa, 1949.

Mannequin portant une robe de la maison de couture Carosa, 1949.

↘

Herbert List

Youth and Roman Bust, *portrait of Swiss painter Rolf Dürig, 1949.*

Jüngling vor römischer Büste, *Porträt des Schweizer Malers Rolf Dürig, 1949.*

Jeune homme et buste romain, *portrait du peintre suisse Rolf Dürig, 1949.*

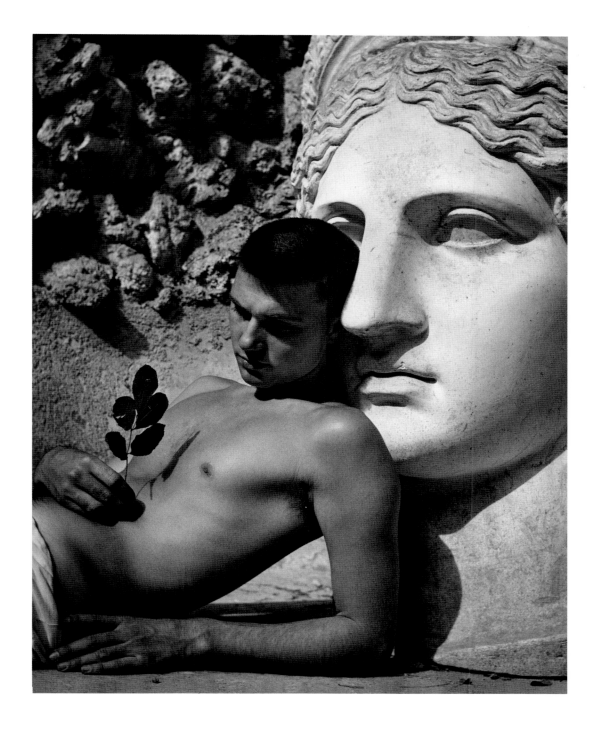

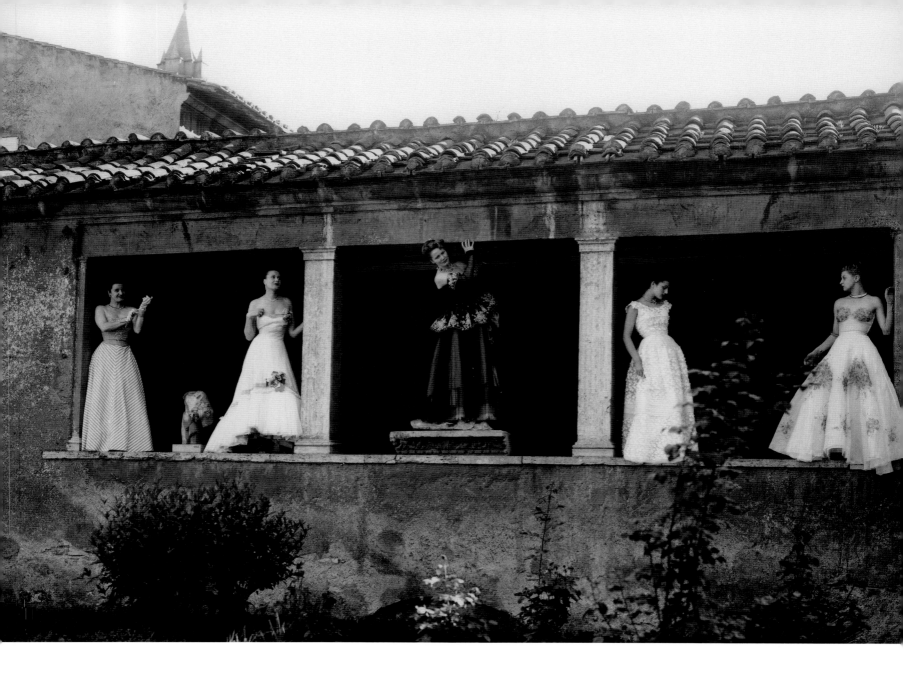

"Our newspapers […] seem to me to be shockingly provincial. It's clear enough from the way they talk about people […] What our actresses get up to is never a secret: Silvana is wearing trousers, Sophia is studying French using records, another Silvana is bored. If you don't know the surnames of these young ladies, that's your problem."

„*Unsere Zeitungen […] haben für mich etwas alarmierend Provinzielles. Schon die Art, wie sie über die Leute reden. […] Nichts von dem, was unsere Schauspielerinnen tun, bleibt ihnen verborgen: Silvana geht in Hosen, Sophia lernt mit Schallplatten Französisch, eine andere Silvana langweilt sich – und wenn ihr den Nachnamen der Fräuleins nicht kennt, habt ihr eben Pech gehabt!*"

«*Nos journaux […] me paraissent d'un provincialisme affligeant. Que l'on songe seulement à leur manière de désigner les gens. […] Impossible d'ignorer ce que font nos actrices: Silvana tourne un film en pantalon, Sophia apprend le français à l'aide de disques, une autre Silvana s'ennuie: si vous ne connaissez pas les noms de famille de ces demoiselles, tant pis pour vous.*»

ENNIO FLAIANO, *LA SOLITUDINE DEL SATIRO,* **1960**

Pasquale De Antonis

Models at the Terme di Diocleziano posing in evening dresses by the fashion houses Fontana, De Gasperi Zezza, and Gattinoni, 1948.

Mannequins präsentieren in den Diokletiansthermen Abendkleider der Modehäuser Fontana, De Gasperi Zezza, Gattinoni, 1948.

Mannequins dans les thermes de Dioclétien en robe du soir des maisons de couture Fontana, De Gasperi Zezza et Gattinoni, 1948.

Slim Aarons

The wedding of Tyrone Power and Linda Christian in the church of Santa Francesca Romana provided gossip material for the capital's newspapers for days, January 1949.

Die Hochzeit von Tyrone Power und Linda Christian in der Kirche Santa Francesca Romana schrieb Geschichte und füllte tagelang die Klatschspalten der Hauptstadtpresse, Januar 1949.

Le mariage de Tyrone Power et de Linda Christian dans l'église Santa Francesca Romana fit date et alimenta des jours entiers la chronique mondaine de la capitale, janvier 1949.

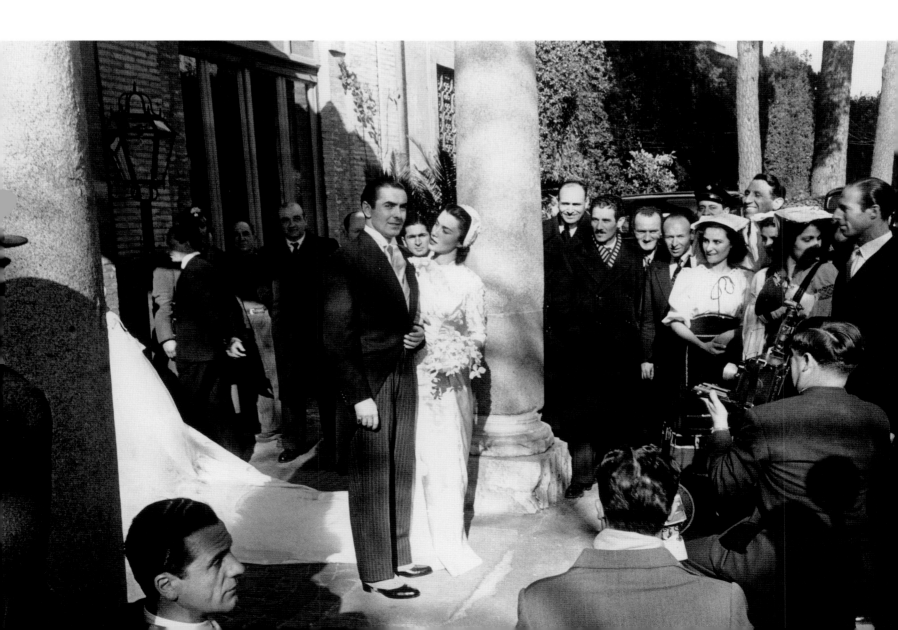

246

"My God, how boring these love stories are. Always the same sentences, always the same episodes: only the characters change."

„Mein Gott, wie langweilig diese Liebesgeschichten doch sind. Immer die gleichen Worte, immer die gleichen Geschichten, nur das Personal ändert sich."

« Mon Dieu, comme ces histoires d'amour sont ennuyeuses. Toujours les mêmes phrases, toujours les mêmes aventures : seuls les personnages changent. »

LUCIANO EMMER, *UNA DOMENICA D'AGOSTO,* 1950

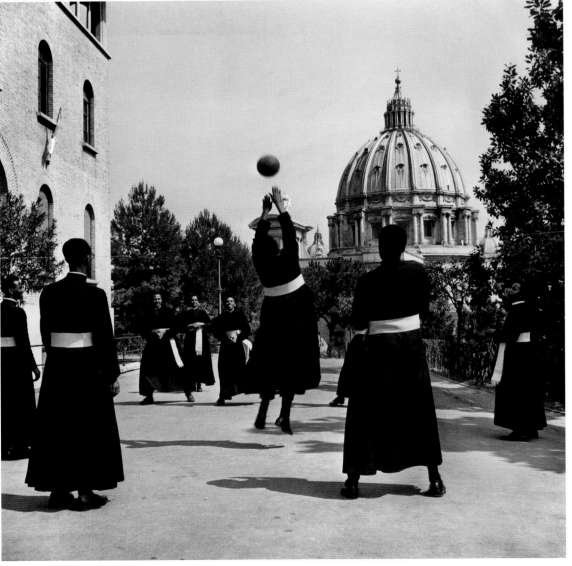

←
David Seymour

Vatican City: young seminarians playing volleyball in a courtyard, 1949.

Seminaristen beim Ballspiel in einem der Innenhöfe des Vatikan, 1949.

Cité du Vatican : jeunes séminaristes jouant au volley-ball dans une cour, 1949.

→
Anonymous

In its oldest areas, the district of Trastevere is a network of alleyways dotted with many small squares. It still retains traces of a popular and more typical Roman life. Wider, more functional squares were created with the opening of Viale Trastevere. In the early post-war period many streets in this area still preserved the atmosphere of a village, 1950.

Die ältesten Gegenden von Trastevere bestehen aus einem Gewirr von Gassen mit unzähligen kleinen Plätzen. Noch heute findet man dort Spuren eines Lebens, wie es die einfachen Römer führen. Erst der Bau des Viale Trastevere mit seinen großen, dem modernen Verkehr angepassten Plätzen hat das geändert. Nach dem Krieg ging es auf vielen Gassen des Viertels noch zu wie auf einem Dorfplatz, 1950.

Dans sa partie la plus ancienne, le quartier de Trastevere constitue un enchevêtrement de ruelles ponctuées de nombreuses petites places ; aujourd'hui encore, il conserve les traces et les usages d'une vie populaire, typiquement romaine. Des places plus vastes et plus fonctionnelles furent aménagées après le percement du viale di Trastevere. Juste après-guerre, une atmosphère paysanne imprégnait encore un grand nombre de rues du quartier, 1950.

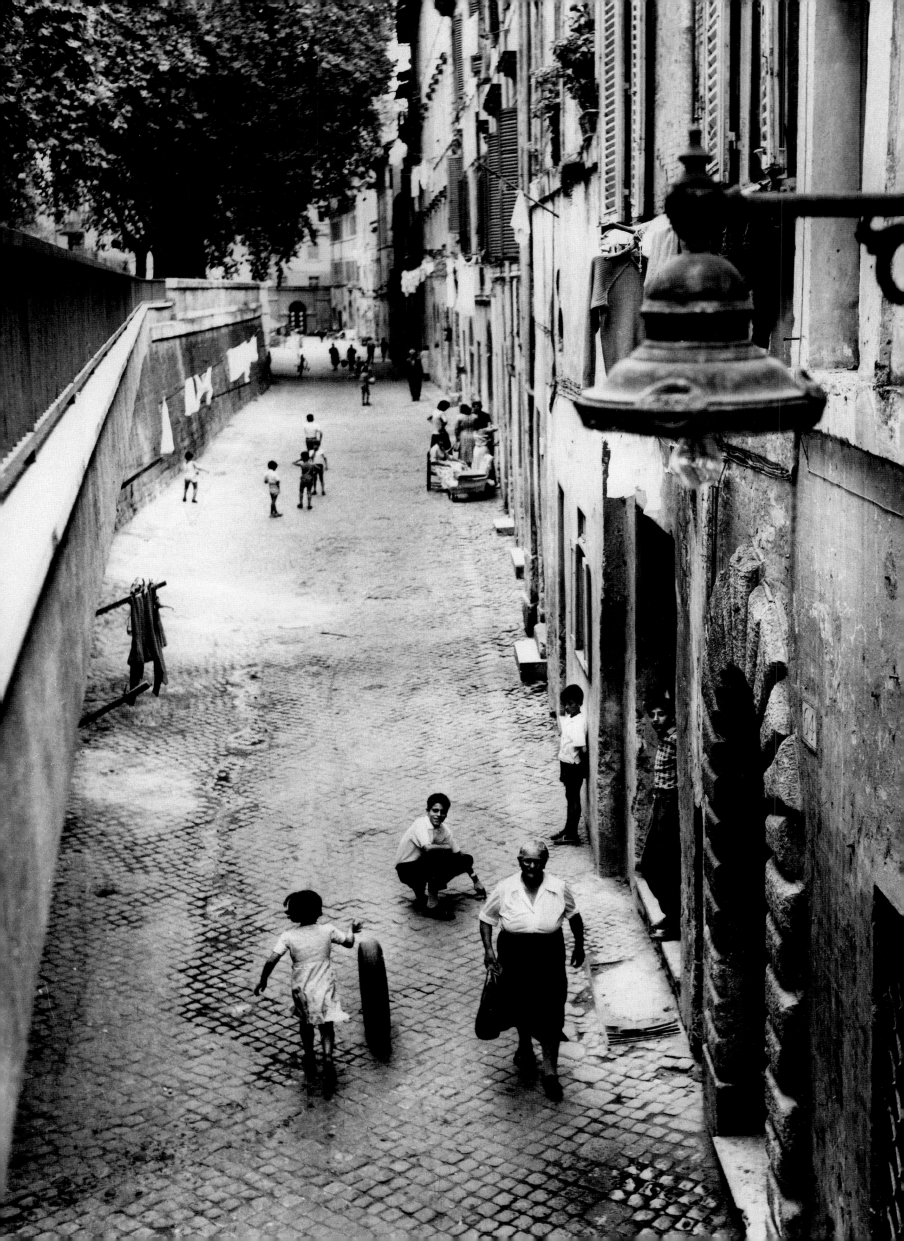

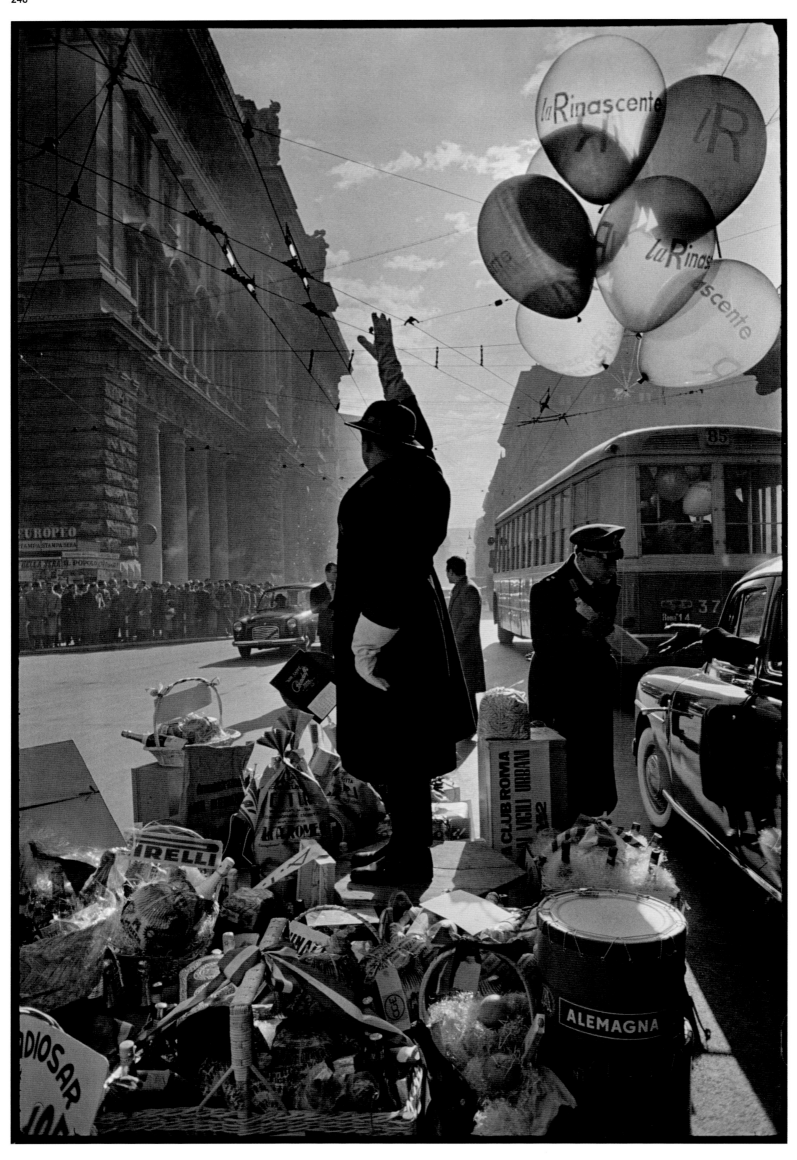

→
Anonymous

In the post-war period, the rapid increase in traffic resulted in the proliferation of unsightly road signs, 1954.

Der stetig zunehmende Verkehr führte in der Nachkriegszeit auch zu einem üppigen und nicht selten verwirrenden Anwachsen des Schilderwalds, 1954.

Après-guerre, le trafic augmenta rapidement et donna lieu à une signalétique routière abondante, envahissante, 1954.

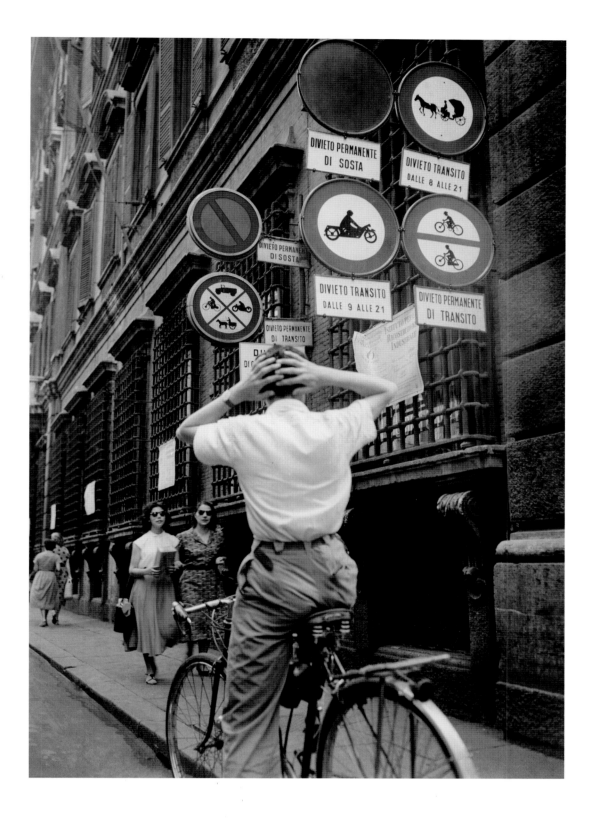

←
Henri Cartier-Bresson

According to a tradition that has since disappeared, on the feast of Befana (January 6), traffic police in the city used to receive gifts from businesses or from drivers: panettoni, sparkling wines, and more, amassed around the platform from which they conducted traffic, 1951.

Einem heute ausgestorbenen Brauch zufolge erhielten die römischen Verkehrspolizisten am 6. Januar, dem Dreikönigstag, von Firmen und Autofahrern Panettonekuchen, Sekt und andere Aufmerksamkeiten geschenkt, man türmte sie um den Sockel herum auf, von dem aus die Polizisten den Verkehr regelten, 1951.

Une tradition, aujourd'hui disparue, voulait qu'à l'occasion de la fête de la Befana (6 janvier) les agents de police reçoivent en cadeau, de sociétés et de simples automobilistes, des panettoni et du vin mousseux notamment, qui étaient déposés autour de la plate-forme d'où ils réglaient la circulation, 1951.

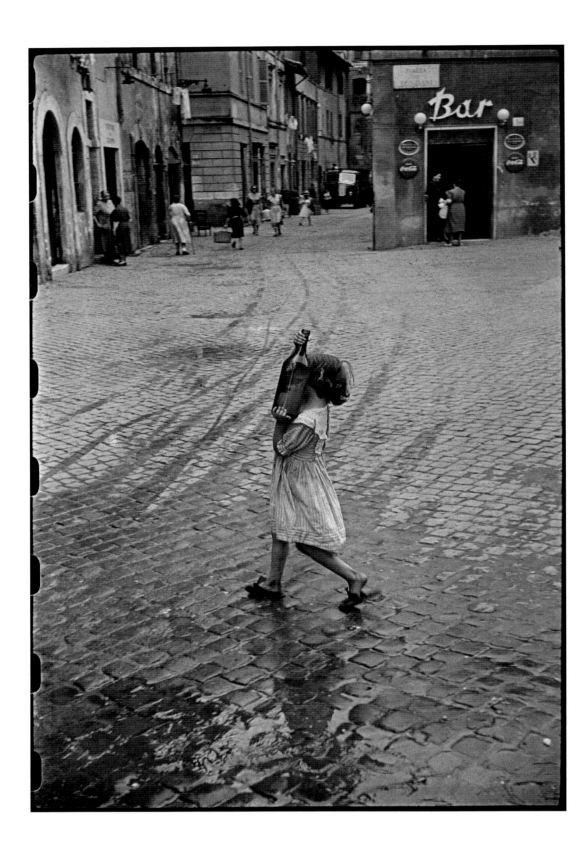

←
Henri Cartier-Bresson

*In the background we can see a typical bar
featuring an ornate sign, two light globes,
and a number of enamelled metal ads on
the wall flanking the entrance, 1952.*

*Die Bar am Ende des Platzes ist mit einem
schwungvollen Schriftzug, zwei Kugellater-
nen und mehreren Werbetafeln aus Emaille
auf der Hauswand ausgestattet, 1952.*

*En arrière-plan, un bar populaire typique
avec une enseigne aux caractères fantaisistes,
deux globes lumineux et de nombreuses
plaques publicitaires en tôle émaillée fixées
au mur de part et d'autre de l'entrée, 1952.*

→
Henri Cartier-Bresson

*A typical fixture of popular bars: the tasseled
curtain to protect from the flies, 1952.*

*Zur Ausstattung einer typischen Espressobar
in einem einfachen Viertel gehört der
Schnurvorhang, der die Fliegen draußen
halten soll, 1952.*

*Un élément typique des bars populaires:
le rideau de perles pour se protéger des
mouches, 1952.*

pp. 252/253
Henri Cartier-Bresson

*The street is the theater of the people: chil-
dren playing with skooters, a donkey, a milk
delivery tricycle, 1952.*

*Die Straße bietet allen und allem eine Bühne:
spielenden Kindern mit Tretrollern, einem
Esel, dem Lieferfahrrad eines Milchgeschäfts,
1952.*

*La rue est un théâtre populaire: des enfants
jouent avec des trottinettes, un âne, le tricycle
d'un laitier, 1952.*

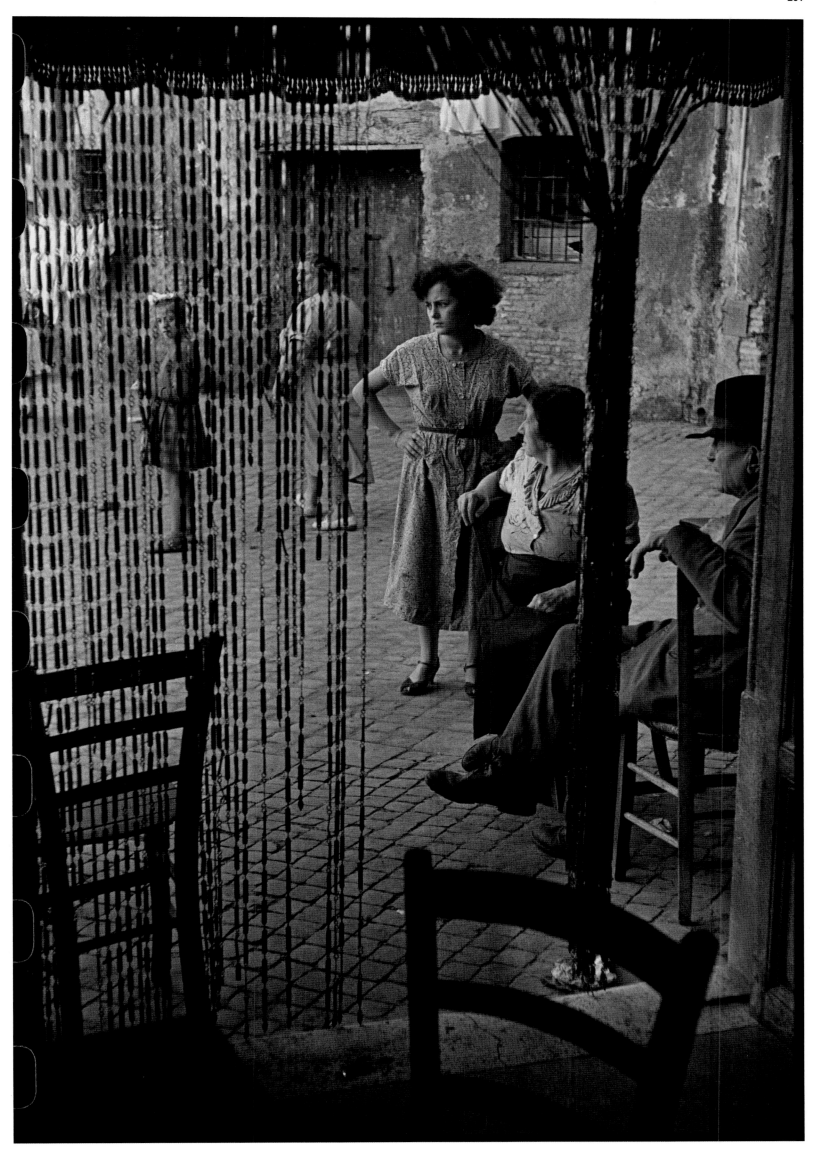

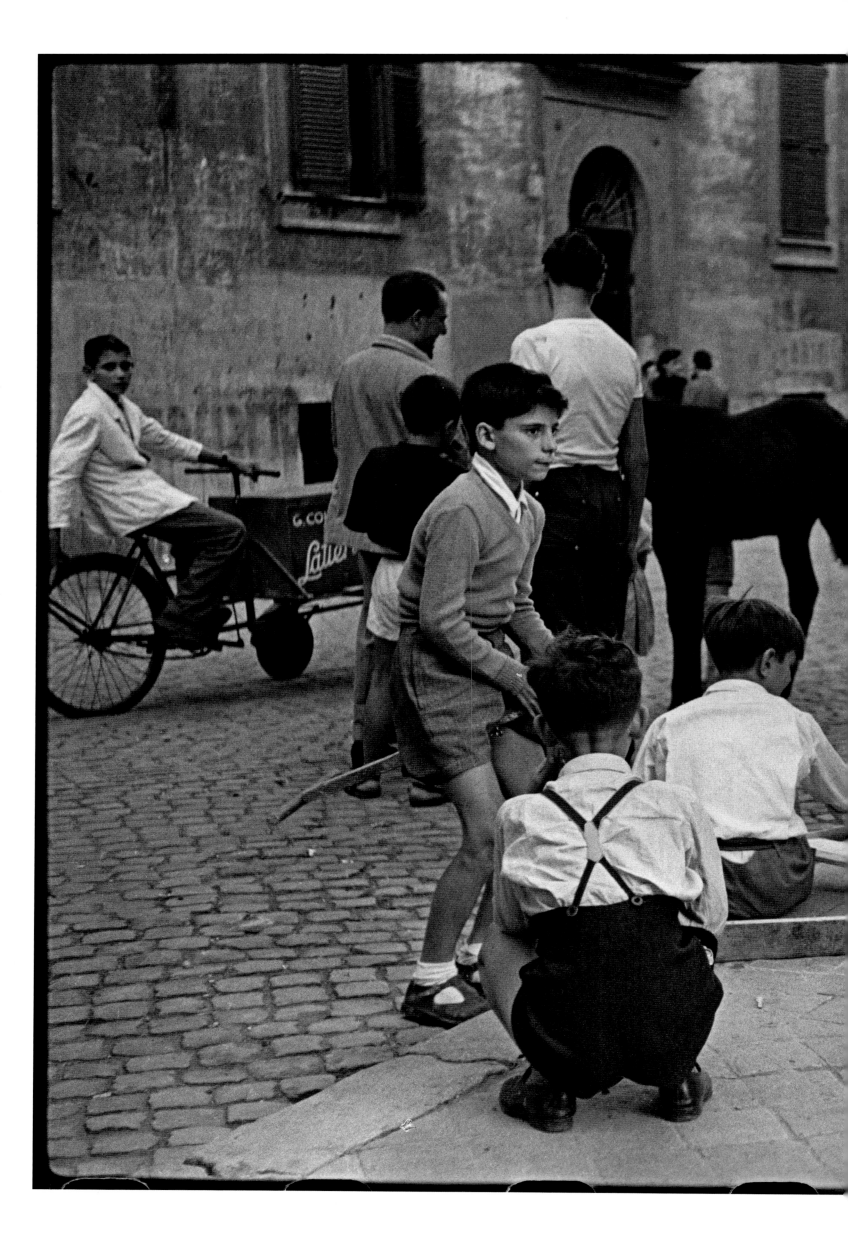

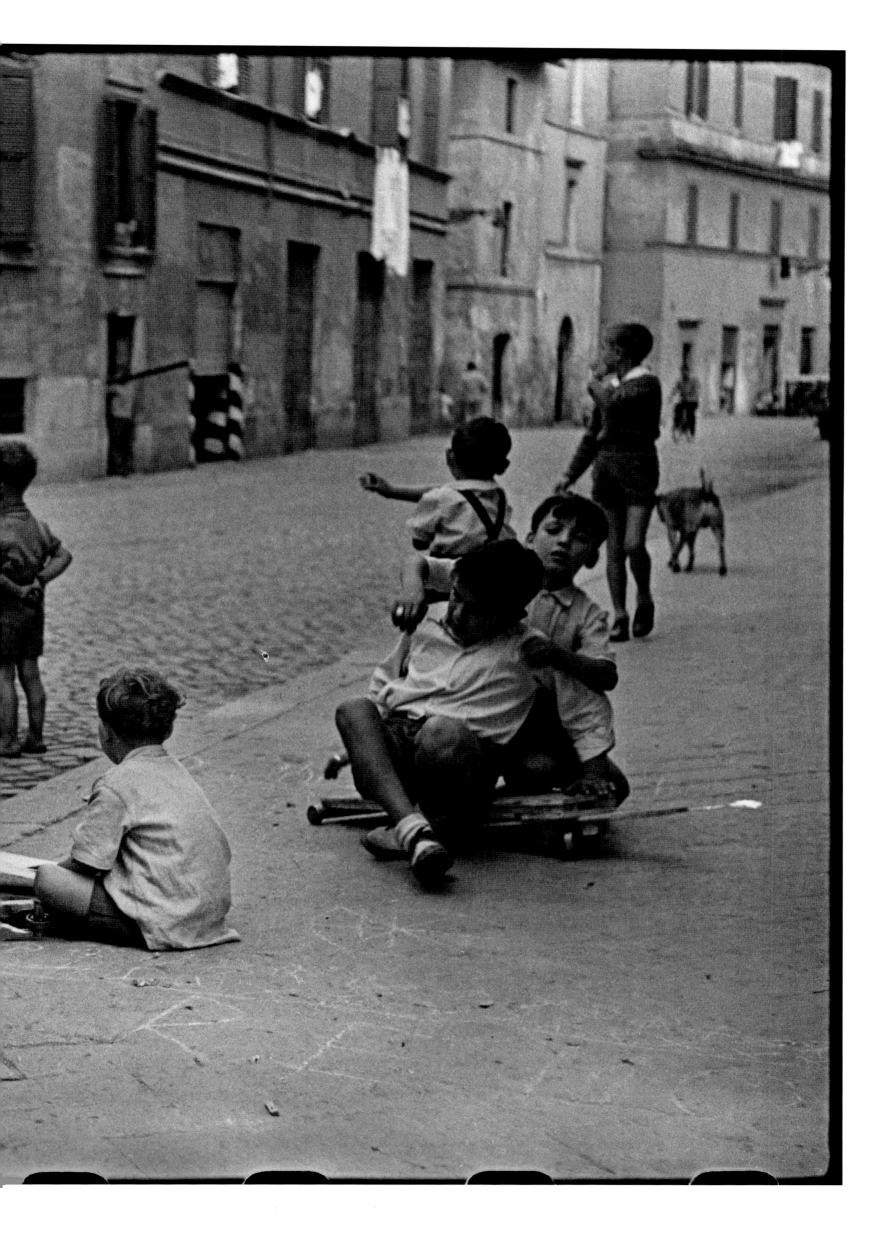

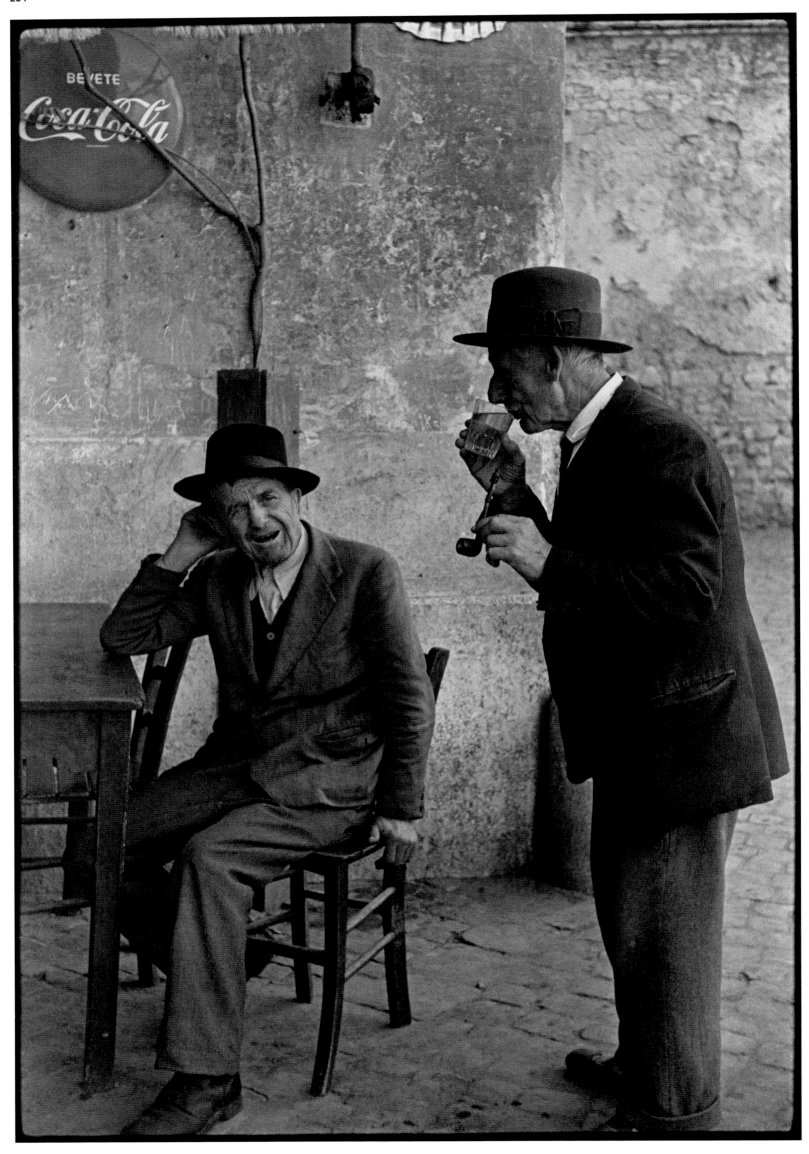

←

Henri Cartier-Bresson

*Vices in Trastevere: smoking and drinking
(wine, not Coca-Cola), 1952.*

*Trastevere: Man gönnt sich ein Pfeifchen und
dazu ein Gläschen (Wein, nicht Coca Cola),
1952.*

*Le vice règne à Trastevere où l'on fume et
l'on boit (du vin, pas du Coca-Cola), 1952.*

↘

William Klein

*Every kind of motorcycle in Italy was used
with extraordinary virtuosity and in the most
varied modes (here: Holy Family mode), 1956.*

*In der Benutzung motorisierter Zweiräder
entwickelten die Italiener eine virtuose
Vielfalt (hier das Modell „Heilige Familie"),
1956.*

*En Italie, chaque type de deux-roues était
utilisé avec une virtuosité extraordinaire et
dans les styles les plus variés (ici, style Sainte
Famille), 1956.*

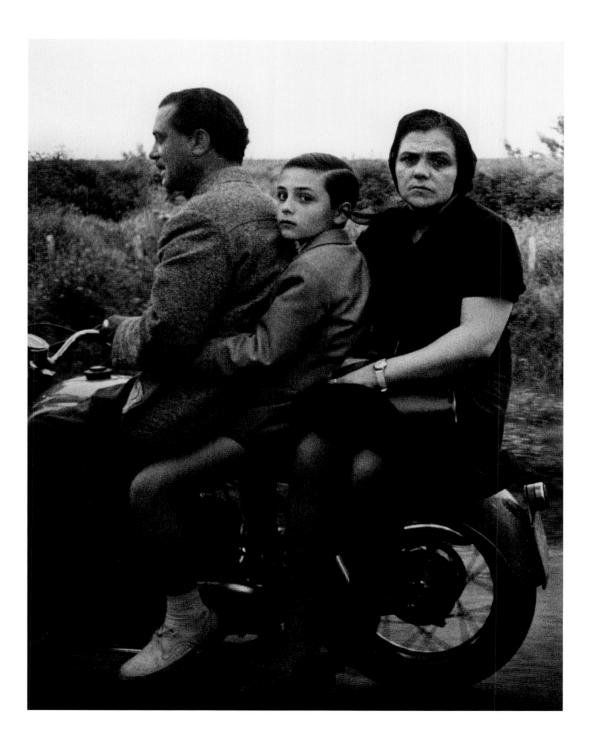

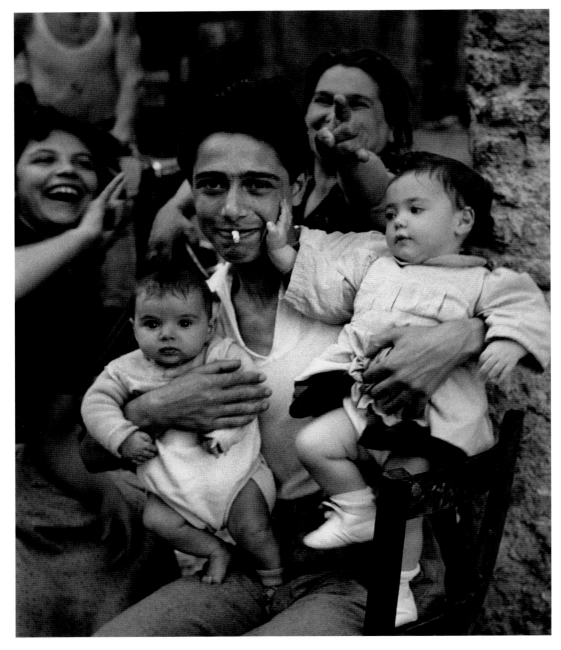

←
Herbert List

People of Trastevere, 1951.

Menschen in Trastevere, 1951.

Habitants de Trastevere, 1951.

→
James Whitmore

Lunch al fresco in the city center in a dead end street, August 1952. "The virtues of eating and drinking are not merely the virtues of gourmandise, pagliate and carbonara and Frascati; they are above all social virtues, a profound sense of companionship, human contact, friendship, the most sacred thing for the people of Rome." (Carlo Levi, Il popolo di Roma, *1960)*

Mittagstisch in einer Sackgasse im Stadtzentrum, August 1952. „Die Vorzüge des römischen Essens und Trinkens sind nicht nur solche des Gaumens: Kalbsdarm, Carbonara und Frascati – sondern vor allem gesellschaftliche Tugenden, ein tiefer Sinn für Gemeinschaft, für die Begegnung unter Menschen, die Freundschaft: das Heiligste, das es für die einfachen Römer gibt." (Carlo Levi, Il popolo di Roma, *1960)*

Déjeuner en plein air dans une impasse du centre, août 1952. « Le plaisir de manger et de boire n'est pas seulement d'ordre gourmand; pagliate [sorte de tripes], spaghetti à la carbonara et vin de Frascati; c'est surtout un plaisir social, l'expression d'un sens profond de la compagnie, du contact humain, de l'amitié, chose la plus sacrée pour le peuple de Rome. » (Carlo Levi, Il popolo di Roma, *1960)*

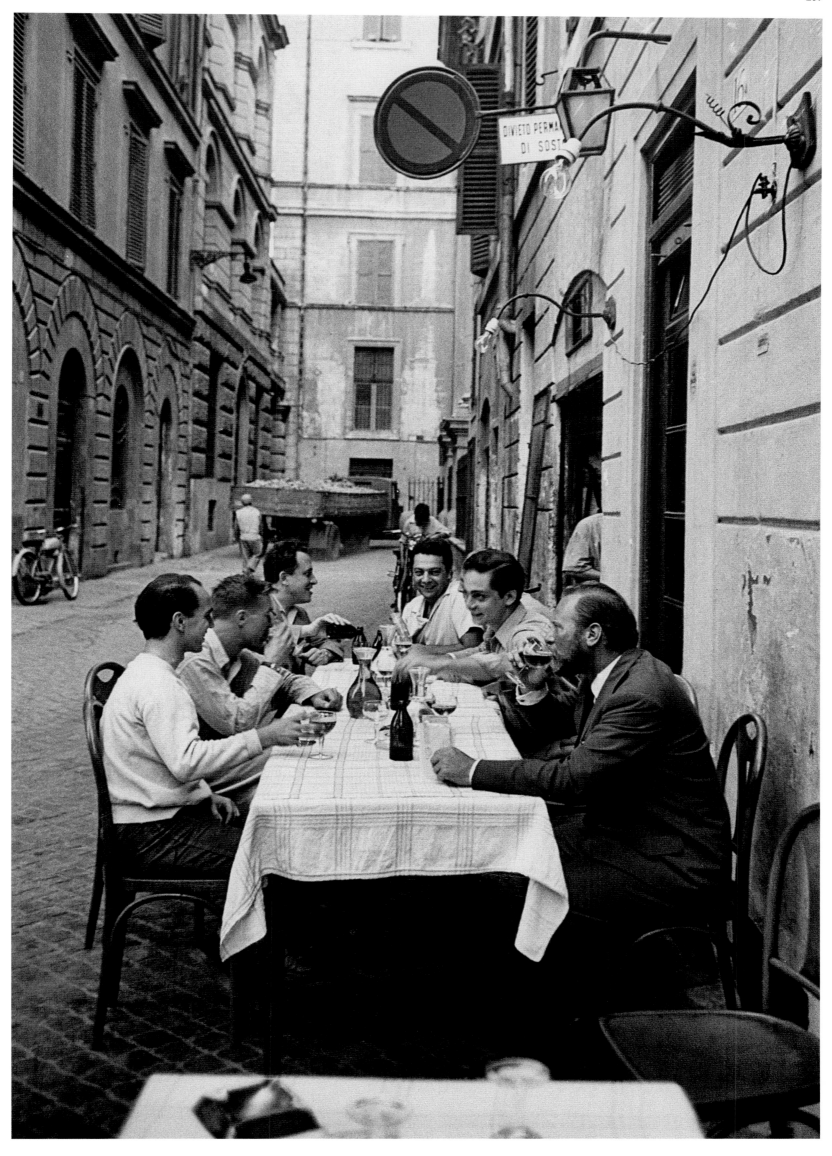

pp. 258/259
David Seymour

*Historic center: artisan workshop, fruit
vendor, political posters, 1952.*

*Römische Altstadt: Bilderladen, Obsthändler,
Wahlplakate, 1952.*

*Vieux centre : atelier d'artisan, vendeur de
fruits, affiches politiques, 1952.*

←

Robert Capa

Receptions, entertainment, celebrations: in Rome, partying was a beloved social occasion during the years of the economic miracle, 1951.

In den Wirtschaftswunderjahren wurde die „Party" zu dem gesellschaftlichen Ereignis schlechthin: Empfang, Zeitvertreib, großes Fest, 1951.

Réceptions, soirées, fêtes: la « party » fut à Rome un événement mondain qui connut son heure de gloire au temps du miracle économique, 1951.

↓

Robert Capa

Party watched over by Venus: an exchange of glances. Seen here, actress and model Capucine, 1951.

Party im Angesicht der Venus: das Spiel der Blicke, mit Capucine, Schauspielerin und Mannequin, 1951.

« Party » sous l'égide de Vénus : jeux de regards. On reconnaît l'actrice et mannequin Capucine, 1951.

Robert Capa

Party watched over by Venus: an exchange of glances. Seen here, actress and model Capucine, 1951.

Party im Angesicht der Venus: das Spiel der Blicke, mit Capucine, Schauspielerin und Mannequin, 1951.

« Party » sous l'égide de Vénus : jeux de regards. On reconnaît l'actrice et mannequin Capucine, 1951.

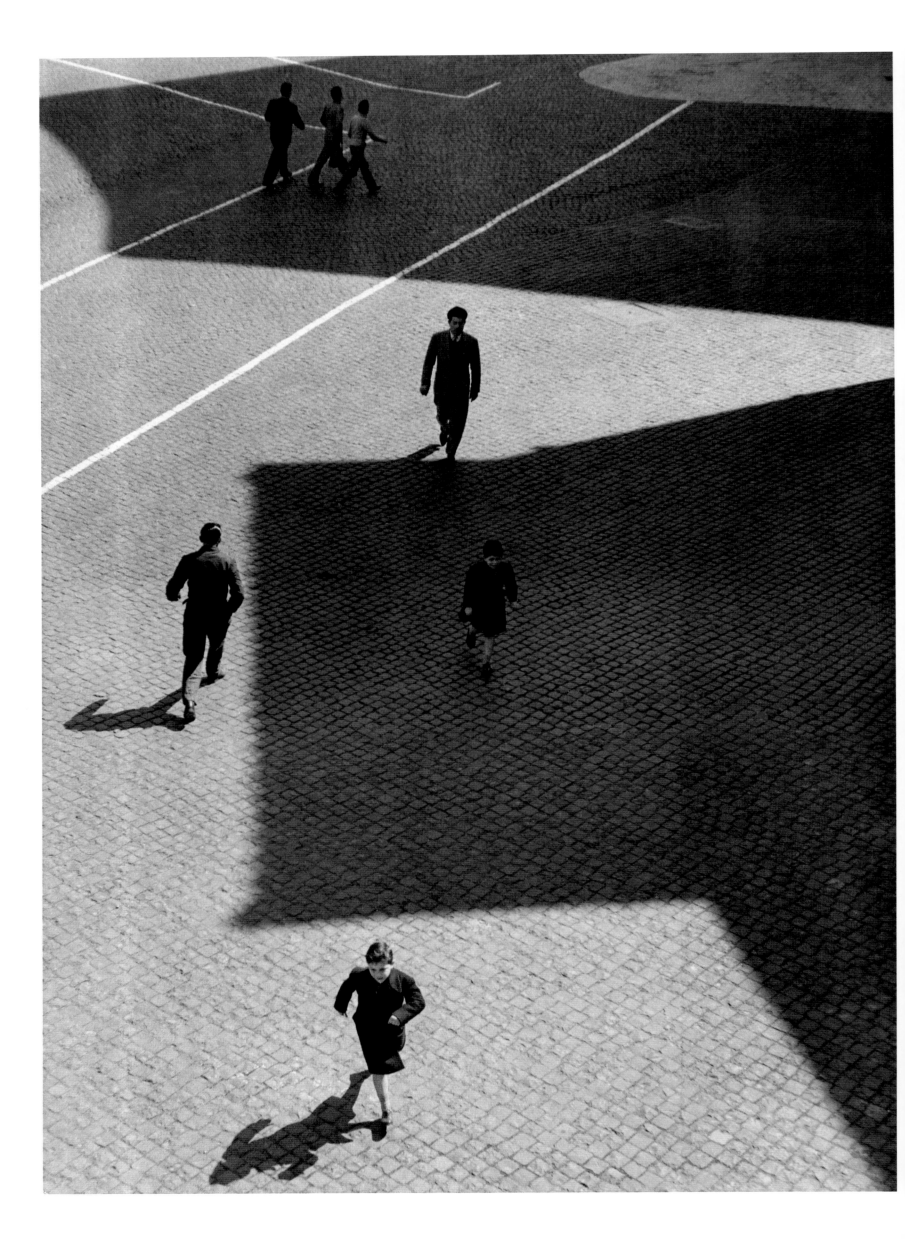

"Among the many things that have changed over these twenty years [1920–1940] is the appearance of the streets of Rome: once the streets were paved with blue Roman cobblestones; now the road is made of black, polished asphalt, the same as any other modern metropolis; [...] on the polished asphalt yesterday's world becomes more remote."

„Eines hat sich geändert am Bild der römischen Straßen in den letzten zwanzig Jahren: Früher waren sie mit bläulichem römischem Kiesel gepflastert, heute sind die Straßen mit schwarzem glänzendem Asphalt bedeckt wie in jeder anderen modernen Großstadt; [...] und auf dem Glanz des Asphalts rückt die Welt von gestern in noch weitere Ferne."

« Parmi tant d'autres, il est une chose qui durant ces vingt années [1920–1940] a modifié l'aspect des rues de Rome : jadis les rues étaient couvertes de pavés romains et elles étaient bleues ; aujourd'hui la rue est recouverte d'un asphalte noir et brillant, celui de toutes les métropoles modernes ; [...] sur l'asphalte brillant le monde d'hier se fait plus lointain. »

CORRADO ALVARO, *ITINERARIO ITALIANO,* 1941

←

Herbert List

Trastevere, Via della Lungarina: houses' shadows on the sanpietrini *(cobblestones), 1953.*

Trastevere, Via della Lungarina, Schatten auf dem Kopfsteinpflaster, 1953.

Trastevere, via della Lungarina : ombres des maisons sur les pavés, 1953.

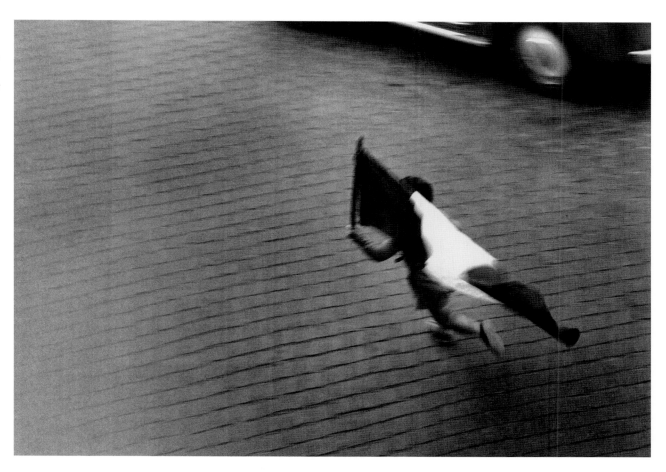

↑

Herbert List

Via della Lungarina: after a victory by the national football team, a child runs to the Ponte Palatino waving the Italian flag (the tricolore)*, 1953.*

Via della Lungarina – nach dem Sieg der Fußballnationalmannschaft läuft ein Junge mit der italienischen Fahne in der Hand Richtung Ponte Palatino, 1953.

Via della Lungarina, lors de la victoire de l'équipe nationale de football, un enfant court vers le pont Palatino en faisant flotter le drapeau italien, 1953.

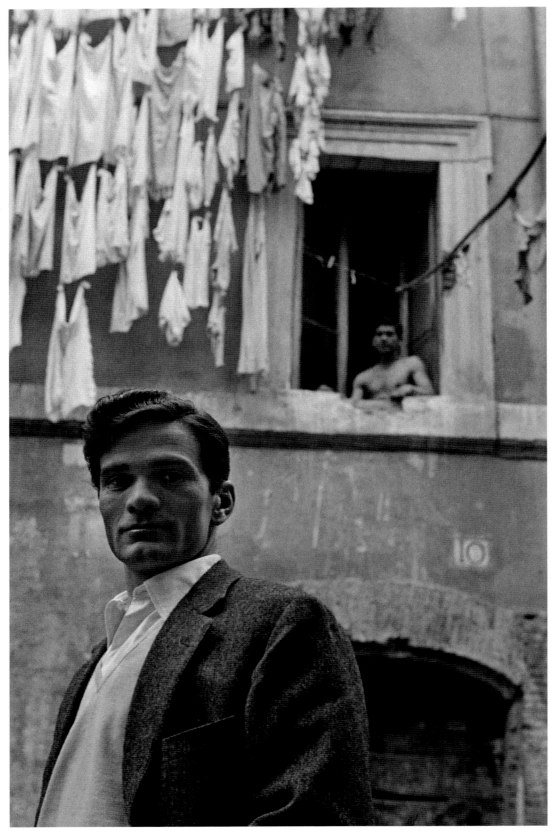

←
Herbert List

Pier Paolo Pasolini in a street of Trastevere, the district of the ancient city center that he loved most because it was the most authentic place of the people, 1953.

Pier Paolo Pasolini vor einem Haus in Trastevere, dem Stadtviertel von Rom, das er am meisten liebte, weil dort noch einfache Menschen lebten, 1953.

Pier Paolo Pasolini dans une rue de Trastevere, le quartier du vieux centre qu'il préférait, car le plus populaire, 1953.

→
Elliott Erwitt

Via delle Botteghe Oscure, a street not far from the Pantheon, elements of Roman urban fixtures: warm-colored plasterwork, white marble street sign with its lapidary characters, the plaque of an insurance company, a public telephone sign, a light globe, and enamelled metal bar sign, 1955.

Die Via delle Botteghe Oscure in der Nähe des Pantheon mit den charakteristischen Elementen des römischen Stadtbilds: Wandputz in warmem Ocker, Straßenschild in weißem Marmor mit Schriftzug in großen Antiqualettern, Kugellaterne, Plakette einer Versicherungsgesellschaft, Hinweisschild eines öffentlichen Fernsprechers und Emailleschilder neben dem Eingang zur Bar, 1955.

Via delle Botteghe Oscure, non loin du Panthéon, des éléments typiques du paysage urbain de Rome : enduits aux couleurs chaudes, plaques de rue en marbre blanc aux caractères lapidaires, globe lumineux et plaques en tôle émaillée d'un bar, plaque d'une compagnie d'assurance, enseigne de téléphone public, 1955.

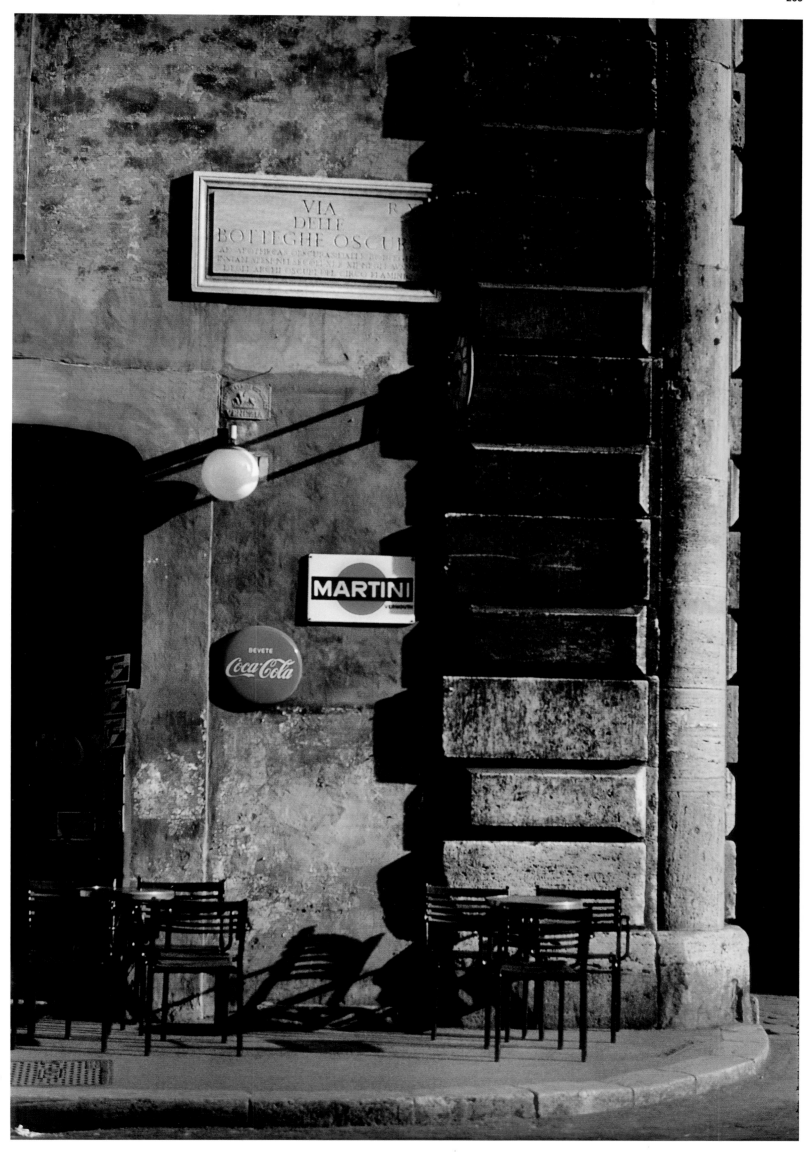

"On buses, and during some hours of the day, in the so-called 'rush hour,' you could say that human flesh becomes one, especially in the summer, with light clothes, extra-light in the case of women […], there is a fine art in knowing how to place oneself. Throngs are everywhere, practically a tradition that the citizens of Rome cherish above all others, to buy a stamp you have to crush and be crushed."

„Im Bus und zu bestimmten Zeiten, den sogenannten Stoßzeiten, erreicht das menschliche Fleisch gewissermaßen die Vereinigung, vor allem im Sommer, bei leichter Kleidung, besonders leicht bei den Frauen, […] herrscht eine hohe Kunst der Standortwahl. Das Gedrängel ist allgegenwärtig, man könnte meinen, eine Institution, auf die der römische Bürger Wert legt wie auf keine andere; wer eine Briefmarke kaufen will, muss drängeln und sich drängeln lassen."

« Dans les autobus, à certaines heures, dites de pointe, on peut dire que la chair humaine parvient à l'unité, spécialement l'été, avec les robes légères, légérissimes, des femmes; […] on découvre l'art raffiné de bien savoir se placer. La cohue est partout, on dirait une institution à laquelle le Romain semble tenir comme à aucune autre : pour acheter un timbre-poste, vous devez bousculer et vous faire bousculer. »

ALDO PALAZZESCHI, *ROMA,* **1953**

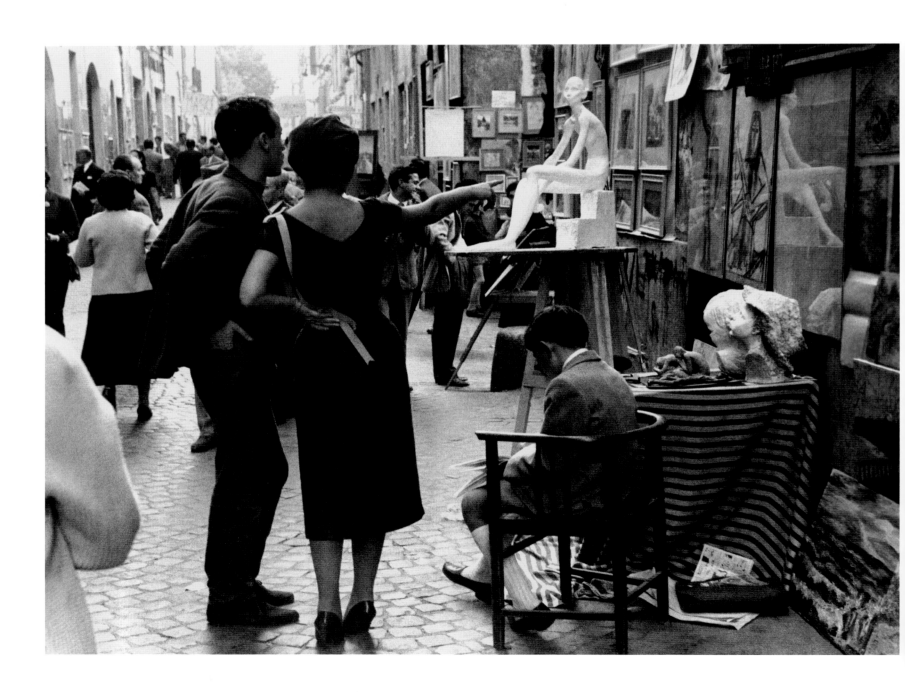

Mario Carbone

Via Margutta, in the Roman district of Campo Marzio, is the artists' street, internationally known as the heart of the Roman "Latin Quarter," where, among others, lived Giorgio De Chirico, Federico Fellini, and Anna Magnani. It has featured in many songs and films, 1958.

Die Via Margutta im Stadtbezirk Campo Marzio, das Herz des römischen Quartier Latin, ist eine Straße der Künstler; hier lebten unter anderem Giorgio De Chirico, Federico Fellini und Anna Magnani. Die Via Margutta taucht in zahlreichen Filmen und Liedern auf, 1958.

Située dans le quartier du Campo Marzio, la via Margutta est la rue des artistes; elle est mondialement connue comme le cœur du « Quartier latin » de Rome où vécurent, notamment Giorgio De Chirico, Federico Fellini, Anna Magnani; un grand nombre de films et de chansons lui ont été dédiés, 1958.

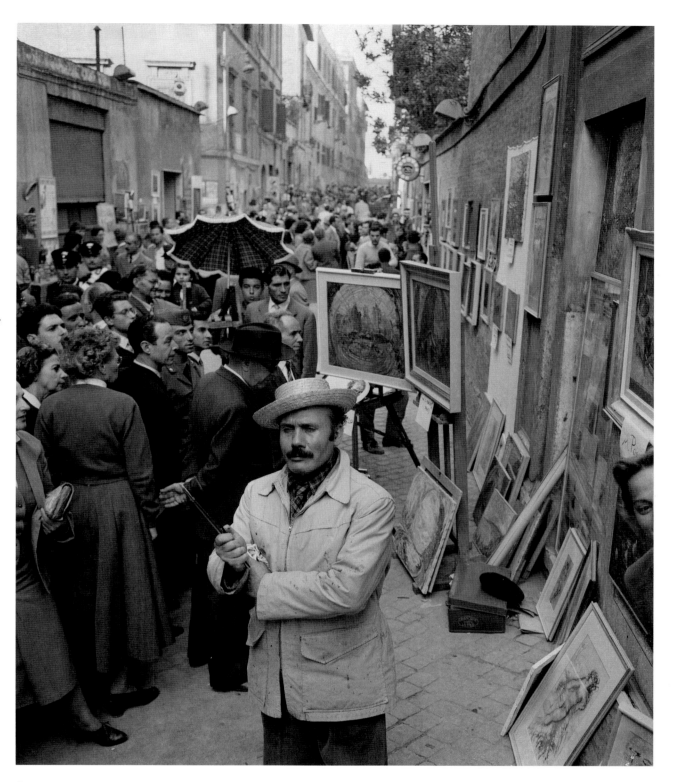

↑
Mario Carbone

In 1953 a group of artists staged the first "Art Fair in Via Margutta," which soon became a recurring event. Paintings, sculptures, and objects, the product of various and contrasting artistic trends between abstract art and social realism, were exhibited along the road, in the style of a village fair, 1954.

1953 veranstaltete eine Gruppe von Künstlern die erste „Kunstmesse in der Via Margutta", die schnell zu einem regelmäßigen Treffpunkt wurde. Wie auf einem Jahrmarkt waren Bilder, Skulpturen und Kunstgegenstände im Freien ausgestellt, Werke der verschiedensten Kunstrichtungen der Zeit, von der Abstraktion bis zum Sozialistischen Realismus, 1954.

En 1953, un groupe d'artistes inaugura la première « Fiera d'arte in Via Margutta » qui ne tarda pas à devenir un rendez-vous régulier. Sur toute la longueur de la rue étaient exposés en plein air comme dans une kermesse peintures, sculptures et objets d'art issus des courants les plus variés de la culture artistique de l'époque, entre abstraction et réalisme social, 1954.

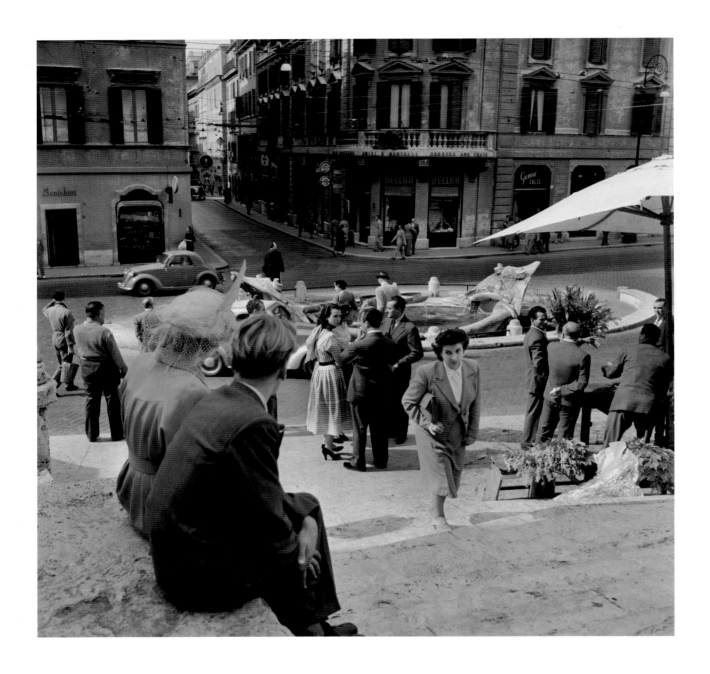

Jacques Rouchon

The Spanish Steps have always been a meeting place for tourists and Romans alike, 1955.

Die Spanische Treppe ist von jeher ein Treffpunkt für Römer und Romreisende, 1955.

Depuis toujours, Romains et touristes se mêlent et se rencontrent sur les marches de l'escalier de Trinità dei Monti, 1955.

Jacques Rouchon

A café in Largo Magnanapoli, at the foot of the Villa Aldobrandini gardens, 1955.

Straßencafé am Largo Magnanapoli unterhalb des Parks der Villa Aldobrandini, 1955.

Café situé Largo Magnanapoli, au pied du jardin de la villa Aldobrandini, 1955.

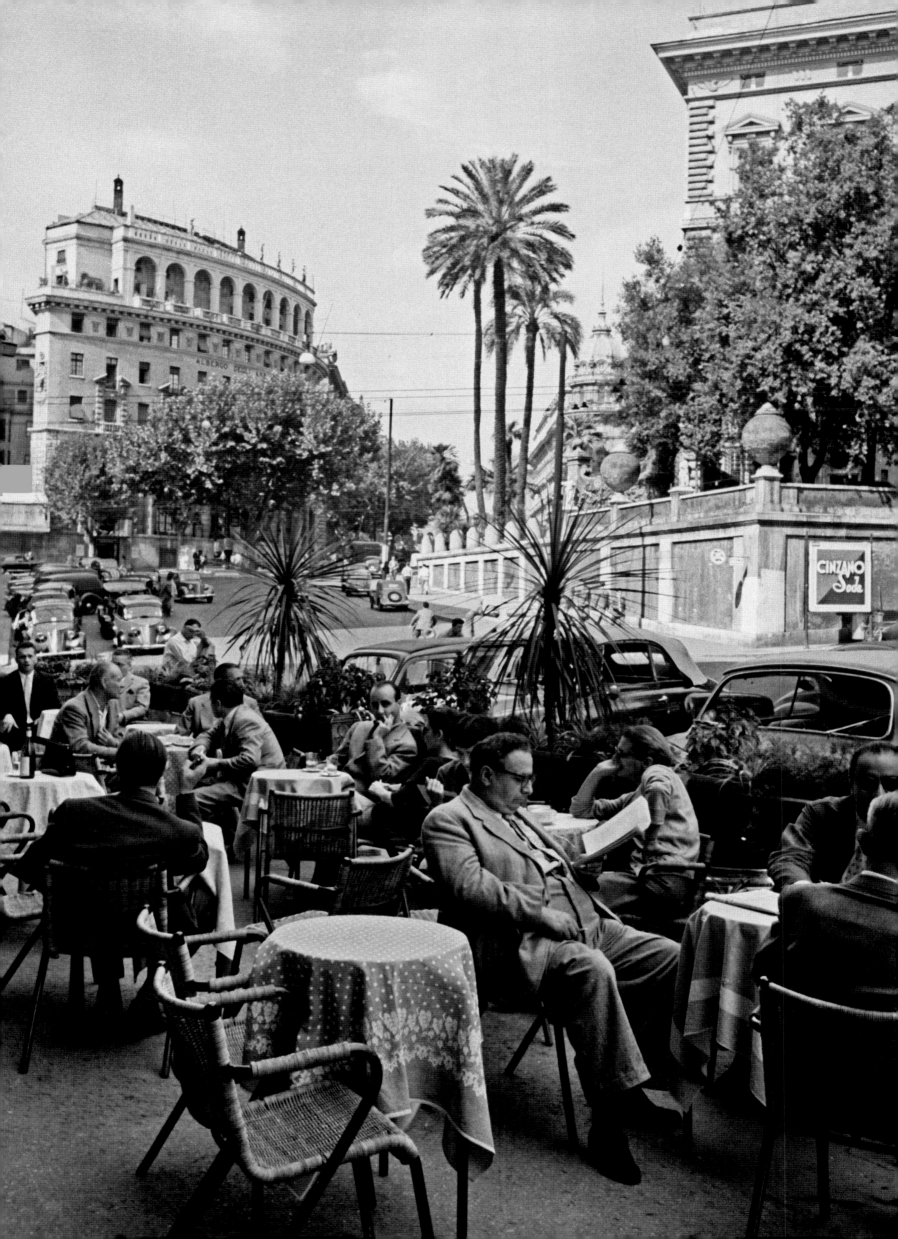

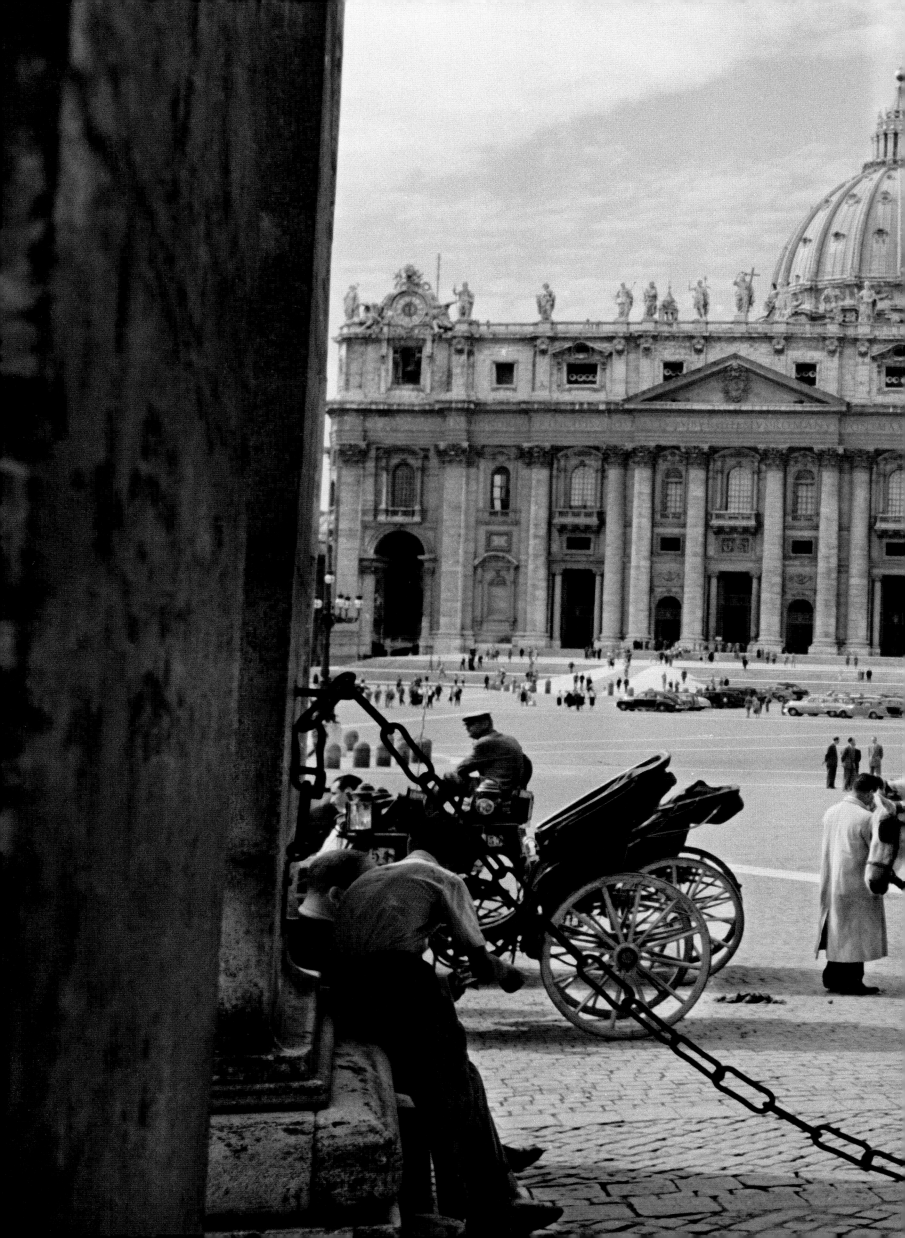

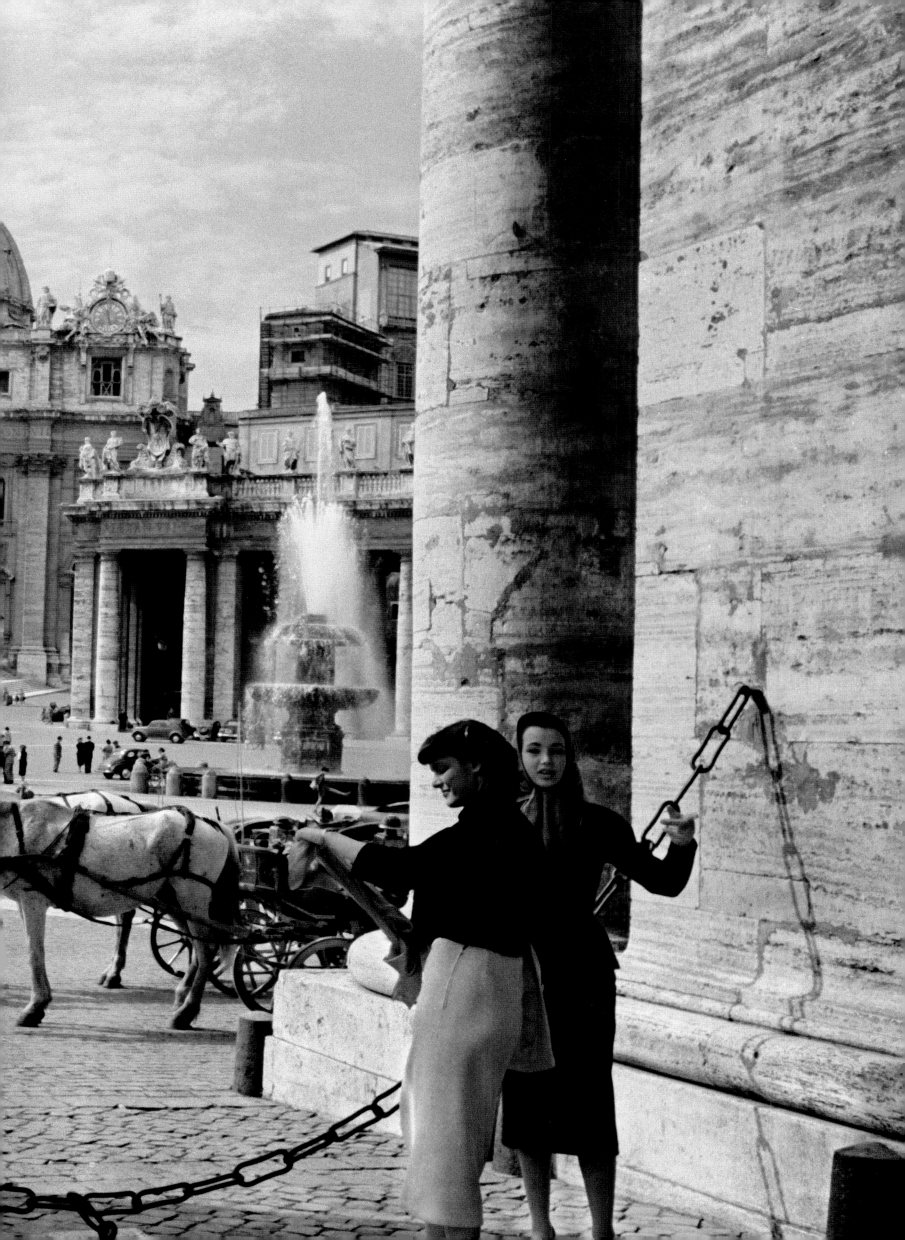

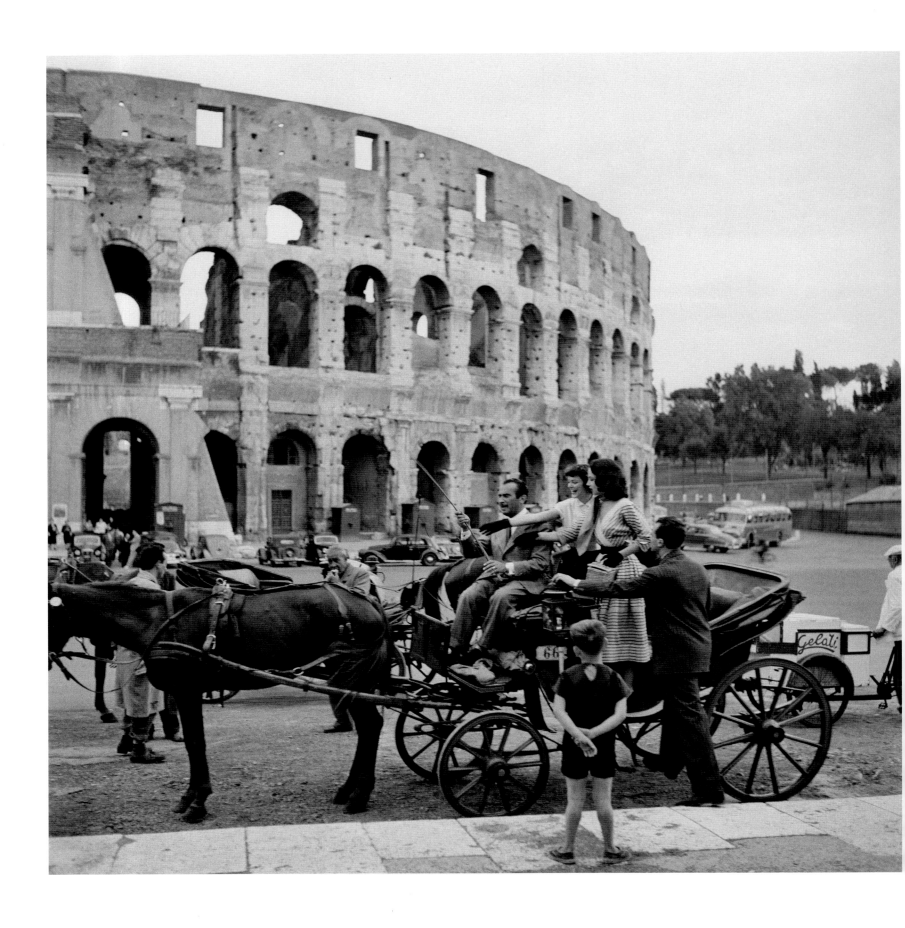

pp. 270/271
Jacques Rouchon

Horse carriages in St. Peter's Square. In the mid-1950s tourism had not yet turned into the intolerable mass-phenomenon that it is now, 1955.

Droschken auf dem Petersplatz. Mitte der 1950er-Jahre Jahre besaß der Tourismus noch nicht die unerträgliche Massendimension von heute, 1955.

Calèches, place Saint-Pierre. Au milieu des années 1950, le tourisme ne possède pas encore le caractère insupportable d'un phénomène de masse, 1955.

↑
Jacques Rouchon

Horse carriage in front of the Colosseum. This is one in a series of images in which the photographer captured aspects of tourism and urban life in Rome with wit and originality; they often feature two couples of young tourists, 1955.

Pferdedroschke vor dem Kolosseum. Die Aufnahme ist Teil einer Serie, in der Rouchon römisches Leben und Romtourismus geschickt in Szene zu setzen versteht. Häufig treten Reisende als Doppelpaar auf, 1955.

Calèche devant le Colisée. Le cliché fait partie d'une série où le photographe français montre avec fraîcheur et non sans malice divers aspects de la vie urbaine et du tourisme à Rome ; deux couples de jeunes touristes se retrouvent souvent sur ces clichés, 1955.

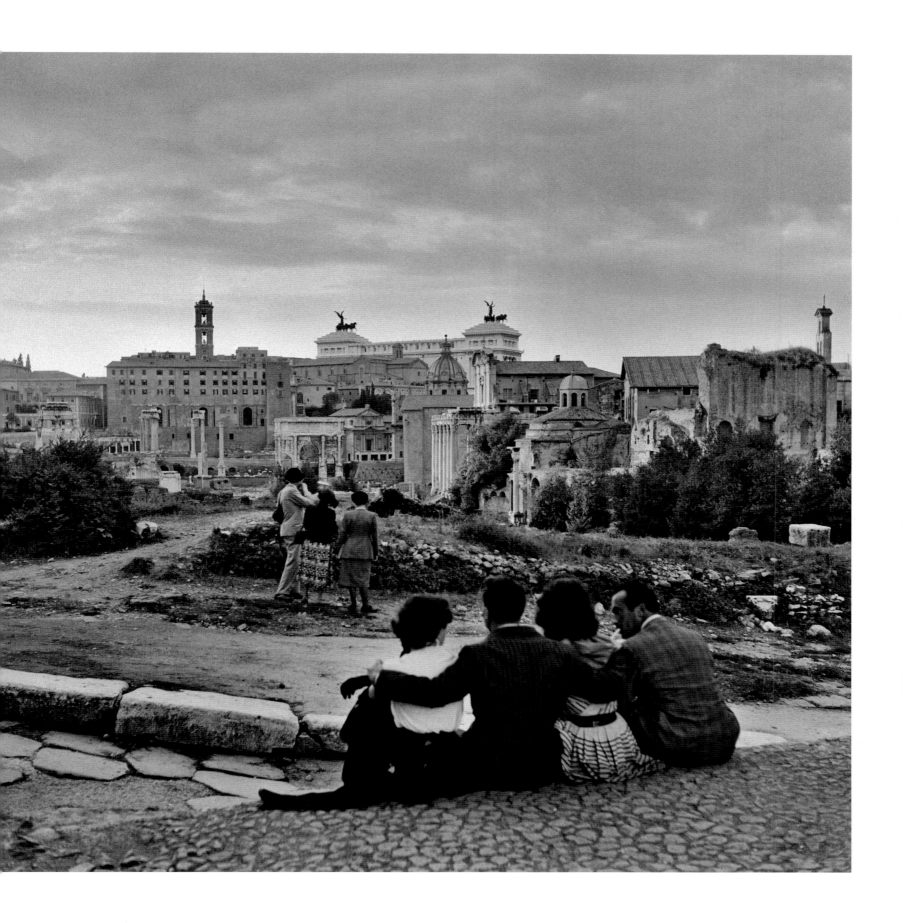

↑
Jacques Rouchon

Tourists at the Roman Forum. The image reveals Rouchon's witty approach: the tourists could pass for young Romans, 1955.

Touristen auf dem Forum Romanum. Geschickt versteht es Rouchon in seinen Reportagen, Besucher als Römer erscheinen zu lassen, 1955.

Touristes au Forum romain. L'image révèle l'esprit malicieux du reportage romain de Rouchon : les touristes peuvent passer pour de jeunes Romains, 1955.

pp. 274/275
Jacques Rouchon

The two couples of young tourists featuring in Rouchon's Roman series, seen here sitting in the restaurant on the terrace of the Hassler Hotel, 1955.

Hier lässt Rouchon die beiden Touristen-pärchen, denen wir auf seinen Rombildern immer wieder begegnen, auf der Terrasse des Hotels Hassler Platz nehmen, 1955.

Les deux couples de jeunes touristes qui animent les clichés du reportage romain de Rouchon sont attablés à la terrasse de l'hôtel Hassler, 1955.

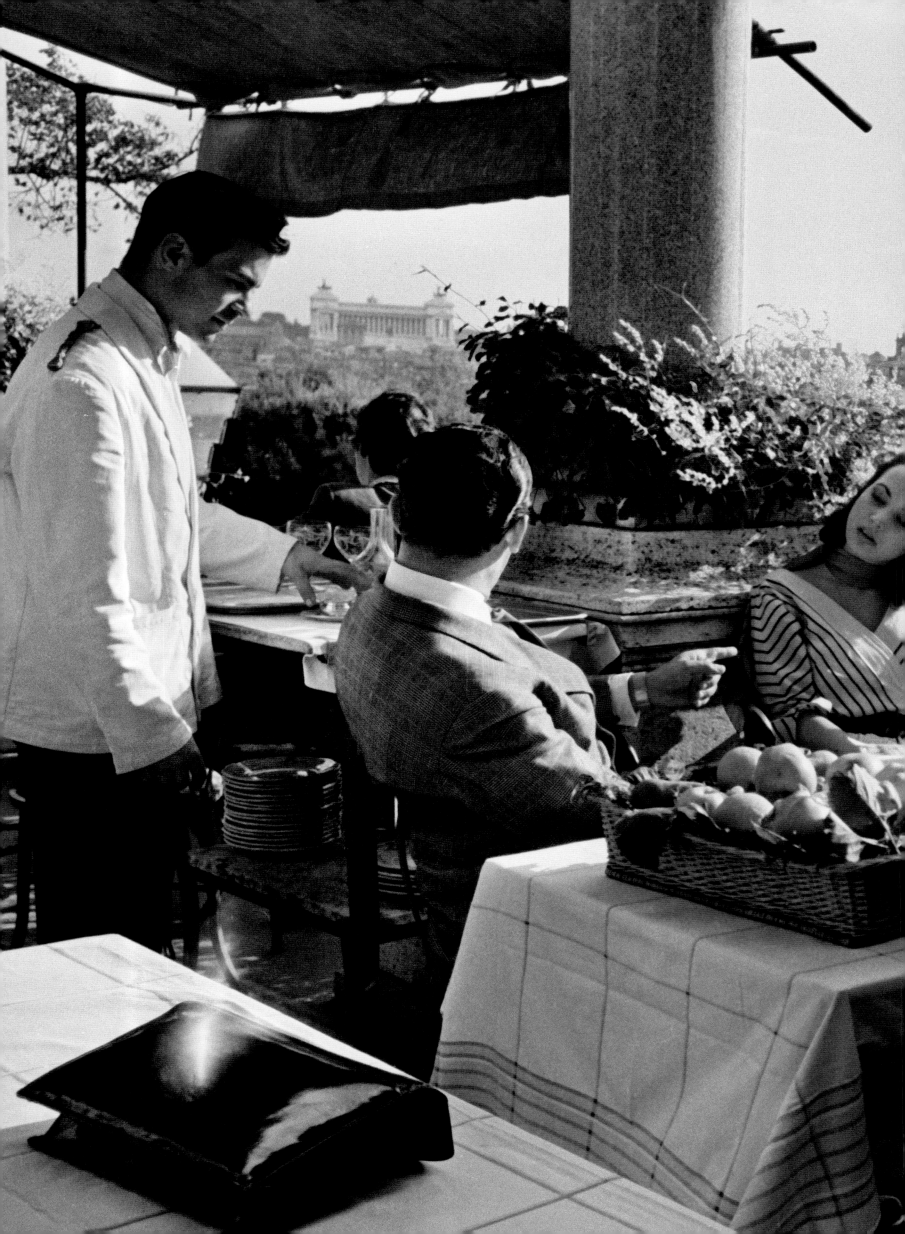

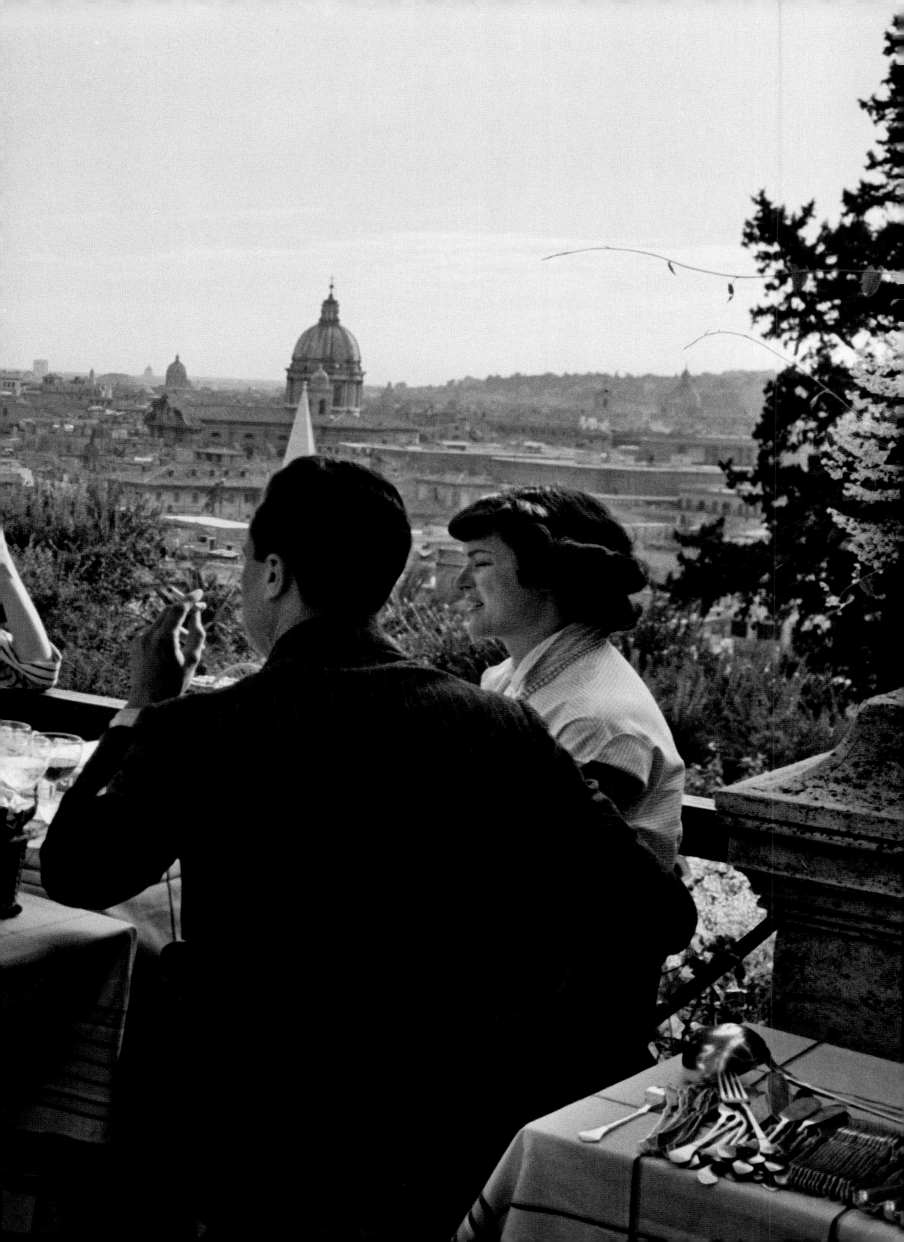

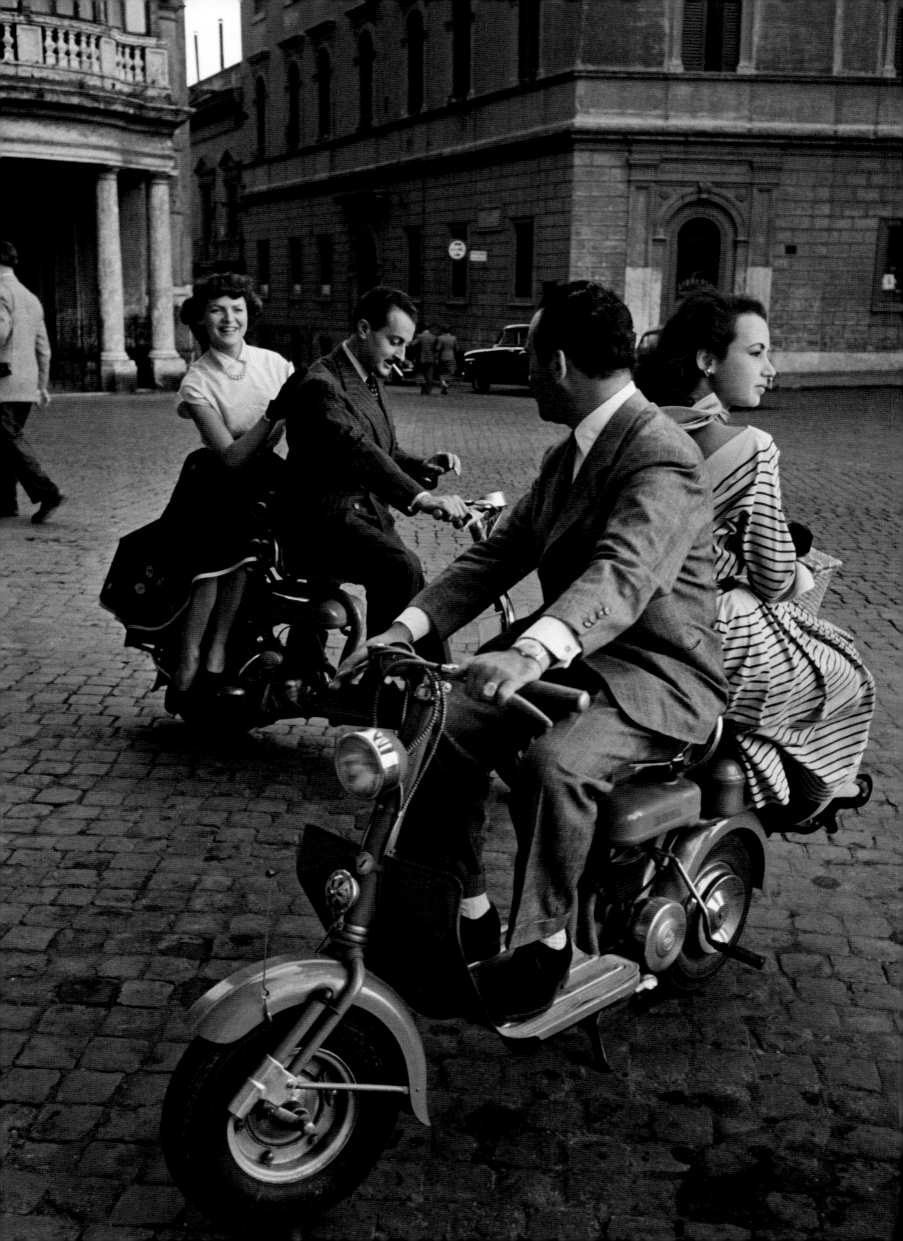

↑
Jacques Rouchon

Two curious tourists study the merchandise displayed in a typical Roman hardware store, 1955.

Zwei Touristinnen stöbern neugierig in der Auslage eines typischen römischen Haushaltswarenladens, 1955.

Deux touristes observent avec curiosité les ustensiles ménagers d'une droguerie typiquement romaine, 1955.

←
Jacques Rouchon

Vespa (and Lambretta) scooters were popular worldwide, but in Italy they were used with extraordinary flair and creativity, 1955.

Vespa (und Lambretta) wurden auf der ganzen Welt gefahren – aber wohl nur in Italien mit so viel Virtuosität und Einfallsreichtum, 1955.

Si la Vespa, et la Lambretta, firent la conquête du monde entier, c'est en Italie et nulle part ailleurs qu'elles furent utilisées avec une extraordinaire virtuosité et dans les styles les plus variés, 1955.

→
David Seymour

Sophia Loren on the balcony of her Roman home, 1955. The most beautiful definition of Loren was pronounced by William Klein: "Free, brutal, aloof, half cat and half whale, superb Sophia, hailing from the South. Wild Sophia, larger than life, a Graeco-Roman wrestling champion. Next to her, other women don't exist, and the men even less. What man might be worthy of her? A gladiator, a fire-eater, a film-maker? I can't imagine." Nonetheless, she married a film producer, Carlo Ponti.

Sophia Loren auf dem Balkon ihrer römischen Wohnung, 1955. Die beste Beschreibung der Loren stammt von William Klein: „Frei, brutal, verächtlich, halb Katze, halb Wal, herrliche Sophia, überlebensgroß, Meisterin im griechisch-römischen Stil. Neben ihr hören die anderen Frauen auf zu existieren, und erst recht die Männer. Welcher Mann wäre ihrer würdig? Gladiator, Feuerschlucker, Filmproduzent – mir fällt keiner ein!" Am Ende war sie aber doch mit einem Produzenten verheiratet: mit Carlo Ponti.

Sophia Loren sur le balcon de son appartement romain, 1955. C'est William Klein qui a brossé le plus beau portrait de Sophia Loren: « Libre, brutale, dédaigneuse, mi-chat, mi-baleine, superbe Sophia, venue du Sud. Sauvage Sophia, plus grande que nature, championne de lutte gréco-romaine. À côté d'elle, les autres femmes n'existent pas; les hommes encore moins. Quel homme serait digne d'elle? Gladiateur, mangeur de feu, producteur de cinéma? Je ne vois pas. » Et pourtant, elle épousa Carlo Ponti, un producteur de cinéma.

↑
Slim Aarons

Ursula Andress and Novella Parigini, 1955.

Ursula Andress und Novella Parigini, 1955.

Ursula Andress et Novella Parigini, 1955.

pp. 280/281
William Klein

Klein observed: "The art of coiffing, one of the great Roman industries. For a shave and hair-cut there are monthly subscriptions. Almost all the young hairdressers come from the South, where barber shops are still a meeting place and where, between one customer and the next, hairdressers play the guitar." 1956.

Der Fotograf merkt an: „Die Kunst des Haarschnitts – eine der großen römischen Branchen. Für Rasur und Frisur gibt es Monatsabonnements. Die jungen Barbiere kommen fast ausnahmslos aus dem Süden, wo der Salon noch allgemeiner Treffpunkt ist und der Coiffeur zwischen zwei Kunden zur Gitarre greift und aufspielt", 1956.

Commentaire de Klein: « La coiffure – une des grandes industries romaines. Pour la barbe et les cheveux, il existe des abonnements mensuels. Les jeunes coiffeurs viennent presque tous du Sud, où les boutiques de barbiers sont encore des centres de réunion et où les coiffeurs, entre deux clients, jouent de la guitare », 1956.

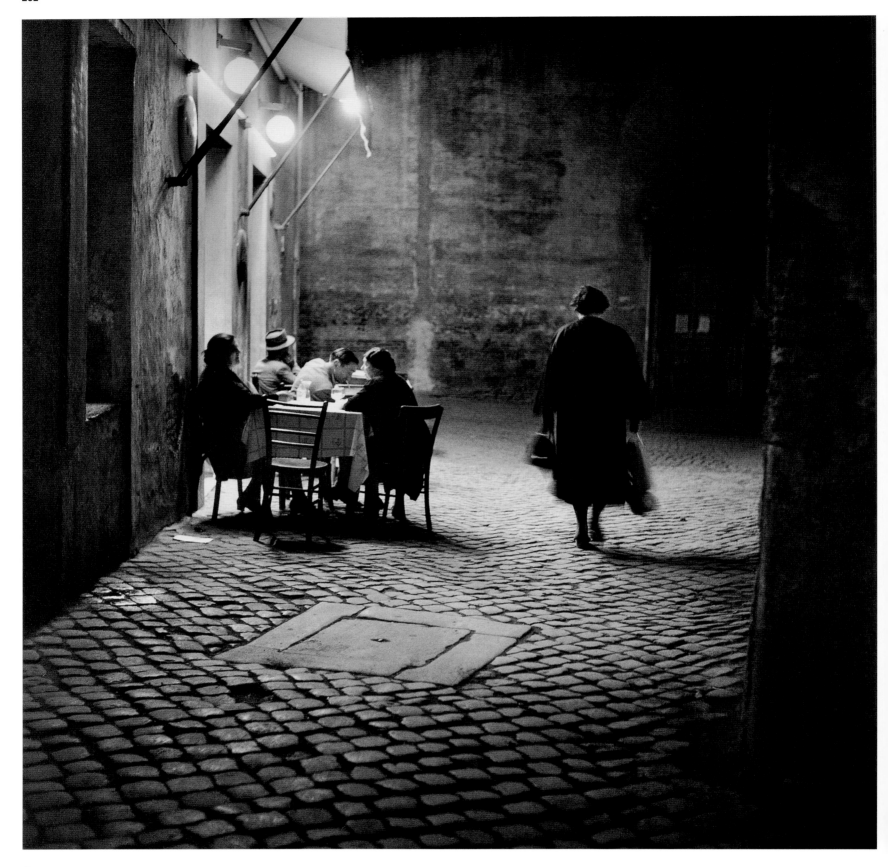

↑

Franz Hubmann

A Roman district beloved by tourists seeking local color, and celebrated in films, Trastevere has an ancient tradition of osterias and trattorias offering generous and gluttonous cuisine, 1957.

Von Touristen und Filmemachern wegen seines Lokalkolorits geliebt, verfügt Trastevere nicht zuletzt über eine lange Tradition der Osterien und Trattorien, die in diesem Viertel immer schon eine üppige, nahrhafte Kost auf dem Speiseplan hatten, 1957.

Quartier de Rome apprécié des étrangers en quête de couleur locale, célébré par le cinéma, Trastevere possède une longue tradition d'osterie et de trattorie à la cuisine généreuse et goûteuse, 1957.

*"Sunday is always Sunday
and as soon as people wake up,
they will be happy and will spend
their few pennies of happiness."*

*„Sonntag ist immer Sonntag,
kaum wacht man auf,
ist man glücklich und gibt
das bisschen Glück aus, das man hat."*

*« Dimanche sera toujours dimanche
et à peine réveillé chacun
sera heureux de dépenser
ces deux sous de bonheur.»*

PIETRO GARINEI & SANDRO GIOVANNINI,
IL MUSICHIERE, 1957

→

Carlo Bavagnoli

*An iconic image of neorealist photography:
a woman laughing unabashedly at a joke she
has just told, Trastevere, January 1958.*

*Das Bild einer sich vor Lachen über einen
selbst erzählten Witz schüttelnden Römerin
wurde zu einer Ikone der „neorealistischen"
Fotografie, Januar 1958.*

*Image culte de la photographie néoréaliste:
le rire incontrôlé d'une femme du peuple à la
fin de la blague qu'elle a racontée, dans une
osteria de Trastevere, janvier 1958.*

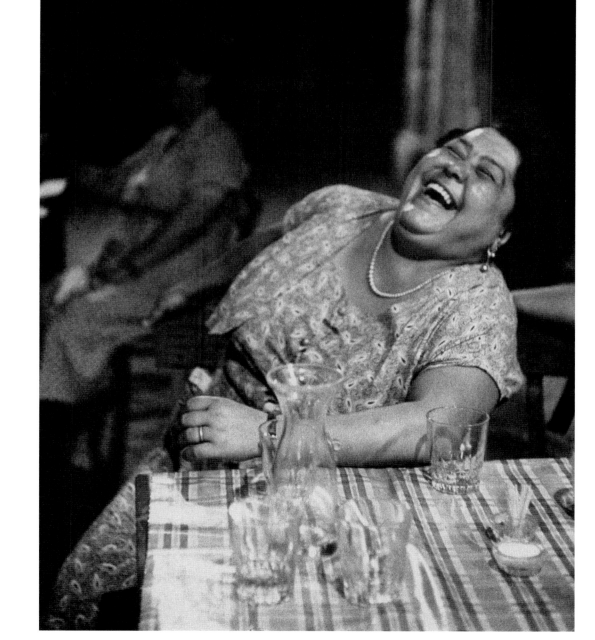

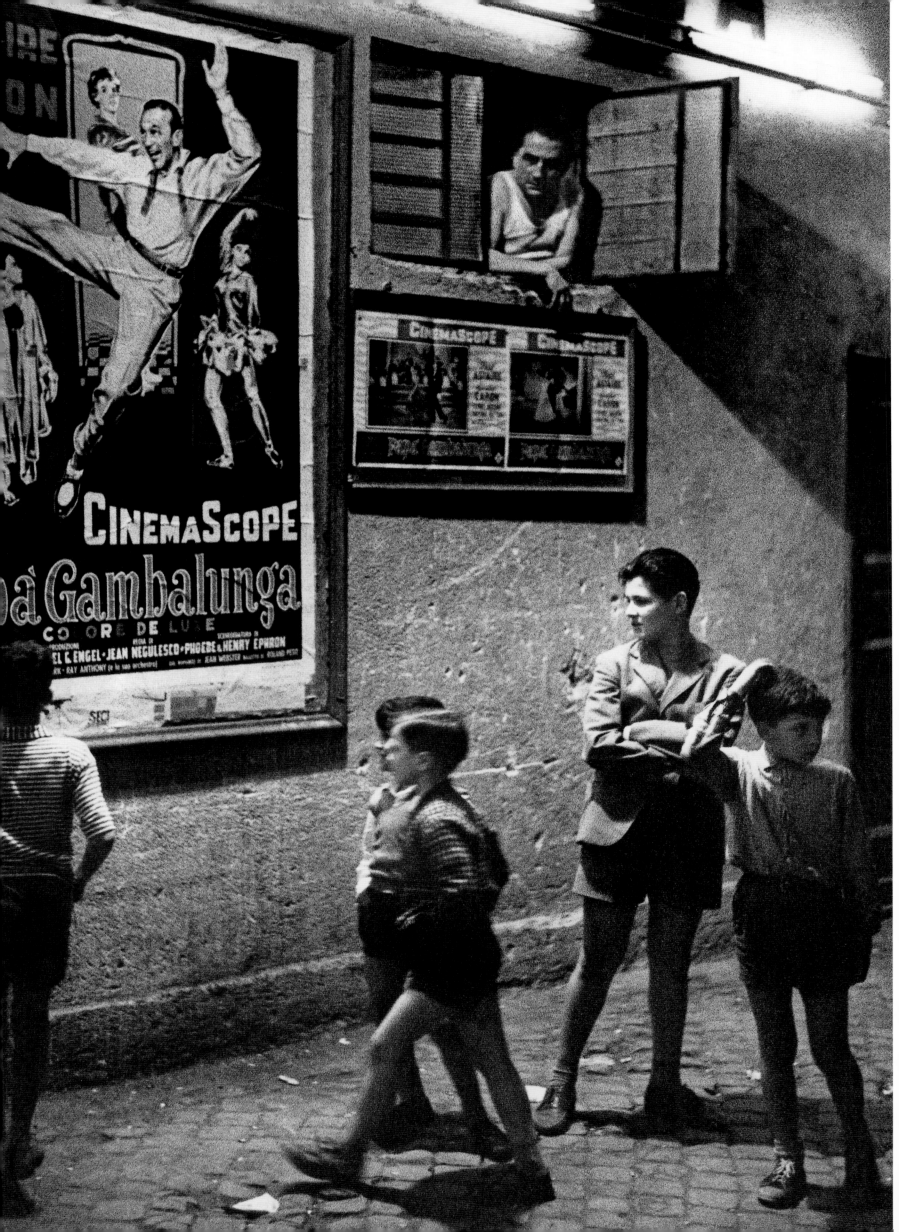

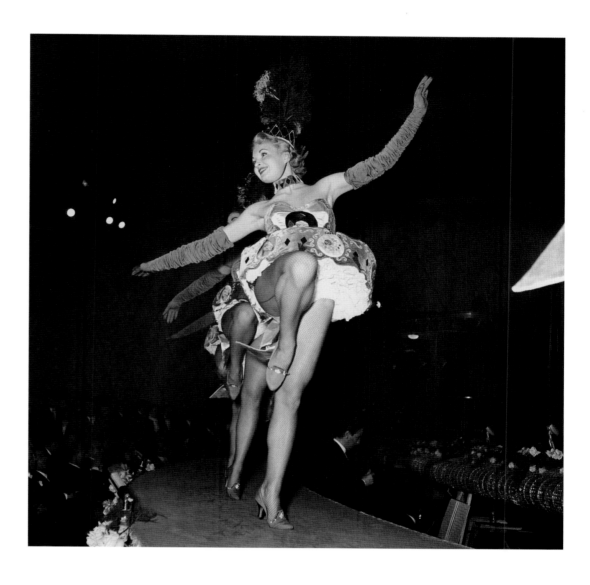

←
Herbert List

Trastevere: from the window of the room where he runs the projector, the operator watches children looking at the movie poster for Daddy Long Legs *with Fred Astaire, in Cinemascope, 1955.*

Aus dem Fenster des Vorführraums eines Kinos in Trastevere sieht der Mann am Projektor Jungen auf der Gasse zu, die das Plakat zu dem Musikfilm Daddy Langbein *mit Fred Astaire in Cinemascope betrachten, 1955.*

Trastevere: depuis la fenêtre de la cabine de projection, l'opérateur observe les enfants qui regardent l'affiche de Papa longues jambes, *un film avec Fred Astaire, en cinémascope, 1955.*

↑
Istituto LUCE

Popular in Rome between the 1950s and 1960s, revue was a mixture of words, music, dance, and comedy sketches inspired by minor current events and traditional erotic-sentimental clichés, united by a tenuous leitmotif and fixed characters, especially the soubrettes (showgirls). Tobia, la candida spia (Tobia, the Candid Spy) *by Garinei and Giovannini at the Teatro Sistina, December 1954.*

Das Revuetheater erfreute sich im Rom der 1950er- und 1960er-Jahre großer Popularität. Eine Mischung aus Sprechtheater, Musik, Tanzdarbietungen und komischen Szenen, die auf Klatschmeldungen oder bekannte Liebes- und Beziehungsklischees Bezug

nahmen. Das Ganze im Rahmen einer Conference und mit festem Personal, namentlich einer Soubrette. Hier ein Bühnenfoto aus Tobia, la candida spia *von Garinei und Giovannini im Teatro Sistina, Dezember 1954.*

Très populaire à Rome dans les années 1950 et 1960, la revue est un mélange de prose, de musique, de danse et de sketches s'inspirant de l'actualité et de clichés érotico-sentimentaux, qu'unissent un mince fil conducteur et la présence de personnages fixes tels que la soubrette. Tobia, la candida spia *de Garinei et Giovannini au Teatro Sistina, décembre 1954.*

*"Rome, Rome, Rome, Rome: young and decrepit, poor and billionaire,
intimate and withered, small and infinite."*

*„Rom, Rom, Rom, Rom: jung und verbraucht, bitterarm und milliarden-
schwer, intim und exhibitionistisch, engstirnig und schrankenlos."*

*« Rome, Rome, Rome, Rome, jeune et décrépite, pauvre et milliardaire,
intime et effeuillée, étroite et infinie. »*

ALDO PALAZZESCHI, *ROMA*, 1953

\rightarrow

Carlo Bavagnoli

Two little girls from Trastevere, 1958.

Zwei Mädchen aus Trastevere, 1958.

Deux fillettes de Trastevere, 1958.

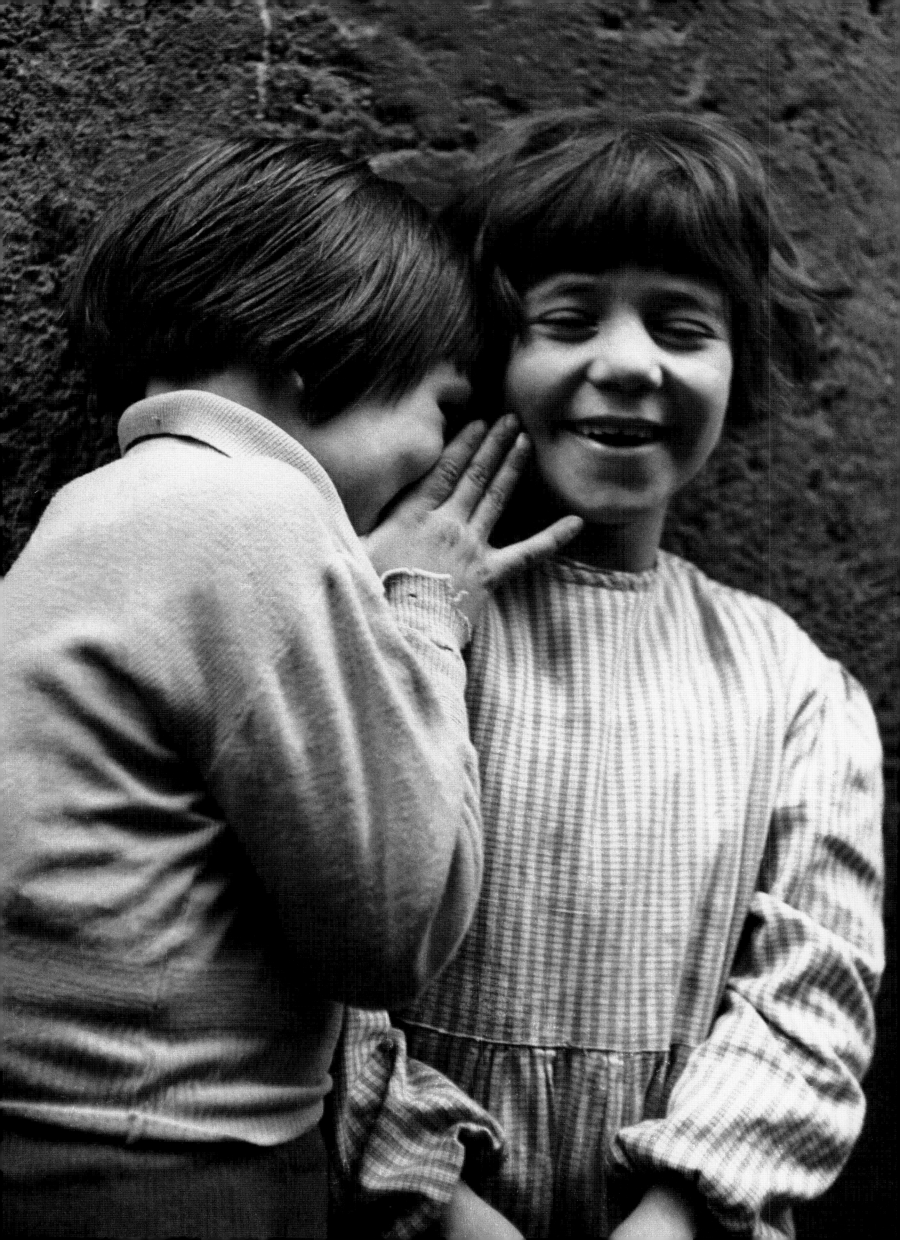

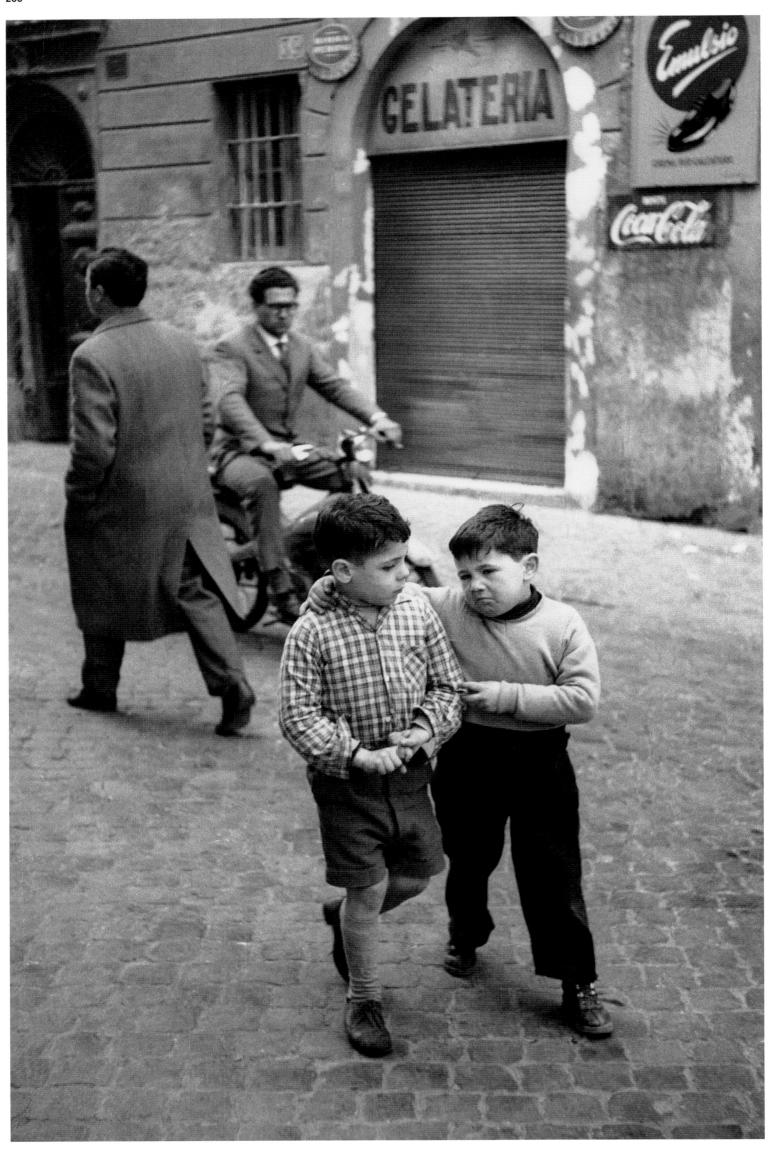

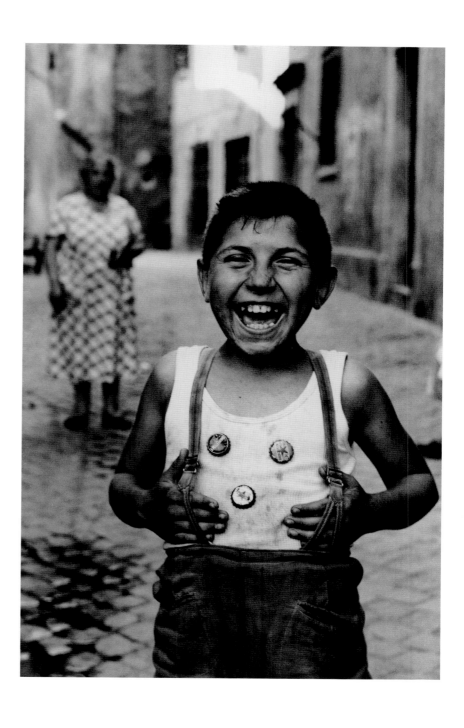

Carlo Bavagnoli

Trastevere: an ice cream parlor, a man on a Vespa passing by a pedestrian, and two children making friends, 1958.

Trastevere: eine Eisdiele, ein Vespafahrer und ein Passant begegnen sich, zwei Jungen werden dicke Freunde, 1958.

Trastevere: la boutique d'un glacier, un homme sur une Vespa et un passant qui se croisent, deux enfants qui fraternisent, 1958.

Carlo Bavagnoli

A boy from Trastevere. The popular children's game of tappi *began in Italy after the war, following the widespread diffusion of the metal bottle caps, previously practically unknown. Each competing player makes the cap advance along a marked path (usually the pavement) with the crown upwards, by a click of his fingers (the index finger "springs" when it is released by the thumb), ensuring that the cap runs the required distance without turning upside down, 1958.*

Junger Bursche aus Trastevere, 1958. Das beliebte Kronkorkenspiel der römischen Kinder wurde in der Nachkriegszeit erfunden, als dieser bisher unbekannte Flaschenverschluss weite Verbreitung fand. Die Mitspieler schnippen mit dem zuvor hinter den Daumen gespannten Zeigefinger einen Kronkorken mit der glatten Seite nach unten entlang einer (meist auf dem Gehsteig) auf den Boden gezeichneten Linie genau so weit, wie er soll, ohne dass dieser sich überschlägt, 1958.

Gamin de Trastevere. Au lendemain de la guerre, les capsules métalliques des boissons en bouteilles, inconnues jusqu'alors, se diffusèrent et donnèrent lieu à un jeu très populaire pratiqué par les enfants. Chaque joueur fait avancer d'une chiquenaude une capsule, bord dentelé tourné vers le haut, le long d'un parcours tracé sur un support (un trottoir bien souvent), et fait en sorte que celle-ci parcoure la distance voulue sans se retourner, 1958.

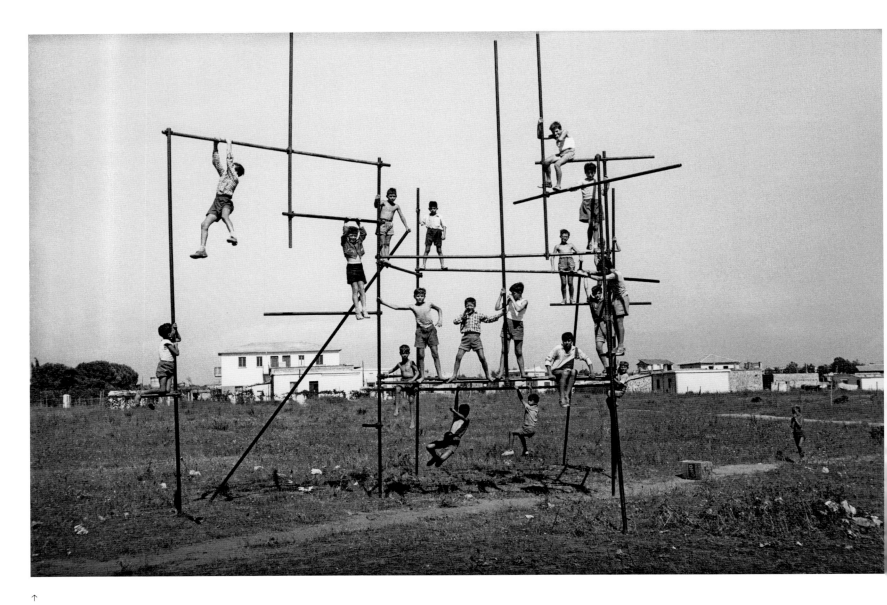

↑
Carlo Bavagnoli

*Trastevere: boys playing on scaffolding pipes
for posters, 1958.*

*Trastevere: Jungen turnen auf einem
Gerüst für Plakate aus Rohren der Marke
Innocenti herum, 1958.*

*Trastevere: gamins jouant sur un
échafaudage pour affiches, 1958.*

→
Mario Carbone

*A group of bricklayers – many wearing their
typical paper cap made from newspapers –
during the lunchtime break, sitting on the
steps of the fountain in Piazza del Popolo; on
the top step a young clerk holding a leather
briefcase is having a conversation with a
pretty lady who is wearing sandals, 1956.*

*Römische Maurer – einige mit dem charak-
teristischen, aus Zeitungspapier gefalteten
Hut – bei der Mittagspause auf den Stufen
des Brunnens in der Mitte der Piazza del*

*Popolo, während auf der obersten Stufe ein
Angestellter mit Aktentasche einer jungen
Dame in Sandalen den Hof macht, 1956.*

*Équipe de maçons – plusieurs sont coiffés
d'un chapeau fait d'une feuille de journal –
à l'heure du casse-croûte sur les marches de la
fontaine de la piazza del Popolo; sur la plus
haute marche, un jeune employé avec une
serviette en cuir s'entretient avec une gracieuse
jeune fille chaussée de sandales, 1956.*

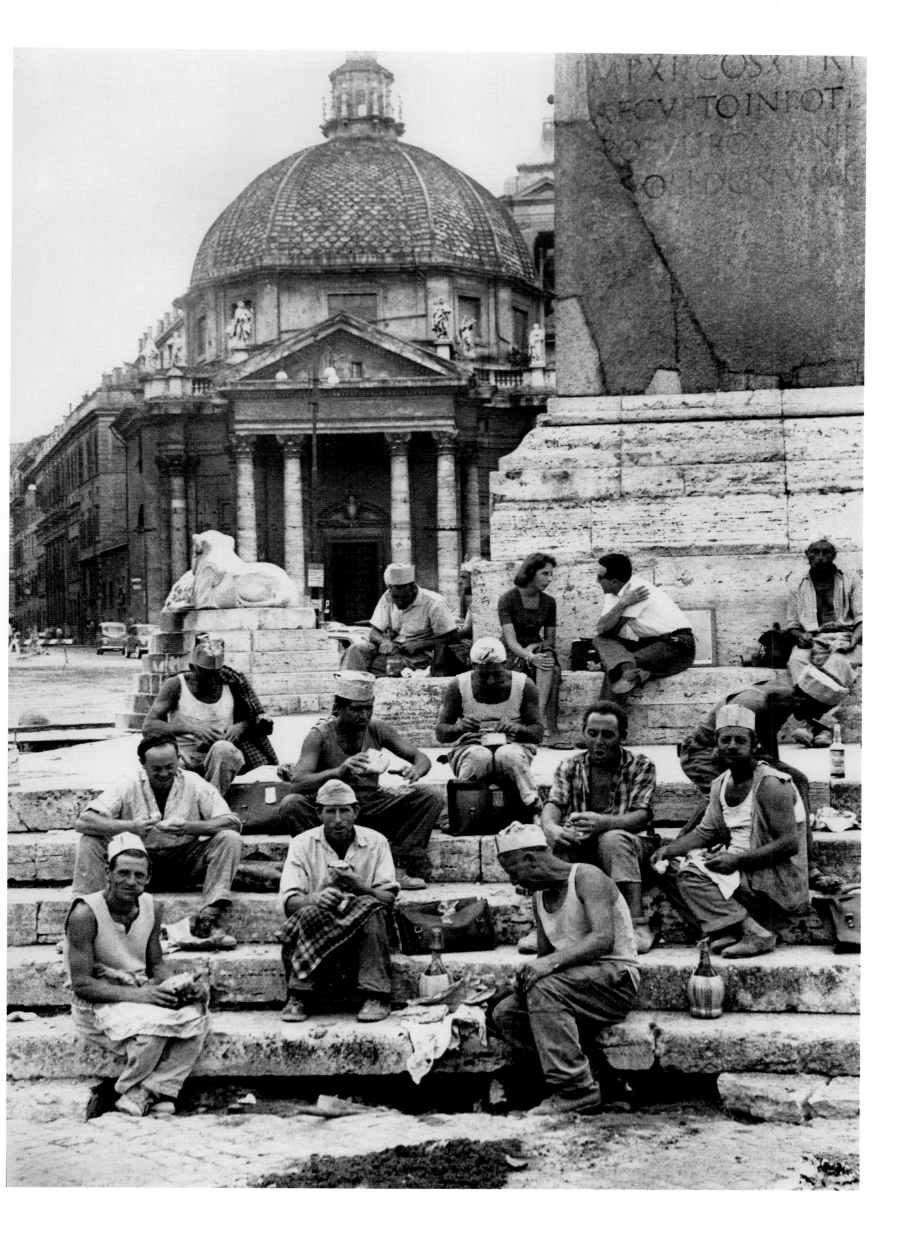

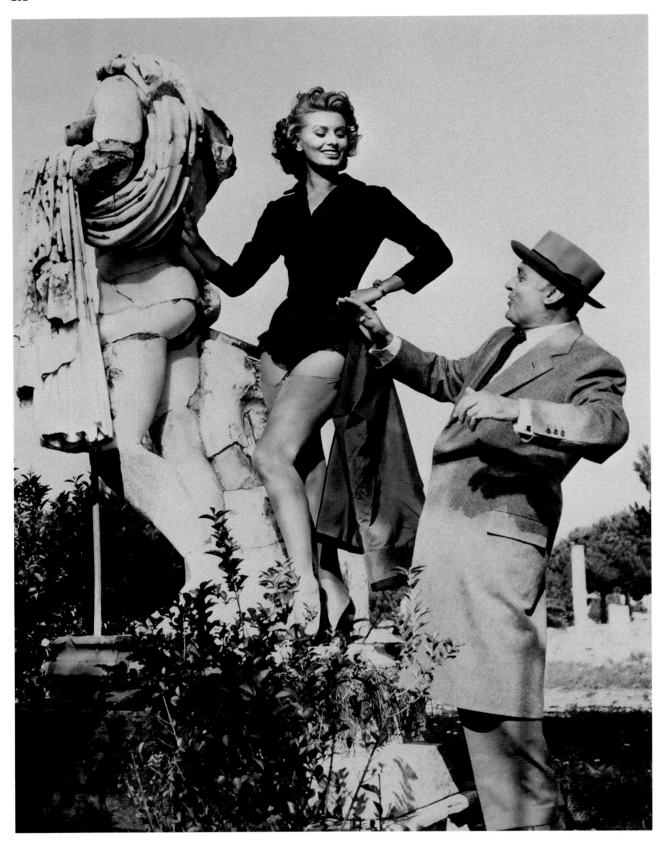

↑

Anonymous

Sophia Loren in the movie What a Woman! *by Alessandro Blasetti, 1956.*

Sophia Loren im Film Wie herrlich, eine Frau zu sein *von Alessandro Blasetti, 1956.*

Sophia Loren dans le film La Chance d'être femme *d'Alessandro Blasetti, 1956.*

→

Anonymous

Audrey Hepburn and Gregory Peck on the Spanish Steps in William Wyler's film Roman Holiday, *1953.*

Audrey Hepburn und Gregory Peck auf den Stufen der Spanischen Treppe in Ein Herz und eine Krone *von William Wyler, 1953.*

Audrey Hepburn et Gregory Peck sur les marches de l'escalier de la piazza di Spagna dans le film Vacances romaines *de William Wyler, 1953.*

"Each in its own way was unforgettable. It would be difficult to…Rome, by all means Rome. I will cherish my visit here, in memory, as long as I live."

„Jede Stadt ist auf ihre Weise unvergesslich. Trotzdem muss ich sagen … Rom, ja, Rom ganz bestimmt! Die Erinnerung an meinen Besuch hier wird mich nicht verlassen, solange ich lebe."

« Dans son genre, chaque ville est inoubliable. Néanmoins, je dois dire… Rome, oui, Rome, sans aucun doute. Je garderai le souvenir de cette visite aussi longtemps que je vivrai. »

WILLIAM WYLER, *ROMAN HOLIDAY*, 1953

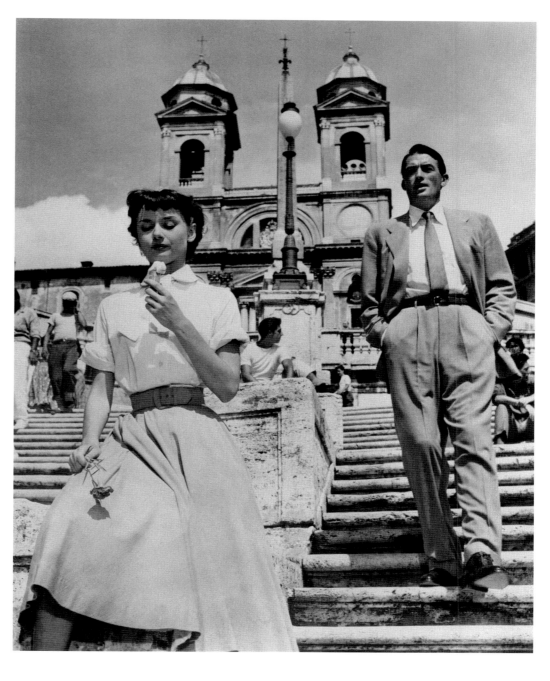

"Here's [...] the guardian of the Cinecittà accessories stockroom. Twenty centuries are watching us. A tourist in Rome cannot fail to discover some frescoes surviving in cafés, the busts of emperors with a Vespa. And our Roman guardian with his proconsular belly does not disappoint."

„Dies also [...] der Aufpasser der Requisitenkammer von Cinecittà. Zwanzig Jahrhunderte sehen uns an. Jeder Tourist kann im Café Gesichter wie aus einem Fresko entdecken, Büsten von Kaisern über einer Vespa thronend. Unser römischer Wachmann mit dem Bauch eines Prokonsuls gehört auch dazu."

« Voici donc [...] le gardien du magasin d'accessoires de Cinecittà. Vingt siècles nous regardent. Un touriste à Rome ne manque pas de découvrir au café des rescapés de fresques, des bustes d'empereurs à Vespa. Et notre gardien romain au ventre proconsulaire ne déçoit pas. »

WILLIAM KLEIN, *ROME*, 1959

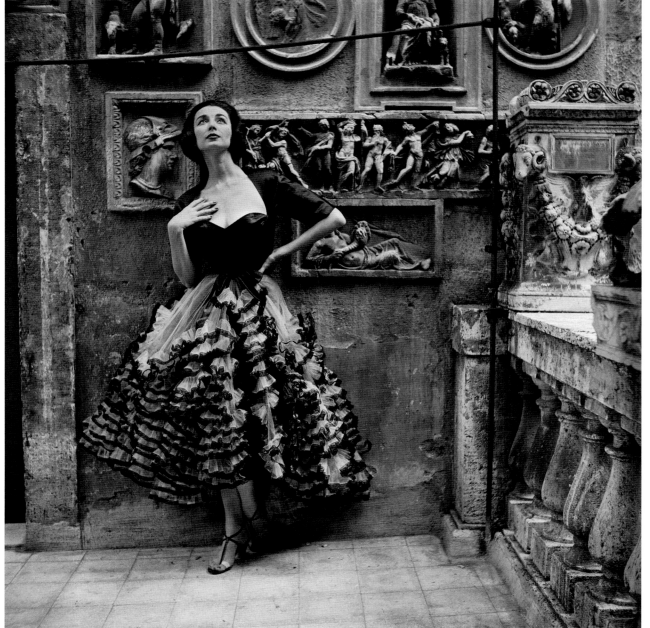

←
Genevieve Naylor

Dorian Leigh wearing a skirt designed by Simonetta Visconti, c. 1955.

Dorian Leigh in einem Rock nach Entwurf von Simonetta Visconti, um 1955.

Dorian Leigh présente une jupe dessinée par Simonetta Visconti, vers 1955.

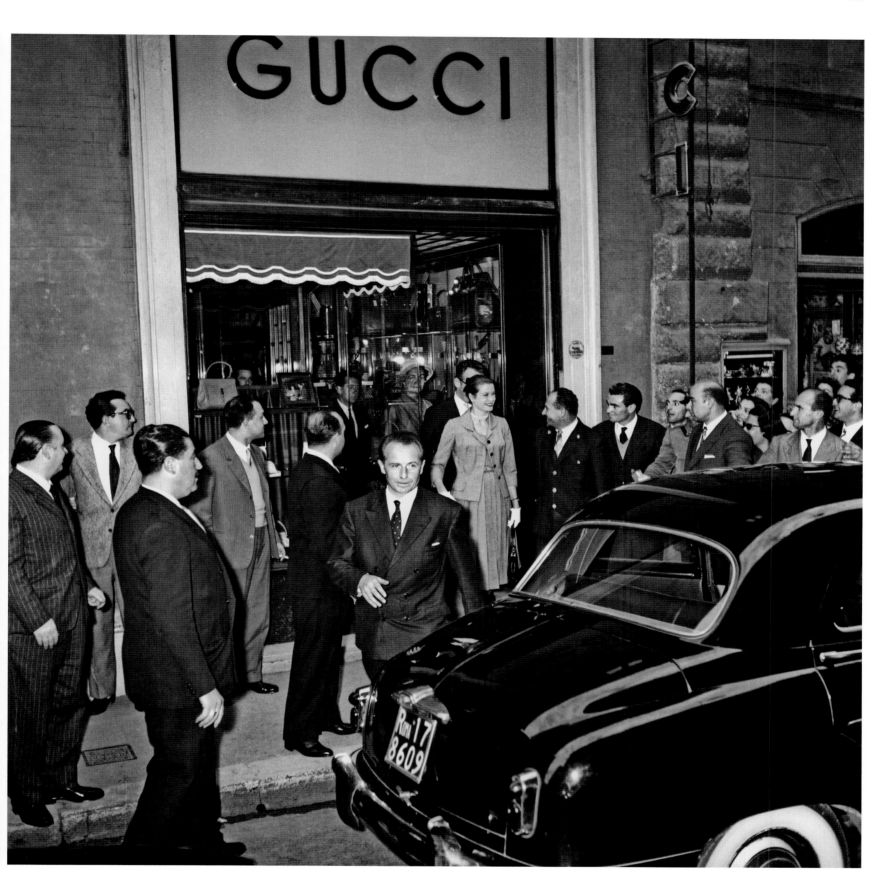

↑
Reporters Associati

*Grace Kelly comes out of the Gucci boutique
in Via dei Condotti surrounded by a crowd
of onlookers, and followed by her husband,
Prince Rainier III of Monaco, 1959.*

*Grace Kelly beim Verlassen der Gucci-Filiale
in der Via Condotti, umringt von Schaulus-
tigen und gefolgt von ihrem Gatten, Prinz
Rainier von Monaco, 1959.*

*Grace Kelly quitte la boutique Gucci de la
via dei Condotti, entourée d'une foule de
curieux. Elle est accompagnée de son mari,
le prince Rainier III de Monaco, 1959.*

pp. 296/297
William Klein

*In Rome there are innumerable bars, one for
every street corner; on hot summer evenings,
when Romans spend as much time as possible
outdoors, bars turn into cafés and, with a
clever combination of small tables and light
and noisy chairs, they invade the little space
left available by the surrounding traffic; there
you can talk about anything, and you can
enjoy the urban vignettes happening in front
of you, 1957.*

*Rom verfügt über zahllose Espressobars, an
jeder Straßenecke eine. An heißen Sommer-
abenden, wenn der Römer sich so viel im
Freien aufhält wie möglich, werden sie zu
echten Cafés und nehmen mit ihren Tisch-
chen und ihren federleichten laut scheppern-
den Stühlchen das bisschen Platz für sich in
Besitz, dass der Verkehr übrig lässt; man redet
über Gott und die Welt und genießt, was
immer die Stadt an Schauspielen zu bieten
hat, 1957.*

*À Rome, les bars sont innombrables, il y en a
un à chaque coin de rue; durant les chaudes
soirées d'été, lorsque les Romains restent
dehors aussi longtemps que possible, tables et
chaises aussi légères que bruyantes viennent
promptement transformer en café le moindre
espace laissé libre par la circulation; et là, on
parle de tout, on participe et l'on profite du
spectacle de la vie urbaine, 1957.*

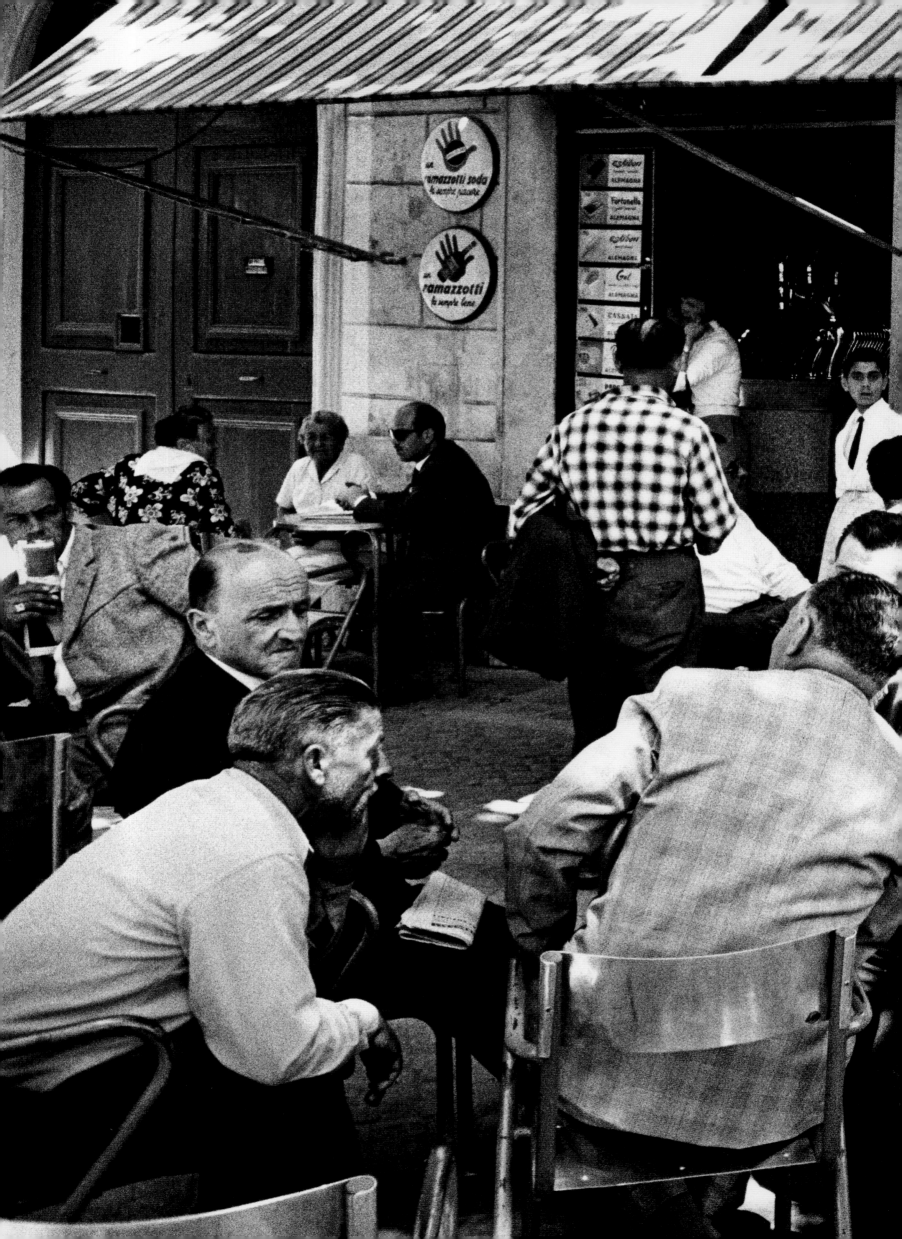

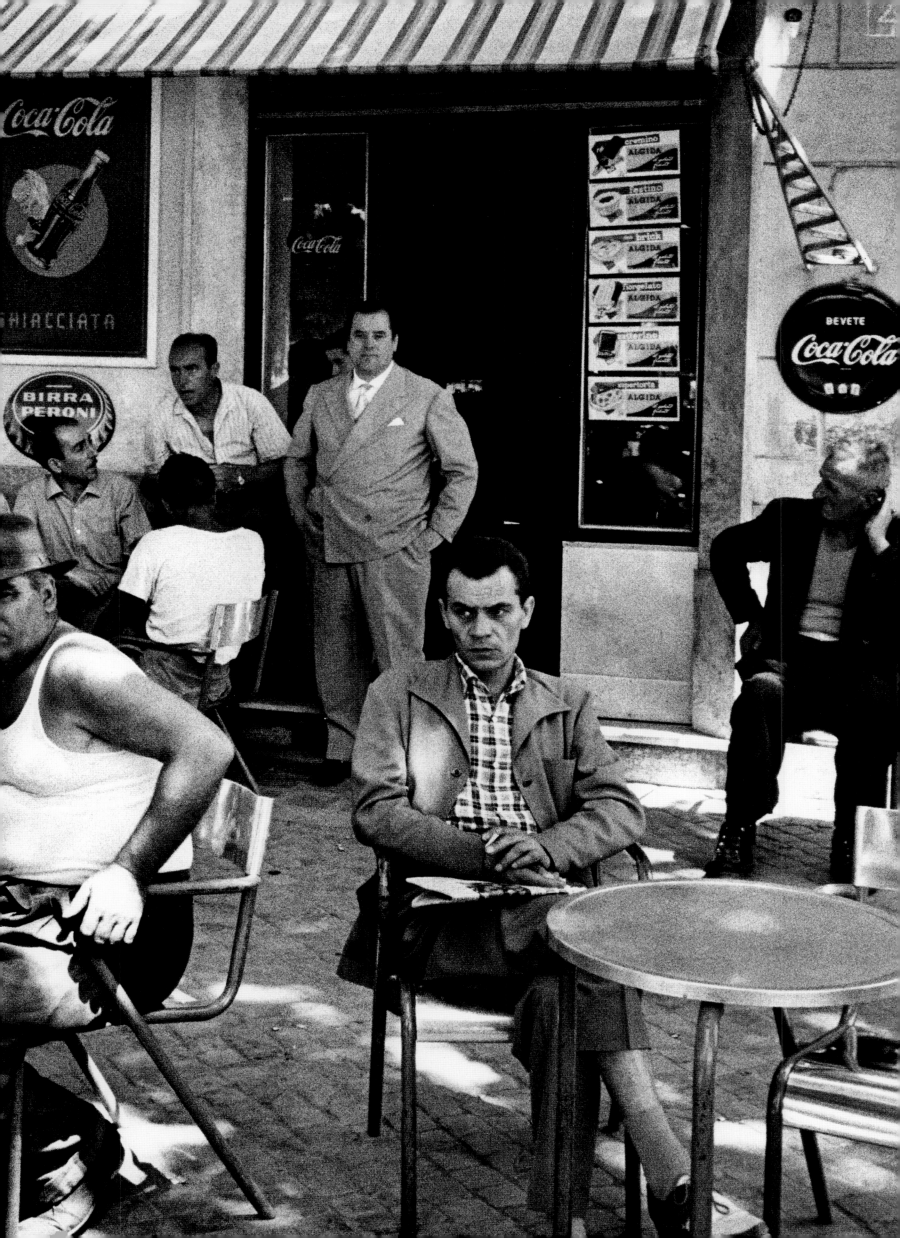

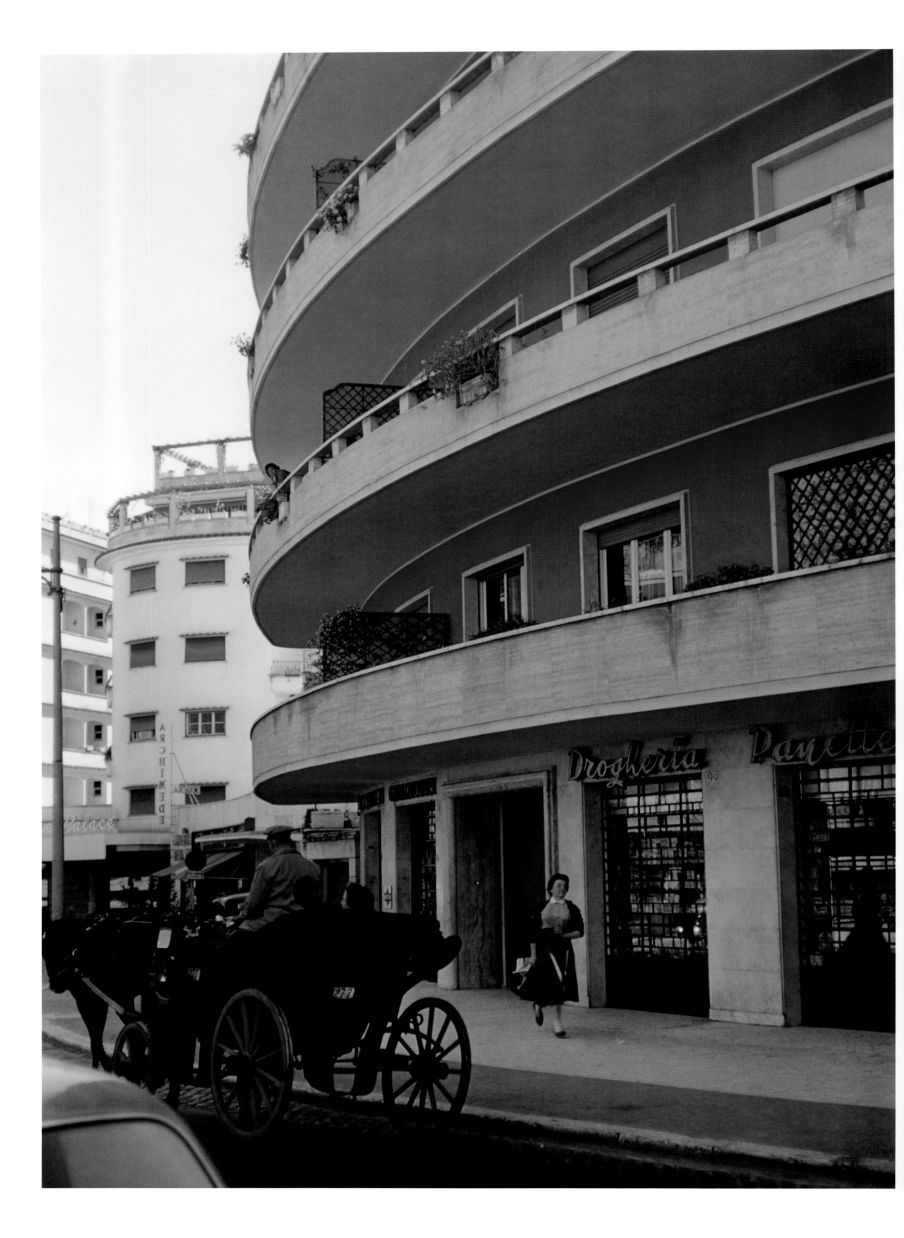

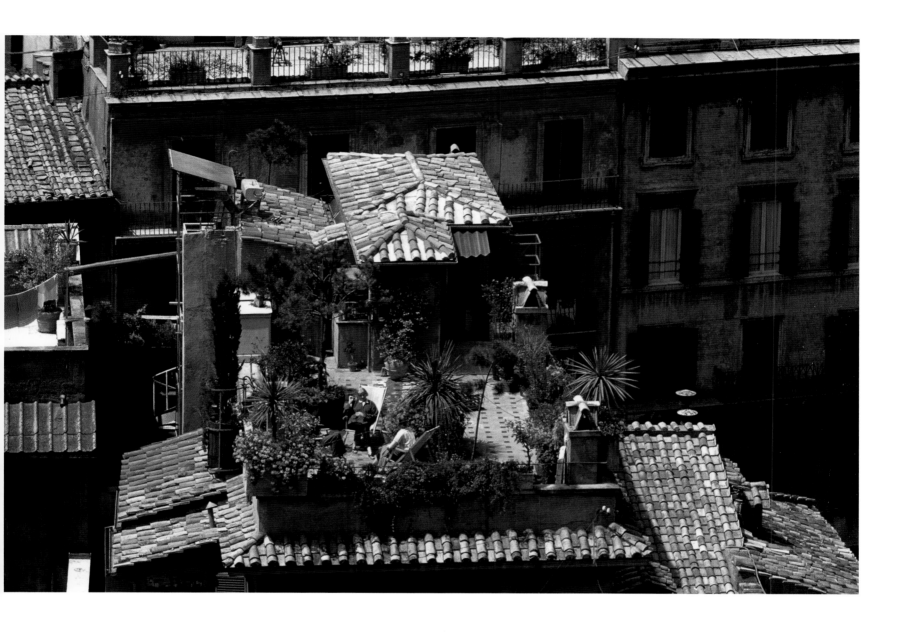

←

Melville Bell Grosvenor

Typical apartment building in the district of Parioli, which was originally built to house the officials of the Fascist regime, and was completed in the 1950s as an upper-middle-class residential area, 1957.

Typisches Apartmenthaus im Paroli-Viertel, einer Gegend, die ursprünglich für die Funktionäre des faschistischen Regimes begonnen und in den 1950er-Jahren als Wohnviertel für das gehobene Bürgertum zu Ende gebaut wurde, 1957.

Immeuble d'habitation typique du quartier des Parioli, destiné à l'origine aux hiérarques du régime fasciste, devenu dans les années 1950 une zone résidentielle habitée par la bourgeoisie, 1957.

↑

B. Anthony Stewart

Jasmine, roses, oleanders, lemon, and pine trees form a garden on terrace of the attic near the Spanish Steps owned by Iris Tree, the poet and actress known for her eccentric personality, humor, and adventurous life, 1957.

Jasmin, Zitronenbäume, Rosen, Oleander und kleine Pinien machen aus einer Dachterrasse unweit der Spanischen Treppe einen veritablen Garten. Er gehört der englischen Dichterin und Schauspielerin Iris Tree, bekannt für ihre exzentrische Persönlichkeit, ihren Humor und ihr abenteuerliches Leben, 1957.

Jasmin, citronniers, rosiers, lauriers roses et pins transforment en jardin la terrasse d'un appartement proche de la piazza di Spagna, habité par Iris Tree, poétesse et actrice anglaise connue pour sa personnalité excentrique, son humour et sa vie aventureuse, 1957.

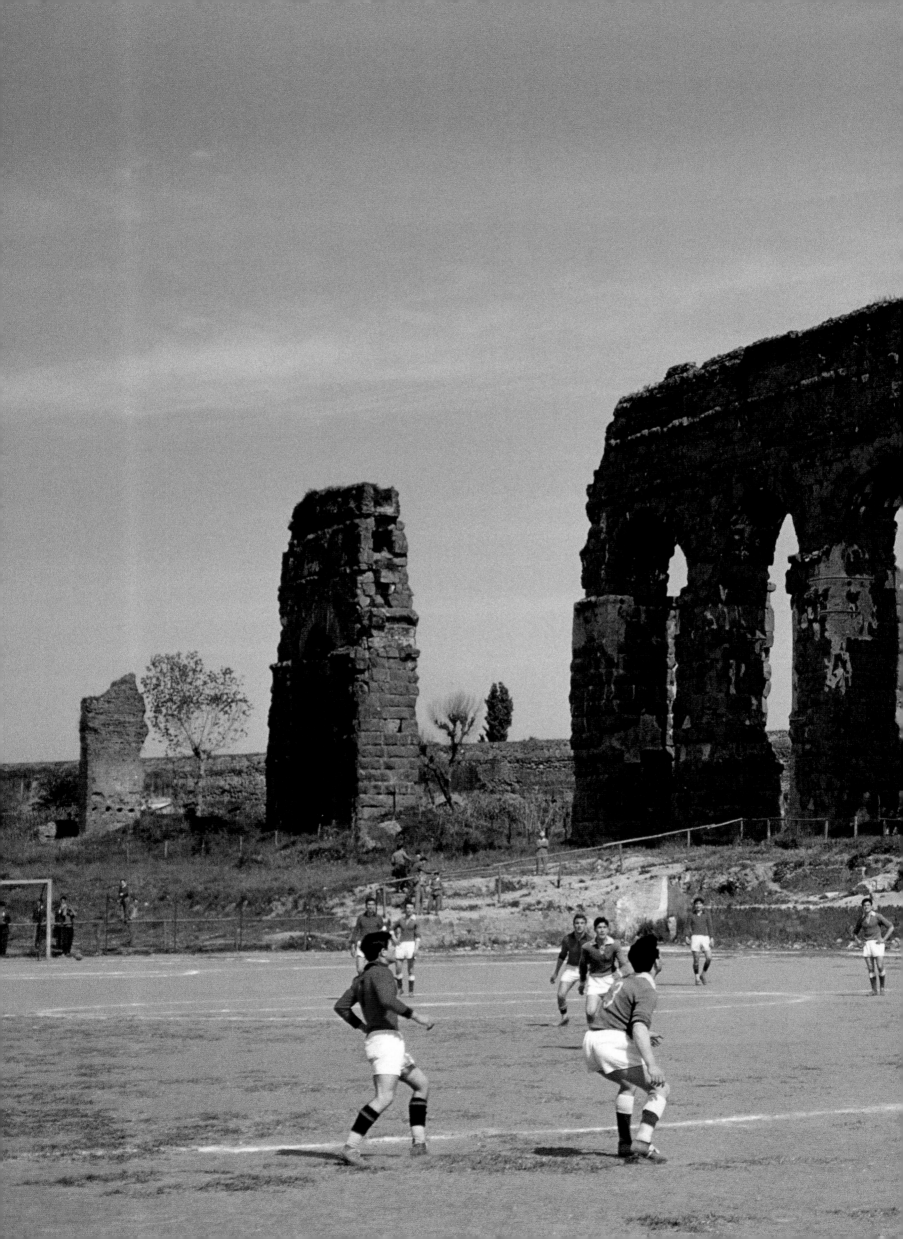

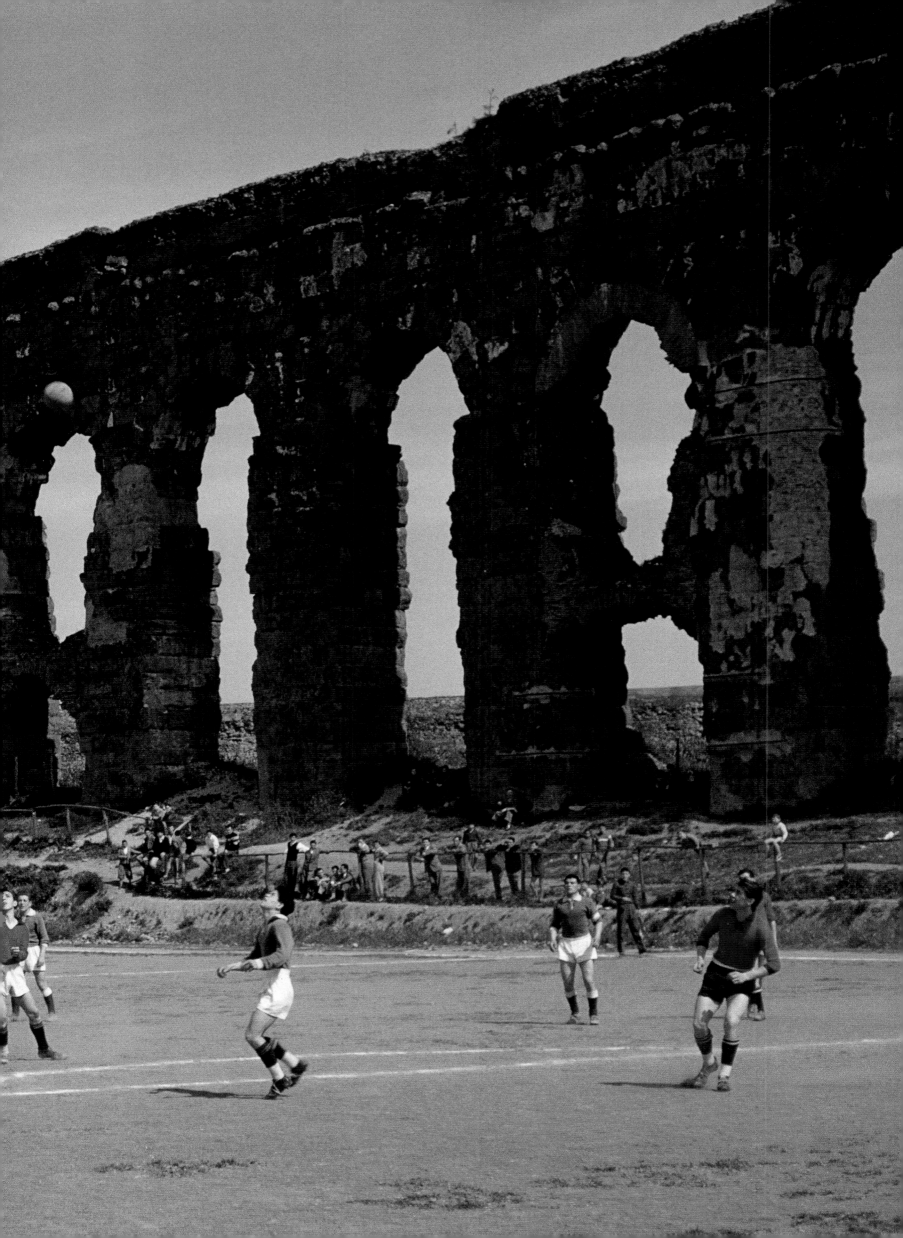

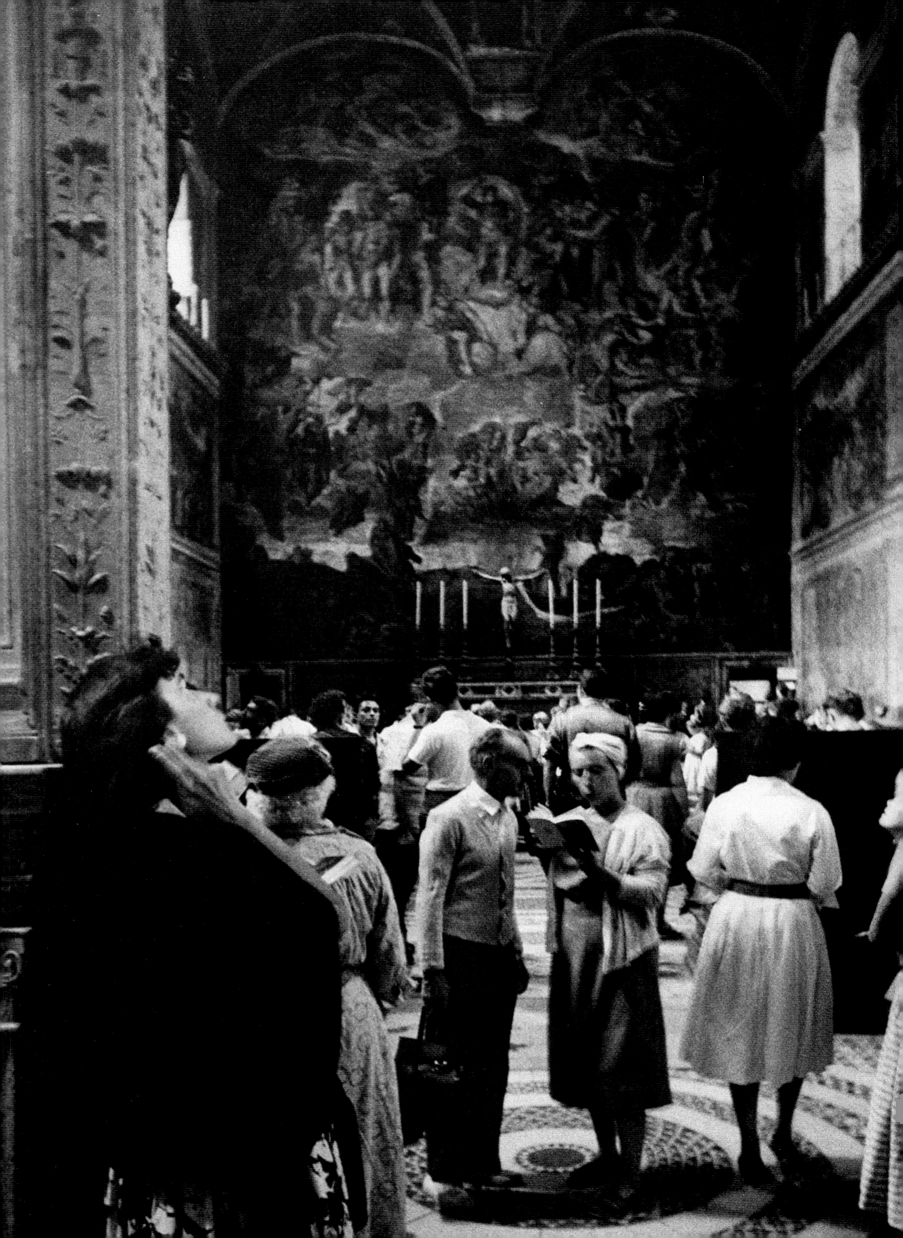

"I envy you, tourist, who arrive here / drink in the Forum and the excavations / then all of a sudden you find / the Trevi Fountain, all for you! / There's a Roman legend / linked to this old fountain / that says that if you throw a coin in / you force destiny to bring you back here."

„Tourist, du hast es gut, kommst nach Rom / und saugst dich voll mit Foren und Ruinen. / Dann stehst du plötzlich / vor dem Trevibrunnen ganz allein für dich. / Es gibt eine Legende hier in Rom / zu diesem alten Brunnen: / Wirfst eine Münze du hinein / führt einst das Schicksal dich zurück."

«Je t'envie touriste, toi qui arrives / Tu t'imprègnes de forums et de fouilles / Puis soudain tu te trouves / à la fontaine de Trevi qui est tout à toi / Il existe une légende à Rome / Liée à cette vieille fontaine / Elle dit que si tu y jettes une piécette / Le destin te permettra de revenir.»

RENATO RASCEL (PIETRO GARINEI, SANDRO GIOVANNINI), *ARRIVEDERCI ROMA*, 1955

←
David Lees

Tourists visiting Michelangelo's frescoes in the Sistine Chapel, 1959.

Rombesucher vor Michelangelos Fresken in der Sixtinischen Kapelle, 1959.

Touristes visitant la chapelle Sixtine ornée des fresques de Michel-Ange, 1959.

pp. 300/301
B. Anthony Stewart

Boys playing football at the foot of the arches of an ancient aqueduct, April 1957.

Junge Römer beim Fußballspiel zu Füßen eines antiken Aquädukts, April 1957.

Jeunes gens jouant au football au pied d'un aqueduc antique, avril 1957.

pp. 304/305
Tony Vaccaro

People gathered in St. Peter's Square watch Pope Pius XII addressing the crowd from the balcony of his studio. In an image of particular intensity, the spectators' emotions are revealed in their facial expressions, 1954.

Gespannt verfolgt die Menge das Erscheinen von Papst Pius XII. am Fenster seines Arbeitszimmers. Eindringlich vermittelt das Bild die unterschiedlichen Charaktere der Gläubigen, 1954.

Place Saint-Pierre, la foule assiste à l'apparition du pape Pie XII à la fenêtre de son bureau. Dans un cliché d'une intensité rare, l'émotion révèle les personnalités dans leur diversité, 1954.

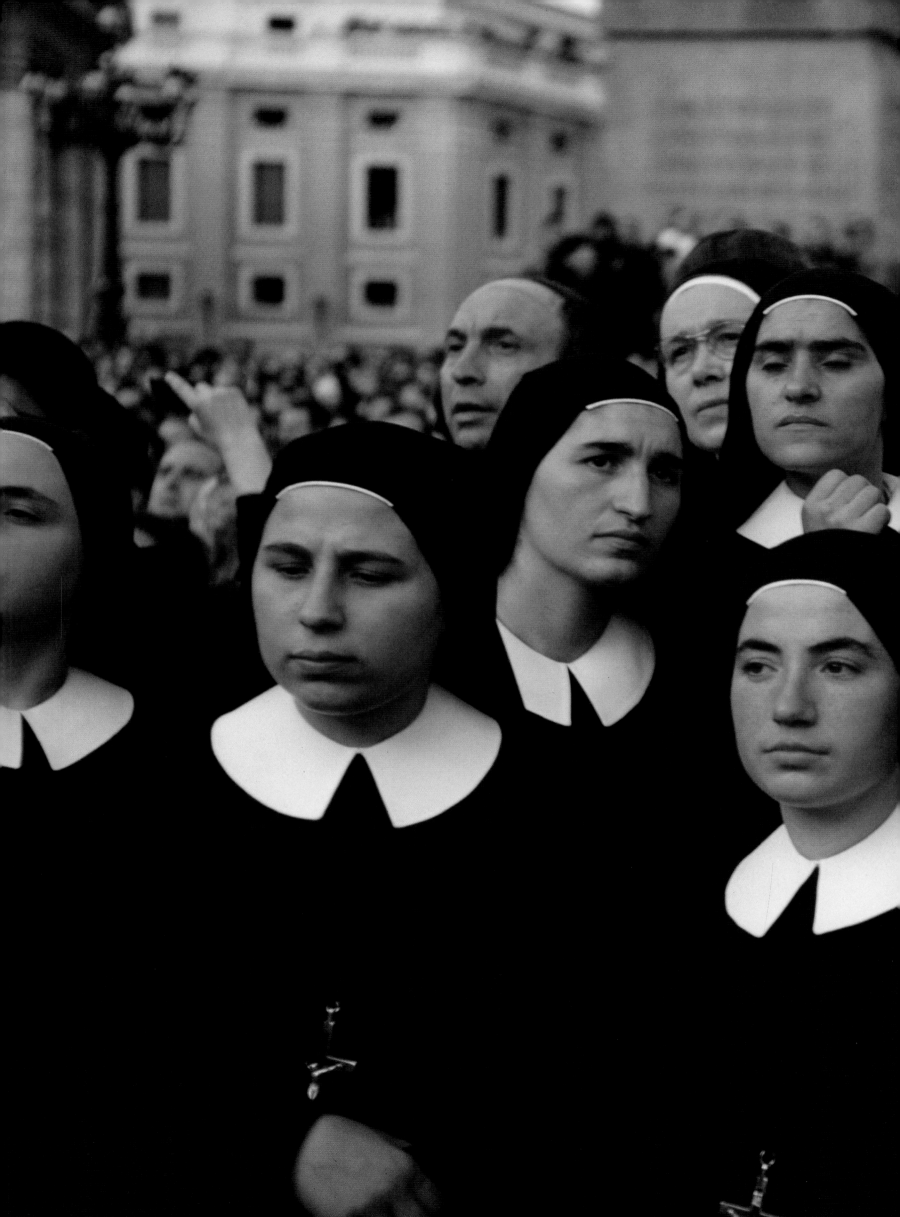

↑
Carlo Bavagnoli

*People of Trastevere during a
procession, 1958*

*Menschen in Trastevere bei einer
Prozession, 1958.*

*Habitants de Trastevere durant
une procession, 1958.*

→
Carlo Bavagnoli

Procession in Trastevere, 1958.

Prozession in Trastevere, 1958.

*Procession dans le quartier de
Trastevere, 1958.*

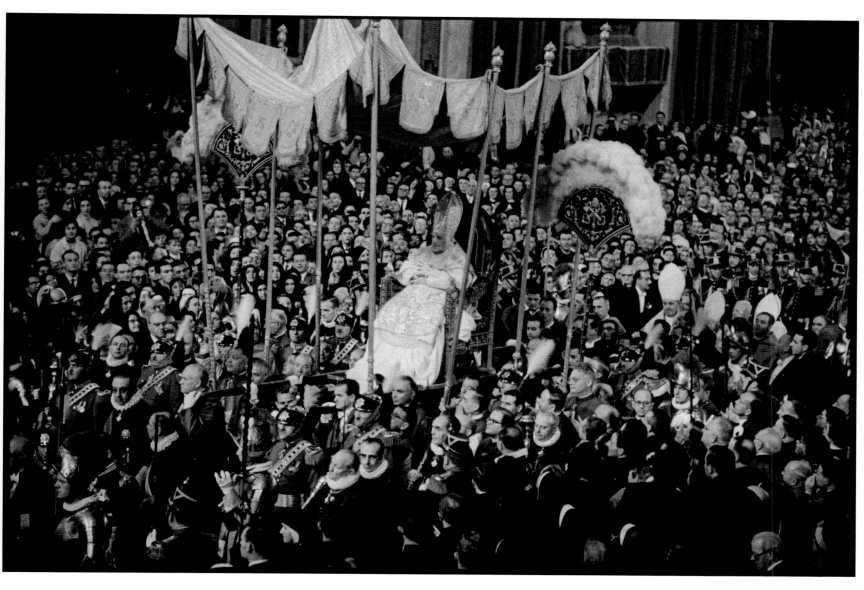

←↑

Henri Cartier-Bresson

Two moments in the coronation of Pope John XXIII in St. Peter's. The ceremony, followed on television by dozens of countries, 40,000 guests inside the church, and a crowd of 100,000 people gathered in the square, was marked by the friendly and affable demeanor of the new pope, November 1958.

Zwei Momentaufnahmen von der Papst- krönung Johannes' XXIII. in St. Peter. Die Zeremonie fand vor 40.000 geladenen Gästen und laufenden Kameras statt, auf dem Peters- platz versammelten sich 100.000 Gläubige. Die Leutseligkeit des neuen Papstes bestimm- te auch dieses Ereignis, November 1958.

Deux moments de l'intronisation du pape Jean XXIII à Saint-Pierre. Suivie par les télévisions de dizaines de pays, par 40 000 invités à l'intérieur de la basilique et par une foule de 100 000 personnes sur la place, la cérémonie fut marquée par la bonhomie du nouveau pontife, novembre 1958.

↑
Henri Cartier-Bresson

Following an accident, drivers exchange details on the bonnet of a Cinquecento, watched by a crowd of passers-by and a traffic policeman, c. 1959.

Umgeben von Schaulustigen und Passanten nehmen die an einem Unfall beteiligten Fahrer in Gegenwart eines Verkehrspolizisten auf der Kühlerhaube eines Fiat 500 das Protokoll auf, um 1959.

Après un accident, les conducteurs dressent un constat à l'amiable sur le capot d'une Cinquecento, sous le regard plus ou moins curieux des passants et d'un agent de police, vers 1959.

pp. 310/311
Henri Cartier-Bresson

A distinguished gentleman reads his newspaper while he enjoys the soundtrack of the fountains of Piazza del Pantheon, 1959.

Distinguierter älterer Herr bei der Zeitungslektüre vor dem Pantheon, begleitet vom Rauschen des Brunnenwassers, 1959.

Piazza del Pantheon, un homme élégant lit son journal, en profitant du chant de l'eau de la fontaine, 1959.

→
Henri Cartier-Bresson

At the end of the 1950s, traffic became increasingly chaotic and disconcerting, giving the Romans the opportunity to exercise their peculiar skill of commenting with words and gestures on anything that happened around them, 1959.

Ende der 1950er-Jahre nimmt der Autoverkehr immer chaotischere und bedrohlichere Ausmaße an, und die Römer entwickeln eine besondere Fähigkeit, das Verkehrsgeschehen mit Gesten und Worten anschaulich zu kommentieren, 1959.

À la fin des années 1950, la circulation automobile devient de plus en plus chaotique et inquiétante dans la capitale, donnant ainsi aux Romains l'occasion d'exercer leur talent particulier pour commenter les événements de la rue à l'aide de gestes et de mots, 1959.

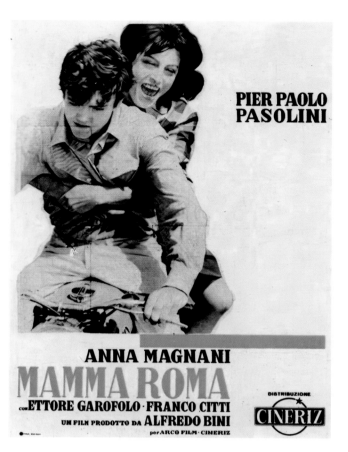

PIER PAOLO
PASOLINI

ANNA MAGNANI
MAMMA ROMA
con ETTORE GAROFOLO · FRANCO CITTI
UN FILM PRODOTTO DA ALFREDO BINI
per ARCO FILM · CINERIZ

DISTRIBUZIONE
CINERIZ

"In front of my house lived an old man, a rich man, he was practically being swallowed by his millions […] During the time of Fascism, you know, Mussolini says to him: 'Make me a neighborhood for the people' – that would be Pietrarancio. This guy makes the first house, beautiful, all master walls, with toilets that you could cook in, so nice he had made them. Mussolini comes back, says to him: 'Well done, that's just what I wanted'. This son of a bitch, as soon as the Duce left, he made just the toilets, he stopped making the houses altogether. Now they call that district 'Cessonia' (The Toilet)!"

„Vor meinem Haus stand ein Alter, einer von den Reichen, einer von den Millionen-schweren […] Bei den Faschisten dann kommt Mussolini und sagt: ‚Bau mir ein Viertel fürs Volk', was dann später Pietrarancio war. Der Kerl baut also das erste Haus: schön, mit massiven Wänden und mit Scheißhäusern, dass man drin 'ne Küche einrichten könnte, so proper war alles gemacht. Und Mussolini sagt: ‚Sehr gut, so wollte ich das!' Und dieser Hurensohn? Als Mussolini dann weg war, hat er nur noch die Scheißhäuser gebaut und keine Häuser mehr. Deshalb heißt das Viertel bei uns auch ‚Scheißhausen'!"

« En face de chez moi, il y avait un vieux, riche, riche à millions… […] À l'époque des fascistes, Mussolini lui dit : "Fais-moi un quartier pour le peuple" – le futur Pietrarancio. Il fait la première maison, belle, tout en murs solides, avec des toilettes, des toilettes tellement belles qu'on pouvait y faire la cuisine. Mussolini vient, il lui dit : "Bravo, c'est ce que je voulais." Ce fils de garce, quand le Duce est parti, il n'a fait que les toilettes, les maisons il ne les a plus faites ; maintenant, le quartier, on l'appelle "Cessonia" ! [cesso signifie toilettes] »

PIER PAOLO PASOLINI, *MAMMA ROMA,* 1962.

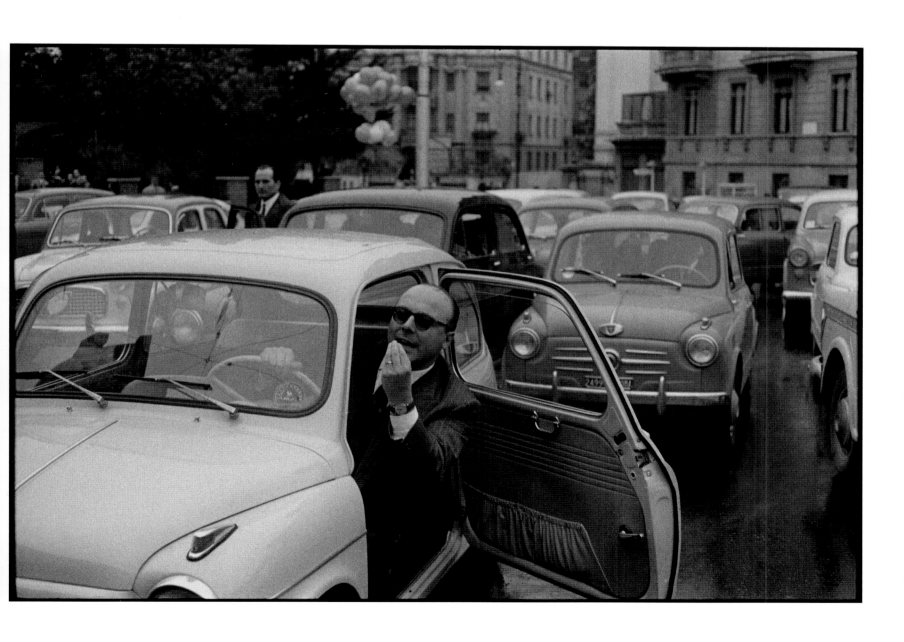

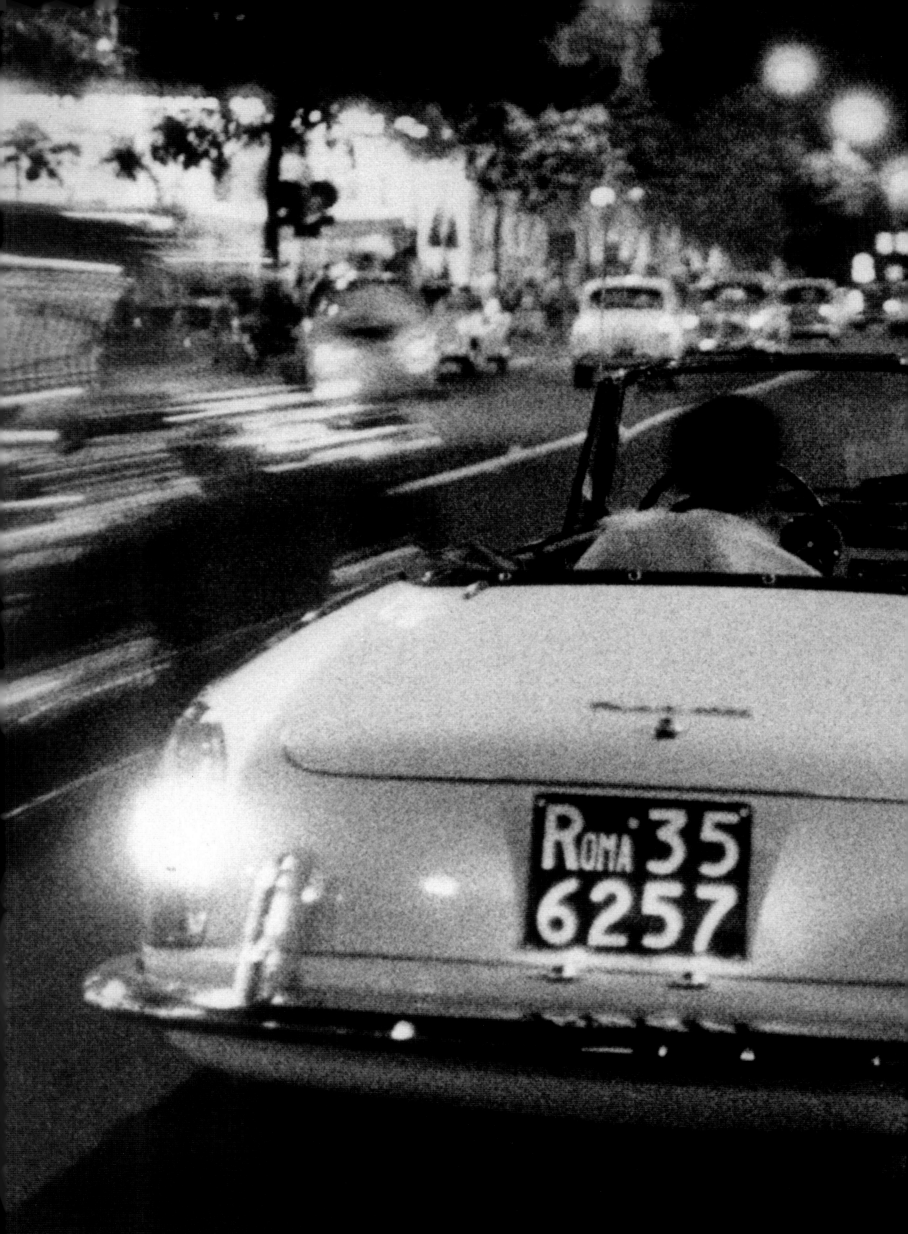

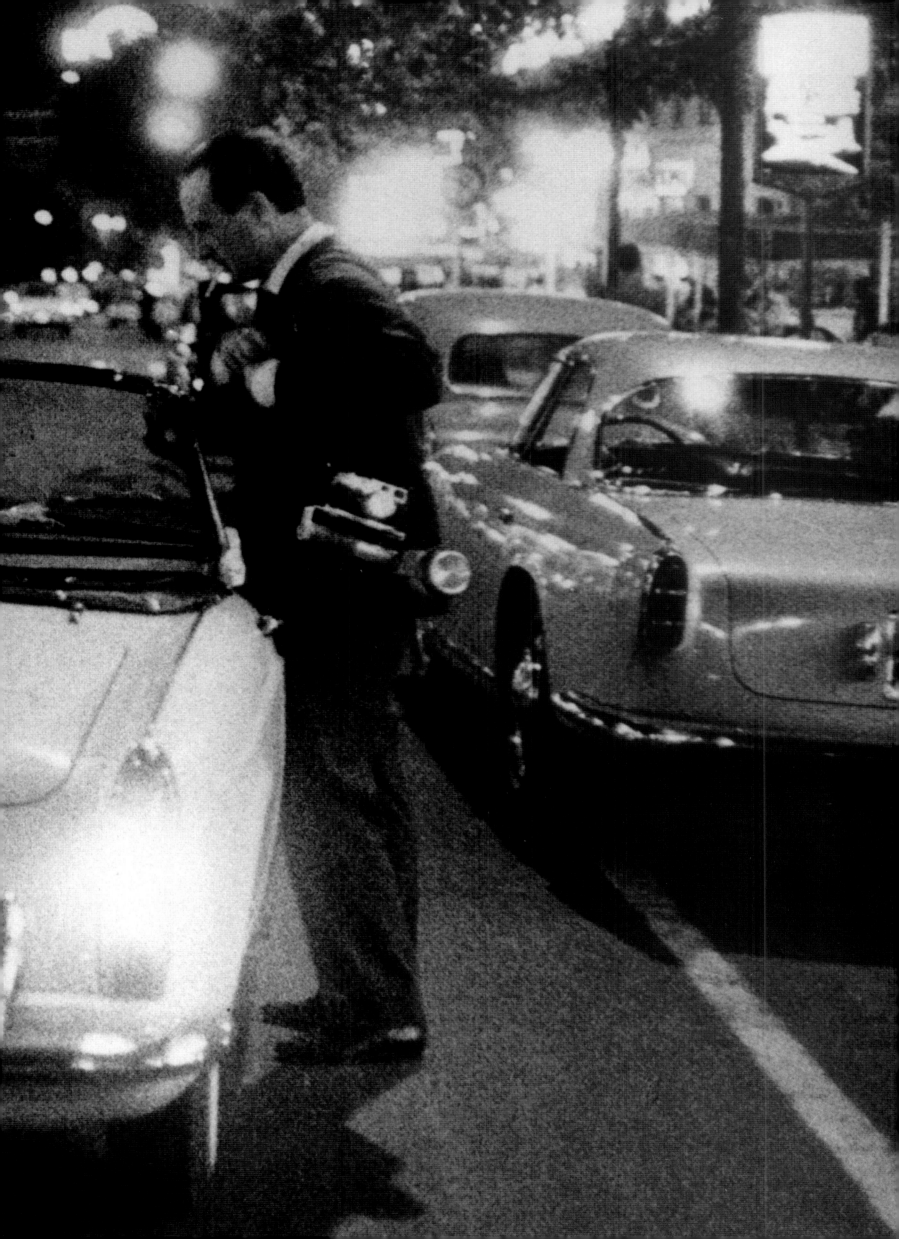

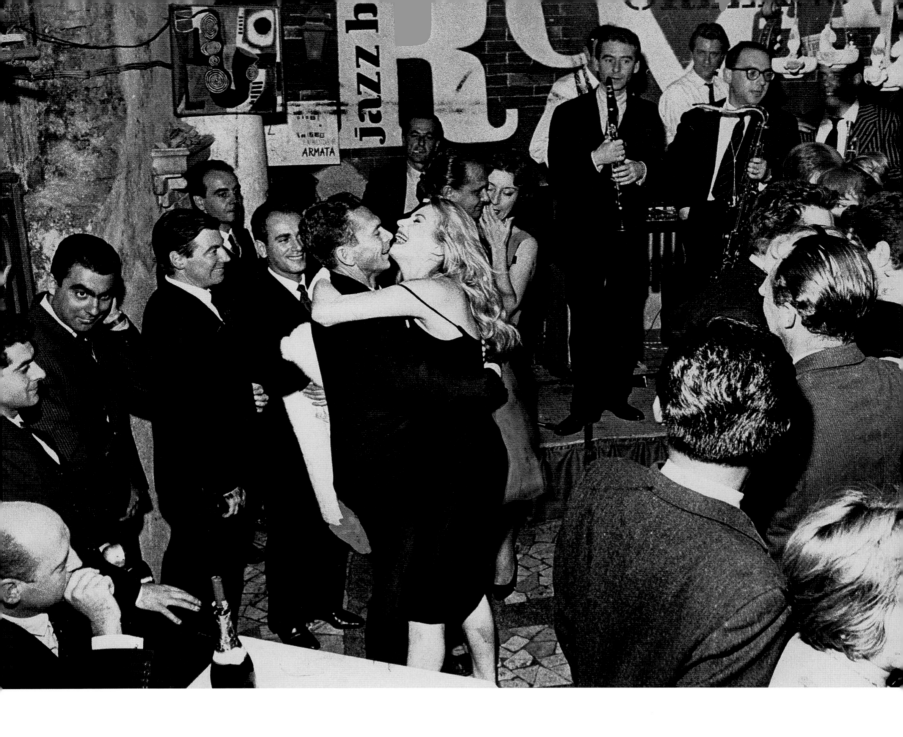

pp. 314/315
Tazio Secchiaroli

The paparazzo *Tazio Secchiaroli and the press agent Enrico Lucherini (in the car), in Via Veneto. Via Veneto was known as the privileged site of social life in the 1950s and 1960s, with its many cafés and hotels frequented by celebrities, and became legendary thanks to Fellini's film* La dolce vita. *It was a rich hunting ground for the* paparazzi, *c. 1958.*

Der Paparazzo Tazio Secchiaroli und der Presseagent Enrico Lucherino (am Steuer) auf der Via Veneto. In den 1950er- und 1960er-Jahren genoss die Via Veneto mit ihren vielen Cafés und Hotels, in denen die Schönen und Berühmten verkehrten, den Ruf, Schauplatz des mondänen Lebens par excellence zu sein, ein Ruf, der durch Fellinis La dolce vita

zum Mythos wurde. Für die Paparazzi war die Via Veneto ein äußerst dankbares Pflaster, um 1958.

Le paparazzo Tazio Secchiaroli et l'attaché de presse Enrico Lucherino (au volant) dans la via Veneto. Devenue un haut lieu de la vie mondaine dans les années 1950 et 1960, cette rue mythique devait sa renommée à ses nombreux cafés et restaurants fréquentés par des célébrités; elle fut définitivement consacrée par La dolce vita *de Fellini. Pour les paparazzi, elle constituait un fructueux terrain de chasse, vers 1958.*

↑
Anonymous

Against the background of its ancient grandeur, 1950s Rome became the stage of every whim and eccentricity, flashy social displays, flamboyant and frivolous love stories, blatantly public private lives, easy prosperity and easy squandering, glamour and gossip magazine covers, poor but beautiful, nonchalant ostentation and secret weaknesses. Anita Ekberg dances with Gérard Herter during a party at Rugantino, December 1958.

Vor der Kulisse antiker Größe wird das Rom der 1950er-Jahre zur Bühne für jede Art von Ausgefallenheit und Launen. Die mondäne Welt stellt sich zur Schau, Affären werden lustvoll beklatscht, Intimstes vor aller Augen ausgebreitet, Unsummen werden verdient und zum Fenster hinausgeworfen, die

Klatschspalten der Presse sind voll von den Geschichten der Reichen und Schönen und der nicht ganz so Reichen und dennoch Schönen, letzte Hüllen fallen. Anita Ekberg tanzt bei einer Party im Rugantino mit Gérard Herter, Dezember 1958.

Avec son antique grandeur pour décor, la Rome de la fin des années 1950 devient le théâtre d'excentricités et de caprices en tous genres, de manifestations mondaines tapageuses, d'histoires d'amour tumultueuses, de vies privées étalées au grand jour, de fortunes faciles et de gaspillages rapides, de couvertures racoleuses et glamour, d'ostentations désinvoltes et de secrètes faiblesses. Anita Ekberg danse avec Gérard Herter durant une fête au Rugantino, décembre 1958.

"But look, what a beautiful day…Do you think it's fair that one
should go to work on a day like this, with sunshine like this!"

„Was für ein Tag! Und da soll einer zur Arbeit gehen, an so einem
Tag, bei so einem Sonnenschein?"

« Regarde-moi ça, quelle belle journée… Tu trouves ça juste d'être
obligé de travailler un jour comme ça… avec un soleil comme ça ! »

DINO RISI, *POVERI MA BELLI*, 1957

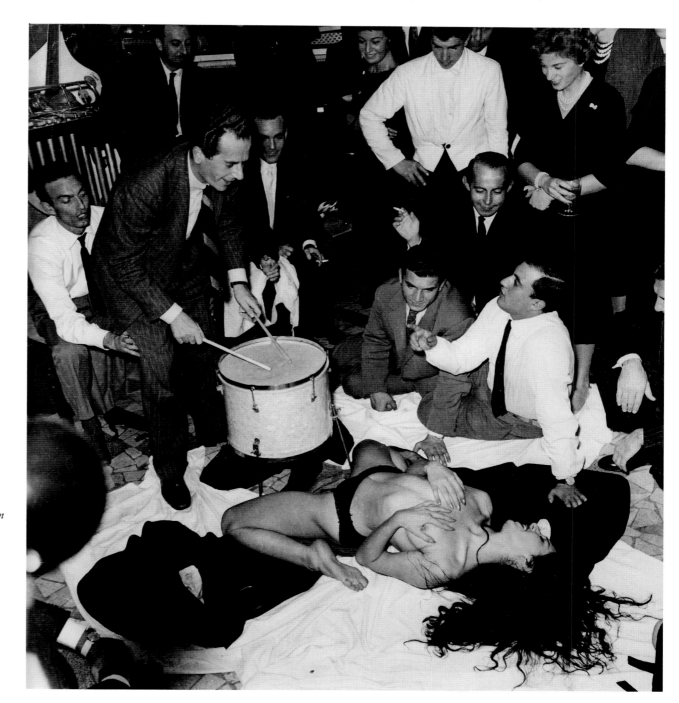

→

Tazio Secchiaroli

*The famous striptease of Aïché Nana
during a private party at Rugantino,
November 1958.*

*Aïché Nana bei ihrem berühmt gewordenen
Striptease während einer Privatparty im
Rugantino, November 1958.*

*Le célèbre strip-tease d'Aïché Nana au
cours d'une fête privée au Rugantino,
novembre 1958.*

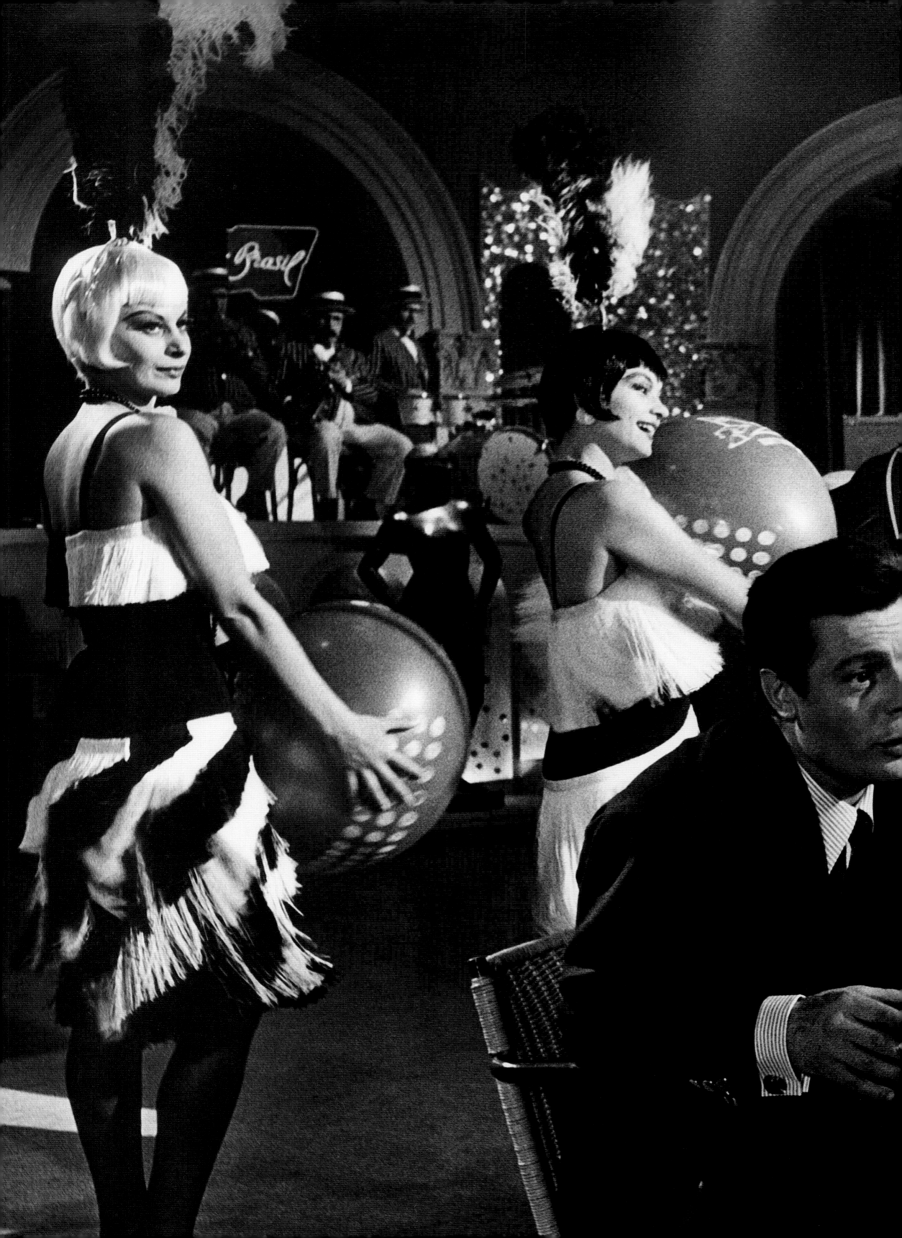

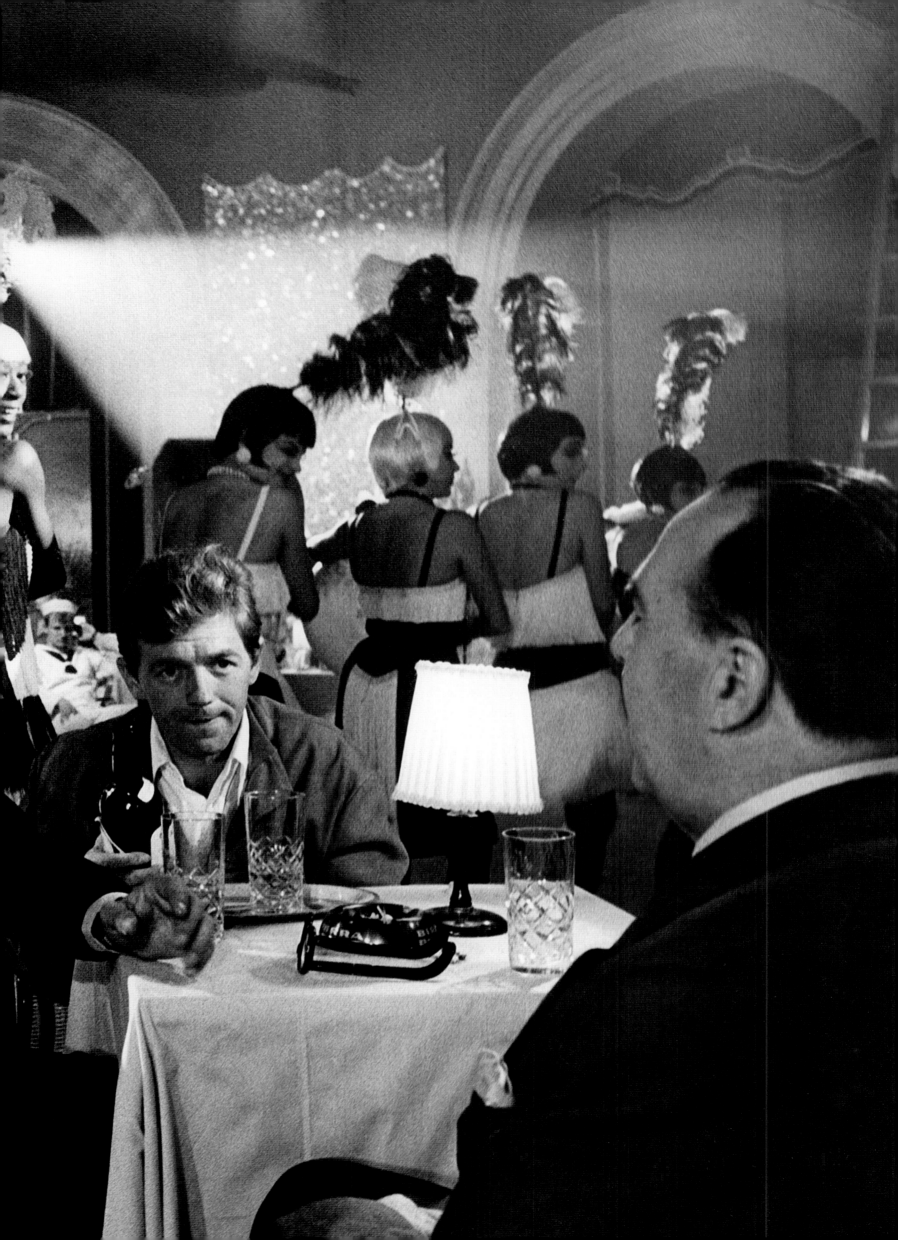

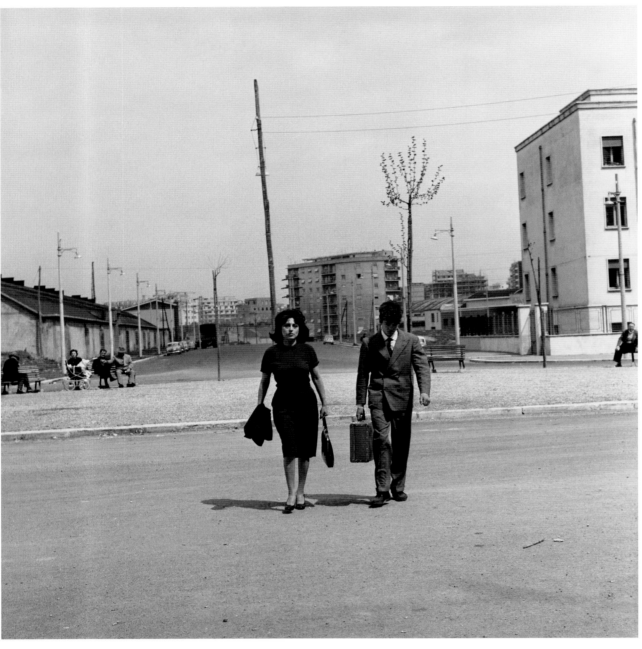

←
Reporters Associati

Anna Magnani and Ettore Garofalo in a photograph taken on the set of the movie Mamma Roma, *the masterpiece by Pier Paolo Pasolini and a milestone of Italian cinema, 1962.*

Anna Magnani und Ettore Garofalo in einer Szene aus Pasolinis Mamma Roma, *einem Meilenstein des italienischen Kinos, 1962.*

Anna Magnani et Ettore Garofalo sur une photographie de plateau de Mamma Roma, *chef-d'œuvre de Pier Paolo Pasolini qui a constitué une étape importante dans le cinéma italien, 1962.*

→
Federico Garolla

Impeccably dressed, Pier Paolo Pasolini plays football with young men in shirtsleeves in the township of Centocelle, in the current Piazzale delle Gardenie, 1960.

Pier Paolo Pasolini, im feinen Anzug, spielt Fußball mit Burschen in Hemdsärmeln aus der Vorortsiedlung Centocelle (wo sich heute der Piazzale delle Gardenie befindet), 1960.

Vêtu avec élégance, Pier Paolo Pasolini joue au football avec des gamins débraillés du quartier de Centocelle, sur l'actuel piazzale delle Gardenie, 1960.

pp. 318/319
Anonymous

A scene of the film La dolce vita *by Federico Fellini: Marcello Mastroianni, Walter Santesso, and Annibale Ninchi sitting at a table in a restaurant where some dancers in Charleston-style costumes perform, 1959.*

Szene aus dem Film La dolce vita *von Federico Fellini: Marcello Mastroianni, Walter Santesso und Annibale Ninchi am Tisch eines Restaurants, wo gerade Tänzerinnen in Charleston-Kostümen ihren Auftritt haben, 1959.*

Scène de La dolce vita *de Federico Fellini: Marcello Mastroianni, Walter Santesso et Annibale Ninchi attablés dans un restaurant où dansent des jeunes femmes en costume charleston, 1959.*

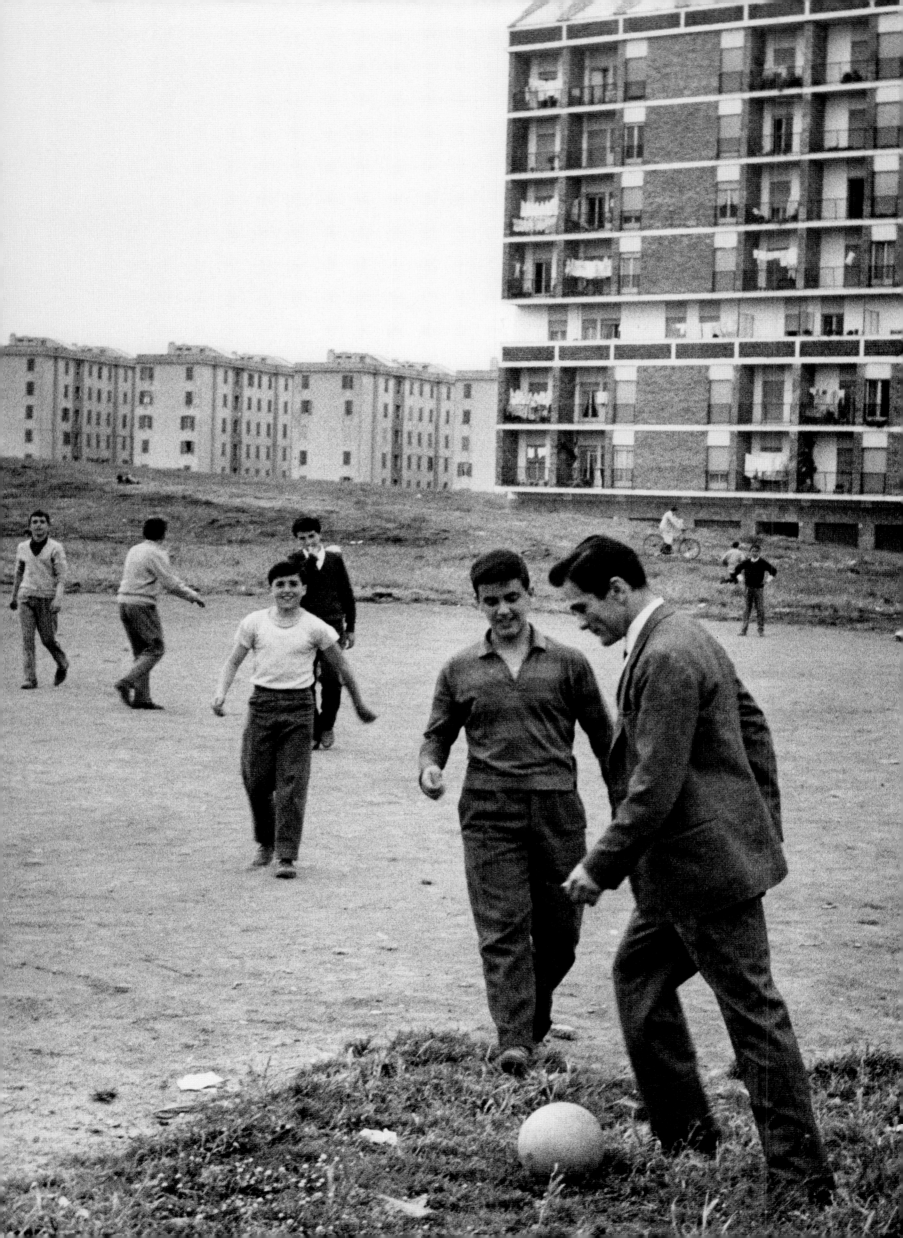

←
Luciano Ferri

Ex-voto on a section of the Aurelian Walls in Viale del Policlinico, c. 1958.

Votivtafeln an der Aurelianischen Mauer auf Höhe der Universitätskliniken, um 1958.

Ex-voto sur une portion du mur d'Aurélien dans le viale del Policlinico, vers 1958.

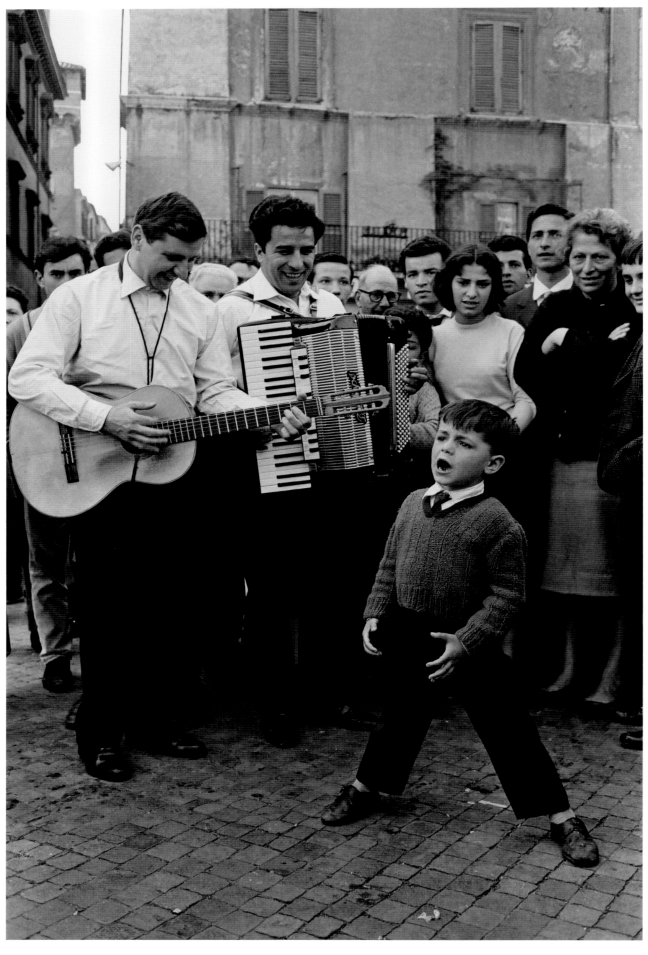

←
Anonymous

A street performance, April 1960.

Konzert auf der Straße, April 1960.

*Récital populaire donné dans la rue,
avril 1960.*

→
Anonymous

*Dave Garroway and Jack Lescoulie in Piazza
Navona in front of the Bar Tre Scalini, an
ice-cream parlor renowned for its* cassata *and*
tartufo, *April 1960.*

*Dave Garroway und Jack Lescoulie vor dem
Eissalon Tre Scalini an der Piazza Navona,
bekannt für sein Cassata- und sein Tartufo-
Eis, April 1960.*

*Dave Garroway et Jack Lescoulie, piazza
Navona, devant Tre Scalini, glacier réputé
pour sa* cassata *et ses* tartufi, *avril 1960.*

"What a man, Mussolini! In Rome, they offered him six wallets
and he refused them." "He refused some wallets? But why?"
"Because they were too few."

„Was für ein Mann, dieser Mussolini – in Rom haben sie
ihm sechs Portefeuilles angeboten, und er hat abgelehnt!"
„Abgelehnt, aber warum?" „Es war ihm zu wenig."

« "Quel homme, ce Mussolini! À Rome on lui a offert six portefeuilles
et il les a refusés" "Il a refusé les portefeuilles? Mais pourquoi?"
"Parce que c'était trop peu."»

DINO RISI, *LA MARCIA SU ROMA*, 1962

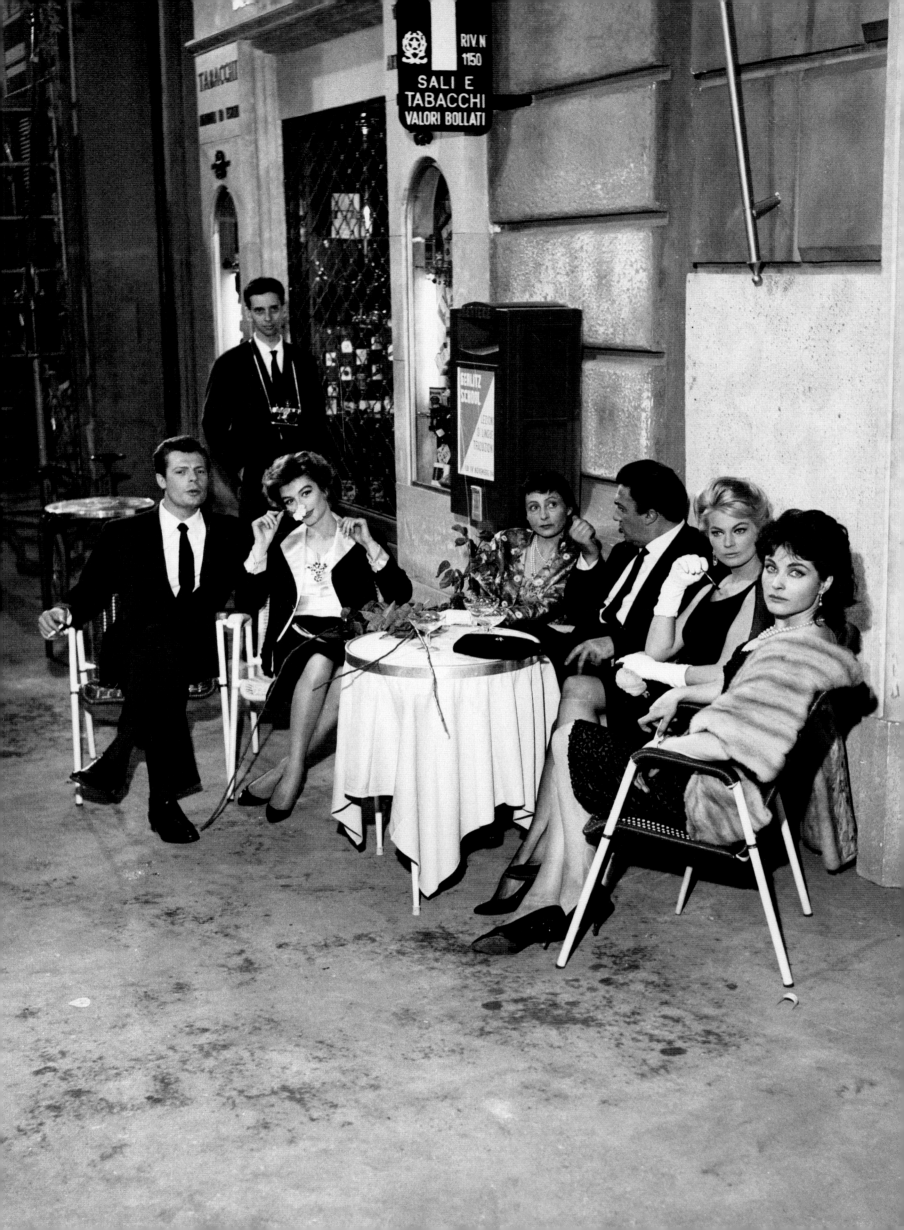

←

Pierluigi Praturlon

*Federico Fellini, Giulietta Masina, and
Yvonne Furneaux at Ciampino Airport,
waiting to leave for the Cannes Film Festival,
May 1960.*

*Federico Fellini, Giulietta Masina und
Yvonne Furneaux warten am Flughafen
Ciampino auf ihre Maschine zum Film-
festival in Cannes, Mai 1960.*

*Federico Fellini, Giulietta Masina et Yvonne
Furneaux à l'aéroport de Ciampino avant
leur départ pour le Festival de Cannes, 1960.*

←

Pierluigi Praturlon

*Marcello Mastroianni, Anouk Aimée,
Federico Fellini, Anita Ekberg, and Magali
Noël sitting around a coffee table at the start
of shooting* La dolce vita, *1959.*

*Marcello Mastroianni, Anouk Aimée,
Federico Fellini, Anita Ekberg und Magali
Noël um einen Tisch versammelt zu Beginn
der Dreharbeiten von* La dolce vita, *1959.*

*Marcello Mastroianni, Anouk Aimée,
Federico Fellini, Anita Ekberg et Magali
Noël, assis autour d'une table au début du
tournage de* La dolce vita, *1959.*

→

Licio D'Aloisio

*Kirk Douglas and Daliah Lavi during a
break on* Due settimane in un'altra città
(Two Weeks in Another Town), *by Vincente
Minnelli, 1962.*

*Kirk Douglas und Daliah Lavi während ei-
ner Drehpause am Set von* Zwei Wochen in
einer anderen Stadt *von Vincente Minnelli,
1962.*

*Kirk Douglas et Daliah Lavi durant une
pause sur le tournage de* Quinze jours
ailleurs *de Vincente Minnelli, 1962.*

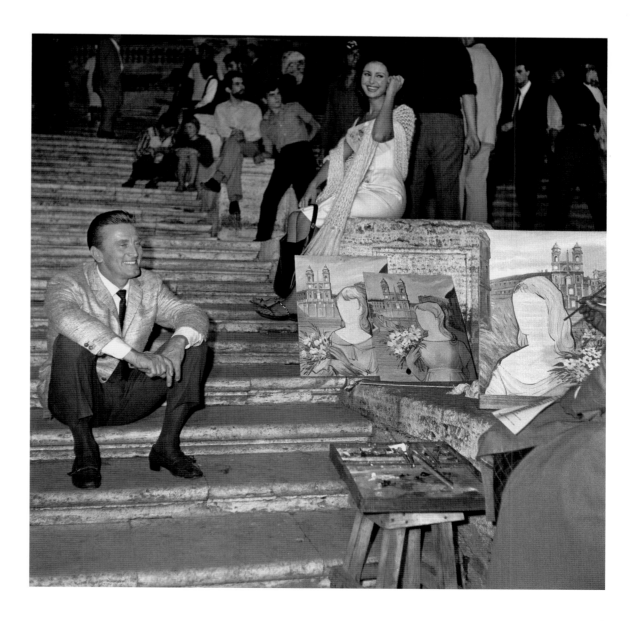

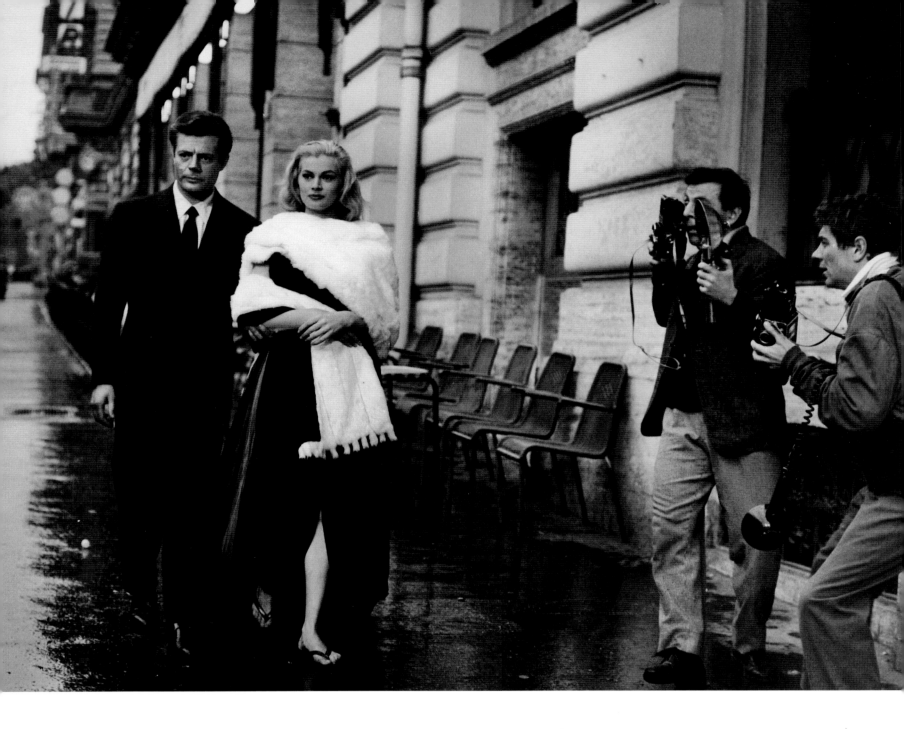

"Of course, it's hard to live and assess oneself in a city where cinema is the only industry. You end up believing that life is lived for cinema, you start developing a photographic eye, you see reality as a reflection of the one that lives and pulsates on the screen. The dog chases its tail, and ends up finding it tasty."

„Es ist natürlich nicht einfach, sich in einer Stadt aufzuhalten und diese einzuschätzen, wo der einzige Industriezweig die Filmindustrie ist. Am Ende glaubt man, dass das Leben dem Film dient, man sieht alles mit dem Blick der Kamera, und die Wirklichkeit scheint einem als Widerspiegelung jener Realität, die auf der Leinwand lebt und pulsiert. Der Hund beißt sich in den Schwanz, und am Ende schmeckt er ihm sogar."

«Certes, il est difficile de vivre et de se juger dans une ville où la seule industrie est le cinéma. On finit par croire que la vie dépend du cinéma, le regard devient photographique, on voit la réalité comme un reflet de celle qui se déroule et palpite sur l'écran. Le chien se mord la queue. Et finit même par la trouver bonne.»

ENNIO FLAIANO, *LA SOLITUDINE DEL SATIRO*, 1960

Pierluigi Praturlon

Marcello Mastroianni and Anita Ekberg photographed by paparazzi *in a scene of the film* La dolce vita, *1959.*

Marcello Mastroianni und Anita Ekberg werden in La dolce vita *von Paparazzi fotografiert, 1959.*

Marcello Mastroianni et Anita Ekberg photographiés par les paparazzi dans une scène de La Dolce Vita, *1959.*

Franco Vitale

Simone Signoret surrounded by journalists on her arrival in Rome for the filming of Adua e le compagne (*Adua and Her Friends*), *1960.*

Simone Signoret wird bei ihrer Ankunft in Rom zu den Dreharbeiten von Adua und ihre Gefährtinnen *von Reportern umringt, 1960.*

*Simone Signoret entourée par les journalistes lors de son arrivée à Rome pour le tournage d'*Adua et ses compagnes, *1960.*

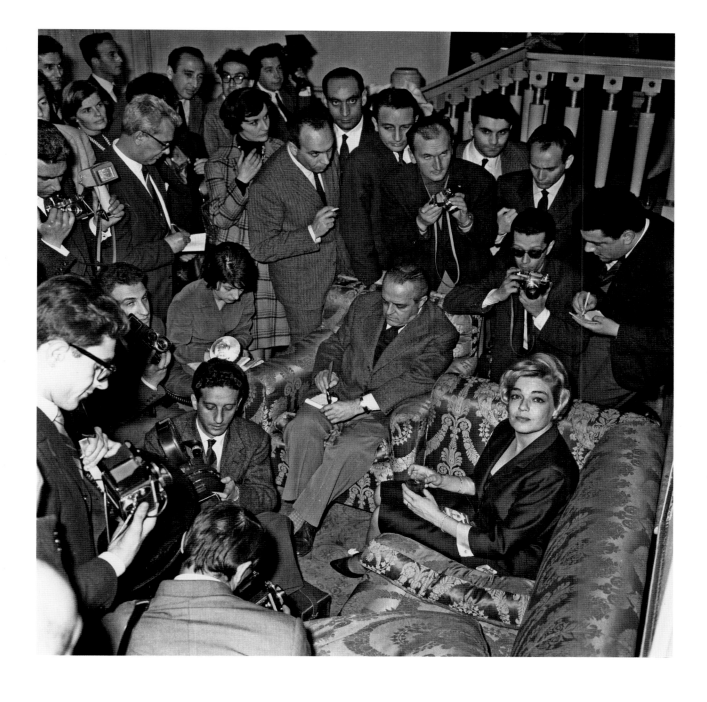

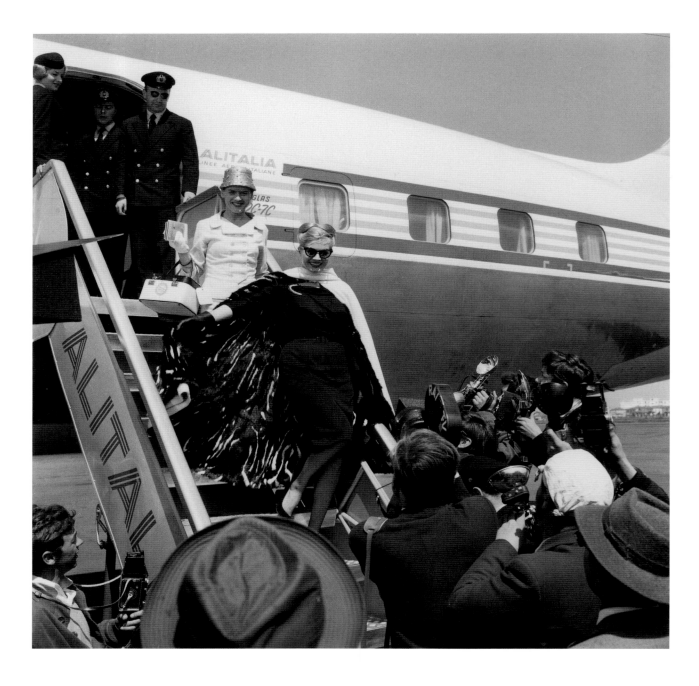

↑
Anonymous

The arrival of Anita Ekberg at Ciampino Airport. "She produces noise," said Fellini of her, "and wants only noise around her," 1959.

Ankunft von Anita Ekberg auf dem Flughafen von Ciampino. „Sie erregt Aufsehen," so Fellini über die Schwedin, „und sie will nichts als Aufsehen um sich herum", 1959.

L'arrivée d'Anita Ekberg à l'aéroport de Ciampino. « Elle fait du bruit, dit Fellini, et elle veut que l'on en fasse autour d'elle », 1959.

→
David Lees

Marcello Mastroianni and Federico Fellini in front of a poster of La dolce vita, *August 1960.*

Marcello Mastroianni und Federico Fellini vor einem Filmplakat von La Dolce Vita, *August 1960.*

Marcello Mastroianni et Federico Fellini devant une affiche de La Dolce Vita, *août 1960.*

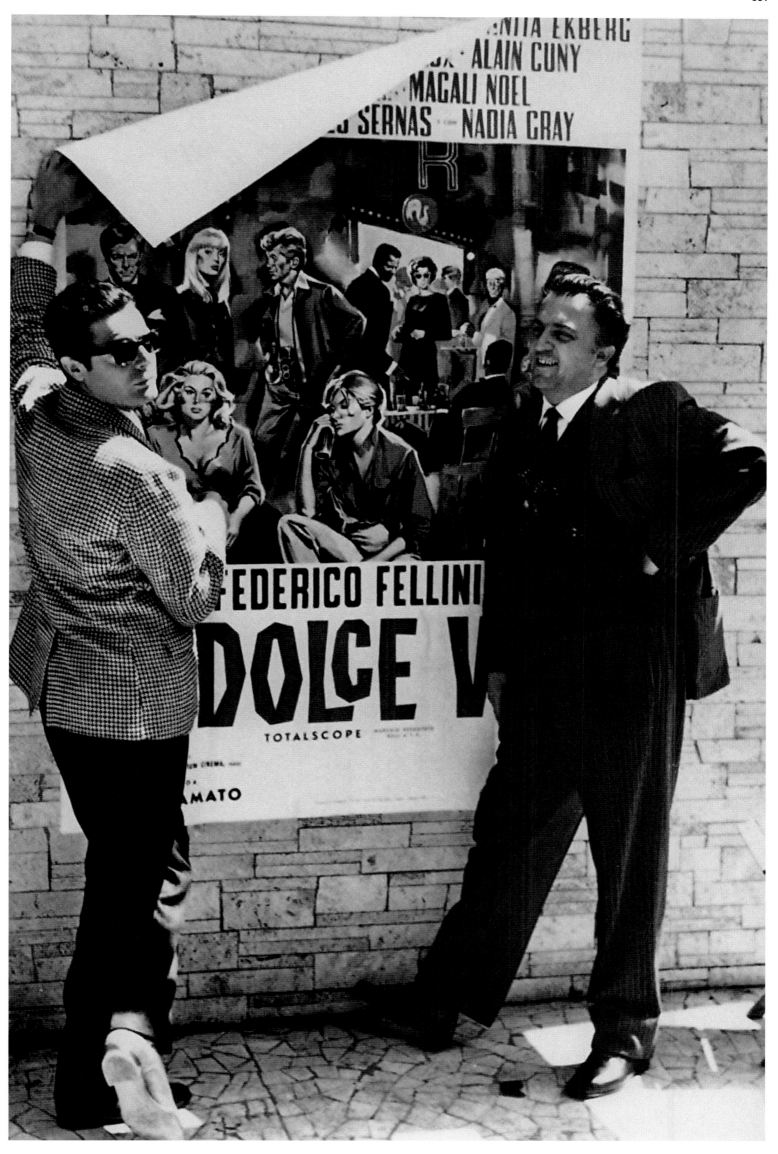

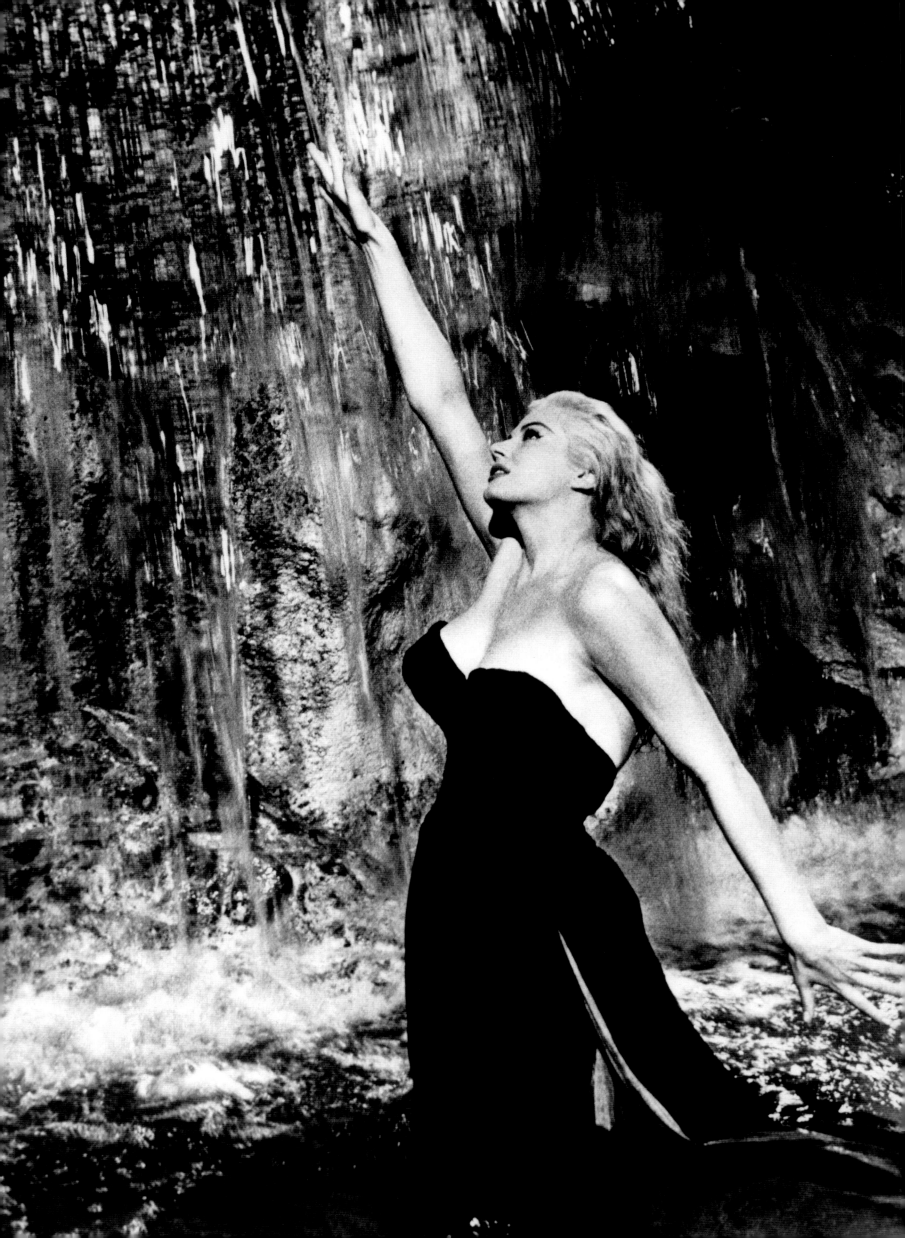

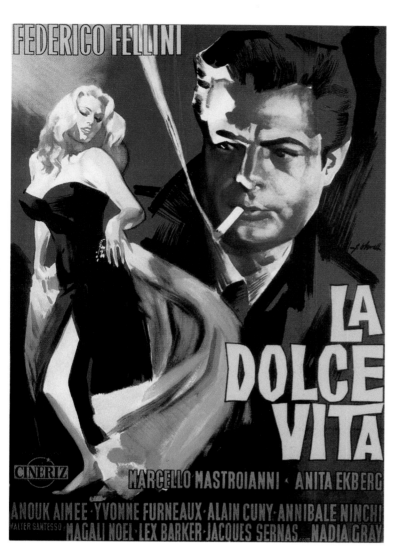

"I actually love Rome a lot: it's a kind of jungle, warm, quiet, where you can hide easily."

„Mir dagegen gefällt Rom sehr, es ist eine Art Dschungel, lau und ruhig, in dem man sich gut verstecken kann."

«Moi, j'aime beaucoup Rome: c'est une espèce de jungle, tiède, reposante, où l'on peut bien se cacher.»

FEDERICO FELLINI, *LA DOLCE VITA*, 1960

←
Herbert Dorfman

Anita Ekberg in the legendary Trevi Fountain scene of La dolce vita, *1960.*

Anita Ekberg in der berühmt gewordenen Szene im Trevibrunnen in La dolce vita, *1960.*

Anita Ekberg dans la fontaine de Trevi, scène mythique de La dolce vita, *1960.*

pp. 334/335
Nicolas Tikhomiroff

Federico Fellini, in a white hat, on the set of Boccaccio '70 *in Cinecittà, with a gigantic canvas featuring Anita Ekberg in the background, 1961.*

Federico Fellini, mit weißem Hut, vor einer Plakatwand mit dem überlebensgroßen Abbild von Anita Ekberg am Set von Boccaccio '70 *in Cinecittà, 1961.*

Coiffé d'un chapeau blanc, Federico Fellini sur le plateau de Boccace 70 *à Cinecittà avec, en arrière-plan, une toile gigantesque représentant Anita Ekberg, 1961.*

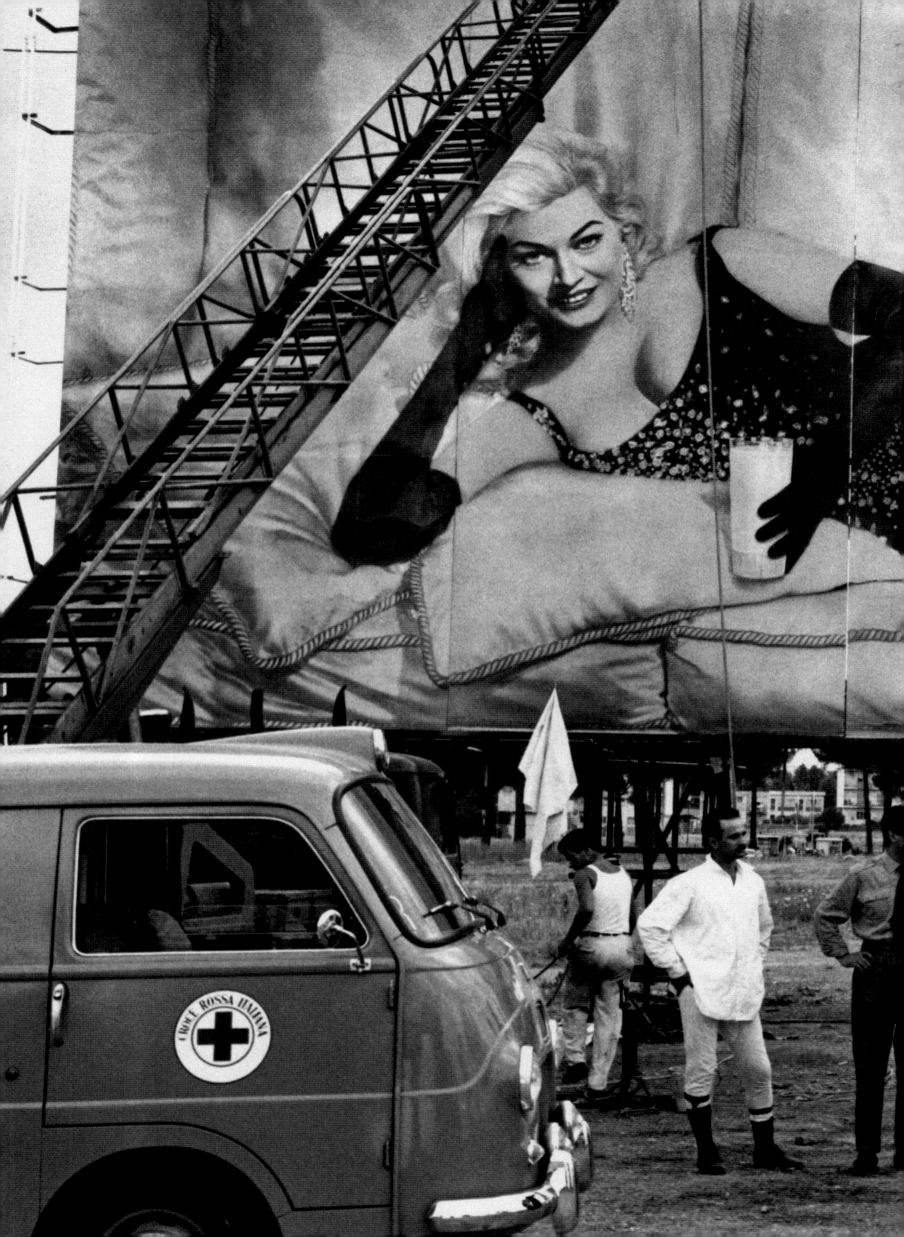

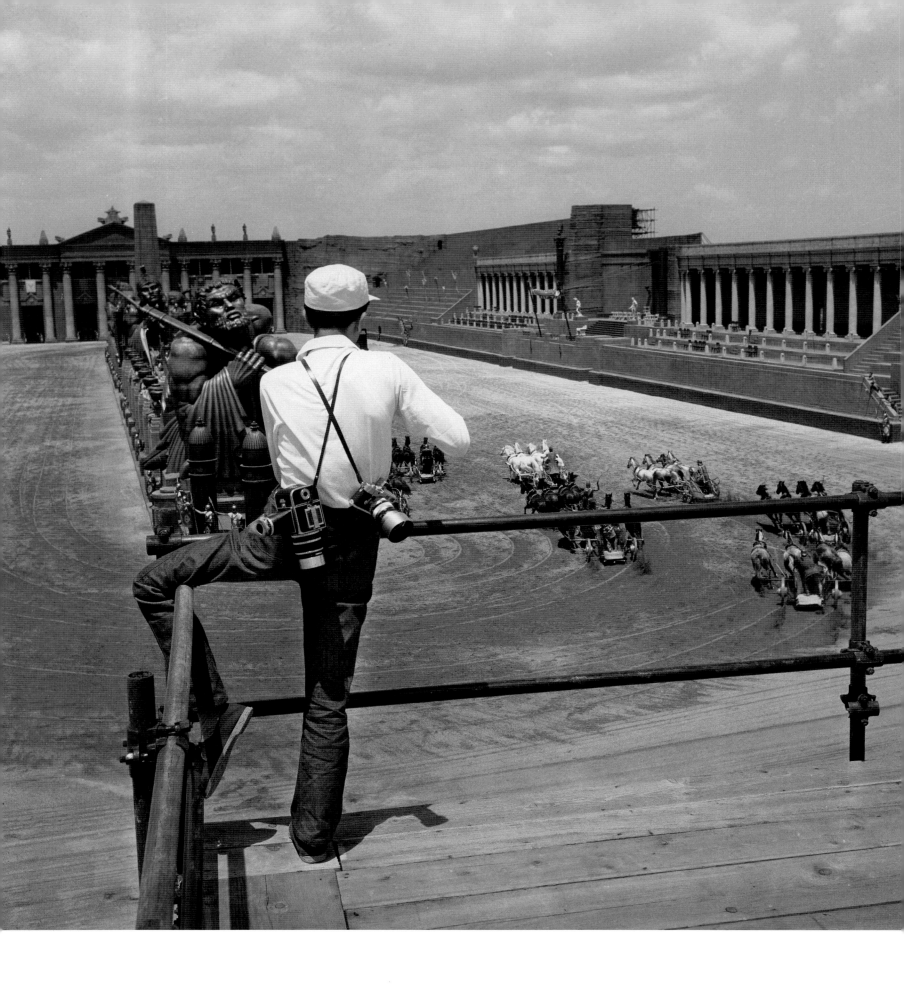

↑

Pierluigi Praturlon

Pierluigi Praturlon takes a picture of the chariot race during the shooting of the epic film Ben-Hur, *1959. Ben Hur (Charlton Heston): "The world belongs to Rome: if you want to live in it, you must be part of it! To resist Rome is stupid!"*

Pierluigi Praturlon beim Fotografieren des Wagenrennens während der Aufnahmen zum Monumentalfilm Ben-Hur, *1959. „Die Welt gehört Rom – wenn du hier leben willst, musst du dazugehören! Sich gegen Rom auflehnen zu wollen, ist dumm." (Ben Hur gespielt von Charlton Heston.)*

Pierluigi Praturlon photographie la course de chars durant les prises de Ben-Hur, *1959. Ben Hur (Charlton Heston): « Le monde appartient à Rome: si tu veux y vivre, tu dois en faire partie! Résister à Rome est stupide! »*

"A NEW KIND OF MOVIE...A SUPERSPECTACLE WITH SPIRITUAL VITALITY AND MORAL FORCE!"
—TIME MAGAZINE

SPARTACUS

TECHNICOLOR®

A Bryna Production · A Universal-International Release

"There is only one way to deal with Rome: you have to serve her, you must humble yourself before her, you must love her. No one can resist Rome."

„Es gibt nur einen Weg, mit Rom zurechtzukommen: Man muss ihm dienen, man muss sich vor ihm in den Staub werfen, man muss es lieben. Niemand kann Rom widerstehen."

« Il n'y a qu'une seule manière de traiter avec Rome : tu dois la servir, tu dois t'humilier devant elle, tu dois l'aimer. Personne ne peut résister à Rome. »

STANLEY KUBRICK, *SPARTACUS,* 1960

→
Keystone Agency

During the filming of Cleopatra *in Cinecittà, Liz Taylor (Cleopatra) and Richard Burton (Mark Antony) fell passionately in love, 1960. Pope Paul VI was troubled by this, and the paparazzi never left them alone. They divorced from their respective spouses and got married in 1964, divorced ten years later, and remarried after just over a year.*

Während der Dreharbeiten zu Kleopatra *(1960) entbrennt zwischen Liz Taylor, die die Titelrolle spielt, und Richard Burton, der Mark Anton verkörpert, eine leidenschaftliche Affäre. Für Papst Paul VI. ein Grund zur Besorgnis, für die römischen Paparazzi ein gefundenes Fressen. Die beiden Schauspieler lassen sich von ihren jeweiligen Ehepartnern scheiden und heiraten 1964. Zehn Jahre später trennen sie sich, um wenige Monate später wieder zu heiraten.*

Durant le tournage de Cléopâtre *à Cinecittà, une passion dévorante s'empara de Liz Taylor (Cléopâtre) et de Richard Burton (Marc Antoine), 1960. Le pape Paul VI s'en inquiéta, les paparazzi sévirent. Les deux acteurs divorcèrent de leur conjoint respectif et se marièrent en 1964, divorcèrent au bout de dix ans et se remarièrent un an et demi plus tard.*

↑

Slim Aarons

Prince and Princess Massimo with their children in the loggia of their house, the 16th-century Palazzo Massimo alle Colonne, 1960.

Fürst und Fürstin Massimo mit ihren Kindern in der Loggia des Palazzo Massimo alle Colonne aus dem 16. Jahrhundert, 1960.

Le prince et la princesse Massimo avec leurs enfants dans la loggia de leur demeure, le palais Massimo alle Colonne du XVIᵉ siècle, 1960.

↑
Slim Aarons

Princess Colonna and her son in Palazzo Colonna, near Piazza Venezia, 1960.

Die Fürstin Colonna mit ihrem Sohn im Palazzo Colonna unweit der Piazza Venezia, 1960.

La princesse Colonna et son fils dans un salon du palais Colonna, proche de la piazza Venezia, 1960.

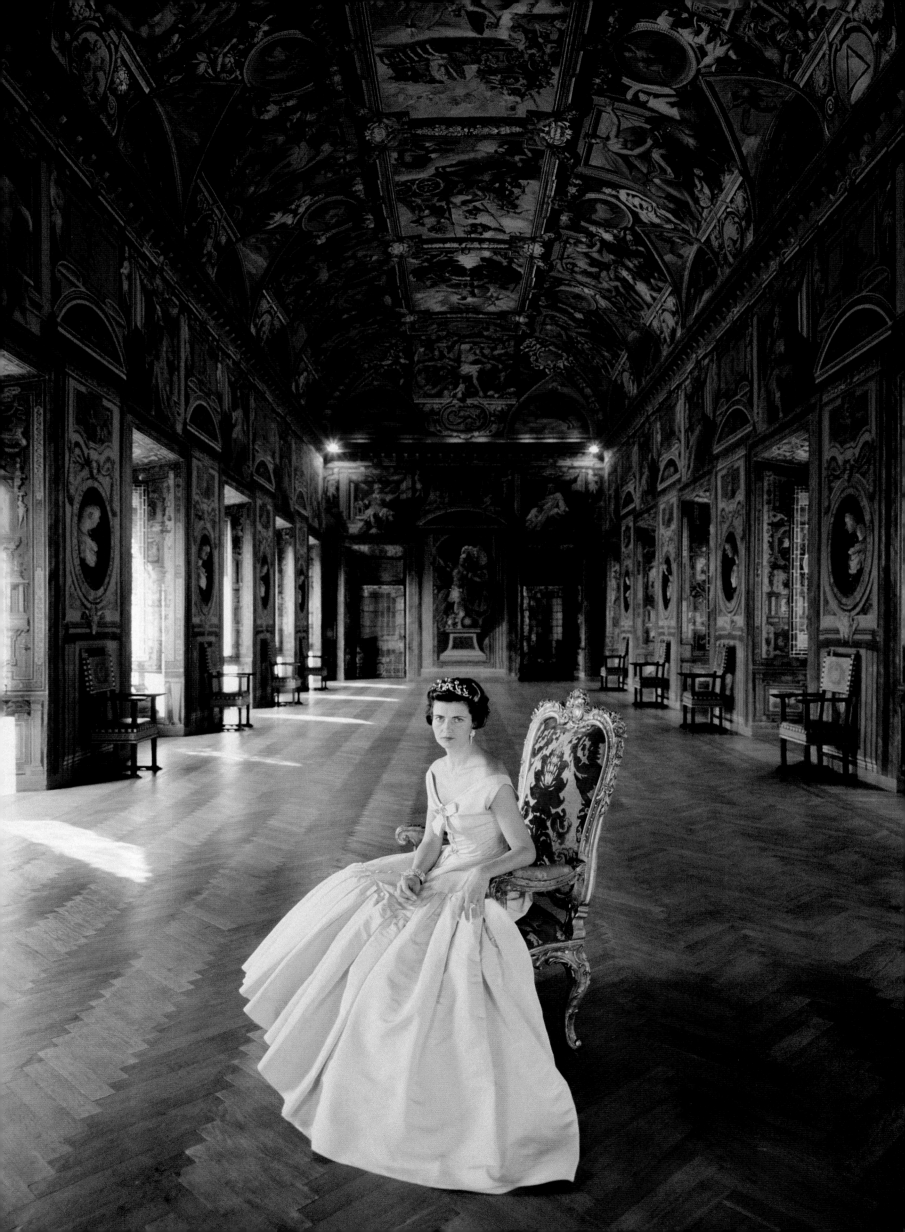

→

Slim Aarons

Prince Alessandro Torlonia and Duke and Duchess Emanuele Torlonia at their stables, 1960.

Fürst Alessandro Torlonia mit Herzogin und Herzog Emanuele Torlonia auf der Reitbahn, 1960.

Le prince Alessandro Torlonia et le duc et la duchesse Emanuele Torlonia aux écuries, 1960.

←

Slim Aarons

Donna Domitilla Ruspoli in the gallery of Palazzo Ruspoli, on the Corso, once known for its lavish parties, and now a major center for temporary exhibitions on art and archeology, 1960.

Donna Domitilla Ruspoli im Freskensaal des Palazzo Ruspoli am Corso, der für seine prachtvollen Feste bekannt ist und in dem heute Wechselausstellungen im Bereich Kunst und Archäologie stattfinden, 1960.

Donna Domitilla Ruspoli dans la galerie du palais Ruspoli situé sur le Corso; renommé jadis pour ses fêtes fastueuses, il accueille aujourd'hui d'importantes expositions d'art et d'archéologie, 1960.

→
William Klein

Klein came to be known as an innovator with his fashion shoots taken in the streets and published in Vogue. *This is the celebrated image of models Nina and Simone on the Spanish Steps, 1960.*

Klein gilt als Erfinder des Straßen-Modefotos, ein Genre, das er unter anderem für die Vogue *entwickelte; hier sein berühmt gewordenes Bild der Fotomodelle Nina und Simone auf der Piazza di Spagna, 1960.*

Klein est connu pour avoir révolutionné la photographie de mode en prenant la rue pour décor, ce qui lui permet de s'imposer, même à Vogue. *Ce cliché des mannequins Nina et Simone pris piazza di Spagna est célèbre, 1960.*

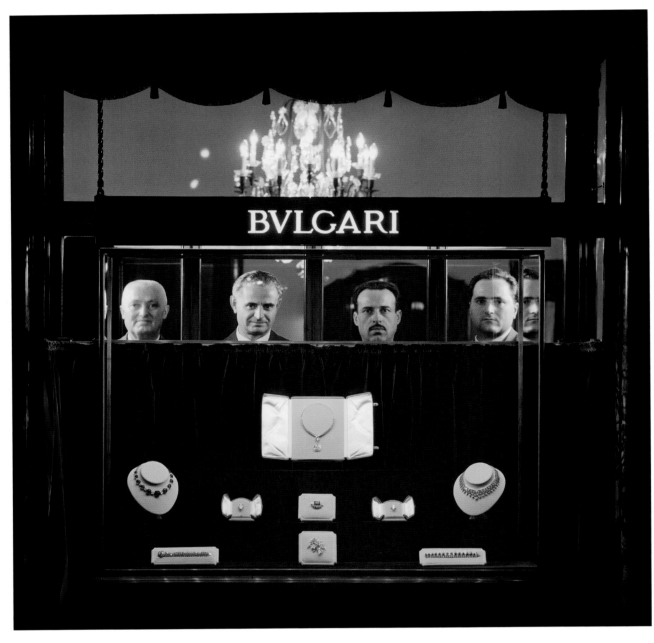

↑
Elliott Erwitt

The window of the Bulgari jewelry store in Via Condotti, 1959. Richard Burton said, "The only Italian word Elizabeth [Taylor] knows is Bulgari."

Schaufenster des Juweliers Bulgari in der Via Condotti, 1959. Richard Burton wusste zu berichten: „Das einzige Wort Italienisch, das Liz [Taylor] kennt, lautet: ‚Bulgari'."

Via Condotti, la vitrine du joaillier Bulgari, 1959. Selon Richard Burton, « le seul mot d'italien qu'Elizabeth [Taylor] connaît est Bulgari ».

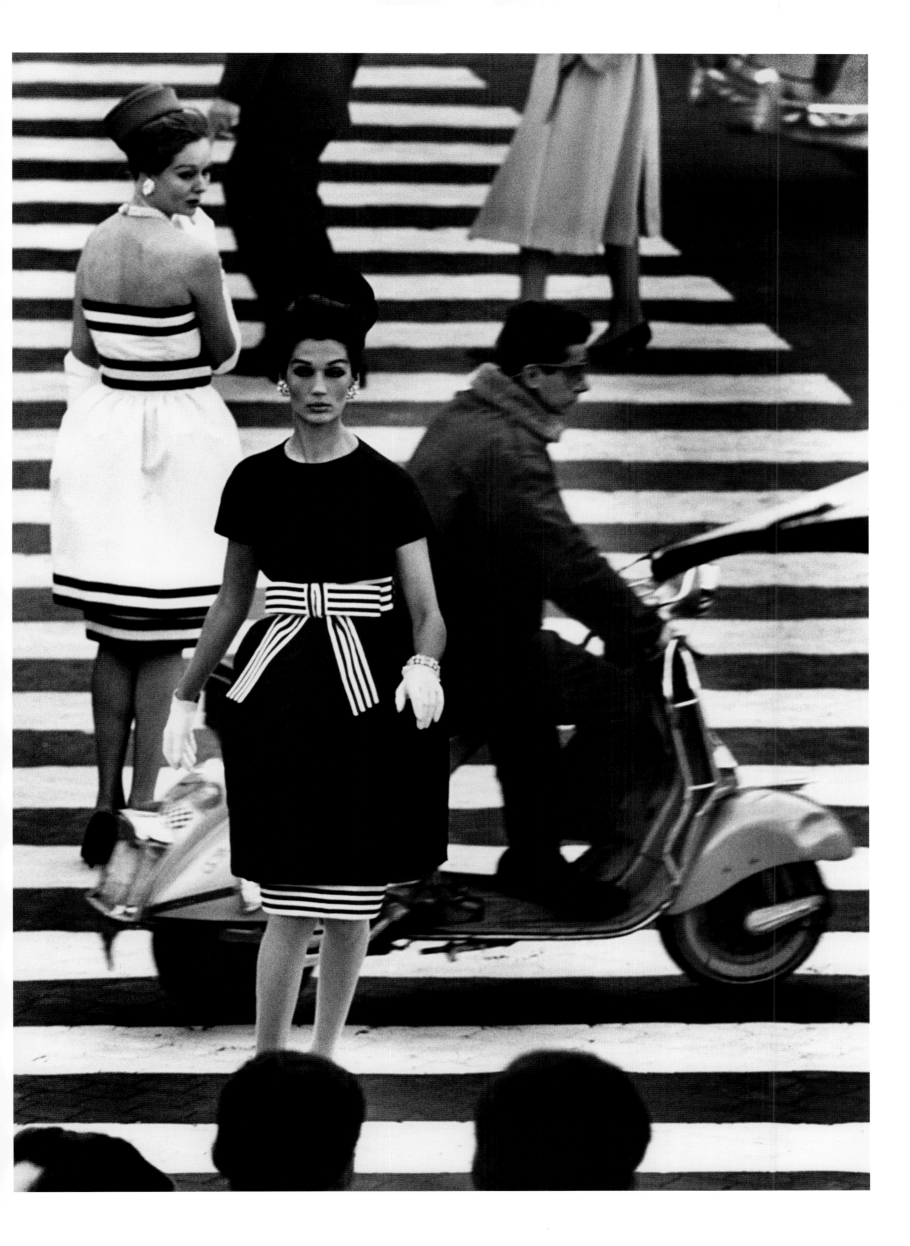

←

Slim Aarons

The Baths of Caracalla were used for the gymnastic competitions at the 1960 Olympics in Rome.

Die Turnwettbewerbe der Olympischen Spiele 1960 wurden teilweise in den Caracalla-thermen ausgetragen.

Lors des Jeux olympiques de Rome en 1960, les thermes de Caracalla accueillirent les épreuves de gymnastique.

↑

Marvin E. Newman

By winning the gold medal at the Olympics in Rome, the 18-year-old Cassius Clay revealed his immense talent, 1960.

Die Goldmedaille bei den Olympischen Spielen in Rom ließ das unglaubliche Talent des damals erst 18-jährigen Cassius Clay erkennen, 1960.

Aux Jeux olympiques de Rome, sa médaille d'or révéla l'immense talent de Cassius Clay alors âgé de 18 ans, 1960.

Cino Del Duca Films presenta

un film di
PIER PAOLO
PASOLINI

ACCATTONE

Prodotto da Alfredo Bini per la Cino Del Duca Films - Arco Film (Roma)

"*If I wanted to make* Accattone *today, I couldn't do it. […] Of course, half or more of the young people living in the Roman townships […] are, from the point of view of their criminal record, law-abiding. They are also good guys. But they're not nice anymore. They are sad, neurotic, uncertain, filled with a* petit-bourgeois *anxiety; they are ashamed to be working-class; they try to imitate the rich kids, the morons.*"

„*Wollte ich* Accatone *heute noch einmal drehen, ich könnte es nicht. […] Über die Hälfte der jungen Burschen, die in den römischen Vorstädten leben […], sind vom Vorstrafenregister her sauber. Es sind auch gute Jungs. Aber sie sind nicht mehr sympathisch. Sie sind traurig, neurotisch, unsicher, von kleinbürgerlicher Ängstlichkeit erfüllt, sie schämen sich, Arbeiter zu sein, sie versuchen, die Mutter-söhnchen und Jüngelchen nachzuahmen.*"

«*Aujourd'hui, si je voulais tourner* Accatone, *je ne pourrais plus le faire. […] Certes, plus de la moitié des jeunes qui vivent dans les faubourgs de Rome […] sont honnêtes du point de vue de leur casier judiciaire. Ce sont même de gentils garçons. Mais ils ne sont plus sympathiques. Ils sont tristes, névrotiques, incertains, emplis d'une peur petite-bourgeoise ; ils ont honte d'être ouvriers ; ils essaient d'imiter les "fils à papa", les "farlocchi" [crétins].*»

PIER PAOLO PASOLINI, "IL MIO 'ACCATTONE' IN TV DOPO IL GENOCIDIO," *CORRIERE DELLA SERA,* **OCTOBER 8, 1975**

→

Walter Limot

A young girl in the Jewish Ghetto. On the walls of Roman buildings one can often find the picturesque – if incongruous – jux-taposition of graffiti and advertisements (Totocalcio is the name of the system of weekly bets on the results of football games), sometimes beside ancient inscriptions, 1960.

Mädchen im jüdischen Getto. Auf den Mauern römischer Häuser findet sich oft eine Vielzahl von Werbeschildern (Totocalcio ist der Name einer beliebten Fußballwette), Kritzeleien – manchmal unmittelbar neben historischen Inschriften, 1960.

Fillette du Ghetto. Sur les murs de Rome se côtoient de manière souvent redondante et pittoresque, des panneaux publicitaires (le Totocalcio est un jeu de pari populaire et hebdomadaire sur les résultats du cham-pionnat de football), des graffitis et, parfois, des inscriptions anciennes, 1960.

BEVETE
Coca-Cola

Totocalcio

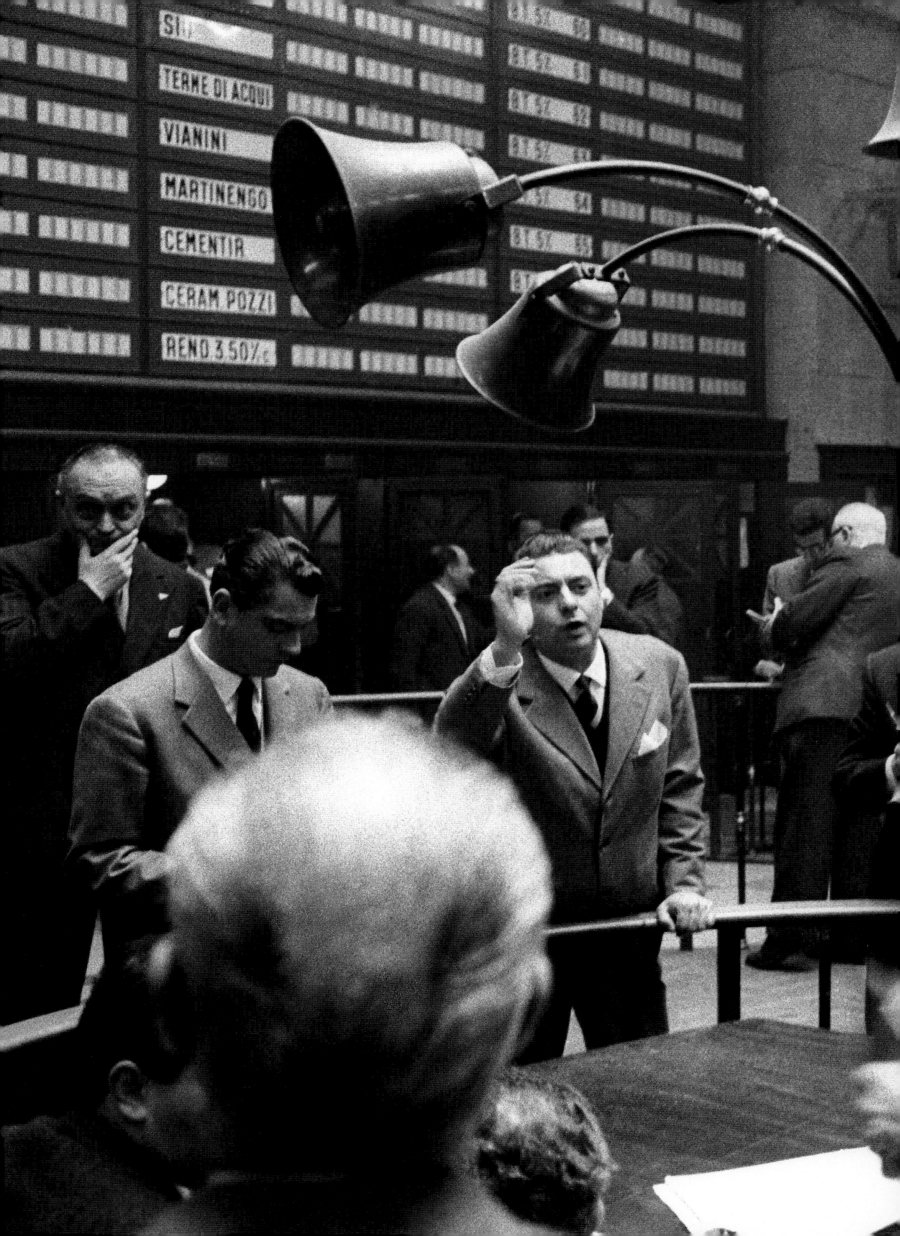

pp. 348/349
Istituto LUCE

*Interior of the Rome Stock Exchange building
in Piazza di Pietra, January 1960.*

*Aktiensaal der römischen Börse an der Piazza
di Pietra, Januar 1960.*

*Intérieur de la Bourse de Rome située piazza
di Pietra, janvier 1960.*

↓
Popperfoto

*Queen Elizabeth II of England visiting
Rome, 1961.*

Königin Elisabeth II. zu Besuch in Rom, 1961.

*La reine Élisabeth II d'Angleterre en visite
à Rome, 1961.*

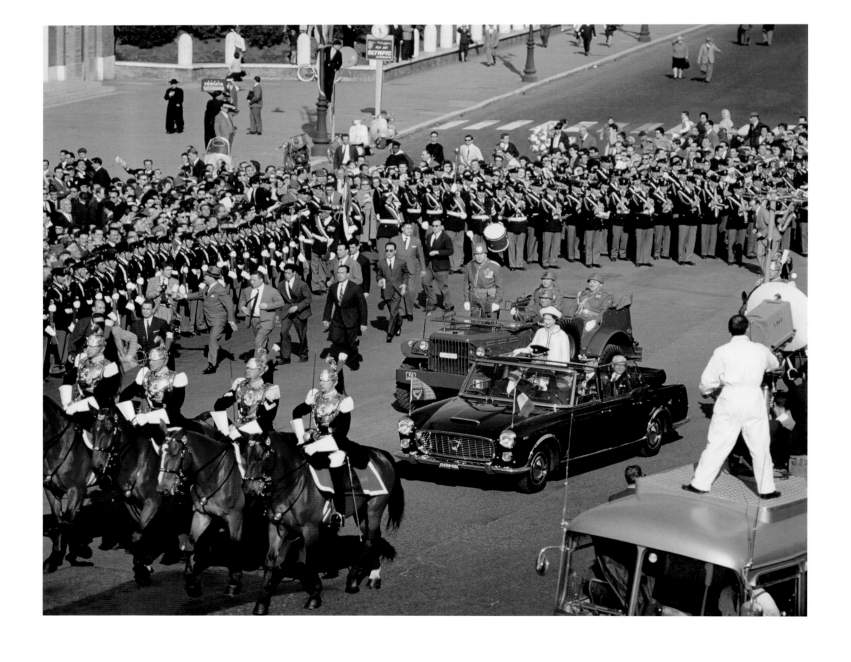

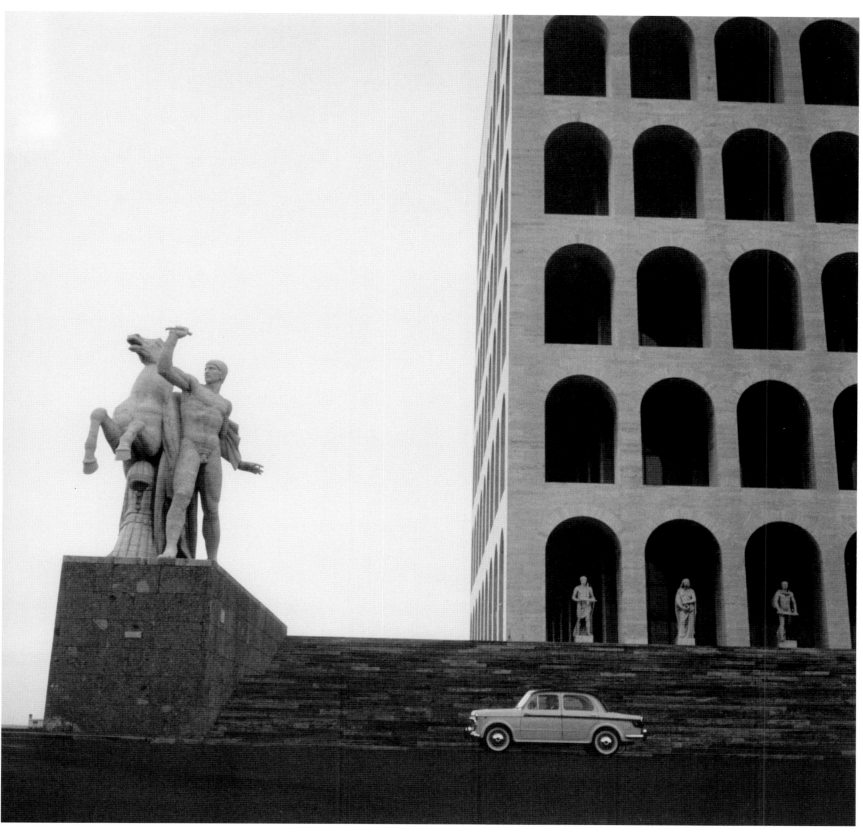

↑
Walter Limot

The Palazzo della Civiltà Italiana was built in 1938 in the area destined for the Universal Exhibition of 1942; it was inaugurated in 1940 (although still unfinished), and completed in the early post-war period. Its heroical, monumental shape – a square structure with four sides of equal dimensions covered in travertine, each featuring 54 arches, erected on a stepped base – had a strong impact on the collective imagination of the citizens of Rome, who nicknamed it the "square Colosseum." It has often been used as a backdrop for films or advertisements, 1960.

Der Palazzo della Civiltà Italiana auf dem eigentlich für die Weltausstellung 1942 bestimmten Gelände wurde 1938 begonnen und 1940, obschon noch im Bau, eröffnet, aber erst nach dem Krieg vollendet. Seine monumentale Erscheinung – ein Kubus auf quadratischem Grundriss, zu dem ein Stufensockel hinaufführt samt an allen vier Seiten identischer Travertinfassade mit 54 Bogen – hat sich tief in das kollektive Bildgedächtnis der Römer eingeprägt, die ihn gern als „Colosseo quadrato" bezeichnen. Seine Architektur wird oft als Kulisse für Werbeaufnahmen und Fernsehspots verwendet, 1960.

La construction du Palais de la civilisation italienne dans le quartier qui aurait dû accueillir l'Exposition universelle de 1942 débuta en 1938; bien qu'inachevé, l'édifice fut inauguré en 1940 et complété au lendemain de la guerre. Avec son allure héroïquement monumentale – un parallélépipède à plan carré érigé sur une base à degrés, avec quatre façades identiques revêtues de travertin et percées de 54 arcades –, il s'est imposé dans l'imaginaire collectif des Romains qui le surnomment familièrement le « Colisée carré ». Il figure souvent en arrière-plan d'œuvres cinématographiques ou de spots publicitaires, 1960.

pp. 352/353
Flip Schulke

Via dei Fori Imperiali, designed by Mussolini, crosses the archeological site of the Forum and leads to the Colosseum, 1962.

Die Via dei Fori Imperiali, angelegt auf Anweisung Mussolinis, zerschneidet die Ausgrabungszone der Kaiserforen und führt direkt auf das Kolosseum zu, 1962.

Créée sous Mussolini, la via dei Fori Imperiali traverse la zone archéologique des forums et conduit au Colisée, 1962.

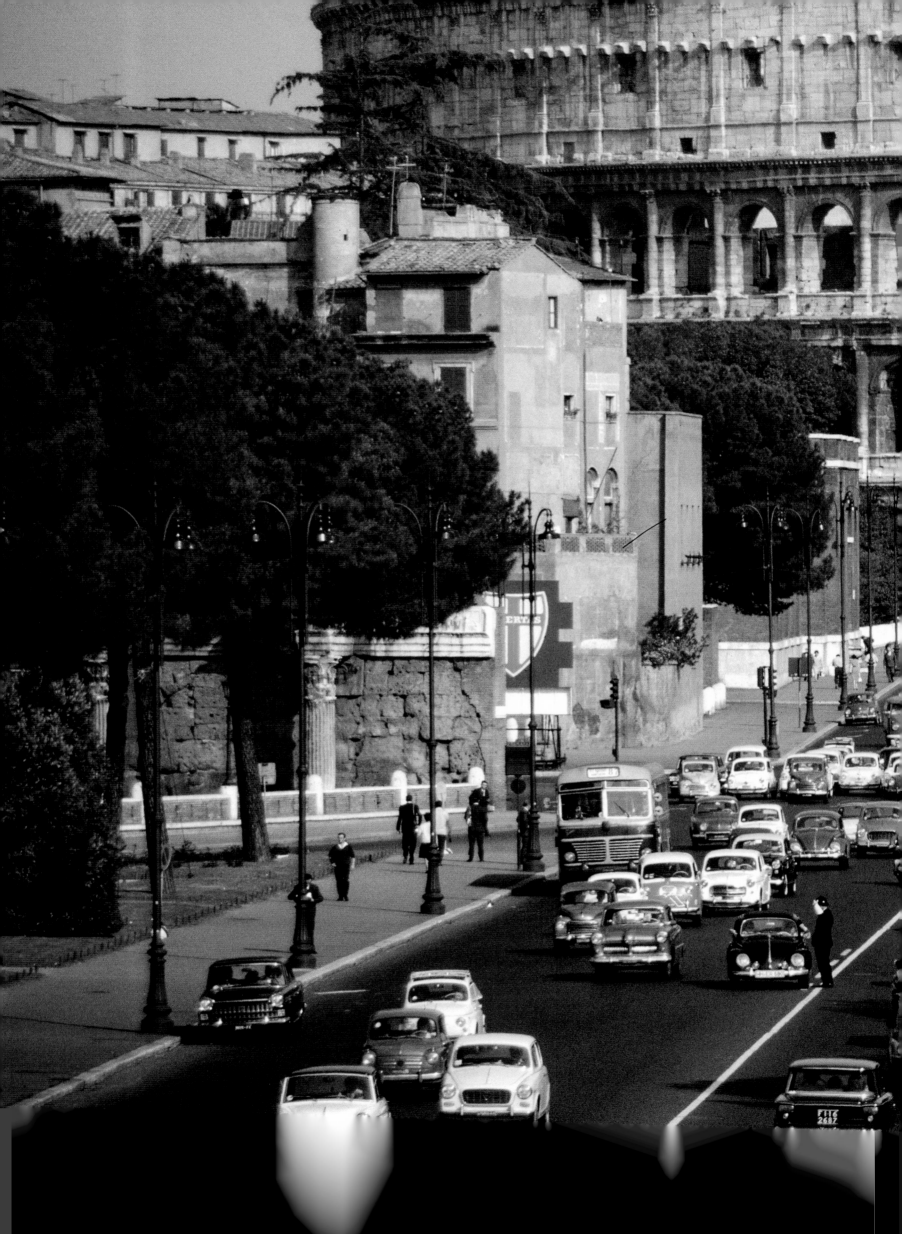

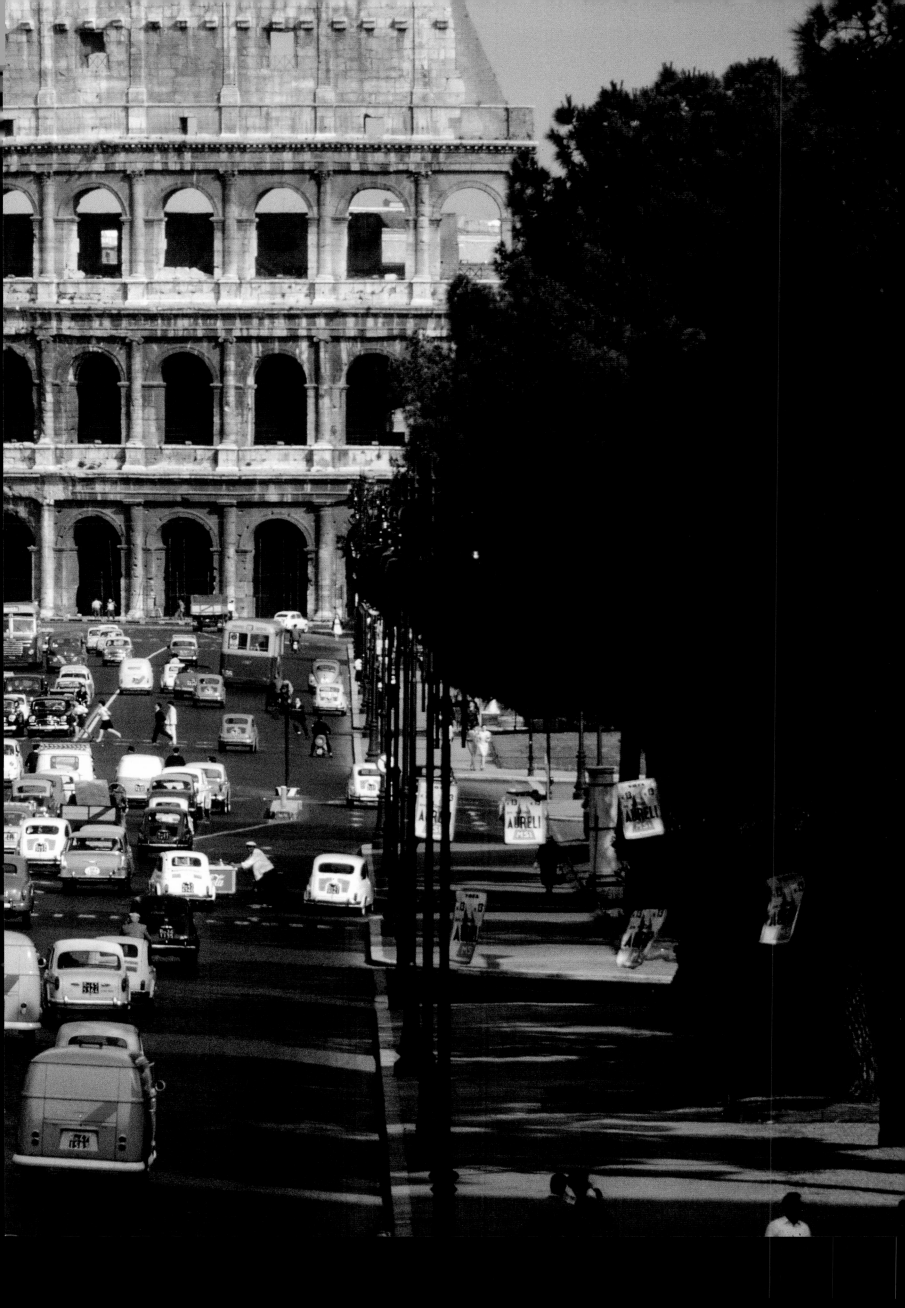

↑

Carlo Bavagnoli

*Vatican City: cardinals during the opening
session of the Second Vatican Council,
November 1962.*

*Kardinäle im Vatikan beim Zweiten Vatika-
nischen Konzil, November 1962.*

*Cardinaux durant la session d'ouverture du
concile Vatican II, novembre 1962.*

→

Carlo Bavagnoli

*John XXIII during the Second Vatican
Council. In less than five years of his papacy,
the "good Pope" revitalized the evangelical
initiatives of the Church, 1962.*

*Johannes XXIII. bei einer Sitzung des Zwei-
ten Vatikanischen Konzils. In seinem nur
fünfjährigen Pontifikat gab der „Papa buono"
entscheidende Anstöße zur Reform der
Kirche, 1962.*

*Jean XXIII durant le concile Vatican II. En
moins de cinq ans, le pontificat du « bon pape
Jean » donna une impulsion évangélisatrice
nouvelle à l'Église, 1962.*

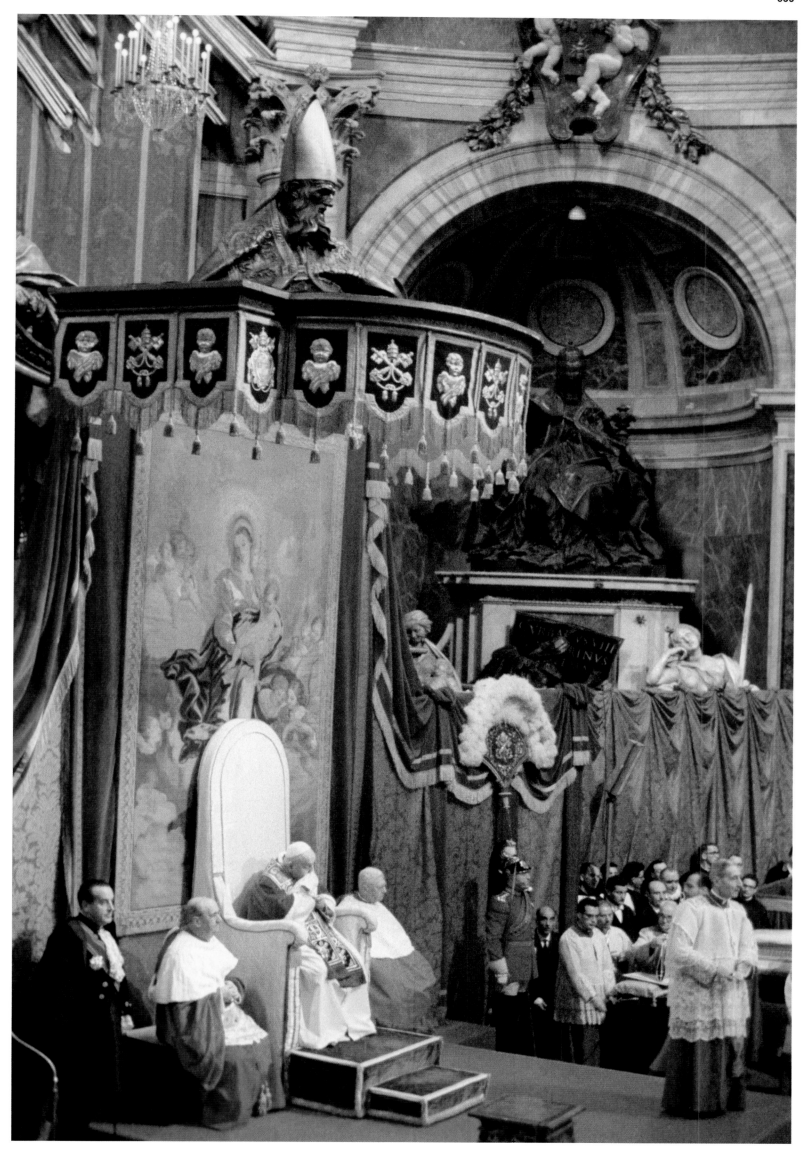

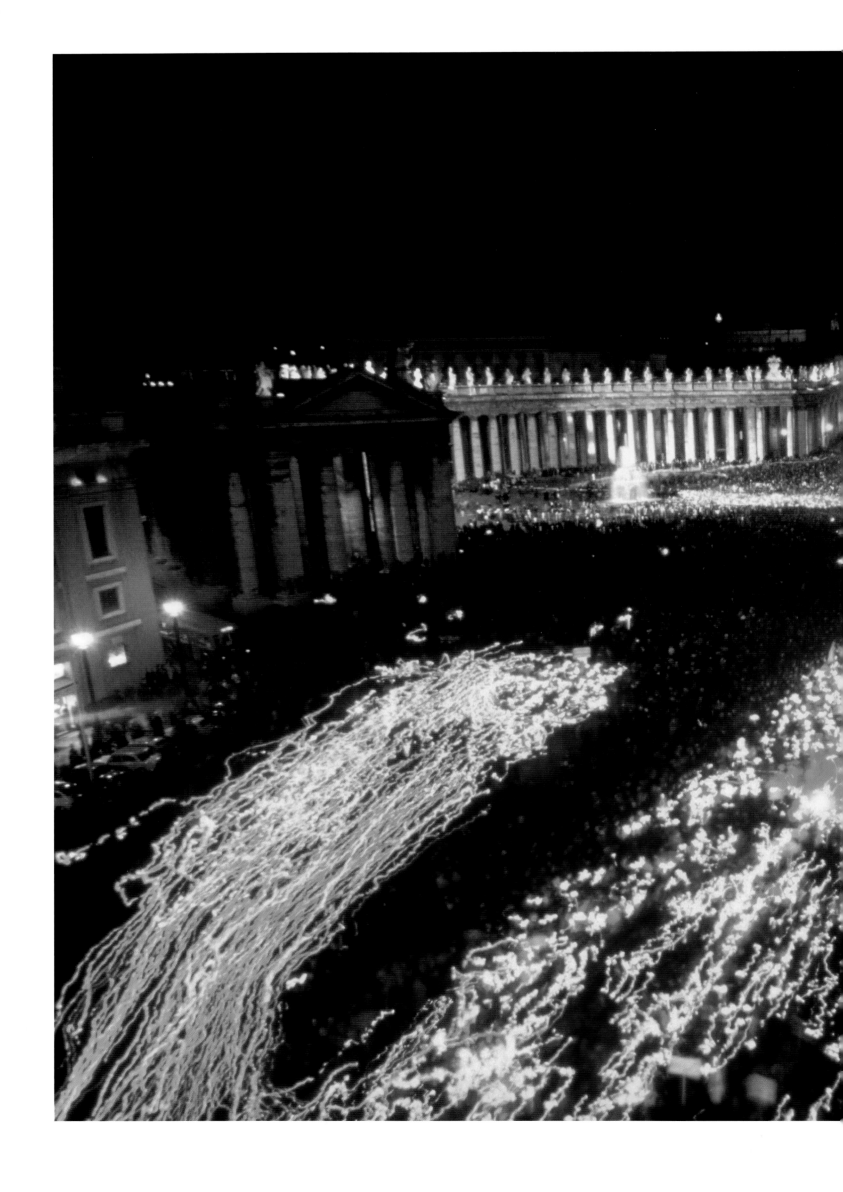

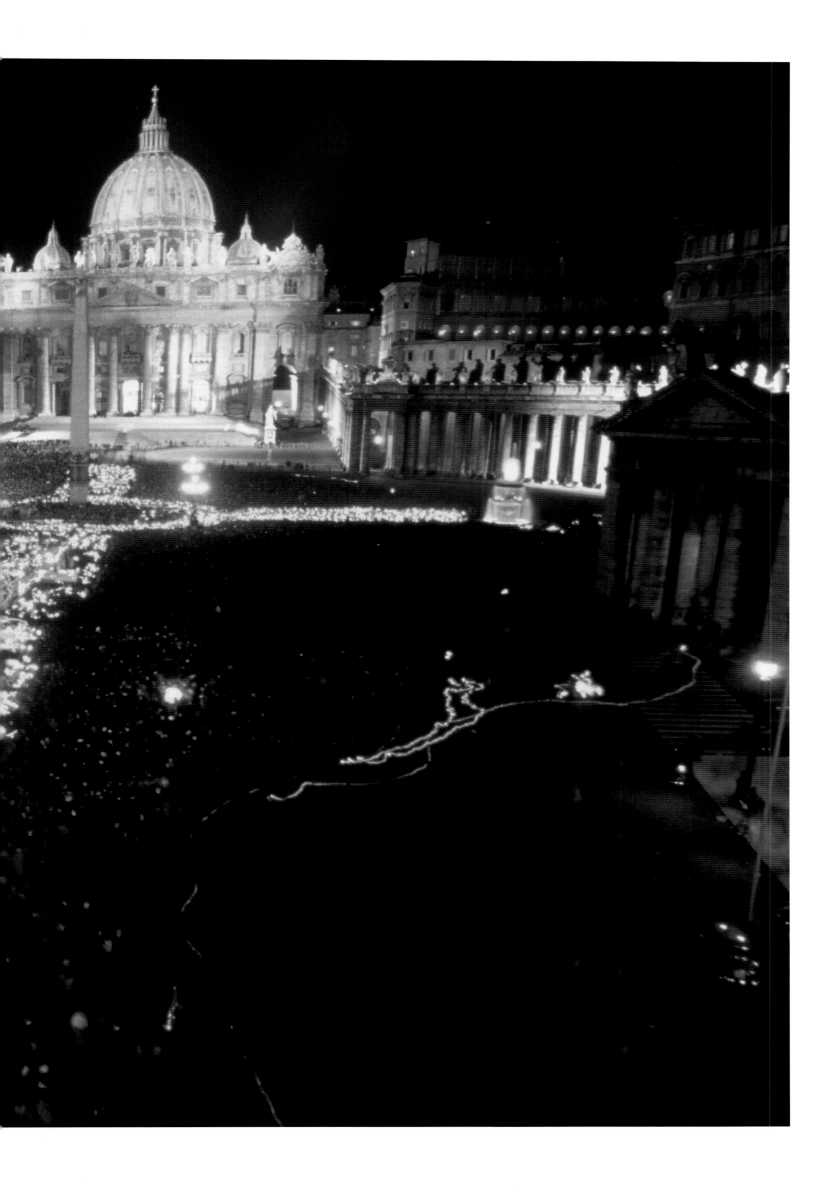

"I am no longer afraid to tell the truth, what I don't know, what
I'm looking for, what I haven't found yet. Only in that way do
I feel alive, and I can look into your loyal eyes without shame.
Life is a party: let's live it together! I have nothing more that
I can say, Luisa, neither to you nor to the others: accept me as
I am, if you can. It's the only way we can try to find ourselves."

„Ich habe außerdem keine Angst mehr, die Wahrheit zu sagen, von
dem zu sprechen, was ich nicht kenne, wonach ich suche, was ich
noch nicht gefunden habe. Nur so fühle ich mich lebendig und
kann dir in deine treuen Augen sehen, ohne mich zu schämen. Ein
Fest des Lebens – lass es uns zusammen leben! Mehr kann ich dir
nicht sagen, Luisa, dir nicht und nicht den anderen: Nimm mich
so, wie ich bin, wenn du kannst. Nur so können wir uns finden."

« Je n'ai plus peur de dire la vérité, ce que je ne sais pas, que je cherche,
que je n'ai pas encore trouvé. C'est seulement ainsi que je me sens
vivant, que je peux soutenir ton regard fidèle sans honte. La vie est
une fête : vivons-la ensemble ! Je ne sais que te dire d'autre, Luisa,
ni à toi ni aux autres : accepte-moi tel que je suis, si tu le peux.
C'est l'unique moyen d'essayer de nous trouver. »

FEDERICO FELLINI, 8 ½, 1963

pp. 356/357
Carlo Bavagnoli

*In the light of torches, crowds converge on
St. Peter's Square at the beginning of the
Second Vatican Ecumenical Council, which
took place over four sessions from 1962 to
1965 during the papacies of John XXIII
and Paul VI. The import of this event was
compared by some to that of the Council
of Trent, 1962.*

*Anlässlich der Eröffnung des Zweiten
Vatikanischen Konzils versammeln sich die
Gläubigen zu einem Lichterzug auf dem
Petersplatz. Das Konzil tagte in vier Sitzungs-
perioden von 1962 bis 1965 unter dem
Pontifikat von Johannes XXIII. und Paul VI.
Von allen ökumenischen Konzilien wird seine
Bedeutung mit der des Konzils von Trient
verglichen, 1962.*

*À la lumière des torches, la foule converge
vers la place Saint-Pierre lors de l'ouverture
du concile œcuménique Vatican II qui se
déroula en quatre sessions entre 1962 et 1965
sous les pontificats de Jean XXIII et Paul VI ;
d'aucuns ont comparé son importance à celle
du concile de Trente, 1962.*

→
Sam Shaw

*Ingrid Bergman and Anthony Quinn in
Piazza del Popolo, filming* The Visit, *directed
by Bernhard Wicki, 1963.*

*Ingrid Bergman und Anthony Quinn auf der
Piazza del Popolo bei den Dreharbeiten zu*
Der Besuch *unter der Regie von Bernhard
Wicki, 1963.*

*Ingrid Bergman et Anthony Quinn, piazza
del Popolo, lors du tournage de* La Rancune,
réalisé par Bernhard Wicki, 1963.

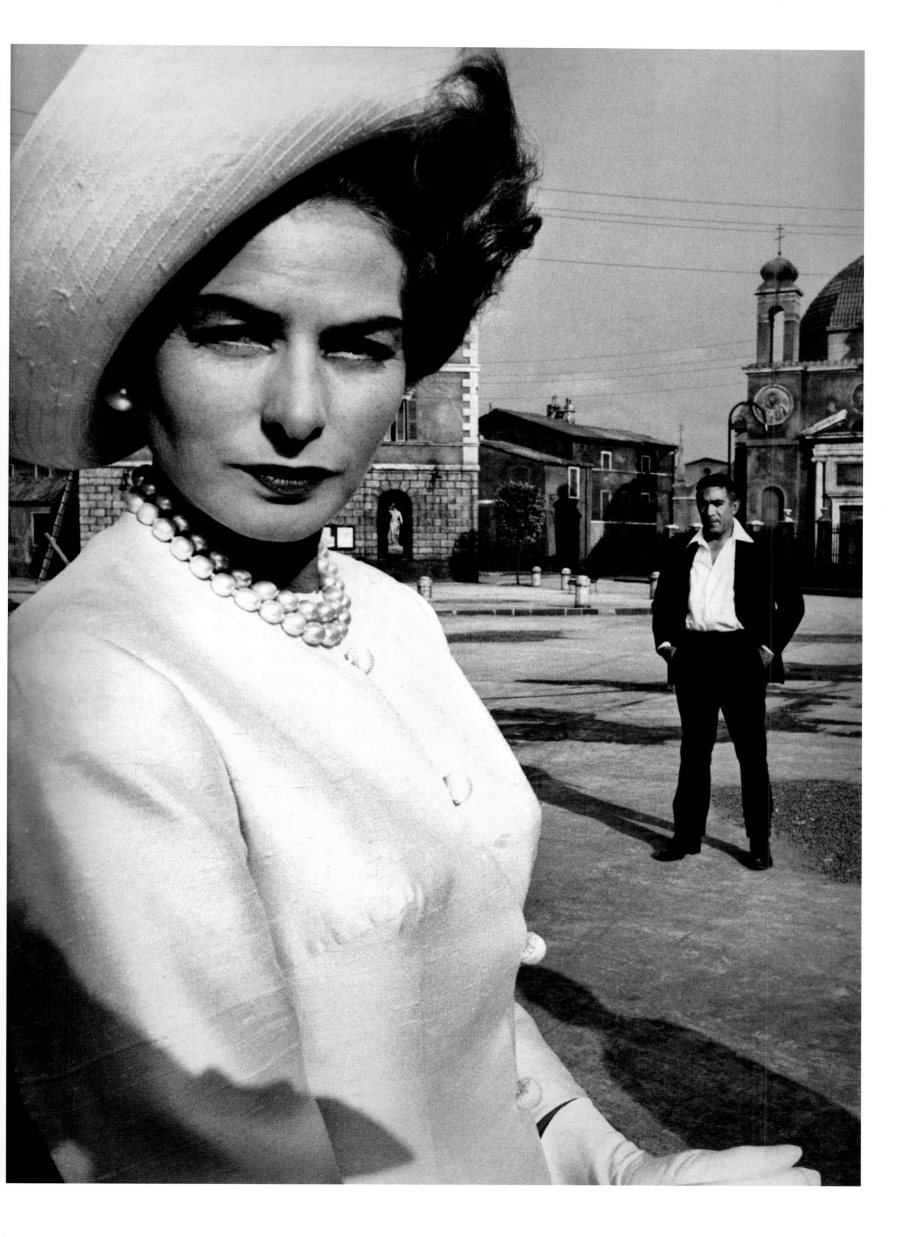

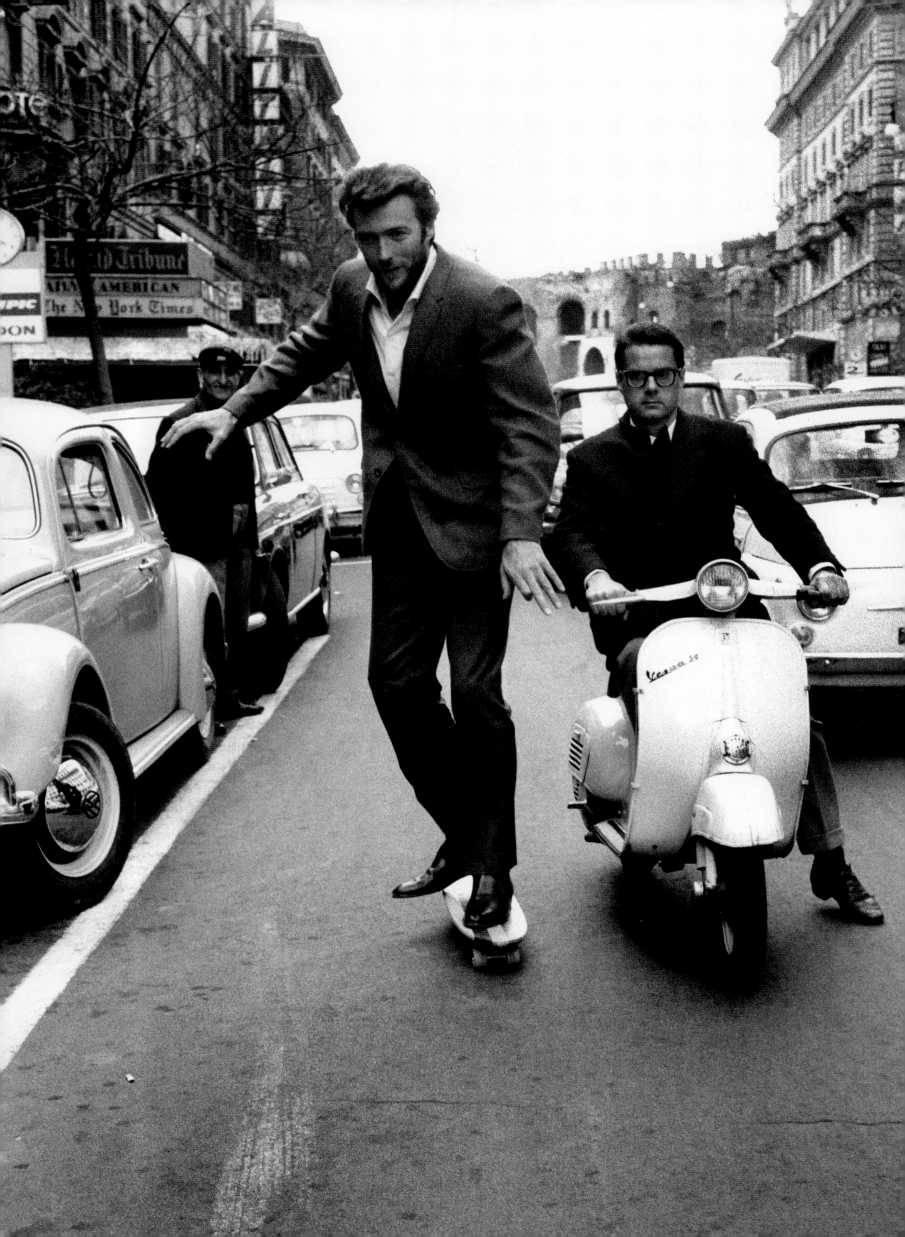

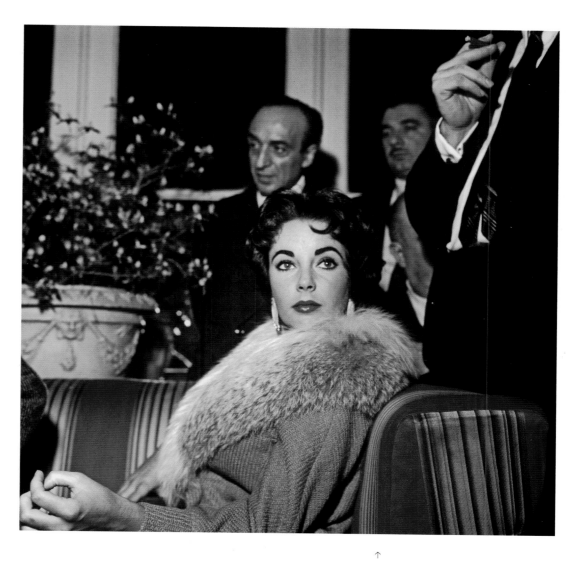

↑
Reporters Associati

Elizabeth Taylor at the Hotel Excelsior in Rome during the press conference for Cat on a Hot Tin Roof, *a film based on the play by Tennessee Williams, directed by Richard Brooks, 1958.*

Elizabeth Taylor im Hotel Excelsior in Rom anlässlich der Pressekonferenz zu Die Katze auf dem heißen Blechdach *von Richard Brooks nach dem gleichnamigen Theaterstück von Tennessee Williams, 1958.*

Elizabeth Taylor à l'hôtel Excelsior de Rome lors de la conférence de presse donnée pour la sortie du film La Chatte sur un toit brûlant *tiré de la pièce de théâtre éponyme de Tennessee Williams et réalisé par Richard Brooks, 1958.*

←
Elio Sorci

Clint Eastwood skateboarding in Roman traffic, 1965.

Clint Eastwood auf dem Skateboard im römischen Verkehr, 1965.

Clint Eastwood sur une planche à roulettes au milieu de la circulation romaine, 1965.

↑
Ferdinando Scianna

Couple at the Piper Club, 1965.

Tanzendes Paar im Piper Club, 1965.

Couple au Piper Club, 1965.

→
Keystone Agency

The traditional Christmas lighting of Via Frattina, 1963.

Traditionelle Weihnachtsbeleuchtung in der Via Frattina, 1963.

Traditionnelles illuminations de Noël dans la via Frattina, 1963.

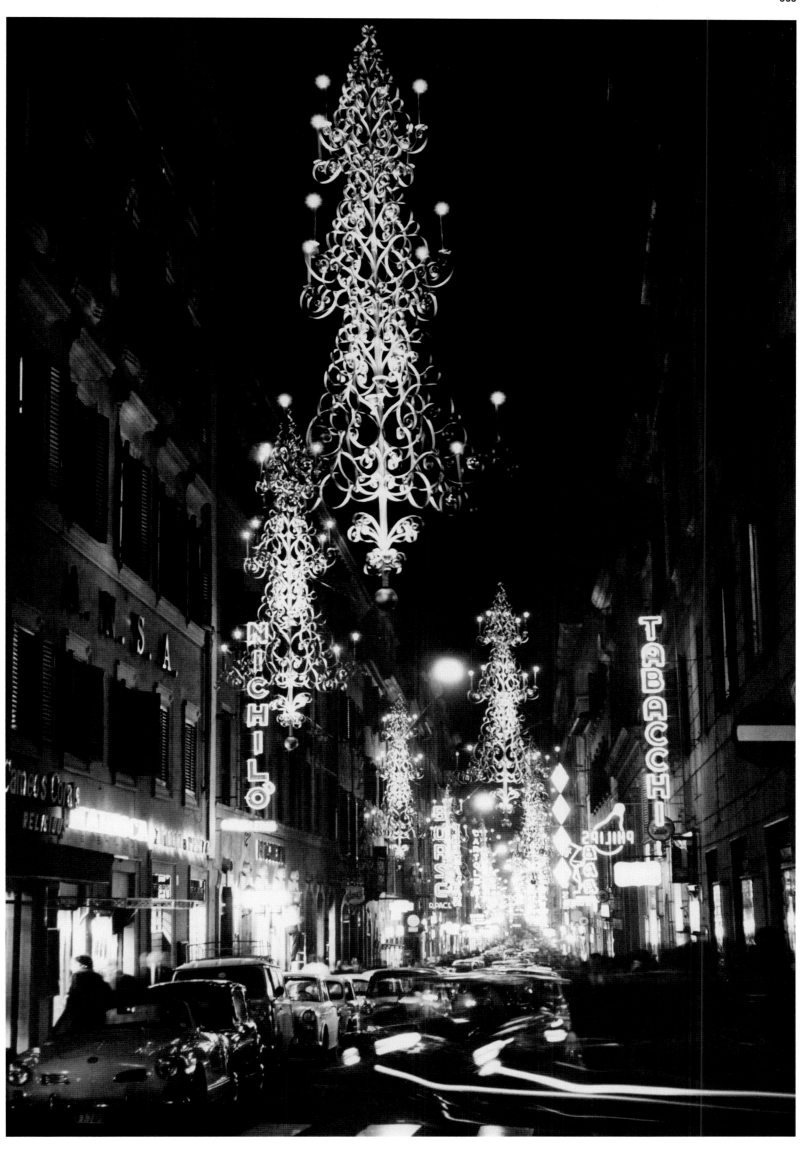

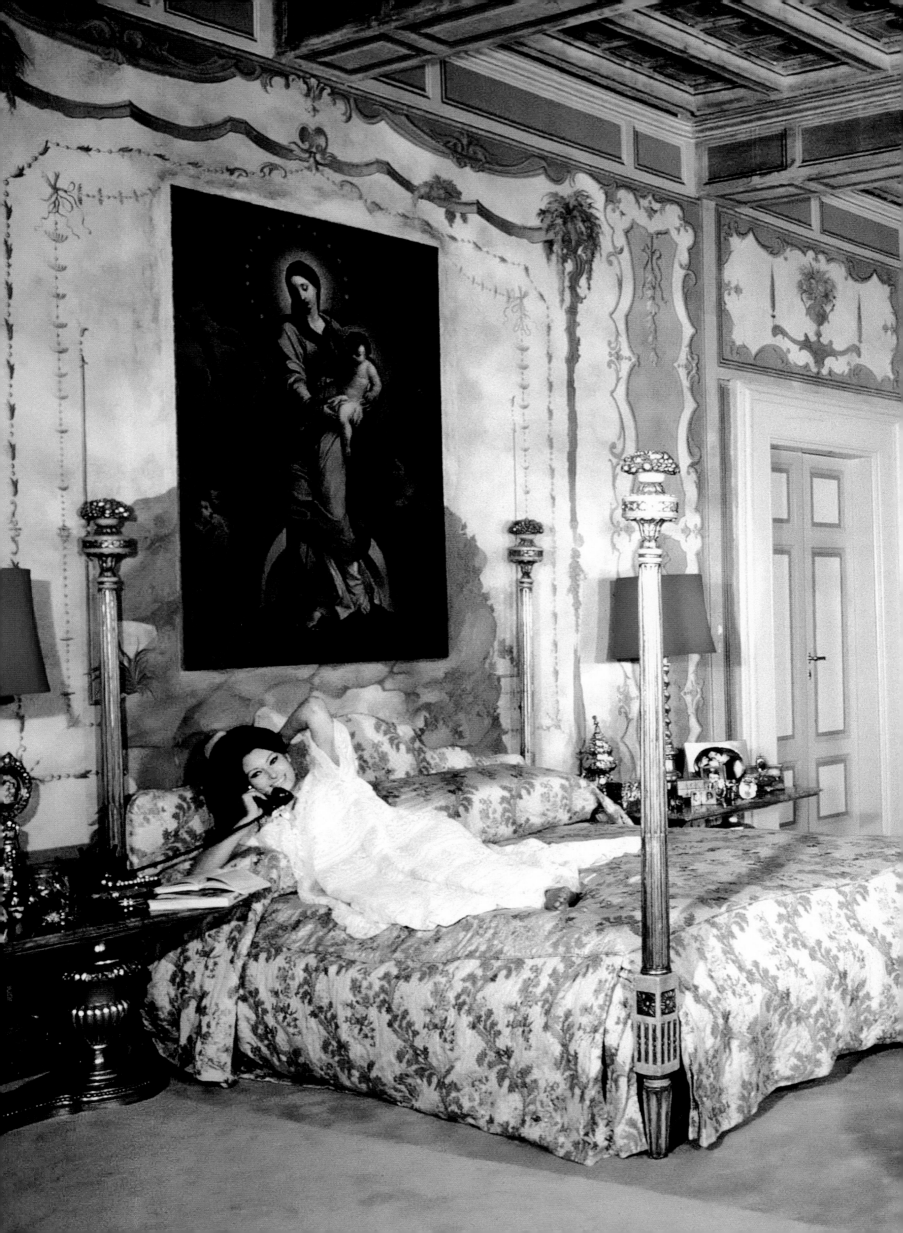

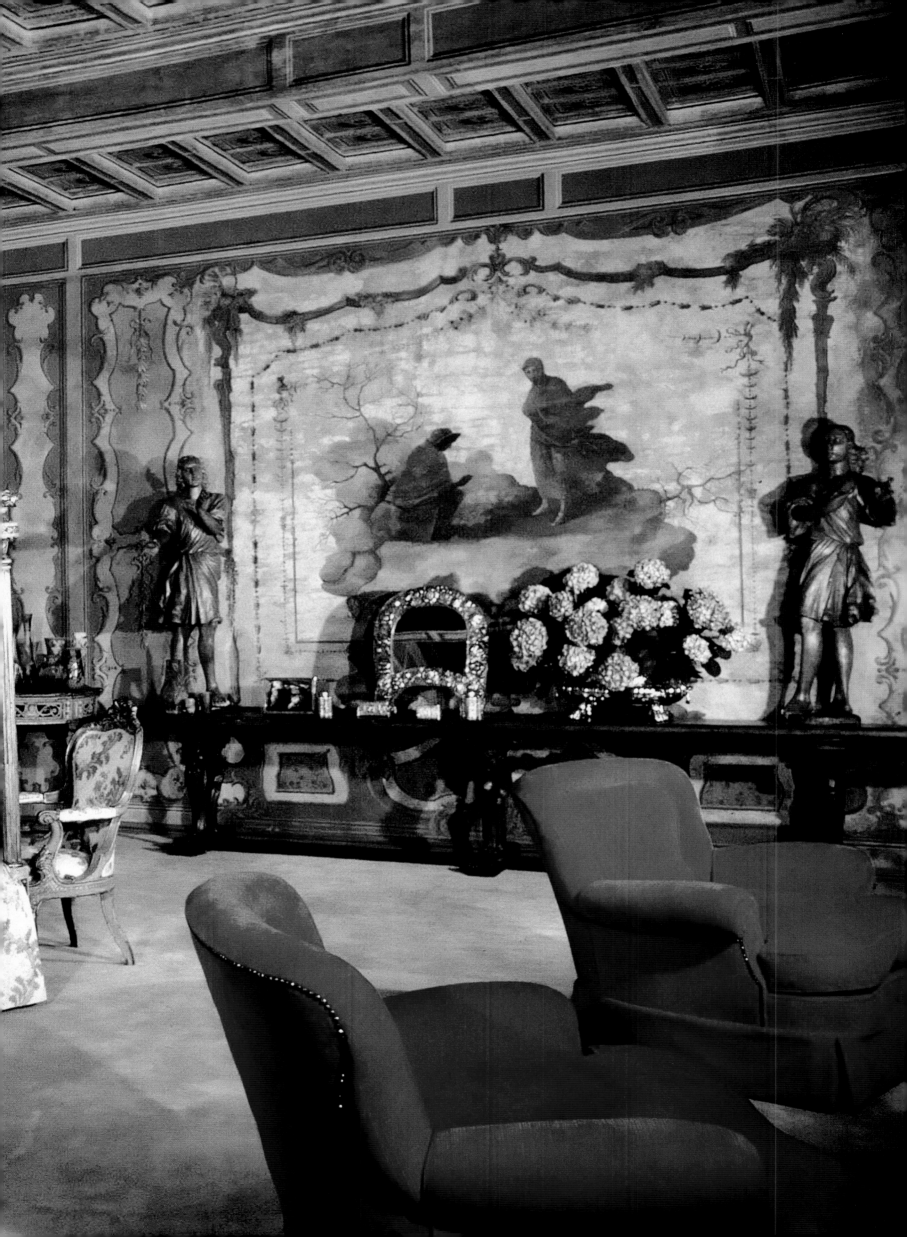

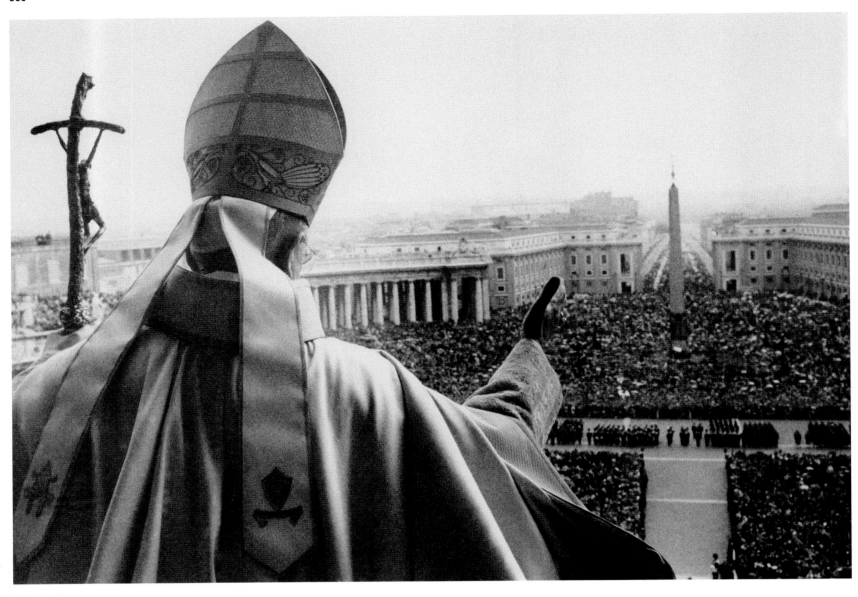

pp. 364/365
Alfred Eisenstaedt

Sophia Loren on the phone, lying on her bed in "the most beautiful house in the world," promised to her by Carlo Ponti, a 16th-century villa on Via dell'Appia Antica, consisting of 50 rooms and a large garden with a pool, 1964.

Sophia Loren am Telefon, auf ihrem Bett im „schönsten Haus der Welt", wie es Carlo Ponti ihr versprochen hatte, einer Villa aus dem 16. Jahrhundert an der Via Appia Antica, mit 50 Zimmern, großem Garten und Swimmingpool, 1964.

Allongée sur son lit, Sophia Loren au téléphone dans la plus « belle maison du monde », telle que promise par Carlo Ponti : une villa du XVIe siècle sur la via Appia Antica, comptant cinquante pièces et un grand jardin avec piscine, 1964.

↑
Keystone Agency

Contrasting with the openness and hope that Pope John XXIII aimed to spread, Pope Paul VI returned to a more dogmatic stance. "From some cracks," he said in 1972, "the smoke of Satan has entered the temple of God. There is doubt, uncertainty, complication, anxiety, dissatisfaction, conflict." Paul VI blesses the crowd gathered in St. Peter's Square, April 1963.

Im Unterschied zu den hoffnungsvollen Anstößen zu einer Öffnung der Kirche, die Johannes XXIII. gegeben hatte, kehrte Paul VI. zu einem dogmatischeren Tonfall zurück. „Seit einiger Zeit", mahnte er 1972, „ist durch vereinzelte Ritzen der Rauch des Satans in den Tempel Gottes eingedrungen: Zweifel, Unsicherheit, Kritik, Unruhe und Konfrontation." Paul VI. segnet die auf dem Petersplatz versammelte Menge, April 1963.

À la différence de Jean XXIII prônant l'ouverture et l'espérance, Paul VI revient sur un terrain plus dogmatique. « Par quelque fissure, déclare-t-il en 1972, la fumée de Satan est entrée dans le peuple de Dieu. Nous voyons le doute, l'incertitude, la problématique, l'inquiétude, l'insatisfaction, l'affrontement. » Paul VI bénit la foule rassemblée place Saint-Pierre, avril 1963.

Elliott Erwitt
Vatican City, 1965.
Vatikanstadt, 1965.
Cité du Vatican, 1965.

"Rome is populated by young priests who wear a beret, priests driving cars, nonchalant priests, while on the boulevards of the Gianicolo and Villa Borghese you see those wearing a Baroque draped cloak, like saints in Romanesque churches, the old priests used to anti-clericalism and to feeling alone."

„Rom ist voller Priester: junge Priester mit Baskenmütze, Priester im Auto, lässige Priester. Dann wieder sind da solche mit barock drapiertem Mantel wie bei einer Heiligenfigur aus einer der Kirchen der Stadt, man trifft sie beim Spaziergang am Gianicolo oder an der Villa Borghese, es sind die alten Priester, die an das Gefühl des Alleinseins gewöhnt sind und an den Antiklerikalismus."

«Rome est peuplée de jeunes prêtres à béret basque, de prêtres en automobile, de prêtres désinvoltes, tandis que ceux qui portent un manteau drapé de manière baroque, comme les saints des églises romaines, se rencontrent en promenade sur le Janicule et à la villa Borghèse, vieux prêtres habitués à la solitude et à l'anticléricalisme.»

CORRADO ALVARO, *ROMA VESTITA DI NUOVO*, 1957

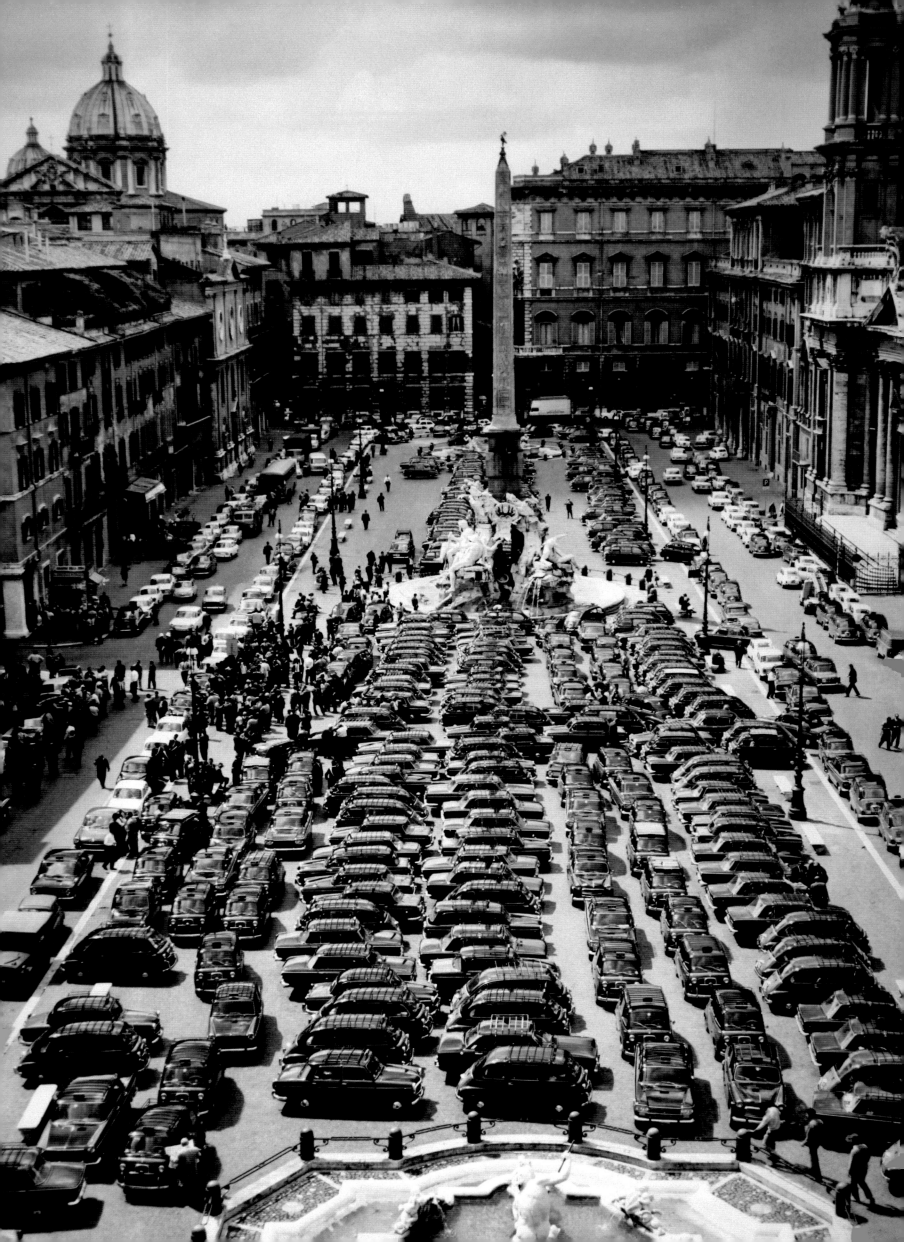

←

Keystone Agency

In the 1960s Roman piazzas were defaced by being used as parking lots. Piazza Navona, c. 1965.

In den 1960er-Jahren wurden die Straßen und Plätze von Rom von einer Flut von Autos mit Beschlag belegt. Piazza Navona, um 1965.

Dans les années 1960, les places de Rome étaient défigurées par leur utilisation comme parcs de stationnement. Piazza Navona, vers 1965.

↑

Horst P. Horst

From the 1950s to the time of his death in 2011, Cy Twombly lived between Rome and Gaeta, 1966.

Von den 1950-Jahren bis zu seinem Tod 2011 hat Cy Twombly in Rom und auf Gaeta gelebt, 1966.

Des années 1950 à sa mort en 2011, Cy Twombly partageait son temps entre Rome et Gaeta, ville côtière à mi-chemin entre Rome et Naples, 1966.

"A people of poets, heroes / saints, thinkers, scientists /
voyagers and migrants."

„Ein Volk von Dichtern, Künstlern und Helden / von
Heiligen, Denkern und Wissenschaftlern / von Seefahrern
und Auswanderern."

« Un peuple de poètes, d'artistes et de héros / de saints,
de penseurs et de savants / de navigateurs et de voyageurs. »

INSCRIPTION ON THE FAÇADE OF THE PALAZZO DELLA CIVILTÀ
ITALIANA IN THE EUR DISTRICT, 1942

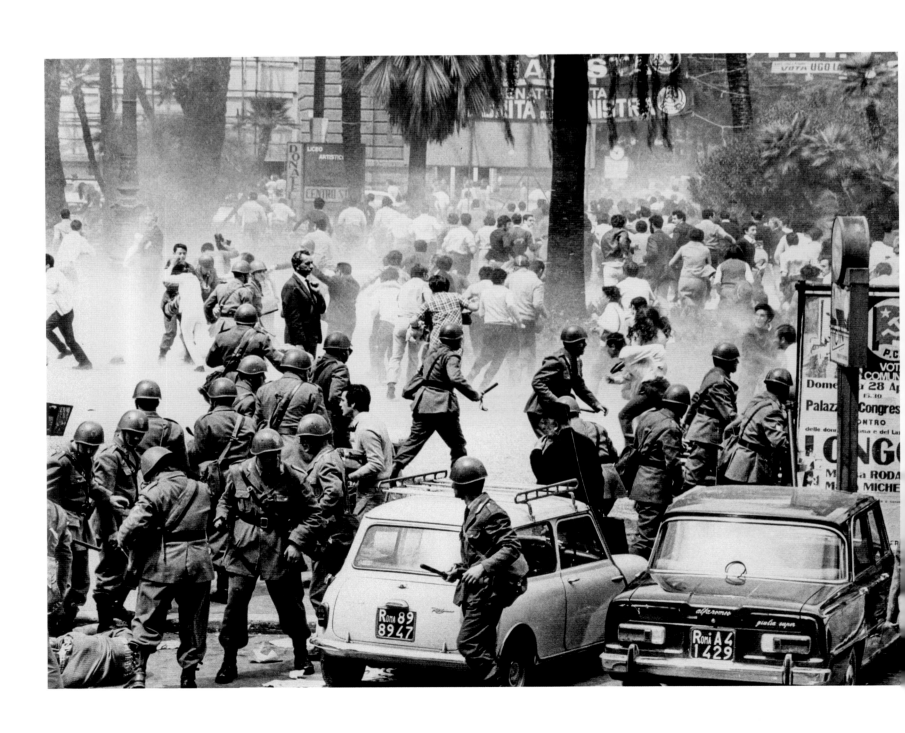

→

Marka/eps

A political protest rally of undergraduate students on the staircase of Trinità dei Monti, 1966.

Protestkundgebung von Universitätsstudenten auf der Spanischen Treppe, 1966.

Manifestation politique d'étudiants sur l'escalier de Trinità dei Monti, 1966.

←

Marka Agency

After a Socialist student was killed when neo-Fascists attacked the Università degli Studi on April 26, there was a series of violent clashes between students of opposing factions, like the one pictured in this image, taken near Palazzo di Giustizia, 1966.

Nachdem bei einem Angriff der Neofaschisten auf die Universität am 26. April 1966 ein sozialistischer Student ums Leben gekommen war, ereignete sich in der Hauptstadt eine Reihe von gewaltsamen Zusammenstößen zwischen den Anhängern entgegengesetzter studentischer Fraktionen, wie hier in der Nähe des Justizpalastes, 1966.

Au lendemain de l'assassinat d'un étudiant socialiste durant une attaque de néofascistes à l'Université degli Studi le 26 avril, de violents heurts éclatèrent dans la capitale entre étudiants de factions rivales, comme le montre ce cliché pris dans le quartier du palais de justice, 1966.

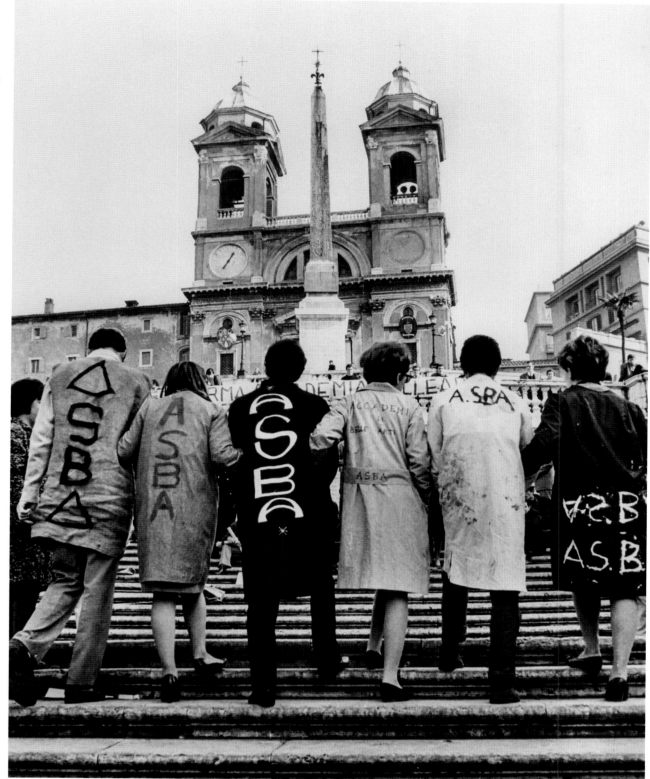

pp. 372/373
Bruno Barbey

In the 1960s, public telephones were still the only means of communication available outside the home. In urban spaces, advertising becomes increasingly intrusive: here we see an ad for Coca-Cola on the restaurant window, one for Perugina chocolate on the wall, and one for Dino Risi's film I mostri *on the façade, 1964.*

In den 1960er-Jahren ist der öffentliche Fernsprecher noch das einzige Kommunikationsmittel von unterwegs aus. Werbung beansprucht immer mehr freie Fläche, wie hier die von Coca-Cola auf der Scheibe, die der Schokoladenmarke Perugina auf der Türlaibung und die für Dino Risis Film I mostri *im Schaukasten, 1964.*

Dans les années 1960, le téléphone public demeure le seul moyen de communication à distance hors de chez soi. La publicité envahit sans cesse davantage les espaces publics: ici, celle de Coca-Cola sur la vitrine, celle du chocolat Perugina sur le mur, ou encore celle du film Les Monstres *de Dino Risi sur la façade, 1964.*

GASSMAN • TOGNAZZI • GASSMAN • TOGNAZZI • GASSMAN

OGGI

• GASSMAN • TOGNAZZI • GASSMAN • TOGNAZZI • GASSMAN • TOGN

i MOSTRI

CIECO

TOGNAZZI • GASSMAN • TOGNAZZI • GASSMAN • TOGNAZZI • GASS

5

From the "Years of Lead" to the Hesitant Cosmopolitan Ambitions of Today
1968–PRESENT DAY

p. 376
Richard Kalvar

Streetcar near the pyramid of Caius Cestius, carrying a group of pilgrims of the ecumenical monastic Christian community of Taizé, 1980.

Straßenbahn vor der Cestiuspyramide, an Bord eine Pilgergruppe der ökumenischen Mönchsgemeinschaft von Taizé, 1980.

Tramway près de la pyramide de Caius Cestius avec à son bord un groupe de pèlerins de la communauté monastique œcuménique de Taizé, 1980.

*"O Rome, in your greatness and beauty what once was
still now flees, and only the fleeting lives on."*

FRANCISCO DE QUEVEDO, *A ROMA SEPULTADA
EN SUS RUINAS,* C. 1640

The last few decades in the history of Rome have been a trail of ashes, a city dominated by political affairs, the Church, and an all-pervading tourism, with the events in the news often considered more important than cultural affairs.

Until the present day, Rome has suffered from a chronic inability to carry out a genuine process of renewal. Throughout its contemporary history, from Pius IX to becoming the capital of Italy, from Fascism to our day, modernization has always remained a relative, elusive concept.

When it became the capital of Italy, Rome was the fourth most densely populated city in the country, after Naples, Milan, and Genoa; subsequently, it came close to three million residents in 1981, and then it began to decrease. It is now the most populous municipality in Italy, and the fourth in Europe, after Paris, London, and Berlin.

The capital of the Republic, the seat of parliament and government, Rome is central in all the political and civic passions of Italy. During the most virulent phases of socio-political disputes and conflict, it was the stage of demonstrations, marches, and strikes. In 1960 tens of thousands of young people protesting against the right-wing government of Christian Democrat Prime Minister Fernando Tambroni clashed against the police. Tambroni was forced to resign, inspiring the development of center-left Italian politics; from that time on the Roman piazzas have witnessed innumerable demonstrations of socio-political discord.

The inability on the part of institutions and political parties to evolve alongside the social renewal and active transformation brought on in the years of the economic miracle led to the student protests of 1968 and 1977; these events set in motion new forms of political and social mobilization, but failed to achieve actual reforms, and in turn opened the way to the season of political violence that ensued. The newly formed coalitions of weakened parties that allowed a sterile government to cling to power, and the chronic institutional corruption at the heart of politics, only succeeded in preventing social growth and fuelling terrorism.

The *Anni di piombo* ("Years of Lead") from the late 1960s to the early 1980s saw attacks by subversive right- and left-wing extremists, the terrorism of the Red Brigades, the kidnapping and assassination of Prime Minister Aldo Moro (1978), the "Clean Hands" scandal (1994), which resulted in the collapse of traditional parties, and revelations of persistent corruption

continued to weaken the credibility of politics in the eyes of many Italian citizens.

In his pursuit of power, Mussolini had used radio, LUCE, television newscasts, and photography as his mass media of communication. Silvio Berlusconi, the Milan entrepreneur who entered the political world in 1994, exploited television above all. He governed Italy between 1994 and 2011 (with a hiatus from 1996 until 2001 under the Romano Prodi government), the profound cynicism of the period hastening the demise of Rome and, indeed, of the entire country.

An unprecedented number of world leaders traveled to Rome to attend the funeral of John Paul II in 2005. The church of Rome is still a power to be reckoned with.

Rome's urban growth has not been kept under control. The vast expansion of the city forms a dense and indifferent mass within an unredeemable disarray. Twenty per cent of the built territory is occupied by illegal buildings, partly relieved by amnesties towards the infringement of building regulations, a political expedient more damaging than the deed itself. And even in the areas legitimately built as speculative ventures the investments went to the construction of houses, ignoring the improvement of the roads. Architects lacked the opportunities of designing a new urban landscape, and had to limit themselves to the occasional, brilliant residential creation.

What can be said of the last few decades? For a brief period (1976–1979) the mayor of Rome was Giulio Carlo Argan, a great art historian from Turin; he succeeded to a certain degree in thwarting the disorder of the urban landscape and the construction development speculation, saving some historical buildings from being taken over by greedy banks and turning them instead into cultural institutions. Nevertheless, Argan's administration was a mere interlude, as were those of Francesco Rutelli (1993–2001) and Walter Veltroni (2001–2008). There are some initiatives that aim at revitalizing the marginal parts of the city built in defiance of building regulations, and that promote residential developments financed by the state, but these projects never seem to last very long.

In 1977 Renato Nicolini – an architect and "councilor for culture" – inaugurated the *Estate romana* (Roman summer), an initiative whereby the monumental spaces of the historic center were used for public shows and performances (particularly cinema and music, at first), open to a large and increasingly young audience.

In 1979 Adriano La Regina, an archaeological superinten-
dent, suggested joining the Forums by means of a green area and
a line of monuments from the Campidoglio to the foot of the
Castelli hills, destroying the urban modifications imposed during
Fascism, in particular in the Via dei Fori Imperiali. In the end,
however, his proposal remained limited to the demolition of Via
della Conciliazione at the foot of the Campidoglio.

With Mayor Gianni Alemanno (2008–2013), the adminis-
tration of the city went backwards. One of the absurd proposals
made in 2010 under his tenure was for the creation of a Formula-1
track in the EUR district, complete with its concrete jungle.

The Vatican is aware of its own prestige, so much greater
in view of the weakness of Italian politics. In 2000 over two mil-
lion people gathered at Tor Vergata for the Youth Jubilee presided
over by Pope John Paul II. In the same year, Rome hosted the
World Gay Pride, and two years later the first gay marriage in Italy
was celebrated at the French Consulate in Rome, with the French
PACS (Pacte Civil de Solidarité: civil solidarity pact) ceremony.

In 2003 Rome was among the cities to stage a large
demonstration against the war in Iraq. 250,000 people attended
Alberto Sordi's funeral, celebrating the most representative
actor of the *commedie all'italiana,* who had starred in 200 films.
The following year an estimated three million people followed
the funerals of Pope John Paul II in St. Peter's Square, in Via
della Conciliazione, or on screens in Rome's main piazzas. The
ceremony, attended by over 200 official delegations as well as rep-
resentatives of all religions, was broadcast live around the world:
with 14 million viewers in Italy, and with a 90 per cent approval
rating, it set a record in the history of Italian television.

In 2002 the Museo d'Arte Contemporanea di Roma
(MACRO) opened, Rome's museum of contemporary art designed
by the French architect Odile Decq; in the same year, a separate
branch of the museum, called MACRO Testaccio, opened in two
pavilions of the former abattoir, near the Piramide Cestia.

In 2010 the MAXXI Museum was inaugurated in the
Flaminio district; it was the first national institution dedicated to
fostering contemporary creativity through organizing exhibitions,
workshops, conferences, laboratories, shows, projections, and
training programs.

The most recent years seem to have marked an increasing
degree of degradation and decline. According to a 2015 survey on
the quality of life in cities around the world, Rome came 52nd.

The historic center has been forsaken by permanent
residents, decreasing from 420,000 to 120,000 in the course of the
last 20 years. Many cinemas have closed their doors: the Colorado,
Academy, Tristar, Arena Flora, Ariel, Aurora, Arizona, Excelsior,
Luxor, Belsito, Archimede, Holiday, Missouri, America, Avorio.
Other cultural centers such as the Rialto and the Teatro Valle have
suffered the same fate.

The Palazzo della Civiltà Italiana in the EUR district
was leased to French investors in 2013 on a 15-year contract, and
inaugurated in 2015. This was an initiative led by Bernard Arnault,
the financer ranking fourth among the wealthiest people in the
world, head of LVMH (Louis Vuitton Moët Hennessy SE), the
French giant which owns such Italian brands as Bulgari, Acqua di
Parma, Rossimoda, Pucci, Berluti, Loro Piana, Cova and Fendi.

Tourism has grown, but it is the consumerist and parasitic
kind of tourism, with the 24-hour all-inclusive bus tours at
30 Euros, that exploits the "greatest" monuments while ignoring
the museums at the outskirts of the city center, settling for souvenir
stores and junk kiosks, and mock-characteristic restaurants. The city
is dirty and polluted. The few amelioration initiatives are super-
ficial, like the authorities' attempts to rein in the fake "centurions"
at the Colosseum or the illegal market stalls at Termini station.

The city "applied to host the 2024 Olympics, with the
pathetic goal of exploiting one more time the only product on
which it has invested since the end of the war: cement" (Christian
Raimo, 2016).

Between November 2015 and June 2016, Rome was left
without a mayor and led by two commissioners: a prefect who
had never previously dealt with Roman affairs at the head of the
municipality; and an expert in civil protection tasked with man-
aging the Jubilee. The administrative elections of 2016 resulted in
the appointment of the candidate from the "Movimento 5 stelle":
for the first time Rome had a woman mayor. The new mayor,
however, gave up on Rome's 2024 Olympic candidature, and the
management of the city remains an ongoing struggle.

Pope Francis has shown that the Church is capable of
renewing itself and achieving a broad public consensus. Only
with the capable day-to-day management of affairs, supported
by an ambitious program for development and the creation of
great projects, could Rome finally – despite its many. problems
and challenges – become the cultural, multi-ethnic capital of the
Mediterranean region.

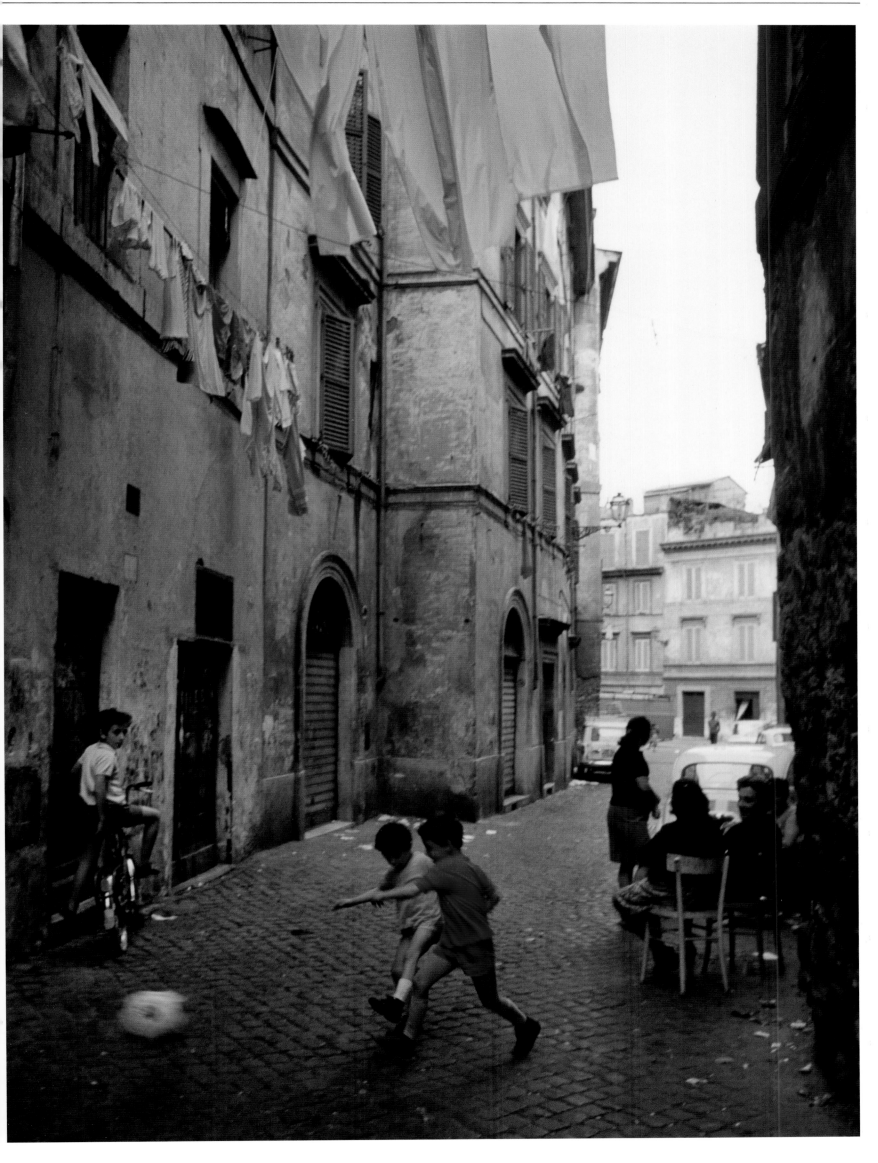

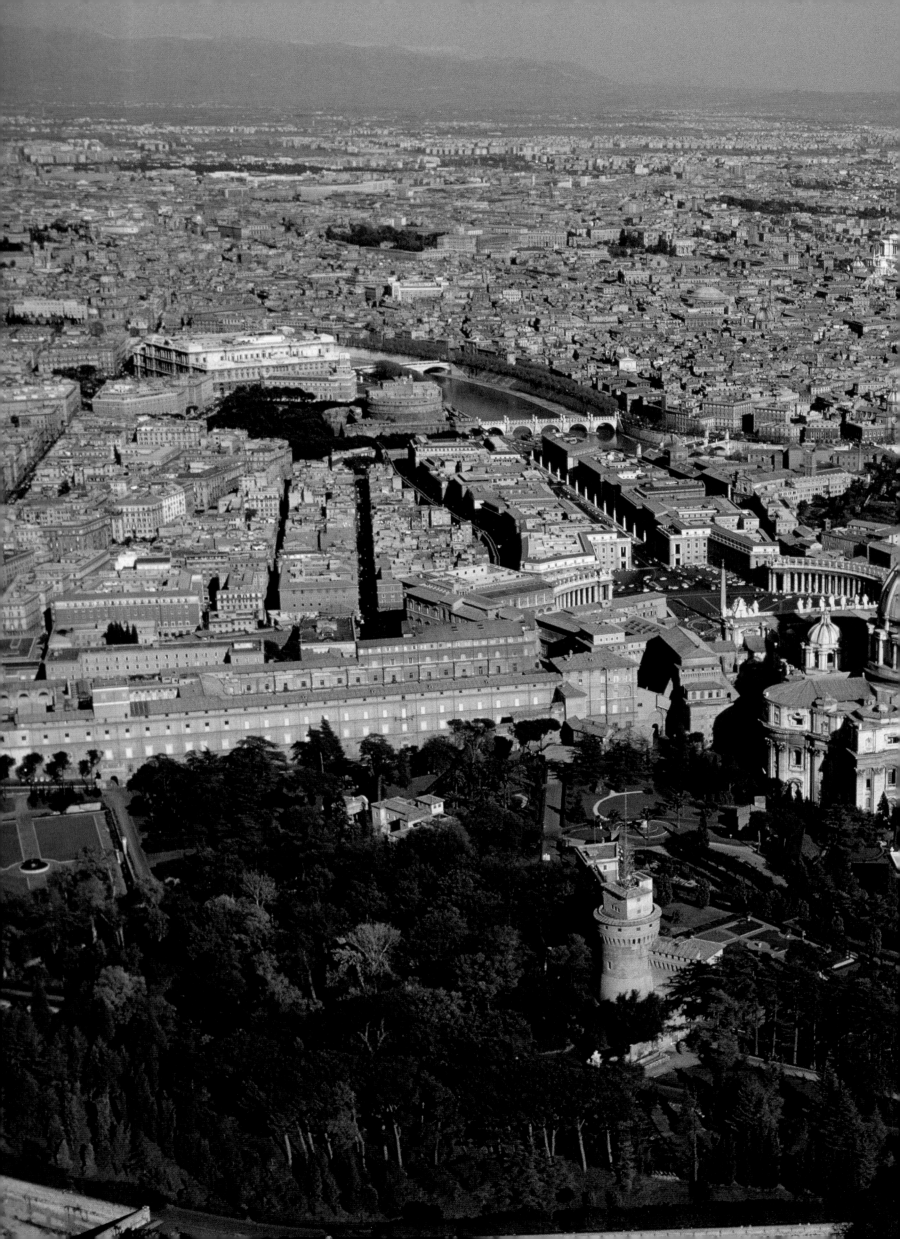

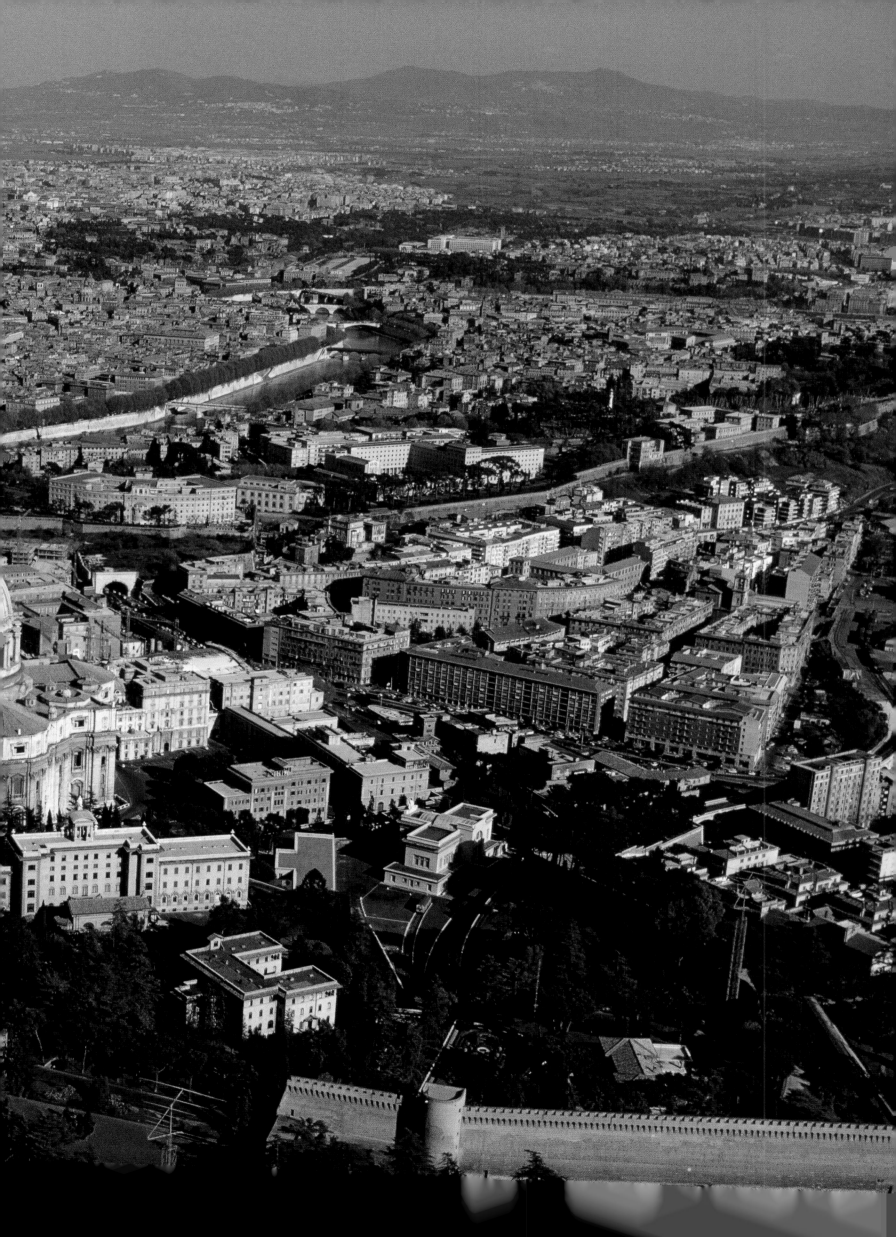

5

Von den „bleiernen Jahren“ bis in die Gegenwart 1968–HEUTE

„In deiner Größe, Rom, und deiner Schönheit verschwand,
was unbeweglich stand und nur was flüchtig, bleibt bestehen."
FRANCISCO DE QUEVEDO, *A ROMA SEPULTADAS*
***EN SUS RUINAS*, UM 1640**

Die vorangegangenen fünf Jahrzehnte waren für die Stadt am Tiber alles andere als einfach. Politische Ereignisse, die Präsenz der Kirche und der ausufernde Tourismus prägen das Bild, die Kultur wird vom Tagesgeschehen meist in den Hintergrund gedrängt.

Bis auf den heutigen Tag leidet Rom unter einem Mangel an Modernität. In allen Epochen seiner neueren Geschichte, vom Pontifikat Pius' IX. und der Hauptstadtwerdung nach 1870 über den Faschismus und die Nachkriegszeit und letztlich bis heute hat die Metropole immer nur Teil-Modernisierungen erlebt, aber nie einen vollständigen Anschluss an die Moderne.

Als Rom Hauptstadt wurde, lag seine Bevölkerungszahl an vierter Stelle in Italien hinter Neapel, Mailand und Genua. 1981 erreichte sie die Dreimillionengrenze, seitdem geht die Einwohnerzahl stetig zurück. Dennoch ist Rom bis heute die einwohnerstärkste Stadt Italiens und rangiert nach Paris, London und Berlin an vierter Stelle in Europa.

In Rom haben Regierung und Parlament ihren Sitz, hier treten die politischen und gesellschaftlichen Spannungen des gesamten Landes zutage. In den Hochphasen der politischen Konfrontation wurde und wird die Hauptstadt regelmäßig zum Schauplatz von Kundgebungen, Demonstrationen und Streiks. Als 1960 Tausende junger Italiener gegen den Rechtsschwenk der Regierung des Christdemokraten Fernando Tambroni demonstrieren, kommt es zu Auseinandersetzungen mit der Polizei. Tambroni muss zurücktreten, eine Mitte-Links-Regierung übernimmt das Ruder. Seit damals werden gesellschaftliche und politische Konflikte immer wieder auf die Straßen und Plätze der Hauptstadt getragen.

Angesichts der Handlungsunfähigkeit von Institutionen und Parteien mündet die gesellschaftliche Dynamik der Wirtschaftswunderjahre in die Studentenunruhen von 1968 und 1977. Neue Formen politischer und gesellschaftlicher Mobilisierung werden erprobt, bleiben auf der Ebene konkreter Reformen aber folgenlos und damit nicht mehr als ein Vorspiel zu der sich anschließenden Zeit der politischen Gewalt. Das Taktieren und Paktieren der politischen Lager, die Folgenlosigkeit des Regierungshandelns, die Schwächung der Parteien und die chronische Korruption verhindern wirkliches gesellschaftliches Wachstum und werden zu Auslösern des Terrorismus.

Die „bleiernen Jahre" mit Attentaten der gewaltbereiten Rechten und der extremen Linken, der Terrorismus der Roten Brigaden, die Entführung und Ermordung Aldo Moros 1978 und

schließlich der Korruptionsskandal der *Mani pulite* 1994 führen letztendlich zum Zusammenbruch der etablierten Parteien. Weitere Korruptionsaffären haben die Glaubwürdigkeit der Politik in den Augen der Italiener in der Folgezeit bis heute schwer beschädigt.

Hatte Mussolini bei seinem Griff nach der Macht und der Festigung seines Regimes die Wochenschauen des Filminstituts LUCE, Rundfunk und Fotografie benutzt, so setzte Silvio Berlusconi, der Mailänder Unternehmer, der 1994 die politische Bühne betrat, auf das Massenmedium Fernsehen. Berlusconi, mit der Unterbrechung der Regierung Prodi (1996–2001) von 1994 bis 2011 an der Macht, hat dem Land und seiner Hauptstadt einen beklagenswerten Niedergang beschert.

Zu den Beisetzungsfeierlichkeiten für Johannes Paul II. im Jahr 2005 reist eine beachtliche Zahl von Staatsoberhäuptern an den Tiber – die katholische Kirche, so zeigt sich, stellt weiterhin einen nicht zu unterschätzenden Machtfaktor dar.

Unterdessen dehnt die Stadt sich weiter ungebremst aus. Ihre Ausläufer bilden eine einzige eintönige Häusermasse ohne jede erkennbare Struktur – ein Zustand, der kaum noch zu ändern ist. Schätzungen zufolge sind 20 Prozent der städtischen Bebauung illegal entstanden. Ein Teil davon wurde durch den baurechtlichen Sanktionserlass des *condono edilizio* – ein von der Politik bereitgestelltes Mittel, das Teil des Problems und nicht der Lösung ist – nachträglich legalisiert. Auch in den offiziell genehmigten Vierteln setzt man, der Logik der Bodenspekulation folgend, vor allem auf Flächenausnutzung und kaum auf angemessene Umfeldgestaltung. Den römischen Architekten bietet sich wenig Gelegenheit, städtebauliche Ideen zu entwickeln, was bleibt, sind gelegentliche Vorzeigeprojekte im privaten Sektor.

Was haben die letzten fünf Jahrzehnte gebracht? In seiner kurzen Amtszeit als Bürgermeister von Rom (1976–1979) gelang es dem bekannten Turiner Kunsthistoriker Giulio Carlo Argan vorübergehend, etwas gegen das städtebauliche Chaos und die grassierende Spekulation im Bausektor zu unternehmen. Argan entzog eine Reihe historischer Bauten den Begehrlichkeiten der Banken und Immobilienhaie und brachte Kulturinstitutionen darin unter. Dennoch blieb die von ihm geführte Kommunalregierung ein Intermezzo, ebenso wie jene unter Francesco Rutelli (1993–2001) und seinem Nachfolger Walter Veltroni (2001–2008). Es kam zu Sanierungsmaßnahmen in illegal am Stadtrand gebauten Siedlungen und einigen Initiativen im sozialen Wohnungsbau, doch fand diese Linie in der Folge keine politische Unterstützung.

1977 rief der Architekt und damalige Kulturdezernent Renato Nicolini die anfangs vor allem Konzerten und Filmvorführungen gewidmete Reihe der *Estate Romana* ins Leben, in deren Rahmen die antiken Denkmalstätten Roms zum Schauplatz kultureller Veranstaltungen für ein breites und zunehmend junges Publikum wurden.

Auf das Jahr 1979 geht der Vorschlag des Leiters der römischen Antikenverwaltung Adriano La Regina zurück, eine zentrale archäologische Zone einzurichten, die als eine Art grüner Keil vom Kapitol bis zur Via Appia und an die Hügelketten der Castelli Romani reichen sollte. Maßnahmen aus der Zeit des Faschismus sollten rückgängig gemacht und namentlich die Via dei Fori Imperiali, welche die Kaiserforen durchschneidet, beseitigt werden. Das Projekt zeitigte jedoch nur sehr begrenzte konkrete Ergebnisse, darunter den Rückbau der Via della Consolazione am Fuß des Kapitols.

Mit Gianni Alemanno als Bürgermeister (2008–2013) erreicht die römische Stadtentwicklungspolitik einen Tiefpunkt. Im EUR-Viertel, so eines der Projekte des Rechtspolitikers, soll mit viel Beton eine Rennstrecke für die Formel 1 gebaut werden.

Angesichts des Versagens der Politik ist sich der Vatikan seiner prestigeträchtigen Rolle in der Ewigen Stadt nur allzu bewusst. Im Jahr 2000 kommen über zwei Millionen Teilnehmer zum Weltjugendtag in Tor Vergata und treffen dort mit dem Papst aus Polen zusammen. Im selben Jahr finden in Rom die Feiern zum World Gay Pride statt; zwei Jahre später wird im französischen Konsulat in Rom das erste schwule Paar in Italien getraut – unter Anwendung der französischen Rechtsform des Pacte civil de solidarité, kurz PACS.

Bei Ausbruch des Irakkriegs 2003 gehen wie in aller Welt auch in Rom die Menschen auf die Straße, um für den Frieden zu demonstrieren. 250 000 Trauernde versammeln sich, als Alberto Sordi, das populärste Gesicht der *Commedia all'italiana*, bekannt aus 200 Filmen, in Rom zu Grabe getragen wird. Auf drei Millionen wird die Zahl derer geschätzt, die im Jahr darauf die Beisetzungsfeierlichkeiten für Johannes Paul II. auf dem Petersplatz, der Via della Conciliazione oder über Großbildleinwänden auf den Hauptplätzen der Stadt verfolgen. Der Gottesdienst, zu dem 200 internationale Delegationen und zahlreiche Vertreter der Weltreligionen erschienen sind, wird weltweit live ausgestrahlt, allein in Italien sitzen fast 14 Millionen Zuschauer vor den Empfangsgeräten, was einer Rekordeinschaltquote von 90 Prozent entspricht.

Im Jahr 2002 nimmt das von der französischen Architektin Odile Decq geplante Museo d'Arte Contemporanea di Roma (MACRO) seinen Betrieb, im selben Jahr auch eine Außenstelle in zwei Gebäuden des alten Schlachthofs am Testaccio unweit der Cestiuspyramide.

Im Flaminio-Viertel wurde 2010 zudem das MAXXI eingeweiht, Italiens erste nationale Museumsinstitution für zeitgenössische Kunst mit einem breiten Programm von Ausstellungen, Workshops, Konferenzen, Veranstaltungen, Filmabenden und Bildungsaktivitäten rund um die Kunst des 21. Jahrhunderts.

In den letzten Jahren ging es mit der Ewigen Stadt weiter bergab. Laut einer weltweit durchgeführten Untersuchung zur urbanen Lebensqualität nimmt die italienische Hauptstadt den 52. Platz ein.

Im historischen Zentrum von Rom leben immer weniger Menschen, in den letzten 20 Jahren ist ihre Zahl von 420 000

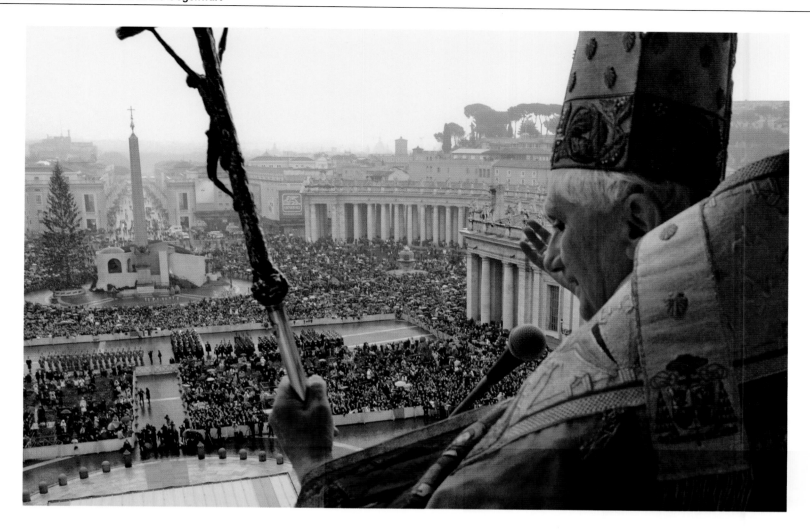

auf 120 000 gesunken. Reihenweise wurden Kinos geschlossen: Colorado, Academy, Tristar, Arena Flora, Ariel, Aurora, Arizona, Excelsior, Luxor, Belsito, Archimede, Holiday, Missouri, America, Avorio, so die Namen der teils historischen Lichtspielhäuser; ähnlich erging es dem Kulturzentrum Rialto oder dem Teatro Valle.

Der Palazzo della Civiltà Italiana im EUR-Viertel wurde 2013 für 15 Jahre an französische Investoren vermietet und 2015 wiedereröffnet. Eingefädelt hat den Deal Bernard Arnault, der weltweit viertreichste Finanzmogul, Chef von LVHM (Louis Vuitton Moët Hennessy), dem französischen Luxusgüterkonzern, zu dessen Firmenimperium auch italienische Marken wie Bulgari, Acqua di Parma, Rossimoda, Pucci, Berluti, Loro Piana, Cova und Fendi gehören.

Derweil nimmt das Touristenaufkommen weiter zu, allerdings in seiner von rücksichtslosem Konsumverhalten bestimmten Ausprägung der 24-Stunden-Bustouren zum Discountpreis. Außerhalb der Touristenrouten liegende Museen und Denkmäler werden links liegen gelassen, nur „historische Highlights" angesteuert, die Besucher mit billigen Souvenirläden und auf „typisch" getrimmter Billiggastronomie abgespeist. Zurück bleiben Luftverschmutzung, verstopfte Straßen und Abfallberge. Das Einzige, wozu sich die Stadtverwaltung aufrafft, sind Alibimaßnahmen wie das Verbot der „Zenturionen" am Kolosseum und einiger illegaler Verkaufsstände am Bahnhof Termini.

Anlässlich der zunächst geplanten Bewerbung Roms um die Ausrichtung der Olympischen Spiele 2024 merkt der römische Schriftsteller Christian Raimo 2016 bissig an, hier werfe die Stadt wieder einmal „das einzige Produkt in die Waagschale, in das sie seit dem Krieg investiert hat: Beton."

Von November 2015 bis Juni 2016 muss die Hauptstadt ohne Bürgermeister auskommen und wird von zwei, durch die Zentralregierung eingesetzte, Präfekten kommissarisch verwaltet: einem Verwaltungsfachmann, der über keinerlei römische Erfahrungen verfügt, und einen Zivilschutzexperten, der das Heilige Jahr managen soll. Die Kommunalwahlen vom Juni 2016 bringen das erste Mal in der Geschichte der Stadt eine Frau ins Kapitol, aufgestellt von der parteienkritischen Fünf-Sterne-Bewegung. Die Olympiabewerbung wurde zurückgezogen, doch viele Aufgaben bleiben nach wie vor zu bewältigen.

Unterdessen beweist Papst Franziskus, dass die katholische Kirche noch immer in der Lage ist, sich zu erneuern und in weiten Kreisen Zuspruch zu gewinnen. Nur wenn es Rom gelingt, seinen Alltag zu bewältigen und zugleich eine ebenso umfassende wie konkrete Vision für seine Zukunft zu entwickeln, wird es – aller Schwierigkeiten und Defizite zum Trotz – zu dem werden, was es sein könnte und sein sollte: zur kulturellen Metropole eines multiethnisch definierten, lebendigen Mittelmeerraums.

5

Des « années de plomb » d'hier aux fragiles espoirs internationaux d'aujourd'hui 1968–AUJOURD'HUI

pp. 384/385
Alberto Fanelli

Vicolo della Volpe, showing signs of decline in the historic center, 2013.

Vicolo della Volpe mit den für die römische Altstadt typischen Zeichen des Verfalls, 2013.

Vicolo della Volpe, illustration du délabrement du centre historique, 2013.

*« Ô Rome, de ta grandeur et de ta beauté a fui ce qui était stable
et seul demeure et perdure ce qui est fugace. »*
FRANCISCO DE QUEVEDO, *A ROMA SEPULTADA EN SUS RUINAS*, VERS 1640

L'histoire des dernières décennies de Rome dessine une longue traînée de cendres. Les événements politiques, la présence de l'Église et l'expansion du tourisme y sont prédominants. Les faits divers finissent souvent par y voler la vedette aux événements culturels.

Aujourd'hui encore, Rome pâtit de l'absence d'un véritable programme de modernisation. Durant toutes les périodes de son histoire récente, celle de Pie IX, celle de la Rome capitale, celle du fascisme et de sa fin et ainsi de suite jusqu'à nos jours, la modernisation de Rome a été relative, toujours inachevée.

Lorsqu'elle fut choisie comme capitale, Rome était derrière Naples, Milan et Gênes en terme de population. En 1981, avant de commencer à se dépeupler, la ville comptait presque 3 millions d'habitants. Elle reste encore aujourd'hui la commune la plus peuplée d'Italie et occupe, à l'échelle de l'Europe, le quatrième rang après Paris, Londres et Berlin.

Siège du Parlement et du gouvernement, la capitale abrite toutes les passions politiques et civiles du pays. Lors des phases les plus aiguës du débat ou de l'affrontement politiques, elle concentre les manifestations, les défilés et les grèves. En 1960, des dizaines de milliers de jeunes, qui protestent contre le virage à droite du gouvernement du chrétien-démocrate Fernando Tambroni, affrontent les forces de l'ordre. Tambroni doit démissionner, ouvrant ainsi la voie au centre-gauche. Dès lors, les places et les rues de Rome seront de plus en plus souvent le théâtre des confrontations sociales et politiques.

L'incapacité des institutions et des partis à tenir compte de la modernisation et du dynamisme social issus du miracle économique conduit aux luttes étudiantes de 1968 et 1977 ; celles-ci suscitent de nouvelles formes de mobilisation politique et sociale dont les effets s'épuisent, faute de véritables réformes ou de résultats concrets, ouvrant ainsi la voie à une nouvelle période de violence politique. Le transformisme, les gouvernements stériles, les partis sans cesse plus faibles et la corruption chronique débouchent sur le terrorisme et font obstacle à un véritable développement social.

Les années de plomb, les attentats de la droite subversive et des extrémistes de gauche, le terrorisme des Brigades rouges, l'enlèvement et l'assassinat d'Aldo Moro (1978), les scandales révélés par l'opération « Mains propres » (1994) aboutissent à l'effondrement des partis traditionnels ; la révélation de nouveaux scandales de corruption politique affaiblit, aujourd'hui encore, la crédibilité de la politique aux yeux des citoyens.

Mussolini avait utilisé la radio, les actualités cinématographiques du LUCE et la photographie comme outils de communication de masse pour conquérir le pouvoir et le consolider ; Silvio Berlusconi, l'entrepreneur milanais qui entre en lice en 1994, recourt surtout à la télévision. Il gouverne l'Italie de 1994 à 2011 (avec une interruption de 1996 à 2001 sous le gouvernement Prodi) et aggrave non sans cynisme la dérive du pays et celle de Rome.

En 2005, lors des obsèques du pape Jean-Paul II, Rome voit affluer un nombre exceptionnel de chefs d'État venus du monde entier. L'Église de Rome demeure une puissance.

La configuration urbanistique de Rome est incontrôlable. Sa gigantesque expansion forme une masse continue, compacte et indifférente, et donne lieu à un désordre auquel il est difficile de remédier. On estime que 20 % du territoire construit l'est de manière abusive, avant d'être partiellement régularisé, un remède politique pire que le mal. Quant aux quartiers édifiés légalement mais issus de la spéculation, les immeubles existent bien mais personne ne s'est préoccupé des voies d'accès. Les architectes n'ont que de rares occasions de renouveler le visage de la ville et ils doivent se contenter de fournir quelques illustrations brillantes dans le domaine de la construction résidentielle.

Que retenir des dernières décennies ? Pendant une brève période (1976–1979) le maire de Rome, Giulio Carlo Argan, turinois et grand historien de l'art, réussit dans une certaine mesure à s'opposer au désordre urbanistique et à la spéculation immobilière en soustrayant à l'avidité des banques et des spéculateurs quelques édifices historiques pour les transformer en institutions culturelles. Mais l'administration Argan n'a qu'un temps, tout comme celle de Francesco Rutelli (1993–2001) et de Walter Veltroni (2001–2008). Si des résultats sont obtenus en matière d'assainissement des quartiers illégaux et périphériques, et de construction résidentielle publique, ils demeurent sans suite.

En 1977 est lancée l'Estate romana [Été romain], une initiative conçue et soutenue par Renato Nicolini, architecte, adjoint à la culture, visant à utiliser les espaces monumentaux du centre comme lieux de spectacles (cinématographiques et musicaux notamment) destinés à un large public de plus en plus jeune.

En 1979, Adriano La Regina, surintendant pour l'archéologie, propose de réaliser une zone archéologique centrale réunissant les forums ; ce projet prévoit la création d'un axe conjuguant verdure et monuments et menant du Capitole aux pentes des Castelli ainsi que la destruction des aménagements monumentaux

←
Augusto Casasoli

Francesco Totti, nicknamed Er Pupone (Big Baby), *world champion in 2006, and captain of the AS Roma football team since 1998, May 2017.*

Francesco Totti, genannt Er Pupone (Riesenbaby), *Mitglied des Weltmeisterschaftsteams 2006 und seit 1998 Kapitän der Mannschaft von AS Rom, Mai 2017.*

Francesco Totti, surnommé Er Pupone (le Poupon), *champion du monde en 2006, capitaine de l'équipe de football de l'AS Roma depuis 1998, mai 2017.*

→
Franco Origlia

Fashion show for the 90th anniversary of Casa Fendi at the Trevi Fountain, July 2016.

Modenschau am und im Trevibrunnen anlässlich des 90. Firmenjubiläums des Modehauses Fendi, Juli 2016.

La fontaine de Trevi, théâtre d'un défilé de mode pour le 90ᵉ anniversaire de la maison Fendi, juillet 2016.

datant du fascisme, la via dei Fori Imperiali en particulier. Les effets réels de cette proposition se limiteront à la démolition de la via della Conciliazione, au pied du Capitole.

Sous le mandat de Gianni Alemanno, maire de 2008 à 2013, l'administration de la ville ne fait aucun progrès. En 2010, on va jusqu'à avancer l'absurde proposition de créer dans l'EUR un circuit de Formule 1 avec invasion de béton.

Le Vatican est conscient de son prestige, lequel est d'autant plus grand que le pouvoir politique est faible. En 2000, plus de 2 millions de pèlerins affluent à Tor Vergata pour les Journées mondiales de la jeunesse en présence du pape Jean-Paul II. La même année se tient à Rome la World Gay Pride ; deux ans plus tard, la première union civile homosexuelle est célébrée en Italie, à Rome, au consulat de France où est conclu un Pacte civil de solidarité (Pacs).

Début 2003 se tient à Rome l'une des plus importantes manifestations mondiales contre la guerre en Irak. Par ailleurs, 250 000 personnes participent aux obsèques de l'acteur Alberto Sordi, champion des comédies à l'italienne, avec quelque 200 films à son actif. Deux ans plus tard, via della Conciliazione et devant les écrans géants installés sur les grandes places de Rome, près de 3 millions de personnes assistent aux funérailles du pape Jean-Paul II place Saint-Pierre ; la cérémonie, à laquelle prennent part plus de 200 délégations officielles et les représentants de toutes les religions, est retransmise en direct et en mondovision ; en Italie, elle est suivie par près de 14 millions de téléspectateurs, avec une audience record pour la télévision italienne.

En 2002 est inauguré le Musée d'art contemporain de Rome (MACRO), œuvre de l'architecte française Odile Decq. La même année, un second siège du musée, le MACRO Testaccio, est ouvert dans deux pavillons des anciens abattoirs de Testaccio non loin de la pyramide Cestia.

En 2010, dans le quartier Flaminio, le musée MAXXI ouvre ses portes. Il est la première institution nationale dédiée à la création contemporaine : expositions, workshops, congrès, ateliers, spectacles, projections et autres sessions de formation.

Les années récentes semblent marquées par une dégradation et une dépression accrues. Selon une enquête menée en 2015 sur la qualité de la vie dans les grandes villes du monde, Rome occupe la 52ᵉ place.

Ne cessant de se dépeupler, le centre historique est passé de 420 000 à 120 000 habitants en vingt ans. De nombreuses salles de cinéma ferment : le Colorado, l'Academy, le Tristar, l'Arena Flora, l'Ariel, l'Aurora, l'Arizona, l'Excelsior, le Luxor, le Belsito, l'Archimede, le Holiday, le Missouri, l'America et l'Avorio. Divers lieux culturels comme le Rialto et le théâtre Valle connaissent un sort identique.

Dans l'EUR, le Palais de la civilisation italienne (Palazzo della Civiltà Italiana), loué en 2013 aux Français pour une durée de quinze ans, est inauguré deux ans plus tard. Le bénéficiaire de l'opération est le financier Bernard Arnault, quatrième fortune mondiale, qui est à la tête du groupe français LVMH (Louis Vuitton Moët Hennessy) ; ce groupe de luxe français contrôle plusieurs marques italiennes dont Bulgari, Acqua di Parma, Pucci, Rossimoda, Berluti, Loro Piana, Cova et Fendi.

Le tourisme se développe mais il s'agit d'une forme parasitaire, consumériste, celle des tours en 24 heures pour 30 euros tout compris, qui se focalise sur les « plus grands » monuments historiques et ignore les musées excentrés, qui se contente des échoppes et des ventes à l'étalage de souvenirs de pacotille et des restaurants pseudo-typiques. La ville est polluée et sale. Les autorités sont incapables d'autre chose que de mesures cosmétiques tels que le contrôle des « centurions » au Colisée et des étals illégaux à Termini.

La ville « est candidate pour accueillir les Jeux olympiques de 2024, avec le médiocre objectif de se développer en misant sur le seul produit dans lequel elle a investi depuis l'après-guerre : le béton » (Christian Raimo, 2016).

Entre novembre 2015 et juin 2016, le fauteuil de maire est vacant et la gestion de la Ville est confiée à un préfet chargé d'administrer la commune – alors qu'il ne connaît rien aux affaires romaines –, et à un expert de la protection civile chargé de la sécurité durant le jubilée. À la suite des élections administratives de juin 2016, une femme, soutenue par le mouvement antiparti 5 Étoiles, est élue maire de Rome. La Ville renonce à se porter candidate aux Jeux olympiques de 2024 et affronte de graves difficultés.

Avec le pape François, l'Église prouve, une fois encore, qu'elle est capable de se renouveler et d'obtenir un large consensus. Il faudrait qu'il en soit de même pour Rome. Que Rome soit capable de gérer la vie quotidienne de ses administrés, qu'elle soit également capable de concevoir et de réaliser un grand projet pour enfin oser devenir, malgré tous ses handicaps et toutes ses carences, la capitale culturelle et multiethnique de la Méditerranée.

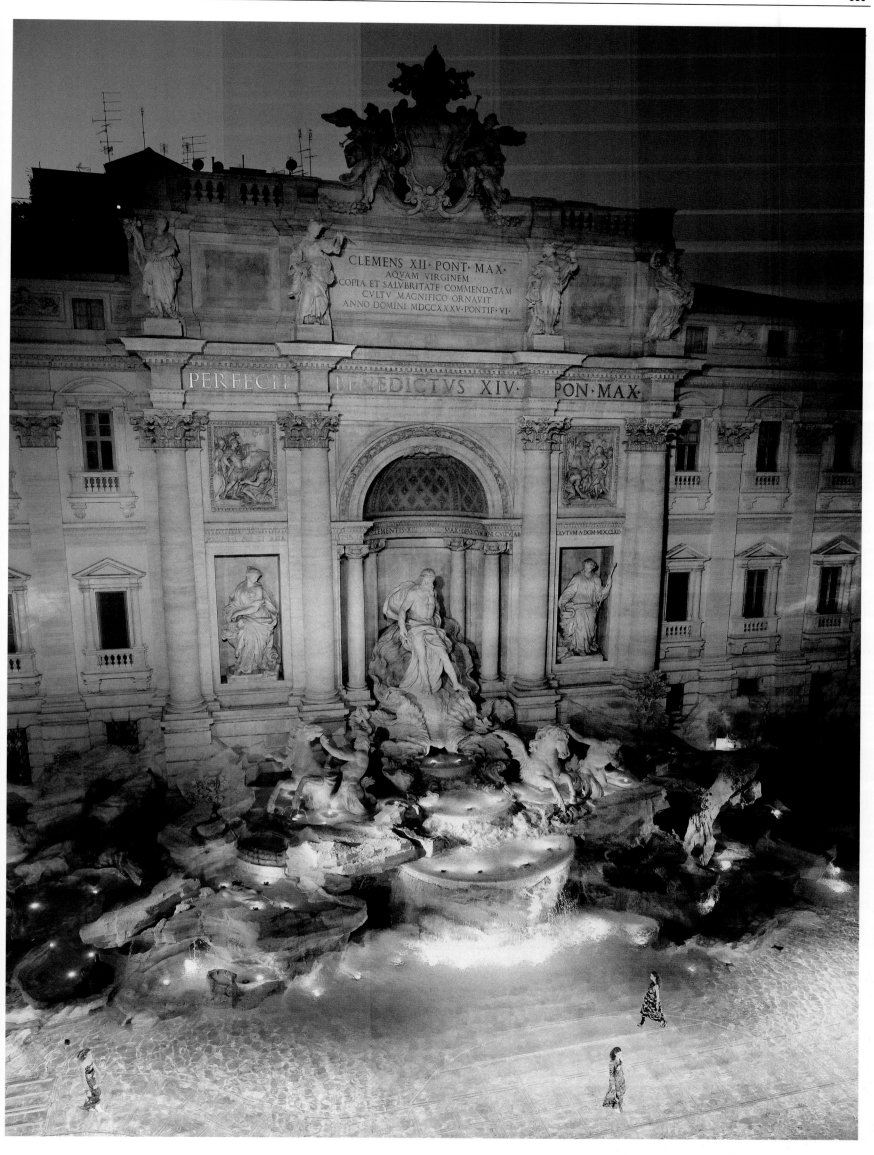

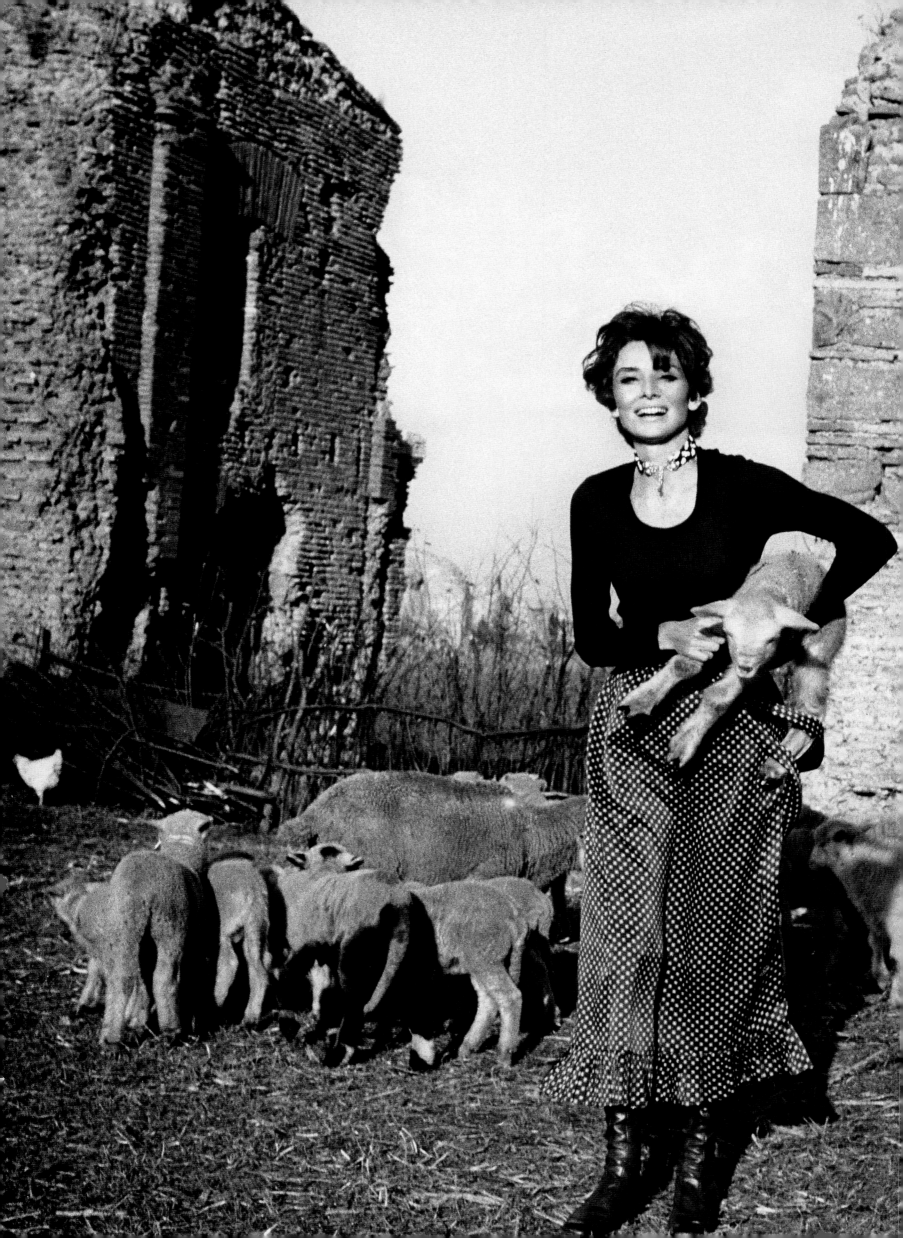

←

Henry Clarke

Audrey Hepburn photographed for Vogue *in a Roman villa, 1971.*

Audrey Hepburn in einer römischen Villa, fotografiert für die Vogue, *1971.*

Audrey Hepburn photographiée pour Vogue *dans une villa romaine, 1971.*

↓

Henry Clarke

Model and journalist Benedetta Barzini in an ensemble by Mila Schön, 1968.

Benedetta Barzini, Journalistin und Mannequin in einem Ensemble der Modeschöpferin Mila Schön, 1968.

Benedetta Barzini, mannequin et journaliste dans une robe de Mila Schön, 1968.

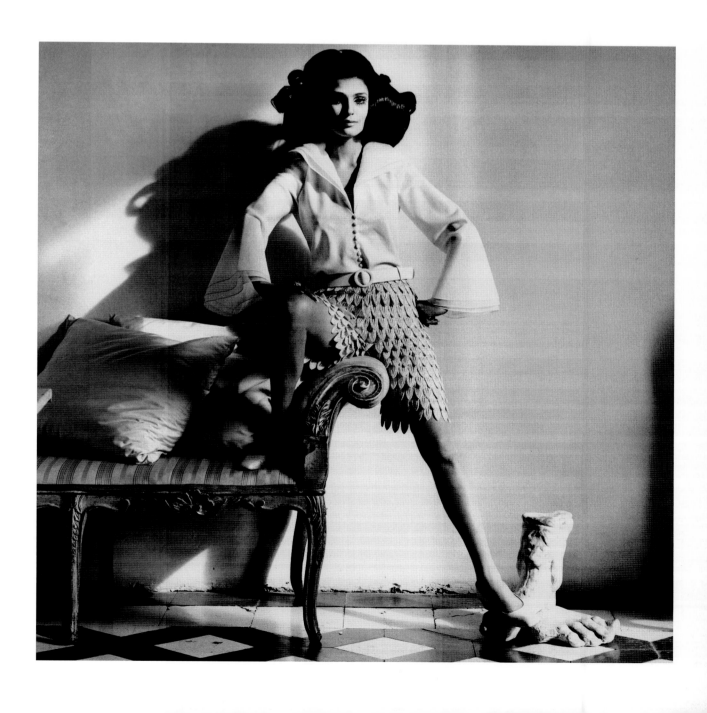

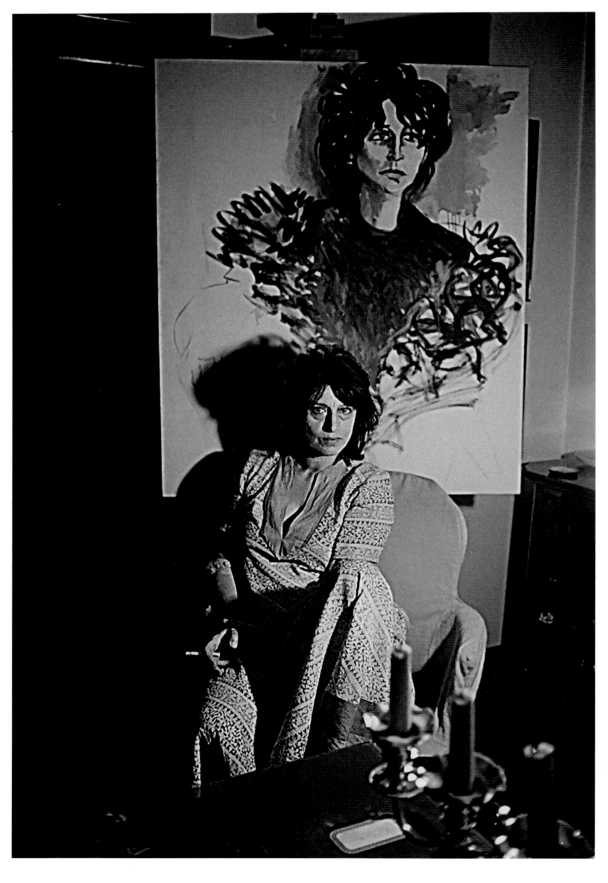

←
Walter Mori

Anna Magnani in her Roman home, sitting in an armchair in front of her portrait by Renato Guttuso, 1968. In his film Roma, *Fellini commented about Anna Magnani: "She could be the symbol of the city […] a Rome seen as a she-wolf and a vestal, an aristocrat and a tramp, somber and comical." 1968.*

Anna Magnani in ihrer römischen Wohnung vor einem von Renato Guttuso gemalten Porträt der Schauspielerin, 1968. In seinem Film Roma *sagt Fellini über die Magnani: „Sie könnte das Sinnbild dieser Stadt sein […] Rom als Wölfin und Vestalin, Adlige und Landstreicherin, finster verschlossen und strahlend komisch." 1968.*

Anna Magnani, chez elle à Rome, assise dans un fauteuil avec dans son dos son portrait peint par Renato Guttuso, 1968. Dans Roma, *Fellini dit de l'actrice: « Elle pourrait être le symbole de la ville […], de Rome vue comme une louve et une vestale, aristocratique et miséreuse, sombre et bouffonne. » 1968.*

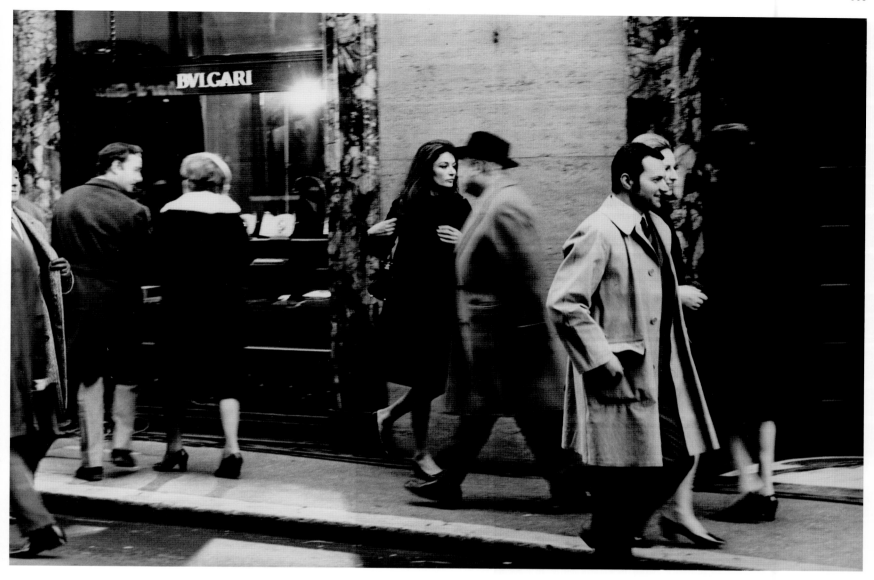

↑

Tazio Secchiaroli

*Via Condotti: Anouk Aimée on the set of
Sidney Lumet's* The Appointment, *1969.*

*Via Condotti: Anouk Aimée auf dem Set
von Sidney Lumets Film* Ein Hauch von
Sinnlichkeit, *1969.*

Anouk Aimée sur le tournage de Rendez-
vous *de Sidney Lumet, 1969.*

394

NINO MANFREDI
VITTORIO GASSMAN
STEFANIA SANDRELLI
ALDO FABRIZI
GIOVANNA RALLI
STEFANO SATTA FLORES

C'ERAVAMO
TANTO AMATI

AGE·SCARPELLI·SCOLA PIO ANGELETTI E ADRIANO DE MICHELI un film di ETTORE SCOLA
TECHNICOLOR

"A surly city, of course, but because she is aware of her role."

„Eine streitbare Stadt, aber weil sie sich ihrer Rolle bewusst ist.“

« Une ville revêche assurément, car consciente de son rôle. »

ETTORE SCOLA, *C'ERAVAMO TANTO AMATI,* 1974

→

Winfield Parks

It's an Oriental life that unfolds on the roof terraces of Roman houses, where people study, work, cook, eat, have guests, dance, wash laundry, sing and make love, 1970.

Über den Dächern Roms wird gelebt wie im Orient, dort wird studiert und gearbeitet, gekocht und gespeist, man trinkt und man tanzt zusammen, singt und liebt sich, 1970.

Vie à l'orientale sur les toits-terrasses de Rome : on y étudie, travaille, mange, reçoit ses amis, danse, lave le linge, chante et fait l'amour, 1970.

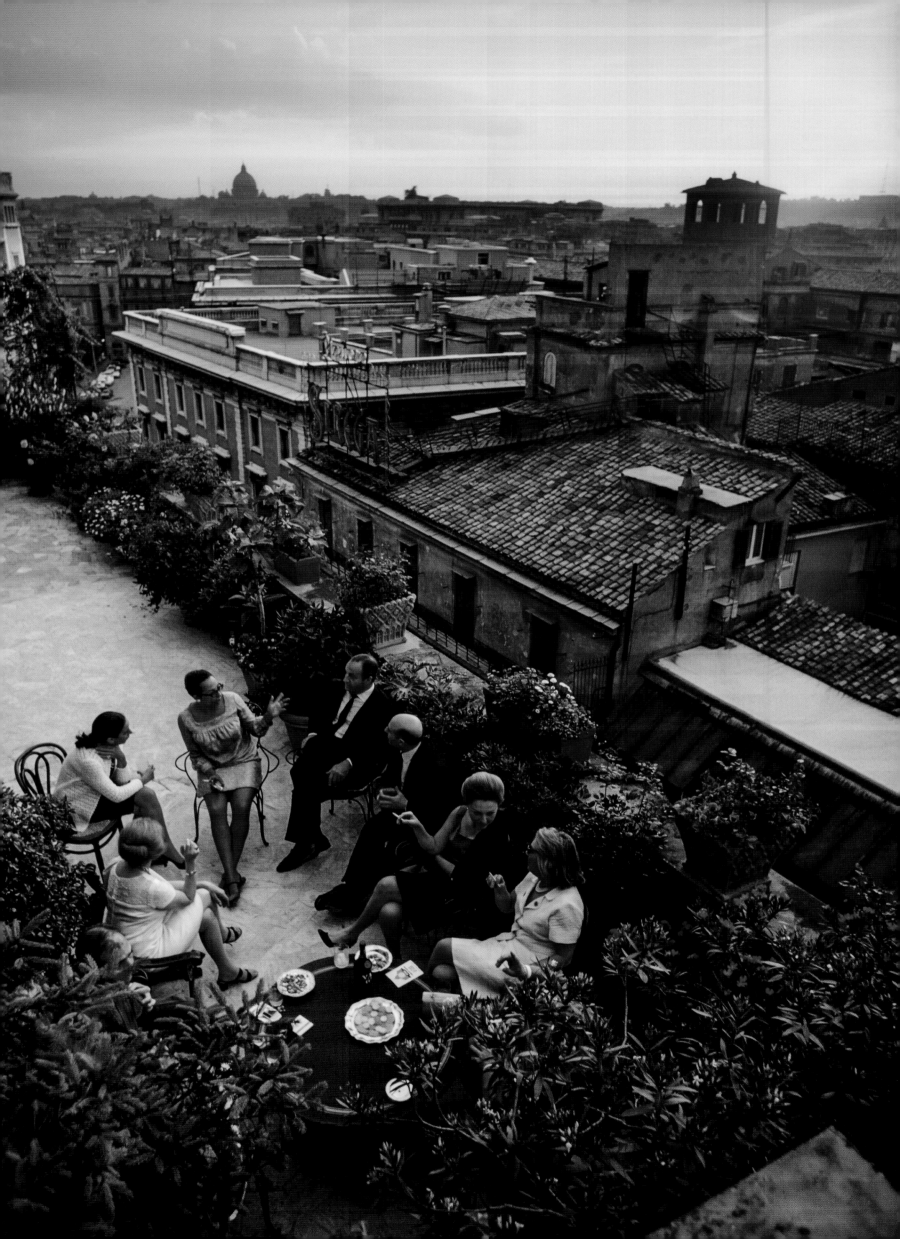

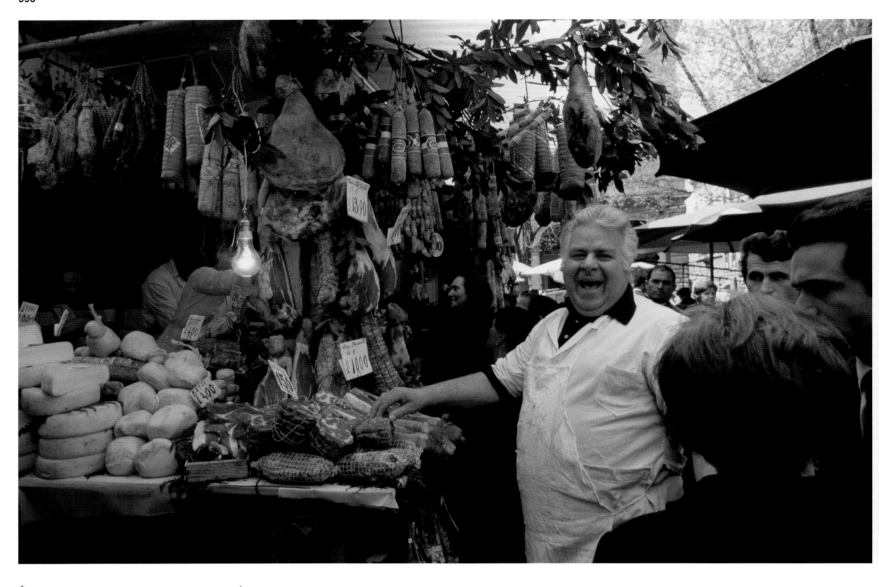

↑
Winfield Parks

In a popular market, a seller expounds on the benefits (and prices) of his produce, 1970.

Ein Händler auf einem der vielen römischen Märkte preist seine Ware an, 1970.

Sur un marché de Rome, un vendeur vante sa marchandise (et ses prix), 1970.

→
Winfield Parks

An elderly florist prepares her bouquets in a street in the historic center, 1970.

Blumenhändlerin in der römischen Altstadt beim Binden von Sträußen, 1970.

Une marchande de fleurs prépare ses bouquets dans une rue du centre historique, 1970.

pp. 398/399
Winfield Parks

With the advent of new means of transport, the modern city has broken the physical, familiar bond between citizens and the monuments.

Der Autoverkehr der modernen Großstadt hat die körperliche Nähe des Menschen zu den Denkmälern der Vergangenheit zerstört.

Avec l'avènement des nouveaux modes de transport, la ville moderne a rompu la relation physique et familière de l'homme avec les monuments historiques.

*"Rome has always been fascinating and vulgar, beautiful
and ugly, international and extremely provincial."*

*„Rom war schon immer zugleich faszinierend und vulgär,
wunderschön und abstoßend, international und provinziell."*

*« Rome a toujours été fascinante et vulgaire, magnifique et
horrible, cosmopolite et très provinciale. »*
STEFANO MALATESTA, 2014

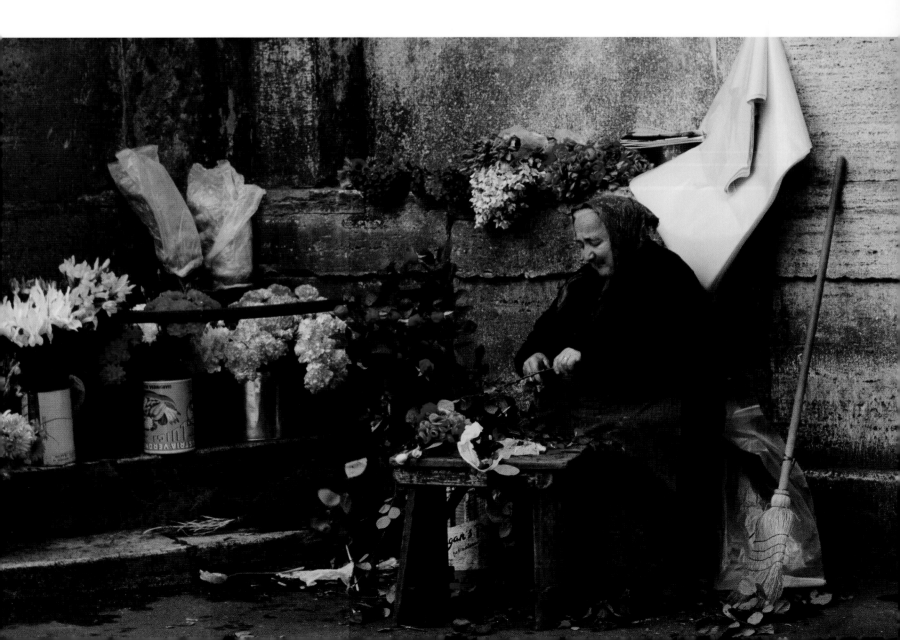

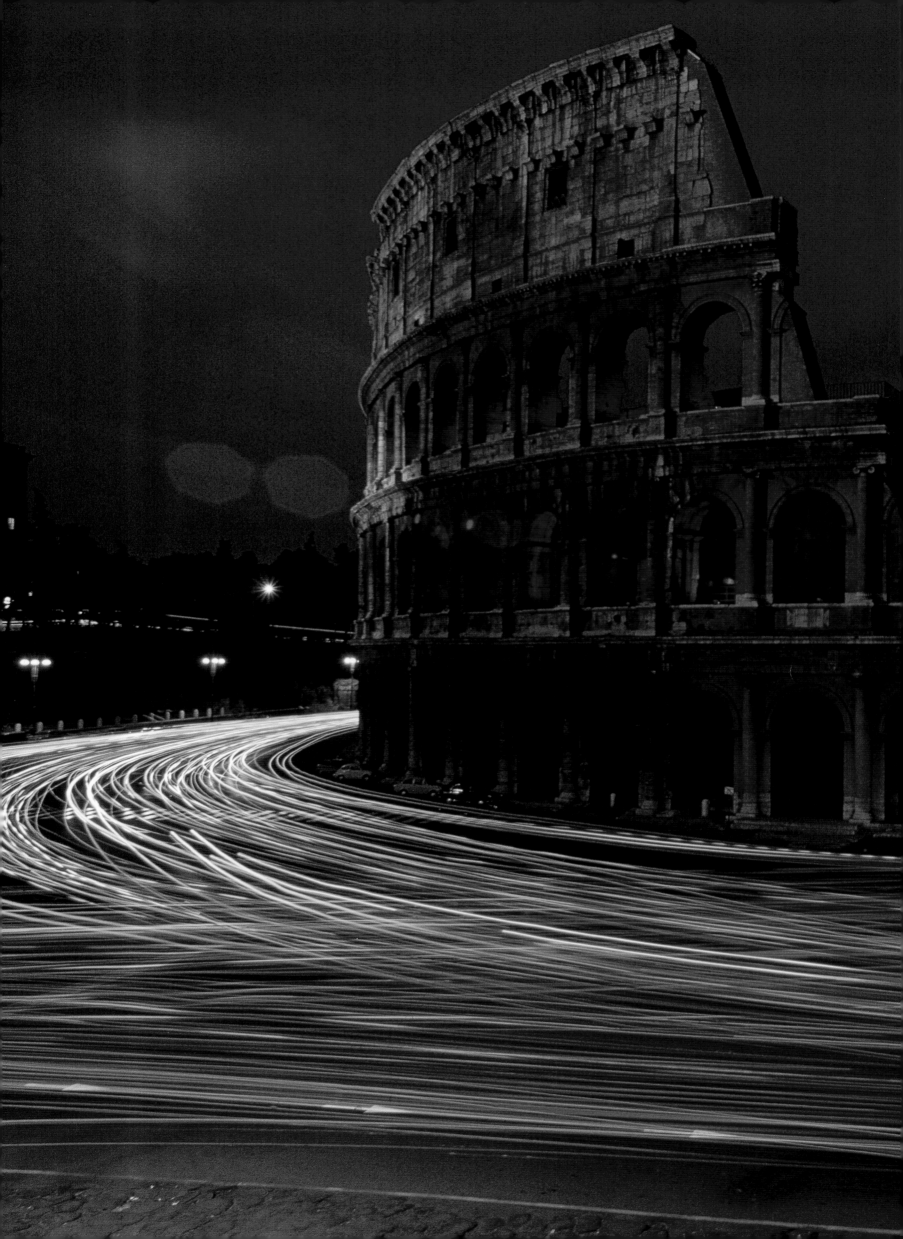

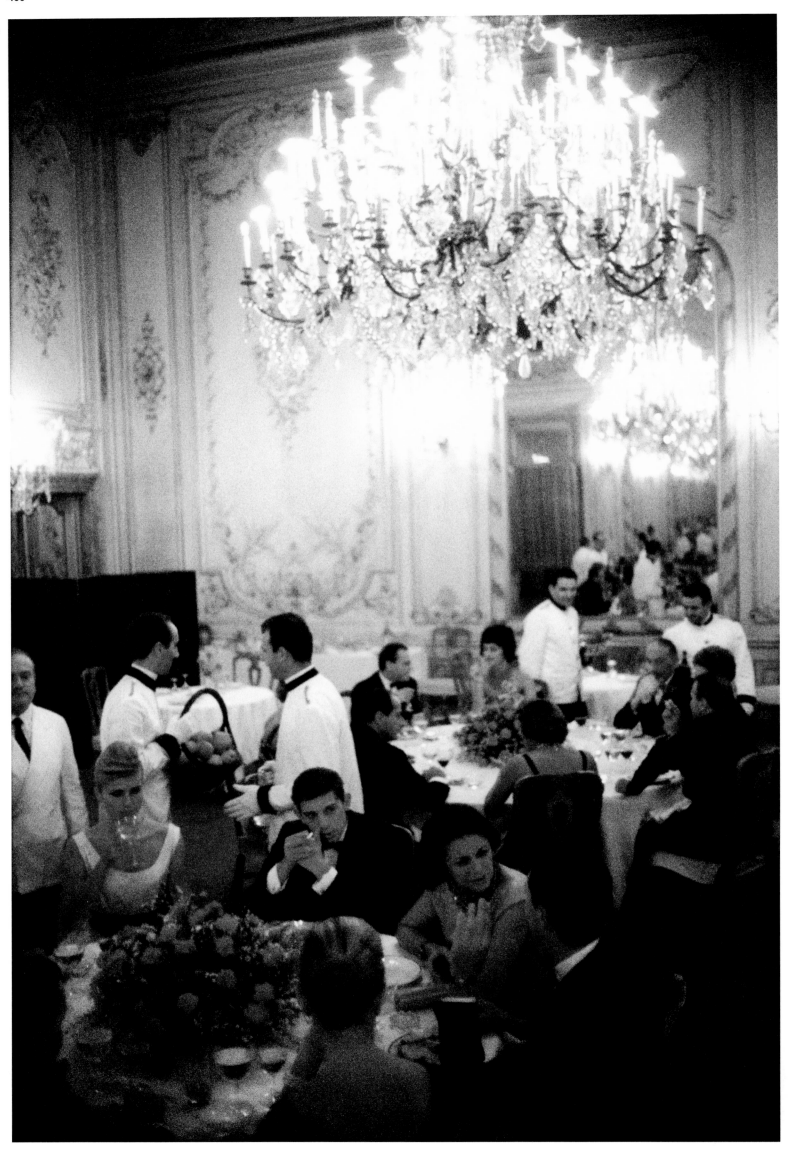

↑
Anonymous

Three friends (Vittorio Gassman, Nino Manfredi, and Stefano Satta Flores) share a plate of pasta in a scene from Ettore Scola's film C'eravamo tanto amati, *1974.*

Drei Freunde (Vittorio Gassman, Nino Manfredi, Stefano Satta Flores) bei einem Teller Pasta al pomodoro in Ettore Scolas Film Wir waren so verliebt, *1974.*

Trois amis (Vittorio Gassman, Nino Manfredi et Stefano Satta Flores) partagent un plat de pâtes à la sauce tomate dans une scène de Nous nous sommes tant aimés *d'Ettore Scola, 1974.*

←
Slim Aarons

A gala reception in Palazzo Brancaccio, 1970.

Galaempfang im Palazzo Brancaccio, 1970.

Soirée de gala au palais Brancaccio, 1970.

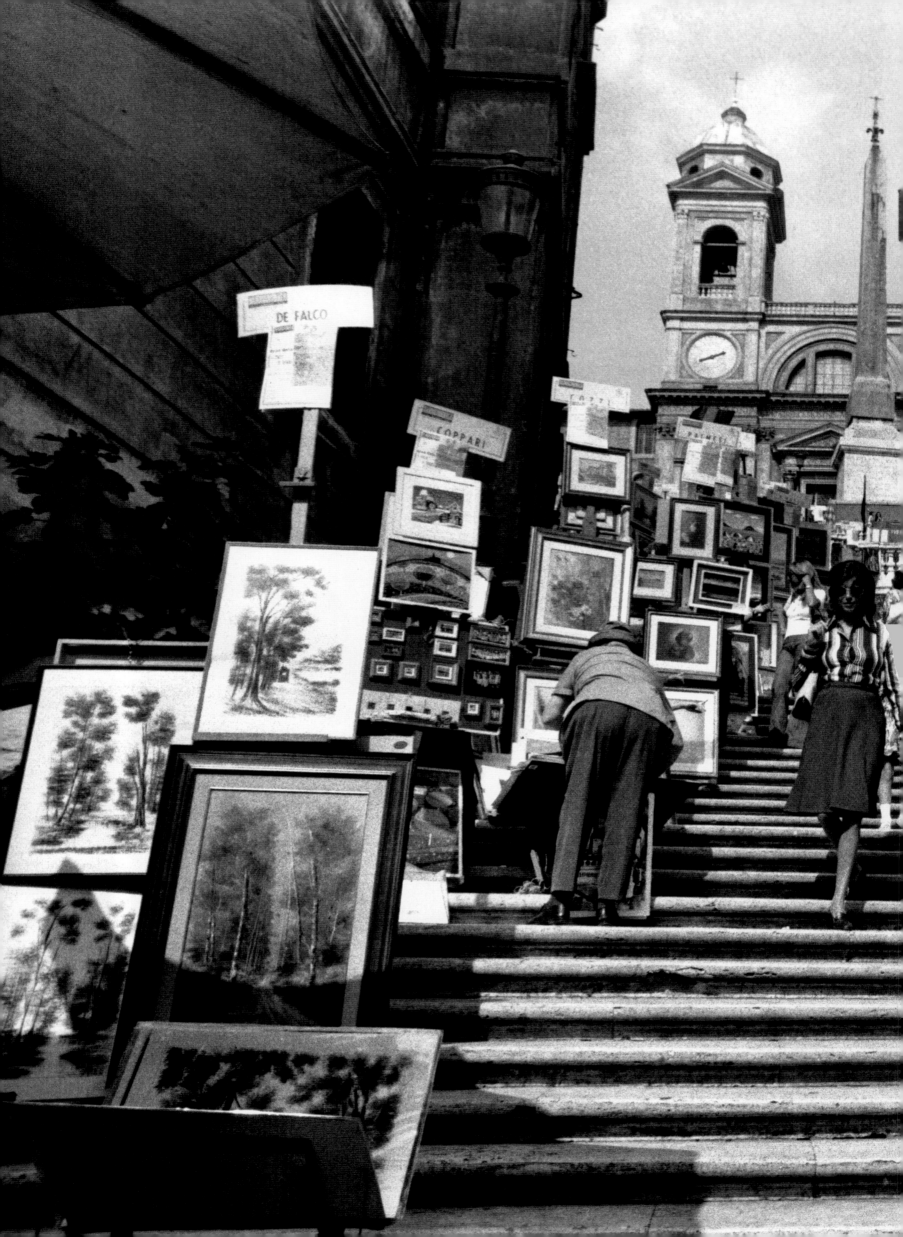

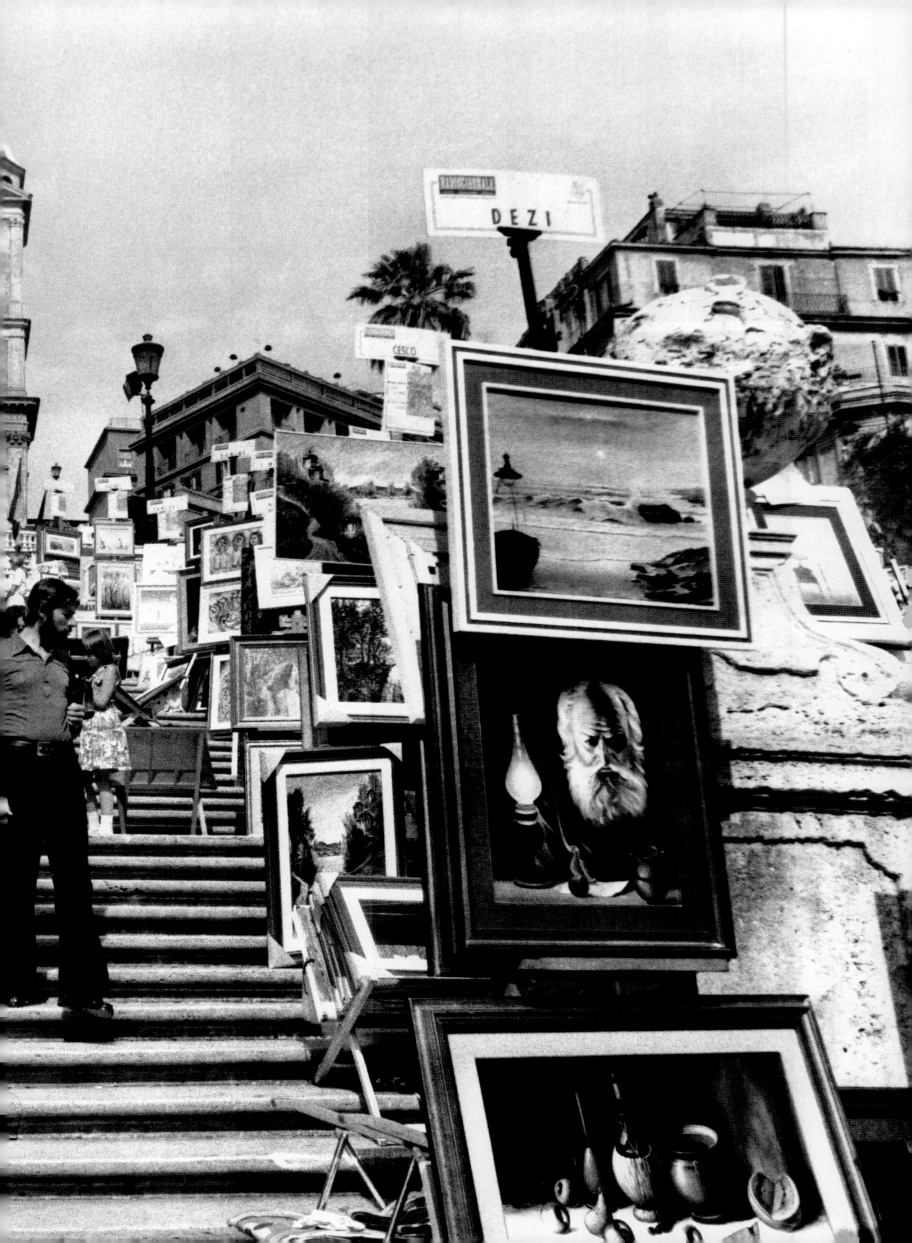

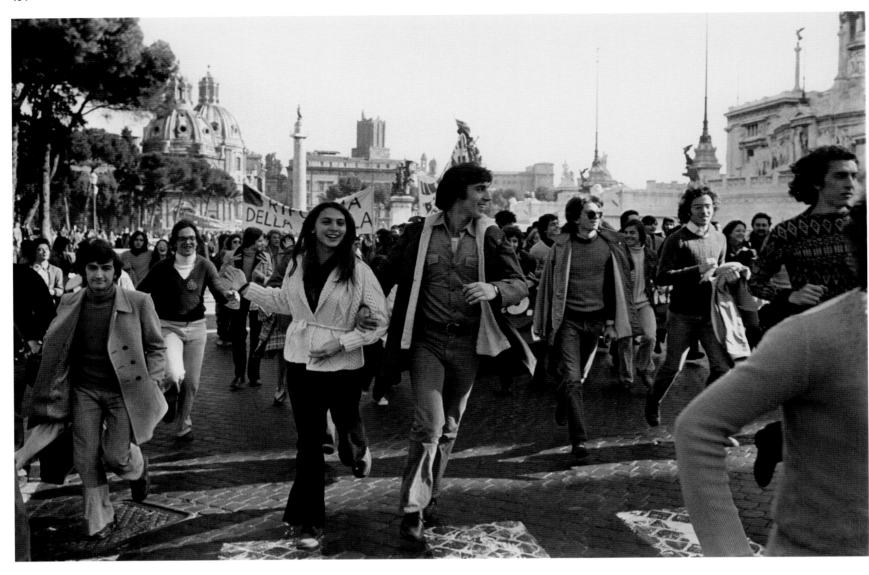

pp. 402/403
Keystone Agency

Even on the steps of Trintà dei Monti, a place at once popular and elegant, the authenticity of people's behavior and attitudes gave way to a vulgar display aimed at attracting the hordes of tourists, 1972.

Auch auf der Spanischen Treppe, für Jahrhunderte Ort natürlicher Eleganz und echter Volkstümlichkeit, macht sich vulgäres Haschen nach den Geldbörsen der Touristenströme breit, 1972.

Même sur les marches de Trinità dei Monti, distinguées et populaires des siècles durant, l'authenticité a cédé le pas à un étalage vulgaire destiné à captiver les hordes de touristes, 1972.

←
Gianni Girani

Students in Piazza Venezia during a demonstration for the reform of the school system, 1972.

Studenten und Schüler auf der Piazza Venezia während einer Kundgebung für die Schulreform, 1972.

Étudiants sur la piazza Venezia manifestant pour obtenir une réforme du système scolaire, 1972.

↓
ANSA Agency

A feminist demonstration supporting the law allowing abortion, 1977.

Frauendemonstration für das Recht auf Abtreibung, 1977.

Manifestation féministe en faveur de la loi sur l'avortement, 1977.

pp. 406/407
Leonard Freed

Posters for the referendum on the divorce law, when the Catholic Church unsuccessfully campaigned to repeal it, and also fought the supporters of conscientious objection, 1974.

Plakate anlässlich des Referendums über die Ehescheidung; die katholische Kirche trat erfolglos für ein „Ja" beim Volksentscheid zur Abschaffung des neu eingeführten Scheidungsrechts ein, 1974.

Affiches pour le référendum relatif à la loi sur le divorce, à l'occasion duquel l'Église catholique échoua à faire triompher le « oui » à l'abrogation et à vaincre les tenants de la liberté de conscience, 1974.

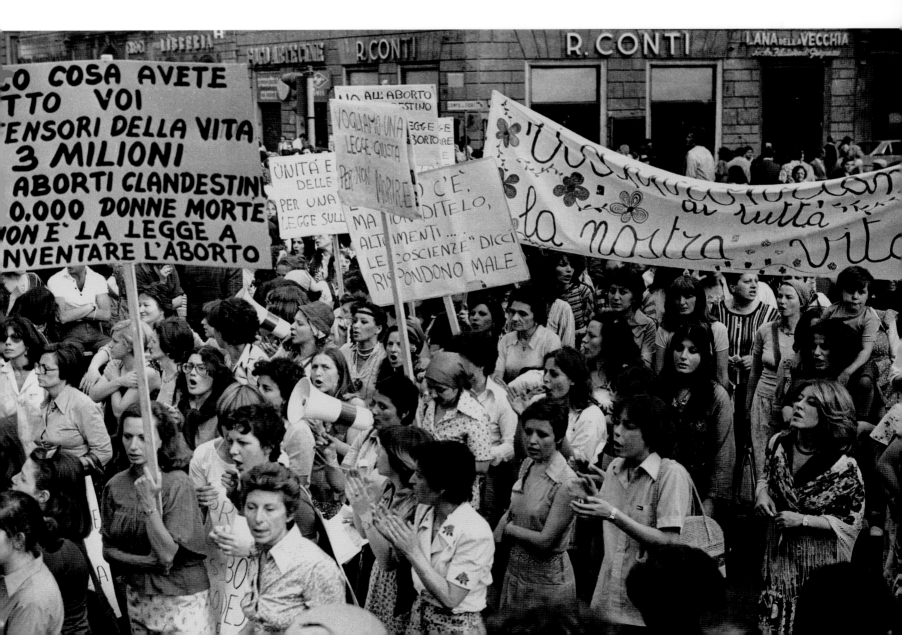

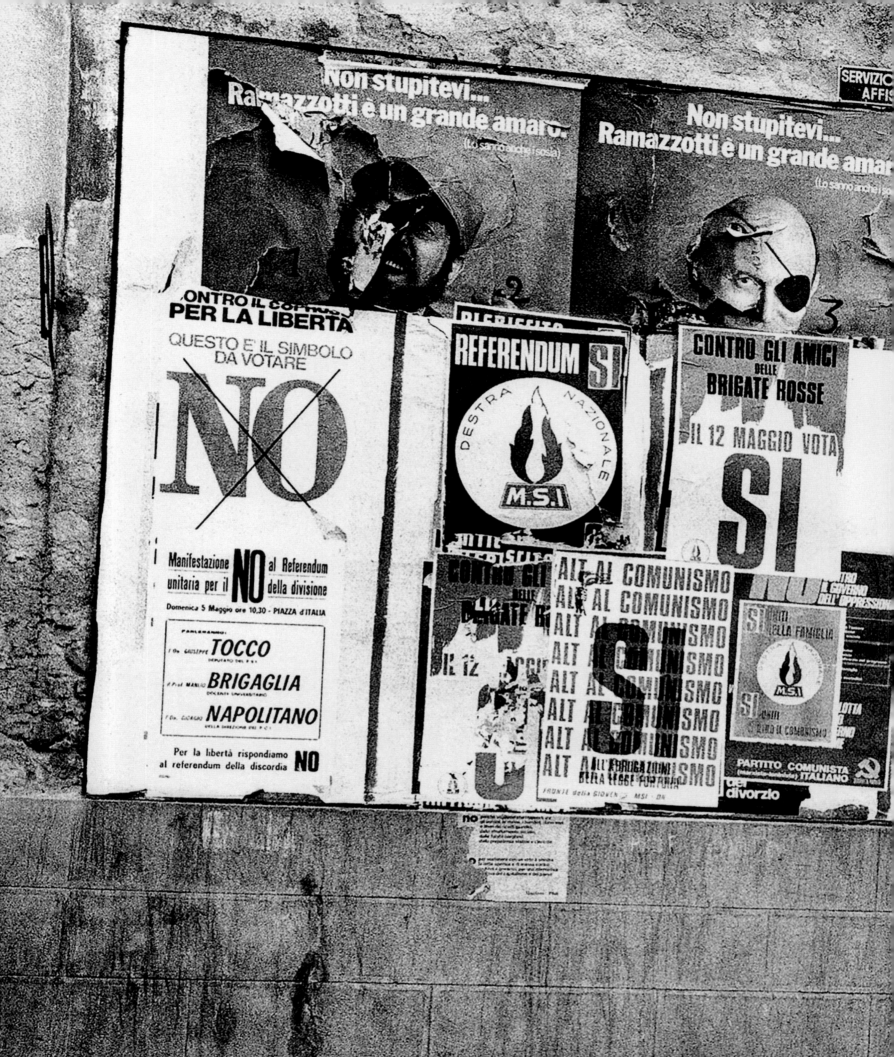

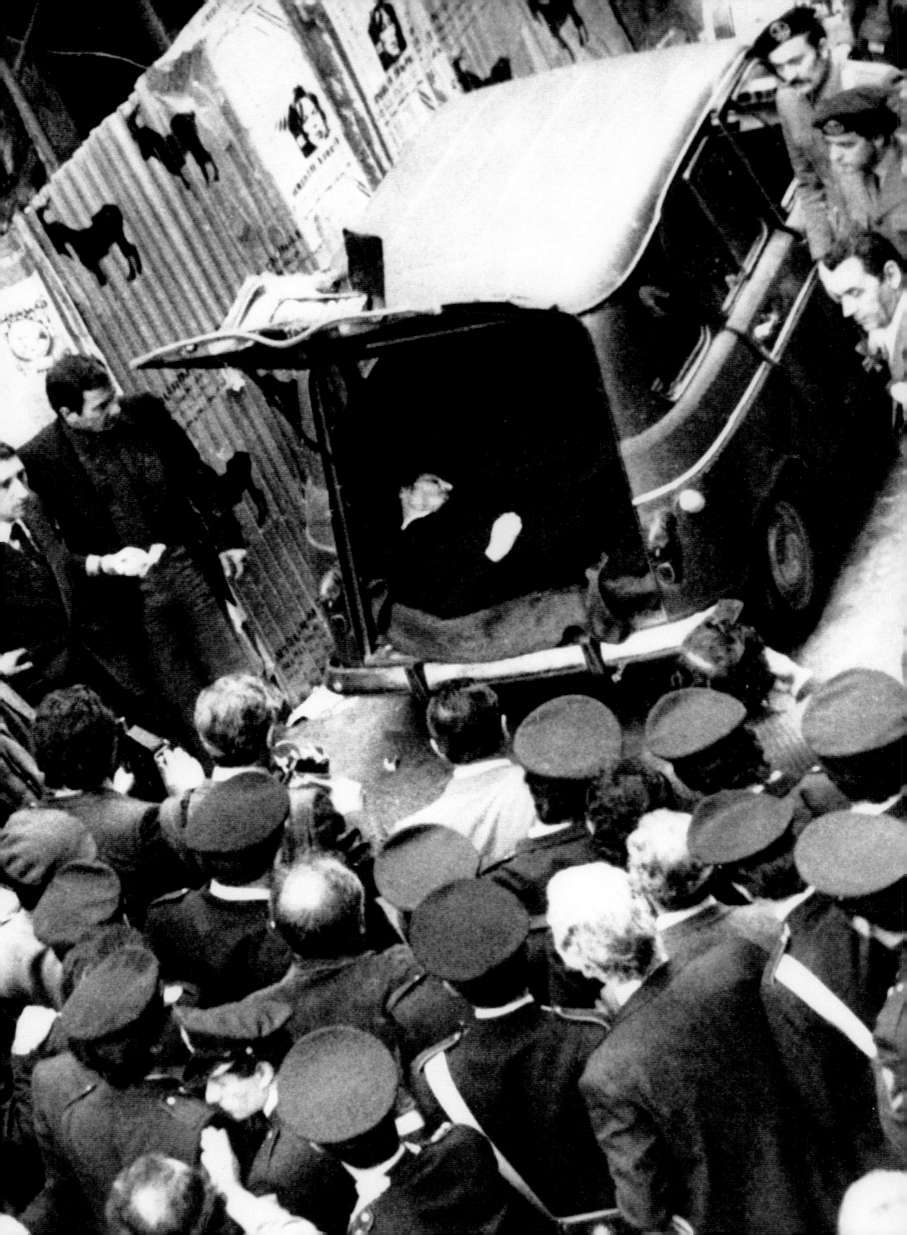

→
Giorgio Lotti

Enrico Berlinguer, First Secretary of the Italian Communist Party and the protagonist of the political season of the "historic compromise," or the rapprochement between the center and the left political parties, on the podium during the 15th party convention, 1979.

Enrico Berlinguer, Erster Sekretär der Kommunistischen Partei Italiens und einer der Hauptvertreter des „historischen Kompromisses" zwischen den politischen Lagern der Linken und des bürgerlichen Zentrums, am Rednerpult beim 15. Parteikongress, 1979.

Enrico Berlinguer, secrétaire général du Parti communiste italien et l'un des principaux acteurs du compromis historique, c'est-à-dire du rapprochement entre les forces politiques du centre et celles de la gauche, à la tribune du 15ᵉ congrès du Parti, 1979.

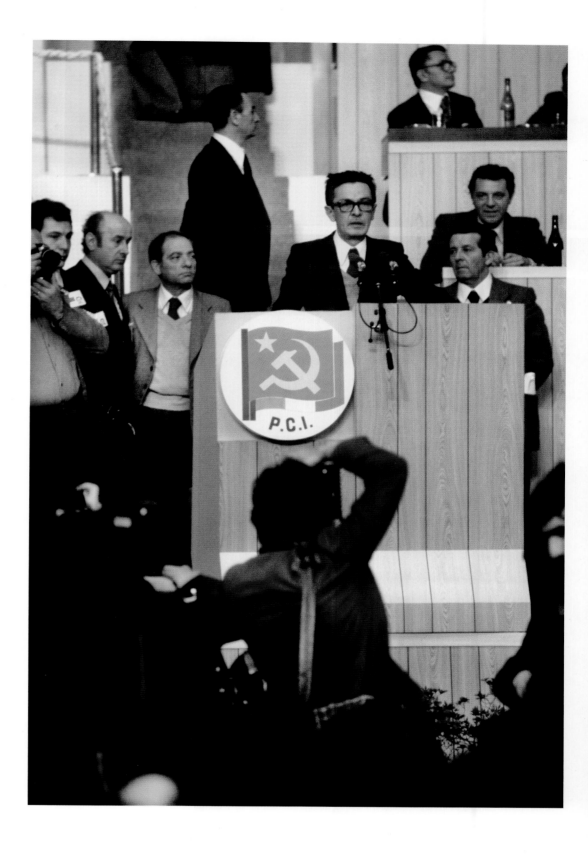

←
Keystone Agency

The discovery of the body of Aldo Moro, the president of the Christian Democratic Party, assassinated by the Red Brigades and left in the trunk of a car in Via Caetani. Some speculated that the killers had left the car between Via delle Botteghe Oscure (Communist Party headquarters) and Piazza del Gesù (Christian Democrats headquarters) to make it clear to everybody that the historic compromise between Catholics and Communists was over, May 1978.

Die Leiche Aldo Moros, des Vorsitzenden der Democrazia Cristiana, wird nach dessen Ermordung durch die Roten Brigaden im Kofferraum eines in der Via Caetani abgestellten Autos aufgefunden. Es heißt, der Wagen wurde genau zwischen den Parteizentralen von Kommunisten und Christdemokraten in der Via delle Botteghe Oscure und der Piazza del Gesù abgestellt, um das Scheitern des „historischen Kompromisses" anzuzeigen, Mai 1978.

Le corps d'Aldo Moro, président de la Démocratie chrétienne assassiné par les Brigades rouges, abandonné dans le coffre d'une voiture garée dans la via Caetani. Le bruit courut que le lieu choisi, à mi-chemin entre la via delle Botteghe Oscure [siège du parti communiste] et la piazza del Gesù [siège de la Démocratie chrétienne], signifiait que le compromis historique entre communistes et catholiques avait vécu, mai 1978.

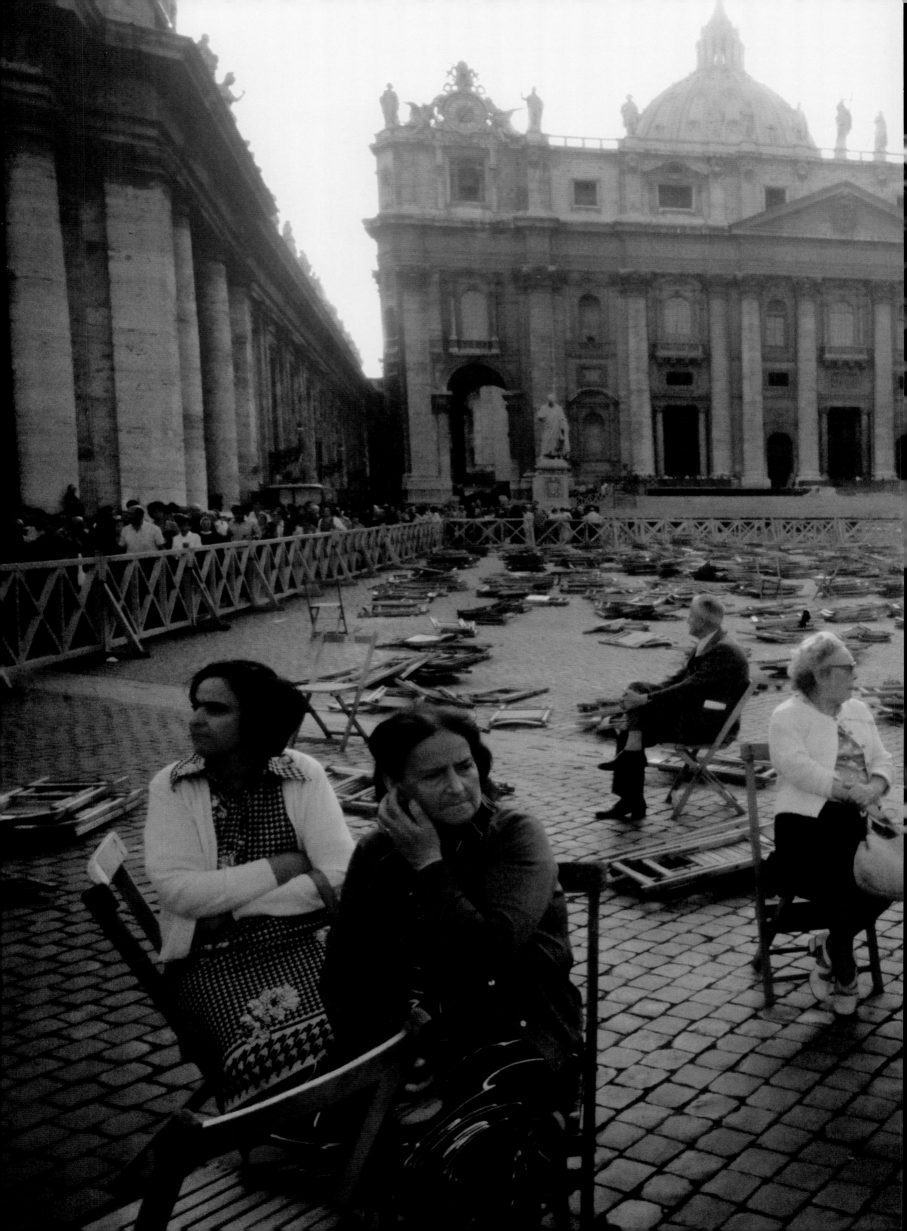

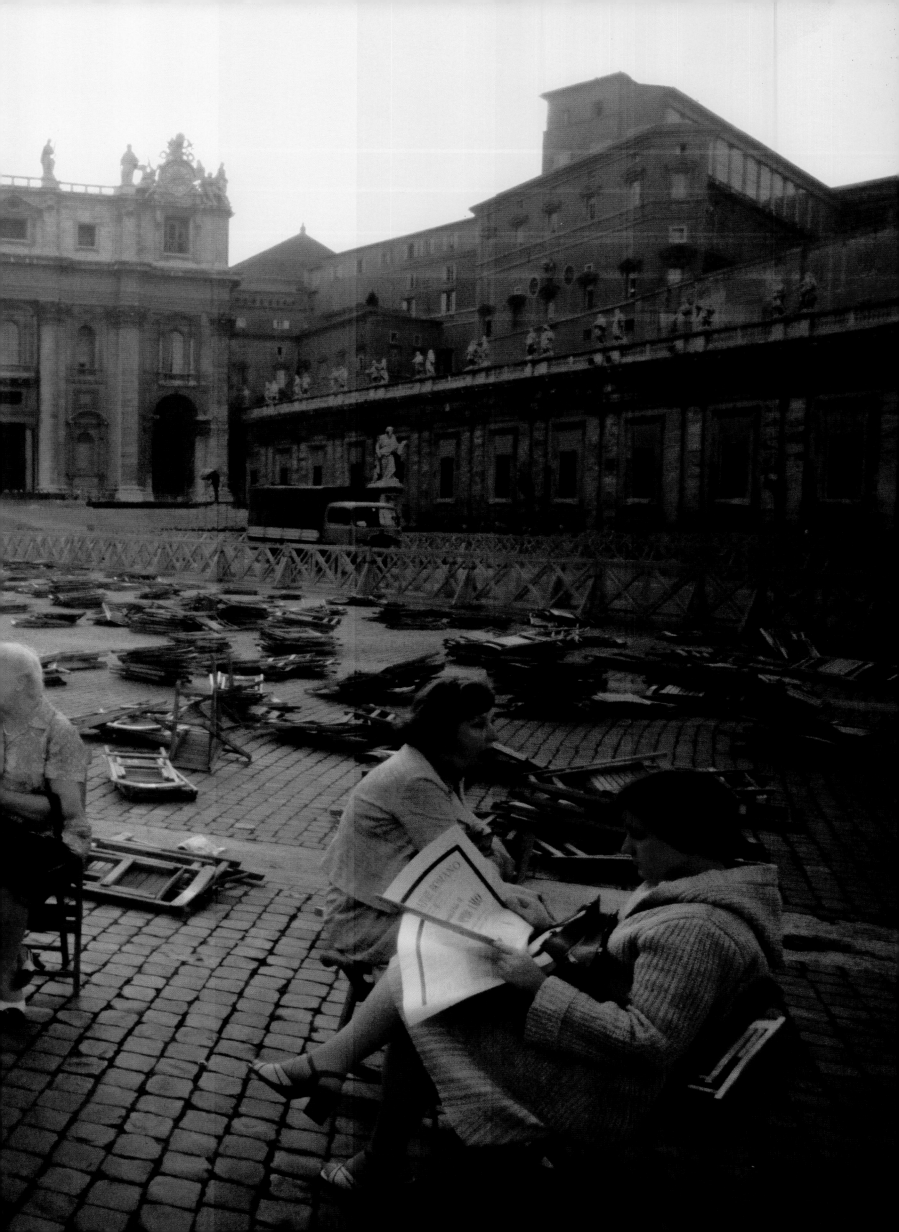

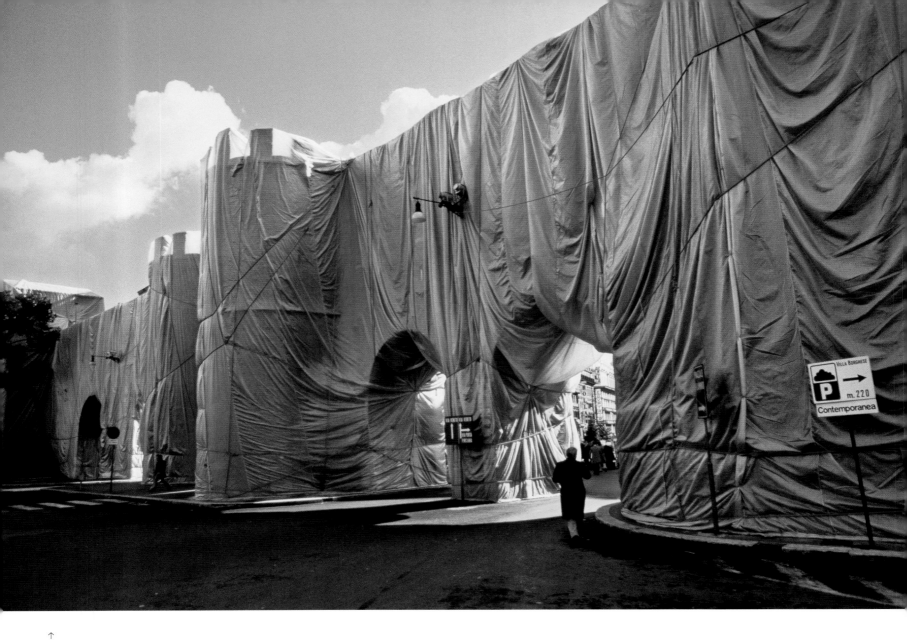

↑

Harry Shunk

The art work Wrapped Roman Wall *by Christo and Jeanne-Claude, which covered 250 meters (820 feet) of the Aurelian Walls with polypropylene fabric and ropes, was completed by 40 construction workers in four days, 1974.*

1974 verhüllten Christo und Jeanne-Claude ein 250 Meter langes Teilstück der Aurelianischen Mauer mit Polypropylengewebe und Seilen. Das Werk Wrapped Roman Wall *wurde in vier Tagen von 40 Arbeitern fertiggestellt.*

L'œuvre Wrapped Roman Wall *de Christo et Jeanne-Claude, qui ont emballé sur 250 mètres une portion du mur d'Aurélien avec une toile en polypropylène et des cordes, opération réalisée en quatre jours par une équipe de quarante ouvriers, 1974.*

pp. 410/411
Richard Kalvar

St. Peter's Square after the funeral of Pope Paul VI, 1978.

Der Petersplatz nach den Trauerfeierlichkeiten für Paul VI., 1978.

Place Saint-Pierre après les funérailles du pape Paul VI, 1978.

→
Steve McCurry

A street seller of reproductions of works of art, reading while seated in his Mini, 1984.

Straßenhändler in Sachen „Kunst" beim Lesen der Zeitung in seinem Mini Morris, 1984.

Vendeur ambulant de reproductions d'œuvres d'art lisant dans sa Mini Morris, 1984.

"*Crying can be done alone, but laughing must be done with someone else.*"

„*Weinen kann man auch allein, aber zum Lachen muss man zu zweit sein!*"

«*On peut pleurer tout seul, mais pour rire il faut être deux.*»

ETTORE SCOLA, *UNA GIORNATA PARTICOLARE*, 1977

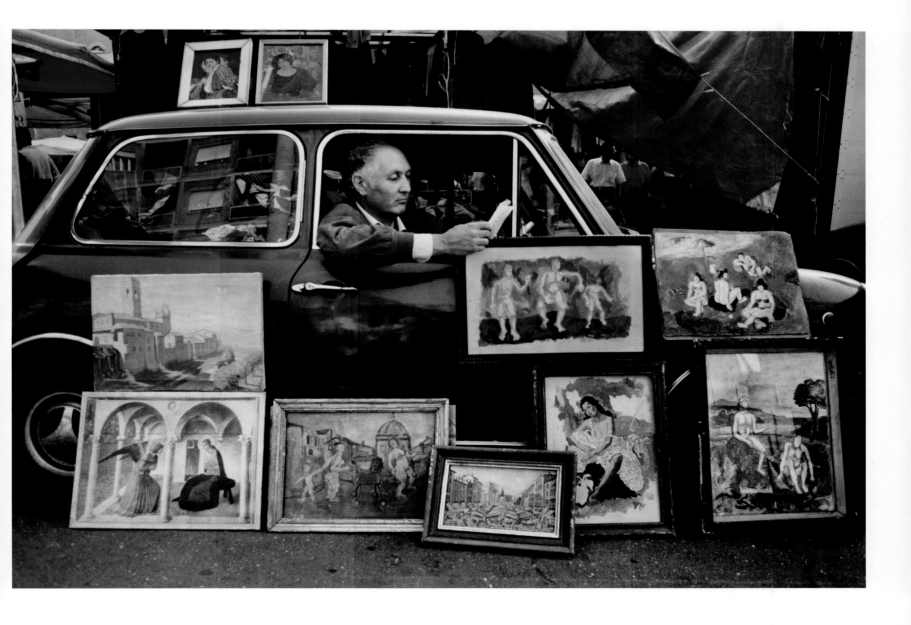

↑
Günther Förg

The Foro Italico sports complex, designed by Enrico Del Debbio and Luigi Moretti, was inaugurated in 1932 as the Foro Mussolini. It was conceived as a monumental architectural complex decorated with works of art, and was completed between 1956 and 1968. The 10,000 square meters of mosaics on the walls and the floor were designed by Giulio Rosso, Gino Severini, Angelo Canevari and Achille Capizzano, and executed by over 200 mosaic artists from the Spilimbergo school of mosaic (Friuli), 1983.

Die Sportanlage des Foro Italico, errichtet nach Plänen von Enrico Del Debbio und Luigi Moretti, wurden 1932 als „Foro Mussolini" eingeweiht, danach wurde bis zum Ende der 1930er-Jahre und nach dem Krieg in den Jahren 1956 bis 1968 daran weitergebaut. Der mit zahlreichen Kunstwerken geschmückte Monumentalkomplex ist unter anderem mit insgesamt 10.000 Quadratmetern Wandmosaiken nach Entwürfen von Giulio Rosso, Gino Severini, Angelo Canevari und Achille Capizzano ausgestattet, die von über 200 Mosaizisten der Fachschule für Mosaikkunst im friaulischen Spilimbergo ausgeführt wurden, 1983.

Œuvre d'Enrico Del Debbio et de Luigi Moretti, inauguré en 1932 sous le nom de Forum Mussolini ; le complexe sportif du Foro Italico est un ouvrage architectonique complexe et gigantesque, orné de nombreuses œuvres d'art. Sa construction, qui se pousuivit tout au long des années 1930, ne fut achevée qu'après la guerre, entre 1956 et 1968. D'une superficie de 10 000 mètres carrés, les murs et les sols sont recouverts de mosaïques dont la conception revient à des artistes tels que Giulio Rosso, Gino Severini, Angelo Canevari et Achille Capizzano et dont la réalisation fut assurée par plus de 200 artisans de l'école des mosaïstes de Spilimbergo (Frioul), 1983.

→
Günther Förg

The Palazzo della Civiltà Italiana, created in the early Fascist period and completed after World war II, was restored between 2008 and 2010, and in 2013 was leased to the Fendi-Arnault group for 2.8 million Euros a year until the year 2028, 1983.

Der Palazzo della Civiltà Italiana. In faschistischer Zeit begonnen und nach dem Ende des Zweiten Weltkriegs fertiggestellt, wurde der Bau 2008 bis 2010 renoviert und 2013 zu einer jährlichen Pacht von 2,8 Millionen Euro bis 2028 an die französische Unternehmensgruppe Fendi-Arnault vermietet, 1983.

Le Palais de la civilisation italienne, dont les travaux débutèrent sous le fascisme, fut achevé après la guerre. Restauré entre 2008 et 2010, il est loué depuis 2013, pour une période de quinze ans, au groupe Fendi-Arnault contre un loyer annuel de 2,8 millions d'euros, 1983.

↑
Bettina Rheims

Ornella Muti poses as a painter, 1989.

Ornella Muti als Malerin, 1989.

Ornella Muti posant en artiste peintre, 1989.

pp. 416/417
O. Louis Mazzatenta

A traditional carrozzella *(horse and carriage) and a Fiat Cinquecento on the Appian Way, 1981.*

Eine traditionelle Pferdedroschke und ein Fiat Cinquecento auf der Via Appia, 1981.

Une calèche traditionnelle et une Fiat Cinquecento sur la via Appia, 1981.

→
Peter Lindbergh

Kristen McMenamy photographed for Vogue, *1985.*

Kristen McMenamy, fotografiert für die Vogue, *1985.*

Kristen McMenamy photographiée pour Vogue, *1985.*

*"Rome is eternal, its decadence
will never end."*

*„Rom ist ewig, sein Verfall
wird niemals enden."*

*« Rome est éternelle, sa décadence
n'aura jamais de fin. »*
GIULIO CARLO ARGAN, 1991

↑
Ferdinando Scianna

Portrait of Maria Grazia Cucinotta, 1996.

Maria Grazia Cucinotta, 1996.

Portrait de Maria Grazia Cucinotta, 1996.

→
Ferdinando Scianna

*Galleria Colonna (now Galleria Alberto
Sordi), fashion story for fashion designer Liza
Bruce, 1990.*

*Model in der Galleria Colonna (heute Galle-
ria Alberto Sordi); aus einer Modebildstrecke
für die Designerin Liza Bruce, 1990.*

*Galerie Colonna (aujourd'hui galerie Alberto
Sordi), «fashion story» pour la styliste Liza
Bruce, 1990.*

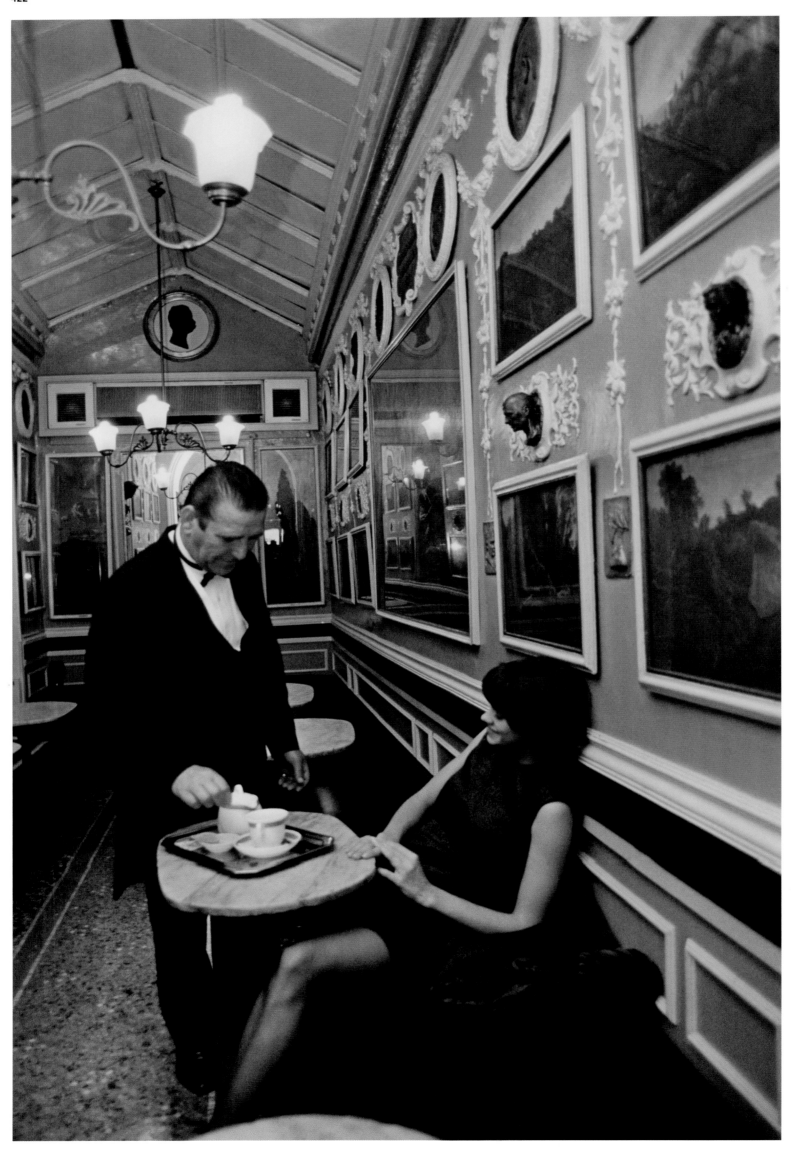

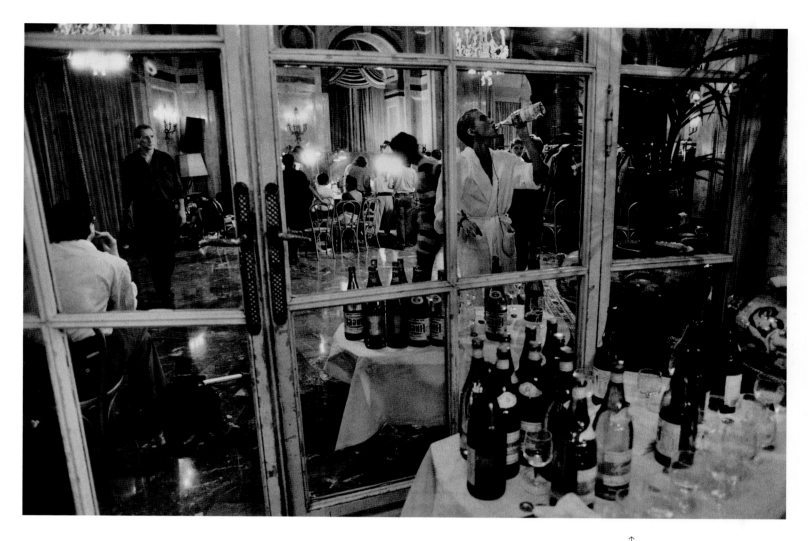

↑
Ferdinando Scianna

Backstage at a fashion show, 1988.

Am Rande einer Modenschau, 1988.

Les coulisses d'un défilé de mode, 1988.

←
Ferdinando Scianna

Caffè Greco, fashion story with Demetra Hampton, 1989.

Caffè Greco, Modebildstrecke mit Demetra Hampton, 1989.

Au Caffè Greco, « fashion story » avec Demetra Hampton, 1989.

pp. 424/425
Livio Anticoli

Pope John Paul II celebrates the ordination ceremony of 11 bishops in St. Peter's, January 1993.

Papst Johannes Paul II. bei der Weihe von elf neuen Bischöfen in St. Peter, Januar 1993.

Le pape Jean-Paul II célébrant l'ordination de onze évêques à la basilique Saint-Pierre, janvier 1993.

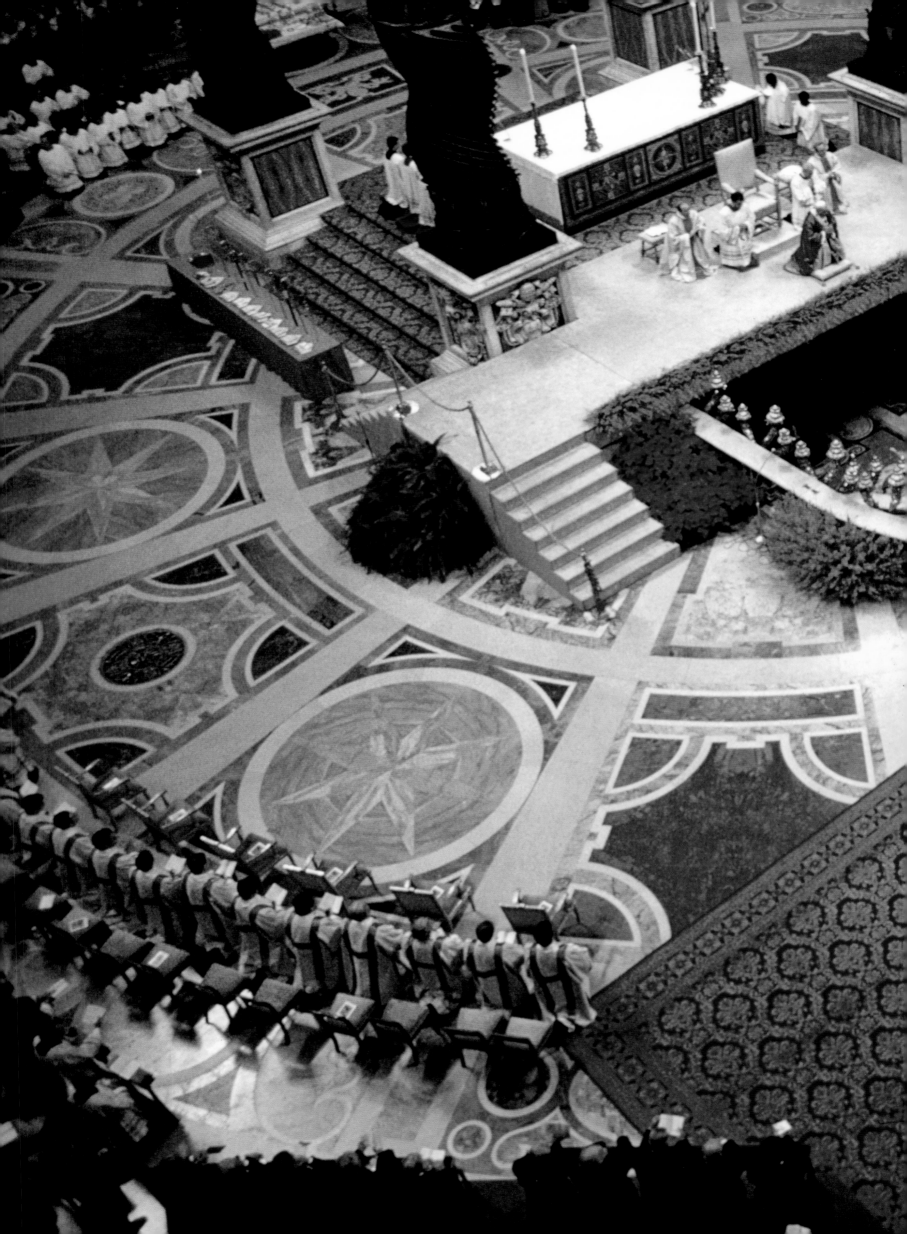

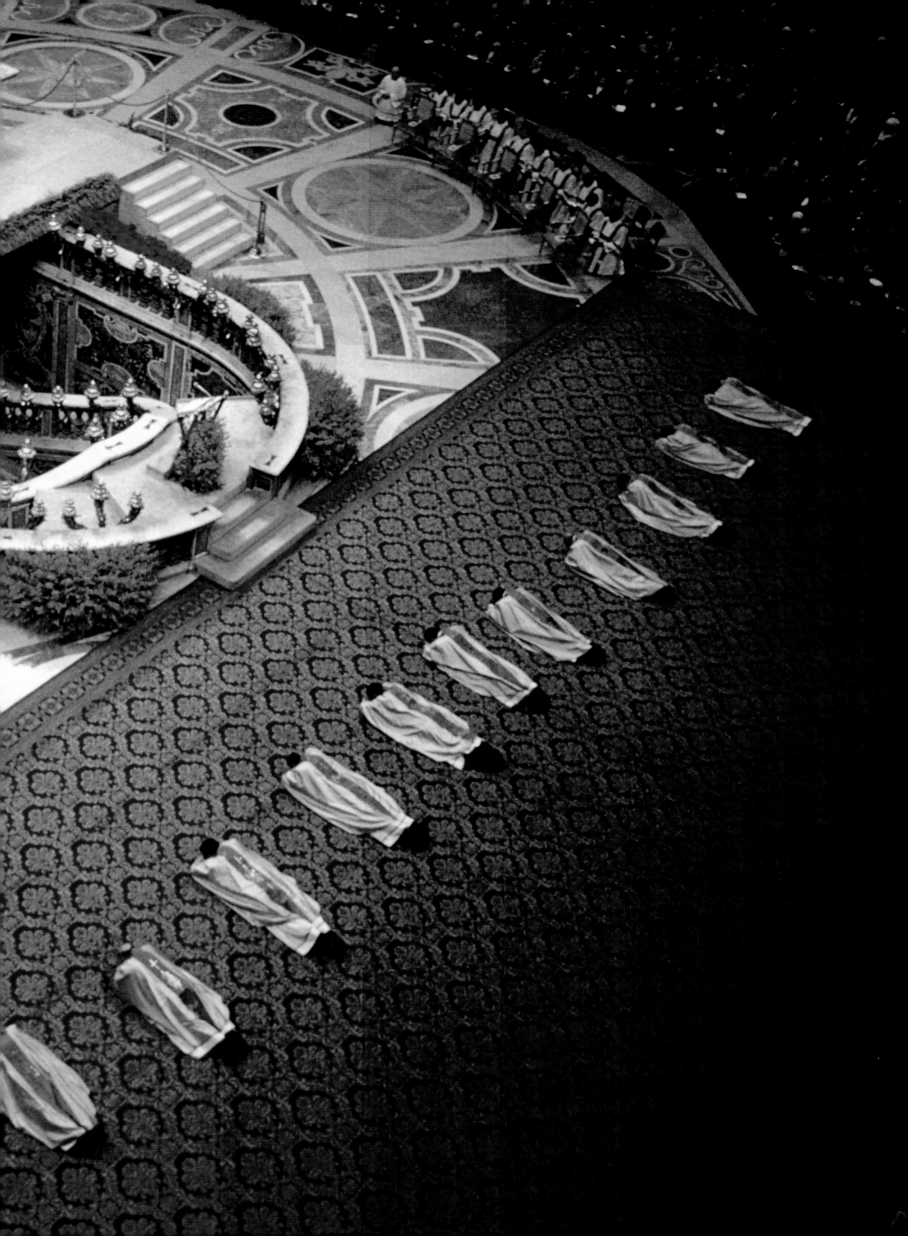

←

Peter Lindbergh

Kate Moss photographed for
Harper's Bazaar, *1994.*

Kate Moss, fotografiert für
Harper's Bazaar, *1994.*

Kate Moss photographiée pour
Harper's Bazaar, *1994.*

↘

Peter Lindbergh

Naomi Campbell photographed for
Harper's Bazaar, *1996.*

Naomi Campbell, aufgenommen für
Harper's Bazaar, *1996.*

Naomi Campbell photographiée pour
Harper's Bazaar, *1996.*

↑
Bettina Rheims

Claude in Rome, wearing a turban, 1998.

Claude mit Turban in Rom, 1998.

Claude à Rome, avec un turban, 1998.

→
Arthur Elgort

Claudia Schiffer at the entrance to the legendary Harry's Bar in Via Veneto, for Valentino, 1995.

Claudia Schiffer am Eingang von Harry's Bar an der Via Veneto, fotografiert für Valentino, 1995.

Claudia Schiffer à l'entrée du légendaire Harry's Bar dans la via Veneto, pour Valentino, 1995.

WOODY
ALLEN

ALEC
BALDWIN

ROBERTO
BENIGNI

PENÉLOPE
CRUZ

JUDY
DAVIS

JESSE
EISENBERG

GRETA
GERWIG

ELLEN
PAGE

TO ROME WITH LOVE

ÉCRIT ET RÉALISÉ PAR WOODY ALLEN

*"Even as a young man I was left-wing, but I couldn't
be a Communist. I could never share the bathroom."*

*„Als junger Mann war ich auch links, aber nie Kommunist,
ich hätte nie das Bad mit anderen teilen können."*

*« Quand j'étais jeune, j'étais de gauche, mais je n'étais pas
communiste, je n'aurais jamais pu partager la salle de bains. »*

WOODY ALLEN, *TO ROME WITH LOVE*, 2012

←

Jonathan Becker

*Valentino and the model Agnese in the
courtyard of Palazzo Mignanelli, the
historic headquarters of his fashion house,
photographed for* Vanity Fair, *2004.*

*Valentino mit dem Fotomodell Agnese im
Innenhof des Palazzo Mignanelli, dem
historischen Firmensitz seines Modehauses,
aufgenommen für* Vanity Fair, *2004.*

*Valentino et le mannequin Agnese dans la
cour du palais Mignanelli, siège historique
de la maison de couture, photographié pour*
Vanity Fair, *2004.*

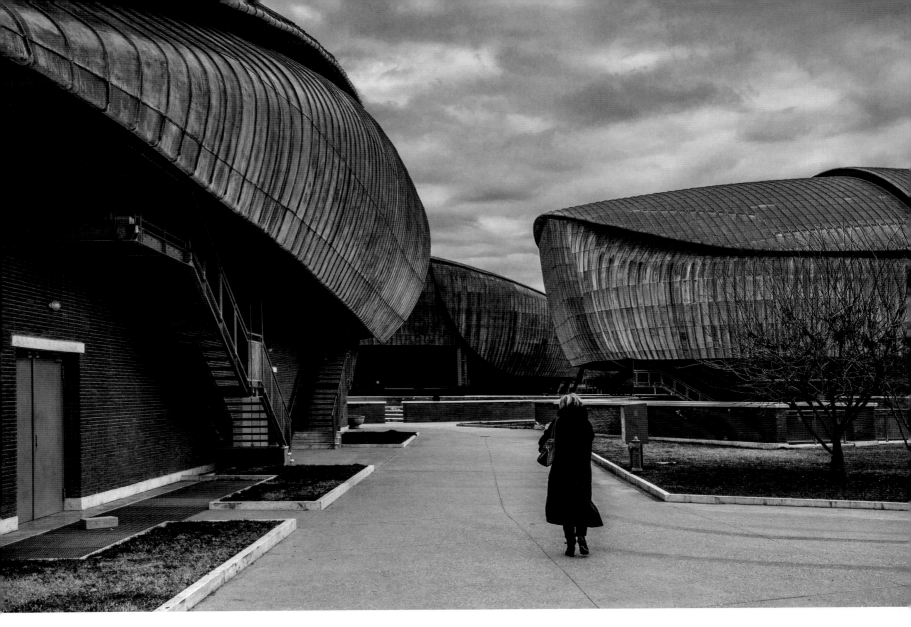

↑

Alberto Fanelli

The Auditorium, designed by Renzo Piano, in the Parco della Musica, an area of five-and-a-half acres in the Flaminio district, between Villa Glori, the Parioli Hill, and the Villaggio Olimpico, 2013.

Renzo Pianos Auditorium im Parco della Musica, einem fünfeinhalb Hektar großen Areal im Flaminio-Viertel zwischen Villa Glori, dem Parioli-Hügel und dem Olympischen Dorf, 2013.

L'Auditorium conçu par Renzo Piano dans le Parco della Musica, espace de 5,5 hectares dans le quartier Flaminio, entre la villa Glori, la colline des Parioli et le village olympique, 2013.

pp. 432/433
Tino Soriano

Via Condotti: a contemporary contrast, 2012.

Via Condotti, Gegensätze der heutigen Zeit, 2012.

Via Condotti, contraste contemporain, 2012.

↓
Roland Halbe

The interior of the Ara Pacis Museum, designed by Richard Meier, 2006.

Innenansicht des von Richard Meier entworfenen Museums der Ara Pacis, 2006.

Intérieur du musée de l'Ara Pacis, œuvre de Richard Meier, 2006.

pp. 436/437
Martin Parr

A traffic policeman directs traffic in front of the Monument to Victor Emmanuel II – a picture not lacking in humor, 2005.

Ein Polizist regelt den Verkehr auf der Piazza Venezia vor dem Denkmal für Viktor Emanuel II. Ein Bild nicht ohne humorvolle Note, 2005.

Un agent de police règle le trafic devant le monument à Victor-Emmanuel II. Une image non dénuée d'humour, 2005.

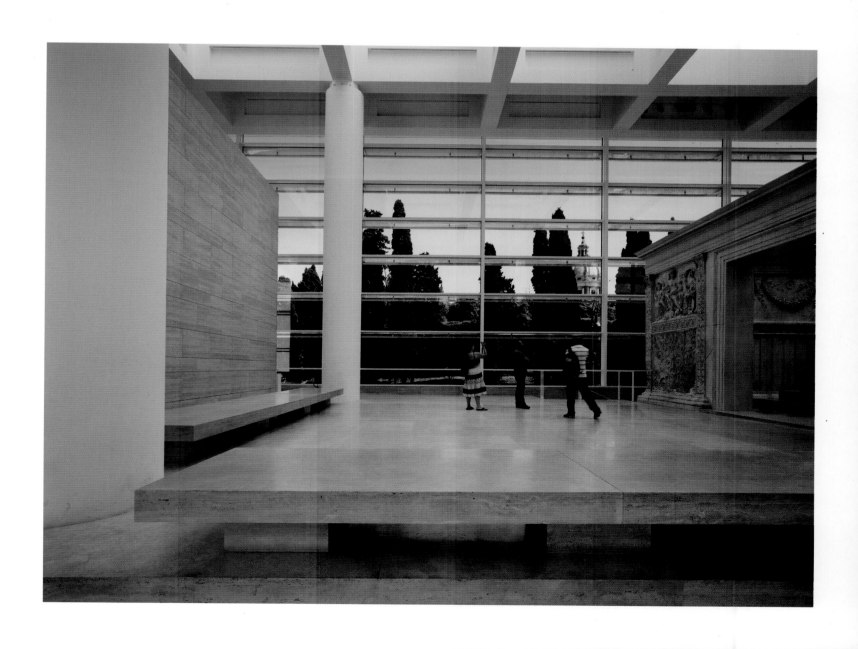

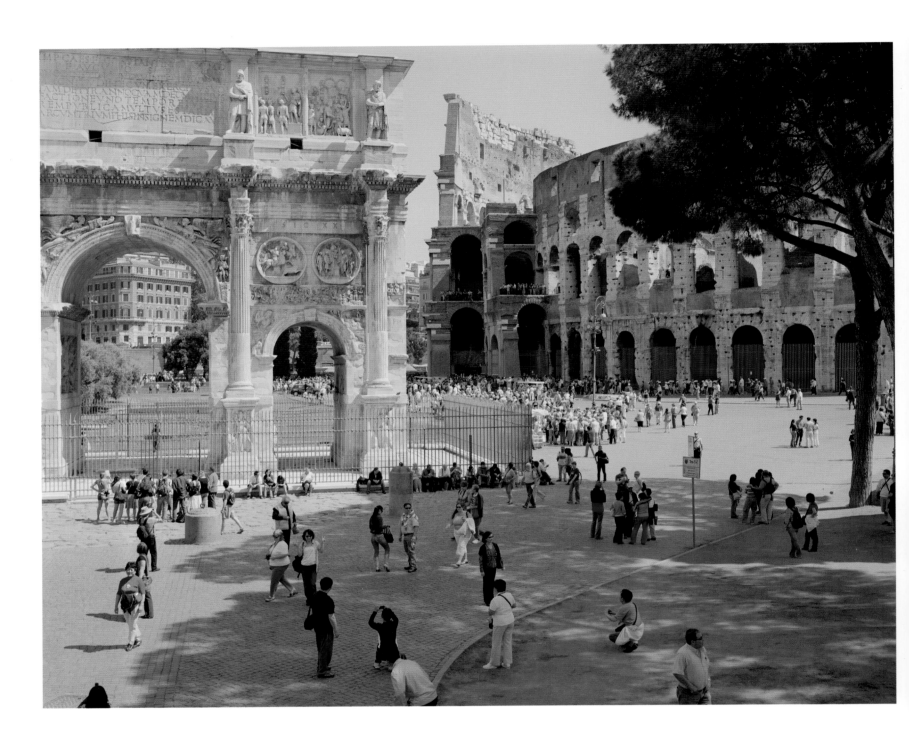

↑

Massimo Vitali

The Roman Forum defaced by mass tourism. Railings prevent people from touching the monuments, 2015.

Touristenströme ergießen sich auf das Forum Romanum, Absperrgitter schaffen eine unüberbrückbare Distanz zu den Denkmälern der Vergangenheit, 2015.

Le Forum romain menacé par le tourisme de masse. Les grilles empêchent tout contact physique avec les monuments historiques, 2015.

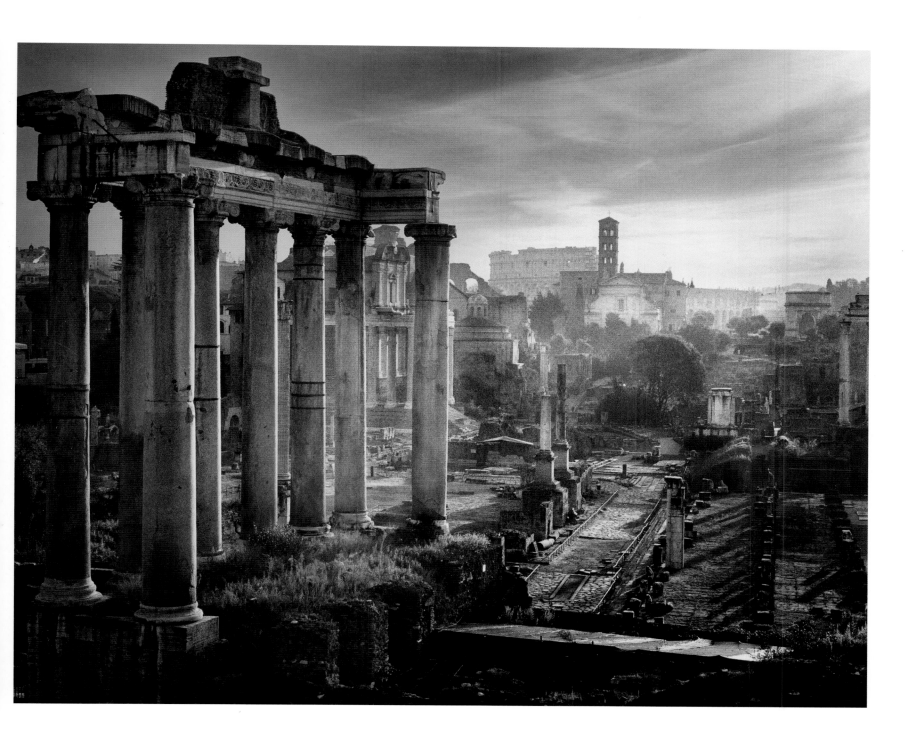

↑

Vincent Peters

The Roman Forum, forever a place filled with historical and symbolic significance in the very heart of Rome, 2015.

Auf dem Forum Romanum verdichtet sich von jeher die historische und symbolische Dimension der Ewigen Stadt, 2015.

Le Forum romain demeure un lieu chargé de valeurs historiques et symboliques au cœur même de la Ville éternelle, 2015.

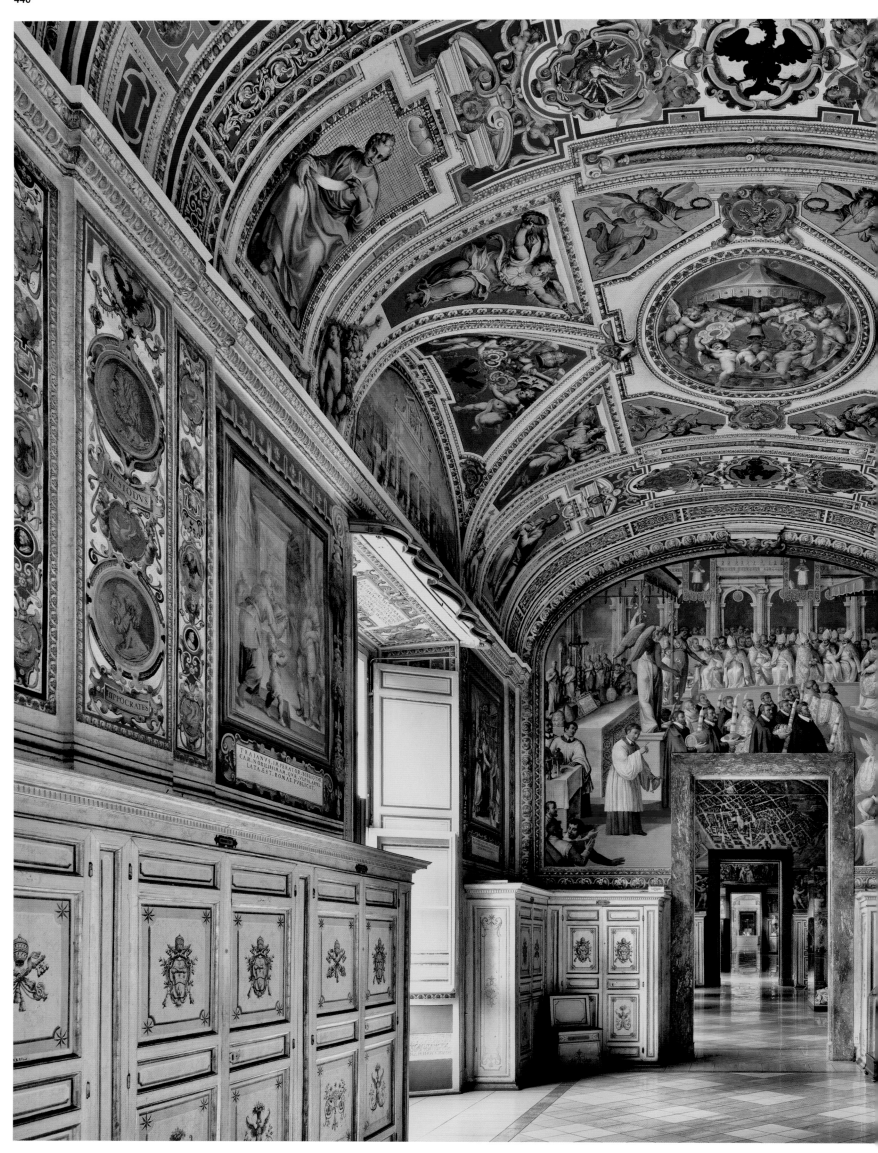

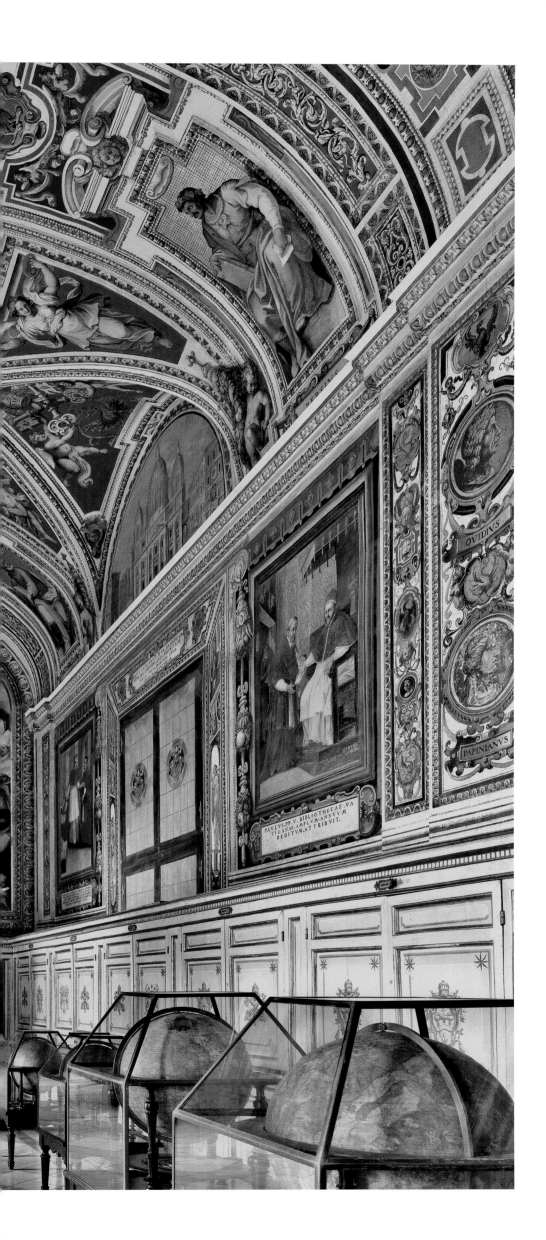

←

Massimo Listri

Created in the 15th century, the Apostolic Library in the Vatican owns one of the most important collections of ancient manuscripts and rare books in the world, 2015.

Die Biblioteca Apostolica Vaticana, deren Ursprünge auf das 15. Jahrhundert zurückgehen, verfügt über eine der bedeutendsten Sammlungen von antiken Handschriften und seltenen Drucken weltweit, 2015.

Fondée au xv^e siècle, la Bibliothèque apostolique vaticane possède une collection de textes anciens et de livres rares parmi les plus importantes du monde, 2015.

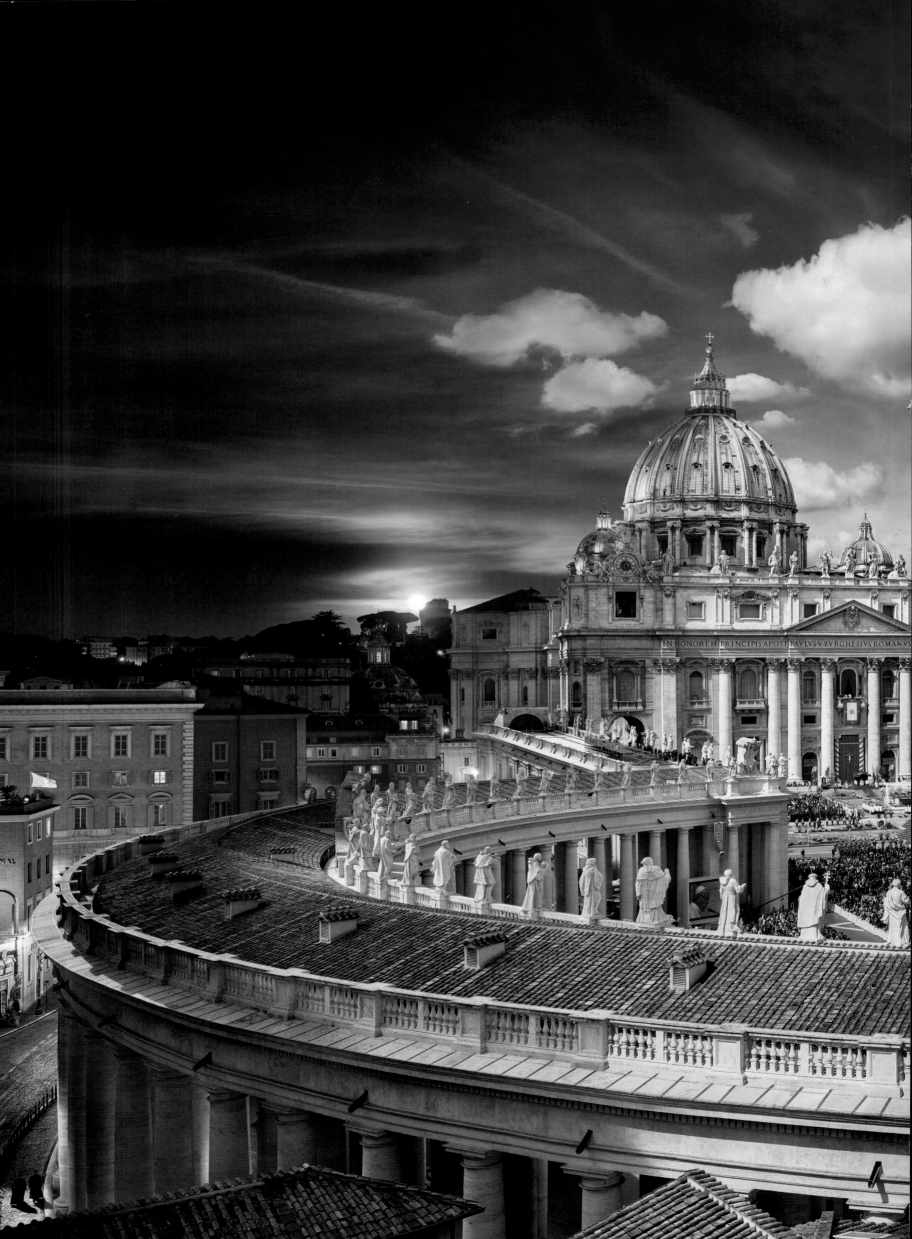

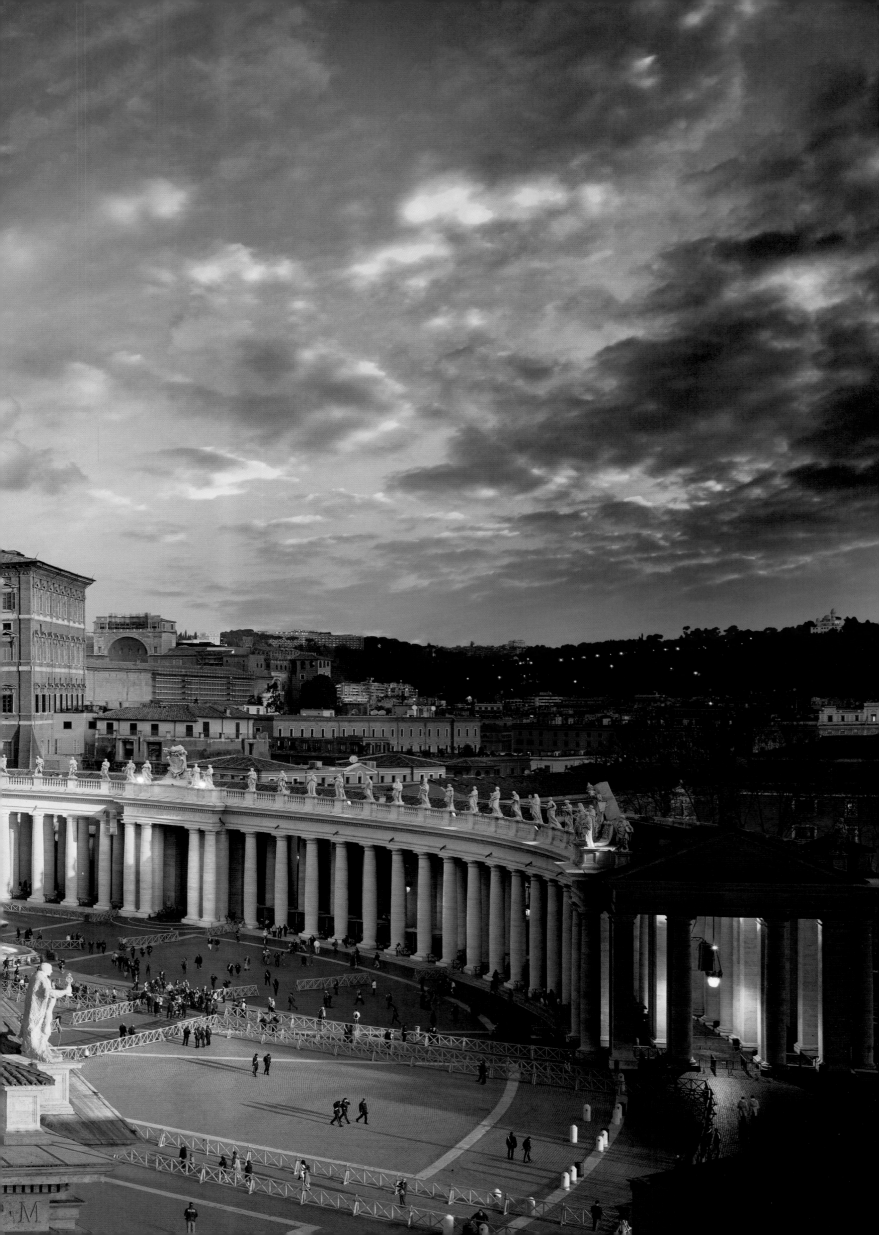

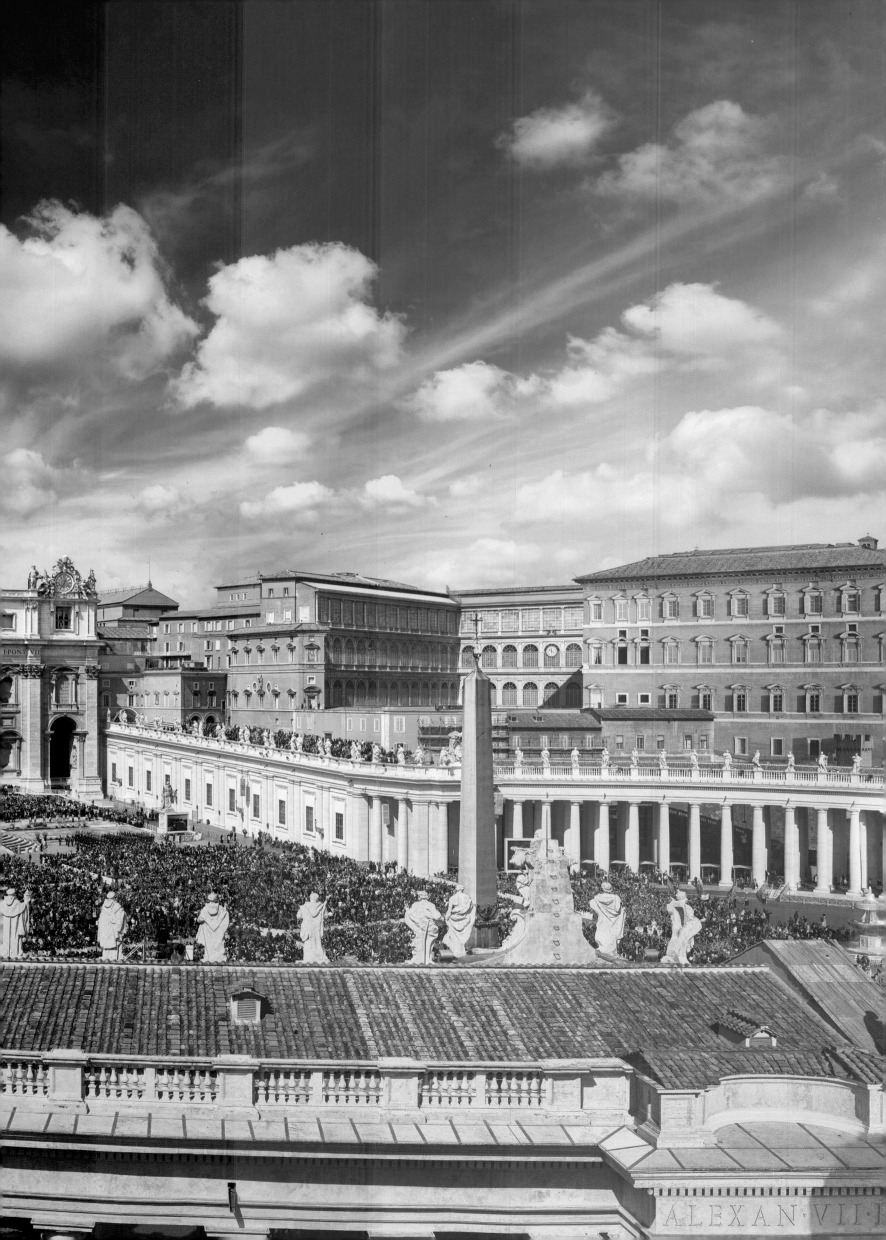

↑
Dave Yoder

Creating a link with the ideals of renewal of the Catholic Church pursued by John XXIII and John Paul II, Francis I forges a profound and genuine relationship with the people, 2015.

Anknüpfend an die Bestrebungen von Johannes XXIII. und Johannes Paul II. zu einer Erneuerung der Kirche, sucht Papst Franziskus mit Entschiedenheit den unmittelbaren Kontakt mit den Gläubigen, 2015.

Renouant idéalement avec l'œuvre de rénovation de l'Église catholique poursuivie par Jean XXIII et Jean-Paul II, le pape François établit une relation profonde et authentique avec le peuple, 2015.

pp. 448/449
Ferdinando Scianna

The relationship between Romans and their urban spaces and monuments has radically altered in the last few decades, 1983.

In den letzten Jahren hat sich das Verhältnis der Römer zum öffentlichen Raum (und zu den Denkmälern der Stadt) stark gewandelt, 1983.

La relation des Romains avec les espaces urbains (et les monuments) s'est profondément modifiée au cours des dernières décennies, 1983.

↓ →

Dave Yoder

Two moments of Pope Francis's constant pursuit to communicate with people humbly and directly, 2015.

Zwei Momente der Begegnung des Papstes Franziskus mit den Menschen, 2015.

Deux instants qui illustrent la volonté du pape François de communiquer avec les gens directement et en toute simplicité, 2015.

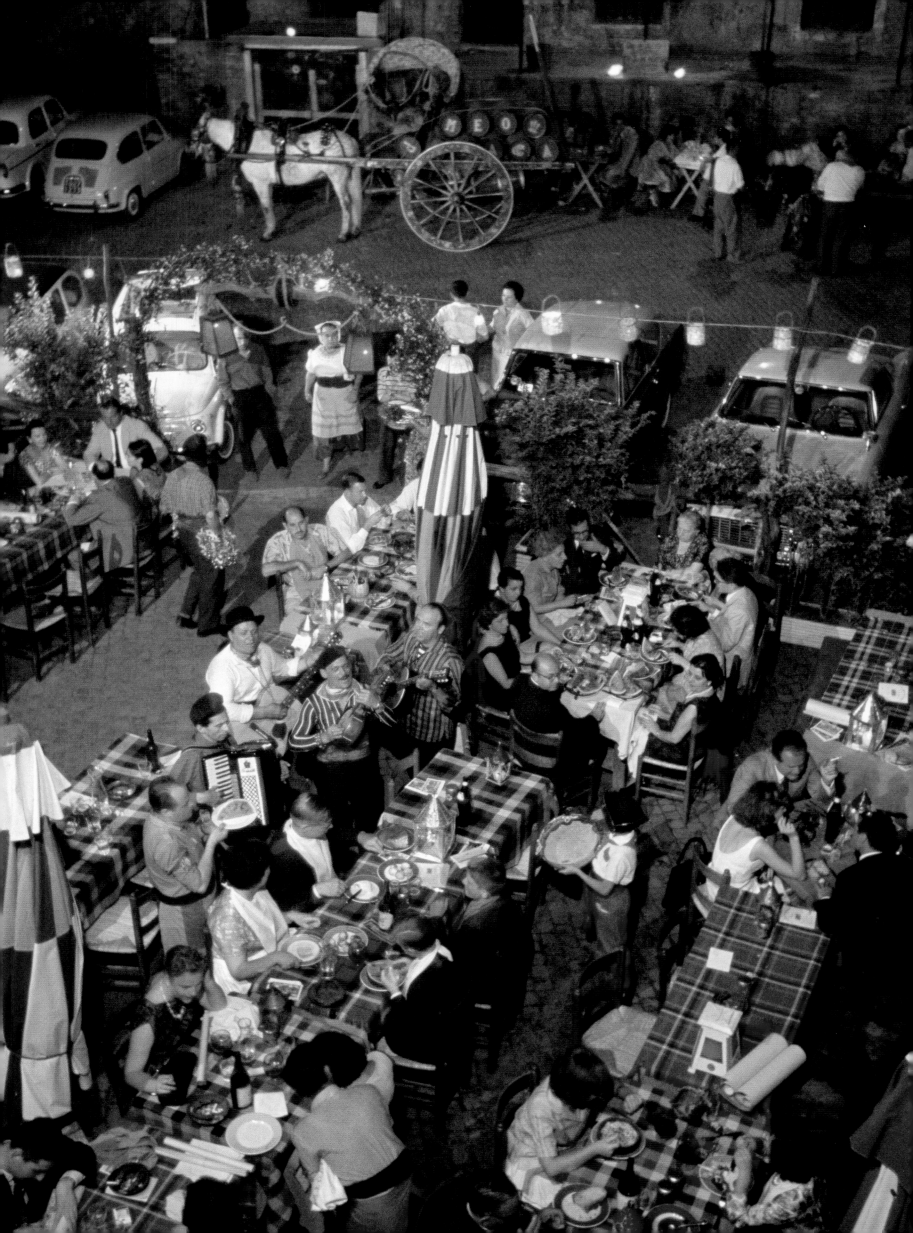

Brief Biographies of the Photographers
Kurzbiografien der Fotografen
Courtes biographies des photographes

Aarons, Slim *(1916–2006)*
George Allen Aarons was born in New York. After working as a photographer during World War II he moved to California and became an established portraitist of actors and celebrities. His photographs have been published in many magazines, such as *Life* and *Harper's Bazaar*. He published several books of photographs, including *A Wonderful Time: An Intimate Portrait of the Good Life* (1974).

George Allen Aarons, gebürtiger New Yorker, Kriegsfotograf im Zweiten Weltkrieg, später in Los Angeles beheimatet, wurde durch seine Porträts bekannter Persönlichkeiten und Schauspieler berühmt. Seine Bilder erschienen in Zeitschriften wie *Life* und *Harper's Bazaar*. Er war Autor mehrerer Fotobücher, darunter *A Wonderful Time: An Intimate Portrait of the Good Life* (1974).

George Allen Aarons est né à New York. Après avoir été photographe de guerre durant la Seconde Guerre mondiale, il s'établit en Californie où il s'impose comme portraitiste d'acteurs et autres célébrités. Ses photographies sont publiées dans divers magazines comme *Life* ou *Harper's Bazaar*. Il est l'auteur de plusieurs livres de photographies dont *A Wonderful Time: An Intimate Portrait of the Good Life* (1974).

Abéniacar, Charles *(?–1912)*
A lawyer and a publicist, he was a photographer in Rome and Naples. Between the end of the 19th and the early 20th centuries, for almost 20 years he worked with *L'Illustration*, *Le Figaro*, and *Illustrirte Zeitung*, providing news and images of Italian events.

Anwalt und Publizist, in Rom und Neapel tätig; um die Jahrhundertwende war er zwei Jahrzehnte lang Italienkorrespondent und -fotograf von *L'Illustration*, *Le Figaro* und der *Illustrirten Zeitung*.

Avocat et publiciste, il est photographe à Rome et à Naples. Entre la fin du XIXᵉ siècle et le début du XXᵉ siècle, il collabore une vingtaine d'années à *L'Illustration*, au *Figaro* et à l'*Illustrirte Zeitung*, fournissant informations et images sur l'actualité italienne.

Altobelli, Gioacchino *(1814–1878)*
A painter, he was a student of Tommaso Minardi. From around 1860 until 1865 he was associated with photographer Pompeo Molins. He patented a two-matrix procedure to create images of monuments with sky and moonlight effects (1866). The views of Rome he edited with Molins are characterized by groups of elegant figures posing for the photograph. He photographed and documented the new railroad of the Papal State. Until around 1875, he was director of the photographic studio that previously belonged to Michele Petagna and from around 1870 to Enrico Verzaschi.

Der Maler, Schüler von Tommaso Minardi und 1860 bis 1865 Kompagnon von Pompeo Molins entwickelte ein 1866 patentiertes Zweiplattenverfahren zur Wiedergabe von Architekturmotiven im Mondlicht und mit Wolkenhintergrund. Charakteristisch für seine Rom-Ansichten sind die elegant posierenden Figuren. Altobelli fotografierte die neuen päpstlichen Eisenbahnlinien. Bis 1875 leitete er die von Michele Petagna gegründete und bis 1870 von Enrico Verzaschi betriebene Fotografische Anstalt.

Peintre, élève de Tommaso Minardi. De 1860 à 1865, il s'associe au photographe Pompeo Molins. Il fait breveter un procédé à deux matrices pour figurer des monuments avec des effets de ciel et de clair de lune (1866). Ses vues de Rome publiées avec Molins se distinguent par la présence de personnages élégants prenant la pose. Il photographie les nouvelles lignes ferroviaires de l'État pontifical. Jusque vers 1875, il dirige le studio photographique qui avait appartenu à Michele Petagna, puis à Enrico Verzaschi à partir du début des années 1870.

Anderson, James *(1813–1877)*
Anderson, Domenico *(1854–1938)*
Isaac Atkinson studied painting in Paris under the pseudonym of Dunbar. In 1938 he moved to Rome, where he was active as a painter and photographer under the name of James Anderson. In the early 1950s he founded a commercial photographic studio and in 1859 published his first album of photographs, which were sold exclusively at the Spithöver bookshop. He was one of the most gifted illustrators of Roman monuments, producing also work in large format. At his death, his studio was inherited by his son Domenico, who enlarged its catalogue, which was later taken up by his children.

Isaac Atkinson studierte zunächst unter dem Künstlernamen Dunbar in Paris Malerei. 1838 ging er nach Rom. Dort wirkte er unter dem Namen James Anderson als Maler und Fotograf. Anfang der 1850er-Jahre gründete er einen eigenen Betrieb, 1859 erschien sein erster Katalog, dessen Motive er exklusiv über die römische Buchhandlung Spithöver vertrieb. Bedeutend sind vor allem Andersons teils großformatige Bilder von römischen Altertümern. Nach seinem Tod wurde das Geschäft von seinem Sohn Domenico weitergeführt, der den Motivkatalog erheblich erweiterte, später von dessen Nachfahren.

Isaac Atkinson étudie la peinture à Paris sous le pseudonyme de Dunbar. En 1838, il s'établit à Rome où il travaille comme peintre et photographe sous le nom de James Anderson. Au début des années 1850, il fonde une entreprise photographique et, en 1859, publie son premier catalogue de photos vendues exclusivement par la librairie Spithöver. Il est l'un des meilleurs interprètes des monuments de Rome, y compris en grand format. À sa mort, son fils Domenico lui succède à la tête de l'entreprise dont il enrichit considérablement le catalogue ; ses fils prendront la relève.

ANSA Agency
Agenzia Nazionale Stampa Associata (Associated National Press Agency) was the first multimedia information agency in Italy, founded in 1945 with the approval of the Allied military authorities, replacing the dissolved Stefani agency.

Die Agenzia Nazionale Stampa Associata, 1945 mit dem Segen der alliierten Besatzung als Nachfolgerin der aufgelösten Agentur Stefani gegründet, war die erste italienische Nachrichtenagentur, die sowohl im Text- wie auch im Bildbereich arbeitete.

L'Agenzia Nazionale Stampa Associata est la première agence de presse multimédia d'Italie, qui voit le jour en 1945 avec l'autorisation des autorités militaires alliées, pour succéder à l'agence Stefani dissoute.

Barbey, Bruno *(1941–2020)*
Born in Morocco, he is a reporter/photographer, and since 1968 has been a member of Magnum. His photographic features have been published in *Time*, *Life*, *Stern*, *Paris Match*, *The Sunday Times Magazine*, and *National Geographic*. He has published several books of photographs.

Der in Marokko geborene Fotojournalist Barbey ist seit 1968 Mitglied von Magnum. Seine Reportagen sind in *Time*, *Life*, *Stern*, *Paris Match*, *The Sunday Times Magazine* und *National Geographic* erschienen; er hat mehrere Fotobücher veröffentlicht.

Né au Maroc, ce photojournaliste est membre de l'agence Magnum Photos depuis 1968. Ses reportages ont paru dans *Time*, *Life*, *Paris Match*, *The Sunday Times Magazine*, *National Geographic*. Il est l'auteur de plusieurs livres de photographies.

Bavagnoli, Carlo *(1932–)*
In 1951, on completing his studies, he enrolled at the law faculty in Milan. At the Accademia di Brera he met Ugo Mulas. He began to collaborate with *Illustrazione Italiana*, *Tempo Illustrato*, and *Cinema Nuovo*, and in 1955 started taking photographs for *Epoca*; the following year he moved to the Roman branch of the magazine. He began a long documentary project on the popular district of Trastevere, thanks to which he made first contact with *Life*, and in 1963 he published this work in the photo book *Gente di Trastevere*, with texts by Federico Fellini.

Nach dem Studium der alten Sprachen schrieb Bavagnoli sich 1951 an der juristischen Fakultät in Mailand ein. An der Brera-Akademie lernte er Ugo Mulas kennen und begann für *Illustrazione Italiana*, *Tempo illustrato* und *Cinema Nuovo* zu fotografieren, 1955 schließlich für *Epoca*, bevor er im Jahr darauf zu deren römischer Redaktion wechselte. Seine über mehrere Jahre entstandenen Fotos aus dem Trastevere-Viertel weckten das Interesse des Magazins *Life*, das Bavagnolis Bilder 1963 mit Texten von Federico Fellini unter dem Titel *Gente di Trastevere* als Buch herausbrachte.

Après avoir fréquenté un lycée classique, il s'inscrit à la faculté de droit de Milan en 1951. À l'Accademia di Brera il rencontre Ugo Mulas. Il commence à faire des photographies pour l'*Illustrazione Italiana*, *Tempo illustrato* et *Cinema Nuovo*. 1955 marque le début de sa collaboration à *Epoca* et l'année suivante, il rejoint la rédaction romaine de la revue. Il entame alors un long travail de documentation sur le quartier populaire de Trastevere grâce auquel il est contacté par *Life* ; en 1963 ce travail fait l'objet d'un livre intitulé *Gente di Trastevere* avec des textes de Federico Fellini.

Becker, Jonathan *(1954–)*
Born in New York; in the mid-1970s he was in Paris, where he met Brassaï. A portrait artist and fashion photographer, he has been published in *The New Yorker*, *Vogue*, *The Paris Review*, and has had a long-standing collaboration with *Vanity Fair*.

Mitte der 1970er-Jahre ging der New Yorker Fotograf nach Paris, wo er Brassaï kennenlernte. Becker lieferte Porträts und Modefotos für den *New Yorker*, *Vogue*, *The Paris Review* und fotografierte lange Jahre für *Vanity Fair*.

Il voit le jour à New York. Au milieu des années 1970, il est à Paris où il rencontre Brassaï. Les clichés de ce portraitiste et photographe de mode ont été publiés dans *The New Yorker*, *Vogue*, *The Paris Review* et *Vanity Fair* auquel il a longtemps collaboré.

Bell Grosvenor, Melville *(1901–1982)*
In 1924 he resigned from the US Navy to work as a photographer for the National Geographic Society, of which he became president in 1957. He was the chief editor of *National Geographic* from 1957 to 1969.

Nach seinem Ausscheiden aus der US-Marine 1924 begann Bell Grosvenor als Fotograf für die National Geographic Society zu arbeiten, deren Präsident er 1957 wurde. Von 1957 bis 1969 leitete er die Redaktion der Zeitschrift *National Geographic*.

En 1924, il démissionne de la Marine américaine pour travailler comme photographe de la National

p. 450
Dean Conger

At Meo Patacca's, one of the most famous trattorias in Trastevere, in the Ghetto.

Tische vor der Trattoria Da Meo Patacca, einer der bekanntesten gastronomischen Adressen von Trastevere in der Gegend des ehemaligen Gettos.

Da Meo Patacca, l'une des plus célèbres trattorie de Trastevere.

Geographic Society dont il devient le président en 1957. Il exerce les fonctions de rédacteur en chef du *National Geographic* de 1957 à 1969.

Belli, Filippo *(1836–1927)*

A painter-photographer, he began to take photographs at the end of the 1850s. Between the mid-1870s and the mid-1880s, he produced a series of views, life subjects, and genre scenes of high formal quality (farmers, washerwomen, water carriers, pipers, etc.) taken in the Roman countryside, for use by artists' studios.

Der „Maler-Fotograf" begann Ende der 1850er-Jahre zu fotografieren. Zwischen Mitte der 1870er- und Mitte der 1880er-Jahre entstand eine Folge von gestalterisch bemerkenswerten „Ansichten und Motiven nach der Wirklichkeit" sowie Genreszenen (Bauern, Waschfrauen, Wasserträgerinnen, Spielleute usw.), aufgenommen in den Dörfern der römischen Campagna, die teils von Malern als Vorlagen benutzt wurden.

« Peintre photographe », il débute la photographie à la fin des années 1850. Entre le milieu des années 1870 et celui de la décennie suivante, il réalise une série de « vues et sujets d'après nature » et des scènes de genre (paysans, lavandières, porteuses d'eau, fifres, etc.) dans les villages de la campagne romaine, également destinées aux artistes pour étude, qui se distinguent par leur grande qualité formelle.

Bruni, Armando *(active between 1911 and 1950)*

Armando Bruni was a renowned photojournalist in the period between the two world wars, producing features on current events, politics and sports during the Fascist era.

In den Jahren zwischen den Weltkriegen war Bruni einer der wichtigsten italienischen Pressefotografen, die das Tagesgeschehen, politische sowie sportliche Ereignisse der faschistischen Jahre dokumentierten.

Durant l'entre-deux-guerres, Armando Bruni se distingue parmi les photojournalistes italiens en illustrant des faits divers et les événements politiques et sportifs marquants de la période fasciste.

Caneva, Giacomo *(1813–1865)*

Trained at the Accademia di Venezia as a perspective painter, he moved to Rome in 1838. He is documented as a painter-photographer, and frequented the circle of the Caffè Greco. He used daguerreotype, calotype, and colloidal processes. In 1855 he published a valuable handbook on photographic technique. His shots reveal a high aesthetic sensibility, and his images were sought after by contemporary travellers and collectors. They include views of Roman monuments, the Roman countryside, costumes, genre scenes, nature studies, and works of art. After his death, some of his negatives were still being used by Ludovico Tuminello.

Nach einer Ausbildung als „Perspektivmaler" an der Kunstakademie Venedig ging Caneva 1838 nach Rom, wo er als „Maler-Fotograf" reüssierte und zum Caffè-Greco-Kreis stieß. Er arbeitete in Daguerreotypietechnik, vor allem mit Kalotypien, später auch im Kollodiumverfahren. 1855 veröffentlichte er ein bedeutendes Handbuch für die fotografische Praxis. Canevas Aufnahmen mit Ansichten der Ewigen Stadt und aus der römischen Campagna, seine Genre- und Trachtenbilder, Naturstudien und Aufnahmen von Kunstwerken verraten einen erlesenen Geschmack und fanden bei Reisenden und Sammlern großen Anklang. Nach seinem Tod vertrieb Ludovico Tuminello Abzüge von einigen seiner Negative.

En 1838, après avoir reçu une formation de « peintre de perspective » à l'Académie de Venise, il s'établit comme « peintre photographe » à Rome où il fréquente le cercle du Caffè Greco. Il emploie la daguerréotypie, et aussi et surtout la calotypie outre le procédé au collodion. En 1885, il publie un remarquable manuel de technique photographique. Une grande sensibilité esthétique imprègne ses clichés, très prisés des voyageurs et des collectionneurs de l'époque ; ils se composent de vues des monuments de Rome et de la campagne romaine, de personnes en costume traditionnel, de scènes de genre, d'études de paysage et de reproductions d'œuvres d'art. Après sa mort, Ludovico Tuminello continuera à utiliser certains de ses négatifs.

Capa, Robert *(1913–1954)*

Born Endre Ernö Friedmann in Budapest, he studied political sciences in Berlin between 1931 and 1933. Passionate about photography, he published some images in *Berliner Illustrirte Zeitung*. In 1933 he emigrated to Paris to escape the Nazis. Between 1933 and 1939 he collaborated with numerous periodicals, such as *Life*, *Time*, and the *Illustrated London News*. In 1935 he participated in the creation of the Alliance agency, for which he created a famous reportage on the Spanish civil war. In 1938 he photographed the Japanese invasion of China, and used color photography for the first time. Subsequently he emigrated to the United States. Between 1941 and 1946 he was the war correspondent for *Life* and *Collier's*; he documented the Allied landing in France and Italy (1944). In 1947, with Cartier-Bresson, Seymour, Vandivert, and Rodger, he founded the cooperative photojournalism agency Magnum. In 1951 he photographed aspects of *la dolce vita* in Rome. He died while reporting on the war in Indo-China (Vietnam).

Endre Ernö Friedmann, geboren in Budapest, studierte von 1931 bis 1933 in Berlin Politikwissenschaften; die *Berliner Illustrirte Zeitung* druckte einige Aufnahmen des passionierten Hobbyfotografen. 1933 floh Capa vor den Nationalsozialisten nach Paris. Von 1933 bis 1939 arbeitete er für *Life*, *Time*, die *Illustrated London News* und andere Zeitschriften. 1935 gehörte er zu den Mitbegründern der Agentur Alliance Photo, für die er seine berühmt gewordene Reportage aus dem Spanischen Bürgerkrieg machte. 1938 dokumentierte er die japanische Invasion in China und verwendete dabei das erste Mal die Farbfotografie. Danach emigrierte Capa in die USA. Von 1941 bis 1946 war er Kriegsberichterstatter für *Life* und *Colliers*, 1944 dokumentierte er die Landung der Alliierten in Frankreich und Italien. Mit Cartier-Bresson, Seymour, Vandivert und Rodger gründete er im Jahr 1947 die unabhängige Fotoagentur Magnum Photos. 1951 machte Capa in Rom Fotos mit Szenen aus dem Dolce Vita. 1954 kam er bei einer Reportage vom Krieg in Indochina ums Leben.

Endre Ernö Friedmann voit le jour à Budapest ; entre 1931 et 1933, il suit des études de sciences politiques à Berlin. Passionné de photographie, il publie plusieurs de ses clichés dans le *Berliner Illustrirte Zeitung*. En 1933, fuyant le nazisme, il émigre à Paris. Entre 1933 et 1939, il collabore à de nombreux magazines tels que *Life*, *Time*, *Illustrated London News*. En 1935, il participe à la création de l'agence Alliance Photo pour laquelle il réalise un reportage sur la guerre d'Espagne qui deviendra célèbre. En 1938, il photographie l'invasion de la Chine par le Japon et utilise la couleur pour la première fois ; par la suite, il émigre aux États-Unis. De 1941 à 1946, il est correspondant de guerre pour *Life* et *Colliers* ; il photographie le débarquement et la campagne des forces alliées en France et en Italie (1944). En 1947, avec Cartier-Bresson, Seymour, Vandivert et Rodger il fonde l'agence coopérative de photoreportage Magnum Photos. À Rome en 1951, il y fixe certains aspects de la *dolce vita*. Il meurt en reportage durant la guerre d'Indochine.

Carbone, Mario *(1924–)*

Learning the art of photography as a very young man in his native region of Calabria, and then in Milan, in 1956 he moved to Rome, where he worked in cinema as a cameraman, director of photography and then director of documentaries with a journalistic slant. In the 1960s he filmed and photographed political and social demonstrations. In 1968 Carlo Levi asked him to accompany him to Lucania to take pictures of the places described in *Christ Stopped at Eboli*. As an cameraman and director, he has collaborated with the investigative film *I misteri di Roma* (1963), from an idea by Cesare Zavattini, in which 15 young authors narrate the life of the city, changed by the demographic growth and the economic boom.

In seiner Jugend erlernte Carbone in seiner kalabrischen Heimat und in Mailand den Fotografenberuf. 1956 ging er nach Rom und arbeitete als Kameramann, Bildregisseur und später auch als Regisseur von Dokumentarreportagen. In den 1960er-Jahren dokumentierte er in Film und Fotografie Arbeiterproteste und politische Demonstrationen. 1968 machte Carbone für Carlo Levi Aufnahmen an den Schauplätzen von dessen Roman *Christus kam nur bis Eboli*. 1963 wirkte er als Kameramann und Regisseur an der von Cesare Zavattini in Auftrag gegebenen Recherchedokumentation *I misteri di Roma* mit, in der 15 junge Autoren vom Leben in der von Wirtschaftsboom und Bevölkerungsexplosion gezeichneten Stadt erzählen.

Très jeune, il apprend le métier de photographe dans sa Calabre natale puis à Milan. En 1956, il part pour Rome où il travaille dans le milieu du cinéma comme opérateur, directeur de la photographie, puis réalisateur de documentaires de nature journalistique. Dans les années 1960, il filme et photographie des manifestations politiques et sociales. En 1968, Carlo Levi lui demande de l'accompagner en Lucanie pour photographier les lieux du *Christ s'est arrêté à Eboli*. En qualité d'opérateur et de réalisateur il prend part au film-enquête *I misteri di Roma* (1963) conçu par Cesare Zavattini, où quinze jeunes auteurs racontent la vie de la ville bouleversée par l'explosion démographique et le boom économique.

Cartier-Bresson, Henri *(1908–2004)*

After training as a painter, he devoted himself to cinema and photography. He was the assistant of Jean Renoir (*Une partie de campagne*, 1936; *La régle du jeu*, 1939), and was commissioned by the information service of the American Army to make the short film *Le Retour* (1945) about the repatriation of refugees and prisoners of war. In 1947 he was a co-founder of the Magnum agency. He brought himself to international attention with his choice of subjects and for his intuitive talent in his snapshots. In 1954 he was the first photographer to be admitted in the USSR. He worked in Italy taking photographs in 1933, in 1951 (Rome and southern Italy), 1952 (Rome), 1953, 1958 (Rome), 1959, and 1968. He published many books of photographs, including *Images à la Sauvette* (The Decisive Moment, 1952), *Les Européens* (1955) and *Henri Cartier-Bresson photographe* (1960). In 1966 he left Magnum, which, however, remained his agent, and from 1970 he dedicated himself exclusively to drawing. A year before his death, the Fondation Henri Cartier-Bresson was founded in Paris.

Nach einem Studium der Malerei widmete Cartier-Bresson sich der Fotografie und dem Film, unter anderem als Regieassistent von Jean Renoir (*Eine Landpartie*, 1936; *Die Spielregel*, 1939). Im Auftrag des Informationsdienstes der US-Armee drehte er den Kurzfilm *Le Retour* (1945) über die Repatriierung von Flüchtlingen und Kriegsgefangenen. 1947 gehörte er zu den Mitbegründern von Magnum Photos. Seine besondere Art der Motivwahl und seine intuitiven Momentaufnahmen verhalfen ihm zu weltweiter Beachtung. 1954 erhielt er als erster westlicher Fotograf ein Visum für die UdSSR. In Italien machte Cartier-Bresson 1933, 1951 (Rom und Süditalien), 1952 (Rom), 1953, 1958 (Rom), 1959 und 1968 Aufnahmen. Zu seinen zahlreichen Fotobüchern gehören *Images à la Sauvette* (1952), *Les Européens* (1955) und *Henri Cartier-Bresson photographe* (1960). 1966 verließ er das Team von Magnum, wurde aber weiter von der Agentur vertreten. Von 1970 an machte er nur noch Zeichnungen. Ein Jahr vor seinem Tod wurde in Paris die Fondation Henri Cartier-Bresson ins Leben gerufen.

Après avoir étudié la peinture, il se consacre au cinéma et à la photographie. Il est l'assistant de Jean Renoir (*Une partie de campagne*, 1936; *La Règle du jeu*, 1939) puis, à la demande du service d'information de l'armée américaine, il réalise le court métrage *Le Retour* (1945) sur le retour des réfugiés et des prisonniers de guerre. En 1947, il est l'un des fondateurs de l'agence Magnum Photos. Il s'impose à l'attention internationale par le choix de ses sujets et l'extraordinaire intuition dont témoignent ses clichés instantanés. En 1954, il est le premier photographe autorisé à se rendre en URSS. Il travaille en Italie en 1933, 1951 (Rome et l'Italie du Sud), 1953, 1958 (Rome), 1959, 1968. Il publie de nombreux ouvrages dont *Images à la sauvette* (1952), *Les Européens* (1955) et *Henri Cartier-Bresson photographe* (1960). En 1966, il quitte Magnum qui demeure son agent et, dès 1970, se consacre exclusivement au dessin. Un an avant sa mort, la Fondation Henri Cartier-Bresson ouvre ses portes à Paris.

Cartoni, Alberto (1898–1976)
He was born in Piediluco, Terni. During World War I he worked as a photographer for the Supreme Command of the Italian Army. During the Fascist period he photographed actors and celebrities, as well as buildings by renowned architects such as Piacentini and Moretti, and the construction of the Mussolini Forum and the district of EUR.

Der aus Piediluco bei Terni stammende Cartoni war während des Ersten Weltkriegs Fotograf des Oberkommandos des italienischen Heeres. In faschistischer Zeit fotografierte er Schauspieler und Persönlichkeiten des öffentlichen Lebens und lichtete die Bauprojekte von Architekten wie Piacentini und Moretti ab sowie die Errichtung des Mussolini-Forums und des EUR-Viertels.

Il voit le jour à Piediluco (Terni). Durant la Première Guerre mondiale, il travaille comme photographe auprès du commandement suprême de l'armée italienne. Sous le fascisme, il photographie des acteurs et diverses personnalités, les ouvrages de plusieurs architectes dont Piacentini et Moretti, la construction du Forum Mussolini et la réalisation de l'EUR.

Casasoli, Augusto (1961–)
A photojournalist from Rome, he began his activity in 1987; in 1994 he founded Agenzia Foto A3 with other photographers, and began his collaboration with Agenzia Contrasto. He has focused especially on features of political current events and sport.

Seit 1987 in Rom tätig, gehörte Casasoli 1994 zu den Mitbegründern der Agentur Foto A3 und begann in der Folge für Contrasto zu arbeiten. Seine Themenschwerpunkte bilden die Bereiche aktuelle Politik und Sport.

Photojournaliste romain, il fait ses débuts en 1987; en 1994, il fonde l'Agenzia Foto A3 avec d'autres photographes et commence à collaborer avec l'Agenzia Contrasto. Il s'est spécialisé dans l'actualité politique et sportive.

Clarke, Henry (1918–1996)
Born in Los Angeles, he started working in the late 1940s as an assistant in the photographic studios of *Vogue* in New York, where he met Horst P. Horst, Irving Penn, and Cecil Beaton. After the war he established himself in Paris, where he became one of the innovators in the field of fashion photography. He worked for almost three decades for various editions of *Vogue*. In 1973 he reduced his commitment to fashion and devoted himself to taking photographs of large residences.

Der aus Los Angeles stammende Clarke begann Ende der 1940er-Jahre in New York als Fotoassistent für die *Vogue* zu arbeiten, dort begegnete er Horst P. Horst, Irving Penn und Cecil Beaton. Nach dem Krieg ging Clarke nach Paris, wo er zu einem der Erneuerer der Modefotografie wurde. Mehr als drei Jahrzehnte arbeitete Clarke für verschiedene nationale Ausgaben der *Vogue*. Von 1973 an verlagerte er das Schwergewicht seiner Arbeit von der Modefotografie auf Bildreportagen für Architekturzeitschriften.

Né à Los Angeles, il commence à travailler à la fin des années 1940 comme assistant dans le service photographique de *Vogue* à New York où il rencontre Horst P. Horst, Irving Penn et Cecil Beaton. Après la guerre, il s'établit à Paris où il est l'un des rénovateurs de la photographie de mode. Pendant une trentaine d'années, il collabore aux diverses éditions de *Vogue*. En 1973, il réduit son activité pour la mode et se consacre à la photographie de belles demeures.

Colamedici, Giovanni Battista (active from the 1860s until the early 1900s)
He worked for the archeologist John Henry Parker, photographing the frescoes of the Neapolitan and Roman catacombs, using magnesium flash. He created the studio Fotografia Artistica Italiana.

Als Fotograf für den britischen Archäologen John Henry Parker tätig, zeichnete Colamedici namentlich für Aufnahmen aus römischen und neapolitanischen Katakomben verantwortlich, bei denen er auch Magnesiumblitzlicht verwendete. Er gründete das Fotoatelier Fotografia Artistica Italiana.

Il travaille pour l'archéologue John Henry Parker, photographiant les fresques des catacombes romaines et napolitaines, et faisant usage d'une lampe au magnésium. Il fonde l'atelier Fotografia Artistica Italiana.

Conger, Dean (1927–2023)
After working with the *Denver Post*, between 1959 and 1989 he was part of the National Geographic Society team, producing many features in Europe, Asia, the USSR, and the USA.

Zunächst Mitarbeiter der *Denver Post*, gehörte Conger von 1959 bis 1989 dem Fotografenteam der National Geographic Society an, für die er zahlreiche Reportagen aus Europa, Asien, der Sowjetunion und den USA produziert hat.

Après avoir collaboré au *Denver Post*, il intègre l'équipe de la National Geographic Society (1959–1989) pour laquelle il réalise de nombreux photoreportages en Europe, en Asie, en URSS et aux États-Unis.

Crane, Ralph (1914–1988)
An American of German origins, he worked with *Life* for many years. He worked in black and white and in color, producing features on current events, travel, and celebrities.

Der Amerikaner deutscher Herkunft gehörte lange Jahre zum festen Fotografenteam von *Life*. In Schwarz-Weiß- und Farbaufnahmen widmete er sich bekannten Persönlichkeiten und Ereignissen des Zeitgeschehens sowie der Reisefotografie.

Américain d'origine allemande, il a fait partie de l'équipe de *Life* durant de nombreuses années. En noir et blanc comme en couleurs, il a illustré des faits divers, réalisé des photographies de voyage et fait le portrait de nombreuses personnalités.

D'Alessandri, Antonio (1818–1893)
D'Alessandri, Paolo Francesco (1827–1889)
(Fratelli D'Alessandri)
In 1856 the two brothers established a photographic studio in Rome; their success was due to the high quality of their portraits and to the patronage of the papal court (Antonio was a priest), and later of the Savoy court. In the 1960s, when their commercial success was at its peak, they expanded their business and owned a studio in Naples (with Giacomo Arena), and were represented in Paris and Vienna. For a time they were the official portrait artists for Pius IX and the papal court. They photographed the papal army drills, and in 1867 Antonio produced images of the battlegrounds of Monterotondo and Mentana which circulated also in the form of woodcuts in periodicals such as *L'Illustration*. Between 1887 and 1893 they documented the construction of the banks of the Tiber before and during the works.

Ab 1856 unterhielten die Brüder D'Alessandri ein für seine Porträts, namentlich aus Kreisen der Kurie (Antonio ist selbst Priester) und später auch des savoyischen Königshofs bekanntes Fotoatelier. Auf dem Höhepunkt ihrer Geschäftstätigkeit in den 1860er-Jahren unterhielten sie eine Filiale in Neapel (mit Giacomo Arena) und Vertrieb in Paris und in Wien. Eine Zeit lang besaßen die Gebrüder D'Alessandri das Exklusivrecht an den Porträts Pius IX. und seines Hofstaats und machten Bilder von den Exerzierübungen des päpstlichen Heeres, während Antonio das Schlachtgeschehen von Monterotondo und Mentana in Fotografien festhielt, die auch als Holzstiche in Zeitschriften wie *L'Illustration* erschienen. 1887 bis 1893 dokumentierten sie den Zustand vor und während der Errichtung der Tibermauern.

À partir de 1856, les deux frères ont un atelier de photographie à Rome qui remporte un vif succès dû à la qualité de ses portraits et au fait d'être au service de la cour pontificale (Antonio est prêtre), puis de la maison de Savoie. Dans les années 1860, alors que leur activité commerciale est au plus haut, ils ouvrent un second studio à Naples (avec Giacomo Arena) et disposent de distributeurs à Paris et à Vienne. Pendant un certain temps, ils ont l'exclusivité des portraits de Pie IX et de la cour pontificale. Ils photographient les manœuvres de l'armée du Vatican et, en 1867, Antonio réalise des clichés des champs de bataille de Monterotondo et de Mentana dont sont tirées des xylographies publiées dans des périodiques tels que *L'Illustration*. Entre 1887 et 1893, ils documentent les berges du Tibre avant et pendant les travaux de construction des digues.

De Antonis, Pasquale (1908–2001)
A professional photographer in Pescara starting in the 1930s, in 1936–1937 he attended the Centro Speri-

mentale di Cinematografia in Rome, and in 1939 he moved definitively to the capital city, where he took over the studio of Arturo Bragaglia in Piazza di Spagna. He was an *habitué* of cinematic, artistic, and literary circles, and a friend of Ennio Flaiano. After the war he worked in theater, collaborating with Luchino Visconti. Irene Brin, a journalist and co-founder of the gallery L'Obelisco, encouraged him to dedicate himself to fashion photography, of which he became one of the most sophisticated exponents. Between 1947 and 1968, Brin regularly published his images, often set in the magical ambience of Rome's urban spaces and architecture, in *Bellezza* magazine.

Seit Beginn der 1930er-Jahre als Berufsfotograf in Pescara tätig, besuchte De Antonis 1936/37 das Centro sperimentale di cinematografia in Rom, wohin er 1939 endgültig übersiedelte, um das Atelier von Arturo Bragaglia an der Piazza di Spagna zu übernehmen. Er arbeitete viel im Bereich von Film, Kunst und Literatur und war ein Freund Ennio Flaianos. In der unmittelbaren Nachkriegszeit war er Theaterfotograf für Luchino Visconti. Auf Anregung von Irene Brin, Journalistin und Mitbegründerin der Galerie L'Obelisco wurde er Modefotograf. Von 1947 bis 1968 druckte Brin in der Zeitschrift *Bellezza* seine oft in magischer Atmosphäre vor römischer Kulisse angesiedelten Bilder ab.

Photographe professionnel au début des années 1930 à Pescara. En 1936–1937, il intègre le Centre expérimental du cinéma de Rome et, en 1939, il s'établit définitivement dans la capitale où il reprend le studio d'Arturo Bragaglia sur la piazza di Spagna. Il fréquente les milieux du cinéma, des arts et de la littérature et se lie d'amitié avec Ennio Flaiano. Dans l'immédiat après-guerre, il travaille pour le théâtre en collaboration avec Luchino Visconti. Journaliste et cofondatrice de la galerie L'Obelisco, Irène Brin l'encourage à se consacrer à la photographie de mode dont il devient l'un des interprètes les plus raffinés. De 1947 à 1968, Irène Brin publie régulièrement dans la revue *Bellezza* ses clichés à l'atmosphère magique qui ont pour cadre les rues, les places et les édifices de la capitale.

De Bonis, Adriano *(1820–1884)*
He trained at the Accademia di Belle Arti in Florence. In 1851 he published an edition of the treatise by Vignola and the Italian translation of the *Traité de perspective pratique* by J.P. Thénot. He was active in Rome in the 1850s, working first in calotype, later in the colloidal silver process. He collaborated with the series by archeologist John Henry Parker around 1867–1868. Francis Wey, critic of *La Lumière*, used tens of his photographs as illustrations for the series of articles on Rome published in *L'Illustration*, *Journal Universel*, later collected in the volume *Rome* (1872). He knew Carlo Baldassarre Simelli, who possibly distributed his photographs and transmitted his negatives to the archive of Gustave Eugène Chauffourier. His photographs of architecture and of Roman urban spaces are of a particularly high quality and reveal his training as an architect.

De Bonis studierte zunächst an der Kunstakademie in Florenz; 1851 legte er eine Edition von Vignolas Architekturtraktat vor sowie eine italienische Übersetzung des *Traité de perspective pratique* von J.-P. Thénot. Bereits in den 1950er-Jahren in Rom tätig, zunächst als Kalotypist, dann mit Aufnahmen im Kollodiumverfahren, machte De Bonis 1867/68 Bilder von Ausgrabungsfunden für John Henry Parker. Francis Wey, der für *La Lumière* schrieb, verwendete Dutzende seiner Aufnahmen als Vorlagen für die Illustrationen seiner römischen Artikelserie in *L'Illustration*, die

1872 im Band *Rome* gesammelt erschienen. De Bonis stand in Verbindung mit Carlo Baldassarre Simelli, der möglicherweise dessen Fotografien vertrieb und die Negative in das Archiv von Gustave Eugène Chauffourier einbrachte. Seine Aufnahmen von römischen Bauten, Straßen und Plätzen sind von hoher Qualität und verraten den studierten Architekten hinter der Kamera.

Formé à l'Académie des beaux-arts de Florence, il publie en 1851 une édition du traité de Vignole et la traduction en italien du *Traité de perspective pratique*, *pour dessiner d'après nature* de J.-P. Thénot. Il est actif à Rome dès les années 1850, d'abord comme calotypiste, puis comme adepte du collodion. Il travaille pour l'archéologue John Henry Parker dans les années 1867–1868. Francis Wey, critique d'art du journal *La Lumière*, utilise des dizaines de ses clichés pour illustrer une série d'articles sur Rome publiés dans *L'Illustration*, puis réunis dans le volume *Rome* (1872). Il est en relation avec Carlo Baldassare Simelli, qui a peut-être été le distributeur de ses photos et a transmis ses négatifs aux archives de Gustave Eugène Chauffourier. D'une grande qualité, ses photographies des architectures et des espaces urbains de Rome laissent transparaître sa formation d'architecte.

De Maria, Mario *(1852–1924)*
A painter loved by Gabriele D'Annunzio and known as Marius Pictor, he also dedicated himself to photography, portraying aspects of Roman urban life.

Einer der Lieblingsmaler Gabriele D'Annunzios, bekannt auch unter dem Namen Marius Pictor, hatte De Maria seine Leidenschaft für die Fotografie in Aufnahmen des städtischen Lebens der Hauptstadt einfließen lassen.

Peintre cher à D'Annunzio, connu sous le nom de Marius Pictor, il a donné libre cours à sa passion pour la photographie en fixant certains aspects de la vie urbaine de Rome.

Dussart, Ghislain *(1924–1996)*
Also known as Jicky Dussart, he was a French photographer and painter who worked as a photojournalist for *Paris Match*. He took photographs of famous actresses, in particular Brigitte Bardot, whose image he also used in collages.

Der auch als Jicky Dussart firmierende französische Maler arbeitete als Bildjournalist für *Paris Match* und wurde für seine Fotos großer Schauspielerinnen, namentlich Brigitte Bardots bekannt, die er auch für Kollagen verwendete.

Également connu sous le nom de Jicky Dussart. Photographe et peintre français, il a travaillé comme reporter photographe pour *Paris Match*. Il a photographié des actrices célèbres, Brigitte Bardot en particulier, clichés qu'il a ensuite utilisés dans des collages.

Eisenstaedt, Alfred *(1898–1995)*
German by birth, he participated in World War I. In 1929 he moved to Berlin to work as a photojournalist; in 1934 he photographed the meeting between Mussolini and Hitler in Italy. In 1935 he emigrated to the United States, and the following year he worked as a photographer on the staff of *Life*. His images of news events and celebrities like Sophia Loren or Marilyn Monroe featured in tens of magazine covers. One of his most celebrated pictures is of a sailor embracing a nurse in Times Square in New York on the day of the US victory against Japan (August 15, 1945). He published some books of photographs, including *People* (1973) and *Remembrances* (1999).

Der aus Westpreußen stammende Eisenstaedt, Soldat im Ersten Weltkrieg, ging nach Kriegsende nach Berlin, wo er sich 1929 als Fotojournalist selbstständig machte. 1934 entstanden seine Fotos vom Treffen Hitlers mit Mussolini in Rom. 1935 emigrierte Eisenstaedt in die Vereinigten Staaten, ein Jahr später gehörte er bereits zum Fotografenteam von *Life*, das seine Bilder von Tagesereignissen und von Berühmtheiten wie Sophia Loren oder Marilyn Monroe auf der Titelseite abdruckte. Berühmt wurde sein Bild eines Matrosen, der nach der Kapitulation Japans auf dem Times Square eine Krankenschwester küsst. Zu seinen Fotobüchern zählen Titel wie *People* (1973) oder *Remembrances* (1999).

D'origine allemande, il prend part à la Première Guerre mondiale. En 1929, il s'installe à Berlin comme reporter photographe ; en 1934, il immortalise la rencontre entre Mussolini et Hitler à Rome ; en 1935, il émigre aux États-Unis et, l'année suivante, il entre dans l'équipe des photographes de *Life*. Ses clichés de faits divers et de célébrités, dont Sophia Loren et Marilyn Monroe, illustrent la couverture de dizaines de revues. On se souvient de sa photo montrant un marin embrassant une jeune infirmière à Times Square à New York, le jour de la capitulation du Japon (15 août 1945). Il est l'auteur de plusieurs livres de photographies dont *People* (1973) et *Remembrances* (1999).

Elgort, Arthur *(1940–)*
Born in New York, he studied at Hunter College. In the early 1970s, he began a collaboration with *Vogue* that lasted for over 40 years.

In New York geboren, studierte Elgort zunächst am dortigen Hunter College Malerei. Anfang der 1970er-Jahre begann er für die *Vogue* zu fotografieren, eine Zusammenarbeit, die über vier Jahrzehnte währte.

Né à New York, il étudie la peinture au Hunter College. Au début des années 1970, il commence à travailler pour *Vogue*, collaboration qui durera plus de quarante ans.

Erwitt, Elliott *(1928–2023)*
Born in Paris of Jewish parents of Russian origin, he lived in Italy until 1938. The rise of Fascism forced him to emigrate to the USA in 1939, and there he studied photography and cinema. In 1948 he was in New York, where he met Edward Steichen, Robert Capa, and Roy Stryker. The latter – at the time the director of the photography department of the Farm Security Administration – hired him for a photographic project for the Standard Oil Company of New Jersey. He worked as a freelancer for *Life*, *Look,* and *Holiday*. In 1953 he began working with Magnum, specializing in commercial photography. From 1970 he dedicated himself to cinema, making feature films, television commercials, and documentaries. He published several books of photographs, including *Elliott Erwitt's Rome* (2009).

Als Sohn russischer Juden in Paris geboren, lebte Erwitt bis 1938 in Italien. Auf der Flucht vor dem Faschismus emigrierte die Familie 1939 in die USA. Erwitt studierte Fotografie und Film und ging 1948 nach New York, wo er Edward Steichen, Robert Capa und Roy Stryker begegnete, der ihn in seiner Funktion als Leiter der fotografischen Abteilung der Farm Security Administration für ein Projekt der Standard Oil Company in New Jersey anheuerte. Als freier Fotograf für die Magazine *Life*, *Look* und *Holiday* tätig, wurde Erwitt 1959 Mitglied von Magnum Photos und spezialisierte sich auf Werbefotografie. Seit 1970 drehte er Filme, TV-Spots und Dokumentationen. Zu seinen Bücher zählt unter anderem *Elliott Erwitt's Rome* (2009.)

Né à Paris de parents juifs d'origine russe, il vit en Italie jusqu'en 1938. Fuyant le fascisme, sa famille émigre en 1939 aux États-Unis, où il étudie la photographie et le cinéma. En 1948 à New York, il rencontre Edward Steichen, Robert Capa et Roy Stryker. Ce dernier, qui dirige alors le service photographique de la Farm Security Administration, l'engage pour prendre part à un projet de la Standard Oil Compagny du New Jersey. En free-lance, Erwitt collabore à *Life*, *Look* et *Holiday*. En 1953, il rejoint l'agence Magnum Photos. La photographie publicitaire devient sa spécialité. À partir de 1970, il se consacre au cinéma en réalisant des longs métrages, des spots pour la télévision et des documentaires. On lui doit plusieurs ouvrages dont *Elliott Erwitt's Rome* (2009).

Fabbri, Teodoro *(c. 1887–c. 1911)*

He worked in Rome; in 1887 he took over the photographic studio of Michele Mang in Via Felice (Sistina).

Römischer Fotograf, der 1887 das Fotoatelier in der Via Felice, der heutigen Via Sistina, des bekannteren Michele Mang übernahm.

Actif à Rome ; en 1887 il succède à Michele Mang, plus célèbre, à la tête de l'atelier photographique de la via Felice (Sixtine).

Fanelli, Alberto *(1965–)*

After graduating in computer engineering in Milan, he devoted himself to photography, focusing on portraiture, travel photography, and reportage. His photographs have appeared in Italian and international newspapers and magazines. He has worked with the Singapore National Heritage Board. He has published various 3D photo books.

Nach dem Informatikstudium in Mailand wandte Fanelli sich der Fotografie zu, insbesondere der Porträt-, Reise- und Reportagefotografie. Seine Bilder erscheinen in italienischen und ausländischen Zeitungen und Zeitschriften. Fanelli ist unter anderem für das Singapore's Heritage Board tätig und hat mehrere 3-D-Fotobücher veröffentlicht.

Diplômé en ingénierie informatique de l'université de Milan, il décide en 2007 de se consacrer à la photographie, et notamment au portrait, à la photo de voyage et au reportage. Ses clichés sont publiés dans des journaux et des magazines italiens et internationaux. Il collabore avec le Singapore National Heritage Board. Il est l'auteur de plusieurs livres de photographies en 3D.

Farabola, Tullio *(1920–1983)*

The son of a photographer, he dedicated himself to photojournalism at the end of World War II and documented the final episodes of the war in Milan, the early period of the new Italian state, the country's reconstruction, and the economic boom of the 1960s, as well as news events. In 1945 he created the Farabola Photo agency. Concurrently with his photojournalistic features, he produced studio work, such as cover images for the most popular weekly magazines (*Oggi*, *L'Europeo*, *Gente*, etc.) and daily newspapers (*L'Unità*, *Paese Sera*), as well as record covers.

Der Sohn eines Fotografen begann gegen Ende des Zweiten Weltkriegs als Fotojournalist zu arbeiten. Seine Bilder schildern das Kriegsende in Mailand, das Italien der unmittelbaren Nachkriegszeit, den Wiederaufbau, das Wirtschaftswunder der 1960er-Jahre und das italienische Tagesgeschehen allgemein. 1945 gründete er die Agentur Foto Farabola. Daneben widmete er sich der Arbeit im Fotostudio und schuf eine große Anzahl von Titelbildern für auflagenstarke italienische Wochenzeitungen wie *Oggi*, *L'Europeo*, *Gente* und Ta-

geszeitungen, darunter *L'Unità* und *Paese Sera*, sowie Plattencover.

Fils de photographe, il choisit le photojournalisme à la fin de la Seconde Guerre mondiale, illustrant les derniers soubresauts du conflit à Milan, les débuts du nouvel État italien, la reconstruction et le miracle économique des années 1960, et certains faits divers. En 1945, il crée l'agence Foto Farabola. Parallèlement au reportage photo, il déploie une intense activité en studio, réalisant des clichés pour les unes d'hebdomadaire populaires à grand tirage comme *Oggi*, *L'Europeo*, *Gente*, pour des quotidiens tels que *L'Unità* et *Paese Sera* et pour des pochettes de disques.

Flachéron, Frédéric *(1813–1883)*

An aristocrat from Lyon, and the son of architect Louis Flachéron, he trained at the École Royale des Beaux Arts in Paris. In Rome he became a well-known landscape painter. Around 1848 he worked with calotype and became one of the most prominent members of the circle of photographers who met at Caffè Greco. In 1851 he exhibited his views of Rome at the Great Exhibition of London. In 1866 he left Rome to return to Paris. His virtuosic skill with calotype, characterized by rich, luminous hues, is apparent in his images of monuments, archaeological ruins, and urban sites damaged by the political upheavals of 1849.

Der Sohn des adligen Lyoneser Architekten Louis Flachéron studierte in Paris an der École Royale des Beaux Arts und wirkte anschließend in Rom als Landschaftsmaler. Um 1848 begann er Kalotypien zu machen und wurde einer der Hauptvertreter des Fotografenkreises um das Caffè Greco. Auf der Weltausstellung 1851 in London war er mit römischen Stadtansichten vertreten. 1866 ging er zurück nach Paris. Flachérons virtuose Handhabung der Kalotypie zeichnet sich durch einen lichten Reichtum der Tonwerte aus, der unter anderem für seine Aufnahmen von römischen Antiken, aber auch auf seinen Bildern der bei den Unruhen von 1849 entstandenen Schäden charakteristisch ist.

Aristocrate lyonnais, fils de l'architecte Louis Flachéron, il se forme à l'École royale des beaux-arts de Paris. À Rome, il est connu comme « peintre paysagiste ». Vers 1848, il pratique la calotypie et devient l'un des protagonistes du cercle des photographes du Caffè Greco. En 1851, il expose des vues de Rome à l'Exposition universelle de Londres. En 1866, il quitte Rome et rentre définitivement à Paris. Son utilisation virtuose de la calotypie, aux tons riches et lumineux, est manifeste dans les clichés de monuments et de vestiges archéologiques, et ceux des dommages que les événements de 1849 infligent à la ville.

Förg, Günther *(1952–2013)*

Born in Füssen, Germany, he studied at the Munich Academy of Fine Arts. His creativity found expression through the media of painting, sculpture and graphic design, but he also developed a strong interest in architecture. In the 1980s he began to take photographs (particularly of architecture), which he also used in his work.

Der aus Füssen gebürtige Förg studierte an der Akademie der Bildenden Künste in München. Sein Werk umfasst Malerei, Skulptur und Grafik mit einem Schwerpunkt auf Architekturthemen. In den 1980er-Jahren begann Förg in diesem Bereich auch zu fotografieren und entsprechende Aufnahmen für seine eigenen Arbeiten zu nutzen.

Naissance à Füsssen (Bavière). Il fréquente l'académie des beaux-arts de Munich. Sa créativité qui s'af-

firme dans les domaines de la peinture, de la sculpture et du design, révèle par ailleurs un intérêt marqué pour l'architecture. Dans les années 1980, il se lance dans la photographie d'œuvres d'architecture notamment, et de sujets en lien avec ses créations.

Freed, Leonard *(1929–2006)*

Born in New York, he aspired to become a painter, but in 1953–1954, when visiting several European countries, he became passionate about photography. Starting in 1961 he worked as a freelance photographer, travelling around the world. In 1972 he joined Magnum and focused on documenting social conflict and racial discrimination.

In New York geboren, wollte Freed zunächst Maler werden. Auf einer Europareise 1953/54 entdeckte er die Fotografie für sich, arbeitete seit 1961 als freier Fotograf in aller Welt und wurde 1972 Mitglied von Magnum Photos. Zu seinen wichtigsten Themen gehören die sozialen Unterschiede und die Rassendiskriminierung in den USA.

Né à New York, il désire être peintre. En 1953–1954, durant un voyage à travers l'Europe, il se prend de passion pour la photographie. À partir de 1961, il voyage dans le monde entier, travaillant comme photographe free-lance. En 1972, il entre à l'agence Magnum Photos et s'attache plus particulièrement aux inégalités sociales et à la discrimination raciale.

Garolla, Federico *(1925–2012)*

A Neapolitan journalist, during the early post-war period he worked in Milan, collaborating on photographic reportages for a number of Italian news periodicals (*L'Europeo*, *Tempo Illustrato*, *L'Illustrazione Italiana*, *Oggi*, *Epoca*) as well as other publications abroad. He published images of the Roman fashion ateliers in illustrated magazines. In 1956 he founded and directed Foto Italia for the news agency Italia. An acute observer of social nuances, he photographed artists, intellectuals, and ordinary people. In 1976 he began working for RAI (Italian national broadcasting), directing and presenting documentaries for TV news features.

Garolla, zunächst Journalist in Neapel, ging unmittelbar nach dem Krieg nach Mailand, wo er als Fotograf für zahlreiche italienische und ausländische Tageszeitungen und Magazine arbeitete (*L'Europeo*, *Tempo Illustrato*, *L'Illustrazione Italiana*, *Oggi*, *Epoca*). Seine Bilder von Kreationen römischer Modeschöpfer erschienen in mehreren Wochenzeitschriften. 1956 gründete er die von ihm geleitete Agentur Foto Italia als Teil der Agenzia giornalistica Italia. Neben sozialen Themen machte Garolla sich mit Bildern von Künstlern, Intellektuellen und einfachen Leuten einen Namen. 1976 begann er, als Regisseur und Moderator von Dokumentarbeiträgen für die Nachrichtensendungen der RAI zu arbeiten.

Journaliste napolitain, dans l'immédiat aprèsguerre il est appelé à Milan où il collabore avec des reportages photographiques à de nombreuses revues d'actualités italiennes (*L'Europeo*, *Tempo Illustrato*, *L'Illustrazione Italiana*, *Oggi*, *Epoca*) et étrangères. Dans les journaux de mode, il publie des photos des maisons de couture romaines. En 1956, il fonde et dirige Foto Italia, interface photographique de l'agence de presse Italia. Attentif aux aspects sociaux, il photographie des artistes, des intellectuels et des gens ordinaires. En 1976, il collabore avec la RAI (télévision publique italienne) en qualité de réalisateur et de présentateur de documentaires pour certaines rubriques du journal télévisé.

Haertter, Elsa *(1908–1995)*
A prominent fashion photographer, she worked with great dedication at the weekly magazine *Grazia* in the 1950s and 1960s.

Bedeutende deutsche Modefotografin, die in den 1950er- und 1960er-Jahren regelmäßig für die Zeitschrift *Grazia* fotografierte.

Importante photographe de mode, elle a été une fidèle collaboratrice de l'hebdomadaire *Grazia* dans les années 1950 et 1960.

Halbe, Roland *(1963–)*
Having studied photography at IED (European Institute of Design) in Cagliari, in 1988 he became a freelance photographer specializing in architectural images. He was the official photographer of the exhibition *On-Site: New Architecture in Spain* at MoMA in New York in 2006. His photographs have been published in the most important magazines of contemporary international architecture, such as *Casabella*, *Architectural Review*, and *Architectural Record*.

Nach dem Studium der Fotografie am Istituto Europeo di Design in Cagliari begann Halbe 1988, als freier Architekturfotograf zu arbeiten. 2006 war er offizieller Fotograf der Ausstellung *New Architecture in Spain* am New Yorker Museum of Modern Art. Halbes Bilder erscheinen in den wichtigsten Zeitschriften für zeitgenössische Architektur weltweit, darunter *Casabella*, *Architectural Review* und *Architectural Record*.

Il étudie la photographie à l'Istituto Europeo di Design (IED) de Cagliari, puis travaille comme photographe d'architecture free-lance à partir de 1988. Il est le photographe officiel de l'exposition « On-Site: New Architecture in Spain » au MoMA de New York en 2006. Ses clichés sont publiés dans les grandes revues d'architecture internationales, telles *Casabella*, *Architectural Review* et *Architectural Record*.

Harlingue, Albert *(1879–1964)*
Born in Paris, he created the Harlingue Agency, a distributor of photographs from various sources. After participating in World War I, photographing aspects of life on the front, he returned to Paris and worked as a photojournalist.

Gründer der Bildagentur Harlingue, die Aufnahmen verschiedener Fotografen vertreibt. Als Soldat im Ersten Weltkrieg dokumentierte er das Leben an der Front, nach dem Krieg betätigte er sich in seiner Heimatstadt Paris als Fotojournalist.

Né à Paris, il crée l'agence Harlingue qui commercialise ses clichés et ceux d'autres photographes. Engagé dans une unité de photographie durant la Première Guerre mondiale, il réalise de nombreux reportages sur la vie au front. Après la guerre, de retour à Paris, il travaille comme photojournaliste.

Horst, Horst P. *(1906–1999)*
Horst Paul Albert Bohrmann was born in Weissenfels, Germany. He studied at the Kunstgewerbeschule in Hamburg. In 1930 he moved to Paris and worked as an apprentice with Le Corbusier. He met Hoyningen-Huene, who introduced him to the French editorial team of *Vogue*. In 1932 he was in the United States, where he worked for American *Vogue*. He became well known for his originality in fashion photography and portraiture, using special light effects and sometimes Surrealist elements. Coco Chanel introduced him to Luchino Visconti, with whom he started a love affair and travelled to Tunisia in 1936. He participated in World War II, and on his return to the United States he worked for various magazines, particularly *House and Garden*, *Vogue* (American and French editions), and *Vanity Fair*.

Horst Paul Albert Bohrmann wurde in Weißenfels geboren und studierte an der Hamburger Kunstgewerbeschule. 1930 ging er nach Paris und lernte im Atelier von Le Corbusier. Hoyningen-Huene stellte einen Kontakt zur französischen Redaktion der *Vogue* her; ab 1932 war Horst in den USA für die amerikanische Ausgabe der Zeitschrift tätig. Seine Mode- und Porträtfotografien arbeiten oft mit besonderen Lichteffekten und gelegentlichen Anleihen beim Surrealismus. Coco Chanel machte ihn mit Luchino Visconti bekannt, dessen Geliebter er wurdu und mit dem er 1936 eine Reise nach Tunesien unternahm. Nach seiner Zeit als GI im Zweiten Weltkrieg kehrte er in die USA zurück, wo er für verschiedene Zeitschriften arbeitete, namentlich *House and Garden*, ferner für die amerikanische und die französische Ausgabe der *Vogue* und für *Vanity Fair*.

Horst Paul Albert Bohrmann naît à Weißenfels en Allemagne; il étudie à la Kunstgewerbeschule [école des arts décoratifs] de Hambourg. En 1930, il part à Paris pour se former dans l'agence de Le Corbusier. Il rencontre Hoyningen-Huene qui le met en contact avec la rédaction française de *Vogue*. En 1932, il se rend aux États-Unis où il travaille pour l'édition américaine de *Vogue*. Il s'impose comme un photographe de mode et un portraitiste qui se distingue par des effets de lumière particuliers et, parfois, par des accents surréalistes. Coco Chanel lui présente Luchino Visconti dont il devient l'amant et avec qui il effectue un voyage en Tunisie en 1936. Il prend part à la Seconde Guerre mondiale et, à son retour en Amérique, travaille pour diverses revues, surtout pour *House and Garden*, *Vogue* (éditions américaine et française) et *Vanity Fair*.

Hoyningen-Huene, George *(1900–1968)*
The son of a Russian baron, he studied in St. Petersburg. In 1917 he was in Great Britain, and then in Paris, where he met Man Ray. He produced a series of fashion photographs inspired by Cubism and Art Déco. Starting in 1926 he worked with *Vogue* and with *Harper's Bazaar*. He travelled extensively.

Der Sohn eines russischen Barons studierte in St. Petersburg, bevor er 1917 nach England und von dort nach Paris ging, wo er Man Ray kennenlernte. Seine Modefotografien sind vom Kubismus und vom Art déco inspiriert. Ab 1926 fotografierte er für die *Vogue*, später auch für *Harper's Bazaar* und unternahm zahlreiche Reisen in alle Welt.

Fils d'un baron russe, il étudie à Saint-Pétersbourg. À partir de 1917, il vit en Grande-Bretagne puis à Paris où il fait la connaissance de Man Ray. Il s'inspire du cubisme et de l'Art déco pour réaliser une série de photographies de mode. À partir de 1926, il collabore à *Vogue* puis à *Harper's Bazaar*. Il effectue de nombreux voyages à travers le monde.

Hubmann, Franz *(1914–2007)*
An Austrian freelance photojournalist, he also photographed contemporary artists and was the co-founder of the magazine *magnum*. He is considered by many to be the Austrian counterpart to Cartier-Bresson.

Der freie Fotojournalist aus Wien, der für seine Aufnahmen zeitgenössischer Künstler bekannt wurde und Mitbegründer der Kulturzeitschrift *magnum* war, wurde immer wieder als „österreichischer Cartier-Bresson" bezeichnet.

Ce photojournaliste free-lance autrichien, auteur de portraits d'artistes contemporains, fut l'un des cofondateurs du magazine *magnum*. Pour certains, il est le «Cartier-Bresson autrichien».

Hutton, Kurt *(1893–1960)*
Kurt Hübschmann was born in Strasbourg. In 1934 he emigrated to Britain and worked for *Weekly Illustrated*, and in 1938 he co-founded the weekly magazine *Picture Post*. He is considered one of Britain's pioneers of photojournalism.

Als Kurt Hübschmann in Straßburg geboren, emigrierte Hutton 1934 nach England, wo er für *Weekly Illustrated* arbeitete. 1938 beteiligte er sich an der Gründung der wöchentlich erscheinenden *Picture Post*. Hutton gilt als einer der Pioniere des britischen Fotojournalismus.

Kurt Hübschmann voit le jour à Strasbourg. En 1934, il émigre en Grande-Bretagne où il travaille pour *Weekly Illustrated*. En 1938, il cofonde l'hebdomadaire *Picture Post*. Il est considéré comme l'un des pionniers du photojournalisme en Grande-Bretagne.

Istituto LUCE (L'Unione Cinematografica Educativa)
Created in 1924, it became the Istituto Nazionale LUCE in 1925. It produced films of national propaganda, in particular documentaries and newsreels, at first distributed in schools and cultural institutions, and starting in 1926 in all Italian cinemas. In 1927 it created its own photographic agency, staffed by a team of photographers, providing images approved by the Fascist regime to the Italian and international press. The institute continued its activity in the period following World War II.

Gegründet 1924, seit 1925 als Istituto Nazionale LUCE geführt; produzierte Propagandafilme, vor allem Dokumentationen und Wochenschauen, die zunächst in Schulen und Kulturinstituten, ab 1926 in allen italienischen Kinos gezeigt wurden. 1927 Gründung einer eigenen Bildagentur mit festem Fotografenstamm zur Versorgung von nationaler und internationaler Presse mit dem Regime genehmem Bildmaterial. Nach dem Krieg nahm das Istituto LUCE seine Tätigkeit wieder auf und besteht bis heute.

Fondé en 1924, il devient l'Istituto Nazionale LUCE en 1925. Il produit des films de propagande, dont des documentaires et des actualités cinématographiques diffusés dans les écoles et dans les établissements culturels, puis, à partir de 1926, dans toutes les salles de cinéma d'Italie. En 1927, il crée sa propre agence photographique dotée de sa propre équipe de photographes, qui fournit à la presse italienne et internationale des images approuvées par le régime fasciste. L'institut LUCE poursuit son activité après la guerre.

Kalvar, Richard *(1944–)*
Born in New York, he was the assistant to fashion photographer Jérôme Ducrot. In 1968 he moved to Paris, where he worked for the VU agency. Starting in 1975, he has been a member of the Magnum team.

Der New Yorker begann seine Laufbahn als Assistent des Modefotografen Jérôme Ducrot. Im Jahr 1968 ging er nach Paris, wo er für die Agentur Vu arbeitete. Seit 1975 gehört der Fotograf zum Team von Magnum.

À New York où il est né, il est l'assistant du photographe de mode Jérôme Ducrot. En 1968, il s'installe à Paris où il travaille pour l'agence VU. À partir de 1975, il intègre l'agence Magnum Photos.

Kessel, Dmitri *(1902–1995)*
Of Russian origin, he was involved in the Russian civil war (1919–1921). He emigrated to the USA in 1923,

where he started his business as an industrial photographer. From 1935 he produced photographic features for *Fortune*. He became renowned for his images of World War II, in particular on the liberation of Europe, published in *Life*, a magazine with which he collaborated until 1972. In 1955 Edward Steichen included eight of his images in the travelling exhibition *The Family of Man* organized by Museum of Modern Art in New York.

Nachdem der in Kiew geborene Dmitri Kesselmann im russischen Bürgerkrieg gekämpft hatte (1919–1921), emigrierte er 1923 in die USA. Zunächst als Industriefotograf tätig, arbeitete er ab 1935 für die Illustrierte *Fortune*. Kessel wurde für seine Reportagen im Zweiten Weltkrieg und hier besonders für die in *Life* abgedruckten Bilder von der Befreiung Europas durch die alliierten Truppen bekannt. Edward Steichen nahm acht Bilder Kessels in die Ausstellung *The Family of Man* am New Yorker Museum of Modern Art auf. Bis 1972 war Kessel für *Life* tätig.

D'origine russe, il prend part à la guerre civile en Russie (1919–1921) avant d'émigrer aux États-Unis (1923) où il débute comme photographe industriel. À partir de 1935, il collabore à *Fortune* en qualité de reporter photographe. Il est connu pour ses reportages sur la Seconde Guerre mondiale et en particulier la libération de l'Europe, qui sont publiés dans *Life*, revue à laquelle il collabore jusqu'en 1972. En 1955, Edward Steichen inclut huit de ses clichés dans l'exposition itinérante « The Family of Man » organisée par le Museum of Modern Art de New York.

Keystone Agency
A photographic agency founded in London by Bert Garai at the beginning of the 20th century. In 1960 Bob Mynier, a French photographer, opened a Canadian branch in Montreal. Over the years it has collected a vast photographic archive.

Die Londoner Bildagentur, gegründet zu Beginn des 20. Jahrhunderts von Bert Garai, verfügt seit 1960 über einen von dem französischen Fotografen Bob Mynier ins Leben gerufenen Ableger in Kanada und besitzt eines der umfangreichsten Bildarchive weltweit.

Agence photographique créée au début du XX^e siècle à Londres par Bert Garai. En 1960, le photographe français Bob Mynier ouvre la succursale canadienne à Montréal. L'agence Keystone a accumulé un vaste fonds d'archives photographiques.

Klein, William *(1926–2022)*
Born in New York, he studied sociology. In 1946 he did his military service in Germany, and in 1948 was in Paris, where, interested in figurative arts, he became a pupil of Fernand Léger. He had an exhibition in Milan that caught the attention of architect Angelo Mangiarotti, with whom he initiated a collaboration as a painter. Starting in 1954, he worked for *Vogue*, taking fashion shoots in urban spaces. He has published lavish books of photographs: *Life Is Good and Good for You in New York* (1956), *Rome* (1959), *Moscow* (1964), *Tokyo* (1964), *Paris + Klein* (2002). He has the striking ability to grasp aspects of city life, bringing innovation to the street photography genre. With *Broadway by Light*, in 1958, he began working in feature films, documentaries, and commercials. He lives in Paris.

Der New Yorker Klein studierte zunächst Soziologie und leistete 1946 in Deutschland seinen Militärdienst ab. 1948 ging er nach Paris, wo er sich mit bildender Kunst beschäftigte und Schüler von Fernand Léger wurde. Bei einer Ausstellung seiner Bilder in Mailand

wurde der Architekt Angelo Mangiarotti auf ihn aufmerksam, für den er in der Folge als Maler arbeitete. 1954 entstanden für die *Vogue* Kleins erste Modefotos im Stadtraum. Klein hat zahlreiche Fotobände veröffentlicht: *Life is Good and Good for You in New York* (1956), *Rome* (1959), *Moscow* (1964), *Tokyo* (1964), *Paris + Klein* (2002), in denen er seine Fähigkeit unter Beweis stellt, urbanes Leben in innovativen Formen festzuhalten. Mit *Broadway by Night* von 1958 begann Kleins Arbeit als Regisseur von Spiel-, Dokumentar- und Werbefilmen. Klein lebt in Paris.

Il voit le jour à New York où il étudie la sociologie. En 1946, il effectue son service militaire en Allemagne. Deux ans plus tard, il est à Paris où il s'intéresse aux arts figuratifs et est l'élève de Fernand Léger. À Milan, une exposition de ses œuvres retient l'attention de l'architecte Angelo Mangiarotti avec qui il va collaborer comme peintre. À partir de 1954, travaillant pour *Vogue*, il réalise des photos de mode prises dans des espaces urbains. Il publie de magnifiques livres de photographies : *Life is Good and Good for You in New York* (1956), *Rome* (1959), *Moscou* (1964), *Tokyo* (1964), *Paris + Klein* (2002). Il y fait preuve d'une étonnante aptitude à saisir les aspects de la vie urbaine, renouvelant le genre de la photographie de rue. *Broadway by Light* (1958) marque le début de son travail dans le domaine des longs métrages, des documentaires et des films publicitaires. Il vit à Paris.

Lees, David *(1917–2004)*
Born in Florence, he was the son of theatre director Gordon Craig and poet Dorothy Lees. He worked in Europe and the Middle East as a photojournalist for *Life* magazine, and became well-known for his images of the 1966 floods in Florence, his portraits of celebrities, and his feature on the Vatican Council. After *Life* magazine closed down in 1972, he moved to Milan, dedicating himself to the world of advertising.

Der Sohn des Theaterregisseurs Gordon Craig und der Dichterin Dorothy Lees kam in Florenz zur Welt. Für *Life* war er als Bildkorrespondent aus Europa und dem Mittleren Osten tätig. Bekannt wurde Lees durch seine Bilder von der Arno-Überschwemmung in Florenz 1966, seine Porträts von bekannten Persönlichkeiten und seine Bildreportagen vom Zweiten Vatikanischen Konzil. Nach der Schließung von *Life* ging er nach Mailand, um dort als Werbefotograf zu arbeiten.

Il naît à Florence, fils du metteur en scène Gordon Craig et de la poétesse Dorothy Lees. Reporter photographe pour *Life*, couvrant l'Europe et le Proche-Orient, il est connu pour ses clichés de l'inondation de Florence (1966), pour divers portraits de célébrités et pour ses reportages sur le Concile. Après la disparition de *Life* (1972), il s'établit à Milan et se consacre à la photographie publicitaire.

Leoni, Luigi *(1899–1991)*
In the immediate postwar period, he joined Porry-Pastorel's VEDO photographic agency, where he trained as a photojournalist. In the first half of the 1920s, he began working as a photographer under the name Foto Leoni. He worked with several newspapers, such as *Il Messaggero* in Rome, and later became editor-in-chief of *Lavoro Fascista*. After the liberation of Italy, he was asked to return to *Il Messaggero*. His archive is an important source of material on the imagery of Rome during the war and the Fascist regime.

Seine Ausbildung als Fotojournalist erhielt Leoni unmittelbar nach Ende des Ersten Weltkriegs in Porry-Pastorels römischer Fotoagentur VEDO. Anfang der 1920er-Jahre machte er sich mit einer Agentur unter

dem Namen Foto Leoni selbstständig und belieferte verschiedene Zeitungen, darunter *Il Messaggero* in Rom, bevor er Chefredakteur von *Lavoro Fascista* wurde. Nach Kriegsende kehrte er zum *Messaggero* zurück. Leonis Fotoarchiv stellt eine wichtige Quelle für römische Motive aus der Zeit von Faschismus und Zweitem Weltkrieg dar.

Au lendemain de la Première Guerre mondiale, il entre à l'agence photo VEDO de Porry-Pastorel où il apprend le métier de photojournaliste. Au début des années 1920, il travaille à son compte sous le nom de Foto Leoni. Il collabore à divers journaux dont *Il Messaggero* de Rome, puis devient rédacteur en chef de *Lavoro Fascista*. Après la Libération il est rappelé par *Il Messaggero*. Ses archives constituent un fonds précieux pour l'iconographie de Rome durant le fascisme et la guerre.

Limot, Walter *(1902–1984)*
Pseudonym of Walter Lichtenstein. He was born in Berlin to a middle-class family, and attended a school that included photography in its curriculum. At age 20 he became one of the first film-set photographers of German cinema, and in the following years he worked with great directors such as Lubitsch, Lang, Pabst, Ophüls, and others. In 1933 he left Germany for Paris; in 1934 he was one of the first photographers to join Agence Rapho; he continued to work as a film set photographer for French directors, such as Grémillon, Feyder, Clouzot, and others.

Pseudonym des in Berlin geborenen Walter Lichtenstein. Aus kleinbürgerlichen Verhältnissen stammend, besuchte Lichtenstein eine Fachschule, an der auch Fotografie unterrichtet wurde. Mit 20 einer der wichtigsten Stillfotografen des deutschen Films, arbeitete er mit großen Regisseuren wie Lubitsch, Lang, Pabst oder Ophüls. 1933 Emigration nach Paris, wo er im Jahr darauf als einer der ersten Fotografen für die Agentur Rapho tätig wurde; später auch Stillfotograf für französische Filmregisseure, darunter Grémillon, Feyder, Clouzot und andere.

Pseudonyme de Walter Lichtenstein. Né à Berlin au sein d'une famille de la petite bourgeoisie, il fréquente une école de photographie. À vingt ans il devient l'un des premiers photographes de plateau du cinéma allemand et travaille pour de prestigieux réalisateurs comme Lubitsch, Lang, Pabst et Ophüls, entre autres. En 1933, il quitte l'Allemagne et trouve refuge à Paris ; en 1934, il est l'un des premiers photographes de l'agence Rapho ; il continue à travailler comme photographe de plateau pour divers réalisateurs français dont Grémillon, Feyder, Clouzot, notamment.

Lindbergh, Peter *(1944–2019)*
Born in Lissa, today Poland, he was interested in painting, but devoted himself to photography in the postwar period. Renowned especially as a fashion photographer, he has worked with French *Vogue*, *The New Yorker*, *Vanity Fair*, *Harper's Bazaar*, and *Stern*. He was also a portraitist. In 1992 he produced his first documentary film. He curated the 1996, 2002 and 2017 editions of the *Pirelli Calendar*.

In Lissa im heutigen Polen geboren, studierte Lindbergh zunächst Malerei und wandte sich Anfang der 1970er-Jahre der Fotografie zu. Die Bilder des vor allem für seine Modeaufnahmen bekannten Fotografen erscheinen in der französischen *Vogue*, im *New Yorker*, *Vanity Fair*, *Harper's Bazaar* und im *Stern*. Auch als Porträtfotograf beachtet, drehte Lindbergh 1992 seinen ersten Dokumentarfilm und zeichnete unter anderem für den *Pirelli-Kalender* der Jahre 1996, 2002 und 2017 verantwortlich.

Né à Lissa, aujourd'hui Leszno, en Pologne, intéressé par la peinture, il se consacre à la photographie après la guerre. Surtout connu comme photographe de mode, il collabore à l'édition française de *Vogue*, *The New Yorker*, *Vanity Fair*, *Harper's Bazaar* et *Stern*. Il fut également portraitiste. En 1992, il réalise son premier film documentaire. Il dirige les éditions du calendrier Pirelli de 1996, 2002 et 2017.

List, Herbert *(1903–1975)*
A native of Hamburg, he studied the history of literature at the University of Heidelberg. He worked for his father's business, but, encouraged by Andreas Feininger, and influenced by artists such as Giorgio De Chirico, René Magritte, and Man Ray, in 1930 he started working as a photographer. In the second half of the 1930s he began working for *Vogue*, *Harper's Bazaar*, and *Life*. He met George Hoyningen-Huene, with whom he visited Greece and Italy. His masculine-looking female nudes became widely imitated. He took part in World War II, and in 1948 he was in Paris. He became art director for *Heute*, a German magazine edited by the Allied occupation forces. In the 1950s and early 1960s he travelled extensively (to Italy, Greece, Spain, France, Mexico, and the Caribbean), publishing photographs in *Du*, *Epoca*, *Look*, *Harper's Bazaar*, *Flair*, *Picture Post*, *Life*, as well as many photographic books, including *Rom* (1955).

Der aus Hamburg stammende List studierte in Heidelberg Literaturwissenschaften und arbeitete im väterlichen Kaffeekontor. Unter dem Einfluss der Kunst De Chiricos, Magrittes und Man Rays wandte er sich auf Anregung Andreas Feiningers ab 1930 der Fotografie zu und begann Ende der 1930er-Jahre, für *Vogue*, *Harper's Bazaar* und *Life* zu arbeiten. Mit George Hoyningen-Huene reiste er nach Italien und Griechenland. Lists Männerakte wurden wegweisend. 1948 ging er nach Paris und wurde Kunstredakteur der von den Besatzungsmächten herausgegebenen Zeitschrift *Heute*. In den 1950er- und Anfang der 1960er-Jahre unternahm List zahlreiche Reisen, unter anderem nach Italien, Griechenland, Spanien, Frankreich, Mexiko und in die Karibik; die dort entstandenen Bilder wurden in Zeitschriften wie *Du*, *Epoca*, *Look*, *Harper's Bazaar*, *Flair*, *Picture Post* oder *Life* sowie in mehreren Bildbänden abgedruckt, darunter *Rom* (1955).

Natif de Hambourg, il étudie l'histoire de la littérature à l'université de Heidelberg. Encouragé par Andreas Feininger et influencé par des artistes comme De Chirico, Magritte et Man Ray, il joint en 1930 à son activité commerciale dans l'entreprise paternelle celle de photographe. À la fin des années 1930, il commence à travailler pour *Vogue*, *Harper's Bazaar* et *Life*. Il fait la connaissance de George Hoyningen-Huene avec qui il entreprend un voyage en Grèce et en Italie. Ses nus masculins font école. Il prend part à la Seconde Guerre mondiale. En 1948, il se trouve à Paris. Il est nommé directeur artistique de la revue *Heute* éditée en Allemagne par les forces d'occupation alliées. Dans les années 1950 et au début des années 1960, il effectue de nombreux voyages (Italie, Grèce, Espagne, France, Mexique, Caraïbes); il en rapporte des photographies publiées dans *Du*, *Epoca*, *Look*, *Harper's Bazaar*, *Flair*, *Picture Post* et *Life* ainsi que dans de nombreux ouvrages, dont *Rom* (1955).

Listri, Massimo *(1953–)*
Born in Florence, he is the son of a well-known journalist. First producing photographic portraits of contemporary celebrities, he has subsequently focused on architectural photography, collaborating with various publishers, including Franco Maria Ricci, and recently TASCHEN.

Der in Florenz geborene Sohn eines Journalisten wurde mit seinen Prominentenporträts bekannt, bevor er sich der Architekturfotografie widmete. Listri hat bei verschiedenen Verlagen Fotobücher veröffentlicht, darunter bei Franco Maria Ricci und jüngst auch bei TASCHEN.

Né à Florence, fils d'un journaliste connu. Auteur de portraits photographiques de célébrités, il se consacre ensuite à la photographie d'architecture, collaborant avec divers éditeurs dont Franco Maria Ricci et, plus récemment, TASCHEN.

Lotti, Giorgio *(1937–)*
Starting in 1954, he worked as a photojournalist with newspapers and periodicals such as *Il Mondo*, *Milano Sera*, *Paris Match*, *Epoca* (1964–1997), and *Panorama* (1997–2002).

Lotti war seit 1954 als Bildberichterstatter für Tageszeitungen und Zeitschriften wie *Il Mondo*, *Milano Sera* sowie später *Paris Match*, *Epoca* (1964–1997) und *Panorama* (1997–2002) tätig.

À partir de 1954, il travaille comme reporter photographe pour plusieurs quotidiens et périodiques dont *Il Mondo*, *Milano Sera*, *Paris Match*, *Epoca* (1964–1997) et *Panorama* (1997–2002).

Macpherson, Robert *(1814–1872)*
Scottish by birth and a surgeon by training, he travelled to Rome in 1840, where he became passionate about antiquities and started studying under Tommaso Minardi at the British Academy of Fine Arts. In the early 1850s he began his photographic work, becoming one of Rome's most prominent photographers. Starting in 1857, he published photographic albums, which were prized by travellers and collectors. In 1863 he published a book of photographs on the sculptures in the Vatican museums collections. He produced large-scale views with carefully studied compositions, often characterized by elements shot in close-up. Between 1865 and 1870 he produced a series of panoramic format photographs featuring a very short focal length.

Der schottische Chirurg kam 1840 in die Ewige Stadt, wo er sich in das Studium der römischen Altertümer vertiefte und bei Tommaso Minardi an der British School Malerei studierte. Anfang der 1850er-Jahre wandte er sich der Fotografie zu. Einer der Hauptvertreter der fotografischen Technik in der Tiberstadt, veröffentlichte er 1857 einen ersten Katalog mit seinen Fotografien, die bei Reisenden und Sammlern auf große Bewunderung stießen. 1863 legte er eine Auswahl mit Aufnahmen von Statuen aus den vatikanischen Sammlungen vor. Seine großformatigen Fotografien sind genau komponiert und zeigen ihre Motive häufig in Nahsicht und eng gestaffelt. 1865 bis 1870 entstand eine Serie von streng horizontal angelegten Panoramaaufnahmen mit kurzer Brennweite.

Écossais, chirurgien de formation, il se rend à Rome en 1840 où il se passionne pour les antiquités et fréquente la classe de Tommaso Minardi à l'Académie britannique des beaux-arts. Au début des années 1850, il fait ses débuts dans la photographie, art dont il deviendra l'un des protagonistes. À partir de 1857, il publie des catalogues de ses photographies, très appréciées des voyageurs et des collectionneurs, puis, en 1863, un recueil de photographies des sculptures conservées aux musées du Vatican. Ses clichés sont des grands formats qui proposent des compositions très étudiées, souvent caractérisées par une prise de vue rapprochée et serrée des sujets. Entre 1865 et 1870, il réalise une série de vues avec une focale très courte, au format horizontal de type panoramique.

Mazzatenta, O. Louis *(1938–2020)*
He was born in Ohio from a family of Italian origins. Starting in 1952, he worked for over 40 years for the National Geographic Society in different roles, including picture editor, director of layout and design, writer, and photographer. He launched the *National Geographic Japan* edition of the magazine. He particularly enjoyed working on his features on archaeological finds in Italy and China (and is best known for his 1996 series on the excavation of life-size terracotta warriors of the imperial army in Xi'an).

In Ohio als Sohn italienischstämmiger Eltern geboren, war Mazzatenta ab 1952 über vier Jahrzehnte in verschiedenen Funktionen für die National Geographic Society tätig: als Bildredakteur, Chefgestalter, Autor und Fotograf. Unter seiner Ägide kam *National Geographic Japan* auf den Markt. Mazzatentas bevorzugtes Gebiet war das der Archäologie mit Reportagen von Ausgrabungsstätten in Italien und China (bekannt wurden vor allem seine Bilder von der 1996 bei neuen Grabungen in Xi'an entdeckten lebensgroßen Terrakotta-Armee.)

Il voit le jour dans l'Ohio, au sein d'une famille d'origine italienne. En 1952, il entame une collaboration de quarante années avec la National Geographic Society à divers titres – *directeur du service photo*, *directeur artistique*, écrivain et photographe; par ailleurs, il a supervisé le lancement du *National Geographic Japan*. Ayant une prédilection pour les reportages archéologiques, il en a réalisés en Italie et, en 1996, en Chine à Xi'an où des fouilles mirent au jour une armée impériale de guerriers en terre cuite grandeur nature.

McAllister, T.H. *(active from 1855 until around the end of the 19th century)*
In 1796 John McAllister opened a store selling optical equipment in Philadelphia, which in 1855 was renamed McAllister & Brother by his grandchildren. In 1865, one of the grandchildren, T.H. McAllister, moved to New York, where he opened a shop selling magical lanterns, slides, stereoscopic views, and optical and photographic accessories.

Der 1796 von John McAllister in Philadelphia gegründete Optikerbetrieb wurde 1855 als McAllister & Brothers von seinen Enkeln übernommen. Einer von ihnen, T. H. McAllister, eröffnete in New York eine eigene Niederlassung, die auf den Vertrieb von Laterna-Magica-Geräten, Diapositiven, Stereoskopien und fototechnischem und optischem Zubehör spezialisiert war.

En 1796, John McAllister ouvre un magasin d'optique à Philadelphie que ses petits-fils rebaptisent McAllister & Brother en 1855. En 1865, l'un d'eux, T.H. McAllister, ouvre une succursale à New York, spécialisée en lanternes magiques, diapositives, vues stéréoscopiques et accessoires optiques et photographiques.

McCurry, Steve *(1950–)*
Born in Philadelphia. He has been a member of the Magnum agency since 1986. He is the author of the celebrated 1985 image of an Afghan girl, used on the cover of *National Geographic*.

Der in Philadelphia geborene Reise- und Pressefotograf ist seit 1986 Mitglied von Magnum Photos. Weltweit bekannt wurde sein Porträt eines afghanischen Mädchens auf dem Umschlag von *National Geographic* von 1985.

Né à Philadelphie. Reporter, auteur de photos de voyage et d'actualité, il est membre de l'agence Magnum Photos depuis 1986. On lui doit la photographie devenue célèbre de la jeune afghane à la une du *National Geographic* en 1985.

Molins, Pompeo *(c. 1827–1900)*
Probably a pupil of painter Tommaso Minardi, he was later a photographer associated with Gioacchino Altobelli until 1865. His negatives archive eventually absorbed those of the series of photographs taken by English archeologist J.H. Parker. In 1893 the archive was destroyed in a fire.

Wohl ursprünglich Schüler des Malers Tommaso Minardi war Molins bis 1865 Kompagnon von Gioacchino Altobelli. Die nach und nach in seinen Bestand übergegangenen Negative der Aufnahmen des britischen Archäologen J. H. Parker wurden bei einem Brand seines Bildarchivs 1893 vernichtet.

Élève probable du peintre Tommaso Minardi, il devient photographe et travaille en association avec Gioacchino Altobelli jusqu'en 1865. Par la suite, les négatifs de l'archéologue britannique J.H. Parker rejoignent ses archives qui disparaissent dans un incendie en 1893.

Mori, Walter *(1918–)*
In 1935 he enlisted in the Italian Air Force and during the war he was an aviation photographer in several war zones. In 1959 he became a member of the editorial team of *Epoca*, specializing in features about painters and sculptors.

Ab 1935 bei der italienischen Kriegsmarine, lieferte Mori Fotos vom Seekrieg an sämtlichen Fronten und aus allen Kriegsjahren. 1959 wurde er Redaktionsmitglied beim Wochenblatt *Epoca*, spezialisiert auf Reportagen über Maler und Bildhauer.

En 1935, il s'engage dans l'armée de l'air italienne et, pendant toute la guerre, est photographe de bord sur divers fronts. En 1959, il entre à la rédaction de *Epoca*, se spécialisant dans les reportages sur les peintres et les sculpteurs.

Mydans, Carl *(1907–2004)*
Trained as a journalist at the University of Boston, he began his career as a reporter in 1932 for *American Banker* magazine, and later became a freelancer. In 1935 he worked for the photographic department of the Federal Government's Resettlement Administration (later the Farm Security Administration), which was designed to document the lives of American rural populations during the Great Depression. In 1936 he started a 35-year collaboration with *Life* magazine, photographing the most important events of the time. Taken prisoner by the Japanese in 1941, along with his wife, he was released in time to photograph the liberation of France and Italy by the Allied forces. After *Life* magazine closed down (1972), he worked for *Time* and *Smithsonian* magazine. He is also known for his portraits of famous actors and politicians.

Nach dem Journalistikstudium in Boston begann Mydans 1932 als Fotograf der Zeitschrift *American Banker* und wurde anschließend Freiberufler. 1935 war er für die Fotoabteilung der Federal Resettlement Administration (später Farm Security Administration) tätig, die die Lebensbedingungen der amerikanischen Landbevölkerung während der Weltwirtschaftskrise dokumentierte. 1936 begann er eine über 35 Jahre währende Tätigkeit für das Magazin *Life*, für das er von den wichtigsten Schauplätzen seiner Zeit berichtete. 1941 zusammen mit seiner Frau von den Japanern ge-

fangen gesetzt, kam Mydans rechtzeitig frei, um mit der Kamera von der Befreiung Frankreichs und Italiens durch alliierte Truppen zu berichten. Nach der Schließung von *Life* 1972 arbeitete er für *Time* und *Smithsonian*. Beachtung fanden auch seine Porträtaufnahmen bekannter Schauspieler und Politiker.

Journaliste formé à l'université de Boston, il débute sa carrière de reporter en 1932 pour la revue *American Banker*, puis se met à son compte. En 1935, il travaille pour le service photographique de la Federal Government's Resettlement Administration (future Farm Security Administration), créée pour documenter la vie des populations rurales américaines durant la Grande Dépression. À partir de 1936, il entame une collaboration de trente-cinq ans avec *Life*, photographiant les grands événements de son temps. Fait prisonnier avec sa femme par les Japonais (1941), il est libéré à temps pour photographier la libération de la France et de l'Italie par les forces alliées. Après la disparition de *Life* (1972), il travaille pour *Time* et *Smithsonian Magazine*. Il est connu comme portraitiste d'acteurs célèbres et d'hommes politiques.

Naylor, Genevieve *(1915–1989)*
An American photojournalist and photographer, she was Eleanor Roosevelt's personal photographer. She worked with *Harper's Bazaar* and *Look* magazine.

Die amerikanische Fotojournalistin wurde als Privatfotografin Eleanor Roosevelts bekannt und hat unter anderem für *Harper's Bazaar* und *Look* gearbeitet.

Photojournaliste américaine, connue pour avoir été la photographe attitrée d'Eleanor Roosevelt. Elle a collaboré à *Harper's Bazaar* et *Look*.

Newman, Marvin E. *(1927–2023)*
Born in New York, he studied sculpture and photography, first at Brooklyn College, and then from 1949 to 1952 at the Chicago Institute of Design with Harry Callahan. He worked with several periodicals such as *Sports Illustrated*, *Life*, *Look*, *Newsweek*, and *Smithsonian*. One of his favorite subjects was the urban life of New York.

Geboren in New York, studierte Newman zunächst Fotografie am Brooklyn College und von 1949 bis 1952 am Institute of Design in Chicago bei Harry Callahan. Seine Bilder erschienen in verschiedenen Zeitschriften, darunter *Sports Illustrated*, *Life*, *Look*, *Newsweek*, *Smithsonian*. Zu seinen Lieblingsmotiven zählten Szenen aus dem städtischen Leben New Yorks.

Né à New York, il étudie la sculpture et la photographie au Brooklyn College, puis, de 1949 à 1952, à l'Institute of Design de Chicago avec Harry Callahan. Il collabore à divers périodiques, dont *Sports Illustrated*, *Life*, *Look*, *Newsweek* ou *Smithsonian Magazine*. L'un de ses thèmes de prédilection était la vie à New York.

Origlia, Franco *(1956–)*
Born in Rome, he studied at DAMS (Disciplina delle Arti Musica e Spettacolo) in Bologna. From 1988 to 2001 he worked for the Sygma agency, and after 2002 for Getty Images. During the course of his career he has produced images of current events, celebrities, sports, travel, and advertising.

Der gebürtige Römer hat an der Universität Bologna Kunst studiert. Von 1988 bis 2001 war er für die Agentur Sygma tätig, seit 2002 wird er von Getty Images vertreten. Origlia ist auf Bilder vom Zeitgeschehen, von Menschen der Gegenwart, Sportereignissen, Reisen und auf Werbefotografie spezialisiert.

Né à Rome, il fait études au DAMS à Bologne. De 1988 à 2001, il travaille pour l'agence Sygma et, à

partir de 2002, pour Getty Images. Ses clichés ont trait à l'actualité, à des personnalités contemporaines, au monde du sport, aux voyages et à la publicité.

Orkin, Ruth *(1921–1985)*
The daughter of a Hollywood actress, she was a self-taught photographer. She worked with *Theater Week*, *Chess Review*, and, after the war, for *Life*, *Look*, *Ladies' Home Journal*, *Cosmopolitan*, *Coronet* as a photojournalist and a portraitist. She also produced some films.

Die Tochter einer Hollywood-Schauspielerin brachte sich selbst das Fotografieren bei und lieferte Reportagen und Porträts für Zeitschriften wie *Theater Week* und *Chess Review*, nach dem Krieg auch für *Life*, *Look*, *Ladies' Home Journal*, *Cosmopolitan* und *Coronet*. Sie hat außerdem mehrere Filmprojekte realisiert.

Fille d'une actrice de Hollywood. Photographe autodidacte. Elle collabore à *Theater Week*, *Chess Review* et, après la guerre, à *Life*, *Look*, *Ladies' Home Journal*, *Cosmopolitan* et *Coronet* comme photojournaliste et comme portraitiste. Par ailleurs, on lui doit plusieurs films.

Paris, Gaston *(1903–1964)*
This celebrated Parisian photographer was the only salaried employee of *Vu* magazine, founded in 1928 by Lucien Vogel. His photo features covered different subjects: the 1937 Universal Exhibition, sports, the world of entertainment, actors, etc. At times his images had Surrealist undertones. Between the end of the 1930s and the 1950s he worked with the French *Détective* magazine.

Gastons Ruhm gründet sich nicht zuletzt darauf, dass er der einzige festangestellte Fotograf der 1928 von Lucien Vogel gegründeten Zeitschrift *Vu* war. Der Pariser berichtete von der Weltausstellung 1937, von Sportereignissen, aus der Theater- und Filmwelt. Zuweilen besitzen seine Aufnahmen eine surrealistische Note. Von Ende der 1930er- bis in die 1950er-Jahre war Gaston für die Zeitschrift *Détective* tätig.

La renommée de ce journaliste parisien est liée à son intense activité de seul et unique photographe salarié du magazine *Vu*, fondé en 1928 par Lucien Vogel. Les sujets de ses reportages sont des plus variés : l'Exposition universelle de 1937, le sport, le monde du spectacle, les acteurs, etc. Il n'est pas étranger à une certaine veine surréaliste. Entre la fin des années 1930 et les années 1950, il collabore à *Détective*.

Parks, Winfield *(1932–1977)*
He was renowned especially for his long-lasting collaboration with the National Geographic Society from 1961 to 1977, including text and photographic features taken over numerous travels around Europe, Asia, the Middle East, and South America.

Bekannt vor allem als Fotograf der National Geographic Society, für die er von 1961 bis 1977 sowohl Beiträge als auch Bilder lieferte, unternahm Parks zahlreiche Reportagereisen in Europa, Asien, dem Nahen Osten und Südamerika.

Il est surtout connu pour sa collaboration avec la National Geographic Society (1961–1977), pour ses photographies et ses textes rapportés de dizaines de voyages en Europe, en Asie, au Proche-Orient et en Amérique du Sud.

Parr, Martin *(1952–)*
He studied at the Faculty of Art and Design in Manchester. Influenced by Man Ray and by kitsch postcards, he developed a style in his imagery that was based on humor – sometimes bordering on the grotesque – capturing aspects of contemporary life,

including mass tourism. He published fashion photographs in *Friend* magazine. In 1994 he became a member of Magnum.

Parr studierte an der Designfakultät der Universität Mancheste und entwickelte, beeinflusst von Man Ray und der Ästhetik der Kitschpostkarte, einen ironischen Blick auf die Aspekte und Absurditäten des modernen Lebens, namentlich des Massentourismus. Seine Modefotografien erscheinen in *Amica*. Seit 1994 ist Parr Mitglied von Magnum Photos.

Parr étudie à la faculté d'Art et de Design de Manchester. Influencé par Man Ray et par les cartes postales kitsch, il élabore un genre où il saisit avec un humour frôlant parfois le grotesque certains aspects de notre temps, dont le tourisme de masse. Il publie des photographies de mode dans la revue *Amica*. Depuis 1994, il est membre de Magnum Photos.

Patellani, Federico *(1911–1977)*
As an officer of the Italian army, he was responsible for photographing the operations of the Corps of Engineers during the war in Ethiopia (1935–1936). From 1939 he worked as a photojournalist with the weekly publication *Tempo*. During World War II, he took photographs of the war in Russia (under the pseudonym Pat Monterosso) and in Italy. He is considered an important exponent of neorealist photography and has documented social, cultural, and political aspects of Italian life after the war. In 1952 he founded his own photographic agency, Pat Photo Pictures. His photographic features of Italy and abroad were published in *Tempo*, *Le Ore*, *Epoca*, *Life*, *Picture Post*, *Sie und Er*, and *Schweizer Illustrierte*.

Als Offizier dokumentierte Patellani die Einsätze der italienischen Pioniereinheiten im Äthiopienkrieg 1935/36 und arbeitete ab 1939 lange Jahre für das Wochenblatt *Tempo*. Im Zweiten Weltkrieg fotografierte er (unter dem Pseudonym Pat Monterosso) das Kriegsgeschehen in Russland und Italien. Als wichtiger Vertreter der neorealistischen Fotografenschule dokumentierte er das gesellschaftliche, kulturelle und politische Leben im Nachkriegsitalien. 1952 gründete Patellani eine eigene Fotoagentur, die Pat Photo Pictures. Seine Bildreportagen erschienen in italienischen und internationalen Zeitschriften wie *Tempo*, *Le Ore*, *Epoca*, *Life*, *Picture Post*, *Sie und Er* und der *Schweizer Illustrierten*.

Officier de l'armée italienne, il est chargé de photographier les opérations du Génie lors de la guerre d'Éthiopie (1935–1936). À partir de 1939, il entame une longue collaboration avec l'hebdomadaire *Tempo* comme reporter photographe. Durant la Seconde Guerre mondiale, il documente de la guerre en Russie (sous le pseudonyme de Pat Monterosso) et en Italie. Considéré comme un représentant important de la photographie « néoréaliste », il a illustré les aspects sociaux, culturels et politiques de la vie italienne dans l'après-guerre. En 1952, il fonde sa propre agence, la Pat Photo Pictures. Ses reportages sont publiés en Italie et à l'international dans *Tempo*, *Le Ore*, *Epoca*, *Life*, *Picture Post*, *Sie und Er* et *Schweizer Illustrierte*.

Peiffer Watenphul, Max *(1896–1976)*
Peiffer Watenphul trained as a painter at the Bauhaus in Weimar. During his fellowship at the German Academy of Villa Massimo between 1931 and 1932, he took a series of photographs of ancient and Renaissance Rome, infused with magic realism.

Max Peiffer Watenphul sudierte Malerei am Weimarer Bauhaus. Während seines Aufenthalts in der Villa Massimo 1931/32 machte er Aufnahmen von römischen Motiven aus Antike und Renaissance, die

von einer eigenwilligen Art magischen Realismus geprägt sind.

Max Peiffer Watenphul a étudié la peinture au Bauhaus à Weimar. Durant sa résidence à l'Académie allemande Villa Massimo, entre 1931 et 1932, il fit une série photographique sur l'art ancien et de la Renaissance à Rome, toute empreinte de « réalisme magique ».

Petagna, Michele *(1831–1877)*
An artist and engraver from Rome, he founded the photographic studio Fotografia Romana in Florence in 1858. In 1864 he opened a studio in Rome, specializing in the production of stereoscopic views. In January 1866 he entrusted this venture to Gioacchino Altobelli, and returned to Florence, where he worked until his photographic studio went bankrupt in 1875.

Aus Rom stammender Druckgrafiker, der um 1858 in Florenz das Atelier Fotografia Romana gründete. 1864 eröffnete er in Rom ein auf Stereoskopaufnahmen spezialisiertes Atelier, das er im Januar 1864 an Gioacchino Altobelli übergab. Wieder in Florenz, betrieb er sein dortiges Atelier weiter bis zu dessen Konkurs im Jahr 1875.

Graveur et chalcographe d'origine romaine, il crée à Florence l'atelier Fotografia Romana vers 1858. En 1864, il ouvre un studio à Rome, spécialisé dans la production de vues stéréoscopiques, qu'il confie à Gioacchino Altobelli en janvier 1866 afin de pouvoir retourner à Florence où il travaille jusqu'à la faillite de son établissement en 1875.

Peters, Vincent *(1969–)*
A photographer and film director from Germany, he began taking photographs during a trip to Thailand in the 1980s. From the 1990, he focused on photographing fashion and celebrities for many international magazines all over the world, such as *Glamour Magazine*, *Esquire*, *Harper's Bazaar*, *Town and Country*, *Marie Claire*, *Vogue* (German and Italian editions).

Der in Deutschland geborene Fotograf und Kinoregisseur begann während einer Thailandreise zu fotografieren und ist seit 1990 als Mode- und Celebrity-Fotograf für zahlreiche Blätter wie *Glamour Magazine*, *Esquire*, *Harper's Bazaar*, *Town and Country*, *Marie Claire*, *Vogue* (deutsche und italienische Ausgabe) tätig.

Né en Allemagne, photographe et réalisateur de cinéma. Il commence à faire des photos au cours de voyages en Thaïlande dans les années 1980. À partir de 1990, il se consacre à la photographie de mode et de célébrités, collaborant à de nombreux périodiques internationaux comme *Glamour Magazine*, *Esquire*, *Harper's Bazaar*, *Town and Country*, *Marie Claire*, *Vogue* (éditions allemande et italienne).

Photoglob Zürich
In 1888, the company and publishing house Orell Füssli of Zurich patented in Austria-Hungary an innovative photographic process, adopted a year later under the brand name Photochrom. This process made it possible to transfer elements of a black-and-white negative onto lithographic plates equal to the number of colors to be used when printing in transparent ink, from a minimum of four sheets to a maximum (some years later) of 18. This procedure required a manual intervention for the selection of colors, the retouching of shapes, the introduction or elimination of different items (people, vehicles, etc.). In 1895, Orell Füssli, Photochrom Zürich and Lichtdruckerei Schröder formed Photoglob Co., whose headquarters were in Zurich; they produced a wide range of photochromic lithographs of views of countries around the world, in

seven different format. These prints, and their postcard versions, flooded the tourist market until World War I.

1888 meldete das Verlags- und Druckhaus Orell Füssli in Zürich ein Verfahren für Österreich-Ungarn zum Patent an, das im Jahr darauf unter der Markenbezeichnung „Photochrom" auf den Markt kam. Es ermöglichte die Belichtung mehrerer lithografischer Platten (je eine pro Farbe, anfangs vier, später bis zu 18) mit den entsprechenden Partien eines Schwarz-Weiß-Negativs zum Abzug in transparenten Druckfarben. Auswahl und Bearbeitung der einzelnen Farbpartien wurden von Hand vorgenommen, Farbtöne konnten verstärkt oder abgeschwächt, Konturen nachgezogen, einzelne Details weg- oder hineinretuschiert werden (Passanten, Fahrzeuge usw.). 1895 fusionierten der Photochrom-Verlag des Druckhauses Orell Füssli und die Lichtdruckerei Schröder zur Aktiengesellschaft Photoglob & Co. mit Sitz in Zürich. Diese vertrieb weltweit auflagenstarke Photochromserien, die auch als Postkarten gedruckt wurden, in insgesamt sieben verschiedenen Formaten.

En 1888, la société et maison d'édition Orell Füssli de Zurich fait breveter en Autriche-Hongrie le procédé, adopté un an plus tard sous la marque « Photochrom », qui permet de transférer des éléments d'un négatif photo en noir et blanc sur un nombre de plaques lithographiques égal au nombre de couleurs utilisées lors de l'impression à l'encre transparente ; le nombre de ces plaques va d'un minimum de 4 à un maximum de 18 (atteint après quelques années). Le procédé requiert une intervention manuelle pour choisir les couleurs, retoucher les formes, introduire ou supprimer des éléments (personnes, véhicules, etc.). En 1895, les sociétés Orell Füssli, Photochrom Zürich et Lichtdruckerei Schröder fusionnent pour créer la Photoglob Co. dont le siège est à Zurich. Elle produit une large gamme de gravures photo-chromolithographiques en sept formats différents, proposant des vues de nombreux pays du monde, qui envahissent le marché touristique avant la Première Guerre mondiale et sont également proposées sous forme de cartes postales.

Porry-Pastorel, Adolfo *(1888–1960)*
Considered the father of Italian photojournalism, at first he worked with the newspapers *La Vita* and *Il Giornale d'Italia*. In 1908 he founded the photographic agency Foto VEDO (Visioni Editoriali Diffuse Ovunque: Editorial Visions Distributed Everywhere). In 1915 he photographed Mussolini being arrested in Piazza Barberini in Rome when he was about to lead a pro-intervention rally. He also took photographs during his participation in World War I. The image of Mussolini in high uniform, with the feather of his hat ridiculously folded over his face by the wind was published and derided in Britain. Following that incident, Italy established a tight censorship of its photographic material. Porry-Pastorel documented the urban works of the Fascist regime (the opening of Via dell'Impero, etc.) and organized photographic campaigns for the regime's propaganda, sometimes including actual performances (the promotion of an autarchic system and national control of agriculture, known as "the battle for grain," etc.).

Der „Vater des italienischen Fotojournalismus" arbeitete zunächst für die Tageszeitungen *La Vita* und *Il Giornale d'Italia*. 1908 gründete er die Bildagentur VEDO (Visioni Editoriali Diffuse Ovunque). 1915 machte Porry-Pastorel Bilder von der Verhaftung Mussolinis bei einer Kundgebung für den Kriegseintritt Italiens auf der Piazza Barberini. Als Kriegsteilnehmer fotografierte er das Frontgeschehen im Ersten Weltkrieg.

Sein Bild von Mussolini, dem der Federbusch seiner Galauniform ins Gesicht gerutscht ist, wurde, versehen mit sarkastischen Kommentaren, in England abgedruckt, was zur Einführung der Fotozensur in Italien führte. Porry-Pastorel begleitete die faschistischen Stadtumbauarbeiten (Öffnung der Via dell'Impero usw.) mit der Kamera und legte für das faschistische Regime mehrere Fotoserien, etwa zur Autarkiewirtschaft oder zur „Getreideschlacht", mit teils inszenierten Propagandabildern auf.

Il est considéré comme le père du photojournalisme italien. À ses débuts il collabore aux quotidiens *La Vita* et *Il Giornale d'Italia*. En 1908, il fonde l'agence photographique Visioni Editoriali Diffuse Ovunque (VEDO). En 1915, piazza Barberini à Rome, il photographie l'arrestation de Mussolini alors que ce dernier s'apprêtait à présider un comité d'interventionnistes. Pendant la Première Guerre mondiale à laquelle il participe, il réalise de nombreux clichés. L'image de Mussolini en grand uniforme, la plume de son couvre-chef rabattue de manière ridicule sur son visage par un coup de vent est publiée en Grande-Bretagne et y fait l'objet de commentaires sarcastiques. Dès lors, l'Italie instaure une censure sur le matériau photographique. Il illustre les grands travaux entrepris par le régime fasciste (percement de la via dell' Impero, etc.) et organise diverses campagnes photographiques de propagande avec parfois des mises en scènes (autarchie, « bataille du blé », etc.).

Praturlon, Pierluigi *(1924–1999)*

Starting as a street photographer in 1946, he quickly became the most important stage photographer for films made in Italy between 1959 and 1987; he also portrayed the most prominent Italian and foreign actors. Notable among his photographic books is *Paparazzi* (2008).

Nach Anfängen als „Straßenfotograf" 1946 wurde Praturlon schnell zum wichtigsten Standfotografen des italienischen Films der Jahre 1959 bis 1987 und schuf viele Porträts italienischer und ausländischer Schauspielgrößen. Von seinen Fotobüchern ist besonders das 2008 erschienene *Paparazzi* zu erwähnen.

Après avoir débuté comme « photographe de rue » en 1946, il devient le premier photographe de plateau du cinéma italien entre 1959 et 1987 et le portraitiste des plus grands acteurs italiens et étrangers. Parmi ses livres de photographies, on rappellera *Paparazzi* (2008).

Primoli, Giuseppe *(1851–1917)*

A count from the Roman nobility, related to the Bonaparte family, he was a cosmopolitan individual who belonged in high society and the intellectual circles of Rome and Paris. He began to be passionate about photography around 1880, as did his brother, Luigi. From then to the beginning of the 20th century, he took a large number of shots during his travels, and also in Rome, where he photographed members of the aristocracy and their pastimes, scenes of popular life, and the events of his time. The images he produced reveal his sharp observation of his subjects, and his sensitive visual perception. His photographic archive is kept at the Fondazione Primoli in Rome.

Angehöriger des römischen Adels und verwandt mit den Bonapartes, bewegte Graf Primoli sich in der italienischen Hautevolee und in den Intellektuellenkreisen von Paris und Rom. Um 1880 begann er gemeinsam mit seinem Bruder Luigi zu fotografieren. Bis in die frühen Jahre des 20. Jahrhunderts entstand eine beeindruckende Folge von Momentaufnahmen von seinen Reisen und vom Leben in Rom, wo Primoli Leben und Zeitvertreib der Aristokratie, Alltags-

szenen und Tagesereignisse festhielt. Seine Fotografien verraten große Intuition und Bildkraft. Das Archiv seiner Aufnahmen wird von der Fondazione Primoli in Rom verwaltet.

Membre de l'aristocratie, comte apparenté à la famille Bonaparte, cosmopolite, il fréquente la haute société et les cercles intellectuels de Rome et Paris. Vers 1880, avec son frère Luigi il se prend de passion pour la photographie. Dès lors et jusqu'au début du xxᵉ siècle, il réalise une extraordinaire série d'instantanés au cours de ses voyages et à Rome, où il photographie les membres de l'aristocratie et leurs passe-temps, des scènes de la vie populaire, et divers événements. Ses clichés témoignent d'une vive intuition dans le choix des sujets et d'un exceptionnel talent visuel. Ses archives photographiques sont conservées à la Fondation Primoli à Rome.

Rastellini, Marisa *(1929–)*

From 1953 to 1956 she worked as a graphic artist for the weekly *Il Contemporaneo*, then as a photographer for the periodical *Cinema Nuovo*, for which in 1955 she created an important feature, *Roma Proibita*, about life in the Roman slums. She subsequently worked for other illustrated periodicals.

Von 1953 bis 1956 als Grafikerin für die Wochenzeitschrift *Il Contemporaneo* tätig, fotografiert Rastellini auch für *Cinema Nuovo*, für das 1955 ihre viel beachtete Reportage *Roma proibita* aus den Barackensiedlungen am Stadtrand entstand. Später arbeitete sie für weitere italienische Illustrierte.

De 1953 à 1956, elle collabore comme graphiste à l'hebdomadaire *Il Contemporaneo* et comme photographe à *Cinema Nuovo* pour lequel elle réalise en 1955 un important reportage sur les bidonvilles de Rome intitulé *Roma proibita*. Par la suite, elle travaille pour d'autres périodiques illustrés.

Relang, Regina *(1906–1989)*

Studied painting in Stuttgart and Berlin, and in 1932 gained a diploma as an art teacher. She then moved to Paris, where she developed an interest in photography, and specialized in travel and fashion photography. Her fame as a fashion photographer became established in the 1950s and 1960s, reaching its peak in the 1970s. She has worked for major magazines such as *Vogue*, *Madame*, *Bild der Frau*, and *Harper's Bazaar*.

Nach ihrem Studium der Malerei in Stuttgart und Berlin, das sie im Jahr 1932 mit dem Meisterschülertitel abschloss, ging Relang nach Berlin, wo sie sich selbst das Fotografieren aneignete und sich auf Reise- und Modefotografie spezialisierte. In den 1950er-, 1960er-, vor allem aber in den 1970er-Jahren feierte die Fotografin in diesem Bereich große Erfolge, und ihre Bilder erschienen in den wichtigsten Modezeitschriften wie *Vogue*, *Madame*, *Bild der Frau* oder *Harper's Bazaar*.

Elle étudie la peinture à Stuttgart et à Berlin. Professeur d'art diplômée en 1932, elle s'établit à Paris où, en autodidacte, elle cultive son intérêt pour la photographie, se spécialisant dans le domaine des voyages et de la mode. Sa renommée de photographe de mode s'affirme dans les années 1950 et 1960 et culmine au cours de la décennie suivante. Elle a collaboré aux plus grandes revues de mode dont *Vogue*, *Madame*, *Bild der Frau* et *Harper's Bazaar*.

Rheims, Bettina *(1952–)*

Born in Neully-sur-Seine, after completing her studies she worked as a fashion model. Starting in 1978 she dedicated herself to fashion and advertising photography, collaborating with *Marie Claire*, *Vogue*, and

Égoïste. In 1984 she joined the Sygma agency and photographed prominent artists and politicians. She has published many books of photographs.

Die in Neuilly-sur-Seine geborene Rheims arbeitete nach dem Studium zunächst als Mannequin und von 1978 an als Mode- und Werbefotografin; *Marie Claire*, *Vogue*, *Égoïste* drucken ihre Bilder ab. 1984 ging sie zur Agentur Sygma, für die sie Persönlichkeiten aus Kunst und Politik fotografierte. Rheims hat zahlreiche Fotobücher veröffentlicht.

Elle naît à Neuilly-sur-Seine. Après ses études, elle devient mannequin. À partir de 1978, elle se consacre à la photographie de mode et de publicité. Elle collabore à *Marie Claire*, *Vogue*, *Égoïste*. En 1984, elle entre à l'agence Sygma pour laquelle elle photographie des personnalités du monde des arts et de la politique. Elle est l'auteur de nombreux ouvrages de photographies.

Rive, Robert *(1817–1868)*
Rive, Julius *(1823–1888)*

Born in Breslau, Prussia (now Wrocław, Poland), into a French-Huguenot family, in the early 1850s the two brothers moved to Naples, where they founded an important photographic studio under the name of Robert Rive. Like Giorgio Sommer's studio, theirs was one of the first to include high-quality views of the entire territory of the new Italian republic in its catalogue. The roles the two brothers held in their is still the object of speculation.

Anfang der 1850er-Jahre übersiedelten die beiden in Breslau geborenen, aus hugenottischer Familie stammenden Brüder nach Neapel und eröffneten dort eine auf Robert Rive eingetragene Fotografische Anstalt. Wie Giorgio Sommer gehörte Rive zu den Ersten, die Motive aus dem gesamten Gebiet des neu gegründeten Königreichs Italien anboten und dies in hoher Qualität. Welche Funktion die beiden Brüder genau im Betrieb der von ihnen gegründeten Firma spielten, ist noch nicht abschließend geklärt.

Nés à Breslau (Prusse) dans une famille d'origine française et huguenote, les deux frères s'établissent à Naples au début des années 1850 et y fondent un important studio photographique au nom de Robert. À l'instar de celui de Giorgio Sommer, le studio Rive est l'un des premiers à couvrir, par ses clichés de vues de la péninsule, tout le territoire de la nouvelle Italie, proposant des images de grande qualité. La part respective des deux frères dans l'activité de la société demeure mal connue.

Roesler Franz, Ettore *(1845–1907)*

A painter and watercolor artist, he was the author of *Roma pittoresca/Memorie di un'era che passa* (Picturesque Rome/Reminiscences of a passing era), a series of 120 watercolors produced between 1878 and 1896, based on his own highly polished photographs, a visual document of Rome's urban spaces prior to the transformations that occurred in the 20th century.

Für seine 120 Aquarelle umfassende zwischen 1878 und 1896 entstandene Folge *Pittoreskes Rom/Erinnerungen an eine Zeit, die verschwindet* mit Ansichten des römischen Stadtbilds vor der Umgestaltung seit der Jahrhundertwende, nutzte Roesler Franz eigene Fotografien von beachtlicher Qualität.

Peintre et aquarelliste, auteur des séries *Roma pittoresca/Memorie di un'era che passa*, composées de 120 aquarelles réalisées entre 1878 et 1896: témoignage visuel de Rome avant les transformations du xxᵉ siècle, celles-ci furent exécutées à partir des photographies d'une grande qualité formelle que Roesler Franz avait lui-même prises.

Rouchon, Jacques *(1923–1981)*
He was born in Paris. During World War II he partici-
pated in the Resistance; after the war he photographed
the cities around Paris that had been destroyed. He
subsequently produced photographs of French society,
fashion, portraits of contemporary celebrities, and ad-
vertisements. He worked for several magazines, joined
Agence Rapho, and opened his own studio.

Geboren in Paris, beteiligte Rouchon sich an der
Résistance und fotografierte nach 1945 die vom Krieg
heimgesuchten Städte im Umland von Paris. Später
folgten Reportagen zu gesellschaftlichen Themen, Mo-
defotografie, Porträts von Persönlichkeiten des Zeitge-
schehens und Werbeaufnahmen. Rouchon fotografier-
te für verschiedene Presseorgane, gehörte zur Agence
Rapho und unterhielt ein eigenes Fotoatelier.

Né à Paris. Après la Seconde Guerre mondiale
durant laquelle il prend part à la Résistance, il photo-
graphie les villes sinistrées des environs de Paris. Par
la suite, il se consacre au reportage sur divers aspects
de la société française, à la photographie de mode, au
portrait de personnalités et à la publicité. Il collabore
à divers périodiques, entre à l'agence Rapho et crée
son propre studio.

Sanders, Walter *(1898–2004)*
Born in Germany, he studied economics. He worked as
a freelancer for several German publications, but with
the rise of Nazism he moved to the USA. In 1938 he
started to work for *Life* magazine, and from 1944 to
1961 he was a member of its photographic team, for
which he produced news stories during World War II.

Der in Deutschland geborene Sanders studierte
zunächst Wirtschaftswissenschaften, um anschließend
als freier Fotograf für deutsche Zeitungen zu arbeiten.
Nach der Machtergreifung ging er in die USA und
arbeitete ab 1938 für *Life*, für das er während des
Zweiten Weltkriegs von der Front berichtete und zu
dessen festem Fotografenteam er von 1944 bis 1961
gehörte.

Né en Allemagne. Après des études en sciences
économiques, il travaille comme photographe free-
lance pour diverses publications allemandes. Lors de
l'avènement du nazisme, il part aux États-Unis. En 1938,
il commence à collaborer à *Life* et, de 1944 à 1961,
il fait partie de l'équipe de photographes de la revue,
pour laquelle il effectue des reportages de guerre
durant la Seconde Guerre mondiale.

Schulke, Flip *(1930–2008)*
An American photojournalist, he established himself
in the 1950s, documenting with dedication the life
and activity of Martin Luther King, Jr., the civil
rights movement, and moments in the lives of John F.
Kennedy, Fidel Castro, Muhammad Ali, and the early
astronauts. He was also a pioneer of underwater
photography.

Der US-amerikanische Fotojournalist erlangte ab
den 1950er-Jahren Bekanntheit unter anderem als
engagierter Chronist des Wirkens von Martin Luther
King und der Bürgerrechtsbewegung. Er fotografierte
John F. Kennedy, Fidel Castro, Muhammad Ali und
die ersten amerikanischen Raumfahrer. Schulke gilt
als Pionier der Unterwasserfotografie.

Photojournaliste américain, il se fait connaître à
partir des années 1950 en illustrant avec passion la vie
et l'œuvre de Martin Luther King Jr, les luttes pour les
droits civiques, certains moments de la vie de John F.
Kennedy, Fidel Castro, Mohamed Ali et des premiers
astronautes. Il est connu pour être l'un des pionniers
de la photographie sous-marine.

Scianna, Ferdinando *(1943–)*
After studying at the Faculty of Arts and Philosophy at
the University of Palermo, he met Leonardo Sciascia in
1963, the friendship that ensued being crucial to the
development of his political engagement. He moved to
Milan in 1967 and began working as a photojournalist
and as a Paris correspondent for *L'Europeo*. He is now
a member of the Magnum agency.

Scianna studierte zunächst Geisteswissenschaften
an der Universität Palermo. 1963 begegnete er Leonar-
do Sciascia, eine Freundschaft, die wegweisend für
Sciannas Arbeit wurde. 1967 ging er nach Mailand
und arbeitete als Bildreporter und Sonderkorrespon-
dent für *L'Europeo*, dessen Pariskorrespondent er spä-
ter wurde. Heute ist Scianna Mitglied von Magnum
Photos.

Il fréquente la faculté de lettres et de philosophie de
l'université de Palerme. Sa rencontre avec Leonardo
Sciascia en 1963 et l'amitié qui en naît jouent un rôle
déterminant dans l'orientation de sa carrière. En 1967,
il s'établit à Milan et commence à collaborer à *L'Europeo*
comme reporter photographe et envoyé spécial avant
de devenir le correspondant de la revue à Paris. Il est
membre de l'agence Magnum Photos.

Secchiaroli, Tazio *(1925–1998)*
In 1943 he photographed the American soldiers who
liberated Rome. In 1951 he joined the VEDO agency,
founded by Porry-Pastorel, and in 1955 he and Sergio
Spinelli created Roma Press Photo agency, whose pro-
duction ranged from political features to celebrity gos-
sip. In 1958 he came to fame for photographing the
scandalous striptease of Turkish dancer Aïché Nana at
Rugantino during the birthday party for Countess
Olghina di Robilant. The dancer was sentenced to two
months in jail and subsequently banished from Italy;
the venue was shut down indefinitely. Secchiaroli used
to ride through Via Veneto and the surrounding areas
on a Lambretta, taking animated snapshots of the pro-
tagonists of *la dolce vita* – actors, celebrities, wealthy
tourists – images that injected new life into illustrated
magazines. Recognizing his talent, Fellini asked him to
join him on set as a stage photographer. In 1963 he
met Sophia Loren and became her personal photogra-
pher. He published several books of photographs.

1943 machte Secchiaroli Fotos von der Befreiung
Roms durch US-Truppen. 1951 ging er zu Porry-Pasto-
rels Bildagentur VEDO, bevor er 1955 mit Sergio Spi-
nelli die Agentur Roma Press Photo gründete. Berühmt
wurde Secchiaroli durch seine Skandalbilder vom
Striptease der türkischen Tänzerin Aïché Nana bei der
Geburtstagsparty der Gräfin Olghina di Robilant im
Lokal Il Rugantino. Nana wurde zu zwei Monaten Ge-
fängnis verurteilt und ausgewiesen, das Rugantino auf
unbestimmte Zeit geschlossen. Auf seiner Lambretta
über die Via Veneto und ihre Nebenstraßen kurvend,
machte Secchiaroli Blitzlichtaufnahmen vom dortigen
Nachtleben und seinen Protagonisten, Schnappschüsse,
die das Bildrepertoire der Illustrierten revolutionierten.
Fellini, der Secchiarolis Fähigkeiten schätzte, ließ ihn
am Set seiner Filme fotografieren. 1963 lernte Secchia-
roli Sophia Loren kennen und wurde ihr Privatfoto-
graf; er hat mehrere Fotobücher veröffentlicht.

En 1943, il photographie les soldats américains qui
libèrent Rome. En 1951, il intègre l'agence VEDO de
Porry-Pastorel, puis, en 1955, avec Sergio Spinelli, il crée
l'agence Roma Press Photo dont l'activité va de la chro-
nique politique à la chronique mondaine scandaleuse.
En 1958, le strip-tease de la danseuse turque Aïché
Nana au Rugantino lors de la fête d'anniversaire de
la comtesse Olghina di Robilant fait scandale et lui

assure la célébrité. La danseuse est condamnée à deux
mois d'emprisonnement, puis expulsée d'Italie ; le local
est fermé pour un temps indéterminé. Monté sur une
Lambretta, Secchiaroli parcourt la via Veneto et les rues
adjacentes et photographie au flash les protagonistes
des soirées de la *dolce Roma* – acteurs, célébrités
diverses et riches touristes – obtenant des instantanés
pleins de vie qui renouvellent l'imaginaire de la presse
illustrée. Fellini, qui voit tout le potentiel du photo-
graphe, l'appelle sur le plateau de ses films. En 1963,
Secchiaroli fait la connaissance de Sophia Loren et
devient son photographe attitré. On lui doit plusieurs
livres de photographies.

Seymour, David *(1911–1956)*
Polish-born David Szymin, known as David Seymour
or under the pseudonym Chim, was one of the found-
ers in 1947 of the Magnum agency. He established
himself in Rome, and with his dispassionate power of
observation took photographs of ancient Italian reli-
gious traditions of Italy, as well as celebrity portraits.

Der polnische Fotograf David Szymin alias David
Seymour, auch unter dem Pseudonym Chim bekannt,
gehörte im Jahr 1947 zu den Mitbegründern von
Magnum Photos. Er übersiedelte nach Rom, wo er mit
nüchternem Blick namentlich das religiöse Brauchtum
der Italiener dokumentierte und Porträts bekannter
Persönlichkeiten schuf.

Polonais, David Szymin, *alias* David Seymour, aussi
connu sous le pseudonyme Chim, prend part à la fon-
dation de l'agence Magnum Photos en 1947. Il s'établit
à Rome où, d'un œil désenchanté, il photographie
surtout les traditions religieuses italiennes et fait le
portrait de personnalités connues.

Shaw, Sam *(1912–1999)*
Born in New York, as a young man he opened a paint-
ing studio with Romare Bearden, with whom he con-
tinued to collaborate even after he decided to devote
himself to photography. His photographs were based
on different subjects: show business, the world of arts
and letters, news, society, politics, etc. He was particu-
larly renowned for his portraits of actors. The image of
Marilyn Monroe with her dress floating up while she
is standing on a subway grille has become iconic. He
worked with Magnum. His images have been pub-
lished in *Collier's*, *Paris Match*, *L'Europeo*, *The Daily
Mail*, *Der Stern*, *Harper's Bazaar*. Starting in the 1960s,
he produced feature films, mainly with John Cas-
savetes. His heirs created the Shaw Family Archives.

Als junger Mann gründete Shaw eine Atelierge-
meinschaft mit Romare Bearden, mit dem er auch
nach seiner Hinwendung zur Fotografie weiter zusam-
menarbeitete. Seine Themen sind unterschiedlicher
Natur: Showbusiness und Film, die Welt von Kunst
und Literatur, Journalismus, Gesellschaft, Politik und
anderes mehr. Bekannt wurden vor allem Shaws
Schauspielerporträts, wie das zur Ikone gewordene
Bild von Marilyn Monroe mit wehendem Rock über
einem Lüftungsschacht. Zeitweise für Magnum Photos
tätig, wurden Shaws Fotos in Magazinen wie *Colliers*,
Paris Match, *L'Europeo*, *The Daily Mail*, *Stern* oder
Harper's Bazaar abgedruckt. Ab Beginn der 1960er-Jah-
re war Shaw als Filmemacher und Produzent tätig,
Letzteres vor allem für John Cassavetes. Sein Nachlass
ist in die Shaw Family Archives eingegangen.

Né à New York. Dans sa jeunesse il ouvre un atelier
de peinture avec Romare Bearden avec qui il continue
de collaborer même après avoir décidé de se consacrer
à la photographie. Ses clichés sont très divers, abordant
le spectacle, les arts et les lettres, le journalisme, la

politique et les faits de société. Réputé pour ses portraits d'acteur, son cliché de Marylin Monroe, la jupe soulevée par l'air s'échappant d'une grille d'aération du métro, est devenu une icône. Il a travaillé pour l'agence Magnum Photos. Ses photos sont publiées dans *Colliers*, *Paris Match*, *L'Europeo*, *The Daily Mail*, *Stern*, *Harper's Bazaar*. À partir du début des années 1960, il réalise ou produit des films, notamment de John Cassavetes. Ses héritiers ont fondé les Shaw Family Archives.

Shunk, Harry *(1924–2006)*
Schunk (later Shunk) was born in Reudnitz, Leipzig. From 1957 until 1973 he worked with Hungarian photographer János Kender, forming the Shunk-Kender team. He is renowned for his images of the creative process and the artwork of many European and American artists (nouveau réalisme, pop art, mimimalism, postminimalism, conceptual art, performance).

Unter dem Namen Schunk in Reudnitz bei Leipzig geboren, bildete Shunk von 1957 bis 1973 ein Team mit dem ungarischen Fotografenkollegen János Kender. Shunk wurde vor allem für seine Aufnahmen von den Arbeiten amerikanischer und europäischer Künstler des Nouveau Réalisme, der Pop-Art, des Minimalismus und Postminimalismus, der Konzept- und Performancekunst und deren Entstehungsprozesse bekannt.

Schunk (puis Shunk) voit le jour à Reudniz (Leipzig). De 1957 à 1973, il travaille avec le Hongrois János Kender avec lequel il forme le tandem Shunk-Kender. Il est connu comme photographe des œuvres et des procédés de création de nombreux artistes européens et américains (nouveau réalisme, pop art, minimalisme, postminimalisme, art conceptuel, performance).

Simelli, Carlo Baldassarre *(1811–1885)*
Having studied the fine arts, he specialized in perspective and engraving, and was also active as a painter. He began taking photographs possibly in the mid-1850s; his nature studies and genre scenes were particularly appreciated by other artists. In 1864 he published his first work, a photographic series on Christian archeology. He became a friend of archeologist John Henry Parker, and from 1867 provided photographic illustrations for his publications.

Nach einem Kunststudium mit anschließender Spezialisierung als Perspektivmaler und Druckgrafiker wirkte Simelli zunächst als Maler, bevor er in den 1850er-Jahren zu fotografieren begann. Seine Aufnahmen mit Naturstudien und Genreszenen fanden vor allem bei seinen Künstlerkollegen großen Anklang. 1864 veröffentlichte er einen ersten, in mehreren Lieferungen erscheinenden, mit fotografischen Aufnahmen illustrierten Band zur christlichen Archäologie. Simelli schloss Freundschaft mit John Henry Parker und steuerte ab 1867 Aufnahmen zu dessen archäologischen Publikationen bei.

Étudiant en art, il se spécialise en perspective et en gravure et travaille ensuite comme peintre. Vers le milieu des années 1850, semble-t-il, il se lance dans la photographie, domaine où il est apprécié par les artistes pour ses paysages et ses scènes de genre. En 1864, il publie, sous forme de fascicules, un premier ouvrage d'archéologie chrétienne illustré de photographies. Il se lie d'amitié avec l'archéologue John Henry Parker et, à partir de 1867, collabore activement avec lui en fournissant les illustrations photographiques de ses publications.

Sommer, Giorgio *(1834–1914)*
Born in Germany, in 1857 he moved to Italy, and after a brief period in Rome, where he worked with fellow German Edmond Behles (1841–1921), he moved to

Naples, where he created a commercial photographic studio that became one of the most important in Italy. His and Rive's companies were the first to produce large catalogues (starting in the early 1870s) of views of all the Italian regions, from the Alps to Sicily. All his images were of a very high formal quality.

Der aus Deutschland stammende Sommer übersiedelte 1857 zunächst nach Rom, wo er mit seinem Landsmann Edmund Behles (1841–1921) zusammenarbeitete, und dann nach Neapel. Der dort von Sommer gegründete fotografische Betrieb wurde zu einem der wichtigsten kommerziellen Anbieter von Fotomotiven in ganz Italien. Neben Rive war Sommer einer der Ersten, die umfangreiche Kataloge auflegten (ab Beginn der 1870er-Jahre), die Motive aus allen italienischen Regionen enthalten. Sommers Bilder zeichnen sich durch große formale Qualität aus.

D'origine allemande, il s'établit en Italie en 1857. Après un bref séjour à Rome où il travaille avec son compatriote Edmond Behles (1841–1921), il part pour Naples où il fonde un studio photographique qui ne tarde pas à être l'un des plus importants d'Italie. Son entreprise et celle de Rive sont les premières à réunir dès le début des années 1870 de riches catalogues de vues de toutes les régions d'Italie, des Alpes à la Sicile. Ses clichés sont toujours d'une grande qualité formelle.

Sorci, Elio *(1932–2013)*
One of the most famous among the Roman *paparazzi*. His most celebrated photographs shows the actor Walter Chiari attacking photographer Tazio Secchiaroli, who had caught him with Ava Gardner (1958).

Einer der bekanntesten römischen Paparazzi. Berühmt wurde Sorcis Foto von Walter Chiari, wie dieser auf Tazio Secchiaroli losgeht, der den Schauspieler in Begleitung von Ava Gardner aufgespürt hatte (1958).

L'un des paparazzi les plus célèbres. Son cliché de l'acteur Walter Chiari agressant le photographe Tazio Secchiaroli, qui l'a surpris en compagnie d'Ava Gardner (1958), est passé à la postérité.

Soriano, Tino *(1955–)*
Born in Barcelona, he has produced photo features of travels and current events for *National Geographic*. Since 2010 he has been the art director of the Fotonature festival in La Palma. He has published a number of books of photographs.

Der in Barcelona geborene Soriano fotografiert für *National Geographic* im Bereich Reise und Zeitgeschehen. Seit 2010 ist er künstlerischer Leiter des Festivals Fotonature in La Palma. Von Soriano sind mehrere Fotobücher erschienen.

Né à Barcelone. Il travaille pour le *National Geographic* et est l'auteur de reportages photographiques de voyage et d'actualité. À partir de 2010, il dirige le festival Fotonature de La Palma. On lui doit plusieurs ouvrages de photographies.

Stewart, B. Anthony *(1904–1977)*
From 1927 to 1969 he produced narrative-documentary features for *National Geographic*.

Von 1927 bis 1969 war Stewart für *National Geographic* tätig. Sein Werk trägt dokumentarisch-narrativen Charakter.

De 1927 à 1969, il travaille pour le *National Geographic*, réalisant des documentaires avec le souci de raconter une histoire.

Suscipj, Lorenzo *(1802–1855)*
An optician, he was one of the first to produce daguerreotypes of Rome. He was the author of the re-

markable daguerreotype panoramic view of Rome in eight plates. A series of 23 daguerreotypes he made was purchased by John Alexander Ellis, who planned to publish a collection of daguerreotype prints in *Italy Daguerreotyped*, a project that, however, did not come to completion. He also produced some series of stereoscopic views of Rome.

Der Optiker war einer der ersten römischen Daguerreotypisten und als solcher Urheber eines aus acht Platten bestehenden Panoramas der Ewigen Stadt. John Alexander Ellis erwarb eine Folge von 23 Daguerreotypien von Suscipj für eine *Italy Daguerreotyped* betitelte, aber nie erschienene Sammlung. Suscipj schuf auch Serien mit römischen Ansichten in Stereoskopie.

Technicien en optique, il est l'un des premiers à réaliser des daguerréotypes à Rome. Il est l'auteur d'un exceptionnel panorama de Rome en daguerréotype, constitué de huit plaques contiguës. Une série de 23 de ses daguerréotypes est acquise par John Alexander Ellis dans le cadre de son projet de publication d'une collection de gravures tirées de daguerréotypes. Suscipj a également réalisé une série de vues stéréoscopiques de Rome.

Tikhomiroff, Nicolas *(1927–2016)*
He was born in Paris from a family of Russian immigrants. After World War II he started working for periodicals such as *Marie France*. From 1959 he joined Magnum agency, producing features on the Algerian War, Vietnam, Cambodia, Laos, as well as meeting film directors such as Welles, Fellini, and Visconti. He was also a fashion and advertising photographer; he retired in 1987.

Geboren in Paris als Sohn russischer Emigranten, begann Tikhomiroff nach Ende des Zweiten Weltkriegs, für *Marie France* und andere Zeitschriften zu fotografieren. Ab 1959 arbeitete er für Magnum und veröffentlichte Reportagen vom Algerienkrieg, aus Vietnam, Kambodscha und Laos, fotografierte Filmregisseure wie Orson Welles, Federico Fellini und Luchino Visconti. Tikhomiroff war auch als Mode- und Werbefotograf aktiv, bevor er sich 1987 von der Berufsfotografie zurückzog.

Il naît à Paris dans une famille d'émigrés russes. Au lendemain de la Seconde Guerre mondiale, il commence à collaborer à plusieurs magazines dont *Marie France*. À partir de 1959, il travaille pour Magnum Photos, réalisant des reportages sur la guerre d'Algérie, le Vietnam, le Cambodge et le Laos, et rencontrant des réalisateurs tels que Welles, Fellini et Visconti. Par ailleurs, il a exercé son métier dans le monde de la mode et de la publicité avant de renoncer à la photographie professionnelle (1987).

Tuminello, Ludovico *(1824–1907)*
A photographer active in Rome from the early 1840s, in 1849 he became compromised by the political events linked with the Roman Republic, and he moved to Turin. After a trip to Egypt, he returned to Rome in the late 1860s. In 1870 he photographed Italian troops and camps besieging the city. In the 1870s and 1880s, he edited and distributed prints he had produced from negatives by Giacomo Caneva, who had died in 1865.

Bis Ende der 1840er-Jahre in Rom als Fotograf tätig, ging Tuminello, durch seine Verwicklung in die Römische Republik von 1849 politisch kompromittiert, nach Turin. Nach einer Ägyptenreise war er ab Ende der 1860er-Jahre wieder in der Tiberstadt. 1870 machte er Aufnahmen vom Aufmarsch der italienischen Truppen und der Belagerung des päpstlichen Rom. In den

1870er- und 1880er-Jahre vertrieb Tuminello Abzüge von Bildern des 1865 verstorbenen Giacomo Caneva unter eigenem Namen.

Photographe actif à Rome dès le début des années 1840. Compromis avec la République romaine de 1849, il part pour Turin. Après un voyage en Égypte, il est de retour à Rome dès la fin des années 1860. En 1870, il photographie les campements italiens et les troupes qui assiègent la ville. Dans les années 1870 et 1880, il édite et diffuse en son nom des gravures tirées des négatifs de Giacomo Caneva mort en 1865.

Ufer, Oswald *(1828–1883)*
An engraver of German origins, he began taking photographs of Rome and surroundings around 1860. He associated with his compatriot Michele Mang; when he later returned to Germany, he gave his archive to Michele Mang.

Der aus Deutschland stammende Druckgrafiker machte um 1860 erste Fotografien in Rom und Umgebung und hatte ein gemeinsames Atelier mit seinem Kompagnon und Landsmann Michele Mang, dem er bei seiner Rückkehr nach Deutschland sein Archiv abtrat.

D'origine allemande, graveur, il commence à photographier Rome et ses environs vers 1860. Il s'associe avec Michele Mang, un compatriote. Par la suite, il retourne en Allemagne et cède ses archives à Michele Mang.

Vaccaro, Tony *(1922–2022)*
An Italian-American photojournalist, he is renowned for the features he produced during World War II, such as the Normandy landings and the fall of Berlin. After the war he stayed in Europe, working for the US Department of War and for the newspaper *Stars and Stripes*. In 1948 he was in Paris, where he worked for *Weekend Magazine*. From 1954 to 1969 he divided his time between New York and Rome; he collaborated with *Flair, Look, Life, Venture, Harper's Bazaar, Town and Country, Quick,* and *Newsweek*. Over the years he produced photographs on the subjects of war, fashion, travel, and celebrity portraits.

Der italo-amerikanische Pressefotograf wurde durch seine Reportagen aus dem Zweiten Weltkrieg bekannt, wie die Landung in der Normandie und der Fall von Berlin. Nach Kriegsende blieb er in Europa und fotografierte für das War Department und für *Stars and Stripes*. 1948 ging er für das *Weekend Magazine* nach Paris. Von 1954 bis 1969 arbeitete er in Rom und New York, u. a. für *Flair, Look, Life, Venture, Harper's Bazaar, Town* and *Country, Quick* et *Newsweek*. Vaccaro betätigte sich als Kriegs-, Mode, Reise-, Porträt- und Starfotograf.

Photojournaliste italo-américain, connu pour les nombreux reportages qu'il réalisa durant la Seconde Guerre mondiale dont celui sur le débarquement de Normandie ou sur la chute de Berlin. Au lendemain de la guerre, il reste en Europe où il travaille pour le War Departement et pour *Stars and Stripes*. En 1948, il se trouve à Paris où il collabore à *Weekend Magazine*. Entre 1954 et 1969, il exerce son activité professionnelle entre New York et Rome; il collabore à *Flair, Look, Life, Venture, Harper's Bazaar, Town and Country, Quick* et *Newsweek*. Au fil du temps, il a été tour à tour photographe de guerre, de mode, de voyage et portraitiste de célébrités.

Vandeville, Éric *(1958–)*
A freelance French journalist and photojournalist, he has been taking photographs since 1986. He uses digital photography. In 2006 he published *Splendeurs et mystères du Vatican*.

Freier Journalist und Bildberichterstatter; fotografiert seit 1986, verwendet eine Digitalkamera. 2006 erschien von ihm der Band *Splendeurs et mystères du Vatican*.

Journaliste et reporter photographe free-lance, il pratique la photographie professionnelle depuis 1986. Il travaille avec un appareil numérique. En 2006, il a publié *Splendeurs et mystères du Vatican*.

VEDO Agency
→ Porry-Pastorel

Vitale, Franco *(1935–2007)*
He was born in Rome. As a young photographer in the Cavicchioli studio he first came into contact with film sets. In the early 1960s he worked for different agencies, dividing his time between cinema and current events, and was one of the *paparazzi* who documented the period of *la dolce vita*. Some years later he became a freelance film-set photographer, working with directors from Italy (including Bolognini, Lattuada, Ferreri, and Dario Argento from 1977), and from abroad (such as Stanley Kramer and John Huston).

Der in Rom geborene Vitale begann als junger Mann beim Fotoatelier Cavicchioli, das ihn in den Filmstudios von Cinecittà einsetzte. Anfang der 1960er-Jahre Jahre arbeitete er für verschiedene Bildagenturen und berichtete als Paparazzo aus der Welt des Films und vom Tagesgeschehen zu Zeiten des Dolce Vita. Einige Jahre später verlegte er sich auf die Tätigkeit als Setfotograf für italienische Regisseure wie Bolognini, Lattuada, Ferreri, vor allem aber, ab 1977, Dario Argento; dazu kamen ausländische Regisseure wie Stanley Kramer und John Huston.

Il voit le jour à Rome. Jeune photographe du studio Cavicchioli, il fréquente les plateaux de tournage. Au début des années 1960, il travaille pour différentes agences, alternant cinéma et faits divers et illustrant l'époque de la *dolce vita* en qualité de paparazzo. Par la suite, il se consacre exclusivement à la photographie de plateau en free-lance, illustrant le travail de réalisateurs italiens comme Bolognini, Lattuada, Ferreri et surtout Dario Argento à partir de 1977, ou étrangers comme Stanley Kramer et John Huston.

Vitali, Massimo *(1944–)*
Born in Como, he studied photography at the London College of Printing. At the beginning of the 1960s, he began working as a photojournalist for several Italian and European magazines, partly thanks to the support of Simon Guttmann, the founder of the Report agency. In the early 1970s he began working for cinema and television.

Der aus Como stammende Vitali studierte Fotografie am London College of Printing und ist seit Beginn der 1970er-Jahre auch dank der Unterstützung durch Simon Guttmann als Pressefotograf für verschiedene europäische Blätter tätig. Seit Anfang der 1970er-Jahre arbeitet er auch für Film und Fernsehen.

Né à Côme, il étudie la photographie au London College of Printing. Dans les années 1960, il fait ses débuts comme reporter photographe pour diverses publications européennes et italiennes, bénéficiant de l'intérêt que lui porte Simon Guttmann, fondateur de l'agence Report. Dans les années 1970, il commence à travailler pour le cinéma et la télévision.

Whitmore, James *(1932–2000)*
He was an American photojournalist. Between 1949 and 1962 he worked for *Time* and *Life*, and produced a great number of features on subjects like the American Academy in Rome (1957), the Vatican, the 1960 Rome Olympics, the wars in the Middle East, and the Soviet Union.

Der amerikanische Fotoreporter war von 1949 bis 1962 für *Time* and *Life* tätig; besondere Beachtung fanden seine Bilder von der American Academy in Rom (1957), aus dem Vatikan, von den Olympischen Spielen in Rom 1960 sowie von den Kriegsschauplätzen im Nahen Osten und aus der Sowjetunion.

Photojournaliste américain. Il a travaillé pour *Time* et *Life* entre 1949 et 1962, réalisant de nombreux reportages, notamment sur l'American Academy de Rome (1957), le Vatican, les Jeux olympiques de Rome (1960), l'Union soviétique et sur les guerres au Proche-Orient.

Wilkes, Stephen *(1957–)*
Born in New York, he is known especially for his photographic features on abandoned and dilapidated buildings, such as those featured in the *Ellis Island Ghost* series. His fine arts and photojournalistic images have been published in *Vanity Fair, Sports Illustrated,* and *The New York Times Magazine*.

Der New Yorker Wilkes ist vor allem für seine Fotoreportagen über verlassene und verfallene Häuser bekannt, z. B. *Ellis Island Ghost*. Seine Kunstfotos und seine journalistischen Bilder werden in *Vanity Fair, Sports Illustrated* und im *The New York Times Magazine* abgedruckt.

Né à New York, il doit sa renommée à ses reportages photographiques sur des édifices abandonnés ou en ruine, comme ceux de la série *Ellis Island Ghost*. Ses clichés de sujets artistiques ou relevant du photojournalisme sont publiés dans *Vanity Fair, Sports Illustrated* ou dans *The New York Times Magazine*.

Wolff, Paul *(1887–1951)*
A physician by training, he took up photography first as an amateur. In 1920 he created a photographic agency in Frankfurt specializing in travel and advertising, and later industrial photography. In 1943–1944 he took part in the documentation of works of art threatened by the war in Germany.

Der Arzt und Amateurfotograf gründete 1920 in Frankfurt eine auf Reise-, Werbefotografie, später auch auf Produktfotografie spezialisierte Bildagentur. 1943/44 war er an der Dokumentation vom Krieg bedrohter deutscher Kunststätten beteiligt.

Docteur en médecine, photographe amateur à ses débuts, il crée une agence à Francfort en 1920, qui se spécialise dans la photographie de voyage et de publicité et par la suite dans la photographie industrielle. En 1943–1944, il participe à une campagne de documentation sur des œuvres d'art menacées par la guerre en Allemagne.

Yoder, Dave *(?–)*
Born in Indiana, he grew up in Tanzania. He has published his photographs in several periodicals, such as the *New York Times*, and often works with the *National Geographic Magazine*.

Yoder wurde in Indiana geboren und wuchs in Tansania auf. Seine Bilder erscheinen in der *New York Times* und anderen Zeitungen und Zeitschriften; intensive Zusammenarbeit mit dem *National Geographic Magazine*.

Il voit le jour dans l'Indiana et grandit en Tanzanie. Ses photographies ont paru dans différents périodiques dont *The New York Times*; une intense collaboration le lie au *National Geographic*.

Recommended Viewing
Filmempfehlungen
Les films à voir

Cabiria, Giovanni Pastrone (*1914*)
During the Second Punic War (3rd century BC), Cabiria, a child sold as a slave to Carthage, is rescued by a Roman patrician and his slave Maciste. The most expensively produced as well as the most celebrated Italian silent movie, it is almost three hours long, contains numerous extras and monumental stage sets. D'Annunzio created the names of the characters (Maciste became legendary and inspired subsequent movies) as well as its captions.

Während des Zweiten Punischen Krieges (3. Jh. v. Chr.) wird die kleine Cabiria als Sklavin nach Karthago verkauft, aber von einem römischen Patrizier und dessen Sklaven Maciste befreit. Bekanntester und teuerster Stummfilm Italiens, gedreht mit unzähligen Komparsen, kolossalen Szenenbildern und fast drei Stunden Spielzeit. Gabriele D'Annunzio erfand die Namen der Figuren (Maciste wurde in Italien zum Mythos und Filmheld) und schrieb die Zwischentexte.

Au cours de la deuxième guerre punique (IIIᵉ siècle av. J.-C.), Cabiria, une enfant vendue comme esclave à Carthage, est sauvée par un patricien romain et par son esclave Maciste. Ce film est le péplum le plus célèbre et le plus cher du cinéma muet italien : près de trois heures de projection, d'innombrables figurants, des décors gigantesques. Gabriele D'Annunzio inventa le nom des personnages – celui de Maciste, devenu mythique, inspira d'autres films – et rédigea les intertitres.

One Night in Rome, Clarence Badger (*1924*)
The client of a palm-reader recognizes in her the woman who disappeared after a dramatic scandal following her husband's suicide.

Der Kunde einer Wahrsagerin erkennt in dieser eine Frau wieder, die nach dem Skandal um den Selbstmord ihres Mannes verschwunden war.

Le client d'une chiromancienne reconnaît en elle la femme qui a disparu à la suite des scandales provoqués par le suicide de son mari.

Il Signor Max, Mario Camerini (*1937*)
A Roman newspaper agent leads a double life, aspiring to climb his way into the elegant circles of society, but eventually recognizes the emptiness of that world. A classic example of the so-called comedy of *telefoni bianchi* (white telephones).

Der Betreiber eines römischen Zeitungskiosks führt ein Doppelleben, um in die Kreise der feinen Gesellschaft zu gelangen, deren Sinnentleertheit er aber schließlich erkennen muss. Musterbeispiel für das „Kino der weißen Telefone".

Un marchand de journaux romain menant une double vie aspire à fréquenter le beau monde dont il finit par prendre conscience de la vacuité. Un bon exemple de comédie des «téléphones blancs».

Teresa Venerdì, Vittorio De Sica (*1941*)
A charming doctor struggling with debts, torn between a foolish girlfriend and an intrusive lover, meets an orphan with whom he can be himself again. A brilliant early Roman comedy by De Sica.

Ein Arzt und Frauenheld, der bis über beide Ohren in Schulden steckt, schwankt zwischen einer törichten Verlobten und einer aufdringlichen Geliebten, bis er bei einem Waisenmädchen zu innerer Ausgeglichenheit findet. Brillante römische Komödie des frühen De Sica.

Un médecin bourreau des cœurs et criblé de dettes, partagé entre une fiancée sotte et une maîtresse possessive, rencontre une orpheline auprès de laquelle il finit par trouver son équilibre. Une comédie romaine brillante de De Sica à ses débuts.

Roma città aperta, Roberto Rossellini (*1945*)
The vicissitudes of a country girl and her boyfriend, a typographer, during the Nazi occupation of Rome; a Communist engineer who is a member of the resistance and his lover; and a priest. Produced under difficult economic and technical conditions, only two months after the liberation of Rome, the film caught international attention and is considered to be the first neorealist work.

Vor der Kulisse des von den Deutschen besetzten Rom folgt der Film den Schicksalen einer Frau aus dem Volk und des mit ihr verlobten Druckers, eines kommunistischen Ingenieurs im Widerstand, sowie eines Pfarrers. Mit einfachsten finanziellen und technischen Mitteln nur zwei Monate nach der Befreiung der Stadt gedreht, fand *Rom, offene Stadt* internationale Beachtung und markierte den Beginn des italienischen Neorealismus.

Dans la Rome occupée par les nazis, le destin tragique d'un prêtre, d'une femme du peuple et de son compagnon typographe, d'un ingénieur communiste membre de la Résistance et de sa maîtresse. Réalisé dans des conditions économiques et techniques difficiles, deux mois à peine après la libération de Rome, le film s'imposa à l'attention internationale et fut considéré comme l'œuvre fondatrice du néoréalisme.

Paisà, Roberto Rossellini (*1946*)
From a story by Vasco Pratolini and a screenplay co-written by Federico Fellini, the film, starring mostly non-professional actors, recounts in six episodes the advancement of the Allied troops from Sicily to northern Italy. In the episode about Rome, a young woman lures a drunk American soldier. The film is considered one of the peaks of neorealist Italian cinema.

Das auf einer Erzählung von Vasco Pratolini basierende Drehbuch entstand unter Mitarbeit von Federico Fellini und wurde hauptsächlich mit Laiendarstellern verfilmt. Der Film schildert in sechs Episoden den Vormarsch der alliierten Truppen von Sizilien bis nach Norditalien. In den in Rom gedrehten Szenen erliegt ein betrunkener GI den Verlockungen einer jungen Römerin. *Paisà* gilt als Meisterwerk des neorealistischen Kinos.

Avec un scénario auquel contribua Vasco Pratolini, une mise en scène à laquelle collabora Federico Fellini et la participation d'acteurs non professionnels pour la plupart, ce film évoque en six épisodes l'avancée vers le nord de l'Italie des troupes alliées débarquées en Sicile. Dans l'épisode romain, une jeune fille séduit un soldat américain ivre. Le film est considéré comme l'un des chefs-d'œuvre du cinéma néoréaliste italien.

Sciuscià, Vittorio De Sica (*1946*)
The protagonists are the kids who offer to shine the shoes of the Allied soldiers to earn a little money. It is based on a popular legend about a boy buying a horse; it is because of the horse, whom the boy loves passionately, that the story will end in tragedy.

Die titelgebenden Schuhputzjungen bieten alliierten Soldaten ihre Dienste an und kommen zu Geld. In Anlehnung an eine volkstümliche Legende kauft einer von ihnen sich ein Pferd, das er heiß und innig liebt, das aber zum Grund für das tragische Ende der Geschichte wird.

Les héros du film sont les gamins qui, pour gagner de l'argent, proposent aux soldats alliés de cirer leurs chaussures. Le scénario reprend une légende populaire selon laquelle l'un des enfants s'est acheté un cheval qui, aimé à la folie, provoquera la tragédie finale.

Sotto il sole di Roma, Renato Castellani (*1948*)
A group of kids in Rome after World War II. Starring non-professional actors, it is an example of so-called "pink neorealism" (*neorealismo rosa*).

Die Geschichte einer Gruppe junger Römer während des Zweiten Weltkriegs, inszeniert mit Laiendarstellern; Beispiel des sogenannten „rosafarbenen Neorealismus".

Un groupe de gamins à Rome durant la Seconde Guerre mondiale. Interprété par des acteurs non professionnels, le film est un exemple de « néoréalisme rose ».

Ladri di biciclette, Vittorio De Sica (*1948*)
Just after the war, an unemployed father and his son look for a bicycle that was stolen, indispensable for the job the father has just found. Travelling across Rome, they encounter solidarity, indifference, and hostility. Featuring non-professional actors, it is a masterpiece of neorealist cinema.

Mit seinem kleinen Sohn durchstreift ein Vater auf der Suche nach seinem gestohlenen Fahrrad, das er für seine neue Arbeit braucht, das Rom der unmittelbaren Nachkriegszeit und trifft auf Solidarität, Gleichgültigkeit und Feindschaft. Gespielt von Laiendarstellern, ein Klassiker des Neorealismus.

Avec son jeune fils, un chômeur part à la recherche de la bicyclette qu'on lui a volée et qui lui est indispensable pour le travail qu'il vient de trouver ; parcourant la Rome de l'immédiat après-guerre, il rencontre solidarité, indifférence, hostilité. Un chef-d'œuvre du néoréalisme interprété par des acteurs non professionnels.

Una domenica d'agosto, Luciano Emmer (*1950*)
A genre film: the Ostia beach on a Sunday in August 1949.

Am Badestrand von Ostia an einem Augustsonntag des Jahres 1949 angesiedelte Gesellschaftskomödie.

Une comédie de mœurs : la plage d'Ostie, un dimanche d'août 1949.

Bellissima, Luchino Visconti (*1951*)
Film director Blasetti organizes a competition at Cinecittà to select the little girl who will star in his movie. Roman mothers come running; Maddalena, a working-class woman, would do anything to have her child chosen, but soon discovers the cruel world behind the film-star dream. An insightful melodrama, but above all the striking portrait of a woman, played by Anna Magnani.

Der Regisseur Blasetti veranstaltet in Cinecittà ein Casting, um die Rolle eines kleinen Mädchens in seinem nächsten Film zu besetzen. Maddalena, eine Frau aus dem Volk, ist bereit, alles zu tun, damit ihre Tochter die Rolle bekommt, muss aber die Grausamkeit der Traumfabrik erkennen. Intelligentes Melodram und Porträt einer Frau mit einer wunderbaren Anna Magnani in der Hauptrolle.

Le réalisateur Blasetti organise un concours aux studios Cinecittà pour trouver la fillette qui jouera dans un de ses films. Les mères de Rome accourent ; Maddalena, une femme du peuple, qui est prête à tout pour que sa fille soit choisie, découvre la cruauté de l'usine à rêves. Un mélodrame intelligent, mais aussi et surtout un portrait de femme magnifiquement incarné par Anna Magnani.

Quo Vadis, Mervyn LeRoy (*1951*)
The fourth film version of the novel by Polish author Henryk Sienkiewicz, winner of the Nobel Prize for

Literature in 1905. The events take place in Rome under Nero's reign, during the conflict between Christians and the corrupt officials of the imperial government.

Vierte Verfilmung des Romans des polnischen Literaturnobelpreisträgers von 1905 Henryk Sienkiewicz. Der Film schildert die Ereignisse in Rom zur Zeit von Kaiser Nero zwischen christlichem Edelmut und der Verkommenheit des Kaiserhofs.

Quatrième interprétation cinématographique du roman de Henryk Sienkiewicz, écrivain polonais, lauréat du prix Nobel de littérature en 1905. Les événements ont lieu à Rome sous le règne de Néron, époque où le christianisme se heurte à la corruption du gouvernement impérial.

Roma Ore 11, Giuseppe De Santis (1952)

The staircase of a newly reconstructed building collapses, crushing a group of women from different backgrounds, who had flocked there in response to an ad for a typist job. Based on a true story.

Die Treppe eines Büroneubaus stürzt ein und reißt mehrere Frauen in den Tod, die sich auf eine Annonce für eine Stellung als Schreibkraft gemeldet hatten und deren Geschichten erzählt werden. Beruht auf einer wahren Begebenheit.

L'escalier d'un immeuble récemment reconstruit s'effondre, entraînant dans sa chute un groupe de femmes aux existences diverses, venues répondre à une petite annonce pour un poste de dactylographe. Inspiré d'un fait divers.

Umberto D, Vittorio De Sica (1952)

An elderly ministry official who struggles in life but endures with great dignity. De Sica and screenplay writer Cesare Zavattini look beyond the risks and limits of populism and realism. Giulio Andreotti, then the undersecretary of theater and entertainment, fiercely opposed the film because, albeit under a poetical light, it revealed the state of dejection of the country.

Geschichte eines verarmten pensionierten Beamten, der sich seine Würde bewahrt hat. De Sica und Zavattini, der am Drehbuch beteiligt war, gelingt es, Grenzen und Gefahren von Populismus und Naturalismus zu transzendieren. Der Film stieß auf die erbitterte Gegnerschaft Giulio Andreottis, damals Staatssekretär für Theater und Film, weil in ihm, wenn auch in dichterischer Form, das schreiende Elend vieler Italiener beim Namen genannt wird.

L'histoire d'un ex-fonctionnaire ministériel réduit à la misère mais demeurant d'une grande dignité. De Sica et Zavattini transcendent les risques et les limites du populisme et du naturalisme. Giulio Andreotti, alors sous-secrétaire d'État chargé du spectacle, critiqua violemment le film qui, malgré sa poésie, montre la misère du pays de manière crue.

Le ragazze di Piazza di Spagna, Luciano Emmer (1952)

From his study window on the Spanish Steps, a professor watches the unfolding lives of three peasant women who work in a tailor's workshop. It was a comedy of "pink neorealism."

Von seinem Büro an der Spanischen Treppe aus verfolgt ein Professor das Schicksal dreier einfacher Frauen, die in einer Schneiderei arbeiten. Komödie des „rosafarbenen Neorealismus".

Depuis son bureau situé piazza di Spagna, un professeur est témoin de la vie de trois femmes qui travaillent dans un atelier de couture. Comédie du « néoréalisme rose ».

Stazione Termini, Vittorio De Sica (1953)

A short-lived affair between a married American woman and an Italian teacher comes to an end with a painful farewell at the train station. Screenplay by Cesare Zavattini, with a script for the English version (*Indiscretion of an American Wife*) rewritten by Truman Capote.

Die kurze Affäre zwischen einer verheirateten Amerikanerin und einem italienischen Lehrer nimmt im Bahnhof Termini ein dramatisches Ende. Drehbuch von Cesare Zavattini, dessen Dialoge für die englische Fassung von Truman Capote verfasst wurden.

Une brève liaison entre une Américaine mariée et un enseignant italien prend fin à la gare dans la tourmente des adieux. Mise en scène de Cesare Zavattini, dialogues réécrits par Truman Capote pour la version anglophone.

Roman Holiday, William Wyler (1953)

On a visit to the Italian capital, a princess (Audrey Hepburn) escapes the supervision of her dignitaries. For 24 hours she goes across the city on a Vespa, in the company of a journalist (Gregory Peck) who, at an official reception, pretends not to recognize her – giving up a sensational scoop about her which would benefit his career.

Zu Besuch in der italienischen Hauptstadt, entwischt eine Prinzessin ihren Aufpassern und erlebt in Begleitung eines amerikanischen Journalisten, der sie auf seiner Vespa durch Rom kutschiert, 24 Stunden Freiheit. Beim offiziellen Empfang am Tag danach lässt der Journalist sich nichts anmerken und verzichtet auf die Story seines Lebens.

En visite dans la capitale italienne, une princesse échappe à la surveillance de ses gardes du corps et durant vingt-quatre heures, parcourt incognito la ville sur une Vespa en compagnie d'un journaliste qui fait semblant de ne pas la reconnaître lors d'une réception officielle et renonce ainsi au reportage sensationnel qui lancerait sa carrière.

La bella di Roma, Luigi Comencini (1954)

An assertive woman who works as a cashier is courted in turn by a boxer, an elderly widower, and a carpenter, characters created to illustrate the traditional Italian vices.

Eine selbstsichere Kassiererin zwischen einem Boxer, einem in die Jahre gekommenen Witwer und einem Anstreicher; Sittenbild verbreiteter italienischer Untugenden.

Autour d'une caissière sûre d'elle-même, tourne un boxeur, un veuf d'âge mûr et un tapissier, qui illustrent les vices traditionnels des Italiens.

La Romana, Luigi Zampa (1954)

The story of Adriana, who models for a painter, during the early years after World War II. Based on the novel by Alberto Moravia.

Die Geschichte von Adriana, einer Römerin in der Zeit des Faschismus, die einem Maler erst mal nur Modell sitzt…; nach dem Roman des Schriftstellers Alberto Moravia.

Dans l'immédiat après-guerre, l'histoire d'Adriana, modèle d'un peintre… D'après le roman d'Alberto Moravia.

Una pelliccia di visone, Glauco Pellegrini (1956)

When a suburban housewife wins a mink fur coat, her life is turned upside down. In 1950s Rome, a mink fur coat was a prized status symbol.

Als sie einen Nerzmantel gewinnt, kommt das Le-

ben einer Hausfrau aus der römischen Vorstadt in Unordnung. Nerzmäntel galten im Rom der 1950er-Jahre als Statussymbol.

L'existence d'une ménagère de banlieue est bouleversée lorsqu'elle gagne un manteau en vison. Dans les années 1950, à Rome, le manteau de vison est un signe de réussite.

Poveri ma Belli, Dino Risi (1957)

Two thugs from Trastevere woo a seamstress; she flirts with them both, but eventually chooses a third suitor. A comedy of "pink neorealism."

Zwei Halbstarke aus Trastevere machen der Verkäuferin eines Schneiderladens den Hof; sie flirtet mit beiden und nimmt einen dritten. Komödie des „rosafarbenen Neorealismus".

Deux séducteurs de Trastevere se disputent les faveurs d'une employée d'un atelier de couture qui flirte avec les deux mais en préfère un troisième. Comédie du « néoréalisme rose ».

Un maledetto imbroglio, Pietro Germi (1959)

Based on Carlo E. Gadda's novel *Quer pasticciaccio brutto de via Merulana* (That Awful Mess on the Via Merulana, 1957). When it came out, the film was considered the best murder mystery of Italian cinema; it was set in the early days of Fascism. Germi directed it, wrote its screenplay, and played the protagonist.

Nach Carlo E. Gaddas Roman *Die grässliche Bescherung in der Via Merulana*. Bei seiner Premiere als bester italienischer Kriminalfilm gefeiert; spielt zu Beginn der faschistischen Zeit. Germi führte Regie, schrieb das Drehbuch und spielte den Kommissar.

Tiré du roman de Carlo E. Gadda, *L'Affreux Pastis de la rue des Merles* (1957). Lors de sa sortie, il fut considéré comme le meilleur film policier du cinéma italien. L'intrigue se passe au début du fascisme. Germi en est le réalisateur, le scénariste et l'interprète.

Ben Hur, William Wyler (1959)

An epic film about the history of ancient Rome (100,000 extras, almost 500 speaking actors) that still holds a record number of Oscars.

Monumentalfilm über das antike Rom mit 100.000 Komparsen und 500 Sprechrollen; der mit den meisten Oscars ausgezeichnete Film bis heute.

Gigantesque péplum sur la Rome antique (100 000 figurants, près de 500 acteurs parlants) qui a battu tous les records aux Oscars.

La dolce vita, Federico Fellini (1960)

A great panoramic depiction of 1960s Rome, with all its ambiguities. Marcello (Mastroianni), a provincial young man, a journalist looking for scoops, leaps from one experience to the next; outwardly a brilliant man, he is disenchanted, masking his thoughts under his skepticism and cynicism, but at his core deeply dissatisfied. A film at once excessive, grotesque, lyrical, and magical, with fleeting moments of intense realism.

Panorama des zeitgenössischen Rom mit all seinen Widersprüchen. Marcello (Mastroianni), ein junger Journalist aus der Provinz, immer auf der Suche nach spektakulären Geschichten, nach außen hin brillant und illusionslos (mal skeptisch, mal zynisch), in Wahrheit aber unzufrieden und auf der Suche. Ein überladener, zugleich grotesker, opernhafter, magischer Film, mit plötzlich aufscheinenden veristischen Momenten.

Vaste fresque du monde romain contemporain et de ses ambiguïtés. Marcello (Mastroianni), jeune provincial, journaliste en quête de scoops, qui accumule les expériences, est apparemment brillant, désenchanté

(sceptique ou cynique), mais en réalité profondément insatisfait. Film tout à la fois surchargé, grotesque, lyrique, magique avec de brefs et soudains moments d'une intense vérité.

Spartacus, Stanley Kubrick (1960)

The last Hollywood epic about the history of Rome. Spartacus, a Thracian gladiator, leads slaves in an uprising against the Roman government, wins a battle against a legion of soldiers, and is defeated by the army led by Crassus, who crucifies thousands of slaves on the Via Appia. It contains magnificent scenes of battles and violence.

Letzter der historischen Hollywoodmonumentalfilme über Rom. Der thrakische Gladiator Spartacus führt einen Sklavenaufstand an und besiegt eine Legion in der Schlacht, bevor er von Crassus besiegt wird, der Tausende Sklaven entlang der Via Appia ans Kreuz schlagen lässt. Grandiose Schlacht- und Gewaltszenen.

Le dernier des péplums historiques de Hollywood sur Rome. Gladiateur originaire de Thrace, Spartacus prend la tête d'une révolte d'esclaves contre le gouvernement de Rome, remporte une bataille contre une légion, mais est vaincu par l'armée de Crassus qui fait crucifier des milliers d'esclaves le long de la via Appia. Magnifiques scènes de bataille et de violence.

Il gobbo, Carlo Lizzani (1960)

A young southern Italian man who lives in the Roman suburbs, nicknamed "the Hunchback," fights the Fascists and the Nazis. After the liberation of the city, he becomes a bandit and robs speculators and black-market opportunists to give money to the poor; eventually he is killed by the police in a shootout. The film is based on the true story of the "hunchback from Quarticciolo."

Ein junger süditalienischer Einwanderer aus der Vorstadt, genannt „der Bucklige", kämpft gegen italienische Faschisten und deutsche Besatzer. Nach der Befreiung raubt er Spekulanten und Schwarzmarkthändler aus und verteilt die Beute unter den Armen, bis er von der Polizei bei einer Schießerei getötet wird. Der Film greift eine wahre Geschichte auf.

Un jeune homme, surnommé « il gobbo » [le bossu], originaire du sud de l'Italie et vivant dans la banlieue de Rome, se bat contre les fascistes et les nazis. Après la libération de la ville, il s'adonne au banditisme, volant les spéculateurs et les acteurs du marché noir et distribuant son butin aux pauvres avant d'être tué par la police lors d'un échange de coups de feu. Le film s'inspire de l'histoire vraie du « gobbo del Quarticciolo ».

Totòtruffa '62, Camillo Mastrocinque (1961)

A comedy in which a former writer of variety shows and a friend organize small-scale scams. In one of the sketches, Totò tries to sell the Trevi Fountain to a tourist.

Komödie über einen ehemaligen Varieté-Autor, der mit einem Freund kleine Betrügereien aushecht. In einer der Episoden versucht Totò, den Trevibrunnen an einen Touristen zu verschachern.

Comédie où un ex-auteur de variétés et son ami organisent de petites escroqueries. Dans l'une des séquences, Toto essaie de vendre la fontaine de Trevi à un touriste.

Accattone, Pier Paolo Pasolini (1961)

In the squalor and desolation of the Roman suburban shanty towns, against a background of lassitude and discouragement, the tale of a working-class man who exploits a prostitute and draws an innocent young girl into prostitution. The story takes on the significance of the universal human tragedy, poetry expressed through cinema. It was the first Italian film to be classified as suitable only for viewers over 18 years of age.

Im Schmutz und in der Hoffnungslosigkeit der römischen Vorstadt spielende, von Resignation geprägte Geschichte um einen Mann aus dem Lumpenproletariat, der auf Kosten einer Prostituierten lebt und schließlich ein junges Mädchen auf den Strich schickt. Poesie in Form eines Films, der Dimensionen der menschlichen Tragödie annimmt. Erster italienischer Film mit Altersfreigabe nicht unter 18.

Dans la misère et la désolation de la banlieue romaine, l'existence caractérisée par le manque de combativité d'un sous-prolétaire qui survit en exploitant une prostituée et conduit à la prostitution une jeune fille innocente ; un destin qui touche à la tragédie humaine universelle. De la poésie sous forme de cinéma. Premier film italien à être interdit aux moins de 18 ans.

La commare secca, Bernardo Bertolucci (1962)

The body of a prostitute is found on the shores of the Tiber (commare secca means death). Each of the suspects has an alibi and tells his story. The film is based on a subject by Pasolini.

Am Tiberufer wird die Leiche einer Prostituierten gefunden. Jeder der Verdächtigen hat ein Alibi und erzählt eine eigene Geschichte. Der Film basiert auf einer Geschichte von Pier Paolo Pasolini.

Le cadavre d'une prostituée – la « commare secca » est la mort – est découvert sur les rives du Tibre. Chacun des suspects a un alibi et raconte sa propre histoire. Pasolini est à l'origine du sujet du film.

Mamma Roma, Pier Paolo Pasolini (1962)

Mamma Roma (Anna Magnani), a prostitute, has a teenage son with whom she wants to build a new life, but without success: the boy is arrested for theft and dies in prison after the brutal treatment he suffers. The Roman suburbs are portrayed as a huge expanse of land stretching silently under the sun: tragic, hostile, and indifferent to human feelings. It is one of the greatest masterpieces of Italian cinema.

Mamma Roma (Anna Magnani), eine römische Prostituierte, die einen Sohn hat, will neu anfangen, scheitert aber. Der Junge wird wegen Diebstahl verhaftet und stirbt im Gefängnis an den Folgen der dort erlittenen Misshandlung. Die römische Peripherie liegt endlos und stumm unter der Sonne, tragisch, feindlich, gleichgültig gegenüber jeder menschlichen Empfindung. Eines der größten Meisterwerke des italienischen Kinos.

Mamma Roma (Anna Magnani), prostituée, a un fils adolescent avec lequel elle aimerait commencer une nouvelle vie ; elle n'y parviendra pas car le garçon est arrêté et meurt en prison à la suite de mauvais traitements. La périphérie romaine, très étendue, muette sous le soleil, tragique, hostile, indifférente aux sentiments. L'un des chefs-d'œuvre du cinéma italien.

La marcia su Roma, Dino Risi (1962)

A finely-spun comedy, a satire of the early Fascist period. The tragicomic adventures of two poor devils drafted by chance and under duress by a brigade of Black Shirts.

Mit feiner Ironie erzählte Satire über die Anfänge des Faschismus und die tragikomischen Abenteuer zweier Tagediebe, die zufällig in einen Trupp Schwarzhemden auf dem „Marsch nach Rom" gesteckt werden.

Comédie empreinte de finesse, satire du fascisme des débuts avec ses milices. Les aventures tragi-comiques de deux pauvres types engagés par hasard et de force dans une brigade de Chemises noires.

Il Sorpasso, Dino Risi (1962)

For a 40-year-old extrovert conscious of the failure of his private life and obsessed with his fear of old age, going for a car race against a new friend on a sultry and deserted Sunday in August becomes a second chance to prove himself. But the adventure ends in tragedy. A masterpiece of Italian comedy produced during the economic boom.

Ein extrovertierter Vierziger, im Wissen um sein persönliches Scheitern und getrieben von der Angst vor dem Alter, trifft auf einen jungen Mann, mit dem er sich an einem heißen Augustsonntag auf eine atemlose Autofahrt begibt, die ihm Genugtuung verschaffen soll, aber tragisch endet. Meisterwerk der Filmkomödie der Wirtschaftswunderjahre.

Pour un quadragénaire extraverti, mais conscient de l'échec de sa vie privée et obsédé par la crainte de vieillir, une course automobile avec un nouvel ami par un dimanche étouffant et désert se présente comme une revanche. L'aventure se termine tragiquement. Chef-d'œuvre de la comédie italienne du boom économique.

8 1/2, Federico Fellini (1963)

"The film […] is an inner monologue alternating with rare glimpses of reality […]. The two childhood episodes in the rustic house in Romagna and of the boy's first encounter with the woman on the Rimini beach are the most beautiful parts of the film, and among the highlights of all of Fellini's work." (Alberto Moravia)

„Der Film […] ist ein innerer Monolog, unterbrochen vom gelegentlichen Einbruch der Wirklichkeit […]. Die beiden Episoden aus der Kindheit in einem Bauernhaus der Emilia Romagna und der ersten Begegnung des Protagonisten mit einer Frau am Strand von Rimini gehören zu den schönsten des ganzen Films und von Fellinis gesamtem Oeuvre." (Alberto Moravia).

« Le film […] est un monologue intérieur alternant avec de rare fragments de réalité […]. Les deux épisodes de l'enfance dans la maison de campagne romagnole et de la jeunesse marquée par la première rencontre avec la femme sur la plage de Rimini sont les plus beaux du film et parmi les plus beaux de toute l'œuvre de Fellini » (Alberto Moravia).

La ricotta, Pier Paolo Pasolini (part of Ro.Go, Pa.G) (1963)

In a film about the Passion of Jesus, an extra who plays one of the thieves dies on the cross from indigestion after eating too much ricotta. Considered an insult to religion, the film was banned and Pasolini sentenced to four months in jail.

Bei den Dreharbeiten zu einem Jesusfilm erstickt ein Komparse, der einen der Schächer am Kreuz spielt, an einem unverdauten Ricottakäse. Der Film wurde wegen Verletzung religiöser Gefühle beschlagnahmt und Pasolini in erster Instanz zu vier Monaten Haft verurteilt.

Dans un film sur la Passion du Christ, l'un des larrons meurt sur la croix d'une indigestion de ricotta. Jugé blasphématoire, le film fut censuré et Pasolini condamné à quatre mois de réclusion avec sursis.

Adulterio all'italiana, Pasquale Festa Campanile (1966)

A high comedy: Marta discovers her husband's infidelity and decides to give him a taste of his own medicine.

Eine brillante Komödie: Marta entdeckt die Untreue ihres Mannes und beschließt, ihm mit gleicher Münze heimzuzahlen.

Une comédie brillante : Marta découvre l'infidélité de son mari et décide de lui rendre la monnaie de sa pièce.

Certo, certissimo, anzi ... probabile, Marcello Fondato (1969)

After sharing a house with a manicurist friend, a telephone operator marries an upholsterer and finds out that he has a relationship with an American house painter. Based on Dacia Maraini's novella *Diario di una telefonista*.

Eine Telefonistin heiratet, nachdem sie lange Zeit mit einer befreundeten Kosmetikerin zusammengewohnt hat, einen Tapezierer und entdeckt, dass dieser etwas mit einem amerikanischen Anstreicher hat. Komödie nach Dacia Marainis *Diario di una telefonista*.

Après avoir longtemps habité avec une amie manucure, une standardiste épouse un tapissier et découvre que celui-ci a une liaison avec un Américain, peintre en bâtiment. Comédie d'après *Diario di una telefonista* de Dacia Maraini.

Nell'anno del Signore, Luigi Magni (1969)

In 1825, under Pope Leo XII, cardinals and the police harass the people and guillotine the revolutionary *carbonari* from Romagna. But every night fierce satirical epigrams against the clergy appear, hanging from the statue of Pasquino.

1825: Unter Leo XII. wird das Volk von Kardinälen und Polizeispitzeln schikaniert, und Angehörige der römischen Freiheitsbewegung landen auf dem Schafott. Doch jede Nacht erscheinen neue Zettel mit satirischen Epigrammen voll beißendem Spott gegen den Klerus an der seit Jahrhunderten diesem Zweck dienenden Statue des Pasquino.

En 1825, sous le pontificat de Léon XII, cardinaux et sbires oppriment le peuple et envoient les *carbonari* romains à la guillotine. Mais chaque nuit, en signe de protestation, des pamphlets anticléricaux sont accrochés à la statue de Pasquin.

Roma, Federico Fellini (1972)

The capital city in a young man's reminiscences from the 1930s in the reality of the 1970s (the protagonist is the director's alter ego). The taste for the grotesque sometimes prevails, resulting in an uneven film that does not do justice to Fellini's art.

Das Rom der 1930er-Jahre in seiner Erinnerung und das Rom der 1970er-Jahre in der Realität gesehen durch die Brille eines jungen Mannes (und Alter Ego des Regisseurs). Der Hang zum Grotesken führte dazu, dass Fellini in diesem Film nicht immer auf der Höhe seiner Erzählkunst war.

La capitale hier et aujourd'hui: la Rome des années 1930 dans les souvenirs de jeunesse du héros (l'alter ego du réalisateur) et la Rome des années 1970, celle où il vit. Le goût du grotesque l'emporte parfois et empêche Fellini de rester au plus haut niveau.

L'Udienza, Marco Ferreri (1972)

An official on leave goes to Rome to have an audience with the Pope, but his wait lasts for months, until one night, sick with pneumonia, he dies in front of the papal palace.

Ein Beamter auf Urlaub fährt nach Rom, um mit dem Papst zu sprechen, doch er muss Monate auf eine Audienz warten, bis er schließlich vor den Türen des päpstlichen Palasts an einer Lungenentzündung stirbt.

Un officier en permission se rend à Rome pour obtenir une audience avec le pape; l'attente dure des mois, et une nuit, une pneumonie emporte l'officier qui meurt devant le palais pontifical.

C'eravamo tanto amati, Ettore Scola (1974)

A comedy that spans nearly 30 years of Italian life, from 1945 to 1974. Three former partisan friends – a Communist hospital worker, a provincial teacher who aspires to be a journalist, and a lawyer who works as an estate agent – meet on several occasions, eventually getting together in Rome, each recalling in his own way dashed hopes, betrayed ideals, failed revolutions.

Komödie über drei Freunde, in der drei Jahrzehnte Leben in Italien (1945 bis 1974) Revue passieren. Die Wege der ehemaligen Partisanen – ein kommunistischer Krankenpfleger, ein Lehrer in der Provinz, der eigentlich Journalist werden möchte, und ein Anwalt, der als Immobilienmakler arbeitet – kreuzen sich immer wieder und führen schließlich nach Rom, wo jeder der drei seine enttäuschten Hoffnungen, verratenen Ideale und verpassten Revolten heraufbeschwört.

Comédie retraçant trente ans d'histoire italienne, de 1945 à 1974. Trois amis ex-partisans : un brancardier communiste, un enseignant de province aspirant journaliste et un avocat devenu agent immobilier se retrouvent dans la capitale, où chacun évoque à sa manière les espoirs déçus, les idéaux trahis et les révolutions ratées.

Gruppo di famiglia in un interno, Luchino Visconti (1974)

A 60-year-old American professor decides to retire among books and paintings in his house in an ancient palace of Rome, inherited from his Italian mother. The story gets complicated with the arrival of a group of relatives.

Ein amerikanischer Professor beschließt, sich nach der Pensionierung in eine von seiner italienischen Mutter geerbte Wohnung voller Bilder und Bücher in einem alten römischen Haus zurückzuziehen. Kompliziert wird die Geschichte, als Verwandte sich einstellen.

Entouré de livres et de tableaux, un professeur américain sexagénaire mène une existence recluse dans l'appartement d'un vieux palais romain que lui a légué sa mère italienne. L'affaire se complique avec l'arrivée de bruyants voisins.

Brutti, sporchi e cattivi, Ettore Scola (1976)

In a suburban shanty town of Rome, an immigrant from Puglia browbeats his poor and numerous family and brings home a kind-hearted prostitute. A tragicomic and grotesque farce on the human conditions in the poorer Roman neighborhoods, an apt counterpoint to the tragic vision of Pasolini's *Accattone* and *Mamma Roma*.

Ein Einwanderer aus Apulien tyrannisiert seine ebenso zahlreiche wie mittellose Familie und bringt eine Prostituierte mit gutem Herzen in seiner Baracke in der römischen Vorstadt unter. Tragikomische, zuweilen groteske Farce über die Lebensbedingungen in den römischen *borgate*; Gegenstück zu Pasolinis tragischer Version des Themas in *Accatone* und *Mamma Roma*.

Dans un faubourg de Rome, un patriarche originaire des Pouilles tyrannise sa famille, aussi nombreuse que pauvre, et finit par ramener dans son taudis une prostituée au grand cœur. Une farce tragi-comique et grotesque sur la condition humaine dans les faubourgs, à comparer avec la vision tragique d'*Accatone* et de *Mamma Roma* de Pasolini.

Una giornata particolare, Ettore Scola (1977)

In 1938, in a building vacated by its residents who have gone to witness Hitler's visit to Mussolini, a young mother disappointed with her husband and a young homosexual meet and have a brief and "particular" love story. This is Scola's highest achievement among his comedies, masterfully interpreted by Sophia Loren and Marcello Mastroianni.

Während alle das Haus verlassen, um den Besuch Hitlers bei Mussolini 1938 mitzuerleben, bleiben eine junge, von ihrem Mann enttäuschte Mutter und ein junger Homosexueller allein zurück. Zwischen beiden entspinnt sich eine kurze, außergewöhnliche Liebesgeschichte. Scolas beste Kinokomödie, mit Marcello Mastroianni und Sophia Loren in Hochform.

En 1938, dans l'immeuble qui se vide de ses résidents partis voir le défilé organisé pour la venue de Hitler à Rome, une jeune mère de famille déçue par son mari et un journaliste homosexuel vivent une brève et «particulière» histoire d'amour. Un chef-d'œuvre de Scola magistralement interprété par Sophia Loren et Marcello Mastroianni.

Ecce bombo, Nanni Moretti (1978)

A depiction of the Roman world of former 1968 activists: their political disenchantment, self-consciousness, popular radio, rock music, independent theater, and television.

Das Rom der 68er-Jahre, zehn Jahre danach: politische Desillusionierung, Selbstkritik, freie Radiostationen, Off-Theater, Rockmusik, Fernsehen.

Une représentation de la Rome des jeunes ex-soixante-huitards : désenchantement politique, autocritique, radios populaires, rock, théâtre off, télévision.

La Luna, Bernardo Bertolucci (1980)

An Italian-American singer leaves New York to go to Italy with her son. In Rome, she discovers that he takes drugs, and in an attempt to save him she has an incestuous relationship with him.

Eine italo-amerikanische Sängerin fährt mit ihrem Sohn nach Italien. In Rom entdeckt sie, dass dieser Drogen nimmt; beim Versuch, ihm zu helfen, kommt es zu einer inzestuösen Begegnung.

Une chanteuse italo-américaine quitte New York pour l'Italie avec son fils. À Rome, elle découvre qu'il se drogue et dans sa tentative pour le récupérer elle ne recule pas devant des relations incestueuses.

La terrazza, Ettore Scola (1980)

A group of old friends meet for an informal dinner on a Roman terrace: a glimpse at the interaction of different individuals and points of view united by their disillusionment.

Ein Kreis alter Freunde trifft sich auf einer römischen Dachterrasse zu einem Abend mit kaltem Büfett. Unterschiedliche Charaktere und Standpunkte treten zutage, was sie vereint, sind verlorene Illusionen.

Un groupe de vieux amis se retrouve un soir autour d'un buffet dressé sur une terrasse romaine : divergents mais unis par une même désillusion, caractères et points de vue se manifestent et interagissent.

Il marchese del Grillo, Mario Monicelli (1981)

A semi-imaginary character, the Marchese del Grillo, Duke of Bracciano, the secret chamberlain of Pope Pius VII, sets up jokes and pranks in papal Rome.

Der halbfiktive Marchese del Grillo und Herzog von Bracciano, Geheimkämmerer von Papst Pius VII., heckt im päpstlichen Rom seine Streiche aus.

Personnage semi-imaginaire, le marquis del Grillo et duc de Bracciano, camérier secret du pape Pie VII, organise farces et plaisanteries dans la Rome pontificale.

The Scarlet and the Black, Jerry London (1983)
Based on the novel by J.P. Gallagher, this the true story of Monsignor Hugh O'Flaherty, the Catholic priest who defied German colonel Kappler and saved thousands of Jews, many escaped prisoners of war from the Allied forces, and many anti-Fascist refugees in Rome under the Nazi occupation.

Nach dem Buch von J. P. Gallagher. Die Geschichte von Monsignore Hugh O'Flaherty, eines irischen Priesters in Rom, der es mit SS-Kommandeur Kappler aufnimmt und Tausenden Juden, geflohenen alliierten Kriegsgefangenen und Antifaschisten, die in das von den Deutschen besetzte Rom geflohen sind, das Leben rettet.

Tiré du livre de J.P. Gallagher. L'histoire vraie de monseigneur Hugh O'Flaherty, prêtre catholique qui défia le lieutenant-colonel Kappler et sauva la vie de milliers de juifs, de nombreux prisonniers de guerre alliés évadés et de bon nombre d'antifascistes réfugiés dans la Rome occupée par les nazis.

La famiglia, Ettore Scola (1986)
A retired Italian professor from a bourgeois family, who lives in the Roman district of Prati, finds a photo taken in 1906 and relives the memories of his life in Rome up to the year 1986.

In seinem Haus im gutbürgerlichen Prati-Viertel lässt ein alter Italienischlehrer sein Leben in der Tiberstadt bis in die Gegenwart Revue passieren. Anlass ist eine Fotografie aus dem Jahre 1906.

Dans un appartement du quartier Prati à Rome, un bourgeois, professeur d'italien à la retraite, fait appel à ses souvenirs en regardant une photo de 1906 et se remémore les événements qui ont marqué son existence dans la capitale jusqu'en 1986.

The Portrait of a Lady, Jane Campion (1996)
A magnificent, intense, and sensual interpretation of Henry James's novel by a celebrated Australian director.

Meisterhafte Interpretation voller Intensität und Sinnlichkeit des Romans von Henry James durch die große australische Regisseurin.

Interprétation magistrale, intense et sensuelle, du roman de Henry James par la grande réalisatrice néo-zélandaise.

Ospiti, Matteo Garrone (1998)
Two young Albanian immigrants living in Rome work in a restaurant. One settles in the home of a young photographer and the two become friends. The other, a restless character, befriends an elderly Sardinian man who accompanies his sick wife around the city every day.

Zwei junge albanische Einwanderer arbeiten in einem römischen Restaurant. Der eine zieht in die Wohnung eines jungen Fotografen aus der Mittelschicht und schließt Freundschaft mit ihm, der andere, ein unruhiger Kopf, begegnet einem alten Mann aus Sardinien, der jeden Tag seine geistig verwirrte Frau spazieren führt.

Deux jeunes immigrés albanais vivent à Rome et travaillent dans un restaurant. L'un d'eux s'installe chez un jeune bourgeois, photographe professionnel, et en devient l'ami. L'autre, esprit plus inquiet, se lie avec un Sarde âgé qui accompagne tous les jours sa femme handicapée mentale à travers la ville.

Caro diario, Nanni Moretti (1999)
A film divided into three stories. The first is a memorable ride on a Vespa across a semi-deserted Rome in August, ending at the site of Pasolini's murder in Ostia.

Der drei Episoden umfassende Film beginnt mit einer unvergesslichen Fahrt durch das halbverlassene, hochsommerliche Rom und endet an dem Ort, wo Pasolini in Ostia am Strand erschlagen wurde.

Composé de trois histoires. La première est une mémorable traversée en Vespa d'une Rome semi-déserte en août; la chevauchée prend fin à Ostie sur le lieu où Pasolini fut assassiné.

Estate romana, Matteo Garrone (2000)
An actress of 1970s avant-garde theater returns to Rome after many years, but nothing is as it used to be. A remarkable achievement by one of the best contemporary Italian film directors.

Eine Schauspielerin des Avantgarde-Theaters der 1970er-Jahre kehrt nach vielen Jahren zurück nach Rom, doch nichts ist wie früher. Bemerkenswerter Film eines der besten Regisseure des heutigen italienischen Kinos.

Une comédienne du théâtre d'avant-garde des années 1970 revient à Rome après des années d'absence et tout lui paraît différent. Une œuvre remarquable de l'un des meilleurs réalisateurs italiens contemporains.

Gladiator, Ridley Scott (2000)
In the 2nd century AD, Roman general Maximus is arrested by emperor Commodus (son of Marcus Aurelius), who also has his wife and son killed. Having become a slave and then a gladiator idolized by the crowd, he kills Commodus in a duel and dies with him. Historically absurd, but spectacularly postmodern.

Commodus, Sohn von Kaiser Mark Aurel (2. Jh. n. Chr.), lässt den General Maximus verhaften und dessen Frau und Sohn umbringen. Maximus, in die Sklaverei geraten und inzwischen von der Menge gefeierter Gladiator, tötet Commodus im Zweikampf, bei dem er selbst stirbt. Historisch ebenso ungenaues wie spektakuläres postmodernes Leinwandepos.

Au IIᵉ siècle ap. J.-C., le général romain Maximus est arrêté sur ordre de l'empereur Commode (fils de Marc Aurèle) qui fait assassiner sa femme et son fils. Devenu esclave, puis gladiateur idolâtré par la foule, il tue Commode lors d'un duel et meurt. Historiquement faux, spectaculairement postmoderne.

La stanza del figlio, Nanni Moretti (2001)
The son of a psychoanalyst, Giovanni, dies during a scuba-diving accident. Giovanni reflects on all the occasions when he has failed in his relationship with his son, and that, had they gone differently, might have saved his life.

Der Sohn des Psychoanalytikers Giovanni kommt beim Tauchen ums Leben. Resigniert erinnert der Vater sich an die Momente, in denen er sich seinem Sohn gegenüber falsch verhalten hat. Hätte er anders gehandelt, hätte er ihm vielleicht das Leben retten können.

Le fils du psychanalyste Giovanni meurt d'un accident de plongée. Giovanni passe en revue les occasions perdues, tous les moments qu'il n'a pas su partager avec son fils et qui vécus différemment lui auraient peut-être sauvé la vie.

Gente di Roma, Ettore Scola (2003)
Following a bus travelling across Rome from morning to evening, the film captures various moments and aspects of life in the city. An achievement that highlights the director's finesse.

Der Film begleitet einen römischen Autobus vom Morgen bis zum Abend auf seiner Fahrt durch die Stadt und beleuchtet vielfältige Momente und Aspekte des urbanenLebens. Scola stellt hier wieder einmal seinen präzisen Blick unter Beweis.

Du matin au soir, en suivant un autobus qui parcourt Rome, le film saisit divers moments et différents aspects du quotidien de la ville. Un témoignage de la finesse du réalisateur.

Pranzo di ferragosto, Gianni Di Gregorio (2008)
On a weekend in August, in the deserted city of Rome, a man must take care of four elderly women whose families are on holiday.

Ein Junggeselle steht vor der Aufgabe, sich an einem Wochenende im August um vier alte Damen zu kümmern, deren Familien in die Ferien gefahren sind.

Durant un week-end d'août, dans la ville désertée, un homme doit prendre soin de quatre dames âgées dont les familles sont parties en vacances.

Scontro di civiltà per un ascensore a Piazza Vittorio, Isotta Toso (2010)
The story of a multi-ethnic group of people living in a 19th-century palace in Rome, based on a novel of the same title by Amara Lakhous.

Nach dem gleichnamigen Roman von Amara Lakhous, der von dem nicht immer einfachen Aufeinandertreffen der Kulturen in einem alten Mietshaus an der Piazza Vittorio erzählt.

Tiré du roman éponyme d'Amara Lakhous, *Choc des civilisations pour un ascenseur Piazza Vittorio*.

To Rome with Love, Woody Allen (2012)
Four amusing stories of Americans dealing with Rome. This is the director's humorous take on the commonplaces about Rome and the Romans.

Vier unterhaltsame Geschichten über Amerikaner in Rom. Fingerübung des bekannten Regisseurs, die mit den Klischees über Rom und die Römer spielt.

Quatre histoires humoristiques d'Américains aux prises avec Rome. Un divertissement du réalisateur à partir des lieux communs sur Rome et les Romains.

La grande bellezza, Paolo Sorrentino (2013)
A disenchanted journalist lives in a luxurious apartment with a large terrace overlooking the Colosseum and participates in the city's social life with a mixture of cynicism and nostalgia, involvement and detachment.

Ein innerlich resignierter Journalist lebt in einem Luxusapartment samt Terrasse mit Blick auf das Kolosseum. Dem Treiben der mondänen römischen Kreise folgt er mit einer Mischung aus Zynismus und Nostalgie, Engagement und Distanz.

Un journaliste désenchanté habite un luxueux appartement avec une grande terrasse donnant sur le Colisée; il prend part à la ville mondaine romaine avec un mélange de cynisme et de nostalgie, d'intérêt et de détachement.

Recommended Listening
Musikempfehlungen
Les chansons à écouter

The song title is followed by the name of its most famous performer, who has often been the reason for the song's success; when the performer did not write the song, the composer and lyricist are given in brackets.

Auf den Titel des Musikstücks folgt der Name des bekanntesten Interpreten – der dem Stück oft zu seiner Popularität verholfen hat – sowie, falls der Interpret nicht der Urheber ist, in eckigen Klammern der Name von Textdichter und Komponist.

Le titre de la chanson est suivi du nom de l'interprète le plus célèbre, qui a souvent fait la fortune de la chanson, et, entre crochets – lorsque l'interprète n'est pas l'auteur – des noms des auteurs des paroles et de la musique.

Fiori trasteverini, [anonymous] *(19th century)*
A famous 19th-century Roman song performed by, among others, Gabriella Ferri, Alvaro Amici, and Lando Fiorini. It's a classic tavern song: a celebration of the people, proud of their simple way of life. Now people sing it together at traditional folk festivals.

Bekanntes römisches Lied aus dem 19. Jahrhundert, gesungen unter anderem von Gabriella Ferri, Alvaro Amici und Lando Fiorini. Klassisches Wirtshauslied, in dem die kleinen Leute stolz ihre einfachen Freuden besingen; wird heute oft auf Volksfesten vorgetragen.

Célèbre chanson romaine du xixᵉ siècle interprétée par Gabriella Ferri, Alvaro Amici et Lando Fiorini, entre autres. Il s'agit d'une chanson d'auberge typique : le petit peuple chante à sa propre gloire, fier de son mode de vie simple. Aujourd'hui, elle est surtout chantée lors des fêtes populaires.

Le streghe, Leopoldo Fregoli [Nino Ilari, Alipio Calzelli] *(1891)*
This song won the first contest for the most beautiful Roman song, which took place on the evening between June 23 and 24, 1891, at the osteria Facciafresca, just outside Porta San Giovanni. Written in the style of a romance, its lyrics allude to the pagan festival that preceded the commemoration of the feast of Saint John.

Gewinner des ersten Wettbewerbs für das schönste Lied von Rom, der in der Nacht vom 23. auf den 24. Juni 1891 in der Osteria Facciafresca vor der Porta San Giovanni abgehalten wurde. Der Text des Hexenlieds im Stil einer Romanze erinnert an ein altes heidnisches Fest, das in dieser Nacht, der Nacht vor dem Johannistag, im antiken Rom gefeiert wurde.

La chanson fut lauréate du premier concours de chanson romaine qui se tint dans la nuit du 23 au 24 juin 1891 dans l'auberge Facciafresca près de la porta San Giovanni. Proche de la romance, le texte conserve les traces de la fête païenne remplacée par la Saint-Jean.

Affaccete (Nunziata), Lina Cavalieri [Nino Ilari, Antonio Guida] *(1893)*
Presented to the San Giovanni song contest in 1893 with the original title *Affaccete*, it did not win, but became an extraordinary success with the public. Accompanied by guitars and mandolins, evoking the starry sky and the scent of the summer night, it is possibly the most beautiful of the Roman serenades.

Beim Liederwettstreit von San Giovanni 1893 unter dem Titel *Affaccete* mit dabei, erhielt das Stück zwar keinen Preis, wurde aber ein Publikumserfolg. Mit Gitarren- und Mandolinenbegleitung gesungen, beschwört es den Sternenhimmel und den Duft einer Sommernacht herauf; das vielleicht schönste römische Abendlied.

Cette chanson fut présentée lors du concours de la Saint-Jean en 1893 sous son titre original : *Affaccete* ; elle ne fut pas lauréate du concours mais connut un extraordinaire succès grâce au public. Avec son accompagnement de guitares et de mandolines et ses paroles évoquant un ciel étoilé et les parfums d'une nuit d'été, il s'agit de l'une des plus belles sérénades romaines.

Nina si voi dormite, [Romolo Leopardi, Amerigo Marino] *(1901)*
A classic of the popular songs in *romanesco* (Roman dialect), it won the San Giovanni song contest in 1901, and is still considered one of the best traditional Roman songs.

Klassiker des volkstümlichen römischen Liedes, Sieger des Wettbewerbs von San Giovanni 1901; gilt bis heute als eines der besten Stücke der römischen Liedtradition.

Un classique de la chanson populaire romaine, lauréate du concours de la Saint-Jean en 1901, elle est considérée aujourd'hui encore comme l'une des meilleures de la tradition romaine.

Gira e fa' la rota, unspecified performer, [Carlo Innocenzi, Marcella Rivi] *(c. 1910)*
A *stornello* (folk song) popular among petty criminals for its reference to the "step" of the prison of Regina Coeli. The song also mentions the marshal of the Guards of the City, Domenico Marcellini, nicknamed "the Little Butcher," since he was the figure most feared by Roman criminals.

Lied der römischen Unterwelt, bekannt vor allem die Strophe über das römische Zuchthaus Regina Coeli. Der im Text erwähnte Maresciallo der Stadtwache, Domenico Marcellini, genannt „er macellaretto" (der Schlächter), war der Albtraum der römischen Verbrecher.

Chanson populaire sur la pègre connue pour sa strophe sur l'escalier conduisant à la prison de Regina Coeli. Elle évoque Domenico Marcellini, dit « er macellaretto », le maréchal des logis, qui fut la bête noire de la pègre romaine.

La pizzicarola, Ettore Petrolini [Temistocle Della Bitta, Ernesto Capparucci] *(1913)*
It is rumored that Petrolini performed this song dressed as a woman; he was considered one of the greatest interpreters of "minor" theater repertoire, variety, revue, and curtain-raiser shows. True to his irreverent attitude toward dictatorship, when this great actor was awarded a medal by Mussolini, he thanked him by saying: "E io me ne fregio!" (a pun on the words "fregio," to receive a decoration, and "frego," not to give a damn).

Petrolini, einer der wichtigsten Interpreten der römischen Kleinkunstbühnen seiner Zeit, der das Lied als Frau verkleidet gesungen haben soll, war für seine Ablehnung des faschistischen Regimes bekannt. Als Mussolini ihm einen Orden verleihen ließ, bedankte er sich mit einem „… den kann er sich an den Hut stecken!"

Petrolini la chantait costumé en femme, dit-on, lui qui était considéré comme l'un des plus remarquables interprètes des formes de spectacle tenues pour mineures, comme la variété ou la revue. Lors de la remise de la médaille que Mussolini avait décidé de lui attribuer, l'attitude irrévérencieuse du grand acteur envers la dictature le conduisit à remercier en ces termes : « Je m'en fous ! ».

L'eco der core, Romolo Balzani [Oberdan Petrini, Romolo Balzani] *(1926)*
In this song, Balzani embodied the most authentic aspects of being Roman. A multifaceted artist – an actor, music arranger, singer – he was hugely successful among his contemporaries.

Romolo Balzani verkörperte als Sänger den Römer schlechthin. Der seinerzeit sehr beliebte, vielseitige Künstler war Schauspieler, Arrangeur und Sänger in einer Person.

Dans ses chansons, Balzani a incarné la romanité dans ses aspects les plus authentiques ; il fut un artiste aux multiples facettes, acteur, arrangeur et chanteur, et remporta un grand succès auprès de ses contemporains.

Barcarolo Romano, Romolo Balzani [Pio Pizzicaria, Romolo Balzani *(1929)*
One of the most famous Roman songs in the world, recorded in countless versions. Since the year it came out there has been practically no show dedicated to Rome that has not featured this melancholy tune.

Dieses Schifferlied gehört zu den weltweit bekanntesten römischen Melodien, von der unzählige Aufnahmen und Bearbeitungen existieren. Seit ihrer Uraufführung vergeht in Rom kein Jahr, in dem die melancholische Barkarole nicht auf die Bühne kommt.

L'une des chansons romaines les plus célèbres du monde, comptant un nombre infini d'enregistrements et d'arrangements. Depuis l'année de sa présentation, rares sont été les spectacles et les manifestations dédiés à Rome où cette mélodie mélancolique n'a pas été chantée.

Campo Testaccio, Totò Castellucci *(1931)*
This was the first song dedicated to the Roma football team, and takes its name from the small stadium where the team played from 1929 to 1940. Few knew of the existence of this song, except for those who had heard it directly, because it had not been recorded. It was Sandro Ciotti, a great sports journalist, who rediscovered it and shared it with the public in 1980.

Erstes der Mannschaft von AS Rom gewidmetes Lied, dessen Titel an das kleine Fußballstadion erinnert, in dem der Verein von 1929 bis 1940 spielte. Da keine Aufnahmen mehr existierten, geriet es beinah in Vergessenheit, bis der Sportreporter Sandro Ciotti es 1980 wieder bekannt machte.

Première chanson dédiée à l'AS Roma, elle prit le nom du petit stade où l'équipe de football joua entre 1929 et 1940. Hormis les témoins directs, rares sont ceux qui en connaissaient l'existence car aucun enregistrement ne subsistait. C'est Sandro Ciotti, grand journaliste sportif, qui la tira de l'oubli en 1980.

Pe' Lungotevere, Romolo Balzani [Rinaldo Frapiselli, Romolo Balzani] *(1932)*
An image of the Lungotevere boulevard by the Tiber as it was at the time: a lovers' promenade under the trees, accompanied by the murmur of the river.

Das Tiberufer, wie es früher einmal war: Liebespaare spazieren im Schatten der Bäume und lauschen dem Rauschen des Flusses.

Les rives du Tibre ou Lungotevere se présentent telles qu'elles étaient alors : une promenade pour les amoureux sous les arbres, accompagnée par la voix du fleuve.

Tanto pé cantà, Ettore Petrolini [Alberto Simeoni, Ettore Petrolini] *(1932)*
Introduced by a nonchalant "spoken-word" section, this composition has become a classic of Roman folk songs. In 1970 it was revived by Nino Manfredi at the Festival of Sanremo, becoming a huge success.

Mit seiner schnoddrig gesprochenen Einleitung ein Klassiker des volkstümlichen römischen *stornello.* 1970 präsentierte der Schauspieler Nino Manfredi, der beim Festival von Sanremo zu Gast war, das Stück zu aller Überraschung als Sänger – und landete damit einen Hit.

Commençant par une déclamation parlée désenchantée, ce texte est devenu un classique de la chanson populaire romaine. En 1970, invité du festival de San Remo, Nino Manfredi s'en fit inopinément l'interprète, ce qui lui procura un succès éclatant.

Casetta de Trastevere, Alfredo Del Pelo [Alfredo Del Pelo, Alvaro De Torres, Alberto Simeoni] *(1934)*
This song voices the dismay of the Romans faced with the great urban demolitions of the city in the 1930s. The owner of an old house overlooking the river gazes sadly on as the home where his mother lived is destroyed.

Untröstlich muss der Besitzer eines alten Hauses am Tiberufer mit ansehen, wie das Häuschen seiner Mutter abgerissen wird; das Lied schildert die Gemütsregungen, mit denen die Römer den großen Umbau ihrer Stadt in den 1930er-Jahren zur Kenntnis nahmen.

La chanson exprime la douleur des Romains témoins des démolitions qui bouleversèrent Rome dans les années 1930. Le propriétaire d'une vieille maison bâtie sur la grève du fleuve assiste avec tristesse à la destruction des lieux où avait vécu sa mère.

Quanto sei bella Roma (Canta si la voi cantà), Carlo Buti [Cesare Andrea Bixio, Enzo Bonagura, Alvaro De Torres] *(1934)*
A love song dedicated to Rome, and a classic of the Roman song tradition, it was given an exceptional performance when Anna Magnani sang it in the film *Abbasso la ricchezza* (1946).

Diese Liebeserklärung an die Stadt Rom wurde zum Klassiker des römischen Liedguts. Eine außergewöhnliche Interpretation verdanken wir Anna Magnani in dem Film *Abbasso la ricchezza* von 1946.

Ce chant d'amour dédié à Rome, un classique de la chanson romaine, eut une interprète exceptionnelle en Anna Magnani dans le film *Abbasso la ricchezza* (1946).

Chitarra romana, Carlo Buti [Bruno Cherubini, Eldo Di Lazzaro] *(1935)*
Included by many artists in their repertoire, this song became enormously popular thanks to Claudio Villa. Its tune has been arranged in many versions, ranging from the tango to the romance (Luciano Pavarotti included it as a favorite in his own performances).

Viele Sänger haben dieses Stück in ihr Repertoire aufgenommen, Claudio Villa machte es bekannt. Die Melodie lässt sich gut variieren, vom Tango bis zur Romanze existieren Bearbeitungen (nicht umsonst hatte Luciano Pavarotti es bei seinen Konzerten fest im Programm).

Cette chanson, qui figure au répertoire de nombreux artistes, connut un énorme succès grâce à Claudio Villa. Sa mélodie s'est prêtée à des arrangements allant du tango à la romance – ce n'est pas un hasard si Luciano Pavarotti en fit un cheval de bataille de ses spectacles.

Vecchia Roma, Claudio Villa [Luciano Martelli, Mario Ruccione] *(1948)*
Born in Trastevere's Via della Lungara, Villa was one of the great performers of Roman songs.

Claudio Villa, der selbst aus Trastevere stammte, war einer der großen Interpreten des römischen Liedes.

Né via della Lungara dans le quartier de Trastevere, Claudio Villa fut un grand interprète populaire de la chanson romaine.

Three Coins in the Fountain, Frank Sinatra [Jule Styne, Sammy Cahn] *(1954)*
A song written for Jean Negulesco's American comedy. It won the Academy Award for Best Original Song in 1954.

Für die US-Komödie gleichen Titels von Jean Negulesco geschrieben; 1954 mit dem Oscar für die beste Originalkomposition ausgezeichnet.

Chanson écrite pour la comédie américaine éponyme de Jean Negulesco. Elle a été lauréate de l'Academy Award for Best Original Song en 1954.

Arrivederci Roma, Renato Rascel [Pietro Garinei, Sandro Giovannini] *(1955)*
The story of a tourist's longing to be back in Rome, a song that became famous all over the world.

Das Lied vom Touristen, der sich voller Nostalgie nach Rom zurücksehnt, ging um die Welt.

Cette histoire d'un touriste malade de nostalgie, avec Rome en arrière-plan, a fait le tour du monde.

Domenica è sempre domenica, Mario Riva [Pietro Garinei, Sandro Giovannini] *(1957)*
A song included in the soundtrack of the film by the same title, and the theme tune of the famous TV show *Il Musichiere*, hosted by Mario Riva, which had a record 19 million viewers.

Musik zum gleichnamigen Film und Erkennungsmelodie der italienischen Fernsehsendung *Il Musichiere*, moderiert von Mario Riva, die Einschaltquoten von bis zu 19 Millionen Zuschauern erreichte.

Bande-son du film éponyme et indicatif de « Il Musichiere », célèbre émission de télévision présentée par Mario Riva dont l'audience atteignit près de 19 millions de spectateurs.

Venticello de Roma, Renato Rascel *(1957)*
A song that celebrates the famous *ponentino*, the light wind that punctually brings a refreshing breeze to the Roman evenings in spring and summer.

Besingt die leichte, von Westen kommende Brise, die römische Frühlings- und Sommerabende so angenehm erfrischt.

La chanson célèbre le *ponentino*, une brise qui, au printemps et en été, se lève immanquablement à la tombée de la nuit et apporte une agréable fraîcheur aux soirées romaines.

Le Mantellate, Ornella Vanoni [Giorgio Strehler, Fiorenzo Carpi] *(1959)*
The women's prison of Mantellate was situated in Via della Lungara; the building was originally a monastery of the Servants of Mary, recognizable by their long black cloak (*mantelle*). The song evokes this place of penance where, over many centuries, the hours of the day were marked by the sound of a bell.

Lied über das Frauengefängnis in der Via della Lungara, ein ehemaliges Kloster der Servitinnen Mariens, die an ihrem langen schwarzen Mantel zu erkennen waren. Jahrhundertelang bestimmte der Schlag der Glocke das Leben seiner Insassinnen.

Jadis, dans la via della Lungara se trouvait la prison de femmes des Mantellate, ancien monastère des Servites de Marie, reconnaissables à leur long manteau noir. La chanson évoque le lieu de peine où, des siècles durant, les heures de la journée étaient scandées par le tintement d'une cloche.

On an Evening in Roma (Sott'er Celo de Roma), Dean Martin [Sandro Taccani, Umberto Bertini, Nan Fredricks] *(1962)*
The dream of the romantic walk under the Roman sky, sung by the Italian Hollywood star, whose real name was Dino Paul Crocetti. The song featured on his album *Dino: Italian Love Songs*.

Der italo-amerikanische Hollywoodstar Dean Martin (der eigentlich Dino Paul Crocetti hieß) besingt einen romantischen Spaziergang unter römischem Himmel; auf dem Album *Dino: Italian Love songs*.

La mythique promenade romantique sous le ciel de Rome chantée par une star italo-américaine de Hollywood dont le vrai nom est Dino Paul Crocetti. La chanson figure dans l'album *Dino: Italian Love Songs*.

Roma nun fa' la stupida stasera, Nino Manfredi [Pietro Garinei, Sandro Giovannini, Armando Trovajoli] *(1962)*
An iconic song from a celebrated musical comedy: *Rugantino*, a love story between braggarts and petty criminals in Rome during the Papal Kingdom, against a backdrop of triumphal arches and Roman ruins, the ancient port of Ripetta and the Campo Vaccino, taverns and palaces, churches and squares.

Bekannteste Nummer aus einer der bekanntesten römischen Musikkomödien, *Rugantino*, eine Liebesgeschichte aus der Zeit, als der Papst noch weltlicher Herrscher war, angesiedelt zwischen römischen Ruinen und Triumphbogen, am verschwundenen Tiberhafen der Ripetta, auf dem Feld des Forum Romanum, in Wirtshäusern, Palästen, Kirchen, auf Plätzen und Gassen; es wird geprahlt, und es werden Messer gezückt.

Chanson emblématique de *Rugantino*, l'une des plus célèbres comédies musicales. Retraçant l'histoire d'amour d'un jeune voyou fanfaron, elle se déroule au xixᵉ siècle dans la Rome pontificale, entre le port, disparu, de Ripetta et le Campo Vaccino, sur fond d'arcs et de ruines, d'auberges, de palais, d'église et de places.

Ciumachella de Trastevere, Lando Fiorini [Pietro Garinei, Sandro Giovannini, Armando Trovajoli] *(1963)*
Another song from the musical comedy *Rugantino*: Ciumachella is the affectionate nickname that Rugantino uses to address Rosetta.

Lied aus der Musikkomödie *Rugantino*. Ciumachella („mein Schneckchen") ist der Kosename des Titelhelden für seine Angebetete Rosetta.

C'est l'une des chansons de la comédie musicale *Rugantino*: Ciumachella est le nom affectueux avec lequel Rugantino s'adresse à Rosetta.

Heart of Rome, Elvis Presley [Alan Blaikley, Geoff Stephens, Richard Howard] *(1970)*
Nostalgic musings about Rome on leaving the city. Elvis Presley, however, never visited Rome.

Nostalgischer Abschied von der Ewigen Stadt. Elvis ist nie in Rom gewesen.

Nostalgie d'avoir à quitter Rome. Pourtant, Elvis Presley n'est jamais venu à Rome.

Lella, Edoardo De Angelis [Edoardo De Angelis, Stelio Gicca Palli] *(1971)*
A song inspired by stories circulated in the literary environment of Gadda and Pasolini. Young De Angelis won the Cantagiro contest with this ballad in Roman dialect that became part of the history of Italian songwriting.

Ballade aus der Welt der einfachen Leute, die Erinnerungen De Angelis' an die literarischen Kreise um Gadda und Pasolini verarbeitet. Der junge De Angelis gewann mit dem Stück in römischem Dialekt, das seitdem fest zum italienischen Liedrepertoire gehört, den Cantagiro-Preis.

Texte d'inspiration populaire, né des souvenirs de l'auteur liés aux milieux littéraires proches de Gadda et de Pasolini. Très jeune, De Angelis fut vainqueur du Cantagiro avec cette ballade romaine qui a marqué l'histoire de la chanson italienne.

Porta Portese, Claudio Baglioni [Claudio Baglioni, Antonio Coggio) *(1972)*
A soldier on leave goes to the flea market of Porta Portese to buy blue jeans and observes the different market stalls: the old woman who sells a photograph of Pope John XXIII, another who sells junk, and yet another selling nude photographs of Brigitte Bardot.

Ein Soldat auf Ausgang geht auf den Flohmarkt von Porta Portese, um ein Paar Bluejeans zu kaufen. An einem Stand bietet eine alte Frau Fotos von Papst Johannes XIII. feil, daneben Krimskrams und einen Stand weiter gibt es Nacktfotos von Brigitte Bardot.

Un soldat en permission se rend au marché aux puces de Porta Portese pour acheter un jean et observe les étals : la vieille qui garde une photo du « bon pape » Jean sur son stand, le marchand de pacotille et celui qui vend des photos de Brigitte Bardot nue.

Roma capoccia, Antonello Venditti *(1972)*
In 1972 the radio show *Supersonic* played a ballad by an unknown Roman songwriter. Dialect gave the verses just the right expressive hues, and the tune was not a mere accompaniment for the lyrics but a fully-developed orchestral arrangement. A declaration of love and hate towards a city that contains the good and evil of the world, the old and the new, the sacred and the profane.

1972 wurde in der Rundfunksendung *Supersonic* die Ballade eines unbekannten römischen Liedermachers gespielt, der sich als originelles Talent entpuppte. Der Dialekt gab dem Lied genau die richtige Färbung, die Musik war mehr als bloße Begleitung, sondern ein echtes Orchesterarrangement. Im Text erklärt der Sänger seine Hassliebe zu einer Stadt, die alles Gute und alles Schlechte dieser Welt in sich vereint, das Alte und das Neue, das Heilige und das Profane.

En 1972, l'émission de radio « Supersonic » diffusa la ballade d'un chanteur-compositeur romain qu'elle contribua ainsi à faire connaître. Le dialecte donne une teinte juste aux vers, la musique ne se contente pas d'être un simple accompagnement, mais constitue un véritable arrangement orchestral. Une déclaration d'amour-haine à une ville qui abrite tout le bien et le mal du monde, le vieux et le nouveau, le sacré et le profane.

Semo gente de borgata, Edoardo Vianello [Franco Califano, Edoardo Vianello, Wilma Goich] *(1972)*
A description of the harsh daily life and the hope for a better future of the residents of Roman shanty towns. The song, sung in a Roman accent by the duo

of Edoardo Vianello (from Rome) and Wilma Goich (from the region of Liguria), became a 1970s hit.

Der schwierige Alltag der Bewohner der römischen Vorstadt und ihre Hoffnung auf ein besseres Morgen. Von dem Römer Edoardo Vianello und Wilma Goich, die aus Ligurien stammte, im Duo gesungen, kletterte der Song an die Spitze der Hitparaden.

Le quotidien difficile et l'espoir d'un lendemain meilleur chez les habitants des faubourgs. Le duo constitué du Romain Edoardo Vianello et de Wilma Goich, une Ligure chantant en dialecte romain, occupa les premières places aux hit-parades des années 1970.

Me so' magnato er fegato, Gigi Proietti [Claudio Baglioni, Antonio Coggio] *(1973)*
The lyrics of this Roman folk song were originally intended for a female voice, with the title in the feminine (*Me so' magnata er fegato*), as it was supposed to be performed by Monica Vitti.

Dieses römische Volkslied wurde ursprünglich in der weiblichen Form *Me so' magnata er fegato* für Monica Vitti geschrieben.

Cette chanson populaire d'inspiration romaine, qui fut composée au féminin à l'origine et intitulée *Me so' magnata er fegato*, aurait due être interprétée par Monica Vitti.

Nun je da' retta Roma, Gigi Proietti [Luigi Magni, Armando Trovajoli] *(1973)*
A song written for the film *La Tosca* (1973), an ironic-grotesque rewriting of Sardou's drama, written and directed by Luigi Magni. The protagonist incites the citizens to an uprising, but they pay him no heed, preferring to forget their troubles by singing folk songs and waiting for a less turbulent kind of change.

Komponiert für den Film *La Tosca* von 1973, Drehbuch und Regie: Luigi Magni, in dem der bekannte Opernstoff persifliert wird: Der Held ruft die Stadt auf die Barrikaden, aber die Römer singen lieber ihre Liedchen und warten, bis sich die Verhältnisse von ganz allein und ohne Aufruhr ändern.

Chanson composée pour le film *La Tosca* (1973) – écrit et réalisé par Luigi Magni – qui reprend sur le ton ironico-grotesque le drame de Victorien Sardou. Le héros appelle à la révolte la ville qui ne l'écoute pas et se réfugie dans la chanson et l'attente d'un changement pacifique.

Roma (non si discute, si ama), Antonello Venditti *(1974)*
This song, more widely known with the title of *Roma Roma*, is sung before matches at Rome's Olympic Stadium after the players' names are read out. If the game ends with a Roma victory, the public sing *Grazie Roma*, another famous song by the same songwriter, written in 1983 when Roma won its second *scudetto* (championship badge).

Der besser als *Roma Roma* bekannte Gesang wird nach der Bekanntgabe der Mannschaftsaufstellung vor den Spielen des AS Rom im Stadio Olimpico angestimmt. Bei einem Sieg der Mannschaft heute nach dem Spiel ergänzt durch Vendittis anlässlich des zweiten Pokalgewinns 1983 geschriebenes *Grazie Roma*.

Plus connue sous le nom de *Roma Roma*, cette chanson précède les matchs disputés au stade Olympique après l'annonce de la composition des équipes. En cas de victoire, on interprète *Grazie Roma*, autre célèbre chanson du même auteur, composée en 1983 lorsque l'équipe remporta son deuxième *scudetto*.

Roma nuda, Franco Califano *(1977)*
A disappointed lover drags himself along the streets of Rome at night. Over his career, Califano, one of the most original Italian songwriters, has recorded 32 albums, and has written over 1,000 poems and songs, including pieces for other artists, many of whom have reached the top in Italian and international charts.

Ein unglücklich Verliebter schleicht nachts durch die Straßen und Gassen der Stadt. Califano ist einer der originellsten Liedermacher der italienischen Musikszene und hat insgesamt über tausend Gedichte und Lieder geschrieben, dazu Liedtexte für andere Künstler. Viele davon wurden zu nationalen oder internationalen Hits.

Un amoureux déçu erre à travers les rues et les ruelles de Rome pendant la nuit. Califano, l'un des chanteurs-compositeurs les plus originaux de la scène musicale italienne, a publié 32 albums au cours de sa carrière et composé près de 1 000 poésies et chansons, sans oublier de nombreux textes pour d'autres artistes, dont plusieurs sont arrivés en tête des classements en Italie et dans le monde.

La sera dei miracoli, Lucio Dalla *(1980)*
The signature tune closing the investigative TV program *La notte della Repubblica* hosted by Sergio Zavoli, aired from 1989 to 1990. Dalla's songs have been a kind of soundtrack for generations of Italians.

Teil der Schlussmusik der Reportage-TV-Sendung *La notte della Repubblica* von Sergio Zavoli. Dallas Lieder haben das Leben von Generationen von Italienern begleitet.

La chanson fut utilisée en guise de générique de fin de « La notte della Repubblica », l'émission de journalisme d'investigation de Sergio Zavoli diffusée en 1989–1990. Les chansons de Dalla ont accompagné à la manière d'une bande-son la vie de générations d'Italiens.

Te c'hanno mai mannato, Alberto Sordi [Claudio Mattone, Franco Migliacci] *(1981)*
A song in Roman dialect, made successful by Alberto Sordi, and one that has remained hugely popular for a long time thanks to its irreverent take on the relationships between people.

Dialektsong, bekannt vor allem durch Alberto Sordi, welcher seinen Erfolg als Schauspieler der Fähigkeit verdankte, das moderne Miteinander mit schräger Ironie auf die Leinwand zu bringen.

Chanson en dialecte romain dont Alberto Sordi assura le succès : elle dut sa popularité prolongé à la manière désinvolte dont elle évoque les rapports entre les gens.

Roma spogliata, Luca Barbarossa *(1981)*
This song, Luca Barbarossa's first, became very popular after he performed it at the Festival of Sanremo. An acoustic track in the style of a country ballad, it describes the capital city with both disenchantment and affection.

Barbarossas erster Song, mit dem er mit großem Erfolg auf dem Festival von Sanremo auftrat. Stück mit Akustikgitarre und Country-Arrangement, das die Hauptstadt nüchtern aber liebevoll porträtiert.

Première chanson de Barbarossa avec laquelle il prit part au festival de San Remo et obtint un grand succès. Cette mélodie d'inspiration country décrit la capitale avec désenchantement mais non sans affection.

Grazie Roma, Antonello Venditti *(1983)*
Sung for the first time at Rome's Circus Maximus during the celebration of the victory of Roma FC

in 1983, accompanied by the whole, euphoric city, this song also became hugely popular outside of Rome.

Bei der Feier nach dem Pokalgewinn von AS Rom 1983 im Circus Maximus das erste Mal aufgeführt, verlieh *Grazie Roma* dem Enthusiasmus einer ganzen Stadt Ausdruck und fand auch jenseits von Rom ein großes Echo.

Lancée au Circus Maximus lors de la fête organisée en 1983 en l'honneur de l'équipe de l'AS Roma qui venait de remporter le *scudetto*, soulevant l'enthousiasme de la ville tout entière, la chanson gagna une grande popularité, y compris hors de la capitale.

Vacanze romane, Matia Bazar [Carlo Marrale, Giancarlo Golzi] *(1983)*

A track from the album *Tango*, this song looks back nostalgically to Rome's past ("Rome, where are you?"), but without making reference to any particular period. The title recalls the film with Gregory Peck and Audrey Hepburn (1953), and the lyrics mention two operettas of the early 20th century: *Il paese dei campanelli* and *La vedova allegra*, as well as the film *La dolce vita* by Fellini.

Der Song vom Album *Tango* beschwört die alten Zeiten ("Wo bist du, Rom?") ohne direkten Bezug auf eine bestimmte Epoche, während der Titel auf den Film mit Gregory Peck und Audrey Hepburn von 1952 zurückgeht und im Text zwei Operetten aus der ersten Hälfte des 20. Jahrhunderts (Lehars *Die lustige Witwe* und *Il paese dei campanelli* von Carlo Lomardo) sowie Fellinis *La dolce vita* zitiert werden.

La chanson, extraite de l'album *Tango*, évoque avec nostalgie le passé de Rome («Roma, dove sei?») sans référence à une période précise. Le titre rappelle le film éponyme (*Vacances romaines*) avec Gregory Peck et Audrey Hepburn (1953); quant aux paroles, elles citent deux opérettes des premières décennies du xxᵉ siècle, *Il paese dei campanelli* et *La Vedova allegra*, ainsi que *La Dolce Vita* de Fellini.

Adesso tu, Eros Ramazzotti *(1986)*

This song ensured the success of the boy from Cinecittà at the 1986 Festival of Sanremo, marking the beginning of his international career.

Mit diesem Lied gewann der Junge aus der *borgata* von Cinecittà 1986 das Festival von Sanremo und begann seine Karriere als internationaler Schlagerstar.

C'est la chanson qui a fait triompher le *ragazzo* des faubourgs de Cinecittà au festival de San Remo en 1986 et a marqué le début de sa carrière internationale.

Via Margutta, Luca Barbarossa *(1986)*

Via Margutta is a street in the center of Rome, in the district of Campo Marzio, an area known as the "foreigners quarter," at the foot of the Pincian Hill. The lyrics evoke the memories of war and poverty, comparing them with life in the city in the present day.

Die Via Margutta im Stadtbezirk Campo Marzio in der römischen Altstadt zu Füßen des Pincio ist das Viertel der Ausländer. Das Lied erinnert an die Zeiten von Krieg und Armut und vergleicht sie mit den Zuständen von heute.

La via Margutta se situe au centre de Rome, dans le secteur du Champ de Mars, zone connue comme quartier des étrangers, à proximité du Pincio. Les paroles évoquent la guerre et la pauvreté par rapport à la vie actuelle de Rome.

La nevicata del '56, Mia Martini [Carla Vistarini, Luigi Lopez, Fabio Massimo Cantini, in collaboration with Franco Califano] *(1990)*

This song about the exceptional snowfall in Rome in 1956 was Mia Martini's entry in the Festival of Sanremo in 1990; once again she won the critics award (which, starting in 1996, was named after her).

Mit diesem Lied, das an das schneebedeckte Rom im Winter 1956 erinnert, nahm Mia Martini 1990 am Festival von Sanremo teil und gewann den Kritikerpreis (der seit 1996 nach ihr benannt ist).

Avec cette chanson rappelant la neige qui recouvrit exceptionnellement Rome en 1956, Mia Martini prit part au festival de San Remo en 1990 et obtint le prix de la critique, qui porta son nom à partir de 1996.

Strade di Roma, Michele Zarrillo *(1992)*

Debuted at the Festival of Sanremo, this tells the story of a lonely and melancholy man walking across a Rome "which breathes silence and nostalgia."

Der Wettbewerbssong für Sanremo erzählt von einem Mann, der einsam und traurig durch die „Stille und Wehmut" der römischen Straßen läuft.

Dans cette chanson présentée au festival de San Remo, l'auteur évoque une Rome «dont émane silence et nostalgie» et que parcourt un homme triste et seul.

Casal de pazzi, Renato Zero *(1993)*

This song, loosely based on the writings of Pier Paolo Pasolini, is featured on the album *Quando non sei più di nessuno*, marking Renato Zero's comeback and his subsequent success.

Mit diesem, vage an Pasolini angelehnten Song aus dem Album *Quando non sei più di nessuno* gelang Renato Zero sein Comeback.

Librement inspirée des écrits de Pier Paolo Pasolini, cette chanson fait partie de l'album *Quando non sei più di nessuno*, grâce auquel Renato Zero renoua définitivement avec le succès.

Non solo a Roma, Francesco Baccini *(1993)*

In this song from the album *Nudo*, the Genoese songwriter voices the love-hate relationship of many Italians have with Rome.

Der Cantautore (Liedermacher) aus der genuesischen Schule verleiht in diesem Lied der Hassliebe vieler Italiener zu Rom eine Stimme; auf dem Album *Nudo*.

Avec ce morceau, qui fait partie de l'album *Nudo*, le compositeur-interprète de l'école génoise exprime le sentiment d'amour-haine que de nombreux Italiens éprouvent pour Rome.

Ho fatto un sogno, Antonello Venditti *(1997)*

This is the only previously unpublished song in the album *Antonello nel Paese delle Meraviglie* released in 1997 in a limited and numbered edition, containing some of Venditti's most successful tracks arranged in a symphonic style.

Einziges bisher unveröffentlichtes Stück des Albums *Antonello nel Paese delle Meraviglie* mit für Sinfonieorchester arrangierten Versionen, das Venditti 1997 als nummerierte Sonderedition seiner Erfolge veröffentlichte.

Il s'agit de la seule chanson inédite de l'album *Antonello nel Paese delle Meraviglie* publié par Venditti en 1997 en édition limitée, avec des copies numérotées et contenant plusieurs de ses succès dans un arrangement symphonique.

Il cielo su Roma, Colle der Fomento [Colle der Fomento, Franco Micalizzi] *(1999)*

A rap song that portrays the well-known traits of Rome. In 2006 the mayor of Rome, Walter Veltroni, invited the band to perform this song in Milan, to represent the culture of the capital city.

Rap-Song, der ein markantes, nicht immer freundliches, aber allgemein bekanntes Rom-Bild zeichnet. Bürgermeister Walter Veltroni schickte die Gruppe damit 2006 als Kulturbotschafter nach Mailand.

Un rap qui évoque une Rome aux traits nettement définis, souvent douloureux, et universellement connus. En 2006, Walter Veltroni invita le groupe à chanter ce texte à Milan pour représenter la culture de la capitale.

Cinecittà, Baustelle *(1999)*

The song is featured in *Sussidiario illustrato della giovinezza*, the debut album of the trio from Montepulciano that successfully emulates the musical narrative of Jay-Jay Johanson. This track contains many references to the creative spirit and the artistic and cultural legacy of the capital city.

Auf dem Debütalbum des Trios aus Montepulciano, das Inszenierungen nach dem Vorbild von Jay-Jay Johanson auf die Bühne bringt, enthaltenes Stück voller Anspielungen auf das Rom der Kunst und der Kultur.

La chanson fait partie de *Sussidiario illustrato della giovinezza*, premier album du trio de Montepulciano qui rivalise avec un modèle proposé par Jay-Jay Johanson: celui du sketch en musique, rehaussé ici d'incessantes références à l'imaginaire artistique et culturel attaché à la capitale.

Roma di notte, Tiromancino *(2000)*

Made of unconventional sounds and lyrics, a song that takes aim at Rome viewed as an expensive, bureaucratic, narrow-minded, dirty, and even delirious city.

Eine Klanggestalt und ein Text jenseits der Konvention zeichnen diesen musikalischen Aufschrei gegen das teure, bürokratische, verschlossene, dreckige, um den Verstand bringende Rom aus.

Paroles et musique n'ont rien de conventionnel. Il s'agit d'une critique de la Rome chère, bureaucratique, fermée, sale et même délirante.

Grande Raccordo Anulare, Corrado Guzzanti *(2001)*

Accompanied by his piano, Guzzanti parodies Roman songwriter Antonello Venditti with a song about traffic and the exits of the great ring road that surrounds Rome. The song became iconic, and the same year it came out Venditti invited his imitator to sing with him on stage at the Circus Maximus celebration for the championship victory of Roma FC.

Nach dem Vorbild des römischen Liedermachers Antonello Venditti lässt Guzzanti sich in diesem Stück vom Verkehr auf dem Autobahnring rund um die Hauptstadt inspirieren. Der Song errang schon bald Kultstatus, und Venditti lud seinen Nachahmer ein, mit ihm bei der Feier für den Pokalsieg von AS Rom im Circus Maximus aufzutreten.

Guzzanti au piano imite le compositeur-interprète romain Venditti dans un texte qui évoque les embouteillages et les sorties de la ceinture périphérique de la capitale. La chanson n'a pas tardé à devenir culte et Venditti a invité son imitateur au Circus Maximus pour chanter lors de la fête en l'honneur du *scudetto* remporté par l'équipe de l'AS Roma.

Amo la mia città, Banda Bassotti *(2006)*
Banda Bassotti is a ska-punk group that formed in
Rome in 1987. In 2006 they released the album *Vecchi
cani bastardi*, which pays tribute to Los Fabulosos Cad-
illacs and The Clash, and raises Italian political issues,
such as the controversial project for a high-speed rail
network known as the TAV line.

Die Ska-Formation der Banda Bassotti entstand
1987 in Rom. 2006 kam ihr Album *Vecchi cani bastardi*
heraus, eine Hommage an Los Fabulosos Cadillacs
und Clash. In den Stücken der Gruppe geht es auch
um Themen der italienischen Tagespolitik wie den
umstrittenen Bau einer Bahnstrecke für den
Hochgeschwindigkeitszug TAV.

La Banda Bassotti est un groupe ska punk né à
Rome en 1987. En 2006, il a sorti l'album *Vecchi cani
bastardi* qui rend hommage aux groupes Los Fabulosos
Cadillacs et The Clash et évoque certains thèmes de la
politique italienne comme la réalisation de la ligne
ferroviaire à grande vitesse Lyon-Turin.

La roma che conosco, Marco Conidi *(2006)*
A hymn to Rome celebrating its virtues and its faults:
"Motorbikes, mopeds, Vespas… roller-coasters. The Rome
I know, it takes two hours to move one yard further /
but as you get stuck in traffic, it shows you Saint Peter's."

Hymne auf die Tiberstadt mit all ihren Stärken und
Schwächen: „Motorräder, Motorroller, Vespas … Ach-
terbahnen./ Das Rom, wie ich es kenne, lässt dich zwei
Stunden lang im Stau steh'n,/ du darsft dabei aber
St. Peter seh'n."

Hymne à Rome avec ses qualités et ses défauts :
«Motos, scooters, Vespas… grand huit./ La Rome que
je connais, deux heures pour faire un mètre / mais pen-
dant que tu restes bloqué, elle te fait voir Saint-Pierre.»

Per le strade di Roma, Francesco De Gregori *(2006)*
Not one of the most famous songs by "the Prince," but
one that best sums up the capital city in its entirety.
From north to south, from the districts of Magliana to
the Tiburtina, even including the "fireflies on the Via
Salaria" and the city's occupied houses.

Eins von den weniger bekannten Liedern des „Prin-
cipe", das aber ein sehr umfassendes Bild der Haupt-
stadt vermittelt, von Nord nach Süd, von der Magliana
bis zur Tiburtina, die „Leuchtkäfer" (Prostituierten)
auf der Via Salaria nicht zu vergessen.

Une chanson qui n'est pas l'une des plus célèbres
du «Principe» mais l'une de celles qui savent le mieux
raconter la capitale dans sa diversité. Du nord au sud,

de la Magliana à la Tiburtina, sans oublier les «lucioles
de la via Salaria» et les immeubles occupés.

Gino e l'Alfetta, Daniele Silvestri *(2007)*
A song adopted as the official anthem of Gay Pride
2007 in Rome.

Das Stück wurde zur offiziellen Hymne des römi-
schen Gay Pride 2007.

Le morceau a été adopté comme hymne officiel de
la Gay Pride de Rome en 2007.

Bar della rabbia, Alessandro Mannarino *(2009)*
The title for this track, and for the whole album,
comes from a bar in the district of Pigneto, which the
songwriter remembers as "the bar I saw in front of my
house, with people drinking and playing cards," and
which he uses as the set for one of his "musical stories"
(interview in *Sky Magazine*, 2009).

Der Titel von Song und Album geht auf den Na-
men eines Lokals im Pigneto-Viertel zurück, das der
Liedermacher als „die Bar gegenüber, mit Leuten beim
Kartenspielen und dabei ein Gläschen" beschreibt, ein
idealer Ort für eine von Mannarinos „musikalischen
Geschichten" (Interview im *Sky Magazine*, 2009).

Le titre de la chanson, et de l'album, est le nom
d'un établissement du quartier Pigneto dont l'auteur-
interprète dit qu'il est «le bar que je voyais en face de
chez moi, avec des gens qui buvaient et jouaient aux
cartes» et où il lui plaît de situer l'un de ses «récits en
musique» (Interview accordée à *Sky Magazine*, 2009).

Piangi Roma, Baustelle *(2009)*
This track is featured on the soundtrack of the film
Giulia non esce la sera (2009) by Giuseppe Piccioni. It
is a melancholy evocation of a Rome that no longer
exists, and of symbols of a past that has also vanished.

Aus dem Soundtrack von Giuseppe Piccionis Film
Giulia non esce di sera von 2009 voll melancholischer
Erinnerungen an ein Rom, das es so nicht mehr gibt,
und verschwundene Sinnbilder einer vergangenen Zeit.

Ce morceau fait partie de la bande-son du film
Giulia non esce la sera (2009) de Giuseppe Piccioni.
Il s'agit d'une évocation mélancolique d'une Rome
qui n'existe plus et d'une série de symboles du passé
qui ont disparu, eux aussi.

Venite tutti a Roma, Alex Britti *(2009)*
A provocation in the form of a song, describing the
city of Rome as a place that is exploding, every day
expanding its territory a little farther.

Provokative Beschwörung einer explodierenden,
sich jeden Tag ein Stück weiter in die Landschaft
fressenden Großstadt.

Chanson provocatrice sur une Rome qui explose
et s'étend de jour en jour.

Dal Pincio, Andrea Belli *(2010)*
With this song Belli won the first edition of the *Amore
per Roma* award in 2010.

Mit diesem Lied gewann Belli 2010 als Erster den
Preis des Songwettbewerbs „Amore per Roma".

Avec cette chanson Andrea Belli a remporté la
première édition du prix Amore per Roma en 2010.

AmoR, Renato Zero *(2013)*
A provocateur and eccentric Roman songwriter, Zero
spent his childhood in Via Ripetta, and his teenage
years in the district of the Montagnola. He has sold
about 40 million records in Italy, and has written over
500 songs (some still unpublished). This song de-
scribes the city as it is today.

Der exzentrische, oft provokant auftretende Cantau-
tore, der seine Kindheit in der Via Ripetta und seine
Jugend im Montagnola-Viertel verlebte, hat in Italien
bisher gut 40 Millionen Platten verkauft und über
500 Lieder geschrieben (einige noch unveröffentlicht).
In diesem Stück setzt er sich mit dem Rom von heute
auseinander.

Excentrique et provocateur le chanteur-compositeur
romain a passé son enfance dans la via Ripetta et son
adolescence dans le quartier de la Montagnola. Il a
vendu près de 40 millions de disques en Italie et com-
posé plus de 500 chansons dont certaines sont inédites.
Celle-ci propose une vision de la capitale aujourd'hui.

L'eternità di Roma, Virginiana Miller *(2013)*
The lyrics give a ruthless description of a decadent city
in a state of crisis, and the song has often been referred
to as a musical counterpart to Sorrentino's film
La grande bellezza.

Das unbarmherzige Porträt einer krisengeschüttel-
ten Stadt im Niedergang wird oft als musikalisches
Gegenstück zu Sorrentinos Film *La Grande Bellezza*
bezeichnet.

Le texte dresse un portrait impitoyable d'une ville
décadente et en crise, et le morceau a été plusieurs fois
désigné comme l'équivalent musical de *La Grande
Bellezza* de Sorrentino.

Recommended Reading
Literaturempfehlungen
Les livres à lire

The Marble Faun: or, The Romance of Monte Beni, Nathaniel Hawthorne *(1860)*
A young Italian nobleman who bears a surprising resemblance with Praxiteles' *Faun*, and a group of artists from abroad meet a stranger during a visit to the Roman catacombs; their lives are profoundly transformed through a web of mysteries and trials.

Ein junger italienischer Edelmann, der dem Faun des Praxiteles verblüffend ähnlich sieht, und eine Gruppe ausländischer Künstler begegnen bei einem Katakombenbesuch einem Unbekannten und geraten in ein Netz von Geheimnissen und Prüfungen, die ihr Leben von Grund auf verändern.

Lors d'une visite des catacombes, un jeune aristocrate italien, présentant une étonnante ressemblance avec le *Faune* de Praxitèle, et un groupe d'artistes étrangers rencontrent un inconnu; épreuves et mystères vont s'entrecroiser, modifiant leur vie et les transformant profondément.

Madame Gervaisais, Edmond and Jules de Goncourt *(1869)*
Madame Gervaisais and her young son go to Rome, where she converts to Catholicism, and under the influence of a priest falls into a kind of religious madness.

Madame Gervaisais reist mit ihrem kleinen Sohn nach Rom. Unter dem Einfluss eines Priesters wird sie katholisch und verfällt einer Art religiösem Wahnsinn.

Madame Gervaisais se rend à Rome en compagnie de son jeune fils. Elle se convertit au catholicisme et, sous l'influence d'un prêtre, sombre dans une espèce de folie religieuse.

Daisy Miller, Henry James *(1878)*
A novella about one of the recurring characters in James's writing: the American girl in Europe affected by the contrast between the two civilizations.

Kurzroman, in dessen Mittelpunkt eine Schlüsselfigur von James' Schaffen steht: eine junge Amerikanerin in Europa am Schnittpunkt zweier Kulturen.

Nouvelle mettant en scène un personnage clé de l'imaginaire jamesien: la jeune Américaine en Europe, au contact de deux civilisations antagonistes.

The Portrait of a Lady, Henry James *(1881)*
A young American woman inherits a great fortune in Great Britain. She meets an adventurer who introduces her to a man she marries, the couple settling in Rome. She later realizes that the marriage was a terrible mistake.

Eine junge Amerikanerin erbt in England ein großes Vermögen, trifft auf eine Abenteurerin, die sie mit einem Mann bekannt macht; sie heiratet ihn und zieht mit ihm nach Rom, muss schließlich aber feststellen, dass die Ehe ein fataler Fehler war.

Une jeune Américaine hérite d'une grosse fortune en Grande-Bretagne. Elle rencontre une intrigante, qui lui présente un homme avec lequel elle se marie et part vivre à Rome. Elle finit par se rendre compte que ce mariage a été une grave erreur.

La conquista di Roma, Matilde Serao *(1885)*
The adventures of a young politician in the circles of the Parliament in Rome under King Umberto: spiritual mediocrity, insubstantial feelings, feigned virtues.

Erlebnisse eines Nachwuchsparlamentariers zur Zeit König Umbertos I.: intellektuelle Ödnis, Oberflächlichkeit der Gefühle, Mittelmäßigkeit.

Les aventures d'un jeune membre du Parlement dans la Rome du roi Humbert Ier: médiocrité intellectuelle, fatuité sentimentale, faiblesse morale.

Il Piacere, Gabriele D'Annunzio *(1889)*
Against the background of Umbertine Rome, the dandy count Andrea Sperelli favors esthetic feelings over morality, torn between the love of two women: one sensual, the other spiritual. The novel marked the success of the so-called Decadent movement in Italian literature.

Andrea Sperelli, Graf und Dandy, hin- und hergerissen zwischen einer sinnlichen Geliebten und einer platonischen Liebe stellt in jeder Situation den Ästhetizismus über die Moral; spielt vor dem Hintergrund der Zeit Umbertos I.; Hauptwerk der literarischen Décadence in Italien.

Rome au temps de Humbert Ier: de jour comme de nuit, qu'il pleuve ou qu'il neige, Andrea Sperelli, comte et dandy, qui fait passer le sens esthétique avant le sens moral, hésite entre l'amour de deux femmes, l'une sensuelle, l'autre spirituelle. Ce roman consacra le succès du décadentisme en Italie.

Cosmopolis, Paul Bourget *(1893)*
The dramatic story of a cosmopolitan man, with Rome as a backdrop. The illustrations were produced from photographs by Giuseppe Primoli.

Das dramatische Leben eines Kosmopoliten in Rom mit Illustrationen nach Fotografien, die Giuseppe Primoli eigens zu diesem Buch machte.

L'aventure dramatique d'un cosmopolite à Rome. Les illustrations dérivent de photographies prises expressément par Giuseppe Primoli.

Quo vadis, Henryk Sienkiewicz *(1896)*
The love story of a Roman patrician and a young Christian woman during Nero's persecution of Christians.

Die Liebe eines römischen Patriziers zu einer jungen Christin inmitten der Christenverfolgung unter Kaiser Nero.

Au temps des persécutions infligées aux chrétiens sous le règne de Néron, les amours d'un patricien romain et d'une jeune chrétienne.

Rome, Émile Zola *(1896)*
The protagonist's story is tightly interwoven with an expansive and convincing portrait of Rome, pervaded by the greed and appetites unleashed after the city became the capital of the new united republic.

Die Erlebnisse des Protagonisten sind untrennbar mit dem gesellschaftlichen und politischen Porträt der Ewigen Stadt im Klima des Spekulationsfiebers nach der Hauptstadtwerdung Roms verbunden.

Le parcours du héros est inséparable d'un portrait large et efficace de Rome, sous l'angle des appétits éveillés par le choix de la ville comme capitale du nouvel État unitaire.

Le Double Jardin, Maurice Maeterlinck *(1904)*
The chapter *Vue de Rome* is a passionate tribute to the greatness of Rome over the centuries and in contemporary life.

Das Kapitel *Vue de Rome* ist Maeterlincks Tribut an die Größe Roms in Geschichte und Gegenwart.

Le chapitre intitulé «Vue de Rome» est un hommage passionné à la grandeur de la Rome des siècles passés et de l'époque contemporaine de l'œuvre.

Il fu Mattia Pascal, Luigi Pirandello *(1904)*
The anxiety, wonder, nostalgia, and disorientation of the protagonist, anguished by the emptiness concealed behind status, appearances, and conventions. Although not always explicitly, many of the sites in the novel can be identified with late-19th-century Rome.

Ängste, Sehnsüchte, Bewunderung und Verwirrung eines Protagonisten, der unter der Leere hinter den Worten, unter den Konventionen und der Fassadenhaftigkeit seiner Zeit leidet. Wenn auch nicht immer ausdrücklich als solche benannt, sind doch viele Schauplätze des Romans dem Rom der Jahrhundertwende abgeschaut.

L'angoisse, l'émerveillement, la nostalgie et l'égarement du protagoniste qui souffre du vide que recouvrent les noms, les apparences et les conventions. Bien qu'ils ne soient pas toujours nommés, nombre de lieux du roman se rapportent à la Rome de la fin du XIXe siècle.

Gli indifferenti, Alberto Moravia *(1929)*
Set in the Fascist period, and covering the space of 48 hours, the story unfolds within enclosed spaces (the interior of a home or a car), focusing on the protagonist's inability to lead a meaningful life.

Wie in einem Kammerspiel (die gesamte auf 48 Stunden konzentrierte Handlung spielt in geschlossenen Räumen bzw. im Auto) tritt die Unfähigkeit der Figuren zu einem authentischen Leben zutage; spielt in der Zeit des Faschismus.

À l'époque du fascisme, l'intrigue, qui se déroule en l'espace de quarante-huit heures dans des lieux clos (à l'intérieur d'une maison ou d'une voiture), met en lumière l'incapacité des protagonistes à mener une vie authentique.

I, Claudius, Robert Graves *(1934)*
A classic of historic narrative in the form of the fictional autobiography of Claudius, one of the most underrated Roman emperors.

Klassiker des historischen Romans in Form einer Autobiografie von Kaiser Claudius, des am meisten unterschätzten Herrschers der römischen Geschichte.

Un classique du récit historique sous forme de biographie romancée de Claude, l'empereur romain le plus sous-évalué de l'Histoire.

Roman Fever, Edith Wharton *(1934)*
In the restaurant on the terrace of a Roman hotel, two wealthy middle-aged American women share their memories and unveil a secret that has changed their lives.

Auf der Terrasse eines römischen Hotels begegnen sich zwei reiche Amerikanerinnen und stöbern in ihrer Vergangenheit, wobei ihnen klar wird, dass ihr Leben von einem Missverständnis gelenkt wurde.

Sur la terrasse-restaurant d'un hôtel de Rome, deux riches Américaines entre deux âges se rencontrent et, revenant sur certains événements du passé, découvrent un quiproquo qui a changé leur existence.

Dame al Macao, Alberto Arduini *(1945)*
During the Umbertine period, statesmen, intellectuals, financiers, journalists, and beautiful women cross paths in the Macao neighborhood.

Im römischen Macao-Viertel des späten 19. Jahrhunderts begegnen sich Politiker, Literaten, Finanzbosse, Journalisten und schöne Frauen.

Au temps du roi Humbert Ier, dans les rues du quartier Macao, se croisent des hommes d'État, des hommes de lettres, des financiers, des journalistes et des élégantes.

La Romana, Alberto Moravia *(1947)*
The story of a young woman, Adriana, in Rome during the Fascist period. In 1954 the novel was adapted into a film by Luigi Zampa, starring Gina Lollobrigida.

Die Geschichte der jungen Adriana in den Zeiten des Faschismus. 1954 von Luigi Zampa mit Gina Lollobrigida in der Hauptrolle verfilmt.

Dans la Rome fasciste, les aventures de la jeune Adriana. En 1954, le roman fut adapté au cinéma par Luigi Zampa avec Gina Lollobrigida dans le rôle-titre.

L'Orologio, Carlo Levi (1950)

One of the best examples of post-war political narrative. Set in the time of the early Republic, during the collapse of the anti-Fascist movement, it depicts Rome in its everlasting essence, the ancient cradle of civilization, a place where the most diverse people and ideals are lost among the relics of papal feasts, labyrinthine ministerial bureaucracy, politicians' debates, and the rats of the shanty town of Garbatella.

Einer der besten politischen Romane der Nachkriegszeit. Die antifaschistische Allianz der eben erst geborenen Republik zerfällt, Rom ist, was es immer war, ein Schmelztiegel der Kulturen, Ort für Menschen unterschiedlichster Herkunft und Ideale. Päpstliche Prachtentfaltung, die Mühlen der Ministerialbürokratie, die Debatten der Politiker und das Elend der Baracken von Garbatella liefern ein verwirrendes Bild der Wirklichkeit.

Un des meilleurs exemples de récit politique de l'après-guerre. Au début de la République, alors que s'annonce le délitement des forces politiques antifascistes, la Rome de toujours, antique creuset de civilisations, lieu où se mêlent les gens et les idéaux les plus divers, s'égare parmi les vestiges des fastes pontificaux, les méandres de la bureaucratie ministérielle, les débats des hommes politiques et les rats des taudis de la Garbatella.

The Roman Spring of Mrs. Stone, Tennessee Williams (1950)

The murky seductions of an American widow, a faded actress, in post-war Rome.

Das Rom der Nachkriegszeit wird zum Ort der zwielichtigen Verführungskunst einer US-Witwe und Schauspielerin, die ihre besten Jahre bereits hinter sich hat.

Dans la Rome de l'après-guerre, les troubles séductions d'une veuve américaine, actrice sur le déclin.

Mémoires d'Hadrien, Marguerite Yourcenar (1951)

A fictional autobiography of Emperor Hadrian, a novel that is also a work of history and poetry, it reveals the emperor's awareness that the greatness of Rome one day will be over, but also his capacity to remain positive in the face of this insight.

Zugleich Biografie und Roman, Dichtung und Geschichtsschreibung, erzählt Kaiser Hadrian die Geschichte seines Lebens in dem Wissen, dass Roms Größe eines Tages untergehen wird, und dennoch fähig, bis zum Schluss positiv zu denken und zu handeln.

Œuvre romanesque, historique et poétique, retraçant la vie de l'empereur Hadrien, conscient que la grandeur de Rome prendra fin, mais néanmoins capable de pensées et d'actions positives jusqu'à la fin.

Roma, Aldo Palazzeschi (1953)

Through the life of a patrician, the pope's secret chamberlain, we get a glimpse of Roman society marred by the misery of the post-war period and the degradation of social customs.

Die Erlebnisse eines römischen Adligen und päpstlichen Kammerdieners geben Einblick in die Gesellschaft des von Elend und Verrohung gezeichneten Rom der unmittelbaren Nachkriegszeit.

La vie d'un patricien, camérier secret de Sa Sainteté, dévoile une société romaine, marquée par la misère de l'après-guerre et par le retour des usages à la barbarie.

Racconti romani, Alberto Moravia (1954)

Narrated in the first person through tight, studied dialogues, episodes of everyday life focussing on people of the lower classes during the reconstruction period. Rome is viewed as shrewd, spirited, and vulgar.

Erzählungen aus der Ich-Perspektive mit ebenso dichten wie genau gearbeiteten Dialogen und Szenen aus dem Alltag meist einfacher Leute in der Zeit des Wiederaufbaus, ungeniert, lebendig, vulgär.

Récits écrits à la première personne, constitués de dialogues concis et très étudiés, bribes de la vie quotidienne de personnages d'origine très modeste pour la plupart à l'époque de la reconstruction ; une Rome de duplicité, de vivacité et de vulgarité.

Der Tod in Rom, Wolfgang Koeppen (1954)

The disquieting and grotesque family reunion of a former SS general turns into drama during a Roman summer, against the first glimpses of the economic boom and the silent and immutable darkness of the streets in the city centre.

Groteske und verstörende Geschichte über einen ehemaligen SS-General in Rom, der seine Familie wiedertrifft, woraufhin sich die Ereignisse überschlagen. Rom zwischen einem strahlenden Sommer, der schon den Wiederaufschwung ankündigt, und den dunklen, stillen Gassen der römischen Altstadt.

Inquiétante et grotesque, une réunion de famille autour d'un ex-général SS se transforme en une expérience dramatique, dans une Rome estivale, entre les premières manifestations du boom économique et l'obscurité silencieuse et immuable des ruelles du centre.

Ragazzi di vita, Pier Paolo Pasolini (1955)

The life of Riccetto and his friends in the Roman suburbs. A masterpiece of post-war Italian literature, it illustrates the unique reality of the Roman working class, magisterially recreating its language.

Riccetto, seine Freunde und ihr Leben in den römischen *borgate*. Eines der Hauptwerke der italienischen Nachkriegsliteratur, das der Gegenwelt des römischen Lumpenproletariats eine authentische Stimme verleiht.

La vie de Riccetto et de ses amis dans les faubourgs de Rome. Chef-d'œuvre de la littérature italienne de l'après-guerre, qui révèle et restitue la réalité « autre » du sous-prolétariat romain dont il recrée le langage de manière magistrale.

La Modification, Michel Butor (1957)

On a train trip from Paris to Rome, the protagonist reflects, reminisces, and daydreams. By the time he arrives in Rome he is a changed man: instead of meeting his lover he decides to write a book about his story.

Die Gedanken, Erinnerungen und Träume eines Mannes auf der Reise von Paris zu seiner Geliebten nach Rom. Dort angekommen verlässt er sie und beschließt, ein Buch über seine Geschichte zu schreiben.

Durant le voyage en train qui le mène de Paris à Rome, le protagoniste se souvient et rêve. À son arrivée à Rome, il a changé ; au lieu de retrouver sa maîtresse, il décide d'écrire un livre sur son aventure.

Quer pasticciaccio brutto de via Merulana, Carlo Emilio Gadda (1957)

A realistic, grotesque, and bitter Rome during the years of Fascism, magnificently depicted in baroque language.

Bitteres, zugleich wirklichkeitsgesättigtes und groteskes Bild der Ewigen Stadt unter dem Faschismus, beschrieben in den Farben einer barocken Sprache.

Une Rome réaliste, grotesque et amère au temps du fascisme, magnifiquement dépeinte dans une langue baroque.

La Ciociara, Alberto Moravia (1957)

Against the dramatic background of the post-war period and the Roman working class, the ordeals of a brave woman unfold among the war's winners and losers. It was adapted into a movie by Vittoria De Sica.

Dramatische Odyssee einer mutigen Frau aus dem Volk zwischen Siegern und Besiegten in der Zeit des Zweiten Weltkriegs; von Vittorio De Sica verfilmt.

Dans une Rome à l'atmosphère dramatique et populaire, l'odyssée d'une femme courageuse entre vainqueurs et vaincus durant la Seconde Guerre mondiale.

Una vita violenta, Pier Paolo Pasolini (1959)

The central character is a hustler who lives on expedients. He goes to jail and then re-enters society; he falls ill with tuberculosis and dies during a flood, trying to save some of the inhabitants of the shanty houses. Together with the 1955 novel *Ragazzi di vita*, it represents the magisterial depiction of life in Roman *bidonvilles* (shanty towns).

Die Hauptfigur ist einer von Pasolinis *ragazzi di vita*. Er lebt von der Hand in den Mund, muss ins Gefängnis, will nach seiner Entlassung ein besseres Leben führen, bekommt Tuberkulose und stirbt bei dem Versuch, einige Slumbewohner aus den Fluten einer Überschwemmung zu retten; Gegenstück zu Pasolinis *Ragazzi di vita* aus dem Jahr 1955 und wie dieses ein literarisch beeindruckendes Porträt der römischen Vorstadt.

Le protagoniste est un *ragazzo di vita* [loubard] ; il vit d'expédients. Après un séjour en prison, il désire s'insérer dans la société. Devenu tuberculeux, il meurt lors de l'inondation d'un faubourg en tentant de sauver les habitants des taudis. Avec *Ragazzi di vita* (1955), cet ouvrage constitue un diptyque d'une grande valeur littéraire sur les faubourgs de Rome.

Tutto è accaduto, Corrado Alvaro (1961, posthumous)

The last part of a trilogy, *Memorie del mondo sommerso*, this novel is a portrayal of Italian society from the beginning of the 20th century until the fall of Fascism. It is the story of a man entangled in the web of power in Mussolini's Rome in spite of himself.

Letzter Teil von Alvaros Trilogie der „Erinnerungen an eine vergangene Welt", in der die italienische Gesellschaft von der Jahrhundertwende bis zum Ende des Faschismus geschildert wird. Der inzwischen in die Jahre gekommene Protagonist gerät gegen seinen Willen in die Fänge des Regimes.

Dernier roman d'une trilogie intitulée *Memorie del mondo sommerso*, l'ouvrage dépeint la société italienne du début du xxᵉ siècle à la chute du fascisme. Une description de la maturité du protagoniste dans la Rome mussolinienne, englué malgré lui dans les jeux du pouvoir.

Mamma Roma, Pier Paolo Pasolini (1962)

The screenplay and diary in prose and verse of the film by the same title; a powerful literary achievement.

Drehbuch und Tagebuchaufzeichnungen in Prosa und Gedichtform zu Pasolinis gleichnamigem Film, konzis geschriebene Literatur auf höchstem Niveau.

Scénario et journal en prose et en vers du film éponyme : textes littéraires d'une rare efficacité et d'une indéniable grandeur.

Le due città, Mario Soldati (1964)
Indifference and opportunism pervade the novel, which unfolds between two cities, Turin and Rome, representing the protagonist's changing attitudes and the differences between two historical periods.

Gleichgültigkeit und Opportunismus vor der Kulisse zweier als Gegenpol fungierender Städte, Turin und Rom, die für unterschiedliche Einstellungen und historische Epochen stehen.

Roman de l'indifférence, de l'opportunisme, partagé entre deux villes, Turin et Rome, qui représentent les différents comportements du protagoniste et les changements intervenus d'une époque à l'autre.

La Storia, Elsa Morante (1974)
The dramatic story of a woman and her two children (one conceived through the violence of a drunken German soldier) in Rome during the war.

Dramatische Geschichte einer Römerin, die sich in den Zeiten des Krieges mit zwei Kindern durchschlagen muss (eines gezeugt von einem betrunkenen deutschen Soldaten, der sie vergewaltigt).

Le destin dramatique d'une femme et de ses deux enfants dont l'un est né d'un viol par un soldat allemand ivre durant la guerre à Rome.

Beard's Roman Women, Anthony Burgess (1976)
After the death of his wife, an author moves to Rome to make a new start. He begins a relationship with an Italian photojournalist, the descendant of Roman poet Gioachino Belli. But later he receives a call from his "dearly departed" wife. The photographs in the original edition are by David Robinson.

Ein Schriftsteller zieht nach dem Tod seiner Frau nach Rom, um seinen Lebensmut wiederzufinden. Er beginnt eine Beziehung mit einer italienischen Fotoreporterin (die von dem römischen Dichter Gioachino Belli abstammt), da erhält er einen Anruf von seiner „Verblichenen". Die Fotoillustrationen der Originalausgabe stammen von David Robinson.

Après la mort de sa femme, un écrivain s'installe à Rome pour reprendre goût à la vie. Il entame une liaison avec une photojournaliste italienne, descendante du poète Gioachino Belli ; c'est alors qu'il reçoit un appel téléphonique de la « chère disparue ». Les photographies de l'édition originale sont de David Robinson.

Le maschere, Luigi Malerba (1995)
Historical novel set in the 16th century: As Rome awaits the arrival of the newly elected Pope Hadrian VI from Spain, two cardinals fight bitterly to be appointed to the post of camerlengo (chamberlain).

Historischer Roman über das Rom des 16. Jahrhunderts. Man erwartet die Ankunft des neu gewählten Papstes Hadrian VI. aus Spanien. Zwei Kardinäle kämpfen mit allen Mitteln um das Amt des päpstlichen Kämmerers.

Roman historique situé au xvie siècle. Alors que Rome attend l'arrivée du nouveau pape Adrien VI parti d'Espagne, deux cardinaux s'affrontent sans pitié pour conquérir la charge de camerlingue.

Angels & Demons, Dan Brown (2000)
The CERN director finds a murdered scientist who has been branded with fire. He asks for the help of a Harvard professor of religious symbolism to find out who killed his friend. The victim's daughter, also a scientist

at CERN, reveals that she and her father worked together on a project to demonstrate the existence of God.

Der Direktor des CERN findet die mit einem Brandmal gezeichnete Leiche eines ermordeten Wissenschaftlers und ruft einen Harvardprofessor und Fachmann für religiöse Symbole zu Hilfe, um herauszufinden, wer seinen Freund getötet hat. Die Tochter des Ermordeten, auch sie Forscherin am CERN, eröffnet ihnen den von ihr und ihrem Vater entwickelten Versuchsplan zum Beweis der Existenz Gottes.

Le directeur du CERN découvre un savant assassiné et marqué au fer rouge. Il fait appel à un professeur de Harvard, spécialiste de symbologie religieuse, pour retrouver l'assassin de son ami. La fille du défunt, également scientifique au CERN, révèle aux deux hommes les recherches qu'elle et son père menaient pour démontrer l'existence de Dieu.

Romanzo criminale, Giancarlo De Cataldo (2002)
Written by a judge and inspired by the true story of the Magliana criminal gang in the 1970s and 1980s.

Auf den Verbrechen der Banda della Magliana in den 1970er- und 1980er-Jahren beruhender Roman aus der Feder eines Richters.

Écrit par un juge et inspiré de l'histoire vraie de la bande criminelle de la Magliana dans les années 1970 et 1980.

Roma fuggitiva. Una città e i suoi dintorni, Carlo Levi (2002)
A collection of Levi's essays dedicated to Rome between 1951 and 1963, portraying moments of popular and daily life in this endangered "wonder." One of the most illuminating books on contemporary Rome.

Sammlung von Texten Carlo Levis über Rom aus den Jahren 1951 bis 1963: Augenblicke aus dem Leben der einfachen Römer inmitten der bedrohten Schönheit ihrer Stadt. Eines der wichtigsten Bücher für das Verständnis des modernen Rom.

Recueil d'écrits que Carlo Levi dédia à Rome entre 1951 et 1963, instants de la vie populaire et quotidienne d'une « merveille » menacée. Un des livres les plus importants pour comprendre la Rome contemporaine.

Senza verso. Un'estate a Roma, Emanuele Trevi (2004)
The reflections of the narrator as he wanders around the streets of Rome during the sweltering summer of 2003, from a church to city streets to a news agent, dwelling on thoughts of a dead friend, a poet.

In der Hitze des Sommers 2003 lässt der Erzähler seine Gedanken schweifen: eine Kirche, Gassen, ein Zeitungskiosk, ein toter Freund und Dichter.

Durant l'été torride de 2003, une flânerie introspective entre une église, une série de rues, un édicule et un ami poète disparu.

Les Murs de Rome, Fanny Bruneth (2005)
Guided by a Roman friend, and equipped with a Leica, a teenager explores the city. She knocks at doors, enters courtyards, discovers the history of her family, and finds a reason for living.

Geführt von einem römischen Freund, ausgerüstet mit einer alten Leica, macht sich ein Junge auf Erkundungsgang durch Rom, klopft an Türen, geht durch Höfe, entdeckt die Geschichte seiner Familie und den Sinn seiner Existenz.

Guidée par un ami romain, armée d'un vieux Leica, une adolescente explore la ville. Elle frappe aux portes, pénètre dans les cours, découvre l'histoire des siens et trouve ses raisons de vivre.

Scontro di civiltà per un ascensore a Piazza Vittorio, Amara Lakhous (2006)
A satire as well as a murder mystery, set in the diverse and multi-ethnic world of Piazza Vittorio.

Gesellschaftssatire und Kriminalroman, angesiedelt in einem Mietshaus an der Piazza Vittorio mit Bewohnern aus aller Herren Länder.

Comédie de mœurs et roman policier dans l'univers multiethnique de la piazza Vittorio.

Un giorno perfetto, Melania G. Mazzucco (2006)
The title (A Perfect Day) is taken from the song by Lou Reed. The crossed lives of a dozen characters on a day in 2001, the beginning of the Berlusconi decade, in a complex, multi-faceted, and sensual city. It inspired a film by Ferzan Özpetek, 2008.

Titel nach Lou Reeds Song A perfect day. Das Leben von zehn Menschen begegnet sich an einem Tag des Jahres 2001, dem Beginn der Berlusconi-Ära, in einer komplexen, facettenreichen, sinnlich konkreten römischen Wirklichkeit.

Le titre dérive de A perfect day de Lou Reed. Les vies croisées d'une dizaine de personnages durant une journée de 2001 qui marque le début de la décennie berlusconienne, dans une ville complexe, charnelle, aux multiples facettes. Ferzan Özpetek en a tiré un film en 2008.

E in mezzo il fiume. A piedi nei due centri di Roma, Sandra Petrignani (2010)
In the company of artists and homeless people, the author listens to intimate tales by the river Tiber, and becomes a pilgrim in awe of Rome, its beauty in turn understated and majestic.

In Begleitung von Künstlern und Clochards lauscht die Autorin auf die geheimen Geschichten, die ihr der Tiber zuflüstert, und pilgert zu mal majestätischen, mal versteckten Orten römischer Schönheit.

En compagnie d'artistes et de clochards, l'auteur écoute les récits intimes apportés par le Tibre et se fait pèlerin de la beauté majestueuse ou discrète de Rome.

L'O di Roma. In tondo e senza fermarsi mai, Tommaso Giartosio (2011)
A journey on foot around the city along a perfect circle through palaces, military barracks, museums, landfills, football fields, cemeteries, railways, and rivers, and including private residences when necessary, so as not to stray from the circular route.

Ein Fußmarsch rund um Rom, ohne vom Anfangsradius abzuweichen, vorbei an Mietshäusern, Polizeikasernen, Museen, Müllhalden, Fußballfeldern, Friedhöfen, Gleisen, Flüssen. Manchmal muss man an eine Tür klopfen, um die Route beizubehalten.

Un voyage à pied autour de la ville, le long d'une circonférence parfaite, à travers palais, casernes, musées, décharges, terrains de foot, cimetières, voies ferrées, rivières, en frappant aux portes pour ne pas s'écarter de la route choisie.

Addio a Roma, Sandra Petrignani (2012)
Between the 1950s and early 1970s, and between history and fiction, a narrative filled with irony recounting cultural and news events – from Via Veneto and Piazza del Popolo to an art gallery, to a film set, or a bookstore – intertwined with the story of the only fictional character of the book, a girl from Trastevere.

Begebenheiten aus Kultur und Zeitgeschehen der 1950er- bis 1970er-Jahre, von der Via Veneto zur Piazza del Popolo, aus einer Kunstgalerie, von einem Filmset und aus einer Buchhandlung verknüpfen sich mit der

Geschichte eines Mädchens aus Trastevere, der einzigen erfundenen Figur in diesem mit viel Ironie erzählten Buch.

Entre les années 1950 et le début des années 1970, entre histoire et fiction, dans un récit empreint d'ironie, les aventures d'acteurs de la culture et la chronique – de la via Veneto et de la piazza del Popolo à une galerie d'art, un plateau de tournage, une librairie – s'entremêlent avec l'histoire d'une jeune fille de Trastevere, seul et unique personnage inventé du livre.

Vite distratte. Una casa di Roma racconta, Paolo Pomati (2013)
A kaleidoscope of "distracted lives," filled with solitude and confusion: the tenants of a condominium in Rome's district of Forte Bravetta.

Ein Kaleidoskop aus „zerstreuten", einsamen, verwirrten Lebensbildern der Bewohner eines Apartmenthauses in der Via del Forte Bravetta in Rom.

Un kaléidoscope de «vies distraites», solitaires, confuses: les occupants d'un immeuble de la via del Forte Bravetta à Rome.

La via del pavone, Alexander Schwed (2013)
When his family go on holiday, an architect stays in Rome to take care of his mother-in-law's peacock. The peacock escapes, setting off an adventurous pursuit along the streets of the capital, a crazy ride behind a tram, a reckless motorcycle ride. Paradoxical and humorous, yet filled with emotion, turmoil, and uncertainty.

Während seine Familie in Urlaub fährt, kümmert sich ein römischer Architekt um den Pfau seiner Schwiegermutter. Der Vogel rückt aus, und der Held macht sich auf eine abenteuerliche Verfolgungsjagd nach dem flüchtigen Federvieh, durchstreift die Straßen der Stadt, rennt wie ein Verrückter hinter einer Straßenbahn her und unternimmt eine halsbrecheri-

sche Fahrt auf dem Motorroller. Ein Buch mit humorvoll bis absurdem Einschlag, das der Verwirrung, dem Versagen und den Gefühlen des Protagonisten breiten Raum lässt.

Alors que sa famille part en vacances, un architecte reste à Rome pour prendre soin du paon de sa belle-mère. L'oiseau s'enfuit: s'ensuit alors pour l'homme une rocambolesque poursuite dans les rues de la capitale, une course folle derrière un tram, une dangereuse virée en scooter. Paradoxal et humoristique, le récit retrace les troubles, les incertitudes et les émotions du héros.

19, Edoardo Albinati (2014)
Through the routes of the No. 19 tramcar, which travels through half of Rome, the narrator makes personal observations on the evolving urban landscapes, and on the different passengers encountered in the various districts.

Dem durch halb Rom führenden Lauf der Straßenbahnlinie 19 folgend, richtet der Erzähler seinen Blick auf wechselnde urbane Landschaften und immer neue Fahrgäste.

Au cours de ses trajets dans le tram 19 qui traverse la moitié de Rome, le narrateur égrène des remarques personnelles sur les paysages urbains qui se succèdent et les différents passagers des quartiers traversés.

La bellezza di Roma, Raffaele La Capria (2014)
A series of tales set in contemporary Rome over a 40-year period, depicting the city as a decadent, degraded place.

Geschichten aus 40 Jahren Rom, in denen die moderne Stadt in ihrem Niedergang und ihrem Verfall beschrieben wird.

Couvrant une quarantaine d'années, une suite de récits avec pour cadre la Rome contemporaine vue comme un lieu de déchéance et de dégradation.

Roma è una bugia, Filippo La Porta (2014)
Places and people in a city at once funereal and filled with wild vitality; a kaleidoscope of optical illusions.

Orte und Menschen einer düsteren und zugleich urwüchsig vitalen Stadt – ein illusionistisches Kaleidoskop.

Lieux et personnes d'une ville funèbre et, dans le même temps, riche d'une vitalité sauvage; un kaléidoscope illusionniste.

Roma. Piazza Esedra, Luigi Pietro Mascheroni (2015)
A personal narrative is interwoven with historical and social events in 1950s Rome.

Das Leben eines Mannes vor dem Hintergrund der historischen und gesellschaftlichen Ereignisse, die Rom seit den 1950er-Jahren geprägt haben.

Les événements de l'existence du protagoniste s'entrecroisent avec les événements historiques et sociaux dans la Rome des années 1950.

Voyage sur un fantôme. Rome, le scooter, et ma mère, Jérôme Orsoni (2015)
A love letter to Rome in which we encounter Nanni Moretti, Pier Paolo Pasolini, Jacob Burckhardt, Friedrich Nietzsche, Stendhal, Audrey Hepburn, and even Antonio Gramsci's cat.

Eine Liebeserklärung an die Ewige Stadt. Der Leser begegnet Nanni Moretti und Pier Paolo Pasolini, Jacob Burckhardt und Friedrich Nietzsche, Stendhal und Audrey Hepburn … und der Katze von Antonio Gramsci.

Une déclaration d'amour à Rome où l'on rencontre Nanni Moretti et Pier Paolo Pasolini, Jacob Burckhardt et Friedrich Nietzsche, Stendhal et Audrey Hepburn, sans oublier le chat d'Antonio Gramsci.

Bibliography
Bibliografie
Bibliographie

Alvaro, Corrado *Roma vestita di nuovo* (Milan: Bompiani, 1957)

Barzacchi, Cesare *L'Italia di Longanesi. Memorie fotografiche* (Milan: Le Edizioni del Borghese, 1964)

Bavagnoli, Carlo *Gente di Trastevere, con testi di Federico Fellini* (Milan: Mondadori, 1963)

Becchetti, Piero *La fotografia a Roma dalle origini al 1915* (Rome: Editore Colombo, 1983)

Becchetti, Piero *Roma nelle fotografie della Fondazione Marco Besso* (Rome: Editore Colombo, 1993)

Becchetti, Piero; Biancini, Laura; Buttò, Simonetta *Roma nelle fotografie della raccolta Ceccarius* (Rome: Editore Colombo 1991)

Becchetti, Piero; Pietrangeli, Carlo *Roma in dagherrotipia* (Rome: Quasar, 1979)

Becchetti, Piero; Pietrangeli, Carlo (ed.) *Roma tra storia e cronaca dalle fotografie di Giuseppe Primoli* (Rome: Edizioni Quasar, 1981)

Becchetti, Piero; Brizzi, Bruno *Roma in tre dimensioni: La fotografia stereoscopica* (Rome: Editore Colombo, 2004)

Bevilacqua, Piero *Il paesaggio italiano nelle fotografie dell'Istituto LUCE* (Rome: Editori Riuniti, 2002)

Bolla, Luisella; Lambiase, Sergio *Storia fotografica di Roma 1900–1918. Dalla Belle époque alla Grande Guerra* (Rome: Edizioni Intra Moenia, 2003)

Bonetti, Maria Francesca, with Dall'Olio, Chiara and Prandi, Alberto (eds.) *Roma 1840–1870. La fotografia, il collezionista e lo storico* (Rome: Peliti Associati, 2008)

Brizzi, Bruno *Roma fine secolo nelle fotografie di Ettore Roesler Franz* (Rome: Quasar, 1978)

Brunetta, G. Piero *Cent'anni di cinema italiano. Vol. 1: Dalle origini alla seconda guerra mondiale* (Rome-Bari: Laterza, 1995)

Brunetta, G. Piero *Cent'anni di cinema italiano. Vol. 2: Dal 1945 ai nostri giorni* (Rome-Bari: Laterza, 1995)

Bruscolini, Elisabetta (ed.) *Roma nel cinema. Tra realtà e finzione, exhibition catalogue* (Milan: Edizioni Marsilio, 2000)

Cavanna, Pierangelo *Bianco su bianco: Percorsi della fotografia italiana dagli anni Venti agli anni Cinquanta, exhibition catalogue* (Florence: Alinari, 2005)

Cavazzi, Lucia; Margiotta, Anita; Tozzi, Simonetta (eds.) *Un inglese a Roma 1864–1877: La Raccolta Parker nell'Archivio Fotografico Comunale* (Rome: Artemide Edizioni, 1989)

Cocteau, Jean *Mon premier voyage (Tour du monde en 80 jours)* (Paris: Gallimard, 1937)

D'Autilia, Gabriele *Storia della fotografia in Italia dal 1839 a oggi* (Turin: Einaudi, 2012)

De Amicis, Edmondo *Le tre capitali* (Catania: Niccolò Giannotta, 1898)

Dell'Arco, Maurizio *Café-chantant di Roma* (Milan: Martello, 1970)

De Luna, Giovanni; D'Autilia, Gabriele; Criscenti, Luca (eds.) *L'Italia del Novecento: Le fotografie e la storia, 3 vols.* (vol. I, tome 1: *Il potere da Giolitti a Mussolini (1900–1945); vol. I, tome 2: Il potere da De Gasperi a Berlusconi; vol. II: La società in posa; vol. III, tome 3: Gli album di famiglia*) (Turin: Giulio Einaudi Editore, 2005/2006)

De Seta, Cesare (ed.) *Giuseppe Pagano fotografo, exhibition catalogue* (Milan: Electa editrice, 1979)

Fagiolo Dell'Arco, Maurizio; Terenzi, Claudia (eds.) *Roma, 1948–1950. Arte, cronaca e cultura dal neorealismo alla dolce vita* (Milan: Skira, 2002)

Fanelli, Giovanni *Histoire de la photographie d'architecture* (Lausanne: Presses Polytechniques et Universitaires Romandes, 2016)

Flaiano, Ennio *La solitudine del satiro* (Milan: Adelphi, 1973)

Frisa, Maria Luisa (ed.) *L'Italia dell'alta moda 1945–1968, exhibition catalogue* (Rome: maxxi, 2014)

Gadda, Carlo Emilio *Eros e Priapo. Da furore a cenere* (Milan: Garzanti, 1967)

Gentiloni Silveri, Umberto (ed.) *4 giugno 1944: La liberazione di Roma nelle immagini degli archivi alleati, exhibition catalogue* (Milan: Skira, 2004)

Giudice, Lia *Le ragazze dell'Alberone* (Florence: Nuova Italia Editrice, 1967)

Gregorovius, Ferdinand *Römische Tagebücher, 1852–1874* (Stuttgart: Verlag der J.G. Cotta'schen Buchhandlung, 1893; Italian edition: *Diari Romani 1852–1874*, 1992)

Insolera, Italo *Roma fascista nelle fotografie dell'Istituto LUCE* (Rome: Editori Riuniti/Istituto LUCE, 2001)

Insolera, Italo; Berdini, Paolo *Roma moderna. Da Napoleone I al XXI secolo* (Turin: Einaudi, 2011)

Insolera, Italo; Di Majo, Luigi *L'EUR e Roma dagli anni Trenta al Duemila* (Rome-Bari: Laterza, 1986)

Insolera, Italo; Sette, Alessandra Maria *Roma tra le due Guerre. Cronache da una città che cambia* (Rome: Fratelli Palombi Editori, 2002)

James, Henry *Italian Hours* (Boston/New York: Houghton Mufflin Company, 1909)

Jannattoni, Livio; Becchetti, Piero *Roma primo Novecento nelle immagini di Alfredo De Giorgio* (Rome: Banco di Santo Spirito, 1988)

Jemolo, Arturo Carlo *Anni di prova* (Vicenza: Neri Pozza, 1969)

Klein, William *Rome* (Milan: Giangiacomo Feltrinelli Editore, 1959)

Lismonde, Pascale (ed.) *Le goût de Rome* (Paris: Mercure de France, 2006)

Lodoli, Marco *Isole. Guida vagabonda di Roma* (Turin: Einaudi, 2005)

Lodoli, Marco *Nuove Isole. Guida vagabonda di Roma* (Turin: Einaudi, 2014)

Lundberg, Bruce W.; Pinto, John A. (eds.) *Steps off the Beaten Path: Nineteenth-Century Photographs of Rome and its Environs. Images from the collection of Delaney and Bruce Lundberg/Sentieri smarriti e ritrovati: Immagini di Roma e dintorni nelle fotografie del secondo Ottocento. Immagini dalla collezione di Delaney e Bruce Lundberg* (Milan: Edizioni Charta, 2007)

Mina, Gianna A. *Con la luce di Roma. Fotografie dal 1840 al 1870 nella Collezione Marco Antonetto/In Rome's Light. Photographs from 1840 to 1870 from the Marco Antonetto Collection, exhibition catalogue* (Milan: 5 Continents, 2015)

Negro, Silvio *Seconda Roma 1850–1870* (Milan: Hoepli, 1943)

Negro, Silvio *Album Romano* (Rome: Gherardo Casini Editore, 1956)

Merlak, Fulvio; Pastrone, Claudio; Tani, Giorgio (eds.) *Gli anni del Neorealismo. Tendenze della fotografia italiana* (Turin: Edizioni FIAF, 2001)

Piantoni, Gianna (ed.) *Roma 1911, exhibition catalogue* (Rome: De Luca Editore, 1980)

Portoghesi, Paolo *Roma un'altra città* (Rome: Edizioni del Tritone, 1969)

Praz, Mario *La casa della vita* (Milan: Adelphi, 1979)

Primoli, Giuseppe Napoleone *Pages inédites recueillies, présentées et annotée par Marcello Spaziani* (Rome: Edizioni di Storia e Letteratura, 1959)

Quaroni, Ludovico *Immagine di Roma* (Rome-Bari: Editori Laterza, 1969)

Ravaglioli, Armando (ed.) *Roma, la capitale: immagini di cento anni, 2 vol.* (Rome: Edizioni Banco di Roma, 1970–1971)

Sanfilippo, Mario *Roma. La costruzione di una capitale 1870–1911* (Milan: Silvana Editore, 1992)

Sanfilippo, Mario *Roma. La costruzione di una capitale 1911–1945* (Milan: Silvana Editore, 1993)

Sanfilippo, Mario *Roma. La costruzione di una capitale 1945–1991* (Milan: Silvana Editore, 1992)

Taine, Hippolyte *Voyage en Italie* (Paris: Librairie Hachette, 1866)

Tani, Giorgio; Maraldi, Antonio; Colombo, Cesare; Pinna, Giuseppe *Gli anni della Dolce Vita. Tendenze della fotografia italiana* (Turin: Edizioni FIAF, 2003)

Taramelli, Ennery *Viaggio nell'Italia del Neorealismo. La fotografia tra letteratura e cinema* (Turin: SEI, 1995)

Terenzi, Claudia; Di Puolo, Maurizio (eds.) *Roma. Sotto le stelle del '44: storia arte e cultura dalla Guerra alla Liberazione, exhibition catalogue* (Rome: Zefiro, 1994)

Turoni, Giuseppe *Nuova Fotografia italiana* (Milan: Schwarz Editore, 1959)

Vidotto, Vittorio *Roma contemporanea* (Rome-Bari: Laterza Editori, 2006)

Viganò, Enrica (ed.) *NeoRealismo, la nuova immagine in Italia 1932–1960* (Milan: Admira Edizioni, 2006)

Vitali, Lamberto *Un fotografo fin de siècle: Il conte Primoli* (Turin: Giulio Einaudi Editore, 1968)

Zanazzo, Giggi *I proverbi romaneschi. Le regole di vita dell'antica saggezza popolare* (Rome: Edizioni Grandmelò, [1885] 1996)

Zannier, Italo *Il dopoguerra dei fotografi, exhibition catalogue* (Bologna: Grafis Edizioni, 1985)

Zannier, Italo *Neorealismo e fotografia* (Udine: Ed. Art &, 1987)

Photo credits
Bildnachweis
Crédits photographiques

© 21st Century Collection/Newcastle University Library 23

© Slim Aarons/Premium Archive/Getty Images 228 top, 231, 236, 237, 245, 338, 339, 340, 341, 344, 400

© akg-images, Berlin/Walter Limot 347, 351

© akg-images/Tony Vaccaro 304/305

© Alinari Archives, Florence 32 bottom, 42 top, 72, 73, 75, 78, 79 top, 79 bottom, 91, 92 top, 114, 322/323

© Ansa/Alinari Archives, Florence 405

© Livio Anticoli/Gamma-Rapho, Paris 424/425

© Bauhaus-Archiv, Berlin, © 2017 Alessandra Pasqualucci, Rom 168

© Carlo Bavagnoli/The LIFE Images Collection/Getty Images 283, 289

© Jonathan Becker 430

© Roger Berson/Roger-Viollet, Paris 225

© Bettmann/Getty Images back cover, 176, 197, 221, 222/223, 232, 233, 249, 292, 293 bottom

© Bibliothèque nationale de France, Paris 24, 28 bottom, 50/51

© Bruni Archive/Alinari Archives Management, Florence 138, 139, 162, 164

© Bruno Barbey/Magnum Photos/Agentur Focus 372/373

© Robert Capa © International Center of Photography/Magnum Photos/Agentur Focus 260, 261

© Mario Carbone, Rome 266, 267, 291

© Henri Cartier-Bresson/Magnum Photos/Agentur Focus 248, 250, 251, 252/253, 254, 308, 309, 310/311, 312, 313

© Archivio Cartoni, Paris 167

© Augusto Casasoli/A3/Contrasto/laif, Cologne 388

© Christo, New York, Photo: Harry Shunk 412

© Henry Clarke/Condé Nast Collection/Getty Images 391

© Henry Clarke/Vogue © Condé Nast Collection 390

© Collection Christophel/Mondadori Portfolio, Milan 230, 330, 333, 431

© Collezioni d'Arte Fondazione Cariparma, donazione Carlo Bavagnoli 287 (inv F 3039.14.069), 288 (inv F 3039.14.075), 290 (inv F 3039.14.068), 306 (inv F 3039.30.018), 307 (inv F 3039.30.079), 354 (inv F 3039.30.015), 355 (inv F 3039.30.008)

© Comune di Roma – Sovrintendenza Capitolina ai Beni Culturali – Museo di Roma, Archivio Iconografico 9, 14, 20, 21, 32 top, 38, 42 bottom, 43, 45, 55, 60, 68, 69, 94/95, 98, 155

© Dean Conger/National Geographic/Getty Images 450

© Ralph Crane/The LIFE Images/Getty Images 234

© Riccardo De Antonis, Rome 240, 241, 242, 244

© Herbert Dorfman/Corbis/Getty Images 332

© Jano Dubravcik/Scheufler Collection/Corbis/VCG/Getty Images 66, 67, 124, 125

© Alfred Eisenstaedt/The LIFE Picture Collection/Getty Images 2, 166, 364/365

© Arthur Elgort 429

© eps/marka, Milan 370, 371

© Elliott Erwitt /Magnum Photos/Agentur Focus 265, 342, 367

© Alberto Fanelli, Milan 384/385, 434

© Archivi Farabola, Milan 140/141, 174

© Franco Fiori/Alinari Archives, Florence 382

© Fondazione Primoli, Rome 61, 92 bottom, 93, 96, 97, 100, 101, 102, 103, 107, 108, 109, 110, 111 top, 111 bottom, 115, 116/117, 118, 119, 120/121, 122, 123

© Fondo Romano, Rome 26/27, 29, 44, 48, 49

© Estate Günther Förg, Suisse/VG Bild-Kunst, Bonn 2017 414, 415

© Fototeca Gilardi, Milan 151

© Leonard Freed/Magnum Photos/Agentur Focus 406/407

© Archivi Garolla, Milan 321

© Courtesy George Eastman Museum, Rochester, N.Y. 70, 71

© Gianni Girani/Reporters Associati & Archivi/Mondadori Portfolio, Milan 404

© Melville B. Grosvenor/National Geographic Creative, Washington, D.C. 298

© Roland Halbe, Stuttgart 435

© Albert Harlingue/Roger-Viollet, Paris 208/209

© Horst P. Horst/Condé Nast Collection/Getty Images 369

© George Hoyningen-Huene/Condé Nast Collection/Getty Images 169

© Hulton Archive/Getty Images 156/157

© Kurt Hutton/Picture Post/Getty Images 207

© Su autorizzazione dell'Istituto Centrale per il Catalogo e la Documentazione – MiBAC 28 top

© Istituto Luce Cinecittà, Rome 144, 153, 158, 159 top, 160/161, 177 bottom, 178/179, 190, 191 193, 195 top, 195 bottom, 198, 206, 212, 227, 285, 348/349

© Richard Kalvar/Magnum Photos/Agentur Focus 376, 410/411

© Dmitri Kessel/The LIFE Picture Collection/Getty Images 5, 229, 235

© Keystone-France/Gamma-Rapho, Paris 152, 165, 175, 177 top, 337 bottom, 363, 366, 368, 402/403, 408

© William Klein, Paris 214/215, 255, 280/281, 296/297, 343

© David Lees/The LIFE Images Collection/Getty Images 302, 331

© Leoni Archive/Alinari Archives, Florence 218, 226

© Library of Congress, Washington, D.C. 76/77

© Licio D'Aloisio/Reporters Associati & Archivi/Mondadori Portfolio, Milan 327 bottom

© Peter Lindbergh, Paris 419, 426, 427

© Herbert List/Magnum Photos/Agentur Focus 192, 243, 256, 262, 263, 264, 284

© Massimo Listri, Florence 440/441

© Archive Mazza-Fanelli, Paris 8, 10/11, 15, 16/17, 30/31, 33, 34/35, 36, 37, 40/41, 47, 54, 62/63, 82/83

© O. Louis Mazzatenta/National Geographic Creative, Washington, D.C. 416/417

© Steve McCurry/Magnum Photos/Agentur Focus 413

© Mondadori Portfolio, Milan 199, 318/319, 401

© Mondadori Portfolio/Giorgio Lotti, Milan 409

© Mondadori Portfolio/Walter Mori, Milan 392

© Movie Poster Image Art/Getty Images 293 top, 337 top

© Carl Mydans/The LIFE Picture Collection/Getty Images 200, 201

© Genevieve Naylor/Corbis/Getty Images 294

© NBC NewsWire/ © NBC Universal/Getty Images 324, 325

© New York Daily News Archive/Getty Images 159 bottom, 316

© Marvin E. Newman/Sports Illustrated/Getty Images 345

© Franco Origlia/Getty Images 389

© Ruth Orkin Photo Archive, New York 238/239

© Gaston Paris/Roger-Viollet, Paris 224

© Winfield Parks/National Geographic Creative, Washington, D.C. front cover, 377, 378/379, 395, 396, 397, 398/399

© Martin Parr/Magnum Photos/Agentur Focus 436/437

© Studio Federico Patellani – Regione Lombardia/Museo di Fotografia Contemporanea, Milano-Cinisello Balsamo 220

© Luigi Pellerano, National Geographic Creative, Washington, D.C. 186, 188/189

© Vincent Peters 439

© Popperfoto/Getty Images 350

© Pierluigi Praturlon/Reporters Associati & Archivi/Mondadori Portfolio, Milan 219, 326, 327 top, 328, 336

© Vittoriano Rastelli/Corbis/Getty Images 113

© Reporters Associati & Archivi/Mondadori Portfolio, Milan 213, 295, 320, 361

© Bettina Rheims, Paris 418, 428

© George Rinhart/Corbis/Getty Images 146/147

© Roger-Viollet, Paris 39, 154, 172

© Bernard F. Rogers Jr./National Geographic Creative, Washington, D.C. 180, 181, 182, 183, 187, 202/203

© Jacques Rouchon/AKG Images, Berlin 268, 269, 270/271, 272, 273, 274/275, 276, 277

© Sam Shaw/Shaw Family Archives/Getty Images 359

© Walter Sanders/The LIFE Picture Collection/Getty Images 228 bottom

© Flip Schulke Archives, West Palm Beach 352/353

© Ferdinando Scianna/Magnum Photos/Agentur Focus 362, 420, 421, 422, 423, 448/449

© Science & Society Picture Library/Getty Images 22, 25

© Tazio Secchiaroli/David Secchiaroli, Rome 314/315, 317, 393

© SeM/Universal Images Group/Getty Images 196, 247

© David Seymour/Magnum Photos/Agentur Focus 246, 258/259, 279

© Elio Sorci/Camera Press, London 360

© Tino Soriano/National Geographic Creative, Washington, D.C. 432/433

© B. Anthony Stewart/National Geographic Creative, Washington, D.C. 299, 300/301, 486

© Nicolas Tikhomiroff/Magnum Photos/Agentur Focus 334/335

© Ullstein Bild 94, 127, 128, 129, 150

© Ullstein Bild – Avocat C. Abeniacar 126 top, 126 bottom

© Ullstein Bild – Histopics 104/105

© Ullstein Bild – Imagno 163

© Ullstein Bild – Imagno/Austrian Archives 145

© Ullstein Bild – Imagno/Franz Hubmann 282

© Ullstein Bild – mirrorpix 133

© Ullstein Bild – Regina Relang 184, 185

© Ullstein Bild – Süddeutsche Zeitung Photo/Scherl Endpapers

© Ullstein Bild – United Archives/Carl Simon 134/135

© Éric Vandeville/Gamma-Rapho, Paris 383

© VEDO/Archivi Farabola, Rome 170, 171

© Franco Vitale/Reporters Associati & Archivi/Mondadori Portfolio, Milan 329

© Massimo Vitali, Lucca 438

© Marc Walter Collection, Paris 56/57, 81, 85, 86, 87, 88/89, 130, 131

© James Whitmore/The LIFE Images Collection/Getty Images 257

© Stephen Wilkes, Westport, C.T. 442–444

© Dave Yoder/l'Osservatore Roma/National Geographic Creative, Washington, D.C. 446, 447 top, 447 bottom

Quotation credits
Zitatnachweis
Sources des citations

7, 13, 19 Giggi Zanazzo, *I proverbi romaneschi. le regole di vita dell'antica saggezza popolare*, Cerroni e Solare, Roma, 1886.

7, 13, 19, 46 Hippolyte Taine, *Voyage en Italie*, Librairie Hachette, Paris, 1866.

23 Nathaniel Hawthorne, *The Marble Faun: or, The Romance of Monte Beni*, Ticknor and Fields, Boston, 1860.

42, 53, 59, 65, 80, 84 Émile Zola, *Rome*, Bibliothèque Charpentier, Paris, 1896.

53, 59, 65 Henry James, *A Roman Holiday*, 1873, in *Italian Hours*, Houghton Mufflin Company, Boston-New York, 1909.

53, 59, 65 Ludovico Quaroni, *Immagine di Roma*, Editori Laterza, Roma-Bari, 1969.

69 Ferdinand Gregorovius, *Römische Tagebücher*, Verlag der J.G. Cotta'schen Buchhandlung, Stuttgart, 1892.

70 Maurice Maeterlinck, *Vue de Rome*, in *Le double jardin*, Charpentier & Fasquelle, Paris, 1904.

74 Henry James, *A Portrait of a Lady*, Houghton, Mufflin and Company, Boston, 1881.

103, 106, 125 Gabriele D'Annunzio, *Il piacere*, Fratelli Treves, Milano, 1889.

112 Letter by Giuseppe Primoli quoted in Lamberto Vitali, *Un fotografo fin de siècle. Il conte Primoli*, Giulio Einaudi editore, Torino, 1968.

127 Henry James, *From a Roman Note-book*, 1873, in *Italian Hours*, Houghton Mufflin Company, Boston-New York, 1909.

132 Trilussa (Carlo Alberto Salustri), *La politica*, 1915, in *Tutte le poesie*, Arnoldo Mondadori, Milano, 1951.

137, 143, 149, 163 Jean Cocteau, *Mon premier voyage (Tour du monde en 80 jours)*, Gallimard, Paris, 1937.

153 Alberto Moravia, *Gli indifferenti*, Alpes, Milano, 1929.

168, 193, 263 Corrado Alvaro, *Itinerario italiano*, Bompiani, Milano, 1941.

170 Antonio Muñoz, *La Roma di Mussolini*, Biblioteca d'Arte Editrice, Roma, 1932.

173, 266, 286 Aldo Palazzeschi, *Roma*, Vallecchi, Firenze, 1953.

205, 211, 217 Pier Paolo Pasolini, in William Klein, *Rome*, Giangiacomo Feltrinelli Editore, Milano, 1959.

206, 212, 218 Miriam Mafai, *Roma, dal 18 aprile alla dolce vita*, in *Roma 1948–1959. Arte, cronaca e cultura dal neorealismo alla dolce vita*, catalogo della mostra, Skira, Milano 2002.

230 *Roma città aperta*, directed by Roberto Rossellini, Excelsa Film, 1945.

235 Claudio Villa (Luciano Martelli, Mario Ruccione), *Vecchia Roma*, from the *album Villa canta la sua Roma*, Fonit-Cetra, 1948.

244, 328 Ennio Flaiano, *La solitudine del satiro*, anthological collection, Rizzoli, Milano, 1973.

246 *Una domenica d'agosto*, directed by Luciano Emmer, Colonna Film, 1950.

256 Carlo Levi, *Il popolo di Roma*, 1960, in *Roma fuggitiva. Una città e i suoi dintorni*, Donzelli Editore, Roma, 2002.

283 Pietro Garinei, Sandro Giovannini, Gorni Kramer, *Domenica è sempre Domenica*, sigla de *Il musichiere*, Combo Record, 1957.

293 *Roman Holiday*, directed by William Wyler, Paramount Picture, 1953.

294 William Klein, *Rome*, Giangiacomo Feltrinelli Editore, Milano, 1959.

303 Renato Rascel (Pietro Garinei, Sandro Giovannini), *Arrivederci Roma*, Dischi ODEON, 1955.

313 *Mamma Roma*, directed by Pier Paolo Pasolini, Arco Film/Alfredo Bini,1962.

317 *Poveri ma belli*, directed by Dino Risi, Titanus/Silvio Clementelli,1957.

325 *La marcia su Roma*, directed by Dino Risi, Fair Film (Roma), Orsay Film (Parigi)/Mario Cecchi Gori, 1962.

333 *La dolce vita*, directed by Federico Fellini, Riama Film/Pathé Consortium Cinéma/Gray-Film, 1960.

337 *Spartacus*, directed by Stanley Kubrik, Bryna Productions, Inc./Universal Pictures Company, Inc., 1960.

346 Pier Paolo Pasolini, "Il mio 'Accattone' in Tv dopo il genocidio", *Corriere della Sera*, October 8, 1975.

358 *8 1/2*, directed by Federico Fellini, Cineriz/Francinex, 1963.

367 Corrado Alvaro, *Roma vestita di nuovo*, Bompiani, Milano,1957.

375, 381, 387 Francisco de Quevedo, *A Roma sepultada en sus ruinas*, c. 1640, in *Selected Poetry of Francisco de Quevedo*, edited by Christopher Johnson, The University of Chicago Press, Chicago & London, 2009.

394 *C'eravamo tanto amati*, directed by Ettore Scola, Deantir/Pio Angeletti, 1974.

397 Stefano Malatesta, introduction to Silvio Negro, *Roma non basta una vita*, Neri Pozza Editore, Vicenza 2014.

413 *Una giornata particolare*, directed by Ettore Scola, Compagnia Cinematografica Champion/Carlo Ponti, 1977.

420 Giulio Carlo Argan, interview with Marc Perelman and Alain Jaubert, 1991, in *Annali dell'Associazione Bianchi Bandinelli*, n. 17, 2005.

431 *To Rome With Love*, directed by Woody Allen, Gravier Productions/Letty Aronson, Benjamin Waisbren, 2012.

Index

p. 2
Alfred Eisenstaedt

Photograph of Sophia Loren taken in 1961, used by the photographer for the cover of his book People (1973).

Sophia Loren 1961, von Eisenstaedt 1973 als Coverfoto für seinen Bildband People ausgewählt.

Le photographe a choisi ce cliché de Sophia Loren pris en 1961 pour illustrer la couverture de son ouvrage People (1973).

p. 486
B. Anthony Stewart

Rome invites reflection. The Sala Paolina in Castel Sant'Angelo with the 16th-century fresco of Emperor Hadrian; in the background, beyond the Loge of Julius II, we see the rione Ponte on the shore of the river Tiber, 1957.

Rom lädt zum Nachdenken ein. Die Sala Paolina in der Engelsburg mit einem Fresko aus dem 16. Jahrhundert, das Kaiser Hadrian zeigt; durch die Loggia Julius II. fällt der Blick auf das Stadtviertel Ponte auf der rechten Tiberseite, 1957.

Rome invite à la réflexion. La salle Pauline du château Saint-Ange avec sa fresque du XVIᵉ siècle représentant l'empereur Hadrien : en arrière-plan, au-delà de la loge de Jules II, le rione/quartier Ponte situé sur la rive droite du Tibre, 1957.

Endpapers
Anonymous

People strolling near the tables outside the Caffè Rosati in Via Veneto, 1936.

Passanten und Gäste an ihren Tischen vor dem Caffè Rosati an der Via Veneto, 1936.

Via Veneto, promeneurs devant la terrasse du Caffè Rosati, 1936.

Acknowledgements
Dank
Remerciements

I am grateful to the entire team at TASCHEN, who have worked to realize this volume in the series *Portrait of a City* with skill and passion, particularly to Benedikt Taschen, who believed in this project. During the editorial process, I have particularly appreciated the organizational skills of Simone Philippi and of the designer Anna-Tina Kessler.

The translation of a text is always a very delicate task, and I am grateful to all the translators for tackling the project with dedication, and also for offering useful observations relating to the original Italian manuscript.

My gratitude goes also to all those who, in different ways and to different degrees, have collaborated with me on this project, in particular: Giovanna Bertelli, Sebastiano Cannavò, Rosa Capobianchi, Francesca Cappellini, Armando Chitolina, Stanislas Choko, Riccardo De Antonis, Reuel Golden, Alba Hernandez, Cristiano Migliorelli (Istituto LUCE), Valeria Petitto (Fondazione Primoli), Jenny Roÿeck, Andrea Sciolari, Simonetta Sergiacomi and Angela Maria D'Amelio (Museo di Roma), Paolo Granata and Nicoletta Saveri (Mondadori Portfolio) and Sarah Wrigley.

This book is dedicated to Nenne, Mino and Cia, Albertina, Sara and Michele, Margherita and Flora.

Mein Dank gilt dem gesamten Team des TASCHEN-Verlags, das mit Kompetenz und Engagement diesen Band der Reihe „Porträt einer Stadt" betreut hat, vor allem Benedikt Taschen, der von Anfang an von diesem Projekt überzeugt war. Während des Entstehungsprozesses habe ich besonders das Organisationstalent von Simone Philippi und der verantwortlichen Grafikerin Anna-Tina Kessler geschätzt.

Den Übersetzern, die sich mit viel Sachverstand ihrer nicht immer einfachen Aufgabe angenommen haben, gilt ebenfalls mein Dank; ihre aufmerksamen Hinweise sind auch dem Originaltext zugutegekommen.

Dank auch an all jene, die in verschiedenster Form am Zustandekommen dieses Buches beteiligt waren: Giovanna Bertelli, Sebastiano Cannavò, Rosa Capobianchi, Francesca Cappellini, Armando Chitolina, Stanislas Choko, Riccardo De Antonis, Reuel Golden, Alba Hernandez, Cristiano Migliorelli (Istituto LUCE), Valeria Petitto (Fondazione Primoli), Jenny Roÿeck, Andrea Sciolari, Simonetta Sergiacomi und Angela Maria D'Amelio (Museo di Roma), Paolo Granata und Nicoletta Saveri (Mondadori Portfolio) sowie Sarah Wrigley.

Ich widme dieses Buch Nenne, Mino und Cia, Albertina, Sara und Michele, Margherita und Flora.

Je remercie toute l'équipe éditoriale de TASCHEN qui a travaillé avec compétence et passion à l'élaboration de ce volume de la série « Portrait d'une ville » ; je remercie tout particulièrement Benedikt Taschen qui a cru dans le projet. Au cours de la réalisation de cet ouvrage, j'ai pu apprécier les qualités d'organisatrice de Simone Philippi et celles de graphiste d'Anna-Tina Kessler.

La traduction des textes étant une opération toujours délicate, j'adresse mes remerciements à tous les traducteurs qui ont généreusement relevé le défi et ont fait part d'observations précieuses sur les textes originaux italiens. Ma gratitude va également à tous ceux qui ont apporté leur collaboration à divers titres et notamment à Giovanna Bertelli, Sebastiano Cannavò, Rosa Capobianchi, Francesca Cappellini, Armando Chitolina, Stanislas Choko, Riccardo De Antonis, Reuel Golden, Alba Hernandez, Cristiano Migliorelli (Istituto LUCE), Valeria Petitto Fondazione Primoli), Jenny Roÿeck, Andrea Sciolari, Simonetta Sergiacomi et Angela Maria D'Amelio (Museo di Roma), Paolo Granata et Nicoletta Saveri (Mondadori Portfolio) et Sarah Wrigley.

Je dédie cet ouvrage à Nenne, Mino et Cia, Albertina, Sara et Michele, Margherita et Flora.

Giovanni Fanelli

EACH AND EVERY TASCHEN BOOK PLANTS A SEED!
TASCHEN is a carbon neutral publisher. Each year, we offset our annual carbon emissions with carbon credits at the Instituto Terra, a reforestation program in Minas Gerais, Brazil, founded by Lélia and Sebastião Salgado. To find out more about this ecological partnership, please check: www.taschen.com/zerocarbon
Inspiration: unlimited. Carbon footprint: zero.

To stay informed about TASCHEN and our upcoming titles, please subscribe to our free magazine at www.taschen.com/magazine, follow us on Instagram and Facebook, or e-mail your questions to contact@taschen.com.

Editorial co-ordination: Simone Philippi, Cologne
Design: Anna-Tina Kessler, Los Angeles
Barcode illustration: Robert Nippoldt
English translation: Antonia Reiner, Toronto
German translation: Achim Wurm, Cologne
French translation: Geneviève Lambert,
 Fontenay-Sous-Bois

Printed in China
ISBN 978–3–8365–6271–3

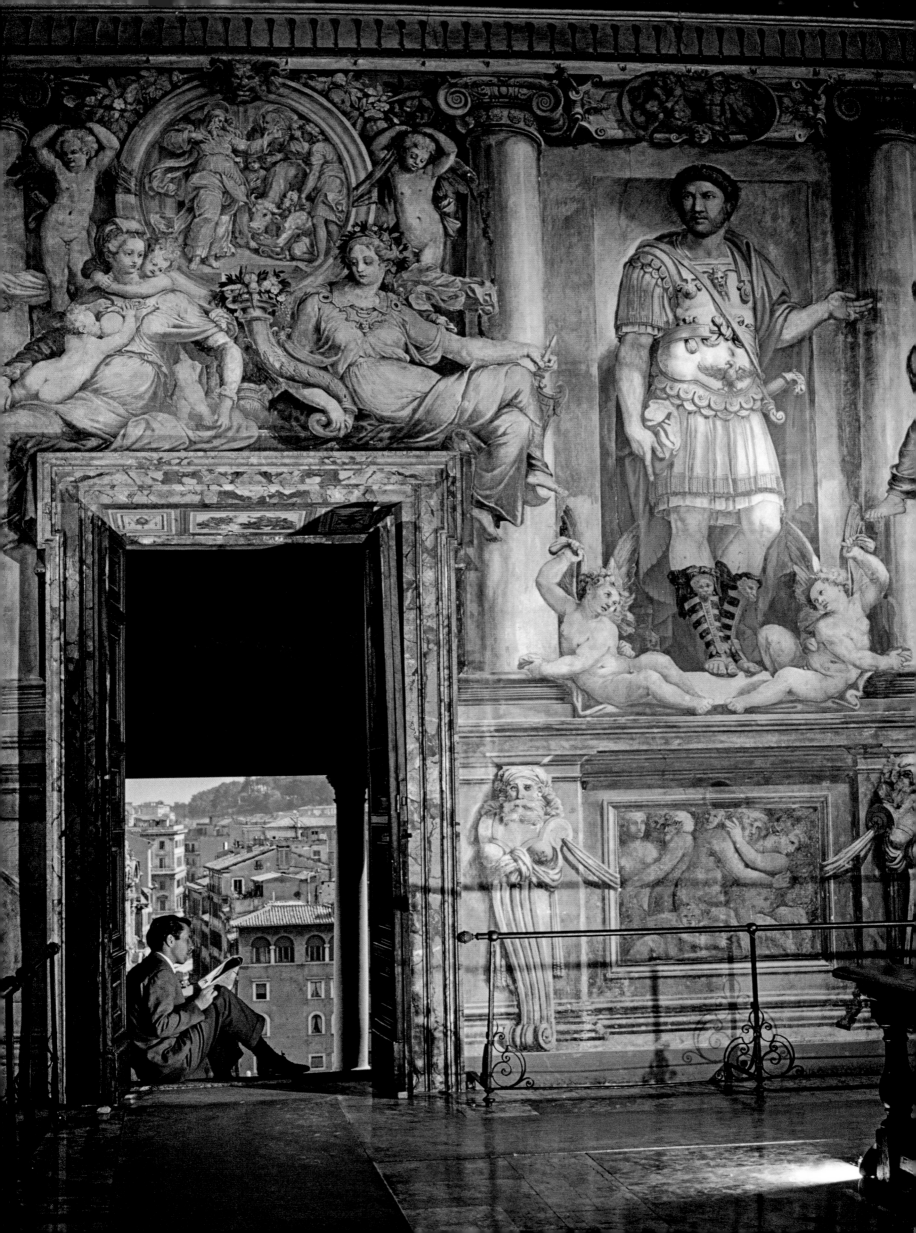

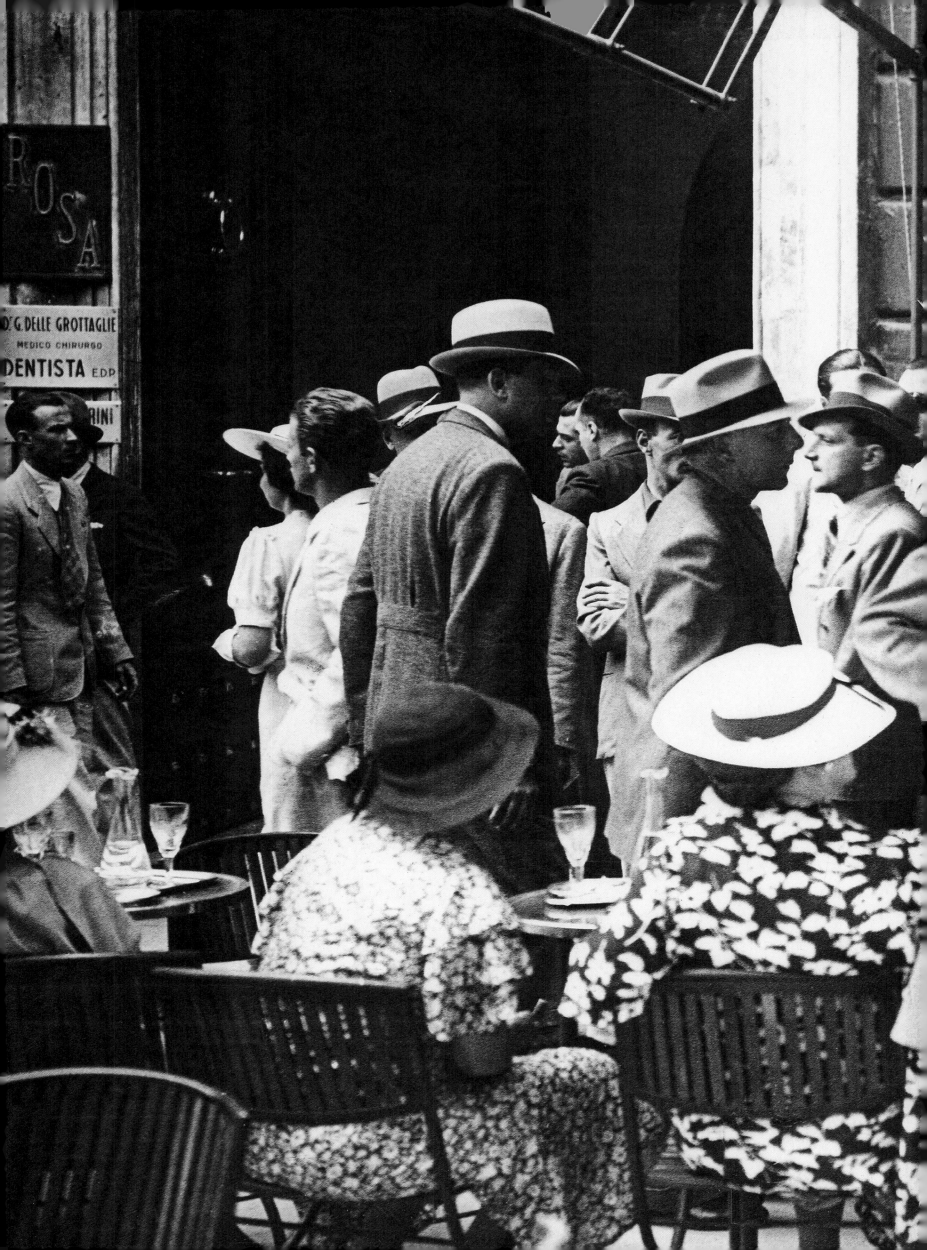